Midwest Studies in Philosophy

Volume XVI

MIDWEST STUDIES IN PHILOSOPHY

EDITED BY PETER A. FRENCH, THEODORE E. UEHLING, JR.,
HOWARD K. WETTSTEIN

EDITORIAL ADVISORY BOARD
ROBERT AUDI (UNIVERSITY OF NEBRASKA)
JONATHAN BENNETT (SYRACUSE UNIVERSITY)
PANAYOT BUTCHVAROV (UNIVERSITY OF IOWA)
RODERICK CHISHOLM (BROWN UNIVERSITY)
DONALD DAVIDSON (UNIVERSITY OF CALIFORNIA, BERKELEY)
KEITH DONNELLAN (UNIVERSITY OF CALIFORNIA, LOS
 ANGELES)
FRED I. DRETSKE (UNIVERSITY OF WISCONSIN, MADISON)
GILBERT HARMAN (PRINCETON UNIVERSITY)
MICHAEL J. LOUX (UNIVERSITY OF NOTRE DAME)
ALASDAIR MACINTYRE (UNIVERSITY OF NOTRE DAME)
RUTH BARCAN MARCUS (YALE UNIVERSITY)
JOHN R. PERRY (STANFORD UNIVERSITY)
ALVIN PLANTINGA (UNIVERSITY OF NOTRE DAME)
DAVID ROSENTHAL (CITY UNIVERSITY OF NEW YORK
 GRADUATE CENTER)
STEPHEN SCHIFFER (UNIVERSITY OF ARIZONA)
MARGARET WILSON (PRINCETON UNIVERSITY)

Many papers in MIDWEST STUDIES IN PHILOSOPHY are invited and all are previously unpublished. The editors will consider unsolicited manuscripts that are received by January of the year preceding the appearance of a volume. All manuscripts must be pertinent to the topic area of the volume for which they are submitted. Address manuscripts to MIDWEST STUDIES IN PHILOSOPHY, Department of Philosophy, University of California, Riverside, CA 92373

The articles in MIDWEST STUDIES IN PHILOSOPHY are indexed in THE PHILOSOPHER'S INDEX.

Forthcoming volumes.

Volume XVII 1992 Wittgenstein's Legacy
Volume XVIII 1993 Philosophy of Science

Available Previously Published Volumes

Volume X 1985 Studies in the Philosophy of Mind
Volume XI 1986 Studies in Essentialism
Volume XII 1987 Realism and Anti-Realism
Volume XIII 1988 Ethical Theory: Character and Virtue
Volume XIV 1989 Contemporary Perspectives in the Philosophy of Language II
Volume XV 1990 The Philosophy of the Human Sciences

Midwest Studies in Philosophy Volume XVI

Philosophy and the Arts

Editors

Peter A. French
Trinity University

Theodore E. Uehling, Jr.
University of Minnesota, Morris

Howard K. Wettstein
University of California, Riverside

University of Notre Dame Press ● Notre Dame, Indiana

Published by the University of Notre Dame Press
Notre Dame, IN 46556
Printed in the United States of America

Library of Congress Cataloging-in-Publication Data

Philosophy and the arts / editors, Peter A. French,
Theodore E. Uehling, Jr., Howard K. Wettstein.
 p. cm. — (Midwest studies in philosophy : v. 16)
 ISBN 0–268–01391–8
 1. Aesthetics. 2. Art—Philosophy. I. French, Peter A.
II. Uehling, Theodore E. III. Wettstein, Howard K. IV. Series.
BH39.P475 1991
700'.1—dc20 91–50200
 CIP

Midwest Studies in Philosophy
Volume XVI
Philosophy and the Arts

Midwest Studies in Philosophy
Volume XVI

James Joyce and Humpty Dumpty*

DONALD DAVIDSON

There is a tension between the thought that what a speaker intends by what he says determines what he means and the thought that what a speaker means depends on the history of the uses to which the language has been put in the past. Relieving this tension, or at least understanding what underlies it, is a leading task of the philosophy of language. To emphasize the role of intention is to acknowledge the power of innovation and creativity in the use of language; seeing history as dominant is to think of language as hedged by—even defined by—rules, conventions, usage. A metaphor, for example, is wholly dependent linguistically on the usual meanings of words, however fresh and astonishing the thought it is used to express; and the interpreter, though he may be hard pressed to decode or appreciate a metaphor, needs know no more about what words mean than can be, or ought to be, found in a good dictionary. A malapropism, on the other hand, is sheer invention. You will not be helped in understanding what Mrs. Malaprop means by her words by looking in the dictionary; but you must grasp what she intends. (Sheridan is, of course, another matter; he is a punster, so to get all that *he* is up to you do need to know what "allegory" normally means as well as what Mrs. Malaprop intends when she mentions the allegories on the bank of the Nile. The airline pilot or steward who assures passengers that "We will be landing momentarily" is not, alas, uttering a malapropism; we know what is meant because we have heard it so often before.)

Humpty Dumpty features here because he is the pure example of the hopeful innovator: "When *I* use a word it means just what I choose it to mean." Joyce is a somewhat different case, though many people may be inclined to deny the difference. This brings me to my theme: Joyce, his views on the use of language, and his use of language.

A Portrait of the Artist as a Young Man is openly, if not quite accurately, autobiographical, but as Harry Levin remarks, it is more credo than autobiography, and, we might want to add, more manifesto than credo. Nowhere else has Joyce prescribed so plainly the aims and standards of the artist.

"My ancestors," says Stephen Deadalus, Joyce's surrogate in *A Portrait*, "My ancestors threw off their language and took another. . . . They allowed a handful of foreigners to subject them. Do you fancy I am going to pay in my own life and person debts they made?" He continues, "When the soul of a man is born in this country there are nets flung at it to hold it back from flight. You talk to me of nationality, language, religion. I shall try to fly by those nets."[1]

How Joyce tried, and the sense in which he succeeded, in flying by the nets of nationality and of religion have been much discussed, and are to some extent understood. He abandoned both his country and his faith, though he never forgot nor forgave either one. Kristian Smidt writes that "Joyce not only feared that Christianity might be true, he felt intimately that behind Christian symbols there 'are massed twenty centuries of authority and veneration'."[2] A similar ambivalence toward Ireland permeated his life and work: in his work he never left it; in his travels he returned seldom and briefly. But how about the other net, the net of language?

Joyce gives this famous formulation of his *non serviam*;

> I will not serve that in which I no longer believe, whether it call itself my home, my fatherland or my church: and I will try to express myself in some mode of life or art as freely as I can and as wholly as I can, using for my defense the only arms I allow myself to use, silence, exile and cunning.[3]

Here all reference to language has been dropped, and in a way not surprisingly. Joyce could leave his country and his church, but could not give up language, despite his weapon of "silence." What then can he have meant by the net of language, and how can he have thought he could fly by it?

In *Stephen Hero*, an earlier and in some ways more revealing autobiographical work than *A Portrait*, Joyce recounts how his friends wanted him, like a patriotic Irishman, to learn Gaelic. He refused. Gaelic is the language Stephen has said his ancestors threw off when they permitted a handful of foreigners to subject them. Stephen will not allow himself to be enlisted by a shallow chauvinism. Should we then, as Harry Levin suggests, conclude that flying by the net of language amounted to no more than—refusing to attend classes in Gaelic?

The subject comes up again in *Ulysses*. Haines, an Englishman visiting Stephen and Buck Mulligan while they are living in the Martello tower at Sandycove, is quizzing Stephen about his religion. "You behold in me, Stephen said with grim displeasure, a horrible example of free thought." While Stephen reflects on the fact that Mulligan will ask him for the key to the tower thus, in Stephen's eye, dispossessing him, Haines goes on, "After all, I should think you are able to free yourself. You are your own master, it seems to me." "I am the servant of two masters, Stephen said, an English and an Italian," and

in reply to a question, he rudely explains, "the imperial British state . . . and the holy Roman catholic and apostolic church."[4] It is hard to believe that for Joyce flying by the net of language meant evading the lame lure of Gaelic in order to accept another foreign master.

In *A Portrait*, Stephen is talking with an English priest. Stephen

> . . . felt with a smart of dejection that the man to whom he was speaking was a countryman of Ben Jonson. He thought:
> —The language in which we are speaking is his before it is mine. How different are the words *home, Christ, ale, master*, on his lips and on mine! I cannot speak or write these words without unrest of spirit. His language, so familiar and so foreign, will always be for me an acquired speech. I have not made or accepted its words. My voice holds them at bay. My soul frets in the shadow of his language.[5]

A phrase here to notice is: I have not made . . . its words.

But of course Joyce valued words of all languages, and especially the words of English.

> He drew forth a phrase from his treasure and spoke it softly to himself:
> —A day of dappled seaborne clouds.—
> The phrase and the day and the scene harmonized in a chord. Words. Was it their colours? He allowed them to glow and fade, hue after hue: sunrise gold, the russet and green of apple orchards, azure of waves, the greyfringed fleece of clouds. No, it was not their colours: it was the poise and balance of the period itself. Did he then love the rhythmic rise and fall of words better than their associates of legend and colour? Or was it that, being as weak of sight as he was shy of mind, he drew less pleasure from the reflection of the glowing sensible world through the prism of a language manycoloured and richly storied than from the contemplation of an inner world of individual emotions mirrored perfectly in a lucid supple periodic prose.[6]

Beauty in language, Stephen maintains, depends on the genre and the form, but in every case "The image . . . must be set between the mind or senses of the artist himself and the mind and senses of others." He then distinguishes the three forms into which art divides. There is first the lyrical form "wherein the artist presents his image in immediate relation to himself . . . he who utters it is more conscious of the instant of emotion than of himself as feeling the emotion." There is then the epical form in which the artist "presents his image in mediate relation to himself and others . . . the centre of emotional gravity is equidistant from the artist himself and from others." Finally, there is the dramatic form. In it, the artist

> presents his image in immediate relation to others The dramatic form is reached when the vitality which has flowed and eddied round each person fills every person with such vital force that he or she assumes a proper and intangible esthetic life. The personality of the artist . . . finally refines itself

out of existence. . . . The mystery of esthetic like that of material creation is accomplished. The artist, like the God of the creation, remains within or behind or beyond or above his handiwork, invisible, refined out of existence, indifferent, paring his fingernails.[7]

These often quoted passages must contain an essential clue to what Joyce had in mind when he spoke of flying by the net of language. The artist, Joyce says, finally "refines himself out of existence"; Stephen repeats these words, and his listener jokingly repeats them once again. Yet how is it possible for a writer to refine himself out of existence by the use of language?

Joyce's conception of aesthetic freedom required that he not be the slave of settled meanings, hypostatized connotations, rules of grammar, established styles and tastes, "correct" spellings. Winning such freedom was for him a supreme act of creation.

The problem is this. In painting, for example, it is not obvious that the artist needs to depend, in creating his effect, on any particular stock of knowledge he shares with the viewer. It is not even plain that there must be a common culture. The writer, however, cannot ignore what his readers know or assume about the words he uses, and such knowledge and expectations can come only from the reader's exposure to past usage. In Lewis Carroll's *Through the Looking-Glass* Humpty Dumpty, the "perfect" innovator, thinks he can mean what he chooses by his words, at least if he pays them extra. At the end of a speech he says to Alice, "There's glory for you!" Alice says she doesn't know what he means. Humpty Dumpty replies, "Of course you don't—till I tell you. I meant 'There's a nice knock-down argument for you!' "

The absurdity of the position is clear. In speaking or writing we intend to be understood. We cannot intend what we know to be impossible; people can only understand words they are somehow prepared in advance to understand. No one knew this better than Joyce. When he spent sixteen hundred hours writing the Anna Livia Plurabelle section of *Finnegans Wake*, he was searching for existing names of rivers, names he could use, distorted and masked, to tell the story. Joyce draws on every resource his readers command (or that he hopes they command, or thinks they should command), every linguistic resource, knowledge of history, geography, past writers and styles. He forces us both to look at and to listen to his words to find the puns and fathom the references.

Flying by the net of language could not, then, imply the unconstrained invention of meaning, Humpty Dumpty style. But neither could it be the result of adopting the lyric form, in which emotion is given "the simplest verbal vesture." The epical form would not achieve Joyce's linguistic ambitions, for in it the writer self-consciously invests his story and his characters with his own personality. Somehow it is the dramatic form, at least as Joyce conceived it, that alone was suited to the task, for it is in the dramatic form that the writer "refines himself out of existence."

In the midst of the Circe episode in *Ulysses* Stephen asks abruptly,

What went forth to the ends of the world to traverse not itself. God, the sun, Shakespeare, a commercial traveller, having itself traversed in reality itself becomes that self. Wait a moment. Wait a second. Damn that fellow's noise in the street. Self which it itself was ineluctably preconditioned to become. Ecco![8]

We recognize the artist under the guises Joyce gave him: God the father, God the son, the sun, Shakespeare ("who, after God, created most"), Ulysses (or Bloom: both commercial travellers). A shout in the street is Stephen's earlier description of God; a shouting in the street is also, Joyce remarks in *Finnegans Wake*, how many people think of his own writing. Ecco; and, given the theme of return to self as the result of original creation, an echo, a *re*sounding.

An echo, a noise in the street, a ghost, may be much more than it seems. "What is a ghost?" asks Stephen in response to the remark that in his view *Hamlet* is a ghost story.

One who has faded into impalpability through death, through absence, through change of manners. Elizabethan London lay as far from Stratford as corrupt Paris lies from virgin Dublin. Who is the ghost from *limbo patrum*, returning to the world that has forgotten him? Who is king Hamlet?[9]

While Stephen prepares us for the mock-serious theory that Shakespeare identified himself with the ghost in *Hamlet* and that therefore Hamlet is Shakespeare's son, Joyce compares himself, an exile from Dublin living in Paris, with Shakespeare self-exiled from Stratford living in London. It is the father-creator, the "lord of language" as Joyce calls Shakespeare, who is the ghost, one who has faded into impalpability, who has refined himself out of existence. We are asked to remember that Shakespeare not only created the play but is also said to have played the part of the ghost in the first performance of the play. "Is it possible," Stephen asks,

Is it possible that that player Shakespeare, a ghost by absence, and in the vesture of buried Denmark, a ghost by death, speaking his own words to his own son's name (had Hamnet Shakespeare lived he would have been prince Hamlet's twin) is it possible, I want to know, or probable that he did not draw or foresee the logical conclusion of those premises: you are the dispossessed son: I am the murdered father: your mother is the guilty queen, Ann Shakespeare, born Hathaway?[10]

In the Scylla and Charybdis scene in *Ulysses*, from which these quotations come, Stephen is, we realize, not only Joyce's stand-in but also his Hamlet. If Bloom is Stephen's surrogate father, Joyce is Stephen's creator. In *Ulysses*, Bloom is a man *nel mezzo del camin di nostra vita*, as was Dante when he wrote this line, as was Shakespeare when he wrote *Hamlet*, as was Joyce when he wrote *Ulysses*. We cannot read an adulterous wife into Joyce's life, though this was a fantasy he seems to have enjoyed, but the similarity between Stephen's Ann Hathaway and Molly Bloom is clear.

Stephen explains how Shakespeare came to marry:

He was chosen, it seems to me. If others have their will Ann hath a way. By cock, she was to blame. She put the comether on him, sweet and twenty-six. The greyeyed goddess who bends over the boy Adonis, stooping to conquer, as prologue to the swelling act, is a boldfaced Stratford wench who tumbles in a cornfield a lover younger than herself.[11]

What is the greyeyed goddess doing here? She is, of course, Athena, the most pervasive female presence in Homer's *Odyssey*, Odysseus' guide, mentor, friend, advisor, and above all his admirer and understander. Why does she play so small a part in Joyce's *Ulysses*? She turns up once more as a stuffed owl who regards Bloom at the end of the day "with a clear melancholy wise bright motionless compassionate gaze." Her identification with Ann Hathaway, and later with Molly Bloom, suggests that Athena may, like Cordelia, play a more important role absent than on the stage, like the artist who has refined himself out of existence.

Shakespeare marries and leaves Stratford for London, but his brush with Ann-Athena leaves him altered. "He had no truant memory," Stephen says. "He carried a memory in his wallet as he trudged to Romeville. . . ." The words carry us to another play Joyce had very much in mind as he worked on *Ulysses*, Shakespeare's *Troilus and Cressida*. Written perhaps a year after *Hamlet*, it belongs to that same period when Shakespeare dwells on the themes of treachery, adultery, and banishment; and of course its observant hero is Ulysses. In *Troilus and Cressida* Ulysses shames Achilles into returning to battle by reminding him that perseverance alone keeps honor bright, that "to have done, is to hang/ Quite out of fashion, like a rusty mail/ in monumental mock'ry." The speech begins, "Time hath, my lord, a wallet at his back,/ Wherein he puts alms for oblivion. . . ."[12] The other theme of *Troilus and Cressida* is also one of a treacherous memory—Cressida's betrayal of Troilus.

If the "note of banishment, banishment from the heart, banishment from the home sounds uninterruptedly" in his middle period, the "plays of Shakespeare's later years. . .breath another spirit—the spirit of reconciliation." Stephen is not impressed; he drily remarks "There can be no reconciliation. . .if there has not been a sundering." Nevertheless, the concept of the third period as embodying the mature art of the creative writer now begins to embrace another idea besides that of a steady progress from phase to phase. The new idea is that of the *nostos* or return, the bold adventure followed by the dangerous but successful odyssey home, the son who slays and replaces the father to become the father in turn, the writer who flies by the net of inherited or imposed language, but makes or remakes his own.

As we. . .weave and reweave our bodies, Stephen said, from day to day, their molecules shuttled to and fro, so does the artist weave and reweave his image. And as the mole on my right breast is where it was when I was born,

though all my body has been woven of new stuff time after time, so through the ghost of the unquiet father the image of the unliving son looks forth.[13]

With Joyce as with Homer's hero we are never quite sure whether exile is voluntary or imposed, whether the lingering in the Calypso's cave of Paris is a delight or a torment. In the same ambiguous vein, it is not clear why a round trip must include a fatal accident, why a return implies a sundering, why a repetition calls for a break. But there seems no question but that in the Joycean-Viconian scheme, creation follows on destruction; the cycle cannot begin again without the vast shattering thunderclap heard throughout *Finnegans Wake*. It is from the "ruin of all space" that the artist builds his language. "The note of banishment sounds uninterruptedly from *The Two Gentlemen of Verona* onward till Prospero breaks his staff, buries it certain fathoms in the earth, reflects itself in another, repeats itself, protasis, epistasis, catastasis, catastrophe."[14]

In a brilliant article written a number of years ago, Nathan Halper analyzed one of the most difficult passages in *Finnegans Wake*.[15] It is a passage almost twenty pages long in the eleventh chapter and it concerns an event supposed to have happened during the Crimean War; a man named Buckley shoots a Russian general. Halper convinces us that Buckley, an authentic Irishman who actually did participate in the Crimean War, is the Archetypical Son; the general is the Archetypical Father. There is a horse race shown on the screen. The horses are Emancipator and Immense Pater. The race is a "dawnybreak," a rising of the sun; the time is heliotropical. The Crimean peninsula is where the primeval crime of the paracidical son took place. "Dublin" in Gaelic turns out to mean a black pool, and Siva's black pool becomes Sea vast a pool—Sevastapol. History records that there was a Russian general in the Crimean war named de Todleben.

There is much more of this, all good dirty fun, part of the funferal of *Finnegans Wake*. At the end comes a reference to Joyce himself who is playing a "Cicilian hurdygurdy." Cicilian because Cecil was Buckley's first name, but also because "Cecil" is derived from the Latin for blind and thus serves to remind us of Joyce, who was nearly blind by the time he wrote *Finnegans Wake*. In the dark Joyce weaves and reweaves his world; de Todleben is known for the fact that each night at Sevastopol he rebuilt the defenses. There is an explosion, the "abnihilization of the etym." Halper concludes: "Joyce is destroying language. He is annihilating meaning—he is re-creating language. In other words—'in other words'—he is writing *Finnegans Wake*."

Harry Levin, writing on this same passage, but before Halper's useful article, came to much the same conclusion. He says of the lethal explosion,

Pessimists may interpret this ambiguous phenomenon as the annihilation of all meaning, a chain reaction set off by the destruction of the atom. Optimists will emphasize the creation of matter *ex nihilo*, and trust in the Word to create another world.[16]

Joyce's way of resolving the tension between invention and tradition is in a way obvious; like any writer he must depend on the knowledge his readers are able to bring to his writings. Much of this knowledge is verbal of course, knowledge of what words ordinarily mean. But in Joyce's case much of what is required must come from other sources. When he uses the word—if that is what it is—"Dyoublong," there is not much chance of guessing what Joyce means, despite the capitalization of the first letter, unless one has Dublin in mind, something Joyce's readers cannot fail to do. So one needs at least to know the reference of the name "Dublin" and the meaning of the phrase "Do you belong?"; finding them both in "Dyoublong" requires more. The destruction of the ordinary structure of ordinary English is nearly complete, but that it forms a very large part of the foundation of Joyce's structure is obvious. A random paragraph from *Finnegans Wake* begins "He beached the bark of his tale; and set to husband and vine" Yet in that paragraph fully a third of the "words" belong to no language at all; something like this percentage probably goes for the book as a whole. And of course there is plenty of destruction that goes beyond merely grinding up familiar words and assembling new words from the pieces; there is the destruction of grammar. Yet the destruction is never for its own sake; as Campbell and Robinson say, there are no nonsense syllables in Joyce.[17] This is certainly right. But then one should wonder what philosophers and linguists mean when they say that speaking and writing are "rule-governed" activities.

Many of Joyce's inventions are of the "Dyoublong" kind: "Makefearsome's Ocean," "Persse O'Reilly" (one of Humphrey C. Earwicker's many names; an earwig is called in French a perce-oreille), "the old cupiosity shape" all turn up in his "meandertale." More complex, and more basic to Joyce's methods, are whole sentences (if that is what they are) with systematically related paranomasias. "Nobody aviar soar anywing to eagle it," is a flip example; "Why do I am alook alike a poss of porter pease?" is another (with suggestions of "like as two peas," a request for a pot of porter, please, and a reference to Piesporter wine). And a last exhibit: "Was he come to hevre with his engiles or gone to hull with the poop." It's clear that when Joyce was flying by the net of language, he did not intend to leave us unentangled.

Joyce achieves many of his effects, it is clear, through a process of accretion: he piles word on top of word, reference on reference, sly hint on crass joke, personal allusion on top of classical quotation. One might expect the result to be a ponderous verbosity, but instead Joyce achieves an extraordinary economy of expression. As he says, "When a part so ptee does duty for the holos we soon grow to use of an allforabit." The child who does his duty soon grows to use the alphabet; so the mature artist learns to let bits of language reverberate on a viconian scale: at one point Joyce compresses it into "Atom, Adam, etym." "What universal binomial denominations would be his as entity and nonentity?" asks the impersonal catechist of the Ithaca episode in *Ulysses*. The three word answer glances at *Pilgrims Progress* and, more significantly, echoes Odysseus' cunning answer to the Cyclops: "Everyman and Noman."

That "Noman," Joyce's invisibility act, brings us by a commodious vicus of recirculation back to the point where—well; I began by asking what Joyce may have meant when he declared that he would fly by the net of language, and I connected this youthful boast with two themes in Joyce: the idea, first, that evolution implies revolution, and that revolution entails both destruction and return to the point of origin, and the idea, second, that the mature literary artist refines himself out of existence. Answers that seem relevant to the question, how did Joyce think he was destroying and remaking language, answers of the sort we have just been rehearsing, do not seem pertinent when we face the second issue: how, by making language according to his own taste, Joyce was refining the artist out of existence? I believe there is an answer to this question, but it goes beyond issues of verbal technique.

And so it should, for many of the accomplishments we are crediting to Joyce, which are correctly characterized by Harry Levin as forms of symbolism, though no doubt promoted in novel ways by Joyce's acrobatic stunts with language, might have been achieved in other ways. Symbolism is usually and most easily implemented by the plainest language; plain language by no means entails plain thought or plain effects. Dante, to whom Joyce in effect compares himself (both are exiles writing compendiously and with generalizing intent about the land and society they have left), Dante, writing, as he tells us, on four different levels simultaneously, chose a relatively simple vernacular. The styles of writers who have been truly creative with language, on the other hand—Aristophanes, Rabelaise, Sterne, Céline, for example—have typically not been highly figurative, allegoric or symbolic.

Joyce's use of language is connected to his view that in its most developed form, what he called the dramatic, the artist "remains within or behind or beyond or above his handiwork, invisible." Like Odysseus the artist can make himself invisible, a noman or a ghost, in many ways: by taking another's name, or country, or race, or language; or by changing himself, like Proteus, into another form.

It might seem that the simplest way for the writer to remove himself from the scene is to let his characters speak for themselves, and to refrain from speaking for them or of them. The suggestion hangs in the air when Joyce calls the third style the dramatic. This hint no doubt contributed to the idea that the truly original element in Joyce's style consists in the use of the interior monologue. Richard Ellman calls the interior monologue "the most famous of the devices of *Ulysses*," and says,

> Joyce had been rapidly moving towards a conception of personality new to the novel. . . . His protagonists moved in the world and reacted to it, but their basic anxieties and exaltations seemed to move with slight reference to their environment. They were so islanded, in fact, that Joyce's development of the interior monologue to enable his readers to enter the mind of a character without the chaperonage of the author, seems a discovery he might have been expected to make.[18]

According to Ellman, then, the device of the interior monologue is one way in which Joyce refined himself, if not out of existence, at least out of the picture. This seems to me an oversimplification for at least two reasons. If having his characters speak for themselves were in itself a convincing way for a writer to withdraw from his work, there would be no way an author could inject himself into his work. But just as nothing an author says can guarantee that we will take an author as speaking for another, nothing can ensure that we will take him as speaking for himself. Sometimes, perhaps, we are sure it is Fielding who is addressing us in his own persona; we are less certain about Sterne; and though the superficial tone is much the same in Defoe, we *know* he is kidding. Sham prefaces, claims about manuscripts found in bottles, endless declarations of sincerity—none of these suffices to put the man before us, nor, often, is it meant to. Only the total context can do that.

The other side of the story is that the interior monologue seldom so much as pretends to stay entirely inside the appropriate character. Even Molly Bloom's soliloquy conspicuously contains elements we cannot easily suppose were, even unconsciously, in that good woman's head.

Harry Levin thinks that here Joyce errs. Commenting on Joyce's telling of Earwicker's dream. Levin says,

> The darker shadings of consciousness, the gropings of the somnolent mind, the state between sleeping and waking—unless it be by Proust—have never been so acutely rendered. But Joyce's technique always tends to get ahead of his psychology. *Finnegans Wake* respects, though it garbles and parodies, the literary conventions. It brims over with *ad libs*, and misplaced confidences and self-conscious stage-whispers. Now and then it pauses to defend itself, to bait the censorship, or to pull the legs of would-be commentators It includes a brief outline of *Ulysses*, and even a letter from a dissatisfied reader. In reply, frequent telegraphic appeals from the author to his "abcedminded" readers . . . punctuate the torrent of his soliloquy periodically. These *obiter dicta* cannot be traced, with any show of plausibility, to the sodden brain of a snoring publican. No psychoanalyst could account for the encyclopedic sweep of Earwicker's fantasies or the acoustical properties of his dreamwork.[19]

We may not agree with Levin—I don't—that these undoubted features of Joyce's style count as a defect, but we can concur that the interior monologue, as Joyce treats it, is not his way of refining himself out of existence.

If we look back to those pregnant passages on literary form in *A Portrait of the Artist*, an ambiguity now emerges. In the epical form, for example, "the centre of emotional gravity is equidistant from the artist himself and from others." Who are these others, the author's characters or his readers? When, in the dramatic form, the artist refines himself out of existence, is he putting distance between himself and Humphrey C. Earwicker, or between himself and his readers? Perhaps Joyce was mainly thinking of the artist's relation to his characters. But as Levin pointed out in the passage I just quoted, Joyce did not choose to remove himself, stylistically or otherwise, from his characters. The

distance his style created, a distance that increased from *Dubliners* through *Ulysses* and reached its extreme in *Finnegans Wake*, was the distance between the text and its readers.

Edmund Wilson, in one of the earliest critical appreciations of Joyce, remarked that both Proust and Joyce express the concept of relativity (which Joyce called parallax in *Ulysses*), in which the world changes "as it is perceived by different observers and by them at different times."[20] Wilson also may have had in mind no more than Joyce's relation to his characters, but it surely would not be wrong to include Joyce's readers as contributing an essential perspective. Shem, "the penman" of *Finnegans Wake*, with whom Joyce clearly identifies, makes clear that this is Joyce's view. "He would not put fire to his cerebrum; he would not throw himself in Liffey; he would not explaud himself with pneumantics." Nevertheless, with "increasing interest in his semantics" you will find him "unconsciously explaining, for inkstands, with a meticulosity bordering on the insane, the various meanings of all the different foreign parts of speech he misused. . . ."[21] He expects his readers to sympathize when he sings, "Flunkey Footle furloughed foul, writing off his phoney," but for all that he expects his readers to decode the "languish of Tintangle."[22]

All reading is interpretation, and all interpretation demands some degree of invention. It is Joyce's extraordinary idea to raise the price of admission to the point where we are inclined to feel that almost as much is demanded of the reader as of the author. Goading his audience into fairly testing creative activity, Joyce both deepens and removes from immediate view his own part in the proceedings. By fragmenting familiar languages and recycling the raw material Joyce provokes the reader into involuntary collaboration, and enlists him as a member of his private linguistic community. Coopted into Joyce's world of verbal exile, we are forced to share in the annihilation of old meanings and the creation—not really *ex nihilo*, but on the basis of our stock of common lore—of a new language. All communication involves such joint effort to some degree, but Joyce is unusual in first warning us of this, and then making the effort so extreme.

Joyce takes us back to the foundations and origins of communication; he puts us in the situation of the jungle linguist trying to get the hang of a new language and a novel culture, to assume the perspective of someone who is an alien or an exile. As we, his listeners or readers, become familiar with the devices he has made us master, we find ourselves removed a certain distance from our own language, our usual selves, and our society. We join Joyce as outcasts, temporarily freed, or so it seems, from the nets of our language and our culture.

Joyce has not, of course, refined himself out of existence; but by the violent originality of his language he has shifted some of the normal burden of understanding and insight onto his bemused readers. The center of creative energy is thus moved from the artist to a point between the writer and his audience. The engagement of the reader in the process of interpretation, forced on him by Joyce's dense, unknown idiom, bestows on the author himself a

kind of invisibility, leaving the interpreter alone with the author's handiwork, absorbed in his own creative task. By creating a hermeneutic space between the reader and the text, Joyce has at the same time doubled his own distance from the reader. This is, I suggest, what Joyce meant by saying the artist refines himself out of existence, and what he implied by his announced intention of flying by the net of language.

NOTES

* This paper is the text of a talk delivered to the Norwegian Academy of Science and Letters on March 10, 1988.

1. *A Portrait of the Artist as a Young Man* (New York, 1928,) 238.

2 Kristian Smidt, *James Joyce and the Cultic Use of Fiction* (Oslo, 1959), 25. I wish to thank Professor Smidt for his expert comments; they have influenced my understanding of Joyce, though I know he would not endorse all that I say.

3. *A Portrait of the Artist*, 291.

4. *Ulysses* (New York, 1986), 17.

5. *A Portrait of the Artist*, 221.

6. Ibid., 194.

7. Ibid., 252.

8. *Ulysses*, 412.

9. Ibid., 154.

10. Ibid., 155.

11. Ibid., 157.

12. *Troilus and Cressida*, III, iii.

13. *Ulysses*, 159–60.

14. Ibid., 174.

15. Nathan Halper, "James Joyce and the Russian General," *Partisan Review* 18 (1951): 424–31.

16. Harry Levin, *The Essential James Joyce* (Harmondsworth, 1963), 15 (first published, 1948).

17. Joseph Campbell and Henry M. Robinson, *A Skeleton Key to Finnegans Wake* (New York, 1944), 360.

18. Richard Ellman, *James Joyce* (New York, 1959), 368.

19. Levin, *Essential James Joyce*, 175.

20. Edmund Wilson, *Axel's Castle* (New York, 1948), 221–22.

21. *Finnegans Wake*, 172–73.

22. Ibid., 418, 232.

What Metaphors Do Not Mean*

JOSEF STERN

That aesthetics has become such a lively, integral part of the contemporary philosophical scene can be traced to at least two factors. First, aestheticians have succeeded in establishing strong connections between their particular concerns and mainstream currents in philosophy—in epistemology, metaphysics, and especially the philosophy of language. Second, they have nurtured a healthy self-awareness in themselves that the problems of aesthetics are often too fragile and subtle to be forced into the mold of one or another off-the-rack theory imported from a core area of philosophy.[1] On the other hand, it is also becoming increasingly better recognized that other areas of philosophy as well as aesthetics stand to gain from their interaction. Problems which, because of their special character, were often relegated in the past to aesthetics—where they were left either to lie fallow or to be cultivated within its narrow boundaries—are now being rediscovered and newly appreciated for what they can tell us about our general theories of language, knowledge, perception, and the like. Those who come to these problems from this last perspective may have little intrinsic interest in aesthetics. However, like exotic phenomena in the sciences, these special problems take on a derivative but no less significant value because of their implications for more central questions.

There is hardly a better example of this development than the problem of metaphor which has been subject to profuse attention by philosophers of all fields over the past dozen years. While aestheticians and literary theorists have addressed the topic almost continuously since Aristotle (and continue productively to do so), in recent years the topic has also attracted numerous philosophers of language, epistemologists, and philosophically minded linguists and cognitive scientists. In this essay, I shall examine one of these recent approaches to metaphor, both to show how current work in the theory of reference and philosophy of language can inform our understanding of this traditional problem in aesthetics and, as important, to demonstrate how sensitivity to an apparently special and remote problem in aesthetics can have considerable

implications for our general conception of semantic knowledge and the theory of meaning.

My text for this lesson will be Donald Davidson's influential account of metaphor, although I shall limit my discussion here to one small part of his story. In his one essay specifically on metaphor, "What Metaphors Mean," Davidson makes two negative claims and one positive proposal.[2] On the negative side, he denies (1) that metaphors have a "metaphorical meaning" in addition to their literal meaning and, apart from the error of treating it as meaning, he also denies (2) that a metaphor has "a definite cognitive content that its author wishes to convey and that the interpreter must grasp if he is to get the message" (262). (3) On the positive side, he proposes, though only in the sketchiest form, that metaphor is an imaginative *use* of language whose intended *effect* is to make us notice likenesses. Of these theses, literally three-quarters of Davidson's main arguments in WMM are in support of (2). In this essay, however, I shall put them aside and assume for the sake of argument that metaphors can and often do 'convey' or 'communicate' (to use neutral terms) some kind of cognitive content.[3] Here I shall address only (1), Davidson's critique of metaphorical meaning—the thesis that the content communicated by a metaphor is, or should be located in, its *meaning*—and his complementary proposal (3) that metaphor is rather a matter of use. In WMM Davidson explicitly presents both this critique and the positive proposal only in a few bare sentences. However, his argument, which articulates a widespread attitude toward the possibility of a semantics of metaphor, should be understood and elaborated through his other writings on radical interpretation and, in particular, one of his most recent essays, "A Nice Derangement of Epitaphs."[4] So, while my aim here is not Davidsonian exegesis, I will freely weave among these essays to construct the strongest case that can be made.

Davidson's account is especially well suited to illustrate my opening observation about aesthetics because Davidson brings to his discussion of metaphor a well-developed theory of meaning which has a clear role in shaping its contours; at the same time he shows considerable sensitivity to the special nuances of the problem. However, I also have an ulterior motive for this extended critique of Davidson which is to motivate a rather different account of metaphor—one that employs metaphorical meanings—that I have begun to develop elsewhere.[5] Because my own account and Davidson's start from such similar positions, it is especially instructive to see where and why we diverge. We both hold that the notion of truth (or reference, of which truth would be a special case) should occupy a central place in a theory of meaning, and we both also draw a sharp distinction between what words mean and what they are used to do. We also agree that, in some sense yet to be explicated, essential to the very notion of metaphor is that the metaphorical "depends" on the literal. And, finally, we both begin from the observation that metaphorical interpretation is highly context-dependent. However, whereas Davidson, along with most other philosophers, draws from this the conclusion that metaphor must be a matter

of use and not meaning, a subject for pragmatics rather than semantics, I argue that we can give a semantics for metaphor precisely by embracing it as a kind of context-dependent expression on the order of the demonstratives and indexicals. In this essay, I shall not attempt to work out my alternative theory in any detail, but at various points in my running critique and in the last section I shall take the opportunity to indicate how the argument might lead to rather different conclusions than Davidson's.

The structure of my argument will be as follows. In Section I, I begin by explaining what exactly is at stake in Davidson's proposal that metaphor should be explained as a use of words which possess only their literal meaning, an explanation that rejects all notions of "metaphorical meaning," including a variant of speaker's meaning for metaphor. In Section II, I then turn to Davidson's conception of literal meaning which plays perhaps *the* central role in his account of metaphor as use and, in Section III, to his argument why what a metaphor communicates should not be considered a kind of metaphorical meaning analogous to literal meaning. In the next two sections, I shall then examine two different ways in which Davidson proposes to explain how words are used to achieve their distinctively metaphorical effect through, or "depending on," their literal meaning. In Section IV, I explore the idea put forth in WMM that utterance of the metaphor *causes* the effects distinctive of metaphor, and in Section V, his suggestion in NDE that a metaphor succeeds in communicating in the same way that a referential definite description succeeds in referring, despite the literal falsity of each. With both of these proposals, but especially the latter, I shall try to show how their specific weaknesses reflect more general difficulties with the underlying conception of semantics Davidson employs in his account of metaphor. In the concluding Section VI, I shall briefly indicate the morals I would draw from these difficulties for the alternative conception of semantics and meaning I employ in my own account of metaphor.

I

Davidson's starting place is "the distinction between what words mean and what they are used to do" (WMM 247). Writers on metaphor, he charges, typically confuse the two: they take what metaphors are used to do—make us recognize hitherto unnoticed "aspects of things" or "surprising analogies and similarities"—"and read these contents into the metaphor itself" (WMM 261), thereby converting them into their meaning. This is wrong because "posit[ing] metaphorical or figurative meanings, or special kinds of poetic or metaphorical truth" in order to explain how "words work in metaphor" is

> like explaining why a pill puts you to sleep by saying it has a dormative power. Literal meaning and literal truth conditions can be assigned to words and sentences apart from particular contexts of use. This is why adverting to them has genuine explanatory power. (WMM 247)

That is, the appeal to metaphorical or figurative meanings is vacuous and, therefore, bad explanation—for a reason somehow connected to their context-dependence.

On the other hand, if we treat a metaphor as a kind of use of words, Davidson says that we can explain how it "brings off" its particular "effect" in terms of "the imaginative employment of words and sentences [which] depends entirely on the ordinary meanings of those words and hence on the ordinary meanings of the sentences they comprise" (WMM 245). In other words, here Davidson seems to be saying that to the extent to which metaphorical interpretation depends on meaning at all, it "depends entirely" on the literal meaning of the words used; however, like dream interpretation to which he also compares metaphorical interpretation, "the act of interpretation is itself a work of the imagination," an act hardly "guided by rules" (ibid.).

Now, many philosophers have reacted to Davidson's bald denial of "metaphorical meaning," and his complementary claim that a sentence used metaphorically only means what its words literally mean, with a mixture of bafflement and disbelief. After all, could Davidson himself really believe that Romeo *means* and *only* means—in any sense of the term 'means'—the literal meaning of 'Juliet is the sun'? There are two responses to this reaction, one short, the other long. The short response is deflationary. Despite his deliberately provocative way of putting it, Davidson is simply drawing a corollary of the familiar distinction between what words mean (the subject matter of semantics) and what they are used to do (the subject matter of pragmatics). Once we conservatively restrict our use of the term 'meaning' to the former and locate metaphor in the latter, then what metaphors "communicate," propositional or not, will ipso facto not be *meaning*.

Davidson's point is not, however, merely terminological, and that brings us to the longer response. One could reply that we might still count the effect of a metaphor as a kind of meaning while maintaining a clear distinction between semantics and pragmatics, by distinguishing between semantic or word-meaning or sentence-meaning, on the one hand, and utterance-meaning or speaker's meaning, on the other, a distinction familiar enough from the work of Grice and Searle. Davidson, however, rules this way out. In the course of denying that metaphors convey any propositional content (beyond their literal meaning), he asserts parenthetically: "nor does [the] maker [of a metaphor] say anything, in using the metaphor, beyond the literal" (WMM 247). This parenthetic remark is not peculiar to Davidson's discussion of metaphor. For in general he expresses doubt about the possibility of codifying the abilities and skills involved in so-called "speaker's" or "utterance meaning" in the form of "principles" (à la Searle) or "maxims" (à la Grice), pre-established or conventional rules which would be either specific to language or linguistic activities like conversation. Instead the kinds of inferences and reasoning these activities employ require only, he says, the "cleverness," "intuition, luck, and skill" which are necessary for *any* rational activity or for "devising a new theory in any field."[6] What words are *used to do* should

never, then, be considered *meaning*, even qualified by the terms 'speaker' or 'utterance.'

This is not the place for a full-dress evaluation of the question whether conversational implicatures and speaker's meaning should be considered varieties of meaning. However, I would like to offer some support for Davidson's view that metaphor in particular, insofar as it is a matter of use, should also not be subsumed under a category of speaker's, or utterance, meaning. Consider briefly Searle's treatment of metaphor along just these lines.[7]

Searle begins from the premise that our ability to understand a metaphor, although not part of our semantic competence (which governs sentence meaning), is nonetheless "systematic rather than random or ad hoc." Therefore, it must be governed by "principles" (of "speaker's utterance meaning") which explain how speakers "can say metaphorically 'S is P' and mean 'S is R,' where P plainly does not mean R."[8] Searle further emphasizes that there is no single principle that serves this purpose for all metaphors; in fact he proposes eight different principles in his essay, with the "confident" proviso that even they are not exhaustive. However, all these principles have the common function that they "call R to mind" given an utterance of P. Now, the question I want to raise is whether these "principles," exhaustive or not, justify thinking of R as a *meaning* of the metaphorical use of P.

Two things are evident when we examine Searle's eight principles. First, the eight principles nicely show that the contents or features [R] that can serve as possible metaphorical interpretations of expressions [P] are as heterogeneous a class as one might ever imagine. The R's can range over features that are either definitionally, or necessarily, (Principle 1) or contingently (Principle 2) true of the P's. But *in general* they need not be *actually* true or even *believed* to be true of the P's. An R feature may only be culturally or naturally "associated with [P] in our minds" (Principle 4) or the condition under which it holds may somehow be "like" that of R (Principle 5). In other words, there is no one interesting principle (e.g., resemblance) that might describe the contents of all metaphorical interpretations; the best we can do is the *un*interesting description that the one, the expression P, "calls the other [the feature R] to mind," and in order to make this relation more interesting, we can describe the range of R's, case by case, in more detail.

For this last purpose, Searle's eight "principles" provide us with a helpful, if rough, catalogue of *what* can serve as an interpretation of a metaphorically used expression, the range of possible values of R. However—and this is the second point—for the very same reason Searle's eight principles provide no *explanation* of how P imparts R. Indeed the descriptive strength of the principles is their greatest explanatory weakness. For the very variety of the principles is such that, taken conjointly, they place no restrictions on the class of possible features that can enter into a given metaphorical interpretation. What one principle rules out, another rules in. Furthermore, it is completely obscure what it is for *one thing to call another to mind*. We simply do not know what kind of psychological ability or complex of abilities this is; surely it is no better

understood than the phenomenon of metaphor which it is meant to explain. Searle himself comes close to acknowledging the explanatory poverty of his account when he says that the "question, 'How do metaphors work?' is a bit like the question, 'How does one thing remind us of another thing?'" However, whereas Searle goes on to say that the two questions are alike in that "there is no *single* answer to either" (my emphasis), it would be more correct to say, as philosophers since Hume have recognized, that what they have in common is that we know *no* answer to either of them. Finally, it should be obvious that, even with an explanation of this psychological phenomenon, not everything that something calls to mind, or reminds us of, is something it *means*. Likewise for metaphor: even allowing that it involves calling a feature to mind, that is surely not sufficient to count the feature a part of its meaning.

In sum, *if* we locate metaphor in the domain of use, Davidson is absolutely right in my opinion that there is no more explanatory power to be gained by thinking of the features communicated by a metaphor as its *meaning*—even as its utterance or speaker's meaning—than as effects which its use causes or makes us see. In other words, why use 'meaning' when all we really mean is use?[9]

Davidson, of course, draws a stronger conclusion than the above conditional. Because he also holds that metaphor *should* be entirely located in the domain of use, he detaches the consequent and asserts that metaphors have no meaning other than their literal meaning. However, one philosopher's *modus ponens* is another's *modus tollens*. The conclusion I would draw from the same argument is that *if* metaphors do have a meaning other than their literal one, then that meaning must be something different from the features they are used to communicate on particular occasions of use. But what might such "metaphorical meaning" be?

Rather than immediately answer that question, let me raise another: What conditions should we require of any candidate in order to be countenanced as *meaning*? Two necessary conditions—which prima facie exclude metaphorical meaning—are already suggested in Davidson's remarks. First, like a theoretical entity in a scientific theory, meanings are posits for which there is no justification unless they explain some regularity in our use of language. Second, since it is words, or types, that have meaning, it must be possible to assign the candidate independently of, or invariantly across, particular contexts of use, i.e., to all tokens of one type.[10] Now, the ordinary notion of literal meaning does seem to pass these two tests: it attaches to types, and it is in virtue of the fact that every token of a given type presumably has the same literal meaning that we are able to explain why they all "do" some things the same—e.g., why they all assert the same content or have the same truth conditions—and other things differently—e.g., their illocutionary or perlocutionary effects. For analogous reasons, metaphorical "meaning" would seem to fail the test: it "is not a feature of the word that the word has prior to and independent of the context of use" and there are no analogous regularities it captures because each metaphorical utterance "says" something different from every other one.

Now, with this much by way of motivation of the point of Davidson's distinction between "what words mean" and "what they are used to do," the question I shall explore for the remainder of this essay is whether Davidson's way of drawing the distinction can carry the explanatory weight he intends it to bear. In the next section I begin by examining his notion of "what words mean," or literal meaning, in light of his general conception of the theory of meaning.

II

Davidson's thesis that a theory of meaning for a natural language is (in whole or part) a theory of truth after the style of a Tarski truth definition is too well known to need introduction. For our purposes, however, not this claim but his more general conception of linguistic interpretation is more relevant. This conception begins from the assumption that a theory of language is a theory of linguistic acts, i.e., utterances, which should be explained as a species of rational acts performed for ultimately non-linguistic purposes.[11] But not only must all language be used for some such function. Although Davidson never explicitly states this, he also works with the assumption that there is one function—namely, communication—which is involved in all uses of language and in whose absence a purported instance of language would only questionably be a use of *language*. It is not clear whether Davidson holds this because he believes that language is in its essence a tool of communication or because he is concerned with language only insofar as it is an instrument of communication but, in either case, this assumption lies behind most of Davidson's further claims.

In particular, because the basic function of language is communication, a minimum of two are necessary to perform a linguistic act: a speaker S and hearer H or, as Davidson prefers, an interpreter I. When communication succeeds, S's utterance is interpreted as he intends; i.e., I's understanding of the utterance corresponds to S's intended understanding of his utterance. Hence, nothing should be lost, Davidson argues, if we shift the explicit object of our theorizing away from the speaker S to the interpreter I.[12] Although I's theory is itself a theory of the linguistic behavior of S, *our* explicit theory is not directly about S's utterances but about what I must know (or his ability) that enables him to interpret S as he (S) intends.[13]

It lies beyond the scope of this essay to describe the many subtle and detailed strokes with which Davidson fills in this picture of the theory of meaning as a theory of the interpretation of communicative utterances. However, four specific consequences that are especially pertinent to his characterization of literal meaning should be mentioned. First, *all* and *only* communicative utterances are the objects of such a theory of interpretation. That is, because utterances of ungrammatical as well as grammatical sentences communicate information, the theory must account for them all, including (as we discover in NDE) malapropisms, slips of the tongue, and half-finished sentence fragments.[14] However, any utterance which does not have the function of communication—

even if it is grammatically well formed—will not fall within the scope of such a theory; indeed such an utterance may not truly be *language* for Davidson.

Second, because communication requires that S and I share I's interpretation of S's words, any admissible theory of interpretation must be such that it could plausibly be shared whenever there is communication.

Third, because communication occurs when I understands what S intends to say, a theory of interpretation should be "adequate" (NDE 444) to the kind of interpretation required for *understanding*. These adequacy requirements are of two sorts: substantive and formal. First, as a substantive condition which follows from the holistic nature of linguistic understanding, Davidson requires that the theory provide interpretations of *all* utterances of the speaker or community in question. Second, as a formal condition, he requires that the theory represent the interpreter's ability to interpret, or understand, a potentially infinite number of novel sentences and expressions in a systematic form that acknowledges his finite capacity. In particular, Davidson proposes to meet this condition by requiring that the interpretation of each utterance be a function of the interpretations of its simple components drawn from a finite stock of basic vocabulary, composed into more complex expressions by a finite stock of rules of composition. Now, it is at this point that Davidson makes his well-known claim that a Tarskian theory of truth *is* "adequate" to interpretation of this kind. Details aside, I would emphasize two general points for our present purposes. (i) The fundamental notion here is understanding, and corresponding to it, interpretation, and it is only because the truth conditions yielded by a Tarski-like theory serve as a measure of understanding that they then come to have the central explanatory role in working out the theory.[15] (ii) It is a *single* type of semantic interpretation, e.g., truth conditions, which is taken to correspond to the required kind of understanding, or interpretation, for all utterances in the language. That is, Davidson leaves no allowance for partial degrees of understanding, or interpretation. This has the enormous advantage of simplicity, but it is also a source of problems.

Fourth—and this is the conclusion for which Davidson argues in NDE— any theory of interpretation that satisfies the previous conditions should not attribute to the interpreter and speaker a common *language* in order to explain how they communicate, at least "if a language is anything like what many philosophers and linguists have supposed," namely, a system of "learned conventions or regularities" available in advance and independently of the occasion of utterance. For any such theory must be plausibly shared by S and I when they communicate, and no such plausibly shared and descriptively adequate theory of this kind is, Davidson argues, what any philosopher or linguist would consider a language. As an alternative, Davidson proposes a complex account of communication in terms of speakers' and interpreters' intentions and mutual beliefs. Each S and I brings to each occasion of utterance his own "prior" theory of interpretation. S brings a theory of how he intends his words to be interpreted, I brings a theory of how he believes S intends his (S's) words to be interpreted.[16] Unfortunately, however, S's and I's prior theories do not in

general fully match as they initially stand. Therefore, S and I revise, or mutually adjust, their respective prior theories in order to achieve the fully shared understanding, or interpretation, of the utterance that constitutes communication. The resulting theories that make communication between S and I possible, Davidson calls their "passing" theories. But passing theories, Davidson emphasizes, are much too utterance-, occasion-, interpreter-, and speaker-specific to count as *languages*. Indeed each passing theory of interpretation is a theory only of a feature of "words and sentences as uttered by a particular speaker on a particular occasion," i.e., of tokens (utterances) rather than types (sentences or words).[17] Hence, what accounts for communication is the sharing of these utterance-specific passing theories rather than a shared language. And because languages are posited only, or primarily, in order to explain how communication by speech is possible, Davidson concludes, "there is no such thing as a language, not if a language is anything like what many philosophers and linguists have supposed" (NDE, 446).

Now, a number of philosophers have found Davidson's conclusion "downright astonishing," an "iconoclastic" reversal undoing many of his best-known claims. Ian Hacking, for example, asks: "Is there no longer language for there to be philosophy of?...[If] True-in-L is at the heart of Davidson's philosophy, [w]hat is left, is there no such thing as an L?"[18] My own view is that Davidson's claim is of a piece with the rest of his philosophy of language, indeed a natural conclusion for him to draw on the basis of his other claims about radical interpretation. However, in order to make clear what he is claiming, it is important to distinguish language as a domain of investigation from language as an explanatory notion. Davidson's provocative conclusion is not meant to deny the existence of language or languages like English and L as domains of investigation, as objects about which we can theorize. He only wants to deny that there is a (philosophically interesting) notion of language which can serve as a means of explanation, as a notion with explanatory power. And as a denial of language as a notion with explanatory power, his negative conclusion is a straightforward corollary of the rest of his theory of meaning. For *if* a theory of interpretation describes the speaker's and interpreter's shared knowledge or ability that is "adequate to [the] interpretation" (NDE 444) of each and every communicative utterance; and an interpretation of an utterance corresponds to its full understanding; and its full understanding consists in knowledge of its truth-conditions; *then* any such theory must inevitably be sensitive to its context for each utterance. That is, each interpretive theory must be attuned to the individual utterance of an individual speaker addressed to an individual interpreter as interpreted in an individual context. And there is no reason to think that such an interpretive ability is governed by rules in the strict, nomic sense required by a language, rather than by rules of thumb—"rough maxims and methodological generalities" supplemented by a healthy dose of "wit, luck, and wisdom" (NDE 446). So, if one focuses only on this kind of interpretation, then, given Davidson's premises, there seems to me to be nothing at all "astonishing" about his conclusion that

it is not in virtue of knowing a language that we are able to arrive at such interpretations.

However, what is striking and perhaps surprising—though not necessarily astonishing—is that, even after having rejected notions like language and after having endorsed his heavily context-oriented theory of interpretation, Davidson nonetheless insists on drawing a sharp distinction between what words mean, or their literal meaning, and what they are used to do. Why? What function does this distinction serve in Davidson's language-liberated theory of interpretation? And, furthermore, *how* in fact is Davidson able to explicate this distinction without falling back, at least tacitly, on what he thinks are bogus explanatory notions like that of language?

First, the point of the distinction. Let's assume that a theory of interpretation is a theory of what (the interpreter believes that) the speaker intends his *words* to mean. The first methodological difficulty an interpreter encountering a speaker will face is that he is not given *words* to interpret but utterances, and the "meaning" of an utterance does not deliver itself already factored into the respective contributions of the words themselves as distinct from their use to mean much else. Moreover, any utterance (like any human act) can be inter-preted, or (as Davidson would say) described, as intended for indefinitely many ends. If we can interpret the utterance *"yoreid sheleg"* as an act of saying that it is snowing, then we can also interpret it as an act advising someone to wear his boots and overcoat, or warning him to drive carefully, or proposing that we go skiing. In order for any sort of theorizing about language to be possible, the first task for the interpreter must be, then, to distinguish among, or systematize, these various kinds of intentional descriptions of an utterance—beginning with the distinction between the meanings of the words themselves and their use. Or to put the point a bit differently: No theory of interpretation can be a theory of "everything" a concrete utterance "means." However, if the theory is only of the meanings of the words used (as distinct from what they can be used to do), then the interpreter already needs a theory in order to identify, or abstract out, *those* meanings from all the further intentions of the concrete utterance he is given in experience. This is the point of the distinction between what words mean and what they are used to do. Yet *how* can Davidson draw this distinction without letting in the very pseudo-explanatory terms like 'language' which he wants to avoid?

Suppose that an utterance is a kind of rational action whose interpretations are its speaker's various communicative and non-communicative intentions and purposes. Davidson proposes that one way to identify the meanings of the words is to order these interpretations or intentional descriptions of the utterance according to their relations to each other as means to ends.[19] Thus my utterance of *"yoreid sheleg"* to my son is a means to saying that it is snowing, the saying of which is a means to encouraging him to believe that we will go sledding tomorrow, which is a means to keeping him from nagging me all night, which is a means to preserving my sanity. The first intention in order in this series—to say such-and-such—Davidson labels the *first meaning* of the utterance, which

in turn is used to achieve the second and later intentions in the ordering (all of which I shall include under the heading of 'secondary intentions'). This notion of first meaning, he now proposes, can serve as an explication of, or at least as a "preliminary stab at characterizing" (NDE 434), the ordinary notion of literal meaning, "what words mean" as opposed to "what they are used to do."[20]

Now, the first meaning of an utterance may indeed be the speaker's first *means* toward achieving his ultimate (non-linguistic) purpose or intention in performing the utterance. But why, because and only because it is first in the order of means, should it be singled out from the other intentions as a special kind of *meaning*—namely, the literal?

Note for a start that Davidson's denial of the explanatory role of language in communication rules out the possibility of connecting first meaning and literal, or word, meaning via the notion of *linguistic* meaning. What makes first meaning literal meaning cannot be—as its etymology "meaning according to the letter" might suggest—that it is the first meaning of an utterance because it is directly *encoded* in the *form* of the words as determined by the rules of language (and not merely conveyed by their use). According to Davidson, there are no such rules of language.

On Davidson's own picture of communication, it may also seem unclear how first meaning can do the work of literal meaning. For the explanatory power of literal meaning is precisely due to its context-independence ("Literal meaning and literal truth-conditions can be assigned to words and sentences apart from particular contexts of use..." [WMM 247]), while first meaning, as we have seen, is context-dependent to the extreme, a feature of "words and sentences as uttered by a particular speaker on a particular occasion." This characteristic of first meaning is, furthermore, no mere artifactual detail of Davidson's theory. Because the theory of interpretation must yield interpretations that correspond to the understanding of utterances—an understanding that consists in knowledge of truth conditions—first meaning must be sensitive to all kinds of contextual parameters for each utterance.

I will leave it to Davidson exegetes to patch up the apparent inconsistency between these two passages. Davidson's actual views apart, we should distinguish two kinds of context-dependence in these cases. The first, which I shall call *pre-semantic* context-dependence, is the context-dependence of our assignments of meanings (whatever one's theory of meaning ultimately is; for now, following Davidson, assume it is truth conditions) to sounds or shapes (or perhaps words, considered just as syntactic entities). We are all familiar with the task, on hearing some concrete sound pattern, of determining the semantic description it should be assigned or with which it should be "typed." I hear the sound pattern 'ei': even knowing that the speaker is speaking English, I must decide whether what I heard was the first person indexical 'I' or the common noun 'eye' or the affirmative 'aye' or the groan 'ai.' In making this judgment, it is obvious that we rely on all sorts of contextual cues—the appropriateness of the alternative types within the immediate sentence and then within the larger discourse, our beliefs about the speaker and his intentions, and so on. Now,

on Davidson's account of communication, this task is more general and more radical. On *every* occasion of utterance, the interpreter is faced with the task of assigning each sound pattern not only one of an alternative number of types *within* a language but rather a "language," or a theory of first meaning, *as a whole*. The interpreter does not, of course, approach this task on each occasion from scratch; he brings to it his prior theory. However, it is at best a matter of chance, or else providence, that his prior theory turns out to fit the speaker's intention. Each new, previously unknown proper or common name, as well as deviations from previous word patterns and malapropisms, is a potential source of misfit that requires revision leading to a different passing theory. Moreover, in each new context, or even at each turn of the discourse, this task begins anew; thus a passing theory is not specific even to speaker, like an idiolect, but to a speaker at a moment, an idiolect-slice. Of course, in constructing his theory which makes these assignments of interpretations to sounds, the interpreter will utilize every available contextual cue or piece of information. So, in this pre-semantic sense, each assignment of a first meaning to an utterance is highly context-sensitive and utterance-specific.

This pre-semantic context dependence which applies to all first meanings of utterances must be distinguished from a second sort of *post-semantic* context-dependence. Having assigned an utterance a first meaning, that utterance may then be used for an indefinite number of extra-linguistic ulterior purposes or intentions. Which of these further intentions is communicated will, of course, depend on the context—the speaker's and interpreter's mutual beliefs, intentions, and expectations. Yet, whichever of these secondary intentions is attributed to the speaker, the first meaning of his utterance remains the same; the same communicative interpretation serves *indifferently* as the first means for all these ulterior purposes. In that sense, we might say that the first meaning of an utterance is the meaning which it has on *all* of its uses to communicate further non-linguistic intentions or, more accurately, *regardless* of how it is so used.[21]

Given these two different ways in which context bears on the interpretation of an utterance, it should now be clear that first meaning is *pre-semantically* context-dependent but *post-semantically* context-*in*dependent. Context functions in assigning a first meaning to a given utterance but, once assigned, that first meaning remains *invariant* regardless of the further extra-linguistic purposes or intentions for which it is used. In this sense, the first meaning of an utterance is *autonomous* of its extra-linguistic purposes.[22] And for this reason, in turn, first meaning is an interesting candidate for literal meaning which, in one sense of the term, is what the words themselves mean no matter how they are used. That is, a criterion of literal meaning is post-semantic context-independence.

In sum, even if we do not accept all the details of Davidson's critique of language as an explanatory notion or his positive account of communication in terms of prior and passing theories, what he does clearly show is that notions like language, on the one hand, and full (including pre-semantic)

context-independence, on the other, are unnecessary in order to settle on a significant notion of literal meaning, what words mean as opposed to what they are used to do.[23] However, what Davidson's own account of literal meaning does assume is that a theory of interpretation is a theory of utterances whose function is communication and whose aim is understanding, understanding which, in turn, is cashed out in terms of knowledge of truth-conditions. The question we must now address is whether this notion of literal, or word, meaning—based on the idea that a theory of meaning is a theory of interpretation, or understanding—can bear the weight of Davidson's employment of it, first, to exclude metaphorical meaning and, second, to explain how utterances are used metaphorically.

III

Davidson's objection to the very idea of metaphorical meaning is that, unlike literal meaning, or what a word means, the metaphorical interpretation, or intention, of an utterance is never "prior to and independent" of its context of use. In light of what we have now said about context-dependence, this objection cannot be that the metaphorical interpretation is pre-semantically context-dependent because so is *all* first or literal meaning. Rather it must be that the metaphorical interpretation is also *post*-semantically context-dependent. That is, what an utterance communicates *qua* metaphor is not autonomous of its extra-linguistic secondary intention or ulterior purpose and, therefore, what it communicates as a metaphor cannot be a kind of meaning.

But what is *the* ulterior purpose, or secondary intention, of a metaphor? As we said earlier, Davidson charges that others start from the "trite and true observation" that "a metaphor makes us attend to some likeness" (WMM 247) and then falsely read the likeness into the utterance as its meaning. For Davidson, on the other hand, this *effect*—i.e., the resemblance or feature we are made to notice—simply is the ulterior purpose of the utterance. That is, metaphor is just one among many uses of language to obtain special effects—"like assertion, hinting, lying, promising or criticising" (WMM 259). But just as no one would suggest that these other uses introduce meanings in addition to the literal/first meanings of their words, so there is no additional kind of meaning we should associate with the metaphorical utterance beyond the literal/first meaning of its words. Whatever explanatory work might be done by such a metaphorical meaning is *already* done by the combination of the literal meanings of the words uttered and their extra-linguistic secondary intention as metaphor to make us notice a certain likeness.

Take Romeo's utterance of 'Juliet is the sun.' Romeo wants to tell us that and why he loves, even worships, Juliet. He does this by telling us how she nourishes him with her caring attention, how he cannot live without her. But this he does, not by expressing those thoughts literally (either because he doesn't have or know the right words, or because he thinks it will be more effective this other way) but by making us notice them, or by inviting us to

discover them, in turn, by likening Juliet to the sun. And this he does, not by literally comparing Juliet to the sun or by visually displaying Juliet and the actual sun, but by uttering the (false) sentence 'Juliet is the sun.' Of course, in order for this utterance to make us consider features which Juliet and the sun share, 'Juliet' must mean Juliet and 'the sun' must mean the sun—i.e., the utterance must have its literal/first meaning. Q.E.D., Davidson would argue, we have fully explained Romeo's utterance while taking into account only the literal/first meanings of the words uttered and the special metaphorical ulterior purpose or intention of the speaker in performing the utterance, namely, to bring features of likeness to our attention. Given this explanation, it would be vacuous to posit in addition yet another kind of metaphorical meaning.

Now, this argument is certainly right up to a point. If the (first) meaning of an utterance must be autonomous of its extra-linguistic purpose or use, and if the purpose of a metaphor (or, more precisely, the metaphorical purpose of an utterance) is to make us notice a likeness, then the meaning of the metaphor cannot itself consist of one of those features of likeness. This Davidson's argument convincingly shows. But, as we hinted earlier, that still leaves open the possibility that the metaphorical meaning might consist of something else. Let me put this argument in somewhat different terms, terms in which Davidson himself would never put it. Suppose metaphors are truth-valued, or express propositions or content, and, in particular, that Romeo's utterance u of 'Juliet is the sun' is true iff Juliet is P, where P is a feature u makes us notice in virtue of which Juliet resembles the sun. What Davidson's argument shows is that P cannot be part of the meaning of u—even though it is a part of its truth condition or propositional content. That is, he shows that the meaning of a metaphor must always be distinguished from its truth conditions or propositional content. However, the argument obviously does not show that no other condition or rule could be the metaphorical meaning of the utterance.

Metaphors are, moreover, not unique insofar as their meaning (if they have one) must be distinguished from their truth conditions or content. Despite Davidson's tendency to conflate, or interchange, "literal meaning" and "literal truth conditions" (as in the passage quoted in Section I), there is a whole class of expressions (commonly taken to be literally used) of just this type whose meaning and truth conditions must be distinguished, although they are systematically related. This is the class of demonstratives and indexicals whose meaning (as I mentioned at the start of this essay) I have elsewhere proposed to take as a model, or paradigm, for the meaning of a metaphor.[24] Thus a demonstrative (word-type) like 'I' has a literal meaning it possesses prior to and independent of any context in which it (or one of its tokens) is used, but that meaning is never itself part of its truth-condition in any context, a truth-condition which, furthermore, will vary systematically from context to context depending on who is speaking. Therefore, given only knowledge of the meaning of the indexical, we are still not in a position to predict (or explain) its content or truth condition in any context—despite the systematic connection between the two. Now, *if* we could find regularities and systematic variations

in the context-dependence of metaphors like those of 'I', we might also, then, motivate an analogous distinction *within* their "interpretation" between their "meaning" and "what they say" (truth conditions or contents on each occasion). So, to return to our previous question, What might a "metaphorical meaning" be? As we have already seen, it cannot be the feature or content expressed by the metaphor in any particular context. Instead I propose taking it to be the conditions that determine the particular features that can enter into what is said by, the content, or truth conditions of metaphorical utterances in their respective contexts. And because these conditions would remain constant from context to context, they would also constitute a kind of metaphorical meaning that belongs to semantics rather than pragmatics.

In order to get a better sense of this alternative notion of meaning exemplified by the meaning of demonstratives, I want to look more closely now at the least explicit part of the story I rehearsed a few paragraphs back, Davidson's account of how we can explain how a metaphor works simply in terms of its first/literal meaning and its metaphorical purpose. The specific part I shall focus on is that in which the utterance of the (literally meant) sentence 'Juliet is the sun' is said to "make us notice" some (interesting or pertinent) feature whereby Juliet resembles the sun, the feature in virtue of which the metaphor can be said to have "worked." In language more familiar in the metaphor literature, this part of Davidson's account corresponds to the claim that "the metaphorical depends on the literal," a formula which for Davidson would be more accurately stated as the claim that the metaphorical *use* of a sentence depends (to the extent to which it depends on meaning at all) on its literal *meaning*. In his various writings, Davidson provides two models for this dependence.[25] In WMM, he suggests that metaphor is a matter of using literal words to *cause* a certain effect that consists in our noticing the likenesses that make the utterance work (or successful) as a metaphor. In NDE, he suggests that the way in which we manage to say something true by metaphorically using a sentence whose literal meaning is false (or, more precisely, whose literal meaning is not that which in the context of utterance is relevant to judging whether the utterance is true) is directly analogous to Donnellan's explanation of how we can refer to an individual with a definite description which does not (literally) denote him. In the next two sections I shall discuss these two proposals.

IV

Davidson introduces his "causal account" of metaphor in the course of comparing metaphors to jokes and dreams, i.e., to kinds of *works* performed or produced with language or imagery.[26] Putting aside dreams for now, the comparison to the joke—as well as to the riddle—is a deep one which goes back as far as Aristotle and deserves to be explored in its own right.[27] The one question that concerns us here is whether metaphors are like jokes specifically with respect to the issue of meaning vs. use. On one negative point, the answer is clearly Yes. Jokes make you laugh, metaphors make you see likenesses. But no

one would posit a "joker meaning" in jokes (in addition to their literal meaning) to explain why they make you laugh, similarly, we should not be tempted to posit a metaphorical meaning in metaphors to explain their effect. Rather "joke or dream or metaphor can, like a picture or a bump on the head, make us appreciate some fact—but not by standing for, or expressing, the fact" (WMM 262). That is, at least like a bump, if a metaphor makes us appreciate some fact, it is by *causing* us to recognize it rather than by expressing it as its meaning or as its propositional content. Just as an apple dropped on his head reputedly caused Newton to think of the First Law of Gravity, so Romeo's (literally interpreted) utterance of 'Juliet is the sun'—a spatio-temporal event—causes him and us to see that Juliet is like the sun in that we cannot live without either of them. And just as the apple neither itself meant nor served as a reason for believing the First Law of Gravity, so Romeo's utterance neither expresses that resemblance as its meaning nor furnishes a reason for believing that Juliet resembles the sun in that respect.

Davidson uses a slew of expressions in WMM to refer to the relation between the utterance of the metaphor and its "effect"—e.g., "makes us see," "alerts," "inspires," "leads us to notice," "prompts," "draws our attention to," "provokes." On the one hand, the differences among these may make one wonder whether there is any one relation at work here. On the other, the epistemic character of all these expressions makes it clear that Davidson's "causal" account should be distinguished from another tradition in the literature on metaphor that also gives central place to its causal power. This is the view, first suggested by Max Black and subsequently developed by many others, that (at least vital) metaphors "create" similarities rather than express or formulate "some similarity antecedently existing."[28] Now, when Black originally proposed this, his formulation left room for a weaker epistemic reading of the claim— that metaphors "create" similarities only in the sense that they *reveal* hitherto unnoticed similarities. In subsequent writing, however, he has emphasized that what he really did mean was the stronger, and more controversial, ontological thesis that metaphors actually *cause* (to exist) the aspects of reality they also enable us to see. Be that as it may, the relation Davidson has in mind is, in contrast, entirely epistemic: the utterance of the metaphor makes or causes us to notice or recognize the resemblances that enter into its effect, or interpretation; it reveals rather than constitutes them.

However, if this is so, then a question of the opposite kind arises: Has it in fact been shown that the sense in which a metaphor reveals, or "makes" us recognize, a resemblance is *causal* at all? There is at least one other possible explanation which I would propose: the sense in which the utterance of a metaphor "makes" its interpreter recognize or notice a specific similarity is analogous to the sense in which a speaker "makes a presupposition" when he asserts a proposition that requires that presupposition in order to render it appropriate in its context (e.g., when I tell you that John was recently divorced, I make the presupposition, known or unknown to you previously, that he was married until then).[29] Similarly, we "make" the interpreter of an utterance *u*

recognize the similarities or features F that are required for an appropriate metaphorical interpretation of u when we utter u in a context in which it is taken to be interpreted metaphorically.[30] But this sense in which an assertion "makes" a presupposition, or the utterance of the metaphor "makes" us recognize a similarity, is not causal, at least if a causal relation requires that the cause be distinct from its effect. Here the similarity we are made to notice, like a presupposition made by an utterance, is not the content of a distinct mental act (presupposing, noticing) which could be separated by an act or will from the overt linguistic behavior, the utterance.[31] In short, then, while Davidson does show that the metaphorically related resemblance or feature is not the meaning of the metaphor but what the utterance "makes" us see, he has yet to show that here the relevant sense of 'make' is a causal notion at all.

There is another significant difference between Davidson's account and most other theories of metaphor like Black's, a difference which is also relevant to Davidson's idea that a metaphor is to be explained in terms of the effects it causes. Most philosophers like Black are concerned with metaphors only insofar as they occur in full statements or utterances. However, within the sentence uttered (say, 'Juliet is the sun') they distinguish (to use Black's terminology) the *focus* ('is the sun'), i.e., the constituent expression(s) used or interpreted metaphorically in the sentence, and the *frame* ('Juliet'), i.e., the remainder of the sentence which is used or interpreted literally. That is, it is really a sub-sentential expression (simple or complex) that undergoes the metaphorical interpretation even though it has that interpretation only when it occurs in the larger frame or context, which is minimally a full sentence. Davidson, on the other hand, can draw no such distinction between focus (the constituent expression that undergoes the metaphorical interpretation) and frame (the context of the interpretation). Because he acknowledges no metaphorical meaning that would attach to one rather than another constituent of the sentence or utterance, there is no prima facie reason to make any such sub-sentential expression "the" metaphor. All there is is whatever makes us notice the "metaphorical" feature or resemblance—and that is the utterance in its totality; obviously no component like 'Juliet' or 'the sun' taken individually could cause us to see a resemblance between the two of them. So, for Davidson the minimal linguistic unit which constitutes "the metaphor"— *what* does the alerting, inspiring, prompting, etc.—is always the full sentence or string uttered in context.

There is, then, more to Davidson's comparison of metaphors to pictures and jokes than perhaps first meets the eye. Like a joke whose effect is a function of its entire telling, or story, and cannot be reduced to, or identified with, any of its isolable parts, like its punchline, it is the total utterance in its context which achieves the metaphorical effect for Davidson. And like pictures which do not, in any well-defined sense, have a syntax,[32] metaphors for Davidson have no internal "metaphorical structure" beyond their literal structure and, as metaphors, they also make no use of their literal syntactic or semantic structure in achieving their effect. To be sure, Davidson repeatedly says that the sentence being used metaphorically has its "literal meaning," but all he in fact turns out

to mean by "the literal meaning of the sentence" are the separate and separable literal meanings and referents of its individual terms. As with T.S. Eliot's poem "The Hippopotamus," yet another work to which Davidson compares metaphor, the way in which metaphors "alert us to aspects of the world by inviting us to make comparisons" is simply by the simultaneous presentation or display—the brute juxtaposition, as it were—of the words of the utterance with their respective literal meanings and referents—regardless, say, of their subject/predicate structure. So, while Davidson claims that the metaphorical depends on the literal, much of what is usually included in our notion of the literal meaning of a sentence does no work in, and is even excluded from, Davidson's account of this dependence-relation.

Furthermore, this limited characterization of literal meaning raises a descriptive problem for Davidson's account. For if it is simply the literal meanings, or referents, of the words used which make us notice the metaphorical resemblance, it is not clear why sentences which differ only in their respective subject-predicate structures, such as 'A man is a wolf' and 'A wolf is a man' (or the ungrammatical strings 'A man-a wolf' or 'A wolf-a man') should have *systematically* different metaphorical effects; ignoring their structural differences, they all invite us to make comparisons between the same *things*.[33]

But apart from this descriptive problem, there is a deeper difficulty with Davidson's "causal" account. Even if we agree with Davidson that there is a causal relation at work in metaphor, the question remains: What kind of *causal explanation* can be given of how the utterance of the literal sentence is related to the specific metaphorically related feature we subsequently notice or see? And, in particular, will such a causal explanation explain how the metaphorical effect (or interpretation) of the utterance "depends on its literal meaning?" What I shall now argue is that to the extent to which Davidson tells us what such a causal explanation of the metaphorical effect would be, there is no reason to think that it would (and perhaps good reason to think that it would not) include an account of this metaphorical/literal dependence. But any account that leaves out this essential feature of metaphor, I would argue (and Davidson seems to concur), is inadequate as an explanation of metaphor.[34]

Before showing how this objection applies to Davidson's rather subtle account, I want to show how the same difficulty arises on a more extreme version of his position which has been put forth by Richard Rorty who invokes Davidson's theory of metaphor as part of a larger project of his own whose aim is to displace the cognitive from the dominating position in science, language, art, and ethics that "the tradition" has assigned it.[35]

Rorty appeals to Davidson because, unlike most everyone else in "the tradition" who explains how metaphors are "indispensable"[36] for scientific, moral, and intellectual progress by forcing them into a cognitivist mold in which they express a special kind of meaning or a sui generis content, Davidson offers him a fully naturalistic yet non-cognitive alternative: he "lets us see metaphors on the model of unfamiliar events in the natural world—*causes* of changing beliefs and desires—rather than on the model of *representations* of unfamiliar

worlds."[37] In order to expose utterances of metaphors as nothing more than non-cognitive causes—"mere stimuli, mere evocations" (291)—Rorty, however, goes considerably further than does Davidson himself: he divests them of their status, not only as bearers of special metaphorical meaning, but also as uses of language and even as intentional, rational actions. Adapting a figure of Quine's, he begins by identifying the "realm of meaning," the proper domain of semantics, as "a relatively small 'cleared' area"—defined by the "regular, predictable, linguistic behavior" which constitutes the literal use of language—"within the jungle of use." Hence, metaphor which is, Rorty claims, unpredictable and irregular by its very nature falls outside the realm of meaning and within the surrounding "jungle." Now, up to this point, Rorty's exposition is more or less faithful to Davidson; however, their respective "jungles of use" are quite different locales in which to place metaphor and it is instructive to see how they differ.

Rorty's "jungle of use" includes, to begin with, not only utterances of words, but also unfamiliar bird-calls, thunderclaps, and indeed the whole spectrum of sounds found in nature. What all these sounds have in common—and apparently makes them a jungle—is that they are all just *noise*: sounds for which we have no prior theory with which we can make sense of them but which, because of their very strangeness and anomalousness, have considerable effect on us. Metaphors, then, are also just a kind of more or less exotic noise, although they stand a tat closer than, say, bird-calls to the cleared space of literal meaning because diachronically they can die—or, as Rorty puts it more dramatically, be "killed off"—and made part of "stale, familiar, unparadoxical, and platitudinous" literal language.[38] However, as long as they are genuinely alive, metaphors are just jungle noises which, given their irregularity and unpredictability, cannot be "understood" or "interpreted" except in "the way that we come to understand anomalous natural phenomena," namely, by revising our antecedent theories to fit them.[39] In a similar way, Rorty acknowledges that metaphors may be "responsible for a lot of cognition," but only in the same non-intentional causal sense of 'responsible' in which "the same can be said about anomalous non-linguistic phenomena like platypuses and pulsars." In short, our ability to "understand" a metaphor does not fall under the rubric of mastery of language (whatever one's theory of linguistic competence may be) and how the metaphor causes its effects also does not involve any of its properties as language or even as a species of intentional action. Like a thunderclap or birdsong, the utterance of a metaphor is nothing but a non-intentional event for all of its causal functioning.

Davidson's "jungle of use" is quite different. As we saw earlier, he also begins with use, i.e., with actual utterances or linguistic acts, whose pretheoretical "meaning" might also be described as a 'jungle' but only in the sense that in that state it is dense and undifferentiated and, only after considerable theory-laden chopping, pruning, and trimming, can be systematically differentiated into the meanings of its words (their literal or first meaning) and the various secondary meanings which constitute all the other things the words

can be used to do. Furthermore, for Davidson, unlike Rorty, what remains when we have cleared away the space of literal meaning, however unruly, wild, and mysterious that surrounding jungle may be, is still intentional, rational linguistic action. Some of the secondary extra-linguistic purposes of these other uses of words may be causal effects of their utterance—as with metaphor—but the utterances are none the worse as rational, intentional human acts because they function as causes. For Davidson, indeed, it is never noise, i.e., non-linguistic, non-intentional events, that falls in our domain of investigation, but intentional human action of which linguistic action is one case. And it is only within that corpus that we distinguish what the words used themselves mean, the subject of semantics, and the many things they are used to do or mean, including (as in metaphor) those things that their use causes us to learn or recognize.

In sum, there is all the difference between Rorty's and Davidson's respective positions. Yet, despite their differences, Rorty's presentation drives home more clearly than Davidson's own presentation of his position one important consequence of his "causal" explanation of metaphor. Although Davidson is right that the fact that the utterance of a metaphor does its work causally is not incompatible with it being an intentional (linguistic) action, what will actually figure in a *causal explanation* of how the metaphor works will contain little if anything of its character as a use of language (or as an intentional act). To the extent to which its causal explanation and the underlying causal laws in its explanation all treat the metaphor simply as a physical event, Rorty is therefore correct to view metaphors just as *noise*, i.e., non-intentional, non-linguistic events. Of course, metaphors are *not* just noise. Their interpretation depends critically on the literal meanings of the words that are used metaphorically—a dependence that is not simply causally necessary—and metaphors are governed by many of the structural constraints, both syntactic and semantic, that govern so-called literal language (as I shall illustrate in Section VI). Hence, Rorty is wrong to describe metaphors *solely* as noise even if it is also possible to explain them *fully* as noise. However, what is right about his description is that a Davidsonian account cannot claim *both* to explain how a metaphor works by means of a causal story and that what the metaphor causes "depends entirely on the ordinary [i.e., literal] meanings of those words." For the causal explanation of a metaphor will treat it just as a non-intentional, non-linguistic event—as a meaningless noise.

Recall that, on Davidson's own account of causal explanation, for one event to be said to cause another it is only necessary that the events be nomologically related under some description of each.[40] The true singular causal statement need not itself instantiate the law or refer to the events in question under their nomologically appropriate description. Hence, we can agree with Davidson that the metaphor-utterance event causes the resemblance-noticing event (even allowing for the anomalism of the mental) insofar as there are grounds to believe that there exists some nomological relation between the two under some description of each—presumably physical (or neurophysiological) descriptions of the events.

But this, as I have already said, is not enough for Davidson. For his claim is not simply that there is *a* causal relation between the metaphorical utterance and what it makes us notice—under some appropriate description of each. Davidson's thesis is that we can explain how the causal "effect" of the metaphor "is brought off by the imaginative employment of words and sentences [which] *depends entirely* on the ordinary meanings of those words and hence on the ordinary meanings of the sentences they comprise" (WMM 247, my emphasis). Therefore, to produce such an explanation, its vocabulary must itself make reference to words, use, and literal (or first) meaning. Of course, Davidson need not himself actually produce such a causal explanation of metaphor, but he also does not give us any reason to believe that any such law is in the offing.

Let me emphasize that I am not objecting to the ultimate possibility of causal explanations of metaphor or, for that matter, of any linguistic phenomenon in terms of the physical or neurophysiological properties of utterances and their effects. Such an explanation would, in principle, treat the utterance of a metaphor and its effect no differently than the auditory perception of a thunderclap or a birdsong and their effects on us. What I am objecting to is the claim that we can *explain* how a metaphor works *both* as a use of language which depends entirely on the literal meanings of its words *and* in terms of its causal relation to the effect of its utterance. We may be able to make the singular causal judgment that Romeo's utterance caused us to see how we cannot live without Juliet just as we cannot live without the sun, but as soon as we try to provide the explicit *explanation* of that relation, we lose the substance of Davidson's claim that it is *as a use of language* that metaphor does its work. Of course, at this point Davidson might reply that we cannot really *explain* metaphor under its description as a use of language which depends entirely on its literal meaning; we can tell a story about each such case (as we did in Section III) but that should not be confused with a nomic explanation. On the contrary, under such a description, metaphor is explanatorily anomalous. But if this is what Davidson really holds, he should say so; for his disagreement with those who hold that we can explain metaphor by metaphorical meanings is not, then, "with the explanation of *how* metaphor works its wonders" (WMM 247, my emphasis) but rather with the possibility of an explanation of metaphor as a linguistic act, period. In order to do what he claims to do, Davidson must produce a causal explanation of metaphor *as* a kind of use of the sentence with its literal meaning in which the explanans itself makes use of literal meanings, words, and so on. But then metaphors would not just be noises or bumps on the head—unless those also bear meanings in the head.[41]

V

The second kind of use of language in terms of which Davidson attempts to explicate how the metaphorical depends on the literal is exemplified by Donnellan's idea of a referential definite description.[42] In this use of a description—in

contrast to its attributive use—the speaker, Davidson claims, succeeds in communicating his intended meaning (or reference) despite the fact that it differs from the literal meaning (or reference) of the words used, which is nonetheless the meaning with which they are in fact used on that occasion. Hence, referential and attributive descriptions are examples for Davidson of two kinds of uses of language which differ in "what they say"[43]—and therefore in their respective truth-values—without their (first) meanings differing. This difference in use Davidson contrasts with the case of malapropisms (and the introduction of new proper and common names) where the meaning of the word used itself changes in its context of utterance. And metaphor, Davidson adds in passing (NDE 440), should be analyzed like a referential definite description, as a use of language, rather than on the model of a malapropism which involves a change of meaning.[44]

Although there are various objections one might raise both against Davidson's presentation of Donnellan's idea of a referential description and against his claim that malapropisms involve a change of meaning, I shall grant him both of these for the sake of argument.[45] What I want to challenge is his further claim that metaphor should be explained in the same way as a referential definite description, i.e., that it is just a use of language which "has," or retains, its (prior) literal meaning while it is used otherwise.

Davidson illustrates the referential use of a definite description by the following case, adapted from Donnellan. A speaker Jones has in mind a particular person—call him Max—whom he believes to have murdered Smith and whom he therefore believes is uniquely designated by the description, 'Smith's murderer'. Seeing Max's behavior in the courtroom dock, Jones exclaims: 'Smith's murderer is insane'. Unfortunately, however, Jones's belief that Max is Smith's murderer is (unbeknownst to him) false. Nonetheless, where Jones uses the description 'Smith's murderer' referentially—i.e., simply as a means or tool to refer to, or single out, Max and not with the intention to describe the individual to whom it refers—Donnellan argues and Davidson agrees that he says "something true" with the sentence 'Smith's murderer is insane' provided Max is insane.

Here there is certainly no reason to think that the referential definite description has undergone a change of meaning just because Jones is able to "say something true" about Max by uttering 'Smith's murderer is insane' even though Max does not satisfy the content of the description. On the contrary, it is *because* Jones (falsely, as it turns out) *believes*, or *represents himself as believing*, that Max is Smith's murderer, *in the standard, prior literal meaning of the words* 'Smith's murderer', that he is able to use that description to refer successfully to Max. And it is either because his interpreter also (falsely) believes that or because he recognizes that Jones (falsely) believes that of Max (in the standard, prior literal meaning of the words) that he interprets Jones's utterance of "Smith's murderer is insane' to be saying something true about Max. Were we to inform Jones that Max is not in fact Smith's murderer (in the standard, prior literal meaning of the words), he would *not* respond

that we have failed to understand the meaning of his use of that description on that occasion, or that he intends for it to have a new passing first meaning in that context which does in fact uniquely designate Max. Instead he would say—given his intention to be using the description referentially—that what's important is that he meant to say something true about Max even though he was wrong in believing that he was Smith's murderer (in its passing literal meaning) and, therefore, wrong (or at least misleading) to use that description. In this case, then, Davidson seems to be absolutely right that "the reference is none the less achieved by way of the normal meanings of the words" and "the words therefore must have their usual reference" (NDE 439–40).

With a malapropism, in contrast, Davidson claims that the word itself acquires as its (passing first) meaning what the speaker intends to say in its context of utterance. For example, when Yogi Berra reputedly thanked the crowd in Yankee Stadium on "Yogi Berra Day" for "making this day necessary," *possible* is what the *word* 'necessary' *meant* on that occasion and not merely what Yogi meant by *using* that word (in its ordinary literal meaning).[46] Here is how Davidson would describe this situation. Yogi's interpreter brings a prior theory of Yogi's linguistic behavior to the occasion of utterance, a theory in which 'necessary' means *necessary*. Hearing the absurdity or inappropriateness of Yogi's utterance with that prior first meaning, he knows that Yogi must have intended to say something else. At this point his interpreter has at least two options. Either he can keep its prior first meaning as its passing first meaning *and* add an ulterior purpose for the utterance—say, take Yogi to be speaking ironically or comically—or he can adjust his prior theory of Yogi's first meanings in order to give the word 'necessary' as its passing first meaning what he believes Yogi intends to be saying on that occasion, namely, *possible*. Now, Davidson does not tell us how Yogi's interpreter chooses to interpret his utterance in one rather than another of these ways. However, if he decides that what Yogi intends to be saying is that he wants to thank everyone for making this day *possible*, then, Davidson would argue, he must be taking *possible* as the passing first meaning of 'necessary' and not simply as something imparted by Yogi's use of 'necessary' in its prior first meaning. For, unlike the case of the referential description where there are grounds for saying that the speaker understands his words in their prior first meaning (namely, the fact that he *believes*, albeit falsely, that Max is Smith's murderer, in the prior first meaning of these words), here there is no such reason to think that Yogi understands by 'necessary' *necessary*, that he intends to say that he wants to thank everyone for making the day *necessary* in its prior first meaning. On the contrary, we would explain why he said what he did by saying that he intended to thank everyone for making the day *possible*—and he believed, or represented himself as believing, that on this occasion 'necessary' just (first) means *possible*. To be sure, Yogi's interpreter can figure this out only because he knows that in Yogi's *prior* theory 'necessary' means *necessary* and 'possible' means *possible*, and he conjectures that Yogi is "confusing" the two (or that the two come to be

confused in his mental lexicon because of their semantic proximity to each other).[47] However, the fact that the interpreter knows the one interpretation "by way of" the other does not show that the latter belongs to his passing theory and should be prior to Yogi's intended interpretation of the word in the passing theory itself. For the passing theory is a theory of what the speaker intends on the occasion of utterance. And Yogi had no such intention—to mean *necessary* by 'necessary'—on that occasion.

In sum, let's grant Davidson both these views: that referential definite descriptions are an instance of speakers using their words to mean or do things other than what the words themselves mean and that malapropisms are an instance of words with one prior first meaning acquiring a new passing first meaning on their occasion of utterance. Now, how should we describe metaphor?

Although Davidson gives no explicit argument for his assertion that the intended interpretation of a metaphor belongs, along with referential definite descriptions, in the realm of use rather than, with malapropisms, in the realm of meaning, presumably his argument would go like this: What a metaphor makes us notice "depends on its ordinary [=literal] meanings" (WMM 247); therefore, "an adequate account of metaphor must allow that the primary or original [=literal] meanings of words remain active in their metaphorical setting" (WMM 249). Hence, a metaphor like 'Juliet is the sun' must "have" its ordinary, primary, or original meaning—i.e., its prior first meaning—as its passing first meaning on its occasion of utterance. This the speaker, in turn, uses in order to make us notice hitherto unnoticed resemblances or features, his ulterior purpose for his metaphorical utterance.

But is the way in which the metaphor "depends" on its literal meaning really like the way in which the referential definite description "depends" on its prior first meaning? Exactly how do "the primary or original meanings of words remain *active* in their metaphorical setting" [my emphasis]? And, in particular, is it so clear that the "dependence of the metaphorical on the literal" is a dependence *within* the passing theory of the utterance between its secondary intention (the feature of resemblance it makes us notice) and its first meaning, rather than a dependence that holds *between* the first meaning of the metaphorical utterance in its passing theory and its first meaning in its prior theory?

The answer to all these questions, I think, is that they have no satisfactory answer with the conceptual resources of Davidson's theory. On the one hand, with metaphorical utterances, unlike referential definite descriptions, there are no analogous grounds for holding that their literal, or prior first, meaning remains their first meaning in their passing theory. With referential definite descriptions, recall that Jones must intend his words 'Smith's murderer' to be understood according to their literal, or prior first, meaning *because* he believes that Max is Smith's murderer (in their ordinary literal meaning), a belief we attribute to him in order to explain why he uses the (improper) description 'Smith's murderer' to refer to Max. But with a metaphor, there is no analogous

reason for claiming that the speaker intends his words to be understood, or interpreted, according to their literal, or prior first, meaning. Romeo, for example, surely does not believe, or represent himself as believing, the absurd or at least patently false proposition that Juliet is the sun—expressed by the literal meanings of the words—when he utters 'Juliet is the sun'. And because there is no reason to hold that he believes that proposition, there are also no grounds for claiming that he himself understands his words, or intends for his interpreter to understand his words, with that prior first meaning on that occasion. Hence, there are no grounds for saying that their prior first meaning should also be considered their passing first meaning on occasions on which words are used, or interpreted, metaphorically.[48]

On the other hand, there are also good reasons not to consign the literal meaning of words used metaphorically *entirely* to the *prior* theory of the utterance. To do so would leave us without a clear candidate for the passing first meaning of the metaphorical utterance inasmuch as the features which the metaphor makes us notice cannot themselves be the first meaning of the utterance (as we argued in Section III). Moreover, as Davidson correctly observes, the literal, or prior first, meaning of the words does, and must, "remain active in the metaphorical setting." That is, whatever we ultimately determine to be the precise relation between the literal and the metaphorical, knowledge of the literal (first) meaning of the words used is necessary *on the occasion of utterance itself* in order to determine their metaphorical interpretation, or what the metaphor makes us notice. And the *relevant* literal meaning is not what the literal meaning of the word *was* on some prior occasion of utterance, but what it actually *is* on the very same occasion on which it is interpreted metaphorically. Therefore, it would not be sufficient to explicate the way in which the metaphorical depends on the literal simply as a kind of diachronic, or causal, dependence that holds *between* the first meaning of the metaphorical utterance in its passing theory and what its first meaning had been in the prior theory. *Within* the passing theory there must also be room for the literal, or prior first, meaning of the utterance. The problem with Davidson's account is making room for this in the passing theory itself. For if interpretations must capture the speaker's and interpreter's *understanding* of the utterance, then where the literal is made the first meaning of the passing theory of the metaphorical utterance, we are forced to say that the speaker himself *understands* his utterance, and intends his interpreter to understand his utterance, according to its literal meaning. And that conclusion, I have argued, is false or, at least, groundless in the case of metaphor.

Put a bit differently, I am arguing that the words as used, or interpreted, metaphorically *do* "have" their literal, or first, meaning as part of their passing and not merely their prior theory of interpretation—because their literal meaning is necessary for determining their metaphorical interpretation. But the appropriate sense of "having their literal meaning" is not one that is or can be expressed with the conceptual apparatus of Davidson's theory. For the words do *not* "have" their literal meaning in the sense that they are, or are intended to

be, *understood* literally. Rather we need another sense of "having" their literal meaning which is different from that which corresponds to our understanding of the utterance and, in turn, is cashed out by truth conditions. In the next and last section of this essay, I will turn to what that other sense might be, but it should be clear that Davidson himself cannot introduce any such alternative without seriously revising his central views about language as an instrument of communication whose interpretation is what we understand by an utterance, namely, its truth conditions. Therefore, what we need is really an alternative theory of meaning.

VI

As I have hinted more than once already, for this alternative conception of meaning we should look in the direction of the demonstratives and indexicals. One crucial difference between the meaning of demonstratives and indexicals and the notion of meaning on which Davidson's theory focuses are their respective "levels" of interpretation. Davidson, largely because of his conception of language as a means of communication, takes meaning to be the understanding shared by speaker and interpreter when they communicate which, in turn, he cashes out in terms of truth conditions or content. Now the truth conditions, or contents, of most words remain invariant from utterance to utterance; therefore, if one concentrates on such "eternal," i.e., context-independent, expressions, it is understandable why he would take their meaning to be an object of understanding. However, demonstratives and indexicals are an exception to this rule. Take Louis XIV's utterance 'L'ètat c'est moi' which is true if and only if the state is Louis XIV.[49] This truth condition should be the first meaning of the utterance according to Davidson's account: in order to communicate both the speaker and interpreter must take it to be the speaker's intention, and this communicative intention of the utterance remains the same regardless of whether Louis utters the sentence in order to announce whom he believes he really is or to warn the masses not to mess with him or to impress them with his wit or to say something memorable for the history books, i.e., regardless of his further secondary intentions.

Yet, this truth condition obviously does not remain the same for all utterances of the sentence 'L'ètat c'est moi.' If Richard Nixon were to utter that same sentence, its truth condition, and first meaning, would be that the state is Richard Nixon. Now, focusing on the demonstrative 'moi' or 'I' as it occurs in this sentence, how can Davidson describe its context-dependence within his theory?

The context-dependence of 'I' is neither pre-semantic nor post-semantic. It is not post-semantic because what varies with context in this case is not an *extra-linguistic* intention or *ulterior* purpose which is performed by the utterance, but rather the *communicative* intention of the utterance, its truth condition or content, what must be understood by both speaker and interpreter for there to be communication. Nor is the context-dependence of 'I' *pre*-semantic, the

way in which (first) meaning or a lexical description or a type is assigned to a (semantically uninterpreted) sound, shape, or word depending on various contextual cues and presuppositions; here the sound 'ai' has *already* been assigned the lexical type of the first person demonstrative 'I' and it is only *because* it has been assigned that type that it is context-dependent in this *additional* way.

In addition to pre- and post-semantic context-dependence, let us now call this third kind of context-dependence of demonstratives *semantic* context-dependence. Here the context functions not to pair a meaning or type with a shape but, where the type associated with the meaning described above is *already* assigned to the shape, to determine a truth condition on a particular occasion of utterance. As we have just seen, semantic context-dependence cannot be reduced to either pre- or post-semantic context-dependence. And, inasmuch as Davidson's understanding-oriented notion of interpretation and, in particular, of first meaning is itself cashed out in terms of truth conditions, the rule associated with 'I' also cannot itself be either first meaning or a generalization of this notion. For suppose that we were to try to abstract out its invariant or constant meaning from among the first meanings of all utterances of tokens of 'I'. Such *invariant first meaning* might, then, be taken to be a better candidate for an explication of literal meaning even if the first meaning of any particular utterance will not do. Nonetheless it will still not be good enough, for the rule of meaning for 'I' (that the truth condition or content of each of its tokens is its actual speaker) will not be included in its invariant first meaning. That rule only *constrains* the possible first meanings of any utterance of 'I' but never is itself *part* of its first meaning on any particular occasion, let alone, part of its invariant first meaning in *all* of its utterances. Yet this rule is exactly what we would take as the meaning—indeed, *literal* meaning—of the word 'I,' what the speaker knows in virtue of his linguistic competence. In Davidson's scheme, however, such a rule just does not fit in; at best it might be considered "zero" meaning.

Demonstratives, then, point us to a general conceptual difficulty with Davidson's account of meaning. For insofar as the meaning of a demonstrative diverges systematically from its truth conditions, there is reason to think that the proper level at which to aim one's theory of meaning should not be the level of understanding furnished by truth conditions which is necessary for communication but at a more abstract level of knowledge.

This more abstract level of knowledge is not, however, unrelated to the kind of understanding required for communication even though it cannot be identified with it. Indeed one important fact which any theory of this more abstract knowledge should explain is what we might call the *autonomy* of meaning: the fact that what expressions (literally) mean is independent, or autonomous, of what individual speakers intend to communicate on given occasions. Not only don't speakers' intentions determine what their expressions (literally) mean; more important, which intentions can be communicated by which specific words is determined, or constrained, by their (literal) meaning.[50] Take 'I' once again. Suppose I, Josef Stern, believe (falsely) that I am Louis

XIV. Suppose that I intend to refer to Louis XIV by my utterance of 'moi' in 'L'ètat c'est moi.' That is, I intend to say that the state is Louis XIV. Suppose I give my interpreter sufficient cues that this is my intention—that I believe that I am Louis XIV and that I intend to be referring to Louis with my uses of the first-person demonstrative. And suppose that in point of fact Louis XIV was the state (whatever that would be). Nonetheless, regardless of my intention and regardless of the fact that my interpreter knows my intention, my utterance of the sentence 'L'ètat c'est moi' will be false. For the meaning of the indexical 'moi,' or 'I,' willy-nilly determines that my utterance on that occasion says that the state is Josef Stern, not Louis XIV—and Josef Stern, as I well know, is no state (whatever that would be).

Indexicals are one case, in the realm of lexical meaning, where the autonomy of meaning reveals itself. Another important but non-lexical class of cases of autonomous meaning involves the meaning carried by grammatical configurations.[51] Consider, for example, the fact that (i)

(i) He saw John in the mirror

cannot be understood as meaning (ii)

(ii) John saw himself in the mirror.

For reasons of space, I shall not review the detailed explanation for this fact about meaning, but the general idea is that what prevents the anaphoric pronoun in (i) from taking the noun 'John' as its antecedent is a formal condition on an abstract representation of the string. However, this condition, like the rule of meaning for 'I', *constrains* the interpretation of the anaphoric construction without itself being *part* of that interpretation. The condition does not state what the anaphoric interpretation *is* or *must* be but what it *cannot* be; it only *excludes* certain interpretations. Thus, this notion of meaning, like that of demonstratives, does not enter into the content of what speakers understand by an utterance but at most circumscribes the bounds of their understanding by ruling out the impossible interpretations.

Now, these examples illustrate the fact that one function of meaning is to constrain speakers' intentions to say certain things with certain linguistic expressions or structures. In order to explain this fact I want to argue in turn that a notion of meaning one level more abstract than truth conditions is necessary. But why can't we account for this fact in terms of truth conditions, the kind of understanding involved in communication? Why not say, as a Davidsonian explanation might propose, that speakers intend to say only what they believe their interpreters will understand or only what they expect others will reasonably be able to interpret them as saying? Just as we do not usually intend to do things we believe nature will prevent us from doing, so a speaker's knowledge of how other people can be expected to behave as interpreters—in light of his knowledge of their previous linguistic experience—constrains his intentions in choosing particular forms to communicate specific contents.[52]

The difficulty in applying this kind of explanation to the facts we have described, the kinds of facts which exemplify the "autonomy" of meaning, is

that it is simply implausible given the kinds of rules which seem necessary to account for those facts. Those rules, in short, are much more general, fixed, and abstract than the sort of context-specific expectations and beliefs that govern the assignment of first meanings according to Davidson's picture of interpretation. Take the demonstrative 'I' again. Neither is its content, or truth-conditional factor, in any particular context itself its meaning nor is its meaning a direct generalization, in any obvious way, from its contents in particular contexts. Rather its meaning is an instance of a still more general schema that holds for all expressions in the class of demonstratives (or, slightly more specifically, indexicals, e.g., 'I,' 'now,' 'here,' 'actually') in all contexts in which they are used. Furthermore, the meaning expresses a condition which applies not to the concrete utterance but to a much more abstract representation: a representation of the utterance, or sentence uttered, which both abstracts away from particulars of its contents in actual contexts and which contains abstract features not explicitly represented in the concrete expression. Thus the meaning of a demonstrative like 'I' must mark the fact that its interpretation (content) is always fixed relative to its context of utterance, regardless of its scope in the sentence and regardless of whether the matrix sentence also contains another expression, or operator, which makes the truth (as opposed to content) of the sentence dependent on circumstances other than that of its context of utterance. For example, if I say 'I might have been assassinated' my utterance is true in my context of utterance if there is some possible circumstance (relative to the circumstance of the context of utterance) in which I, Josef Stern, the individual actually speaking in the context, is assassinated; it is not enough in order for it to be true that there be some possible circumstance (relative to the context) in which whoever might be speaking in that circumstance is assassinated. Finally, it should be noted again that this condition on the interpretation of the demonstrative does not itself yield its interpretation in any context but only constrains its possible interpretations by excluding certain alternatives. So, however speakers come to learn these rules or conditions of the meaning of 'I,' if the autonomy of meaning is to be explained à la Davidson in terms of a speaker's expectations about his interpreter, those expectations will necessarily require the attribution of a knowledge of rules, or conditions, of corresponding generality, systematicity, and abstractness. But knowledge of this kind would be much more fixed, invariant, and inflexible than Davidson's highly context-specific characterization of passing theories would suggest.[53]

What moral do I wish to draw from this story? Davidson's argument moves from the premise that a theory of linguistic or interpretive competence must be a theory of speakers' and interpreters' shared understanding of all communicative utterances to the conclusion that such a theory cannot be a theory of a common language, or grammar, in virtue of which they are able to communicate. However, the same argument might equally well be taken to show that if a speaker's linguistic competence does consist in knowledge of a language, or grammar, then a theory of that competence will not be a theory of a speaker's and interpreter's ability to interpret, or understand, all communicative

utterances, i.e., a theory which accounts for the truth conditions of all utterances in their respective contexts. This is not to deny that understanding an utterance may be a matter of knowing its truth conditions. Rather I am challenging the assumption that a theory of an interpreter's linguistic competence should directly and fully explain his *understanding* of utterances. Instead, I would argue, one's linguistic competence is only one factor that contributes to such understanding. That is, a theory of a speaker's knowledge of language is never a theory of understanding *tout court*, but only of one kind of knowledge specific to the linguistic properties of utterances that only partially determines everything that goes into understanding.[54]

With this background, let me finally return to metaphor. Here, too, I want to propose that a theory of a speaker's semantic competence in metaphor, a theory of metaphorical meaning, should not be assumed to be a theory of his ability to use, or to communicate with, metaphors, a theory of what an interpreter understands when he understands a metaphor, a theory which would itself specify for each utterance of a metaphor the feature or resemblance it expresses on that occasion. Rather, from among the various competences, skills, and faculties that conjointly account for this complex ability (including the interpreter's extra-linguistic knowledge of the relevant contextual parameter), a *semantic* theory of metaphorical interpretation should address only the interpreter's *knowledge of meaning specific to metaphorical interpretation*. To be sure, much of the *evidence* for any such theory will consist of actual utterances with their "full" metaphorical interpretations in their respective contexts, but the semantic theory should account not for that evidence per se—the utterances with their contents in their respective contexts—but only for the one kind of knowledge underlying the speaker's ability to assign such interpretations that is specific to their linguistic, or semantic, properties. It follows, then, that the semantic theory of metaphor will leave untouched a whole range of aspects of metaphor that depend on a larger model of speech performance or use—e.g., criteria of appropriateness, the psychological processing of metaphors, and the various rhetorical and non-cognitive effects of metaphors that bear on their success and belong to their "meaning" in a broad sense of the term. But all this and more: for if the ability to interpret a metaphor even in the limited sense of assigning it a propositional content, or truth condition, in a context involves the contributions of multiple abilities, skills, and presuppositions which are non- or extra-linguistic, such as the ability to judge similarities or recognize salient features or "make" presuppositions of various kinds, then the *semantic* theory by itself will never suffice to determine even the *interpretation*, i.e., truth condition or propositional content, of a metaphorical utterance.[55]

What work, then, does the meaning of a metaphor perform? And with what aspects of metaphorical interpretation should a semantic theory of metaphorical meaning be concerned? In order to factor out the component of the speaker's interpretive ability that belongs specifically to his semantic competence in metaphor, we might begin by identifying those facts about the interpretation of a metaphor that would prima facie be a function specifically

of its meaning. In particular, if meaning in general, as we have been arguing, serves to provide formal, or structural, *constraints* on interpretations—on what speakers can intend to say given particular forms of expression—then for evidence of metaphorical meaning, we should look for signs of formal constraints on possible metaphorical interpretations. In other words, if there exists an interesting notion of metaphorical meaning, then, as with demonstratives and our earlier example of anaphora, there should exist a "level" of interpretation for metaphor which is also *autonomous* of a speaker's intentions and serves to constrain how those intentions—or, in the case of a metaphor, the features of likeness we are "made" to see by its utterance—enter into its interpretation, i.e., content or truth condition. As with demonstratives and the anaphoric constructions, the autonomous aspects of its interpretation would be one kind of data about metaphor that positing a specific level of metaphorical meaning would serve to explain.

To give you a glimpse of these facts, let me conclude this essay with two brief examples of constraints on metaphorical interpretation, examples that correspond to the two examples we have already given of the autonomy of meaning of literal, or non-metaphorical, use of language.

1. It has been frequently observed that in cases of verbphrase anaphora in which the antecedent verbphrase allows multiple interpretations, the antecedent verbphrase and the anaphor must always be given the same interpretation. For example, 'may' can be interpreted either with the sense of permission or with that of possibility in

(1) John may leave tomorrow.

But in (2) and (3)

(2) John *may* leave tomorrow, and the *same* is true of Harry.
(3) John *may* leave tomorrow, and Harry, *too*.

both (italicized) constituents must be given the same interpretation, either that of possibility or that of permission. Now, this fact would seem to be a clear instance of the autonomy of meaning: the speaker's communicative intentions are constrained by a structural condition on the "copying" of the interpretation of the antecedent verbphrase onto the anaphor.[56] And because this constraint has obvious consequences for the truth-value of the sentence, it is a matter of semantic significance or meaning. There is, furthermore, no interesting way in which this condition on verbphrase anaphora can be explained as a condition on use, or defined directly in terms of an interpreter's intentions or expectations à la Davidson. Whatever I intend to say, and whatever I can do to make my audience interpret me as I intend, I simply cannot mean by (2) or (3) that John *has permission* to leave tomorrow, and it is *possible* for Harry to leave then. (2) and (3) are each always only two-ways ambiguous while, if it were a matter of an individual's intentions and mutual expectations, in at least in some contexts it ought to be possible for them each to be four-ways ambiguous. Hence, this is a constraint on interpretation that would appear to call for semantic structure.

Now, similar facts obtain with metaphor. Contrast the interpretation (i.e., content or truth condition) of 'the sun' in the literal sentence

(4) The largest blob of gases in the solar system is the sun.

with its metaphorical interpretation in

(5) Achilles is the sun

or in

(6) Juliet is the sun

Each of these, I will assume, has a different metaphorical interpretation, although exactly how they differ will not matter for our purposes. But consider now the following (semantically) ill-formed sentences which are examples, again, of verbphrase anaphora:

(7) *The largest blob of gases in the solar system is *the sun*, and Juliet/ Achilles *is, too*.

(8) */? Juliet is *the sun*, and Achilles *is, too*.

In each of these sentences, what is ill-formed would seem to be the result of violating the same kind of interpretive constraint at work in (2)–(3). That is, because the interpretation of the antecedent is copied onto the anaphor, both the antecedent and the anaphor must have the same interpretation (whatever that interpretation is). Hence, in (7) where the interpretation of the antecedent is the literal meaning of 'the sun' and the interpretation of the anaphor would seem to be metaphorical (on pain of absurdity), we have one violation. In (8) (which is slightly more acceptable to informants), we have two different *metaphorical* interpretations of 'the sun,' also violating the constraint.[57] Both interpretations are, then, ill-formed—although, as is often the case with such figures, we tend to *impose* an interpretation on the strings despite the violation. However, it is precisely the feeling of play or pun that accompanies such imposed interpretations that reveals the underlying semantical ill-formedness of the strings.

These are examples in which certain aspects of metaphorical interpretation show themselves to be autonomous of—precisely because they serve as constraints on—interpreters' intentions. And as with the earlier examples, it is difficult to see how we might account for these constraints in terms of use or mutual beliefs and expectations. What is needed is rather a structural condition—the same condition that applies to verbphrase anaphora in general—in which case we must attribute to metaphor the semantic structure, or meaning, necessary for the requisite condition to apply.

2. As we also saw earlier, when demonstratives occur within the surface scope of a modal operator, their interpretation is nonetheless determined with respect to their context of utterance and never with respect to the circumstance with respect to which the truth of the sentence is determined. Similar facts obtain with metaphor: the interpretation, i.e., truth condition or content, of the metaphor is always fixed relative to its context of utterance, never relative to

the circumstance on which the truth of the sentence is dependent. Suppose that Paris disagrees with Romeo's utterance of 'Juliet is the sun' but concedes that

(9) Juliet might have been the sun.

(9) will be true just in case there is some possible circumstance w' in which Juliet has the particular set of properties P which is the content of 'is the sun' interpreted metaphorically in its actual context of utterance cm i.e., Juliet must fall in the extension of w' of the relevant property P, but the relevant property P is fixed relative to the context of utterance c, not relative to the counterfactual circumstance w'. It is not sufficient for (9) to be true that Juliet possess whatever property happens in w' to be the content of 'is the sun' were it interpreted metaphorically there. Now, as in the case of demonstratives, this condition does not tell us what the interpretation of the metaphor is; it only tells us what it cannot be. And, again, as in the earlier examples, it is hard to see how we might explain the presence of this constraint in terms of use, intentions, or mutual expectations. Again, this kind of constraint calls for metaphorical meaning.[58]

To conclude: according to the alternative conception of semantics and meaning I have sketched in this last section, a theory of metaphorical meaning will always be much less than the complete story even of a single metaphorical interpretation (truth condition or propositional content) in a context. It will seek to describe and explain only the speaker's knowledge underlying his ability to interpret a metaphor insofar as that knowledge is proper to metaphor and properly linguistic.[59] However, I hope that the restricted character of this notion of meaning will prove to be a strength rather than a deficiency of my account. For it is only by abstracting away from the other contributing factors that jointly determine full metaphorical interpretations—contents or truth conditions—that it becomes possible to discern their underlying meaning or semantic structure. And this is something which past theories of metaphor have never been able to do precisely because they have focused all their attention—unsuccessfully, as writers like Davidson convincingly show—on "rules" or "meaning" that directly yield nothing less than a full understanding of a metaphor in its context.[60]

NOTES

* I want to thank Jay Atlas, Jonathan Berg, Avishai Margalit, James Higginbotham, and Ellen Spolsky for their comments on an earlier version of this material, as well as the audiences at departmental colloquia at the Hebrew University of Jerusalem and Ben-Gurion University of the Negev. I also wish to acknowledge the support of the American Council of Learned Societies during 1988–89 when the original version of this essay was written.

1. For further reflections on this subject, see Ted Cohen, "Aesthetics," *Social Research* 47 (Winter 1980): 600–11.

2. This essay (henceforth: WMM) first appeared in a special issue on metaphor in *Critical Inquiry* 5 (1978): 31–47, and has been subsequently reprinted in, among other places, Donald Davidson, *Inquiries into Truth and Interpretation* (Oxford, 1984), 245–64. All page references are to the latter. In addition to the three main claims mentioned in the text, much—indeed, the overwhelming proportion—of WMM is concerned with criticisms,

large and small, of assorted previous accounts of metaphor. Since these matters do not bear on my present topic, I forgo discussing them here.

3. I address at length these other arguments—each of which touches, I believe, on a sensitive spot for any full-blown account of metaphor—in a work in progress *Metaphor in Context* (of which the present essay is a part). It should be noted that Davidson himself repeatedly falls back into talk of metaphor as if it does convey cognitive content; see, e.g., WMM, 257, 261, 263. As we all know, skepticism is hard to live by.

4. In (among other places) *Truth and Interpretation: Perspectives on the Philosophy of Donald Davidson*, edited by Ernest LePore (Oxford, 1986), 433–46. All references to this essay (henceforth: NDE) are to this publication.

5. See my "Metaphor and Grammatical Deviance," *Nous* 17, no. 4 (November 1983): 577–99; "Metaphor as Demonstrative," *Journal of Philosophy* 80, no. 12 (December 1985): 677–710; and "Metaphor without Mainsprings: A Rejoinder to Elgin and Scheffler, *Journal of Philosophy* 85, no. 8 (August 1988): 427–38.

6. Davidson, "Communication and Convention," in his *Inquiries into Truth and Interpretation*, 279. See also Davidson's prefatory comment to this essay: "The principles of such inventive accommodation [i.e., the principles of conversation] are not themselves reducible to theory, involving as they do nothing less than all our skills at theory construction" (*Inquiries*, xix).

7. John Searle, "Metaphor," in *Metaphor and Thought*, edited by Andrew Ortony (Cambridge, 1979), 92–123.

8. Ibid., 113.

9. Two brief points of clarification: First, my endorsement of Davidson in this paragraph is solely conditional on locating metaphor entirely in use, an assumption with which I shall take issue later in this essay. As I also stated earlier, I am concerned here only with the issue of metaphorical meaning; hence, even if "what a metaphor communicates" is an effect of its use—rather than a kind of meaning, where that term is meant to carry explanatory import—that effect may be propositional and thus (in the ordinary sense) a meaning-like entity. Second, I often write elliptically (and potentially misleadingly) of the features communicated by a metaphor "as effects which its use causes or makes us see," when strictly speaking what the utterance of a metaphor causes is not a feature but an *event* like the interpreter's recognizing or noticing such a feature. However, despite the difference in ontology, nothing in my argument seems to me to be affected by my loose talk. (For both of these points, I am indebted to comments by Jonathan Berg.)

10. Compare Davidson's objections to a figurative meaning for similes:

> The point of the concept of linguistic meaning is to explain what can be done with words. But the supposed figurative meaning of a simile explains nothing; it is not a feature of the word that the word has prior to and independent of the context of use, and it rests upon no linguistic customs except those that govern ordinary meaning. (WMM 255)

11. "Linguistic utterances always have an ulterior purpose....There is perhaps some element of stipulation here, but I would not call it a linguistic act if one spoke 'words' merely to hear the sounds, or to put someone to sleep; an action counts as linguistic only if literal meaning is relevant. But where meaning is relevant, there is always an ulterior purpose....What matters is whether an activity is interestingly considered linguistic when meanings are not intended to be put to use" ("Communication and Convention," 273–74).

12. I.e., nothing should be lost concerning *what* is known by S and I that enables them to communicate, and thus interpret S's behavior. This assumes, however, that we can abstract away from all differences between *how* they respectively produce and comprehend their common interpretation of the utterance.

13. It should be emphasized that, while Davidson often describes the theorist's explicit theory as a theory of I's linguistic, or interpretive, "competence," he denies any commitment to its "psychological reality." In this respect, his program is sharply different from

Chomsky's, even though both of their explicit theories take the form of recursive systems of rules. Note, moreover, that Davidson also refuses to endorse the "physiological reality" of his theory, that it makes "any claims about the details of the inner workings of some part of the brain" (NDE 438). Thus his general motivation seems to stem, not specifically from anti-Cartesianism, but from a view that, because all our evidence is behavior, namely, utterances, we are never justified in doing more than describing the interpreter's behavioral repertoire. Likewise, it is no doubt part of Davidson's motive for shifting away from the speaker to the interpreter to make the theory of meaning more public, to see meaning from a more external and behavioral, and less mentalistic and private, perspective. But like Quine, then, Davidson can at most claim that his theory of interpretation *fits* the interpreter's competence, not that it corresponds to something that *guides* it. The sense in which it is nonetheless a *theory* (inasmuch as it does not attempt any sort of theoretical, i.e., non-observational, explanation) is simply formal: the description has a recursive (inductively specifiable) structure which explicitly describes only a finite fragment of the interpreter's competence but is meant to apply to the potentially infinite totality of utterances in his language.

14. Contrast this view with the idealization involved in the conception of linguistic competence found in most current theoretical linguistics, for example, Chomsky's opening paragraphs of *Aspects of the Theory of Syntax* (Cambridge, Mass., 1965).

15. That understanding is the fundamental notion for Davidson tends, I think, to be obscured by his emphasis, for a variety of reasons, on interpretation. However, when, among other places, he must explain the standards of interpretation, it is understanding to which he turns; see, for example, his comment, while explicating his use of the Principle of Charity, that "the aim of interpretation is not agreement but understanding" (*Inquiries*, xvii). I shall not try to substantiate this claim further here, but, if it is right, then the Davidson-Dummett dispute over whether a theory of meaning ought to take the form of a theory of truth or of warranted assertability ought to be viewed as an *internal* dispute within one camp for whom meaning is understanding—in contrast to those in other camps, such as Chomsky, for whom it is not.

16. More specifically, I's theory is of what he expects S will intend to say with his (S's) particular words on this occasion, given I's prior knowledge of S and of the first meanings S has attached to his (S's) words in the past. S's theory, on the other hand, consists of his intentions that particular words of his will be interpreted by I as saying such-and-such, given his beliefs and expectations about I's ability to interpret him (S) as saying those things with those words. So, if S believes that I will not be able to interpret him as saying such-and-such with certain words, he will not intend for those words to be interpreted in that way.

17. Davidson adds that the conditions of utterance (speaker, audience, and occasion) must also be "normal" or "standard," but he explicitly refuses to explain these terms, so it is not clear what constraints they impose.

18. Ian Hacking, "The Parody of Conversation," in *Truth and Interpretation: Perspectives on the Philosophy of Donald Davidson* edited by E. LePore (London, 1986), 447.

19. Davidson asserts, without argument, that "the intentions with which an act is performed are usually unambiguously ordered by the relation of means to ends" (435), but this is far from obvious. In any case, any given unambiguous ordering would hold only for a particular utterance; there is no a priori reason to think that the first meaning of one token of a type should necessarily be the first meaning of all tokens of that type.

20. Note that Davidson introduces first meaning as a "*preliminary* stab" (NDE 434, my emphasis) at literal meaning, but there is nothing preliminary about the way in which he continues to use it as its explication throughout the remainder of NDE; see, e.g., "Every deviation from ordinary usage, so long as it is agreed on for the moment...is in the passing theory as a feature of what the words mean on that occasion. Such meanings, transient though they may be, are literal; they are what I have called first meanings" (NDE 442).

21. There may be exceptions to this generalization. Knowledge of the secondary intention of an utterance (e.g., knowing that it is a promise or threat) may affect which first meaning is assigned to some word; therefore, the assignment of first meaning may also be sensitive to

the post-semantic contextual features that bear on determination of the utterance's secondary intention.

22. This notion of autonomy is essentially that of Davidson's principle of the *autonomy of linguistic meaning* which he illustrates by the fact that a sentence with a given linguistic meaning can be "used to serve almost any extra-linguistic purpose" ("Thought and Talk," *Inquiries*, 164) Elsewhere, however, his formulation of the principle varies somewhat; cf. "Communication and Convention," 274. All these notions of autonomy of meaning should, however, be distinguished from the notion I discuss in Section VI.

23. One virtue of this explication of literal meaning is that, inasmuch as it acknowledges its pre-semantic context-dependence, it avoids the attacks of the various deconstructionist philosophers and literary theorist who deny the literal/non-literal distinction on the grounds that all meaning is relative to a culture or various kinds of beliefs and presuppositions. True as this observation surely is, all it shows is that all meaning is *pre*-semantically context-dependent; the literal/non-literal distinction, which hinges entirely on *post*-semantic context-in/dependence, is an entirely separate matter. Similar remarks apply to John Searle's recent argument that literal meaning is not context-independent, in "Literal Meaning," *Erkenntnis* 13 (1978): 207–24; all his examples are clearly cases of pre-semantic context-dependence.

24. For the semantic account of demonstratives and indexicals I am assuming here, see David Kaplan, "Demonstratives," (at last published!) in *Themes from Kaplan*, edited by Joseph Almog, John Perry, and Howard Wettstein (Oxford, 1989). In what follows I use the term 'demonstrative' to cover both the proper demonstratives ('This,' 'That') and indexicals ('I,' 'now,' etc.).

25. Note that I take this formula—that the metaphorical depends on the literal—to be describing a dependence that holds in the metaphorical interpretation of an utterance. One might, however, explicate it as referring not to a synchronic relation in language but to a diachronic one—that there first had to be literal language before there could be metaphor—or as a claim not about each individual metaphor but about the language as a whole at a time.

26. See WMM 261, 262.

27. On this connection, see Ted Cohen, "Jokes" in *Pleasure, Preference and Value*, edited by E. Schaper (Cambridge, 1983) and "Metaphor and the Cultivation of Intimacy," *Critical Inquiry* 5 (1978).

28. Max Black, "Metaphor," in his Models and Metaphors (Ithaca, N.Y., 1962), 25–47, esp. 37. Cf. also Nelson Goodman, *Languages of Art* (Indianapolis, 1968), 78. To anticipate a possible misunderstanding: while Black's account places great weight on the creative, hence, causal, power of a metaphor, I am not suggesting that his is a causal theory of metaphor.

29. See Robert Stalnaker, "Presuppositions," *Journal of Philosophical Logic* 2 (1973): 447–57.

30. The claim needs qualification because there is typically no unique similarity or feature that would provide an *appropriate* metaphorical interpretation for an utterance. In *Metaphor in Context*, chap. 5, I attempt to work out the requisite details. On the question when an utterance is taken, or identified, to be metaphorical, see my "Metaphor and Grammatical Deviance."

31. See further Stalnaker, "Presuppositions," 451.

32. On this parallel, see now Richard Moran, "Seeing and Believing: Metaphor, Image, and Force," *Critical Inquiry* 16 (Autumn 1989): 87–112. I also explore this analogy further in *Metaphor in Context*, chap. 7.

33. This objection is not the objection often raised against resemblance or comparison theories of metaphor that resemblance is a symmetrical relation while what metaphors express is not; for I would agree with Amos Tversky that resemblance is itself assymetrical; see his "Features of Similarity," *Psychological Review* 84, no. 3 (July 1977): 322–52. My point here is, apart from the nature of resemblance, that on Davidson's account that makes use only of the literal referents of the component terms, there should be no metaphorical difference among the different strings cited in the text inasmuch as they all refer to the same individuals. At this point, Davidson might of course appeal to "context" to distinguish

among the different metaphors; but, without further explanation as to how the context so functions, it should be clear that such an appeal is simply a way of deferring unsolved problems or depositing them in a theoretician's wastepaper basket.

34. See WMM 249.

35. Richard Rorty, "Unfamiliar Noises I: Hesse and Davidson on Metaphor," *Proceedings of the Aristotelian Society*, supp. vol. 61 (1987): 283–96, esp. 293. Rorty's larger project, it should be noted, is not Davidson's; for reasons of space, here I cannot address this dimension of Rorty's essay.

36. Rorty, "Unfamiliar Noises I," 283, 296. Davidson also emphasizes that his denial of cognitive content to metaphor should not be taken to mean (as it did for many earlier positivists) that it is "confusing, merely emotive, unsuited to serious, scientific, or philosophic discourse" (WMM 246). But his praise of metaphor never reaches the exalted heights of Rorty's; at best for Davidson, "metaphor is a *legitimate* device not only in literature but in science, philosophy, and the law" (ibid., my emphasis).

37. Rorty, "Unfamiliar Noises I," 284. The view Rorty contrasts here with Davidson's is that of Mary Hesse; see her paper (in the joint symposium with Rorty), "Unfamiliar Noises II: Tropical Talk: The Myth of the Literal," *Proceedings of the Aristotelian Society*, supp. vol. 61 (1987): 297–311 (and references therein to her earlier papers on metaphor).

38. Rorty, "Unfamiliar Noises I," 295.

39. Note that this sense in which Rorty claims that metaphors cannot be "understood" or "interpreted," namely, that they cannot be brought under an antecedent scheme (ibid., 290), is much more general than the notion of understanding specific to language, i.e., what it is to understand what a word means. Indeed Rorty's alternative notion of understanding (which fits metaphor) is ironically much closer to the way in which Davidson describes the general process by which speakers and interpreters arrive at a mutual understanding, or interpretation, of their utterances by revising their prior theories to make them suitable as passing theories.

40. See Donald Davidson, "Causal Relations," reprinted in his *Essays on Actions and Events* (Oxford, 1980), 149–62.

41. Although it is never very clear how much Davidson wants us to draw out of the various things to which he compares a metaphor (e.g., pictures, jokes, poems), an objection similar to that raised in the text should apply against the view that metaphorical interpretation should be understood on the model of dream interpretation, as Davidson seems to suggest in his opening sentence of WMM: "Metaphor is the dreamwork of language" (WMM 245). For reasons of space, I cannot explore this intriguing analogy in depth; suffice it to say that, while dream interpretation (say, according to Freud's theory) makes much use of causal relations, the literal meanings of the words (used to report the dream) play little role in its explanation.

42. Keith Donnellan, "Reference and Definite Descriptions," *Philosophical Review*, 75 (1966): 281–304. Despite my objections to Davidson's use of Donnellan's referential descriptions, there is a deeper connection here than meets the eye, and elsewhere, in my own analysis of metaphor as a kind of demonstrative, I have drawn on some other elements that lie beneath the surface of the comparison.

43. Davidson uses this phrase as a primitive notion without explication.

44. In this passage Davidson lumps together irony with metaphor, apparently assuming the commonly held view that all such figures belong to one class with one explanation. In *Metaphor in Context*, I argue, however, that irony and metaphor are two different kinds of non-literal interpretation that should not be treated on a par. Hence, I leave it out of my discussion here.

45. To begin with, Davidson's focus (admittedly inspired by some of Donnellan's original examples) on cases where the referential description does not semantically designate the intended referent is misleading; whether or not a description is referential is independent of whether the description is or is not satisfied by its referent. The description is, rather, referential just in case there is a specific individual for whom the speaker uses the description simply as a means of reference. In the normal case, moreover, the description serves as such

a means because the individual is in fact semantically designated by it; and where the individual does not satisfy it, the speaker must (except in certain special contexts) at least believe that he satisfies it—on pain of being misleading. It is also misleading to contrast, as Davidson does, 'saying something true' with 'the sentence' without at least raising the question whether the speaker has thereby made a statement or expressed a proposition that is true. Although there has been much discussion in the literature over whether Donnellan's distinction is semantic or pragmatic, I would argue that it is both: i.e., intuitions of both kinds are at work in Donnellan's description of his distinction. The semantic dimension of the distinction corresponds to the difference between singular and general propositions. The pragmatic distinction is between "teleological" acts (which refer to a predetermined referent) and "blind" (to refer to whoever happens to meet the description, known or not) uses of descriptions.

46. I owe the example to Sidney Morgenbesser who raised it to illustrate a rather different point. Not everyone might agree that this is an example of a malapropism rather than a kind of semantic error, though it should count as a malapropism on Davidson's characterization. In any case, the same moral can be drawn if the example is not strictly speaking a malapropism. For discussion of the problem of distinguishing malapropism from other kinds of semantic speech errors, see David Fay and Anne Cutler, "Malapropisms and the Structure of the Mental Lexicon," *Linguistic Inquiry* 8, no. 3 (Summer 1977): 505–20.

47. See Fay and Cutler, "Malapropisms and the Structure of the Mental Levicon."

48. Of course, not all metaphors may be absurd or even false when their words are taken literally—e.g., 'No man is an island.' However, even where the utterance, taken literally, would be true in which case we can presume that the speaker may in fact tacitly believe what it literally says, it would be philosophically gratuitous to ascribe such belief *because* that is how he must understand their utterances as metaphors.

49. Here I assume that all demonstratives are directly referential terms, i.e., that their propositional content (in a context) is the individual or thing to which they respectively refer rather than a Fregean sense or some other intensional entity. For argument, see Kaplan's *Demonstratives.*

50. This notion of the autonomy of meaning should be distinguished from Davidson's principle of the same name (see above note 21) which, on none of its formulations, expresses the idea that linguistic meaning constrains speakers' communicative intentions.

51. For an especially clear exposition of current linguistic thinking about these constructions, see James Higginbotham, "Knowledge of Reference," in *Reflections on Chomsky*, edited by Alexander George (London, 1989), 159–65. Although the first version of this section of this essay was written before Higginbotham's essay came to my attention, the present formulation of its argument owes much to his discussion of the same issues.

52. Cf. Higginbotham, "Knowledge of Reference," 162.

53. Because the conditions in question primarily exclude interpretations the sentence does not and never could have, and these excluded interpretations are presumably never part of the linguistic data to which speakers are exposed, the conditions cannot be inductively learned from confirming instances. Therefore, in the "absence of negative evidence" (as this problem is known in the psycholinguistics literature), the question naturally arises, and especially for non-rationalist accounts like Davidson's: How do speakers come to know these conditions? For further discussion, see Higginbotham, "Knowledge of Reference," 162ff, and N. Hornstein, *Logic as Grammar* (Cambridge, Mass., 1984), chap. 1.

54. The contrapositive reasoning I have just rehearsed should be reminiscent of one of Chomsky's arguments for the so-called competence-performance distinction: i.e., because acceptable *use* of language is a function of multiple psychological, physiological, and social abilities and capacities, most of which would not be described as linguistic on any reasonable characterization, a theory of linguistic competence proper will itself never account for acceptable use but will explicate only what the speaker *knows* about the specifically *linguistic* properties that contribute to his complex ability that issues in acceptable *speech*. For a similar conclusion based on rather different arguments, see now Ellen Spolsky, "The Limits

of Literal Meaning," *New Literary History* 19 (1987–88): 419–40, and Ellen Schauber and Ellen Spolsky, *The Bounds of Interpretation: Linguistic Theory and Literary Text* (Stanford, 1986).

In David Kaplan's semantic theory for demonstratives, this knowledge would correspond to the speaker's knowledge of the *character* of an expression rather than knowledge of its content in a context, where the character of a expression is a rule, or function, that determines for each context of utterance the content of the expression in that context. In order to know the actual content of the expression in a context, it is necessary in addition that the interpreter have extra-linguistic knowledge of the relevant contextual parameter. For further details, see Kaplan, *Demonstratives*. It should also be noted that all expressions in the language are assigned characters by the semantic theory, although only those of the demonstratives are non-stable, i.e., determine different contents in different contexts. In effect, then, only for the demonstratives, or for other kinds of context-dependent expressions to which the semantics might be extended, does the character-content distinction make a difference.

55. In "Metaphor as Demonstrative" (see above n. 5), I proposed that we identify the speaker's semantical knowledge underlying his ability to interpret an expression metaphor-ically with his knowledge of its *metaphorical character*, i.e., with the character of the expression as it is interpreted metaphorically. Like the character of a demonstrative or, more generally, any expression (e.g., descriptions) interpreted demonstratively, the character of an expression interpreted metaphorically is a non-stable rule, or function, from its context to its content in that context. In the case of metaphor, the relevant context, or contextual parameter, are certain subsets of (extralinguistic) presuppositions "associated" with the ex-pression being interpreted metaphorically, while its content in a context is usually (at least for predicates) a set of properties. For further discussion, see "Metaphor as Demonstrative," 704–10, and *Metaphor in Context*, chap. 5.

56. Here I follow Edwin S. Williams's analysis of verbphrase anaphora which involves an interpretive (or copying) rule of Discourse Grammar rather than a deletion rule of Sentence Grammar; see his "Discourse and Logical Form," *Linguistic Inquiry* 8, no. 1 (Winter 1977): 101–39. Cf. also Noam Chomsky, *Language and Mind*, enlarged ed. (New York, 1968), 33–35; and Ruth Kempson, *Semantic Theory* (London, 1977), 128–32.

57. According to the semantic theory sketched in "Metaphor as Demonstrative," the violations in (7) and (8) are, in fact, formally different. In (7) the antecedent and anaphor will be structurally described (or interpreted at the level of Logical Form, in Williams's theory) with different interpretive forms or, in my terminology, different characters. So, if the metaphorical character of 'is the sun' is the character of the metaphorical expression 'Mthat['is the sun']' (see below), then (7) will be represented at the level of Logical Form, or at the level corresponding to the speaker's proper semantic competence, by the character of

> (7*) *The largest blob of gases in the solar system *is the sun*, and Juliet/Achilles is *Mthat['the sun']*.

Since 'is the sun' and 'MThat['is the sun']' area expressions with evidently different characters, the violation on copying in (7) will be already at the level of character. In (8), however, the antecedent and anaphor, both being metaphors (i.e., both having metaphorical expression types), will have the same character.

> (8*) */?Juliet is *Mthat['the sun']*, and Achilles is *Mthat['the sun']*.

Hence, their violation of the copying constraint must necessarily occur at the level of content. Now, the different "levels" or "stages" at which the copying constraint is violated do in fact affect our intuitions of unacceptability. It is possible to cancel the implication of univocality at the level of content, as in (8), but not at the level of character, as in (7). Contrast (7**) and 8**):

> (7**) *The largest blob of gases in the solar system is the sun, and Juliet/Achilles is, too—but not in the same sense/way.
> (8**) Juliet is the sun, and Achilles is, too—but not in the same sense/way.

58. It should be noted that on Davidson's account both (6) and (9) are absurdly false according to what they literally mean—which is, of course, all that they mean for Davidson. Hence, insofar as they have the same truth-value, it is not clear how he can even *describe* Romeo's and Paris's disagreement in the situation imagined.

59. Although a full explanation would require a more detailed and technical presentation of the specific semantic theory of metaphor I proposed in "Metaphor as Demonstrative," since I have criticized Davidson on this score, I owe the reader at least an indication here of how I would go about explicating how a metaphorical interpretation of an expression "depends" on its literal meaning. In the above essay, I proposed lexically representing the metaphorical interpretation of an expression \emptyset by the "metaphorical expression" 'Mthat[\emptyset]' which was intended to parallel Kaplan's Dthat-descriptions of the form 'Dthat[\emptyset]' which represent the demonstrative interpretations of arbitrary definite descriptions. Hence, at the level of interpretation corresponding to the interpreter's semantic knowledge of metaphor, 'is the sun' interpreted metaphorically in 'Juliet is the sun' (in the context described in Shakespeare's play) would be represented by the metaphorical expression 'Mthat['is the sun']', whose character would be a function from the "metaphorically relevant" contextual presuppositions "associated" with 'the sun' (interpreted literally) to some property (of Juliet). Here the literal meaning, or character, of the expression 'the sun' is critical in determining the relevant set of associated presuppositions, even though the criterion of relevance may itself vary from context to context. Moreover, here the appropriate sense of 'meaning' (of 'is the sun') is character rather than content because of demonstratives used metaphorically whose character rather than content is obviously what is the relevant (e.g., 'it' in cummings's "a salesman is an it that stinks to please."). However, all this is at the level of the character of the metaphorical expression rather than at the level of its content, or truth condition, in a context. In short, then, on my account, the "metaphorical depends on the literal" in that the metaphorical character of an expression \emptyset interpreted metaphorically (i.e., the character of the metaphorical expression 'Mthat[\emptyset]') is a function of, or depends on, the character of \emptyset (interpreted literally).

60. Apart from accounting for the "autonomous" aspects of this metaphorical interpretation, elsewhere I have presented other reasons for positing a level of metaphorical interpretation like that of character. See "Metaphor as Demonstrative," 681–90, 709–10, "Metaphor without Mainsprings," 436–38, and *Metaphor in Context*, chap. 7.

The Psychology of Aristotelian Tragedy

AMÉLIE OKSENBERG RORTY

Sophocles puts the moral of our story best, and what he says reveals the essence of Aristotelian tragedy.

> Wonders are many and none more wonderful than man . . .
> In the meshes of his woven nets, cunning of mind, ingenious man . . .
> He snares the lighthearted birds and the tribes of savage beasts,
> and the creatures of the deep seas . . .
> He puts the halter round the horse's neck
> And rings the nostrils of the angry bull.
> He has devised himself a shelter
> against the rigors of frost and the pelting rains.
> Speech and science he has taught himself,
> and artfully formed laws for harmonious civic life . . .
> Only against death he fights in vain.
> But clear intelligence—a force beyond measure—
> moves to work both good and ill . . .
> When he obeys the laws and honors justice, the city stands proud . . .
> But man swerves from side to side, and when the laws are broken,
> and set at naught, he is like a person without a city,
> beyond human boundary, a horror, a pollution to be avoided.

What is a tragic drama? Why are we so affected by tragedies, sobered but enlarged, seared but strangely at peace? Why do tragedies—and what we learn from them—bring us such complex, bitter-sweet pleasures?

Aristotle gives us the best explanation we have for our experiences of tragedy. But if we accept his explanation, then we must also accept a good deal of his psychology and ethics. Aristotle's characterization of a tragedy is, perhaps, all too familiar, so familiar that we misread him, replacing his intentions with ours. Tragedy is one of the poetics arts.[1] It is, he says, an imitative

representation (*mimesis*) of a serious (*spoudaios*) action, dramatically presented in a plot that is self-contained, complete, and unified. The protagonists of tragic drama are admirable, not technically speaking heroes or demigods, but larger and better versions of ourselves.[2] In the finest tragedies, the character of the protagonist makes him susceptible to a deflection—to an erring waywardness—that brings disaster, producing a reversal in the projected arc of his life. The story of his undeserved misfortune arouses our pity and fear, clarifying and purifying those reactions in such a way as to bring us both pleasure and understanding. At its best, tragedy brings recognition of who and what we are. Like other forms of poetry, tragedy is philosophic and illuminating, more truthful than history.

Before examining the elements of Aristotle's definition and locating them within the larger frame of his ethics and psychology, we should say something about the kind of theory he holds. Although Aristotle focuses on the formal elements of tragedy—on the best way to structure plots—his is not an aesthetic theory. The pleasures and the insights of tragedy do not rest solely or primarily in their purely formal properties, in the elegance of structural tension and balance. In the arts and crafts—as in biology and metaphysics—form follows function and purpose. The beauty and merit of any individual work—a shoe, a pot, or a tragedy—is a function of the way that its form expresses and fulfills its aims clearly and elegantly, in an appropriate medium and manner. Because they are representational, all the poetic arts include, among their various aims, that of bringing us to some sort of recognition: they fulfill their other aims by way of affecting our understanding.

Incomplete and fragmentary as it is, the *Poetics* conjoins a number of distinct enterprises: it is, to begin with, a philosophical study intended to analyze the structures and functions of the range of poetic genres as if they were biological species. The motto of this mode is: Save the phenomena. But since the phenomena are a species of craft, the *Poetics* is also a book of technical advice. Aristotle's advice to the tragedians is advice about how to fulfill the point of writing tragedies, how to structure dramas in such a way as to produce a specific kind of psychological and intellectual effect. This advice goes beyond telling dramatists how to conform to a model that was derived by an analysis of classical drama, as if Aristotle were a chemist who had analyzed a compound and derived the formula for producing it. Aristotle's way of saving the phenomena of tragic drama has a strongly normative turn, beyond that which is implicit in any technical advice. Indeed, his normative agenda may have so focused his analysis of classical drama that he ignored some of its important features. The motto of this mode is: Save drama against Platonic attacks by naturalizing and rationalizing it. Aristotle set himself the task of showing that good tragic drama—tragic drama properly understood—can promote instead of thwart understanding, that it can atune rather than distort the emotions it arouses. The argument of the *Poetics* is intended to show that the best effects of tragic drama derive from its representational truthfulness rather than from ecstasy; that the turn of the plot depends on human agency rather than demonic

or divine forces; that the primary emotions evoked by tragic drama are pity and fear about what can plausibly happen rather than horror or awe about the way that fate (*Moira*) can, in a strange alliance with chance (*Tuche*), intervene in the natural course of events. It is a person's character (*ethos*) rather than any cosmic justice (*dike*) or vengeance (*nemesis*) that determines his fate. It is for these reasons that Aristotle does not discuss the role of civic and religious rituals surrounding the traditional performances of the classical tragedies: his view is that neither tragedy nor its essential psychological effects depend on retaining their archaic sources or forms. Nietzsche was quite right: Aristotle wanted to transform, if not actually to eliminate any remnants of Dionysian origins of tragedy.

A central instrument in Aristotle's legitimizing tragic drama is his view that tragedy produces its emotional and cathartic effects through *mimesis*, by representing and imitating actions. Instead of seeing *mimesis* as essentially falsifying, he sees it as capable of being correct or truthful. Although he recognizes that every representation involves interpretation, Aristotle is no more a hermeneuticist than he is a formalist. Every representation of an action—whether it is structured as an epic, or in history or oratory—necessarily gives that action some form, a definition and a boundary. To be sure, everyone—protagonist, chorus, even every member of the audience—has his own interpretation of the structure of the action. But there is a truth of the matter, indeed a double truth. To begin with, protagonists can be profoundly mistaken about what they are really doing. Oedipus may have believed that he married the Queen of Thebes, and so he did; but the proper description of that action—the description that should have guided his deliberation—was that he married his mother. Aristotle carries the correctness of actions further: however well individual agents understand their individual actions, these actions can themselves conform or fail to conform to the norm that governs the type of action in which they are engaged. Whatever the Egyptians may have believed about royal agnatic marriages, incest is a violation of order, no matter where it occurs.

Neither self-conscious formalism nor self-conscious hermeneuticism allow for Aristotelian tragedy.[3] For whenever there is the awareness of the play of abstraction or the play of interpretation, we implicitly grant ourselves the power—even if it is only an intellectual power—to elude the ineluctable, escape the inescapability of the tragic plot. To be sure, we could in principle separate the elements that define Aristotelian tragedy, and vary them in such a way as to produce new genres, cousins to Aristotelian tragedy. And indeed later dramatists did redirect the ends of the plays they called "tragedies": Elizabethan critics like Nevyle thought tragedies should show "Gods horrible vengeaunce for sinne;" Corneille intended to evoke the grandeur and gravity of the diction of noble action and passion. By contrast, Lessing stressed the evocation of pity and compassion through simple, unaffected language.[4] Schiller returns to an emphasis on the moral lessons of tragedy, as expressing the tensions between the sublimity of self-legislating freedom and the pathos of human suffering.[5]

Many of our contemporary dramatic 'tragedies' are focused on protagonists who live in a world in which the possibility of nobility is seriously in question. From Aristotle's point of view, debates about whether these dramas are, strictly speaking, tragedies, are idle and empty. Dramatic genres are differentiated by their ends; but the ends of a work of art—indeed the end of any *technē*—also specify the formal structures of the work. To change the form is to shift the end; to shift the end is to change the genre.

MYTHOS AND MIMESIS

"Mythos—a story or plot—," Aristotle says, "is the fundamental principle and soul of tragedy" (1150b2ff.). While there is sorrow, grief, loss, and pain in life, there is tragedy only when the actions and events that compose a life are organized into a story, a structured representation of that life. A drama is not only a *mimesis* of an action, the enactment of story that represents actions by actions and in actions: at its best, it also brings us to an understanding of the shape (*eidos*) and boundary (*horos*) of human action. Like all re-presentation, drama selectively condenses and structures what it presents. It reveals the inner logic and causal organization of an apparently disconnected series of events, encompassing them to form a single extended, self-contained and completed activity. A mythos takes what seemed to be a set of randomly distributed points and represents them in an arc, the trajectory of a well-formed parabola, containing all (and only) the elements and causal relations that are necessary to explain what happens. The delimitation and the definition of an action—its boundaries and its essential point—are coordinate: representing the structure of an action conjoins the arc of its temporal completion with the fulfillment (or failure) of its aims or intentions. We do not know when an action has been completed, let alone whether it has been successfully completed, unless we understand its aim or purpose.

Before we can understand Aristotle's account of how drama represents action, we need to understand his theory of representation. *Mimesis* conjoins two notions. Neither the terms *imitation* nor *representation*, taken separately and independently of one another, fully capture Aristotle's use.[6] Consider: an actor's mask is a representational *mimesis* of the face of a certain kind of character, that of a king or that of a shepherd, for example, as abstracted from their accidental individuating factors. A good mask enables the spectators straightway to identify the King, the Shepherd. Similarly a portrait represents the structure (*morphe*) of an individual's features: it is successful when we can recognize that it is a representation of Pericles rather than Sophocles. A good mask represents those features that reveal what is essential to the type: presumably in showing us what differentiates a King from a Shepherd, it also shows what a king really is; in differentiating Youth and Age, tragedy from comedy, it reveals what is centrally characteristic of each.[7]

Like many other animals, we are constitutionally set to mimic the actions of those around us. It is through *mimesis* as imitation that we first learn,

acquiring the habits that form our character, as well as the skills and abilities that constitute our virtues (1103b21ff.). When imitation works well,—when our models truly represent the essence of these activities, we not only learn how to play, to dance, to make pots, to arrange the matters of the day, but also what playing, dancing, pottery really are, what ends guide and determine the structuring of these activities. Ideally the idiosyncracies of our models drop out, and what remains is the essence of the actions and activities that constitute a well-lived life.

Despite their differences, Aristotle accepts a central part of Plato's account of *mimesis*: A *mimesis* selects and abstracts the structure of what it represents.[8] There is no imitation or representation without interpretation; and no interpretation without some formal abstraction. The representation of an object or an event sets forth the formal organization or schema (*eidos*)—the rationale (*logos*)—of the relation among its parts. A dramatic imitative representation of an action reconstructs the dynamic causal connections among the events that compose it. The criterion for a sound or good imitation of an action is that the representation be truthful, that it captures what is essential to the original, abstracted from the accidental and contingent features of its performance.[9] For good or ill, Aristotle is not a hermeneutical Talmudist; interpretation is not the core human activity; he does not believe that the interpretation of events or actions is endlessly or playfully open; it is not the key to our freedom. While interpretations are indeed perspectival, some perspectives are more revealing, closer to the truth than others. (To be sure, Creon's and Tiresias' perspectives on Antigone's actions are radically different; but they are not on that account equally sound. Creon is, ironically, enough blinded by his failing to grasp what being a ruler requires, while Tiresias clearly foresees the dangers that await Thebes.) The kinds of actions that are centrally significant to a human life—the serious (*spoudaios*) actions involved in ruling a city, in civic and even familial life—have a normative structure. Such actions and activities have an objective end or point; they can succeed or fail in realizing that point. Tragedies represent the way that the protagonist's serious actions—those that are central to defining his life—skew the essential ends of what he does, and how this error, this waywardness brings disaster. The *mimeseis* of tragic drama can be evaluated for their truthfulness: they show how the protagonist's (well-intentioned but mistaken) purposes skew the true or essential ends of his actions and how his *hamartia* brings disaster. For instance, the story of *Antigone* reveals the consequences of Creon's *hamartia*—his failing to understand what it is to be a king, a failing that permeates all that he does.

Many tragedies represent a tale with which the audience is likely to be familiar. The original tale is itself a mimetic representation of a legendary set of events. For such dramas—*Oedipus* is one of them—the audience does a double take, as it were. It recognizes that Sophocles is representing an old tale; and it recognizes that the old tale represents the structure of a certain *sort* of action. That old story, the story of Oedipus, could also be truthfully represented—imitatively re-presented—in an epic; or in music and dance. The

appropriate structuring of a *mimesis* varies with the aim or the purpose of the representation. Had Oedipus been a historical figure, the story of his actions could also have been represented in a chronicle. While a historical treatise represents certain events and actions, it does not, by Aristotle's lights, attempt to produce a particular emotional or motivational effect on its audience. But a political orator could introduce the story of Oedipus in the course of an argument to pursuade a polity to conduct a thorough investigation of a stranger's ancestry before accepting him as a ruler. He would, without distorting the original story, structure his representation of the action in such a way as to bring about a certain kind of political effect. Although the story of Oedipus is, to be sure, not a ordinary story, it is told as a tragedy—a tragedy with universal significance—when it is structured in such a way as to bring about a specific emotional and intellectual effect, by representing the story of an action that undoes a person of high energetic intelligence.

ACTION AND THE UNITY OF ACTION

What then are actions? Human actions are a species of natural motion, motion whose sources are internal to the agent. Avalanches toss great boulders, roots of trees press through rock, animals devour one another, each acting from its own nature, to fulfill its nature. Our natural motions are also of this general kind. We differ from avalanches and animals in that some of our natural motions— those we call our actions—are structured by our intentions, our beliefs and desires. We act—we intervene to change or direct the course of events—in order to fulfill our purposes, ultimately for the sake of what we take to be our happiness (1095a14ff.). When we intentionally and deliberately intervene in the course of events—ringing the nostril of the wild bull, snaring the lighthearted birds—we are not acting against nature. On the contrary we are expressing our natures. We differ from avalanches and animals in that we are capable of intelligent planning and of acting voluntarily, understanding the meaning and normal consequences of what we do; and when it is in our power to have acted differently.

Intelligent action arranges the affairs of life in such a way as to con-duce happiness; but a life of action and activity is more than a well-planned enterprise, one that produces happiness as if it were interest on a crafty busi-ness investment. Happiness is not an outcome or end-product of action and activity. It *is* soul actively engaged in its natural activities, doing its best at its best (1098a15ff.). An action takes the form of an activity when it is self-contained, whole and complete, fully performed, its ends achieved in the very performance.[10] Many actions, particularly those which express basic species-defining traits, are specifications of activities or are embedded within them. Political discussion is, for example, an exercise of the fundamental activity of civic life; similarly the actions involved in botanical or animal dissection are part of the activity of scientific inquiry.

In the *Nicomachean Ethics*, Aristotle remarks that humans are in a way

thought to be partially divine, or at least to share in divinity insofar as they share in *nous*, that is, insofar as they share in intelligence, in mind (1177b27ff.). Contemplation is of course the most preeminent and perfectly formed noetic activity; in it we fulfill what is highest and best in us, purified as it were, of all that is extraneous and contingent. Nevertheless insofar as we act intentionally and intelligently, forming action by thought or *dianoia*, we act in a godlike way, changing the direction of what would otherwise have happened, through and because of our thought-filled and thought-directed interventions.

As we differ from animals in our capacities for thought, we differ from divinities in our susceptibilities to waywardness. Only those who can act intelligently, only those who can grasp the truth of what they do, can act in error and ignorance. Unlike other animals, we can act askew, lawlessly, and although our intentions are always directed to what we believe to be good, we often do not know what is good, even for ourselves. The ends that direct our actions can be opaque to us, even when we are acting from our clearest and best understanding. Indeed it is sometimes precisely our way of being at our clearest and best that undoes us.

Sometimes, it is the very energy and vigor of our purposiveness—the fact that we act in a focused arc of attention—that blinds or at least blurs what appears at the periphery of our intentions. There is no action without focused purpose and the energy to fulfill it; there is no focused, energetic purpose without the lively possibility of disorder, of going wrong. Even intelligent, truth-bound beliefs and well-formed desires for what is genuinely good are not sufficient to carry purposes to their realization. The successful enactment of the strongest, most intelligent desires also requires a certain kind of energy which at its best is confident, often indignant, and sometimes courageous; at its worst, presumptuous and disordering.

Except for self-contained activities that are completed in the very act of performing them, we rarely grasp the structured unity of what we do. That is one of the reasons we cannot judge a person's life happy until he is dead, and perhaps some time after he is dead, when the full shape of his actions are finally revealed, their trajectories completed. The real completion of a person's life—the realization of the projects that were essential to it—does not usually coincide with the natural end of his activity in death. We do not know whether a person has been a wise parent until his children are grown; nor whether he has been a wise statesman until his policies have been in effect for some time (1100a18ff.).

Drama reveals the form and point of the protagonist's actions, their sometimes hidden directions and purposes. In a way, we cannot see what an action really is, until we see it contextualized, embedded in the story of which it is an essential part. Until we see the completed whole in which an action functions, we cannot determine whether it has been well or ill performed, whether it succeeds or fails. An action is only partially identified and directed by the agent's intentions, by the chain of practical reasons that connect it to his general ends. These are, as it were, the logical structure of the beginning and end of his action,

conceived in isolation. But even the logical structure of the agent's intentions do not yet give the full explanation of what he does. Those intentions must also be located in the story that reveals the causal structure of the unfolding of his interactions with other characters.[11] To be sure, in ordinary life, we identify and evaluate actions readily and quickly, without extended investigations into the practical reasoning that formed the agents' intentions or the stories that frame their actions. But that is because we assimilate particular actions to a standard form, supplying the standard stories and intentions that are implicit in our categorized perceptions. It is against the background of such assumptions about the etiology and directions of standard action-types that we judge particular intentions and actions to be well or ill formed, justified or askew.

The stories or plots of tragedies reveal the significant structures that unite serious actions—actions that make a difference to how a person lives, well or ill, happily or unhappily—into a self-contained whole, an activity. But life *is*, according to Aristotle, activity: it is expressed in action and activity (1175a12ff; 1170a20; 1450a16ff.). By connecting the protagonist's serious actions into a story, drama reveals the unified structure of a life. Represented *in* a unified whole, a life can be seen *as* a unified whole, with an intelligible shape (1100b32). That is why tragedies are of enormous and terrifying significance to us, because they are representations of what can go wrong even in the best and most intelligent action, go wrong not merely because chance and accident attend all contingent events, but because of some error or misdirection in the action itself, a deflection that brings a reversal of the very intentions that propelled it.

A plot or story presents discrete events and actions as forming a completed and self-contained whole which can be grasped all at once, as a single activity, lacking nothing, with its component incidents so arranged that if one of them is removed, the whole is disturbed or destroyed (1451a7 and 15ff.). A plot connects the incidents that compose it in three ways: (1) causally, (2) thematically, and (3) it exhibits the connections between the protagonist's character, his thought, and his actions. (1) Aristotle puts the causal connection straightforwardly and simply: the events are linked, shown as happening because of one another (1452a2–4). (2) Repetition is the simplest type of thematic connection; ironic reversal is another (1452aff.). The example Aristotle gives is that of the statue of Mitys falling on his murderer (1452a10). The blind Tiresias is the true seer. Antigone lived to bury her dead; her punishment was to be buried alive. But since she deliberately did what she knew to be punishable by death, she took her own life in the tomb where Creon had placed her. It is such patterned closures as these that give thematic unity to drama. (3) Finally the unity of the plot is manifest in the way that each protagonist's fundamental character traits are expressed in all that he thinks, says, does (1452a2ff.). Oedipus revealed himself kingly in all he did, in all his actions: in the images of his bold speech, in the large scope of his thoughts, in his assurance and high, quick energy; in the directions of his actions, moving always to protect his city.

CHARACTER (ETHOS)

Although tragedy is, according to Aristotle, about action rather than about character (1450a15ff.), the two are coordinate (Rhet I.12.1372ff.). Because character is expressed in choice (*prohairesis*), because choice determines action, and because "eudaimonia takes the form of action" (1450a16), it is a person's character rather than his *daimon* that determines his fate. While in principle a person might have some character traits that are rarely, if ever exercised, character is essentially individuated and fundamentally articulated in choice and in thoughtful action (1139a22–23; 1144b30–32).[12] Since "life is action and activity" (1450a16ff.) tragedy that represents serious action is also a dramatic representation of the way that the protagonist's character is expressed in his fundamental choices, those that affect the way that his life unfolds.

Tragedy represents protagonists who are recognizably enlarged and simplified versions of what is best in us, presented without the multiple extraneous purposes that confuse our actions. They are what we would be if we could undergo an alchemy, a purification of the elements that compose us. They have, in an exemplary form, the character traits and dispositions that are the raw materials of virtue, the intelligence that goes into *phronesis*, the energy that goes into *andreia*, the commitments that go into *philia*, the assurance that goes into greatheartedness. The character structures (*ethe pratteos*) of the protagonists of tragedy are stable: they are expressed in intelligently formed habits of perception and emotion that move smoothly to well-formed deliberation and action.

Given all this, it might seem as if the description of the tragic protagonist is incoherent, and the account of the tragic plot paradoxical. The plot unfolds from a waywardness in the character of the protagonist. But virtue is, by definition, self-regulating and self-correcting; and of course it typically brings happiness. So how can virtue be subject to *hamartia*, how can it involve wayward misunderstanding? There is no adequate translation of *hamartia*.[13] "Flaw" misleadingly suggests that the hamartia is structural, that it is built into the protagonist's character. But if the protagonist's waywardness were part of his character, he would not be an exemplary figure, his suffering would not be undeserved, and we would not pity him. If, on the other hand, his *hamartia* were purely extraneous—like an accidental illness—we would not, seeing his character in action, fear for him. In neither case would the drama be well structured or unified; in neither case, could we learn anything from tragedy; nor would it please us. Yet translating *hamartia* as "error" or "mistake" misleadingly fails to capture the dispositional character of the protagonist's *hamartia*; and in emphasizing its purely intellectual aspect, those notions also fail to capture the way that the protagonist's *hamartia* affects his *thumos* and *pathe* as well as his thoughts. Though a protagonist's *hamartia* can sometimes just involve his making a factual error, it is generally the sort of error that a person of his character is prone to make. In combination with his character, it misleads his action. (For instance, a character given to grand poses might systematically mistake the size and importance of his family estate, and so treat his neighbors

with untoward arrogance.) Character virtues and their susceptibilities are simultaneously cognitive *and* connative: they affect a person's passions and desires, as well as his perceptions and inferences.

In the best tragedies, the reversals of fortune that the protagonists suffer come from something central in them, not from any particular thing that they did, but from a waywardness that could not, even with more foresight or energy, have been prevented. The *hamartiai* that bring misfortune are contingent by-products of admirable character traits, traits that are the natural basis of the virtues and that normally promote thriving. An example might help illuminate Aristotle's point: the character of a courageous soldier explains his taking the sorts of risks that would normally be unwise, his charging the enemy in a way that exposes him to the danger of being wounded in battle. Still, he is not responsible for being wounded, and so we pity his suffering, even while admiring his character. It was possible, perhaps even very likely, that a courageous person like himself would be more likely to be wounded than an ordinary soldier; and so although we might fear for anyone going into battle, we especially fear for him, as he goes into battle. By contrast, we might pity someone who was accidentally wounded by a tile that fell on his head as he walked to the Agora on a windy day; but we do not fear for everyone who walks to the Agora on windy days.

It is as if *hamartiai* were like cancer: contingent growths that arise from the very activities that promote healthy physical development. Noble intentions can, often by the logic and development of their own momentum, lead to actions whose full trajectory reverses their origins. Such reversals are especially likely to occur in interaction among several characters, each acting from the arc of his own intentions.[14] Tragedy reveals that there is, as it were, a canker in the very heart of action. All action is formed by intelligence, to be sure; but by an intelligence directed by a relatively limited purpose. The gap of opacity, and with it the possibility of ignorance and deflection always stands between even the best general purposes and the particular actions that actualize and fulfill them. The tragic hero's *hamartia* is an accident of his excellence: his purposes and energy make him susceptible to a kind of waywardness that arises from his character. Although the occasions that unfold the consequences of the agent's *hamartia* are contingent, they are the sorts of things which might well happen. Once they have occurred, the dramatic action that brings about the reversal of the protagonist's fortune has—in the best of tragedies—a terrible and irreversible inevitability. The focused clarity, the assurance, the vitality and energy of exemplary, excellent action—its very godlikeness—are shadowed by the misdirections that threaten their excellence. Concentration blurs what is at the periphery of attention; courage sets natural caution aside; greatheartedness carries the possibility of arrogance; a person of grandeur, with an unusual scope of action, can readily lose his sense of proper proportion, forget his finitude. Everything that is best in the protagonists make them vulnerable to their reversals: like all living creatures, they naturally strive to realize what is best in them; and it is precisely this that, as their actions unfold, undoes them.

The cancer that is at the heart of the tragic protagonist's *hamartia* often involves his not knowing who he is, his ignorance of his real identity.[15] To know who one is is to know how to act: it involves understanding of one's obligations and what is important in the way one interacts with others. The kind of ignorance that literally involves not knowing one's family is particularly dangerous because it affects all of a person's sacred, political, and ethical conduct. But a protagonist can be superficially, verbally aware of who he is, and yet fail to carry that knowledge through to his conduct, acting as if he were ignorant of what he claims to know. Phaedra's passion for Hippolytus expresses a dramatic *hamartia*: her desire involves her forgetting who she is, the wife of Theseus and stepmother to Hippolytus. In a queen, such a *hamartia* endangers the whole kingdom. Of course Phaedra is not suffering from amnesia or literal ignorance. Nevertheless, her passion for Hippolytus involves her in ethical, character-based wrong-doing.

In a way, there are, in the dramatic world that is composed entirely of serious actions that affect the tenor of a life, no merely intellectual errors. When a drama is composed entirely of serious actions, even factual errors are weighty: a person who is ignorant of his lineage is likely to act improperly. Ignorant of his relations and obligations to those around him, Oedipus does not, in the deepest sense, know how to behave. But Oedipus also suffers another kind of ignorance. His cleverness in answering the riddle of the Sphinx shows that he has a verbal grasp of the boundaries (*horos*) and the vulnerability of human life. Yet his contempt towards Tiresias shows that he has not fully understood the significance of his answer. Acutely aware of his exceptional powers of mind, his actions, thought, and speech reveal his *hamartia*, the arrogance that makes him prone to error.

In the best plots, the *peripeteia* of action—the moment that reverses the protagonist's fortunes—coincides with insightful recognition (*anagnorisis*). Significantly, this recognition typically fulfills the ancient command to know oneself (*gnothi seauton*) (1452a32ff.). In recognizing that he is the son of Laius and Jocasta, Oedipus comes to himself, realizes what he is, as well as what he has done. The reversal of his fortune consists in his fully acknowledging his having violated the fundamental social, metaphysical, and sacred structures that should have directed his actions. As his ignorance was not merely an intellectual error, but a waywardness that pervaded his actions, so too his acknowledgment of his waywardness is not merely a cognitive recognition. It consists in his living out his life, a blind man wandering, "a horror, a pollution to be avoided."

CATHARSIS

No wonder that the reversal of intentions, the change of fortunes of those who are better than ourselves evokes pity and fear. If they are ourselves writ large, then what can happen to them can happen to us as well. Perhaps we are as blind to what we are doing as Oedipus; perhaps we too mistake impetuous rashness for courage, presumption for righteous indignation. Perhaps we too

are ignorant or forgetful of who and what we are.

What difference is there, if any, between the pity and fear that we feel in the normal course of action, and those we experience in and through tragic drama? And how can drama educate us, so that we experience pity and fear appropriately? Normally fear (*phobos*) is particular and functional; it signals danger. The ethical and political question that the phenomena of fear raises is: What is, and what is not worth fearing? Similarly, pity—*eleos*—is normally particular and functional: it signals that a friend or someone like ourselves has suffered an undeserved misfortune.[16] The ethical and political questions are: Whom should we pity? What should we regard as undeserved misfortune? The virtues—certainly courage and perhaps also the kind of civic friendship that is at the core of pity—involve the capacity to have the right emotional reactions at the right time, in the right way, directed to the right objects. In fact the virtues are just that—they are *hexeis*—active appropriate habits of acting and reacting. Courage, for instance, involves knowing what is worth fearing, being able to set aside natural self-protective fears in order to act wisely on behalf of what we most prize. Similarly, appropriate pity involves knowing when misfortune is undeserved, recognizing human finitude and the limits of control and responsibility. It also involves an affective understanding of our solidarity with those who resemble us, sensing our common fate.

But just whom do we pity and fear? The tragic hero? Ourselves? Humankind? All three, and all three in one. Like drama generally, tragedy represents intentions and actions from the agents' point of view, in their language. When they speak in the first person, the protagonists of tragic drama invite our reflective identification: after all, they are like ourselves. Of course the resemblance between the protagonists and ourselves is a general one: we need not be rulers of Thebes, or even Thebans, to identify with Oedipus; nor need we be sisters or even women, to identify with Antigone. We also see the protagonists externally, taking the perspectives of the other characters and of the chorus; and we share in all their reactions.[17] So, to begin with, we feel pity and fear for the tragic hero, but we do not learn appropriate pity and fear by imitating exactly his emotions. For one thing, he does not pity himself: he is grieved or horrified by the unfolding of his actions. And while the tragic hero may fear, he fears the specific consequences of his actions. But in pitying him and fearing for him, we take the reflective spectator's point of view. He fears what may happen: we fear for him. Still when we feel for him, we see ourselves in him, and so we pity ourselves and fear that the kinds of unexpected misfortunes that met the tragic hero can happen to us. Since we are also essentially social and political beings, connected to others by civic *philia*, we treat the welfare of our friends and family as essential to our own welfare. Our *philoi* form a series of expanding circles, starting from the closest family and friends, to partners in a common civic project (*koinonia*) to those who—like members of the human species—share a common form of life.[18] So we also come to enlarge the scope of our pity and fear to its proper objects: to the plight and danger

of those who, like us, attempt to change the course of events to conform to their purposes.

The issue of whether the audience's emotions are, in the end, fundamentally merely self-regarding can be set aside. In fearing for themselves, the audience does not fear for themselves as idiosyncratic individuals. Their fears are simultaneously specific and general: caught up in the action of plot, they fear what seems likely to happen to the tragic hero; but since that fear also has a more general description, as a fear for the undeserved misfortunes that can attend intentional action, they also fear for their *philoi* and for themselves.

But pity and fear are aroused in order to effect a catharsis. The classical notion of catharsis combines several ideas: it is a medical term, referring to a therapeutic cleansing or purgation; it is a religious term, referring to a purification achieved by the formal and ritualized, bounded expression of powerful and often dangerous emotions; it is a cognitive term, referring to the intellectual clarification that involves directing emotions to their appropriate intentional objects.[19] All three forms of catharsis are meant, at their best, to conduce to the proper functioning of a well-balanced soul.

A harmonious soul is by no means apathetic, drained of emotion. Aristotle does not have a hydraulic or drainage-ditch model of catharsis. A room that has been cleaned is not emptied, but brought to its proper order; a body that has been purged is not an empty sack, but one brought to its healthful functioning order, one that absorbs what is nourishing and eliminates what is not. What matters about pity and fear is that they be well formed and well directed. Their not being excessive or deficient will follow from their being well formed, rather than the other way around. (Consider: When a thought is well articulated and expressed, it has the proper place and weight, playing an appropriate role in a person's whole system of beliefs. Similarly, the proper measure of the quantity of an emotion is a function of its having proper objects, not the other way around. In both cases, the thought and the emotion are fulfilled, brought to their appropriate psychological and intellectual functioning, by being properly focused, defined, and articulated.) When pity and fear are appropriately felt, directed to the right things in the right way, according to the *logos* and the measure that is appropriate to them, they can play their natural psychological and civic functions (*Rhet.* II.9 1386b13). But Aristotle does not think that we can become virtuous by attending tragic dramas. To begin with, a person who has undergone catharsis is only as healthy as his body can be made by purging: a purge does not cure high blood pressure or poor eyesight. Furthermore, the virtues are acquired largely through habituation: but we only occasionally attend the theater or read tragic drama. Even if the kind of catharsis that tragedy brings necessarily involves the insight of *anagnorisis*, it cannot by itself make us virtuous. It cannot even assure those virtues centered around pity and fear. We must also practice the appropriate active habits.

The controversy about whether catharsis primarily involves an intellectual clarification or an emotional rectification shadows the controversy about whether *hamartia* is an intellectual error or a characterological flaw, and

whether *anagnorisis* can be purely cognitive.[20] For Aristotle the distinction between intellectual clarification and emotional rectification is spurious and tendentious. In the domain of practical life, cognition, character, and action are coordinate. Despite his repudiation of Plato, Aristotle's insistence on the separation between theory and practice does not entail a radical separation between practical reason and character. The distinction between theory and practice is a distinction between types of activities—both of them cognitive—as characterized by their methods and aims. Because the aims and methods of *episteme* and those of *praxis* are distinct, it is possible for a good scientist to lack practical wisdom and for the *phronimos* to be a poor scientist. But the distinction between theory and practice does not imply that a person could be virtuous without practical intelligence.[21]

The psychotherapeutic expression *working through* is a perspicuous translation of many aspects of the classical notion of catharsis. In *working through* his emotions, a person realizes the proper objects of otherwise diffuse and sometimes misdirected passions. Like a therapeutic *working through*, catharsis occurs at the experienced sense of closure. In recognizing and re-cognizing the real directions of their attitudes, the members of an audience are able to feel them appropriately; and by experiencing them in their clarified and purified forms, in a ritually defined and bounded setting, they are able to experience, however briefly, the kind of psychological functioning, the balance and harmony that self-knowledge can bring to action.

And so, naturally enough, we turn to pleasure.

PLEASURE

What is pleasurable about tragic drama? And since Aristotle claims drama is itself pleasurable, what is pleasurable about drama? Pleasure is not a process or the outcome of a process: it is the unimpeded, uninterrupted exercise of a natural activity (NE 1153a10ff.). The prime cases that reveal the character of pleasure are those natural species-defining characteristics which, like the pleasures of sight, are complete in their very exercise. We do not need any motivation to perform such activities, and they are, when properly performed, on their proper objects, without impediment, intrinsically pleasurable, independently of whatever else they may achieve.[22] Even those pleasures that are relativized to pain or depletion—pleasures like those of recuperation or satisfying hunger—arise from the natural activities of the organism in healing itself or in absorbing nourishment. Properly understood, such pleasures are focused on the activity rather than on the state produced by it.

The pleasure of an action lies in its being fulfilled, completed as the sort of activity that it is, with its proper value achieved. Aristotle has a doubly normative conception of pleasure. To begin with, pleasures are individuated and identified by the actions and activities that they attend, and in which they are immanent. But actions are themselves intentionally individuated and identified. Two persons attending the same dramatic performance may be performing

different actions in going to theater together; though they may both derive pleasure from the drama, their pleasures will differ as their intentions differ. One may be pleased by and in the event, the crowds, the excitement; the other may be absorbed in the unfolding of the drama.

But here, as elsewhere, there are norms. The pleasures of attending dramatic performances have proper forms and proper objects. To begin with, a well-performed tragic production conjoins the exercise of a large range of natural activities. We take pleasure in the activities of the senses on their natural objects: music, dance, spectacle, and the declamation of rhythmical verse are, when well formed and well performed, pleasant. Tragic drama brings the further pleasures of catharsis as a natural therapeutic activity.

Drama also brings the pleasures of *mimesis* and of recognition, both central to that kind of learning which is among our greatest pleasures. We are delighted when a story rightly represents how actions develop, recalling familiar tales, and enabling us to recognize universal but previously unnoticed patterns. Because it represents a story that is complete in itself, uninterrupted by the irrelevant flotsam and jetsam accidents of everyday life, drama brings the pleasures of the sense of closure. Through the unity of drama, we discover that a disjoined and even a disasterous sequence of events can be represented as ordered, with a *logos* that connects the temporal completion of an action with its logical closure. But the representations of the structured actions of tragic protagonists also represent us: in recognizing ourselves to be part of the activity of an ordered world, we take high delight in the discovery that our lives form an ordered activity. When it is well structured and well performed, tragedy conjoins sensory, therapeutic, and intellectual pleasures. Pleasure upon pleasure, pleasure within pleasure, producing pleasure.

LESSONS AND POLITICS

Having shown how tragedy pleases, we must now turn to what it teaches.[23] Drama is twinned with ethics (1451b1ff.). Philosophical ethics presents an account of the character structure of admirable agents, whose actions are well formed, reliably successful. By analyzing the role of *phronesis* in realizing the general ends that constitute thriving, it reveals the logical structure of virtuous action. Drama does not, of course, supplement constructive philosophic ethics by posting a set of moralizing warnings, examples of what to avoid. Nevertheless its lessons are moral, and its moral lessons have political significance.[24]

It is crucial to civic life that individuals, acting for themselves, and acting as citizens on behalf of the *polis*, understand the deep and often hidden structures of the actions that are important to their thriving. To choose and act wisely, we need to know the typical dynamic patterns of actions and interactions. Later moralists—Hume, for example—believed that history, rather than drama, reveals the patterns of action. But Aristotle thought we could not learn moral or political truths from history because it is, by his lights, a chronicle

focused on the particularity of events, rather than on what can be generalized from them (1445lb4).

Tragedies have another ethical and political dimension. Like well-formed rhetoric, they promote a sense of shared civic life, and like rhetoric, they do so both emotionally and cognitively. To begin with, the audience is united, temporarily at least, in sharing the emotions of a powerful ritual performance.[25] But tragedy also conjoins us intellectually, bringing us to be of one mind in a common world. In practical life, the trajectories of individual lives intersect, deflect, or enhance one another. Although every individual's welfare is bound with that of his *philoi*, every cluster of *philoi* have their own directions of excellence. Each forms a distinctive pattern of action and reaction. By presenting us with common models and a shared understanding of the shapes of actions, tragedy—like philosophy and other modes of poetry—moves us beyond the merely individual or domestic, towards a larger, common civic *philia*.

Some say that tragedy teaches us the power of chance, of the force of contingency in determining whether the virtuous thrive. While tragedy does indeed focus on what can go wrong in the actions of the best of men, its ethical lessons are not primarily about the place of accident and fortune in the unfolding of a human life. To begin with, Aristotle says that tragedy is about what can probably or inevitably happen (1451a25ff.). If the stressed lesson of tragedy were the disconnection between intention and action, between action and outcome, it would produce somber modesty and edifying resignation, traits that are hardly central to the Aristotelian scheme of virtues. To be sure, like all the virtues, *megalopsychia* has its shadow *hamartia*: a flaunting arrogance that defies the finite, the limits of human action. Tragic drama shows that what is central to excellence in action—what is intrinsic to the very nature of action—carries the possibility of a certain kind of arrogance and presumption. But we cannot avoid tragedy by becoming modest or resigned: it is in our nature to strive for what is best in us. The lesson of tragedy is not that we should know more, think more carefully; or that we should be more modest and less impetuously stubborn than the protagonists of tragic dramas. Because it is no accident that excellence sometimes undoes itself, one of the dark lessons of tragedy is that there are no lessons to be learnt, in order to avoid tragedy.

OEDIPUS TYRANNOS: AN EXEMPLARY ARISTOTELIAN TRAGEDY

Oedipus is the very model of the Aristotelian tragic hero: writ regally large, his actions reveal what we attempt to do, in acting.[26] He intends to change the course of necessity, to avoid the fate of killing his father and marrying his mother. His are the qualities essential to successful action: he is perceptive and intelligent, quick, energetic, and bold. His purposes are clearly and even sharply focused; the nobility of his character is stable, revealed in everything he does. But it is just the by-products of his excellence—the wayward blindness that can attend strongly focused, strongly energized purpose—that generate

the very actions that undo his directions. He is so intent on fleeing Polybius and Corinth that he does not insist on pressing questions about the rumors of his parentage; he is so outraged by the harsh blows from the stranger at the crossroads that he does not stop to determine the identity of that stranger; he is so focused on ruling Thebes that he did not question Jocasta about any children she might have had with Laios. A more measured man, completely ruled by *phronesis*, might not have suffered Oedipus' reversals, to bring about the very fate he fled. But a more measured man would not have freed Thebes from the Sphinx.

The incidents of the story are unified, causally, thematically, and characterologically. The interactive trajectory of the actions of the protagonists form a single, self-contained whole, a parabola that necessarily reverses the direction of their fundamental intentions, while also expressing their essential, royal characters. The man who saved Thebes by solving the riddle of the Sphinx must again save the city by solving the mystery of the source of its pollution. The man who fled from his fate met that very fate through the expression of his character in action; blinded by his purposes, he blinded himself when he discovered his identity; the heir apparent of Corinth who fled his city, he was doomed to wander cityless, a pariah, a sacred suppliant. He is the solution to the mystery of the city's pollution; and he has become the answer to the riddle of the Sphinx, the man who crawled on all fours in his lamed and fettered infancy, who stood upright in his prime, and who stumbles on a staff in the end.

Aristotle finds *Oedipus* a particularly powerful play because it combines the reversal of the plot (*peripeteia*) with the protagonist's recognition (*anagnorisis*) in such a way as to concentrate pity and fear (1152a25ff.). Oedipus' fall from fortune coincides with his knowledge. But knowledge perfects a man, and so while there is no one more wretched than Oedipus, he is lordly in his very wretchedness. For the original audience, *Oedipus* may have articulated and expressed the fear that their rulers might be unwittingly dangerous; it may also have articulated and expressed pity for those exiles, who, through no fault of their own—yet because of what they were—suffered a life without their *philoi*, "without a city, beyond human boundaries, . . . a horror to be avoided" (1386ba12ff.). The pity and the fears of that original audience are, in a way, also ours, fearing—as always we do—the actions of our rulers, and pitying the many forms that exile takes. Yet Oedipus also represents, in a purified form, the extremes that compose us: he is godlike in his bold presumption, but bestial in his parricide and incest.[27]

Aristotle says that the mind becomes identical with what it thinks (*DA* 430a15; 431a1–8). In witnessing the story of Oedipus, in participating in his final recognition, we are, as he was, transformed by what we have seen and learned. In realizing what we are, in recognizing our kinship with those who over-reach themselves in action, we have come closer to fulfilling our natures as knowers and as citizens. And since pleasure is the unimpeded exercise of a natural potentiality, our double self-realization brings a double pleasure, all the more vivid because we are united, individually and communally, in

realizing that however apparently fragmented, ill-shaped, and even terrible our lives may seem to us in the living, they form a single activity, a patterned, structured whole.[28]

NOTES

1. *Poiēsis* is a species of craft (*technē*). It encompasses a wide range of genres which differ from one another in the objects they represent and in the means and manner by which they represent them (1447a14ff.). Besides tragic and comic dramas, it includes epics, dithyrambic poetry and some sorts of music. Its primary contrasts are rhetoric, history, and philosophy.

2. For the sake of simplicity, I shall speak of the *protagonist* of tragic action even though Aristotle speaks primarily of agents (*prattontes*) and of characters (*ethe prattontes*) rather than of *protagonists*.

3. We can distinguish the naive and sentimental versions of formalism and hermeneuticism. Naive hermeneuticists can present what they take to be *the* interpretation of a work, without developing a general theory that explains and defends perspectival or historical changes in the directions of their interpretations. It is only when critics self-consciously affirm the propriety of perspectival approaches—when they openly reconstruct their texts—that the possibility of a strictly Aristotelian tragedy is brought into question. The ineluctable necessity of the plot of an Aristotelian tragedy is central to its psychological effect. A critic who believes he is in principle entitled to reconstrue and reconstruct the tragic plot stands at a remove from the necessities of the drama. In granting himself a freedom from necessity that is not available to an Aristotelian critic, he has changed the psychology of his response.

4. Alexander Nevyle, "Introduction" to *Ten Tragedies of Seneca* (Manchester, 1887), 162; Corneille *Oeuvres* (Paris, 1862) 1:14ff.; Lessing, *Dramaturgie*, Essay 77, *Gesammelte Werke* (Berlin, 1968) 6:631. References from Marvin Carlson, *Theories of the Theater* (Ithaca, N.Y., 1984).

5. "On Tragic Drama" and "On the Pathetic"

6. Cf. Stephen Halliwell, *Aristotle's Poetics* (Chapel Hill, N.C., 1986), chap. 4. Halliwell argues that Aristotle's view of *mimesis* is unstable because it attempts to fuse the enactment sense of *mimesis* with the representational sense. For an interesting criticism of Halliwell, see Richard Janko's review of Halliwell's book in *Classical Philology* 84, (1989).

7. Cf. John Jones, *On Aristotle and Greek Tragedy* (Oxford, 1962), 41ff.

8. To be sure, Plato is distrustful of imitations, particularly those that appeal primarily to the senses, on the grounds that they tend to distort what they represent. Nevertheless, he regards the world of becoming as an imitation of the eternal world of forms, presumably because it reproduces the structure of that world; and he seems to hold that at least some *mimeseis*—mathematical formulae that represent relations among the most general and abstract forms, for instance—are not sensory.

9. Confucius's view of 'the rectification of names' may illuminate Aristotle's intention. There is a true and normative description of the activities and purposes of a ruler, of a son, of a father. When someone deviates from those structures, there is disorder and danger, both to the agent and those around him. Because it vividly and dramatically presents the consequences of such misunderstandings—such *hamartiai*—, Aristotelian tragedy is an instrument in the 'rectification of names.'

10. The prime example of a self-contained activity is contemplation. But perception and thought are also star examples of *energeiai*. Not every activity is completed instantaneously; and many *energeiai* are also embedded within other activities. The animal activity of self-nourishment, for instance, standardly also involves perception. Some *energeiai*—particularly those that, like nourishment and reproduction, are the expression of natural, species-defining potentialities—involve temporally sequential stages that can only be identified by reference to the self-contained, completed activity in which they appear. An activity can only be identified as such if it has been brought to its natural fulfillment: so, for instance, the

activity of reproduction has not occurred unless an offspring has been produced; nor has an animal engaged in nourishment unless it has absorbed the food it ate. Sometimes an activity encompasses actions and process-movements (*kineseis*) as its stages or segments: as for instance, the action of eating and the process of digestion are part of the activity of self-nourishment; the action of impregnation and the processes gestation are part of the activity of reproduction. But not every action is encompassed within, and identified by the activity in which it occurs; nor is the aim of every type of action intrinsic to it, fulfilled in the very performance. The aims of some actions (those involved in building a house, for example) are external, detachable from the processes that produce them. Standardly *technai* involve movement-processes; and although processes usually take time to complete, some (hammering in a nail, for example) take place virtually instantaneously, without a significant lapse of time. The primary contrast between processes and activities lies in whether their ends are extrinsic or intrinsic, and only secondarily in their temporality.

11. A homely example may illustrate the point: We do not understand why a carpenter hammered a nail just as he did, at this angle, at this place, unless we see that action embedded in the series of actions that constitutes building a certain kind of a roof. We do not know why he built that kind of roof unless we know the intentions of the architect and his client. We do not know whether he built it well, unless we know that those intentions are well formed, that they not only reflect the real needs of the client, but also correctly take into account the effects of gravity, of the stress of the materials, etc.

12. See J. P. Vernant, *Myth and Tragedy in Ancient Greece* (Cambridge, Mass., 1989) 45 and 55–69, on the relation between *ethe pratteos* and *prohairesis*. See also Mary Blundell, "*Ethos* and *Dianoia*," in *Essays on Aristotle's Poetics*, edited by A. O. Rorty (Princeton, forthcoming) for a detailed account of the relations among thought, character, and action.

13. 'Waywardness' is a good, though perhaps somewhat archaic and suspiciously moralistic, rendering. For a good summary of discussions of *hamartia*, see Gerald Else, *Aristotle's Poetics* (Cambridge, Mass., 1967), 378–85. See Vernant, *Myth and Tragedy*, 62ff., for a discussion of the connection between the characterological and intellectual aspects of *hamartia*.

14. Although Aristotle says that in representing the interaction of several actors, Sophocles brought tragedy to its perfection, he unfortunately does not give an account of the interactions among the several *prattontes* of tragic drama. Could individual actors or characters interact in such a way as to form a unified dramatic action? On the one hand, the close connection between *prohairesis* and responsible action suggests that however complexly developed an action might be—complex enough to encompass the whole of a person's life—actions are fundamentally only attributable to individual agents. On the other hand, Aristotle sometimes also seems to leave room for speaking of unified political actions that emerge from public deliberation, and perhaps public choice. It seems clear that in the context of the *Poetics* at least, he is interested in the dramatic unity of an individual's action, even when the drama involves the interaction of several characters. It took Hegel, with a quite different set of interests, to consider the ways in which the dramatic action of tragedy might involve the unification of distinct, and even oppositional characters. In *The Phenomenology of Spirit*, Hegel is not primarily interested in developing a theory of tragedy as such, but in using Greek tragedy to present an analysis of the necessary and irresolvable conflict between the old order of religious law and the new order of positive law, as a stage in the development of self-conscious freedom. Because it differs so radically from the account in the *Poetics*, Hegel presents what is, in effect, an account of a different genre, with a different end.

15. Cf. J. Peter Euben, "Identity and *Oedipus Tyrannos*," *Tragedy and Political Theory* (Princeton, 1990).

16. Cf. *Rhetoric* II. 8. Pity involves both distance and proximity. If the sufferer is too close to ourselves, his impending misfortune evokes horror and terror. If he is too distant, his fate does not affect us. The pity that is evoked in the best tragedies reveals the proper domain of *philia*.

17. See Richard Wollheim, *Painting as an Art* (Princeton, N.J. 1988) for an extended discussion of the way that we, as external observers of painting, identify with an internal

observer who is represented within the painting. Wollheim's discussion can be fruitfully transposed from painting to the literary arts. The contrast between agent and observer is fundamental, and not reducible to the contrast between emotion and thought (for there is emotion and thought on both sides); nor does it reduce to the contrast between the subjective and the objective points of view: for the chorus is not always objective, and the protagonist is not always merely subjective.

18. *Politics* I.1; *NE* 1155a12–22.

19. Cf. Halliwell, *Aristotle's Poetics*, chap. 6; Martha Nussbaum, *The Fragility of Goodness* (Cambridge, 1986), esp. 378–91; S. H. Butcher, *Aristotle's Theory of Poetry and Fine Art* (London, 1907); G. Else, *Aristotle's Poetics* (Cambridge, Mass., 1967).

20. Cf. Jacob Bernays's influential "Aristotle on the Effects of Tragedy" translated by J. and J. Barnes in *Articles on Aristotle* 4, edited by J. Barnes, M. Schofield, and R. Sorabji (London, 1979); S. Halliwell, *Aristotle's Poetics* (Chapel Hill, N.C., 1986), 184–201, and Jonathan Lear, "Katharsis," *Phronesis* (1988).

21. The strong connection between true belief and right desire (*NE* 1139a23ff.) enables Aristotle to develop a solution to the problem of *akrasia*: the *akrates* has temporarily *forgotten* what he dispositionally knows (*NE* 1146b7ff.).

22. Since we are a socio-political species, the activities of intelligent civic life are natural and essential to us. When they are properly performed, uninterruptedly and without impediment, they are intrinsically pleasurable, independently of what they succeed in achieving.

23. There is an ancient, vigorous, and apparently endless debate about whether the fundamental social function of drama is that it pleases or that it teaches. As far as tragedy goes, this is a false dichotomy: it pleases by teaching; it teaches by the ways it pleases. Aristotle adds that it mostly pleases ordinary folk, implying that it pleases the wise largely by teaching (1448b4ff.). Presumably that is because each type gets what it looks for. Cf. Halliwell, *Aristotle's Poetics*, 62–81; Else, *Aristotle's Poetics* 127–34; Butcher, *Aristotle's Theory of Poetry and Fine Art*, chap. 4.

24. *Politics* VIII 5, 1340a15ff. "Since . . . virtue is concerned with delighting, loving, and hating correctly, there is obviously nothing more important than to learn and to become habituated to judge correctly and to delight in decent character and fine actions." When drama gives us pleasures and pains in the appropriate representations of character and actions, it will enable us to take appropriate pleasures in the real things. "Habituation to feeling pain and delight in things that are like [the thing itself] is similar to being in that same state in relation to the truth. For instance, if someone delights in looking at the image of something . . . it [will] be pleasant for him to look at the thing itself. . . ."

25. Aristotle does not limit the emotional effect of tragedies to the audiences of dramatic performances: they also affect those who hear or read the story. Still, an audience that has shared the experience (*pathe*) of a theatrical performance has the further experience of a certain kind of emotional bonding.

26. Cf. Bernard Knox, *Oedipus at Thebes* (New York, 1970). Knox argues that Oedipus represents the ideal Athenian: clever, quick, practical.

27. Cf. J. P. Vernant, *Myth and Tragedy*, 135ff.

28. This essay arose from a conversation with Ruth Nevo; it developed in discussions with Stephen Engstrom, Stephen Halliwell, Henry Richardson, and Stephen White. MindaRae Amiran, Mary Whitlock Blundell, Françoise Balibar, Elizabeth Belfiore, Rüdiger Bittner, Jennifer Church, and Jens Kulenkampff gave me helpful comments, as did the participants in colloquia at the University of New Hampshire, the University of Oregon, the University of California at Santa Barbara, and Hebrew University in Jerusalem.

Poetry as Response:
Heidegger's Step Beyond Aestheticism

KARSTEN HARRIES

1

To begin with, two contrasting determinations of poetry. The first is by Paul Valéry, who defines poetic language as "*an effort by one man* to create an artificial and ideal order by means of a material of vulgar origin."[1] The material of vulgar origin is, of course, everyday language. Valéry's definition acknowledges thus the poet's inevitable dependence on the way we speak first of all and most of the time, even as it emphasizes that the poet must transform such discourse. This transformation is guided by an ideal—Valéry speaks of "pure poetry"—that the poet will always pursue and yet can never seize.

The second determination is found in Heidegger's essay "Language." "What is purely spoken is the poem. . . . Poetry proper is never merely a higher mode (*melos*) of everyday language. It is rather the reverse: everyday language is a forgotten and used-up poem, from which there hardly resounds a call any longer."[2]

Similarity and contrast are obvious enough: both Valéry and Heidegger insist that the poet take leave from and transform everyday language; both appeal to an ideal of purity to indicate the direction of this leave-taking. "Purity" in both cases means first of all liberation from the involvement with the world that characterizes everyday language. But while Heidegger grants that poetry may be understood as "a higher mode of everyday language," he also claims that such an understanding is necessarily incomplete: if poetry departs from everyday language, it does so not so much to replace such language with its aesthetic constructions, but to retrieve the usually forgotten and hidden poetic essence of language, which Heidegger understands as the language of essence. It is this claim, that to understand poetry we should go beyond the kind of aesthetic approach exemplified by Valéry, should replace it with a more ontological approach, that I want to examine.

2

What is meant here by an "aesthetic approach"? To characterize this approach I would like to turn briefly to Alexander Gottlieb Baumgarten's dissertation of 1735, which not only helped to inaugurate a specifically modern approach to poetry and beyond that to art, but also gave us the word "aesthetics" to name what has developed into a main branch of philosophy. In the course of his discussion, Baumgarten likens the successful poem to the world, more precisely to the world as Leibniz describes it: a perfect whole having its sufficient reason in God.[3] In this world nothing is superfluous, nothing is missing: everything is just as it should be. When Baumgarten insists that the poem be like a world, he insists that it, too, be such a perfect whole. As Valéry points out, in the poem "well-known things and beings—or rather the ideas that represent them— somehow change in value. They attract one another, they are connected in ways quite different from the ordinary; they become (if you will permit the expression) musicalized, resonant, and, as it were, harmonically related."[4] To demand that the poem be a perfect whole is to claim that in the successful poem every word is experienced as having to appear just as in fact it does. This includes what Valéry calls the seemingly impossible demand that sound and sense become indissoluble: "it is the poet's business to give us the feeling of an intimate union between the word and the mind."[5] Poetry is the magical incarnation of meaning in the word. This magic is lost when we insist on wresting a meaning from the poem. As Archibald MacLeish demanded, "A poem should not mean/ but be." It should call attention to itself as a self-sufficient presence. What matters is the poem's inner coherence, not that it correspond to or reveal in any way what is. Beauty, on the aesthetic approach, wants to have nothing to do with truth. Poetry does not so much reveal reality as it offers a vacation from reality. Emphasis on the unity and self-sufficiency of the aesthetic object leads thus quite naturally to an emphasis on aesthetic distance, on that separation of art from reality Kant insists on in the *Critique of Judgment*.

The demand for poetic self-sufficiency implies the demand that the poet take leave from everyday language. Everyday language has to preclude such self-sufficiency if it is to function. As Valéry points out,

> . . . the language I use to express my design, my desire, my command, my opinion; this language, when it has served its purpose, evaporates almost as it is heard. I have given it forth to perish, to be radically transformed by something else in your mind; and I shall know that I was understood by the remarkable fact that my speech no longer exists: it has been completely replaced by its *meaning*—that is, by images, impulses, reactions, or acts that belong to you: in short, by an interior modification in you.[6]

If we are to understand the meaning of what is said to us, we may not become too fascinated by the aesthetic surface of the words; our attention may not be focused on the sensuous presence of particular words appearing in a particular

order. We show that we have understood by appropriate responses. The more successful communication, the more evident the instrumental function of our words, which have no value in themselves, but only as means. To serve communication the particular discourse may not intrude itself; it must perish, vanish like coins spent to buy something. "As a result the perfection of this kind of language, whose sole end is to be understood, obviously consists in the ease with which it is transformed into something altogether different."[7]

How different is our understanding of poetry! The poem "does not die for having lived: it is expressly designed to be born again from its ashes and to become endlessly what it has just been. Poetry can be recognized by this property, that it tends to get itself reproduced in its own form: it stimulates us to reconstruct it identically."[8] Characteristic of poetic language, on this view, is a particular kind of self-renewing presence, a presence that has to be denied to words if they are to function effectively in everyday communication. To understand the meaning of what has been said usually is to know also that the particular way in which something was said does not matter: it can be said differently; can be paraphrased or translated into another language. The connection between sound and meaning is felt to be contingent. To get to what matters we have to pass beyond what we actually hear or read. Poetic language effects a breakdown of this passage: poetry lets us focus not just on what is said, but on how it is said, with just these words, placed in just this order.

As a result of this breakdown words lose their instrumental function; the incarnation of meaning lets language become in a sense useless. Already Aristotle remarked on the uselessness of poetry. But if poetry cannot be considered useful in the ordinary sense, it is just this that gives it a special dignity. Just because poetic language does not have an instrumental function, is not a means to some end, it can grant us a sense of being at one with ourselves, of being exempt from the ravages of time, a sense we are denied as long as care and anticipation bind us to the future. Self-renewing, self-repeating, the poem lets the present triumph over the past. Aesthetic experience banishes the terror of time. The eternal recurrence of the same triumphs over that "ill will against time and its 'it was'" in which Nietzsche located the deepest source of our self-alienation.[9] The price of this victory is a retreat from the world. Emphasis on the presence and presentness of the aesthetic object has to lead to an interpretation of the poetic realm as an autonomous sphere, removed from everyday reality and its concerns, indeed removed from reality altogether. Only as long as the work of art is governed by its own aesthetic perfection does it remain pure. This aesthetic approach to poetry demands resistance to all attempts to interpret a poem as being in some sense about reality. The poet takes leave from the instrumentality and referentiality that characterizes everyday language, not to gain a more profound vision of reality, but to replace the insufficiency and imperfection of the world we live in and more especially of its speech with the perfection and self-renewing presence of the poetic world that he has created.

3

While Valéry understands the poem as an ideal and artificial order wrested from everyday language, Heidegger appears to argue the reverse: "Everyday language," he asserts, "is a forgotten and therefore used-up poem."

How can such a claim be defended? Isn't it obvious that poetry, at least as we generally understand the term, presupposes everyday language? To be sure, Heidegger's claim that original language is poetry is familiar. It has its place in a tradition that includes Vico and Herder, although neither would have identified this original poetry with poetry in our late age. Nor, it seems, would Heidegger. Thus he begins his discussion of Georg Trakl's *Ein Winterabend* with this easily granted observation: "The poem's content is comprehensible. There is not a single word, which, taken by itself, would be unfamiliar or unclear."[10] Listen to the poem's first stanza:

> Lang die Abendglocke läutet,
> Vielen ist der Tisch bereitet
> Und das Haus ist wohlbestellt.

> Window with falling snow is arrayed.
> Long tolls the vesper bell,
> The house is provided well,
> The table is for many laid.

All the poet's words are indeed familiar and easily translated. And yet, as Albert Hofstadter's translation shows, the poem itself is not so easily translated, if indeed it can be translated at all. We do not yet get hold of a poem when we grasp the content that survives translation. Consider just the first line:

> Wenn de Schnee ans Fenster fällt,

> Window with falling snow is arrayed.

To preserve at least a trace of the music of Trakl's language, Hofstadter departs from what would be a more literal translation: "When [the reader familiar with Heidegger's *Aus der Erfahrung des Denkens* will know what significance this simple *wenn* holds for him] the snow falls against the window,. . ." But the effort is vain: Trakl's play with vowels and consonants resists translation. It is this play which arrests us and lets the language of the poem become present as everyday language never is. The poem presents itself to us, as Valéry would have it, as an artificial and ideal order created of a substance of vulgar origin.

Heidegger knows this. And yet he insists that "poetry proper is never merely a higher mode of everyday language," claims that it is at the same time a more original speaking. But what sense does this make? How can poetry be both: derived from and at the same time more original than everyday language? To be both, would it not have to present itself to us as a retrieval or repetition

of some supposed poetic origin of everyday language? But does poetry present itself to us as such?

Heidegger's interpretation of *Ein Winterabend* is designed to show that it does; yet the very ease with which Heidegger draws from Trakl's poem his own, independently arrived at view of poetry may let us wonder. Is Heidegger merely reading into Trakl his own preconception of the essence of poetry? What warrants the claim that poetry is not just a late luxury that presupposes other language, but a repetition of the poetic origin of everyday language, of what we may call original poetry? Does everyday language have its origin in such poetry?

To approach this question it is perhaps best, at least initially, not to think of poetry in the usual sense, but to take seriously Heidegger's definition of poetry as "the inaugural naming of being and the essence of all things—not just any speech, but that particular kind which for the first time brings into the open all that which we then discuss and deal with in everyday language."[11] "Poetry" is here assigned an ontological function: like Adamitic naming, "poetry" first lets beings present themselves to us as the kinds of things they are. Thus Heidegger understands "poetry" as the establishment of a world, where "world" names not the totality of facts, but a context of meanings—if we were to think "logic" as broadly as Heidegger would have us think the Greek *logos*, we could say a "logical space," a realm of intelligibility that alone allows things to present themselves to us. So understood, "poetry" is a necessary condition of the presencing of things, of what Heidegger calls their being. If we accept this understanding of poetry, it does indeed follow that "poetry never takes language as a raw material ready to hand, rather it is poetry which first makes language possible."[12] But must or should we do so? What does a poem like Trakl's *Ein Winterabend* have to do with Adamitic speech? Is Heidegger's understanding of poetry more than an arbitrary construction?

To give a first answer to this question, it is not necessary to decide whether or to what extent Heidegger has done justice to what we usually call poetry; it is sufficient to focus on the thesis that language has its foundation in a speaking that is, as Heidegger calls it, "an inaugural naming of being and the essence of all things." It seems difficult not to go at least some distance with Heidegger: if everyday language is language that has come to be established and accepted, must it not have its origin in an establishing and therefore inevitably unfamiliar, strange discourse? But does the fact that first of all and most of the time language is taken for granted allow us to claim that this was not always the case? Heidegger's attempt to give everyday language its foundation in poetry recalls the cosmological argument: the poet resembles God; both create a world.

But has poetry not always presupposed more ordinary speech? If so, what sense does it make to call everyday language "a forgotten and used-up poem"? How are we to understand the priority of poetry? And even if we grant that established language presupposes a linguistic establishing, what reason is there to associate the latter with poetry? This association needs to be supported by an examination of both language and poetry.

4

"Language," Heidegger remarks, "itself is—language and nothing else besides."[13] The tautology here functions to guard against the tendency to place what is under discussion into an already established and taken for granted context. By leading us away from what is to be interpreted to a place on some already available conceptual map, such interpretation threatens to distort and hide what is to be revealed. To forestall this and to focus our attention on the phenomenon of language, Heidegger insists on the obvious: " 'Language is language.' This statement does not lead us to something else in which language is grounded. Nor does it say anything about whether language may be a ground for something else."[14] It does indeed little to illuminate the essence of language. Instead "The sentence 'Language is language,' leaves us to hover over an abyss as long as we endure what it says."[15] It becomes even more questionable as Heidegger expands it: "Language is—language, speech. Language speaks."[16] Heidegger himself raises the obvious objection: does language speak? Isn't it human beings who speak, using language? Implicit in these questions is the contrast between a view that makes us the masters of language, which we use somewhat as we might use an instrument, and another that insists that we cannot place ourselves outside language.

To sharpen this contrast I shall distinguish between a realistic and a transcendental conception of language.[17] By a realistic conception of language I mean one that places language in a more comprehensive context and examines it as a phenomenon among other phenomena. All scientific approaches to language are in this sense realistic. On a realistic interpretation language has an outside. This, however, poses the question: what sense can we make of a reality outside language? Can our understanding escape the limits that language imposes? By a transcendental approach to language I mean one that takes language to be constitutive of our being in the world. According to such an interpretation language has no outside that is in any sense available to us.

Like thesis and antithesis of a Kantian antinomy, both the realistic and the transcendental conception of language can be defended with good reasons. It is indeed difficult to make sense of a reality that transcends language. Any attempt to do so cannot but draw what supposedly transcends language into its domain. Given this difficulty we may well want to grant Derrida's claim that language has no outside, that texts are only about texts; nor is there a master text, a first poem that would provide subsequent discourse with a measure. But such a view has to render discourse uncritical, for it makes it impossible to demand truth or criteria. Once we no longer recognize that language does have an outside in some sense, it dissolves into play. Derrida not only acquiesces in this loss of outside, which would establish language as an autonomous sphere, but appealing to Nietzsche, he would have us affirm it, "with a certain laughter and a certain dance."[18] I find it difficult to join in such postmodern levity. Only if language is in some sense about reality does it have a point, is it meaningful. Meaning requires that our language not be fully constitutive of

reality, that there be a point to speaking of what lies outside language. Thus we are brought back to the realistic interpretation and to its inadequacies. I do not want to engage here in the perhaps futile attempt to reconcile these conflicting demands, but only point to this antinomy rooted in the very essence of language, which we send forth into the world as one thing among others and which yet is presupposed by the world's disclosure.

In Heidegger's essay the contrast between a realistic and a transcendental interpretation appears as the contrast between the usual "identification of language as audible utterance of inner emotions, as human activity, as a representation by image and concept" and a view that recognizes in the speaking of language "that which grants an abode for the being of mortals."[19] While Heidegger considers the former correct in that "it conforms to what an investigation of linguistic phenomena can make out in them at any time,"[20] he insists that it overlooks that language is not just a phenomenon like others, but that it is language alone that grants the space in which phenomena can appear. "Language alone brings what is, as something that is, into the Open for the first time. Where there is no language, as in the being of stone, plant, and animal, there also is no openness of what is, and consequently no openness either of that which is not and of the empty."[21] Heidegger thus calls language "the house of Being."[22] Walking through this house we encounter the things of the world. But since we are usually concerned with what is, and this concern governs our daily encounter with language, we are likely not to attend to the speaking of language that grants human beings their dwelling-place, their world.

5

Where do we encounter the speaking of language? Heidegger gives us a seemingly trivial answer. "Most likely in what is spoken."[23]—But is this not found everywhere? Why turn, as he does, to poetry? Why not to this morning's breakfast conversation?—"Pass the butter, please!" Does language not reveal itself here, too, as language?—Certainly not to those conversing. As Valéry points out, successful communication takes language for granted. Words are sent forth only to perish, to be replaced by meaning.

But what about the person who reflects on such a conversation? Reflection creates distance, dislocates us so that we are able to attend to the words chosen and to recognize such speech for what it is, in this case most likely an example of what Heidegger terms "idle talk," which names not an idling of language in Wittgenstein's sense, but discourse that takes language for granted: we speak the way one speaks in such situations. Recognition of the idleness of idle talk prepares for an awareness of what would be more authentic speech. It should be possible to depend on that awareness in our search for a better example of the speaking of language.

But is some other example likely to prove more illuminating? To look for the speaking of language in the spoken is to consider language not as something now occurring, but as something that has occurred and thus from the

outside. This already presupposes a realistic approach: when language comes into view as something that now lies behind us, it is inevitably understood as part of the world, along with persons and eggs, not as what lets us dwell in the world. Emphasis on the spoken inevitably invites a realistic rather than a transcendental interpretation of language.

Should we then try to grasp language as it is now occurring? But when we try to do so, once again what we grasp is no longer a present speaking, but a speaking that has passed and become something spoken. We cannot avoid searching for the speaking of language in the spoken. "If we must, therefore, seek the speaking of language in what is spoken, we shall do well to find something that is spoken purely rather than to pick just any spoken material at random. What is spoken purely is that in which the completion of the speaking that is proper to what is spoken is, in its turn, an original."[24] Like everything spoken, the purely spoken belongs to the past. If we are to open ourselves to the essential speaking of language, we must escape such domination of the past. Heidegger links the past's sway over language to its impurity. He therefore adds this modification: in the case of the purely spoken, the spoken presents itself as both completed and is ever beginning again, as a past ever reborn in the present—eternal recurrence of the purely spoken.

What are we to make of this? What has already been spoken can itself be a first speaking only if it refuses our attempt to relegate it to the past. If the purely spoken is to be ever beginning, it must be such that we can never be done with it: each time we read or hear what has been purely spoken, the task of interpretation begins anew. There can be no definitive interpretation of such a text. The spoken presents itself not only as a completed speaking, but also as just beginning, its meaning still ahead of us. The past repeats itself in the present, gesturing towards an ever open future.

Without considering poetry, our discussion has moved in the direction of traditional interpretations of its essence. If, as Valéry argues, of all discourse, poetry alone "does not die for having lived," if only poetry rises phoenix-like again and again from its ashes, endlessly becoming what it has been, then "What is purely spoken is the poem."[25] Nor should this affinity between Valéry's aesthetic conception of poetry and Heidegger's conception of the purely spoken surprise us. The purely spoken, as Heidegger understands it, resists being placed in a wider context. Thus it is neither the poet nor his world that speaks to us in the genuine poem. Is it then the transcendental essence of language that poetry reveals?

According to Valéry, too, to the extent that we are caught up in the poetic experience, poetry presents itself to us as having no outside. This loss of outside is inseparable from its establishment of "an ideal or artificial order." Such establishment must take leave from reality: the poet usurps the place of God. And is the same not true of the thinker who would found being in human speech and transform all that is into text? Any philosopher who takes the transcendental approach too seriously is condemned to aestheticism. The magic idealism of Novalis helps to remind us of the proximity of transcendental

philosophy and aesthetic modern poetry, as does the deconstructive play of some of our best critics.

But how close is Heidegger to either? Does he not dissociate his understanding of art, and more especially of poetry quite explicitly from any merely aesthetic approach?[26] And does he not similarly guard against being read as just another transcendental philosopher? His way to language means to lead us beyond both aestheticism and transcendental philosophy. Not that it returns us to a naively realistic approach—the power of transcendental reflection rules out such a return. If the truth of realism is to be recovered, it must be possible to discover transcendence within language. The key to this thinking beyond the opposition of realistic and transcendental approaches to language is sought in poetry, but in poetry understood not aesthetically as creation, but hermeneutically as interpretation.

<div align="center">

6

</div>

How are we to think such a function? If language is, as Heidegger would have it, "the house of Being," and if poetry builds that house, how can there be anything outside that house for the poet to interpret? That Heidegger, too, would give human speech its measure in transcendence is suggested by his emphasis on hearing and listening. "Mortals speak insofar as they listen. They hear the bidding call of the stillness of the dif-ference even when they do not know that call. Their listening draws from the command of the dif-ference (*Unter-Schied*) what it brings out as sounding word. This speaking that listens and accepts is responding (*Ent-sprechen*)."[27]

I shall bracket for the time being the question: what is meant by the call of dif-ference? This much is clear: according to Heidegger, authentic speaking is a responding to a silent call. It is that call, hardly preserved in everyday language, that finally gives human speaking its measure. This forces us to reject the suggestion that Heidegger is committed to a transcendental approach to language. To be sure, Heidegger knows that our access to whatever is is mediated by language; only language allows what is to present itself to us, i.e., gives it being. But Heidegger also insists that our speech has its measure in what, unspoken and concealed, already has a claim on us, already speaks to us. "What is purely spoken" preserves the silent call of what lies beyond our words. A conception of poetry emerges that takes its leave from aestheticism and from its demand for aesthetic self-sufficiency and instead seeks to reappropriate the traditional understanding of authentic speech as a more or less inadequate response to a silent call that issues from beyond human beings.

Plato sketches such a view in the *Phaedrus*. In that dialogue Socrates tells what he presents as an old story concerning the invention of letters. The invention is credited to the Egyptian god Theuth. Extolling the merits of his invention to the god and king Thamus, Theuth claims that it will "make the Egyptians wiser and give them better memories." Thamus remains unconvinced. He predicts just the opposite: the discovery of letters "will create forgetfulness

in the hearer's souls, because they will not use their memories; they will trust to the external written characters and will not remember themselves." The invention of letters, he insists, "is not an aid to memory, but to reminiscence, and you give your disciples not the truth, but only the semblance of truth; they will become hearers of many things and will have learned nothing. They will become tiresome company, having the show of wisdom without the reality."[28]

Long before Heidegger, Plato knew that written words, even as they reveal in some sense what is written about, at the same time tend to cover it up and let us forget its truth. What is written down is in some sense preserved, but such preservation cannot assure genuine appropriation. Nor does speaking carry such assurance. The spoken word, too, is the necessarily inadequate articulation of another "word," Plato speaks of the "intelligent word graven in the souls of the hearers,"[29] in which what is essential reveals itself and becomes intelligible. Understanding is thus more than a repeating of what others have already said. To understand is to listen beyond what has been said to a silent *logos* that is the call of reality that transcends and measures our speaking. Such authentic understanding is made difficult by the fact that our language is not our own. We cannot but speak as one speaks, see as one sees. Language threatens forgetfulness. And, as Thamus insists, this threat is not met, but compounded by writing things down. Written down, words "are tumbled about anywhere, among those who may or may not understand."[30] The written word is thus essentially ambiguous. It does not tell us whether it has its origin in a genuine seeing or hearing. Writing, Socrates goes on to explain, is unfortunately rather like painting: "for the creations of the painter have an attitude of life, and yet, if you ask them questions they preserve a solemn silence."[31]

The same is said to be true of speeches and poetry. Instead of returning to words that in constant use have become worn and taken for granted their lost origin, the poet uses words as his material. Out of this material he creates, a godlike magician, a second world. But this merely aesthetic world offers no real nourishment to the soul: instead of remedying the forgetting that is part of everyday language, it compounds it. Such a poet does not reveal reality, but replaces it with his own reality, which may so capture our imagination that we forget that reality in which poetry, too, has its measure.

The very existence of the Platonic dialogue raises the question whether it is necessary to understand the written word and more especially poetry in this fashion. Is the dialogue form not born of the attempt to restore to common language the soul it has lost in becoming common? The written down and therefore past word becomes present as the reader is invited to participate in a search that leads beyond what has actually been said to a spiritual meaning that the reader has to recover within himself. In that they demand unending interpretation and appropriation, Plato's dialogues are better incarnations of "the living words of knowledge" than the speeches of the rhetoricians.

The Platonic view of genuine speaking as a response to a recollection of a silent *logos* issuing from beyond human beings reappears in the Christian understanding of genuine speaking as a responding to and speaking after the

creative words of God, which are found in his two books, the book of nature and Holy Scripture. The latter grants the written word an authority Plato would have found unacceptable: how can words that have their origin in a past prophetic speaking have genuine life in the present?

Heidegger, too, recognizes that human speech must have its measure in a reality transcending the speaker. The poet is no godlike creator. Just as the prophet's speech gains its authority from its origin in the Divine Word and retains that authority only as long as it lets us recover that origin, so the poet's words can be understood as an "inaugural naming of being" only if they are uttered in response to a reality that not only calls the poet, but continues to call his listeners or readers, so that they can recognize in his words a more than arbitrary saying. Interpreting that call, Plato had spoken of the "intelligent word graven in the souls of the hearers." In *Being and Time* Heidegger had written similarly that "Discourse is the Articulation of Intelligibility. . . . The intelligibility of Being-in-the-world expresses itself as discourse."[32] "Discourse" here translates the German *Rede*, which in *Being and Time* names the Greek *logos*. It should not be taken as synonymous with "language" (*Sprache*). Rather, language is the expression of discourse. "Language is a totality of words—a totality in which discourse has a 'worldly' Being of its own; and as an entity within-the-world, this totality thus becomes something which we may come across as ready-to-hand. Language can be broken up into word-Things which are present-at-hand."[33] So understood, language invites what I have called a realistic approach; it invites the transcendental approach insofar as it is the expression of discourse. Language can thus be understood as the essential impurity of an ideally white discourse, essential because discourse, by its very nature, has to descend into the world, i.e., express itself as language: "Discourse is essentially language, because the entity whose disclosedness it Articulates according to significations, has as its kind of Being, Being-in-the-world—a Being which has been thrown and submitted to the 'world.' "[34] Heidegger thus draws the distinction between discourse and language only to explain why we cannot hold on to it, for the same reason that we cannot give content to the idea of a purely authentic discourse. If, as Heidegger insists, idle talk is the "kind of Being that belongs to Being-with-one-another itself,"[35] all pure, i.e., authentic disclosure has to isolate the self from the community. The only example of an authentic disclosure we are given in *Being and Time* is therefore the silent call of conscience which summons the self that has lost itself to the world back to itself. To the extent that language approaches purity, i.e., authenticity, it will be experienced as a tearing of silence. Mallarmé thus dreams of a silent white poetry, while Ungaretti would have the poetic word be a brief tearing of silence.[36]

In "Language" Heidegger no longer speaks of "the intelligibilty of Being-in-the-world," which gains voice as language, but of the "command, in the form of which the stillness of the dif-ference calls words and things into the rift of its onefold simplicity.[37] What does Heidegger mean by the silent, yet commanding call of dif-ference? Hugo von Hofmannsthal's "The Letter of Lord Chandos" offers a pointer.

7

The case of Hofmannsthal's fictional Lord is simple: a figure of the Austrian poet, who, when still a teenager, had been celebrated as a master of the German language only to be assailed by Nietzschean doubts concerning the power of language to reveal reality, the young Lord, a postmodernist before his time, writes a letter to his well-intentioned older friend, the scientist and philosopher Sir Francis Bacon, in an attempt to explain to this representative of emerging modernism his decision to abandon all literary activity. At issue is the rift that the young poet's aesthetic play with words has opened up between language and things:

> My case in short is this: I have lost completely the ability to think or to speak of anything coherently.
>
> At first I grew by degrees incapable of discussing a loftier or more general subject in terms of which everyone, fluently and without hesitation, is wont to avail himself. I experienced an inexplicable distaste for so much as uttering the words *spirit, soul*, or *body*. . . . The abstract terms of which the tongue must avail itself as a matter of course in order to voice a judgment—these terms crumbled in my mouth like mouldy fungi.[38]

Like a corroding rust this inability to use words, because they have lost touch with what they supposedly are about, spreads to ordinary language which the Lord experiences increasingly as indemonstrable, mendacious, hollow.

> My mind compelled me to view all things occurring in such conversations from an uncanny closeness. As once, through a magnifying glass, I had seen a piece of skin on my little finger look like a field full of holes and furrows, so I now perceived human beings and their actions. I no longer succeeded in comprehending them with the simplifying eye of habit. For me everything disintegrated into parts, those parts again into parts; no longer would anything let itself be encompassed in one idea. Single words floated round me; they congealed into eyes which stared back at me and into which I was forced to stare back—whirlpools which gave me vertigo and, reeling incessantly, led into the void.[39]

But the void left by this disintegration is not completely mute. As language gains an autonomy that threatens to render it meaningless, a minimal, but intense contact with beings is established. The tearing of language by silence grants epiphanies of presence.

> It is not easy for me to indicate wherein these good moments subsist; once again words desert me. For it is, indeed, something entirely unnamed, even barely nameable which, at such moments, reveals itself to me, filling like a vessel any casual object of my surroundings with an overflowing flood of higher life. I cannot expect you to understand me without examples, and I must plead your indulgence for their absurdity. A pitcher, a harrow abandoned

in a field, a dog in the sun, a neglected cemetery, a cripple, a peasant's hut—
all these can become the vessel of my revelation.[40]

In "a shudder running from the roots of my hair to the marrow of my heels"
the young Lord senses the Infinite: "What was it that made me want to break
into words which, I know, *were* I to find them, would force to their knees those
cherubim in whom I do not believe?"[41] And so they would! For the words for
which the Lord is longing would know nothing of the rift separating reality and
language. The words of that language would be nothing other than the things
themselves; that is to say, they would have to be the creative words of that God
in whom neither the Lord nor Hofmannsthal could believe. Nevertheless, the
idea of this divine language functions as a measure that renders our language
infinitely inadequate and condemns him who refuses to sully the dream of that
language to silence.

Despite this inadequacy Hofmannsthal's Lord succeeds in saying quite
a bit, not just about the inadequacy of language, but also about things, e.g.,
a pitcher half-filled with water, left lying beneath a nut-tree. Despite the pro-
claimed inadequacy of language, the poet uses words to tear silence, gesturing
towards the mysterious presencing of things. And Hofmannsthal does not leave
us simply with intimations of the presencing of familiar things. Things are said
not just to be, but to speak to us, although the weight of all that has been
said before us and more importantly written down, makes it difficult to hear
and even more to respond to, if stuttering, to that usually overheard discourse.
With this we arrive at a conception of literature, and, more generally of art,
that breaks with aestheticism and with its demand for poetic self-sufficiency,
a conception that, if only very tentatively, attempts to return to the traditional
understanding of human speaking as a speaking after a silent discourse that
issues from beyond human beings, where the sway of what Heidegger calls
idle talk is the most serious obstacle to that attempt.

8

Things are elusive. As I look out of the window I see the stumps of two
young birch trees, white, pathetic, all that the birch borers left me of their
promise. My description assigns to what I see a place in an already established
and taken for granted language-space. But as I speak of what I see, I also
recognize that no matter what I could say, no matter how rich my descriptions
might become, never will they do justice to these two little stumps. The words
available to me help to describe and thus to communicate what I see; and yet
they cannot capture its infinitely rich particularity. They cannot overcome its
stubborn otherness. Not that this inevitable "failure" of language to close the
gap between word and thing is a defect. Were it not possible to subject the
infinite richness of reality to our measures we would drown in it. To know
what something is to know its place in a logical or linguistic space.

Heidegger does not speak of such a space, but of the "world." As he uses
the term, its function is analogous: to know something is to know its place in

a world, a place that is never so fully determined that it does full justice to the thing in question. The measures we bring to reality, for instance when we see something as a "tree," cannot capture this particular thing in its "thisness." We can thus speak of the thing's transcendence. Or, as Heidegger does, of the rift that separates thing and world. To be sure, only where things find their place in the context of a world, is there understanding. And yet, what Heidegger calls the "thingly" character of the thing prevents the understanding from ever fully penetrating and subjecting it. Genuine understanding thus implies openness to the rift that both separates and joins things and world, to what Heidegger calls "the command of the dif-ference." To be open to this "command of the dif-ference" is to recognize that our speaking has its ground and measure in the silent call of a reality that transcends our speaking.

Heidegger insists that first of all and most of the time such openness is blocked by the way we are inevitably caught up in idle talk. To live and work with others we must have joined their language-games. First of all and most of the time we understand things without having made them our own. We take the adequacy of our words for granted. In everyday language reality and language appear so intimately joined that the rift that separates the two, the violence that is part of all naming, is covered up. The poet, as Heidegger understands him, dissolves this too intimate union. Precisely because in poetry language gains a certain autonomy, it lets us recognize the strange distance that separates words and things. To ascribe revelatory power to poetic language cannot mean that it gives us more adequate descriptions of things than everyday language. That poetry obviously does not do. But by calling its own artificiality to our attention, poetry breaks apart that "whole, consisting of language and the actions into which it is woven," which Wittgenstein calls a language-game.[42] This break opens the rift between words and things. The peculiar adequacy of poetic language depends at least in part on the way it discloses the essential inadequacy of all language.

9

We are now in a position to see why, in spite of Valéry's and Heidegger's apparently so different approaches to poetry, one aesthetic, the other ontological, there is so much that links their views. Valéry is very much aware that the poet's attempt to create a self-sufficient presence cannot succeed. Never will a poem just be and cease to mean. It will always refer to what transcends it, and not just to other texts, but more importantly to what lies beyond all language. But just by attempting to create out of the material of everyday language a self-sufficient aesthetic object, the poet lets us hear the call of dif-ference, opens us to what lies beyond speech.

Heidegger claims that "man speaks only as he responds to language." But language may not be understood here as just a human product. Like "discourse" (*Rede, logos*) in *Being and Time*, "language" here names "the intelligibility of Being-in-the-world." To respond to "language" properly is also to respond

to a call that does not originate with human beings. This is why Heidegger can say that "This responding is a hearing. It hears because it listens to the command of stillness."[43] To listen to "the command of stillness" is to be open to meanings and claims that transcend our words, to be open to that silent *logos* in which speaking has its origin. Heidegger understands poetry as an interpreting response to that origin.

NOTES

1. Paul Valéry, *The Art of Poetry*, translated by Denise Folliot (New York, 1961), 192.

2. Martin Heidegger, "Die Sprache," *Unterwegs zur Sprache* (Pfullingen, 1959), 16 and 31; translated by Albert Hofstadter, *Poetry, Language, Thought* (New York, 1971), 194 and 208.

3. Alexander Gottlieb Baumgarten, *Reflections on Poetry*, translated by Karl Aschenbrenner and William B. Holther (Berkeley and Los Angeles, 1954), par. 68, p. 63.

4. *The Art of Poetry*, 59.

5. Ibid., 74.

6. Ibid., 71–72.

7. Ibid., 72.

8. Ibid.

9. See Friedrich Nietzsche, *Zarathustra*, II, "On Redemption."

10. *Unterwegs zur Sprache*, 18; *Poetry, Language, Thought*, 190.

11. Heidegger, "Hölderlin und das Wesen der Dichtung," *Erläuterungen zu Hölderins Dichtung* (Frankfurt, 1951), 40; translated by Douglas Scott in *Existence and Being* (Chicago, 1949), 283.

12. Ibid.

13. *Unterwegs zur Sprache*, 12; translation, 190.

14. Ibid., 13; translation, 191.

15. Ibid.

16. Ibid.

17. See Karsten Harries, "Two Conflicting Interpretations of Language in Wittgenstein's *Investigations*," *Kant-Studien* 59, no. 4 (1968): 397–409.

18. Jacques Derrida, "Differance," *Speech and Phenomena*, translated by David B. Allison (Evanston, Ill., 1973), 159.

19. *Unterwegs zur Sprache*, 14; translation 192.

20. Ibid., 15, translation, 193.

21. Martin Heidegger, "Der Ursprung der Kunstwerks," *Holzwege* (Frankfurt am Main, 1950), 60; translated by Albert Hofstadter, "The Origin of the Work of Art," *Poetry, Language, Thought*, 73.

22. "Wozu Dichter?" *Holzwege*, 286.

23. *Unterwegs zur Sprache*, 16; translation, 194.

24. Ibid.

25. Ibid.

26. See especially the "Epilogue" to "Der Ursprung der Kunstwerks," *Holzwege*, 66–68; translation, 79–81.

27. *Unterwegs zur Sprache*, 32; translation, 209.

28. Plato, *Phaedrus* 274e–275b, translated by Benjamin Jowett.

29. *Phaedrus* 276a.

30. *Phaedrus* 275e.

31. *Phaedrus* 275d.

32. Martin Heidegger, *Sein und Zeit*, 7th ed. (Tübingen, 1953), 161; translated by John Macquarrie and Edward Robinson, *Being and Time* (New York and Evanston, 1962).

33. *Sein und Zeit*, 161.

34. Ibid.

35. Ibid., 177.

36. Hugo Friedrich, *Die Struktur der modernen Lyrik* (Hamburg, 1956), 90 and 133.

37. *Unterwegs zur Sprache*, 32; translation, 209.

38. Hugo von Hofmannsthal, "The letter of Lord Chandos," *Selected Prose*, translated by Mary Hottinger and Tania and James Stern (New York, 1952), 134–35.

39. Ibid.

40. Ibid., 135–36.

41. Ibid., 137.

42. Ludwig Wittgenstein, *Philosophical Investigations*, translated by G. E. M. Anscombe (New York, 1953), par. 7.

43. *Unterwegs zur Sprache*, 33; translation 210.

MIDWEST STUDIES IN PHILOSOPHY, XVI (1991)

Hell in Amsterdam: Reflections
on Camus's *The Fall*

PHILIP L. QUINN

Near the end of her *Ordinary Vices*, Judith N. Shklar reflects back on the use she has made of incidents from novels and plays. Some, she grants, merely serve to illustrate general moral or political points. However, she thinks others do not illustrate anything but instead serve to reveal something directly. Alluding to the stories from Molière, Hawthorne, and Shakespeare she has recounted, Shklar claims they have an "ability to force us to acknowledge what we already know imperfectly." They can "impose understandings upon us, sooner or later, by removing the covers we may have put on the mind's eye."[1] Shklar's aim is to get us to appreciate a handful of ordinary vices: cruelty, hypocrisy, snobbery, betrayal, and misanthropy. It is to be expected that we will be reluctant to acknowledge them because these vices are ours. So literature comes to the aid of self-knowledge by forcing acknowledgment and imposing understanding of what we would prefer to hide from ourselves. It can serve as an antidote to self-deception, a means to moral lucidity.

Vices other than those Shklar focuses on deserve the moralist's attention, and we may hope that our literature contains stories that can force the careful reader to see these vices for what they are. One such vice is pride. In this essay, I shall argue that Albert Camus's *The Fall* renders the viciousness of pride transparent.[2]

The Fall takes place in a fictional world saturated with Christian symbolism. The very title reminds us of the mythic fall by which Adam and Eve came to have knowledge of good and evil. But this is a Nietzschean world from which supernatural Christian realities are absent, and so in it Christian symbols can only have secular applications. In such a world, Camus's story reveals, unchecked pride will try to create a hell on earth and will consider itself fortunate if it succeeds. It is a dark and disturbing vision. But does the narrative itself render it compelling? Let us look and see.

THE MASK OF INNOCENCE STRIPPED OFF

This novel is a monologue whose speaker wittingly or unwittingly unveils his character and commitments. Set in and around Amsterdam, the story spans five days in a winter after World War II. On the first evening, the speaker introduces himself to his silent auditor in an Amsterdam bar called 'Mexico City'. He is Jean-Baptiste Clamence, though, as we later learn, he has not always gone by this name. The reference to John the Baptist is obvious, and the resemblance of the name 'Clamence' to the French verb 'clamer', to cry out, is not accidental. Our speaker means to be taken for a prophet of some sort. Nor do the religious resonances end there. Clamence reveals that he lives in what had been the Jewish quarter before the Nazis cleaned it up by deporting or assassinating seventy-five thousand Jews. And he goes on to suggest a cosmological picture in which hell is at the heart of things:

> For we are at the heart of things here. Have you noticed that Amsterdam's concentric canals resemble the circles of hell? The middle-class hell, of course, peopled with bad dreams. When one comes from the outside, as one gradually goes through those circles, life—and hence its crimes—become denser, darker. Here, we are in the last circle. The circle of the . . . Oh, you know that? (14)

In Dante's hell, of course, great traitors inhabit the innermost circle, so we may expect Jean-Baptiste to cry out about some betrayal sooner or later. For the time being, though, we get only hints about it contrived to pique the auditor's curiosity. Jean-Baptiste informs him that he once practiced law in Paris but is now a judge-penitent. And as they walk away from the Mexico City at the end of the evening, he also lets him know that he will not cross a bridge at night as the result of a vow. If someone should jump in the water, he says, either you do the same to fish him out and in cold weather run a great risk, or you forsake him there and "suppressed dives sometimes leave one strangely aching" (15). They part after Clamence advises his auditor, who turns out to be a fellow Frenchman, to try the pleasures of Amsterdam's red-light district.

It will take Jean-Baptiste another four days to explain how and why he became a judge-penitent. By way of providing the background of his switch of professions, he devotes the next day's discourse to presenting the auditor with a picture of his life as a Paris lawyer. But it is a picture that undermines itself, as the voluble Clamence must recognize, because he has strategic reasons for making the web of illusion he weaves at this point in the narrative less than fully persuasive.

Clamence's artful story of his life as a lawyer has two themes. One represents his past as a successful combination of the good life and the moral life, both happy and virtuous. His specialty, he tells us, was noble cases, widows and orphans, as the saying goes, and even noble murderers. He was above reproach professionally, never accepting a bribe or getting involved in shady proceedings. He never charged the poor a fee and never boasted of it; on the

contrary, he derived constant pleasure from being generous both in public and in private. His courtesy was famous and provided him with great delights. He loved to help blind people cross the street and to give alms to beggars. Speaking of the constant delights of his professional life, a complacent Jean-Baptiste summarizes his joy in his own excellences thus:

> Being stopped in the corridor of the law courts by the wife of a defendant you represented out of justice or pity alone—I mean without charge—hearing that woman whisper that nothing, no, nothing could ever repay what you had done for them, replying that it was quite natural, that anyone would have done as much, even offering some financial help to tide over the bad days ahead, then—in order to cut the effusions short and preserve their proper resonance—kissing the hand of a poor woman and breaking away—believe me, *cher monsieur*, this is achieving more than the vulgar ambitious man and rising to that supreme summit where virtue is its own reward. (22–23)

Moreover, all these splendid achievements came naturally and without reflection or effort. Few creatures were more natural than he, Jean-Baptiste insists; and he twice proclaims that he was then altogether in harmony with life. There was, as he strikingly puts it, no intermediary between him and life, and thus he felt "bathed in light as of Eden" (27). Indeed, he felt the conviction, extraordinary in view of the fact that he had no religion, that somehow his happy life had been authorized by a higher decree. "Life, its creatures and its gifts, offered themselves to me," he informs his auditor, "and I accepted such marks of homage with a kindly pride" (28).

But there is trouble in paradise. The narrative also reveals that this is no innocent Eden. Nor does pride always wear a kindly face. He aimed for the supreme summits, Clamence acknowledges, because he "needed to feel *above*" (23). He breathes most freely, he adds, if alone, "well above the human ants" (24). And he derived happiness from his professional life chiefly because it satisfied this vocation for summitry:

> It cleansed me of all bitterness toward my neighbor, whom I always obligated without ever owing him anything. It set me above the judge whom I judged in turn, above the defendant whom I forced to gratitude." (25)

In fact, Clamence confesses to a passionate scorn for judges in general and professes to be concerned in no judgment. And he rather cynically remarks that living on the heights is, after all, the only way to be seen and hailed by the largest number. So the second theme of this part of the story represents the narrator's life as a lawyer as driven by a need to be elevated above and, if necessary, at the expense of others, who become objects of disdain or even contempt.

There is, then, a curious and carefully presented doubleness in the character of Clamence as seen from the retrospective point of view of his own narrative. But it takes one of the three epiphanies that are turning points in the

story to force him into awareness of and reflection on this doubleness. Prior to its occurrence he continues going "from festivity to festivity" (30). Then, one evening, the music stopped and the lights went out; the gay party at which he had been so happy came to an end.

He was, he says, standing on the Pont des Arts, filled with a vast feeling of power and completion. As he was about to light a cigarette, a laugh burst out behind him. When he wheeled around to look, there was no one there. As soon as he turned around again, he again heard laughter behind him, a little farther off as if it were going downstream and coming from the water itself. He noticed that his heart was beating rapidly as if the laughter portended a judgment, perhaps one involving ridicule, that he had, unbeknownst to himself, reason to fear. Walking home, he found himself dazed and breathless. Later he heard laughter under his windows. When he opened them, he saw some youths on the sidewalk below loudly saying good night. He shut the windows and went into the bathroom to drink a glass of water. "My reflection was smiling in the mirror," he recalls, "but it seemed to me that my smile was double . . ." (40). Having made the point that this oddly perturbing laughter prodded him into a dawning awareness of his own doubleness, Jean-Baptiste lapses into silence for a moment. He concludes the second day's segment of his monologue with some remarks about the denizens of the bar to whom he now gives legal advice.

When he picks up the thread of his narrative on the evening of the third day, Clamence has become more candid about his urge to dominate. As he and his auditor stroll beside the canals, he remarks that he likes islands because they are easy to dominate. For the sake of provocation, he engages in some vulgar Nietzchean rhetoric:

> Every man needs slaves as he needs fresh air. Commanding is breathing—you agree with me? And even the most destitute manage to breathe. The lowest man in the social scale still has his wife or his child. If he's unmarried, a dog. (44)

More personally, in what he describes ironically as a humble admission, Jean-Baptiste allows that he himself was always bursting with vanity in his Paris days. His good will and serenity were, he now contends, explained by the fact that he recognized no equals and only admitted superiorities in himself. And, though he forgot it after a few days, the episode of the laughter has had a lasting effect by making him acknowledge his doubleness. If he had a shop sign, he fantasizes, it would be a double face, a Janus, with the motto: Don't rely on it. His cards would read: Jean-Baptiste Clamence, play actor. When he had left a blind man on the sidewalk after helping him across the street, he has recently noticed, he used to tip his hat to him, playing to the public since the blind man could not see the gesture. Jean-Baptiste has, in short, begun to distance himself from the role of happy and virtuous Parisian lawyer.

Memory steps in to increase the distance. Clamence now portrays himself as having suffered from amnesia. "By gradual degrees I saw more clearly," he

confesses, "I learned a little of what I knew" (49). First he recalls an embarrassing incident involving an altercation with a motorcyclist which made him look bad. He had been insulted, received a violent blow on the ear, and was unable to retaliate. An officious spectator had jeered at him. From the bitter resentment he recollected he came to recognize in himself a fierce eagerness to get revenge, to strike and conquer. "I discovered in myself," he says, "sweet dreams of oppression" (55). He thus learned that he was on the side of the guilty only so long as he was not their victim:

> When I was threatened, I became not only a judge in turn but even more: an irascible master who wanted, regardless of all laws, to strike down the offender and get him on his knees. After that, *mon cher compatriote*, it is very hard to continue seriously believing one has a vocation for justice and is the predestined defender of the widow and orphan. (56)

So memory's first lesson is that Clamence's public life had been tainted with hypocrisy.

Its next lesson bears on his private life and concerns a woman. Jean-Baptiste describes his relationships with women as games he won twice over because he managed both to satisfy his desires for them and to gratify his self-love by verifying his powers over them. But he recalls a particular woman, whom he had stopped seeing and all but forgotten: she surprised him by relating his deficiencies to a third person. He responded by undertaking a campaign to win her back. As soon as he had succeeded, without really intending it, he began to mortify her, to treat her so brutally that eventually he attached himself to her as a jailor is bound to his prisoner. But the very day she paid tribute aloud to what was enslaving her he began to move away from her and forget her again. Recollection of this incident revealed the full depth of his aspiration to dominance:

> I could live happily only on condition that all individuals on earth, or the greatest possible number, were turned toward me, eternally in suspense, devoid of independent life and ready to answer my call at any moment, doomed in short to sterility until the day I should deign to favor them. In short, for me to live happily it was essential for the creatures I chose not to live at all. They must receive their life, sporadically, only at my bidding. (68)

Memory's second lesson, then, is that even Jean-Baptiste's private life is infected by a will to power that is madly satanic in its extremity.

Upon thinking back to the time when he used to put people in the refrigerator, so to speak, in order to have them on hand when it might suit him, Jean-Baptiste feels an emotion he does not know how to name. "Well, it's probably shame, then," he tells his auditor, "or one of those silly emotions that have to do with honor" (68). In any case, it seems to him that this feeling has never been absent since the adventure he describes as his essential discovery, what he found at the heart of his memory.

Memory's third and final revelation is the second epiphany on which the narrative pivots. Jean-Baptiste now speaks of recalling a November night, two or three years before the evening on which he thought he heard the ominous laughter behind him, when he was walking home by way of the Pont Royal. On the bridge he passed behind a young woman dressed in black. He had only gone some fifty yards beyond the end of the bridge when he heard the sound, which seemed dreadfully loud in the midnight silence, of a body hitting the water. He stopped but did not turn around. Almost at once he heard a cry, several times repeated, moving downstream. Suddenly it ceased. He continued to stand as if rooted to the spot, trembling from cold and shock. "I told myself that I had to be quick," he declares, "and I felt an irresistible weakness steal over me" (70). After standing motionless for a while longer, he walked slowly away. He informed no one. And so here, almost at the midpoint of his narrative, Clamence both reveals and acknowledges the incident that prompts that nameless shamelike feeling and gave rise to that curious vow not to cross bridges at night. By remaining motionless, he falls, and the story so far has shown us that pride and a desire for godlike power have gone before this fall.

So far, though, his story has been a rather conventional tale of moral weakness, albeit one told with considerable artistry. Who among us, after all, has not at some time violated the Christian commandment that the neighbor is to be loved? Which of us has not felt shame, or even guilt, over some small betrayal? According to the Christian doctrine of original sin, we are all fallen creatures, and so in a fictional world shaped by Christian symbols a character like Clamence can function archetypically to represent us all. It is sometimes said in jest that original sin is the only Christian doctrine to derive overwhelming inductive support from common experience. There is, I think something to this idea if it is decoupled from the Augustinian notion that original sin involves inherited guilt biologically transmitted. Kant maintains that there is in each of us a propensity to wrongdoing that is itself morally evil because each of us freely brings it upon himself or herself. "That such a corrupt propensity must indeed be rooted in man," he says, "need not be formally proved in view of the multitude of crying examples which experience *of the actions* of men puts before our eyes."[3] And one of Kierkegaard's pseudonyms, speaking as a psychologist not a theologian, contends that we all make a transition from innocence to guilt by means of some sort of act of libertarian freedom. Speaking of this qualitative leap, Vigilius Haufniensis says:

> Just as Adam lost innocence by guilt, so every man loses it in the same way.
> If it was not by guilt that he lost it, then it was not innocence he lost; and if
> he was not innocent before becoming guilty, he never became guilty.[4]

It would, I think, strain credibility to suppose that Clamence's decision not to come to the aid of the drowning woman marked his fall from innocence into guilt. But even if this fall was only the first he came to acknowledge rather than the first to occur, we may still regard it as symbolic of something that takes place in the life of each of us.

A world in which Christian realities corresponded to Christian symbols would contain a remedy for universal human fallenness. Here on earth a fallen human might, with the assistance of divine gifts of grace, acknowledge guilt, repent of it, do penance, and come to benefit from Christ's atonement. And so the unwary reader might suppose that the vocation of judge-penitent, which Jean-Baptiste has so far put off explaining to his auditor, involves taking the first steps in this process of healing and reconciliation. On this view, a judge-penitent's first task would be self-judgment and an admission of guilty responsibility for having fallen; remorse, contrition, and penance would follow. But this possibility is not to be entertained within the post-Christian prophecy of Camus's narrator. The vocation of judge-penitent turns out to be something quite different in a world without Christian realities. As this gradually becomes clear in the course of the second half of Clamence's story, a vision of a fallen world from which not only redemption but also mercy are absent takes shape.

THE FACE OF PRIDE REVEALED

The next day Jean-Baptiste and his auditor make an excursion to the isle of Marken in order to see the Zuider Zee. Flat, colorless, and dead, the landscape is, he says, a soggy hell, everlasting nothingness made visible. He complains of fatigue and a loss of lucidity; he reveals that he once contemplated suicide but in the end loved life too much to go through with it.

Continuing his narrative, Clamence describes his postlapsarian state of mind. At first he remained eager to elude judgment while continuing to judge others:

> To be sure, I knew my failings and regretted them. Yet I continued to forget them with a rather meritorious obstinacy. The prosecution of others, on the contrary, went on constantly in my heart. (76)

But judgment is not so easily dodged. Clamence likens himself to an animal tamer who cuts himself before going into the cage: the animals will turn on him once they smell blood. Having become aware of dissonance and disorder within himself, he began to feel vulnerable and open to public accusation:

> In short, the moment I grasped that there was something to judge in me, I realized that there was in them an irresistible vocation for judgment. Yes, they were there as before, but they were laughing. Or rather it seemed to me that everyone I encountered was looking at me with a hidden smile. (78)

He discovered he had enemies who could not forgive his past successes; it was as if the whole universe had begun to laugh at him, he insists.

This universal laughter reinforces his awareness of his own doubleness, now generalized to the idea of the fundamental duplicity of the human being. "Then I realized, as a result of delving in my memory," he remarks, "that modesty helped me to shine, humility to conquer, and virtue to oppress" (84–85). And just as his virtues nourished his vices, so also his vices fed his

virtues, or at least created an appearance of virtue. "For example, the obligation I felt to conceal the vicious part of my life gave me a cold look that was confused with the look of virtue," he observes; "my indifference made me loved; my selfishness wound up in my generosities" (85). But, of course, it is the virtues that were surface phenomena, and the vices ruled the depths. Metaphorically speaking, he admits, he used to spit daily in the face of all the blind. Unable to take human affairs seriously, he merely played at being efficient, intelligent, virtuous, civic-minded, shocked, indulgent, fellow-spirited, edifying, and so forth. Increasingly lucid about the corruption within him, Clamence remained in violent revolt against a judgment he felt forming in and around him.

But the crisis deepened. He became obsessed with the thought of death and with the fear that one could not die without having confessed all one's lies. The absolute murder of even a single truth that would occur if any lie remained unexposed at death made him dizzy at times. When he could no longer bear this intensified sense of discrepancy between virtuous surface and vicious depths, he resolved to hurl his duplicity in the face of others, whom he describes as those imbeciles, before they discovered it for themselves. And so he engaged in fantasies of an orgy of self-exposure:

> In order to forestall the laughter, I dreamed of hurling myself into the general derision. In short, it was still a question of dodging judgment. I wanted to put the laughers on my side, or at least to put myself on their side. I contemplated, for instance, jostling the blind on the street; and from the secret, unexpected joy this gave me I recognized how much a part of my soul loathed them; I planned to puncture the tires of invalids' vehicles, to go and shout "Lousy proletarian" under the scaffoldings on which laborers were working, to slap infants in the subway. (91)

These somewhat ludicrous fantasies were, however, only pipe dreams. What Clamence actually did by way of self-disclosure at that time was quite timid and indirect.

In a speech to young lawyers, for example, he suggested the strategy of defending the thief by exposing the crimes of the honest man, in particular, the lawyer. If he were defending a murderer through jealousy, he told them, he would say to the jury:

> I am free, shielded from your severities, yet who am I? A Louis XIV in pride, a billy goat for lust, a Pharaoh for wrath, a king of laziness. I haven't killed anyone? Not yet, to be sure! But have I not let deserving creatures die? Maybe. And maybe I am ready to do so again. (95)

But this equivocal revelation turns out to be no more than a pleasant indiscretion. It proves to be but another evasive tactic. Clamence is not yet prepared either to judge himself or to submit himself to the judgment of others. "You see, it is not enough to accuse yourself in order to clear yourself; otherwise, I'd be as innocent as a lamb," he assures the silent listener; "one

must accuse oneself in a certain way, which it took me considerable time to perfect" (95–96). And, of course, the claim that he would clear himself rather than condemn himself by the proper sort of accusation embodies yet another lie. We are, I think, meant to be familiar enough with Jean-Baptiste's character by this point in his tale, and suspicious enough about his motives, to recognize for ourselves that it is a lie. So far, then, he is neither judge nor penitent.

On the trip back from Marken, he reveals how he came at last to acknowledge his guilt. His final attempt to evade judgment had been to search for oblivion through debauchery. The advantage he derived from some months of orgy was, he observes, that "I lived in a sort of fog in which the laughter became so muffled that eventually I ceased to notice it" (106). But dodging judgment came decisively to an end in the third of Jean-Baptiste's epiphanies. From the upper deck of an ocean liner, he one day spotted far off at sea a black speck on the steel-gray water, and his heart at once began to beat wildly. Though he soon identified it as a bit of refuse, he became aware that he had not been able to endure watching it because he had thought at once of a drowning person. This event triggers a momentous acknowledgment:

> Then I realized, calmly as you resign yourself to an idea the truth of which you have long known, that cry which had sounded over the Seine behind me years before had never ceased, carried by the river to the waters of the Channel, to travel throughout the world, across the limitless expanse of the ocean, and that it had waited for me there until the day I had encountered it. I realized likewise that it would continue to await me on seas and rivers, everywhere, in short, where lies the bitter water of my baptism. (108)

Thus the baptist is baptized, bitterly and perversely, into guilt, not innocence. Jean-Baptiste then recognized it: "I had to submit and admit my guilt" (109), he says.

Jean-Baptiste compares himself to a prisoner in the little-ease, a medieval dungeon whose cramped dimensions allow neither standing upright nor lying down. The condemned man learns guilt there by living on the diagonal, so to speak. And we all, if we are honest, must admit that we are reduced to living hunchbacked in such a cell. "We cannot," Jean-Baptiste insists, "assert the innocence of anyone, whereas we can state with certainty the guilt of all" (110). God is not needed to find us guilty; nor need we wait for the Last Judgment. Human judgment here and now suffices. Each testifies to the crime of all the others, and there are no extenuating circumstances. For three brief years, long ago, religion served as a huge laundering venture, washing away the stains of guilt:

> Since then, soap has been lacking, our faces are dirty, and we wipe one another's noses. All dunces, all punished, let's all spit on one another and— hurray! to the little-ease! Each tries to spit first, that's all. I'll tell you a big

secret, *mon cher*. Don't wait for the Last Judgment. It takes place every day. (111)

In this grim world of universal guilt, described by Clamence with mounting hysteria, pollution is everywhere, all contribute to making it worse, and judgment is irrevocable.

But what of the one who died crucified at the end of those three brief years? Even he, Clamence argues, was not altogether innocent. "If he did not bear the weight of the crime he was accused of," runs the charge, "he had committed others—even though he didn't know which ones" (112). And did he really not know? Innocent children had been slaughtered while his parents were taking him to safety. "And as for that sadness that can be felt in his every act," Clamence asks, "wasn't it the incurable melancholy of a man who heard night after night the voice of Rachel weeping for her children and refusing all comfort?" (112). Confronting this innocent crime, that man found it too hard to hold on and continue. "It was better," Clamence concludes, "to have done with it, not to defend himself, to die, in order not to be the only one to live, and to go elsewhere where perhaps he would be upheld" (113). But he was not upheld and died with an agonizing cry on his lips, a protest at being forsaken. Clamence honors the protest: "He cried aloud his agony and that's why I love him, my friend who died without knowing" (114).

As he was abandoned, Clamence continues, so too are we. He left us alone to carry on, knowing what he knew, but incapable of doing what he did and of dying as he did. There is no help for us to be derived from that death. People tried:

After all, it was a stroke of genius to tell us: "You're not a very pretty sight, that's certain! Well, we won't go into the details! We'll just liquidate it all at once, on the cross!" But too many people now climb onto the cross merely to be seen from a greater distance, even if they have to trample somewhat on the one who has been there so long. (114)

Worse still, his heirs have transformed him from a victim into yet another judge:

They have hoisted him onto a judge's bench, in the secret of their hearts, and they smite, they judge above all, they judge in his name. He spoke softly to the adulteress: "Neither do I condemn thee!" but that doesn't matter; they condemn without absolving anyone. (115)

This wasted world of universal guilt and judgment appears utterly without mercy or prospects of redemption.

Having painted this bleak picture of a world from which Christian realities are absent, Clamence announces his own prophetic mission. When all is said and done, he says, he really is only an empty prophet for shabby times, Elijah without a messiah, showering imprecations on lawless people who cannot endure judgment and so will go to any lengths to escape acknowledging their own guilt. Without law or limit, judgment turns capricious. One condemns all the others while protesting one's own innocence. It is clear to Clamence that

the keenest of human torments is to be judged without a law. Yet we are in that torment. Deprived of their natural curb, the judges, loosed at random, are racing through their job. (117)

The only way to put a stop to this is to lay down the law. And, in a cry that unmasks the face of pride, this empty prophet reveals, at long last, that this is the office of a judge-penitent:

Fortunately, *I* arrived! I am the end and the beginning; I announce the law. In short I am a judge-penitent. (118)

Jean-Baptiste's penultimate monologue concludes with a promise to tell his auditor tomorrow what his noble profession consists of. But by this time we have been given plenty of reasons to doubt its nobility. What this cry expresses is nothing less than the ambition to usurp the place of the absent Christian God, to become the *alpha* and *omega* of the world. There is no trace of penitence in this disclosure of unrepentant pride. It should remind us of another mythic fall, one far worse than that of Adam and Eve.

Jean-Baptiste begins to deliver the final installment of his monologue from his bed. He is feverish, and his talk is frenzied. Admitting that it is hard to disentangle truth from falsity in what he says, he contends that all his stories, true and false, serve to reveal what he has been and what he is. As if to prove the point, he narrates what he calls his "pontifical adventures" (120–21).

During World War II, he says, he had been interned near Tripoli along with a young Frenchman who had fought against Franco in Spain. That man had declared to ten or so of the inmates of the camp the need for a new pope who would live among the wretched instead of praying on a throne and would keep alive the community of their suffering. Jean-Baptiste had been chosen for this office, but he betrayed it by drinking the water of a dying comrade. He convinced himself, he reports, "that the others needed me more than this fellow who was going to die anyway and that I had a duty to keep myself alive for them" (127). Telling this tale, which he admits in passing may be only a dream, gives Jean-Baptiste the idea that one must forgive the pope because he needs forgiveness more than anyone else and especially because "that's the only way to set oneself above him" (127). Pride's insatiable hunger for domination thus comes to the fore once more.

It is emphasized again in the next bit of self-revelation. Jean-Baptiste now shows his auditor a painting, called "The Just Judges," which is one of the panels of the van Eyck altarpiece, "The Adoration of the Lamb," which had been stolen from Ghent in 1934 and replaced by a copy. Among the reasons Jean-Baptiste gives for keeping the painting in his cupboard is that doing so is a way of dominating. "False judges are held up to the world's eye," he says, "and I alone know the true ones" (129–30). Another reason is that "justice being definitively separated from innocence—the latter on the cross and the former in the cupboard—I have the way clear to work according to my convictions"

(130). Those convictions define the difficult profession of judge-penitent, and Jean-Baptiste will now make them explicit.

He says he has practiced this profession throughout his five-day monologue. The purpose of his words is always to silence the laughter and to escape being judged. Since there apparently is no escape because we are the first to condemn ourselves, a judge-penitent must begin by extending the condemnation to all in order to thin it out at the start:

> No excuses ever, for anyone; that's my principle at the outset. I deny the good intention, the respectable mistake, the indiscretion, the extenuating circumstance. With me there is no giving of absolution or blessing. (131)

But this is only a beginning because it does no more than to establish an equality in condemnation, a democracy of guilt. "The judgment you are passing on others," Jean-Baptiste sardonically notes, "eventually snaps back in your face, causing some damage" (137). One must next reverse the procedure in order to win out in the end:

> Inasmuch as one couldn't condemn others without immediately judging oneself, one had to overwhelm oneself to have the right to judge others. Inasmuch as every judge someday ends up as a penitent, one had to travel the road in the opposite direction and practice the profession of penitent to be able to end up as a judge. (138)

And, as his auditor knows from experience, this is just what Jean-Baptiste has been doing, indulging in public confession and accusing himself up and down.

But self-accusation as practiced by a judge-penitent is a subtle art because it also involves baiting a hook. One must, Jean-Baptiste proclaims, construct a portrait which is the image of all and no one, like a carnival mask that is both lifelike and stylized:

> When the portrait is finished, as it is this evening, I show it with great sorrow: "This, alas, is what I am!" The prosecutor's charge is finished. But at the same time the portrait I hold out to my contemporaries becomes a mirror. (139–40)

To see oneself in this mirror is to take the bait. Once this has happened the judge-penitent triumphs:

> When I get to "This is what we are," the trick has been played and I can tell them off. I am like them, to be sure; we are in the soup together. However, I have a superiority in that I know it and this gives me the right to speak. You see the advantage, I am sure. The more I accuse myself, the more I have a right to judge you. Even better I provoke you into judging yourself, and this relieves me of that much of the burden. (140)

The entire monologue up to this point has thus been an effort to entrap the silent auditor by painting a self-portrait that Clamence now acknowledges was both a mask and a mirror. His true face has not yet been fully revealed.

When at last unmasked, it is the face of mad pride. As Kierkegaard notes, "that pride is the maddest that oscillates between deifying and despising oneself."[5] Having already let his auditor know that he despises himself, Clamence now gives free vein to a fantasy of self-deification. He was wrong, he confesses, to say that the essential was to avoid judgment:

> The essential is being able to permit oneself everything, even if, from time to time, one has to profess vociferously one's own infamy. I permit myself everything again, and without the laughter this time. I haven't changed my way of life; I continue to love myself and to make use of others. Only, the confession of my crimes allows me to begin again lighter in heart and to taste a double enjoyment, first of my nature and secondly of a charming repentance. (141–42)

This false repentance is charming precisely because it sets him on a height from which he can judge everybody else. It is intoxicating to dominate others from this height. "I sit enthroned among my bad angels at the summit of the Dutch heaven," Clamence declares, "and I watch ascending toward me, as they issue from the fogs and the water, the multitude of the Last Judgment" (143). He aspires, we now recognize, to reign in hell.

Clamence now rises from his bed. "I must be higher than you," he says, "and my thoughts lift me up" (143). He thinks of all Europe as his kingdom, with hundreds of millions of people as his subjects. "Then, soaring over this whole continent which is under my sway without knowing it," he raves, "drinking in the absinthe-colored light of breaking day, intoxicated with evil words, I am happy—I am happy, I tell you, I won't let you think I'm not happy, I am happy unto death!" (144). This hysterical protest is quickly followed by a despairing expression of a longing for death. Jean-Baptiste imagines himself arrested for possession of "The Just Judges" and decapitated like his namesake:

> Above the gathered crowd, you would hold up my still warm head, so that they could recognize themselves in it and I could again dominate—an exemplar. All would be consummated; I should have brought to a close, unseen and unknown, my career as a false prophet crying in the wilderness and refusing to come forth. (146–47)

So the face of pride is at last open to plain sight. Pride wills to dominate even beyond death. Reflected in Christian symbols, its face is the visage of Satan. A world of judge-penitents would be hell on earth indeed.

Playing his assigned role to the very end, the narrator tempts his auditor, who now lets it be known that he is a Parisian lawyer, to acknowledge their kinship in guilt. "Then please tell me what happened to you one night on the quays of the Seine," he pleads, "and how you managed never to risk your life" (147). And he goes on to command: "You yourself utter the words that for years have never ceased echoing through my nights and that I shall at last say through your mouth: 'O young woman, throw yourself into the water again so

that I may a second time have the chance of saving both of us!' " (147). These are, of course, idle words. And so the story concludes:

> But let's not worry! It's too late now. It will always be too late. Fortunately! (147)

Here we recognize another feature of the traditional hell. There it is indeed always too late to do anything about past guilt, the wills of the damned being everlastingly fixed on evil. But only the damned would consider that to be fortunate. If a world in which each of us must acknowledge having fallen and thereby become guilty really is a world in which there is no possibility of absolution or blessing, then we should fear that our world is such a hell. And, absent Christian realities, we will be unable to forgive one another because we cannot forgive ourselves if we are by nature, or can be tempted into being, such monsters of pride as the false prophet of the story both shows himself to be and implicitly claims we all in fact are. So it is perhaps useful to recall that Satan is the Father of Lies and to remind ourselves that the revelations of a false prophet may be false all the way down.

CONCLUDING REFLECTIONS

Within the fictional world of *The Fall*, there seem to be only two alternatives: nihilism or Christianity. Either each of us announces a law of his or her own, as the judge-penitent does, or there is a transcendent divine law. Either one is able to permit oneself everything, or there are divinely established limits that cannot be transgressed with impunity. The novel argues by example that the nihilistic alternative is untenable. Its narrator cannot escape the cry that sounded over the Seine on the night of his fall. For him, self-judgment and a reluctant acknowledgment of guilt cannot be evaded indefinitely; the bitter water of his baptism awaits him everywhere. So one might be tempted to employ the novel for apologetic purposes and to argue from it that the fact that consciousness of guilt is humanly inescapable can only be explained by the truth of Christian faith. I think this temptation should be resisted.

It is not likely that Camus himself would have succumbed to it. Though he obviously had some respect for Christianity's founder, he consistently looked to the ancient Greek world for an antidote to modern nihilism. He said: "If in order to go beyond nihilism, we have to go back to Christianity, then we may very well follow the movement and go beyond Christianity into Hellenism."[6] I myself doubt that this project is feasible. The idea of reviving ancient Greek culture and, in particular, the notion of limit embodied in its tragedies smacks of what Jeffrey Stout calls "terminal wistfulness."[7] And at times Camus made it clear that he was able to view the prospect of moving into Hellenism from an ironic distance. In an interview in which he stated a preference for the values of the ancient world over those of Christianity, he wryly remarked: "Unfortunately I cannot go to Delphi to have myself initiated!"[8] Nor can most of us.

I consider pride an ordinary vice. So it seems to me that the hellish world Jean-Baptiste Clamence prophesies is not just a figment of an existentialist's overheated imagination, but a real possibility for a post-Christian culture. The popularity of nihilism in our century leads me to believe that there is some positive probability, though I would not care to assign it a precise numerical value, that such a world lies in our future. But Christianity and Hellenism are not the only possible alternatives to it. "Secular faith," as Annette Baier aptly baptizes it, is an alternative to Christian faith.[9] I do not have in mind here precisely her idea of faith that one can establish the possibility of a Kantian Kingdom of Ends by living so as to qualify for membership in it. I am instead thinking of the modest beliefs that human pride can be humbled, or at least kept in check, without divine chastisement and that acknowledging guilt in ourselves need not render us merciless toward others. If a post-Christian culture can mobilize such resources as these, it may well prove strong enough to resist the seductions of the false prophets of nihilism.

NOTES

1. Judith N. Shklar, *Ordinary Vices* (Cambridge, Mass., 1984), 229.

2. Albert Camus, *The Fall*, translated by Justin O'Brien (New York, 1956). Hereafter quotations from this novel will be identified by parenthetical page references in the body of my text.

3. Immanuel Kant, *Religion within the Limits of Reason Alone*, translated by Theodore M. Greene and Hoyt H. Hudson (New York, 1960), 28. I have criticized Kant's account of radical evil in Philip L. Quinn, "'In Adam's Fall, We Sinned All'." *Philosophical Topics* 16, no. 2 (1988): 89–118.

4. Søren Kierkegaard, *The Concept of Anxiety*, translated by Reider Thomte (Princeton, N.J., 1980), 35. I have discussed Kierkegaard's account of hereditary sin in Philip L. Quinn, "Does Anxiety Explain Original Sin?" *Nous* 24 (1990): 227–44.

5. Or, as the English translation puts it: "the most insane pride is that which oscillates between deifying oneself and despising oneself." See Søren Kierkegaard, *The Present Age and Two Minor Ethico-Religious Treatises*, translated by Alexander Dru and Walter Lowrie (London, 1940), 92. For recent discussion of the minor ethico-religious essay, "Has a Human Being the Right to Allow Himself to be Put to Death for the Truth?" from which the quotation comes, see Bruce H. Kirmmse, *Kierkegaard in Golden Age Denmark* (Bloomington, Ind., 1990), 332–36.

6. Albert Camus, *Carnets 1942–1951*, translated by Philip Thody (London, 1966), 120.

7. Jeffrey Stout, *Ethics After Babel* (Boston, 1988), 220–42.

8. Albert Camus, *Lyrical and Critical Essays*, translated by Ellen Conroy Kennedy (New York, 1968), 357. For further discussion, see Bruce K. Ward, "Prometheus or Cain? Albert Camus's Account of the Western Quest for Justice," *Faith and Philosophy* (forthcoming).

9. Annette Baier, "Secular Faith" collected in her *Postures of the Mind* (Minneapolis, 1985), 292–308.

MIDWEST STUDIES IN PHILOSOPHY, XVI (1991)

Beauty and Anti-Beauty in Literature and its Criticism

GUY SIRCELLO

No aesthetic concept *seems* more beside the point in the criticism of litera-
ture than beauty. And it seems even further beside the point the closer to our
own time the literature in question and the more up-to-date the criticism in
question. As a matter of fact, beauty *is* beside the point in trying to understand
literature—in some respects, under some conditions, and from some perspec-
tives. But in other respects, under other conditions and from other perspectives,
beauty neither is nor can be beside the point. And this is so not merely de-
spite the tendencies of some recent literature and criticism to stamp beauty out,
but because of those very tendencies. In this essay I will substantiate these
opinions by exploring a variety of conditions under which beauty can be, can
appear to be, or can be taken to be beside the literary and critical point, as well
as a variety of conditions under which beauty is not, appears not to be, and
cannot be taken to be beside the point. Along the way I shall also implicitly
be giving a variety of constructions to the capacious notion of being "beside
the point."

My exploration will take the following course. The most naive but per-
sistent model of beauty makes it seem literally inapplicable to literary works,
but if we consider a more sophisticated model of beauty, namely my own, and
a sophisticated theory of literature, that of Wolfgang Iser, beauty in literature
becomes not only a possible, but a fascinatingly subtle and complex thing. At
the same time, Iser's theory disposes the reader convinced by that theory to be
insensitive precisely to the kinds of beauty that the theory itself makes possi-
ble. One important reason for this induced insensitivity is the fact that Iser's
theory has the effect of "relocating" beauty from the work and its author to
the reader himself. Again a certain "skeptical" strain in Iser's thought predis-
poses some of Iser's readers not to recognize this relocated beauty. Moreover,
this same skeptical strain leads Iser to find in certain modern texts efforts to
block recognition of that very relocated beauty in the reader. Despite this fact,
Iser's reading of these texts finds in them a tendency to produce even more

interesting relocated beauties in the reader. Finally, Iser's uncovering of these very relocated beauties suggests *future* developments in literary history that not only would subvert the "anti-beautiful" tendencies of modernist literature but would constitute counterexamples to Iser's own literary theory.

2.

It is probably the grammar of "beauty" and its cognates that gives rise to the simplest model of beauty: Beauty, if it is anything at all, is a non-relational, non-contextual property of real (physical) objects, and we apprehend it *via* sensory perception. No philosopher that I know of has held a theory just like this. Most developed theories are quite far from it. A few seconds reflection will readily show up its inadequacies. Yet very intelligent people sometimes make remarks that unreflectively assume one or more elements of it. Even many sophisticated theories of beauty show the influence of this model. It exerts a sort of primal force on our ideas of beauty. I call it the Primitive Model of Beauty.

From the point of view of such a model, of course, a literary work would not seem even *able* to be beautiful, except in the apparently insignificant way that the look of its written or printed form, or the sound of its pronounced form, might be beautiful. But the literary work seems to exist (if that is the right word) primarily as the meanings of its words, or as a function of these meanings, and those are not real (physical) objects; nor are they apprehended by sensory perception. The way we apprehend literary works cannot, it would seem, be understood on an analogy with sensory perception. One reason is that we have access to a literary text by *reading* it. And thus we *cannot*, as in some cases of sensory perception, take the work in "all at once." It takes a longish time—even years—to read a work. And even then, having read it once does not mean apprehending it. For we do, and often must, reread; we "miss" things the first—and subsequent—times. At what point can we be said to apprehend the *beauty* of the work—halfway through, at the end of the first reading, the first rereading? The possible answers begin to make the questions seem silly. It may thus seem wiser to dispense with the notion of beauty altogether in discussing and appraising literature, as very many critics have in fact done—though not, to be sure, only for these reasons.

To conclude, however, on the basis of an unsophisticated model of beauty and of widespread critical practice that beauty is inapplicable to literature is premature for it ignores some commonplace facts of our experience. *Writers* at least like to speak, for example, of how beautifully crafted a story is, how a certain effect is beautifully brought off, how a transition from scene to scene, from mood to mood, from perspective to perspective, is beautifully made. As readers, too, we are struck by how beautifully evocative a passage may be, how beautiful an image may be, or a pattern of images, e.g., the crimson and silver imagery of Keat's *The Eve of St. Agnes*, or how beautiful the conception of an author in a work may be, e.g., Dante's moralized cosmology in *The Divine Comedy*. Such unselfconscious uses of "beauty" with respect to aspects

of literature should make us think that there is after all some *place* for beauty in literature, however uninteresting that fact may be to critics of literature or however unsettling it may be to the Primitive Model of Beauty.

3.

Let us then consider another, subtler model of beauty, one that I think can account for the kinds of "commonplace" and "unselfconscious" experiences of beauty (or uses of "beauty") that I mention above. This is the model of beauty that I construct in my *A New Theory of Beauty*. I will here briefly recapitulate that theory and make some important observations about the key terms of the theory.

The New Theory of Beauty (NTB) locates beauty, not in objects, but in "objects." The difference is crucial and nowhere more so than in discussing literature. An "object" is anything describable that can be the (apparent) referent of the subject term of a proposition of the form "*x* is beautiful." "Objects," thus, need not be physical objects, nor even existent objects.[1] Thus a dress may be beautiful, the *way* you dress may be beautiful, the way you dreamt you dressed may be beautiful, the dress you fantasized about may be beautiful, and the dress the heroine of the novel wears in the opening scene may be beautiful. All are "objects."

NTB specifies necessary, but not sufficient conditions for any "object" to be beautiful. That "object" must possess at least one property of qualitative degree to a very high degree. That property, moreover, may not be one of a deficiency, defect, or lack, or of the appearance of deficiency, defect, or lack.[2] A property of degree is defined as follows: any property that may be (or appear to be) present in two or more "objects" in differing degrees. A property is one of *qualitative* degree if and only if the differences of degree to which it may be present are not enumerable according to a uniform scale comprehending all "objects" that may possess that property. Thus, elegance, vividness, brilliance, being delicate-looking, robustness, muscularity, kindness, honesty are examples of properties, a high degree of which in an "object" fulfills a necessary condition for that "object" to be beautiful. NTB does however specify necessary *and* sufficient conditions for a *property* (of a given "object") to be beautiful: it must be present in the "object" to a very high degree and it must not be one of deficiency, defect, lack or the appearance thereof. Let us call all such properties that may be beautiful, "qualities." Thus every instance of a high degree of a quality is, according to NTB, an instance of beauty.[3]

In order to understand the force and significance of NTB, it is essential to understand that it does *not* presume the existence—either in an ordinary or in a precise metaphysical sense—of qualities. As far as NTB is concerned, it may be the case that there is no "ultimate" reality to *any* qualities—even qualities of existing, physical objects, like the healthiness of the sansevieria on my desk. Just so, it is irrelevant to NTB in determining the beauty of Botticelli's Venus that there is (exists) no Venus that Botticelli painted and hence, obviously, no

qualities that she possesses. It is also essential to grasp that NTB does not presume that *any* qualities are intersubjectively accessible. That is to say, it may be the case, for all that concerns NTB, that all qualities that are apparent to a given person are apparent only to that person.[4] Similarly, of course, it may be that "objects" apparent to one person, may not be apparent to another, as, e.g., dreamt "objects."

One might legitimately wonder, of course, given the existence-neutrality of "objects" and qualities, how it is determinable whether a certain "object" O possesses some quality Q. In *A New Theory of Beauty* I did not address the issue at all; and I am not now prepared to offer a complete account of the epistemology that NTB requires. Suffice it to observe that NTB presupposes that "O is beautiful" can be affirmed by the person S only if O is apparent to S and appears to S to have qualities that are also apparent to S.[5] Two persons thus may agree on whether O is beautiful only if O is apparent to both; and they can agree for the same reasons only if the relevant qualities of O are apparent to both. NTB thus does not pretend to solve certain "metaphysical" or "epistemological" problems about beauty; nor does it claim to be able to resolve disagreements about beauty. It claims only to analyze and "locate" the beauty that persons who do apprehend beauty apprehend.[6]

Further observations about qualities are important. NTB does not suppose that all qualities appropriately described by the same word, e.g., "elegance," are in fact the same quality; nor that qualities appropriately described by different words are different qualities. For all NTB determines, nearly all the qualities properly called "elegant" are in fact different. NTB is thus able to preserve that particularity that is so important in aesthetic matters. It *cannot* be the case for NTB, of course, that every (actual and possible) instance of a quality be an instance of a unique quality. NTB requires that there at least be possible (i.e., imaginable) instances of a given quality exhibiting differing degrees of the *same* quality. A final observation: NTB does not presuppose that all qualities are readily describable, or that they are describable at all in brief, simple, standard, literal, or intersubjectively communicable ways.

<div align="center">

4.

</div>

I want eventually to apply NTB to literature, but to do so requires a plausible model of what the literary work is. The model I will use is that of Wolfgang Iser, as he has worked it out in two books, *The Implied Reader* and *The Act of Reading*. I choose Iser's work for several reasons: First, it is at once a theory of the literary work and of the criticism of literary works. Second, it is accompanied, as it were, by its own application to particular literary works. Third, it is one of several recent theories of literature that take as central the obvious unavoidable, but traditionally underestimated, even ignored fact that our chief access to literary works is by *reading* them. Fourth, although (perhaps because) of all these theories it is among the most conservative, it has had a substantial influence, even in a rather crowded field. And, fifth, though it is not

without its problems, it strikes me as both sensible and plausible. (I do not, however, intend here either to defend or to endorse it.)

Influenced as it is, I surmise, by the work of Roman Ingarden, Iser's theory is subtle and complex; I hope I can get the main lines of it (roughly) right in a few paragraphs. A meaning, or interpretation, of a text is a result of an interaction of the written text and the mental activity of a reader. This is a "concretization" of the text. Such interpretations hence vary from reader to reader, depending upon such factors as the experience, intelligence, and temperament of each reader. Thus the text by itself does not determine a single interpretation. On the other hand, individual interpretations do not vary wildly or uncontrolledly; for the text itself places certain limits and constraints on interpretations. It not only supplies the basic data for interpretation, but these textual data channel interpretation in certain directions rather than in others. Thus each text demands or "calls for" a certain range of readers, whom we can think of as its "proper" readers. (Though these latter terms are my own, the ideas are, though somewhat implicitly, Iser's.)

In working out an interpretation, furthermore, the reader is governed by an overarching principle—that the text be coherent, or, as Iser likes to say, "consistent," both in its parts and on the whole. Thus a given interpretive possibility is scrapped by a reader when that reader becomes aware of textual data, or of other interpretive possibilities, that are discrepant with it. (Such discrepant possibilities Iser calls "alien associations.") On the other hand, the text itself is "polysemantic," which means roughly that it admits of a large number of differing and not necessarily compatible interpretations.[7] There is, therefore, an inherent conflict between the nature of the text and the requirements of its readers. I believe it is because of this discrepancy between a text and its readers' requirements that Iser identifies "illusion" with the result of (coherent) interpretation. This identification seems to mean, on one side, that those "illusions"—in the sense of fictionally created worlds—are the result of readers demanding of the text some coherent interpretation or other. On the other side, the identification seems to imply that the reader who builds this sort of coherent interpretation—or any other kind of coherent interpretation of the text, whole or part—is building an illusion for herself, since the polysemantic "reality" of the text will always be richer than any such interpretation.[8]

Now the interaction between text and reader does not happen all at once. It could not, since it happens in the act of reading, which takes place over time. As we read, according to Iser, we are led by the text to take a series of differing viewpoints, e.g., that of one or another of the characters, of the narrator, of the implied author, etc.. This phenomenon Iser calls the "wandering viewpoint."[9] As the reader moves through the act of reading from his wandering viewpoint, he engages in his interpretive activity, his "consistency-building." Thus for Iser interpretation does not occur only when all the "textual data" are in, say at the close of a complete reading. Rather, as the reader begins to read, the text sets up expectations of what will or might come next. As the reading proceeds, some of these expectations are met, others not, and further

expectations are aroused, based not only upon new "data," but upon the reader's memory of data she has already read. But the expectations are not based simply upon these "raw" data, but upon these data as formed into what Iser calls variously "gestalten," "gestalt-groupings," or "configurative meanings," or what I would call "provisional" interpretations of what is taking place in the text. They are provisional because they are subject to modification as the reader encounters new textual data, and as new "alien associations" occur to her. Iser, furthermore, emphasizes that even at the end of a "complete" reading, all interpretations remain provisional because they may and probably will be modified on succeeding readings.

Now whereas the above processes of consistency-building may be quite conscious, there is another form of interaction between text and reader which is subconscious. That is the formation of "images." The formation of images, as we read, of what we are reading about is a form of what Iser calls "passive synthesis." Iser emphasizes the "ideational" component in image-formation. I am uncertain what the whole importance for him of this fact is; but it is, in part, that images are to a degree results of the interpretive activity described earlier. That is, Iser wants to say that images are not simply "given" by the words of the text, but are partly due to the "configurative meanings" we are constantly giving to the text as we read. Iser also emphasizes the somewhat indeterminate nature of the images—a correlate, I think, of the polysemantic nature of the text. And he also stresses how our images build on one another, influencing later ones and being influenced by our memories of earlier ones. Thus, as we read, the images we have are as constantly shifting as are our more intellectual "gestalten."[10]

5.

An inventory of all those "objects" in a literary text to which qualities—and, hence, in the terms of NTB, beauty—may apply includes the following kinds of "objects": (i) images," (ii) fictional events, characters situations, places, etc., (iii) structures and interrelationships among the latter, (iv) words, phrases, sentences, paragraphs, chapters, etc., (v) patterns, rhythms, and structures of the latter, (vi) relationships among any or all elements in (i) through (v), (vii) special cases of (vi) that constitute the "ways" the author or implied author contrived or apparently contrived the text and fictional elements to bring off certain effects. In terms of Iser's theory, "objects" of all these kinds, except, I believe, for category (iv), are the products of interactions between text and readers. They cannot be for Iser, therefore, "real" objects (or "objects") in the sense of being mind-independent. Furthermore, according to Iser's theory, many "objects" of these kinds that pertain to a given text will vary from reader to reader, not only in terms of *what* they are, but also, presumably, of what qualities, if any, they appear to those readers to possess. Furthermore, some of these "objects" may be transitory and evanescent: images momentarily evoked at one reading and never again, structures hypothesized and later

destroyed, interpretations maintained, even for years, and finally abandoned. Then, too, some of these "objects" and *a fortiori* their qualities may appear to a reader when he is at certain phases of the "wandering viewpoint" and not at others.

None of the latter consequences of Iser's theory of literature are incompatible with NTB. They simply entail the further consequence, when combined with NTB, that such beauty as is apprehended in a literary work often attaches to nonreal "objects," often varies from reader to reader, and often changes (even rapidly) over time and with the perspective of the reader. Together, these consequences suggest a far different picture of beauty in literature from the one given by the Primitive Model. Far from being a real, unchanging, non-relational object with a constant property, the same for all, a literary work *that is profuse in beauty* can be likened to a complicated tapestry of lights, large lights and small, white lights and colored, dim lights and bright, lights constantly shining and lights twinkling on and off—as time passes, as the wind blows, as the observer shifts position—some to reappear again and again, others to die out forever.

This picture of beauty in a literary work is the result of combining NTB with Iser's model of the literary work. But it is important to understand that NTB does not *demand*, even taking Iser's theory as a given, that every literary work conform to this picture. It does not demand *a priori* that a literary work be beautiful, either on the whole or in any of its parts. As far as NTB is concerned, there may be "tapestries" totally without "lights." Furthermore, and very importantly, NTB does not demand that every valued literary work (valued for whatever reason) conform to this complex picture of what it may be like to be beautiful. NTB does not claim to be a comprehensive theory of aesthetic, or any other kind of value; it allows that there may be other forms of value, even of "aesthetic value," in literary works and other artistic and natural "objects."[11] Rather, what the preceding picture of beauty in a literary work does is show how, on the basis of a recent sophisticated model of beauty and a recent sophisticated model of the literary work, beauty *might* appear, given the right text and, of course, the right reader.

6.

It is important to add the qualifier "given the right reader." Beauty does not, even in real objects, and even in circumstances that might make it obvious to an observer adequately equipped to apprehend it, *force itself* upon a reader. A reader who is preoccupied, inattentive, unsure what to look for, predisposed to ignore beauty, or unused to finding it might very well not apprehend beauty that except for those circumstances she would readily apprehend. A similar point holds for all beautiful "objects," but it is especially pertinent with respect to literary works and, paradoxically, especially pertinent with respect to readers of literature who are armed, as Iser and *his* readers are, with a plausible theory of literature. For Iser's theory, while allowing beauty, with the aid of NTB,

to be "located" in a literary work, at the same time predisposes its devotees not to notice it.

One obvious reason for this is that the concept of beauty simply does not figure in Iser's own theory. I think he does not mention it at all. Insofar as he alludes to it, it is in conjunction with what he calls the "classical" view of art as a "polyphonic harmony."[12] Elsewhere, he describes the classical view as one favoring "contemplation"—presumably of the polyphonic harmony.[13] Now both of these ideas—harmony and contemplation—are historically associated with beauty. Beauty has repeatedly been identified in Western thought with forms of "harmony";[14] and the proper attitude towards it has often been taken to be contemplation. But the classical conception of art is precisely Iser's enemy. And therefore, insofar as he identifies a concern for beauty with that conception, beauty, at least in his own eyes, is implicitly his enemy too. In place of the polyphonic harmony of the literary work, Iser puts its semantic richness. This richness *always*—except perhaps in the dullest of texts—eludes the unifying activity of the mind in its attempt to harmonize elements of the text.[15] In place of contemplation, with its suggestion of a kind of static "absorption" of the literary object, Iser puts a *dynamic* experience. This dynamic experience is precisely that of the reader's images and gestalten both being formed and being constantly called into question by his further reading of the text for the semantic richness of the text constantly throws up, during the process of reading it, "alien associations" discordant with *any* given image or "configurative meaning."[16] It is not likely then that Iser and his followers would be ready to find beauty in literary works.[17] Iser's very hostility to beauty, as he (apparently) understands the concept is, we can say, an "anti-beautiful" element of his theory.

I shall be using the term "anti-beautiful" throughout the remainder of this essay, and so I want to give an explicit definition of it. That is anti-beautiful which tends to prevent, obstruct, or discourage the apprehension of beauty. What is anti-beautiful is not necessarily non-beautiful; even the beautiful can be anti-beautiful in certain circumstances, as when the beauty of one thing so far outshines the beauty of another that the beauty of the latter tends to be ignored. Moreover, that which is anti-beautiful need not be so in all respects. Nor need it tend to prevent or obstruct the apprehension of *all* beauty; its anti-beautiful effects may be restricted to certain sorts of beauty, or the beauty of certain sorts of "objects." Finally, although there is a trivial sense in which that which prevents an "object" from *being beautiful*, also prevents the apprehension of beauty in that "object," I explicitly exclude such cases from the realm of the anti-beautiful. Were it not for this exclusion, the non-beautiful would *ipso facto* be anti-beautiful, which I am denying.

But there is a more significant anti-beautiful element in Iser's theory than the one already mentioned. And that is the very "dynamism" of the reading process, which I have argued opens up the multitude of possibilities for locating beauty in a literary work. To argue my point, I need a distinction that is implicit in Iser's writing but, as far as I can find, not explicitly recognized. That is the distinction between "Iserian readers" and "non-Iserian readers." The latter term

refers to all those readers whose activities Iser's theory is meant to *describe* but who are unaware of, or uninfluenced by that theory. The former refers to those readers whose activities are, of course, also described by Iser's theories but who are also aware of and committed to Iser's theory. The distinction correlates roughly with a distinction between the purely descriptive force of Iser's theory and a normative force. As I read him, Iser wants to claim that his theory describes how readers of all literature of all times, places, and dispositions do *in fact* read; but he also wants to persuade his own readers that they *ought* to read literature in the way his theory describes. And there is "space" for his theory to have both of these "perlocutionary forces" precisely because it is possible[18] for a reader armed with and committed to Iser's theory consciously to formulate and reformulate "configurative meanings;" to look for challenges to her interpretations; to take her own images and "gestalten" more tentatively; very deliberately, in other words, to seek out and exploit in her own reading the semantic richness in literary texts.[19]

This distinction allows us to say that, in general, the non-Iserian reader is relatively more passive and less "busy" than the Iserian reader; that the former is more inclined to regard his own images and gestalten as being "given" simply by the text itself rather than being the result of his own activities; that, in general, the reverse is true for the Iserian reader. Such being the case, the Iserian reader is likely to be less "receptive" than the non-Iserian reader to beauties that occur to her in reading[20] the same text in (some of) the same ways.

Now my claims about the Iserian and non-Iserian readers I can only express as "tendencies" or informal probabilities, not as necessities. The grounds for my claims include, on the one hand, the nature of Iser's theory and, on the other, the way in which beauties, of whatever kind and of whatever "objects," characteristically occur to us. Beauty seems to "happen" before us, unbidden, and to "seize" our attention; it thus *seems* to us in apprehending it that it comes from "outside" the apprehending faculty. Thus it seems reasonable that the more inclined we are to regard an "object" as "given" to us from "without," the more likely we are to be "seized" by a beautiful quality of that "object." But, furthermore, in order to apprehend the beautiful qualities in any "object," of whatever status, we must be predisposed to give it, and actually give it, some attention *as* an "object"-from-without. We must, if not exactly contemplate it, at least linger over it. I do not claim that these conditions are necessary conditions for the apprehension of beauty; only that they are circumstances that could make the apprehension of beauty more likely. But if that is so, then it is obvious why the Iserian reader is *less* likely than the non-Iserian reader to apprehend beauty, or at least some kinds of beauty, in a literary work. Taking any image, or any structure that requires some putting together of textual data, as an "object"-from-without is precisely what Iser's theory says is false. And "lingering" over such "objects" with a view to savoring any beauty they might possess is the last thing an Iserian reader would (should) do, since his theory predicts that every such "object" will be undermined, or at least changed, by waves of new data and alien associations as his reading proceeds. Far from

being a theory of the beautiful in literature, Iser's theory turns out to be, *in this particular respect*, a theory that discourages the apprehension of beauty in literature—that is, an anti-beautiful theory.

7.

And yet...there is another respect in which Iser's theory, interpreted once more from the perspective of NTB, again *relocates* beauty in literature, but in a yet more radical way than the way it does with respect to the Primitive Model of Beauty. For by Iser's insistence that images and gestalten are the products of the reader's mental faculties working on the given textual material and by his further insistence that such images and gestalten are constantly changing to take into account the "alien associations" that the semantic profusion of the text is constantly throwing up, he is, in effect, *locating in the reader's own mental activity types of beauty that in more traditional theories have been located either in the text itself or in the author*. Thus it is the Iserian *reader* who may exhibit a high degree of imaginativeness, inventiveness, skill, ingenuity, cleverness, as well as intellectual and emotional sensitivity, agility, adventurousness, and openness in reading a text. And thus it is the reader, and especially the Iserian reader, and especially the expert Iserian reader reading a richly polysemantic text, who becomes beautiful in reading it.

Now this consequence of Iser's theory, interpreted in accord with NTB, is of course ironic in that it locates a phenomenon—beauty—that is traditionally if naively associated only with aesthetic *objects*, in the apprehension of those objects as well. To highlight this radical shift, I will henceforth refer to all beauty of the *reader* reading a literary text as Relocated Beauty. But an intensification of the irony comes from the consequence that this Relocated Beauty is independent of whether what the reader is reading is beautiful or not. Beauty in reading is quite compatible with even extremes of non-beauty in, e.g., the story, the scene, the characters, or the diction of what is read. It seems especially appropriate, then, that a theory like Iser's, which is, as Iser himself is quite clear about, especially sensitive to modern literature, should relocate beauty from work to reader for it is precisely in modern literature that the above-described extremes of non-beauty have become progressively more prominent. It is as if, as the "objective world" of the work has become less and less beautiful, beauty has retreated to the reading activity itself.[21]

It is worth noting here also that the very features of Iser's theory that discourage attention to beauty in the literary object are *not* likely to have that effect with respect to Relocated Beauty. For one thing, it is precisely the Iserian reader who is likely, for reasons already indicated, to read more beautifully than the non-Iserian reader. Furthermore, whereas Iser's theory calls into question the ontological status (the "reality") of literary *interpretations*, it does not, indeed *cannot* coherently call similarly into question the status of acts of literary interpreting. Finally, whereas the constantly shifting images

and gestalten of a literary work discourage the (Iserian) reader from lingering over (or even noticing) their beauty, it is precisely this shifting, sifting, combining, rejecting, and reformulating of images and gestalten that *constitute* the beauty of beautiful reading. Insofar, therefore, as the expert Iserian reader *continues* to read beautifully, she *is lingering* over *that* (relocated) beauty. And, again, it is precisely the Iserian reader whose reading will not only be more likely to exhibit Relocated Beauty, but who will be, by definition, *conscious* of the fact.[22]

8.

Now the argument I make immediately above about the Iserian reader really applies to that reader in only one of his moods. For depending upon how the polysemantic nature of the text is viewed, the mood of the Iserian reader will vary. On the one hand, the Iserian reader may view it optimistically, dwelling on the interpretive opportunity the (alleged) fact affords the reader and the room for "play" it affords his mental faculties. On the other hand, he may take very seriously Iser's theme that no single "consistent" interpretation can ever account for *all* the textual data and semantic associations in a work. He may then see this (alleged) fact as implying the necessary *inadequacy* of the reader's mental faculties before the inexhaustibility of literary "reality." Out of respect for the clearly skeptical nature of this strain in Iser's thought, I will call the latter sort of reader the Pessimistic Iserian reader. The former sort of reader I will call the Optimistic Iserian reader.

It is an interesting irony that the skeptical side of the polysemantic nature of the literary work makes the latter, already an element of beauty in literature, an anti-beautiful element in literature as well. If the Pessimistic Iserian reader is encouraged by this skeptical view to see her own mental activities as necessarily inadequate, then no matter how clever, imaginative, agile, etc., she may be, it will never be clever, imaginative, or agile *enough* for what she sees (and, according to Iser, what she must see) as her task, namely to arrive at a comprehensive and coherent interpretation. But it is precisely viewing her own activities from this perspective that may "take off their edge," make their intellectual qualities seem *not* to be exemplified therein to a high degree. Iser himself however refuses to be, or even to acknowledge the possibility of, a Pessimistic Iserian reader, at least with respect to most texts. His own reading remains resolutely Optimistic.[23] He even explicitly denies, in his discussion of "the" aesthetic experience of reading, an anti-beautiful effect of the continual surfacing of "alien associations." He quotes approvingly a distinction made by B. Ritchie between an alien element that is "surprising" and one that is "frustrating." It is fairly clear from the text, though not pellucidly so, that for Iser "alien associations" should be taken as the former and not as the latter, for frustration "checks" or "blocks" activity and leads not to intellectual activity at all, but to "blind impulse activity."[24]

9.

The texts of Samuel Beckett, on Iser's own reading of them, provide the most interesting challenge to the resolute Optimistic Iserian reader for those texts would seem *prima facie* to demand a Pessimistic Iserian reader as their proper kind of reader. They would seem thus to be quintessentially anti-beautiful texts, even if we consider their effects on Relocated Beauty alone. Iser the Optimist meets this challenge, somewhat murkily in my opinion, by acknowledging the anti-beauty in Beckett's texts (not under that description, of course), but by finding in the reader's response to them forms of Relocated Beauty different from those I have already pointed out.

Beckett's texts, according to Iser, constantly and deliberately confront the reader with contradictions of themselves, thus raising to a high pitch of intensity the polysemanticism possessed by all literary texts.[25] But this fact, instead of liberating the reader, constantly frustrates him. The Beckett texts refuse with a vengeance to satisfy our basic need for "fiction-making," "consistency-building," or "illusion." That is precisely what constitutes their "negativism."[26] But if that is so, then it should be the case that the reader sees her own activities as supremely inadequate, no matter how clever, imaginative, agile, etc., a reader she is. As Iser writes of *Waiting for Godot*, ". . . the text is so designed that it constantly calls forth a desire for determinacy which the spectator cannot escape but which inevitably drives him further and further into the traps of his own limitations."[27] The reader (spectator in this case) is "worried," "baffled," "frustrated." This is a description of a text which is, in my terms, anti-beautiful in the extreme and especially so with respect to the kinds of Relocated Beauty described earlier. As Iser puts it, by quoting Hugh Kenner, ". . . art has suddenly refused to be art and brought forth living pain."[28]

This view of Beckett gives Iser a problem: What can be the appeal of Beckett's work? Beautiful works, and non-beautiful works that stimulate Relocated Beauty in their readers do not raise this problem. Although Iser does not confront this problem head on, he is clearly struggling with it throughout his discussion of Beckett in *The Implied Reader*. His solution to the problem, moreover, can be taken as a solution to another problem—which he never seems to see—of what the appeal of reading at all can be to the Pessimistic Iserian reader. Iser offers two unclearly related kinds of solution, and both of them depend upon new varieties of Relocated Beauty.

Iser's first solution seems to be that Beckett's texts yield an "insight." The insight is variously described, but the complete version would seem to be the following: We all make "fictions," i.e., coherent pictures of the way things are, because we have need to do so; we can escape neither this need nor the attempt to satisfy it; thus all coherent interpretations of reality are, precisely, fictions or illusions; moreover, all such fictions are really projections of our hopes and fears.[29]

Now such an insight, indeed any insight at all, produced in a reader is, I want to argue, a form of Relocated Beauty. This is so whether the alleged

insight is, as Iser surely believes in this case, truly an insight or whether it is *merely* the experience in (or appearance to) the reader of such insight. For whether real or not, the alleged insight is presumably *experienced* as a real insight, i.e., as the intuition of a "truth." Indeed, if it were not, the alleged insightfulness of the Beckett texts could not solve the problem of their appeal. But to have the *experience* of an insight is at least this: to feel suddenly *certain* of the object of the insight. Iser himself uses the term "certainty" to describe this insight and implies that it is the only certain knowledge we have.[30] But to be highly certain of a thing is precisely to have, if only for a moment, a beautiful quality.[31]

Iser's second solution is both more interesting and more obscure. He *suggests* that the Beckett reader, as a result of the above insight, *may* (not will) become "free" of the restrictions of her own fiction-making.[32] Of what such freedom consists, Iser is very unclear. He cannot mean freedom from fiction-making or the need that generates it, because he insists many times that these are inexpungable from human nature. Whatever it is, it seems to be the same freedom that he attributes to some of Beckett's *characters*.[33] This latter freedom Iser describes solely in terms of a lack of "earnestness." Earnestness about what? I speculate that it is about their desires for coherence and sense in the world and their attempts to satisfy them by fiction-making. Not to be "earnest" about such things is, perhaps, not to take them too seriously, not to be burdened by them. Though what this in turn means is obscure.

Iser may provide further illumination about this freedom in a very puzzling section of his chapter on Beckett. The section is puzzling because it is so brief, so obscure, and so apparently unconnected with the rest of the chapter. It is about Beckett's text *Imagination Dead Imagine*. Iser concludes the section thus:

> This text is not a sterile monologue, it is an invitation to participation. The words themselves seem almost to beg to be embraced on their own terms. The phrase logically negates itself, destroying its own meaning, and it is this destruction of meaning that lends the phrase its potential to be experienced by the reader.
>
> What is "gained" by this can perhaps be summed up by a quotation from John Cage, who states in his *Silences*: "Our intention is to affirm this life, not to bring order out of chaos nor to suggest improvements in creation, but simply to wake up to the very life we're now living, which is so excellent once one gets one's mind and one's desire out of its way and lets it act of its own accord."[34]

I suggest here, but can only suggest, that the freedom Iser has in mind is identical with the attitude Cage describes—an "affirmation of life" that sees life's "excellences" once the "mind" (consistency-building?) and "desires" (the need for coherence?) are "out of the way."

If my suggestion is right, then the consequences of Iser's point with respect to beauty are remarkable indeed. Quite apart from the fact that the

freedom thus allegedly producible by Beckett's texts is a quality, a high degree of which in some fortunate reader would be an instance of Relocated Beauty, the kind of affirmation Cage seems to be talking about is a point of view which *returns* beauty to the world after its Iserian "relocation." Even more, I will argue, it is a point of view from which the whole experienced world in every nook and cranny, including its experiencer, is transformed into a thing of "absolute" beauty.

The point of view Cage describes in the passage quoted by Iser is one highlighted and idealized in the literature of some meditative traditions, e.g., Zen Buddhism. In his classic *Zen Mind, Beginner's Mind*, Shunryu Suzuki, for instance, calls a similar point of view "true practice." There are many ways in which Suzuki describes such "practice," but one that gets close to the Cage passage is the notion of "naturalness." Naturalness is an attitude that comes out of "emptiness" or "nothingness." The latter consists in large part in not taking one's desires seriously ("non-attachment") or one's "ideas" seriously ("believing in nothing"). With naturalness comes "joy in life," which means "having everything."[35]

But such qualities in the subject have as their other side a view of the "everything" that one "has" in having these qualities. This view is that every existence—including ourselves and our own activities, feelings, and desires—is a "flashing into the vast phenomenal world" and, as such, is another expression of the "quality of being" itself. The quality of being makes of every existence the very particular thing it is. And yet, by virtue of exhibiting the quality of being, each existence is connected with everything else.[36] The image here is of everything (every "object" in my sense), within us and without, being with respect to its quality of being an infinitesimal, equal, and undifferentiated part of the same being, while at the same time and precisely because of this, being intensely particular.

Now it is a real question whether a coherent theoretical account can be given of a quality that involves at once both such vast interconnectedness and such intense particularity. But it is enough for my present purposes to assume that such a quality can figure in at least some persons' *experiences*. I also will assume that such a quality conforms to the technical sense of "quality" according to NTB. But the latter assumption raises the question how to interpret a "high degree" of such a quality. I submit that a natural interpretation of the latter is to suppose that what Suzuki is really talking about, as the effect of "practice," is precisely the experience of this quality of being to the highest degree. That is, one experiences an "object" as possessing a greater degree of this quality the more interconnected it seems with other "objects" and the more intensely particular it simultaneously seems. This suggestion implies, interestingly, that *some, if minimal, degree* of the quality of being is experienced in *all* forms of consciousness, since virtually no "object" is ever experienced as unconnected with others or is in *no* measure particular. And this implication brings us back to the passage by Cage, who emphasizes perceiving, under the new "affirmative" viewpoint

we can "awaken to," the "very life" we are (now) living, but only as more "excellent."

To summarize my points in the immediately above: (1) the kind of freedom that Iser says *may* be a result of reading Beckett is, or can be, a form of Relocated Beauty; (2) this very beauty has, as an "objective" counterpart, the apprehension of a special kind of beauty in any and all aspects of the world, or in the world as a whole, where "world" does not designate anything necessarily exclusive of the reader herself. I want to stress, furthermore, that interpreting this "freedom" in terms of this dual form of beauty does not necessarily make of the world—of "reality," as Iser would say—a coherent and organized whole. Viewed from the vantage point of this sort of "freedom," the world remains exactly as discordant and disorderly as it is. Beauty with respect to the quality of being, as I understand it, is as compatible with chaos as it is with harmony.

But if Iser is right that a reading of Beckett can lead to this sort of freedom, and if I am right in my interpretation of this freedom, then the consequence is interesting indeed. For it follows that a theory of literature with many anti-beautiful aspects (like Iser's) held by a reader with anti-beautiful assumptions (like the Pessimistic Iserian reader) with respect to quintessentially anti-beautiful texts (like Beckett's) may produce a beauty and an apprehension of beauty of the sublimest kind.

10.

In the introduction of his theory Iser writes the following about "traditional," i.e., pre-Iserian, theories of literature and criticism:

> It would appear that modern art and literature are themselves beginning to react against the traditional form of interpretation: to uncover a hidden meaning. If so, this bears out an observation applicable since the era of Romanticism, that art and literature react against the norms of prevailing aesthetic theory in a manner that is often ruinous to that theory.[37]

But these statements may be turned on Iser's own theory. If the first of them is true, and if Iser's own analyses of certain influential texts of modern literature are sound, then Iser's theories had already become (before he explicitly formulated them) the *implicit* theories prevailing in a leading strain of modern literature. Indeed, Iser's very point about Beckett—the most recent author Iser discusses—is that his work produces, as "insight," the very proposition that Iser's theory analytically and discursively formulates. Therefore, if the second of Iser's statements above still applies to contemporary literature, Iser's theories, if they are not already "ruined" by contemporary writers—whoever they may be—are surely "ripe" for such ruin.

I suspect that Iser's theory has already been so ruined, but I am not experienced enough as a reader of contemporary literature to be confident about the matter. (But see note 41.) I claim here, however, the philosopher's privilege to speculate on possibilities. I will try to lay out conditions that literary texts

(whether recently past, present, or to come) must exhibit in order to effect such a ruin. In so doing, however, I will rely heavily on Iser's own analysis of Beckett. It seems to me that Iser suggests already in that analysis a kind of literature that could both constitute a counterexample to his own theory and at the same time render the Iserian reader, whether Optimistic or Pessimistic, irrelevant to itself.

Such a literature must, above all, be so incoherent with respect to the "story" it tells—or, in Iserian terms, the fictions it allows its readers to make from the text—that it goes far beyond merely "frustrating" the reader's attempt at "consistency-building." It must contain such a level of incoherence that the blocking of the reader's impulse to make sense of the story is so blatant and obvious that "consistency-building" does not even begin. It thus must go beyond the stage of causing "pain" to the reader and thus go beyond being anti-beautiful in the way that Beckett's texts are—except perhaps for a close-minded Iserian reader.

Iser's only example of an art form that "ruins" traditional theory is pop art. Art in this style, says Iser, make its "meaning" so blatant and obvious that two things happen:

> First, pop art thematizes its own interaction with the expected disposition of the observer: in other words, by explicitly refusing even to contain a hidden meaning, it directs attention to the origins of the very idea of hidden meanings, i.e., the historically conditioned expectations of the observer. The second implication is that whenever art uses exaggerated effects of affirmation, such effects serve a strategic purpose and do not constitute a theme in themselves. Their function is, in fact, to negate what they are apparently affirming.[38]

Applying these ideas to our hypothetical literature, we can say that such literature would (1) lay bear the historicity (and hence limited applicability) of *Iser's* theory and (2) "negate" the very thing they appear to be affirming, which in this case would be the very thing that Beckett's texts give "insight" into and that Iser's theory analytically formulates. But what would it be to "negate" such a complex proposition? It is not, I submit, to deny the truth of it, anymore than pop art denies that it is "of" hamburgers and cans of soup. It is rather to suggest that these propositions are *beside the point* in understanding that art. Thus, just as it is beside the point to discuss the representational content of pop art, it would be beside the point to engage in all the Iserian reader's characteristic "busyness' with respect to our hypothetical literature. But what then might be *to* the point? Precisely the freedom that Iser says *might* happen *after* the "pain" and the "insight" that a Beckett text more directly produces in its readers. In other words, the reader that these hypothetical texts ideally call for would be as much beyond the Iserian reader as Iser alleges certain *characters* in Beckett's works are beyond the reader that those texts call for.[39]

The effect, in turn, of such freedom might be, if my analysis of it is right, not only a certain kind of Relocated Beauty, but also an apprehension

of the literary work itself as a thing of beauty, possessing the highest degree of the "quality of being." But were it to appear thus, it would take on a certain concreteness because of both its intense particularity and its essential connectedness with, among other things, its own visible and audible words and sentences. At the same time, it would take on a vast connectedness with everything else literary and, especially, non-literary. It would become a "thing" among an infinitude of other "things"—just one more "flashing into the phenomenal world." The meanings of its words would not be denied—how could they?—but they too would be seen by me as reader as simply other "things" no more, but no less significant than the "meanings" my sansevieria, my shoe, and the sunshine outside have for me.[40] And, most significantly, there would seem to me (in the reading) to be no possible variation in the *beauty* of this literary thing, no matter how I, the reader, changed (and, therefore, of course, no matter *which* reader of the work I am). For within the frame of the freedom hypothetically induced by these texts, the high degree of the quality of being they possess would remain constant, irrespective of which *other* properties they are experienced as possessing. The beauty these texts would thus appear to have to me, as a reader properly attuned to them, would also appear to be as constant, as unchanging, and as independent of my puny existence as anything could possibly be in this "vast phenomenal world."[41]

Such hypothetical texts could thus become, in the minds of their proper readers, things of unconditioned beauty, as much in conformity as any other thing could possibly appear to be with the Primitive Model of Beauty.

NOTES

1. I emphasized the latter point insufficiently in my *A New Theory of Beauty* (Princeton, N.J. 1975).

2. Examples of which are: being unintelligent, being unsophisticated, or being deformed or being unintelligent-seeming, being unsophisticated-seeming, or being deformed-looking.

3. This terminology does not appear in *A New Theory of Beauty*. A "quality" is, in the language of that book, a Property of Qualitative Degree (PQD) that is *not* one of deficiency, defect, or lack or of the "appearance" thereof. The present terminology is, I believe, doubly more beautiful: it is both more convenient and more euphonious. The new terminology does appear, however, in my *Love and Beauty* (Princeton, N.J., 1989).

4. However unlikely this supposition may be. What is more likely is that some qualities are apparent to "everyone," some only to greater or smaller classes of people, and some to single individuals only. What is *actually* the case is determinable, if at all, only by further study.

5. "Being apparent" is admittedly vague, because it has to cover a lot of territory. The way O and its qualities are or can be apparent to S depends upon the kind of "object" O is— real, fantasized, dreamt, fictional, etc.—and also whether it is visual, auditory, olfactory, etc.

6. Again, taking "apprehend" in an existence-neutral sense.

7. Iser actually seems to mean that "the best" or most worthwhile texts are polysemantic, for he admits that some simple-minded popular texts do admit single "consistent" interpretations.

8. Wolfgang Iser, *The Implied Reader* (Baltimore, Md., 1974), 284; Wolfgang Iser, *The Act of Reading* (Baltimore, Md., 1978), 124.

9. Iser, *Act of Reading*, 108–18.

10. Ibid., 135–59.

11. In this respect, NTB is quite unlike Mary Mothersill's theory of beauty in *Beauty Restored* (Oxford, 1985). It remains possible, of course, that *all* forms of genuinely aesthetic value could eventually be understood in some way or other as "involving" beauty as NTB understands it. But if that were to turn out to be the case, it would be a derived result of NTB, not an explicit initial claim.

12. Iser, *Act of Reading*, 112.

13. Ibid., 14.

14. The identification of beauty and harmony is a large part of what I call elsewhere Western Civilization's "unitarian" tradition in beauty theory. This unitarianism has been utterly dominant. My own theory, which I conceive of as "fragmentarian," does not fit into the unitarian tradition; and, while it can recognize harmonious forms of beauty, it definitely does not identify beauty and harmony. Cf. my "Beauty in Shards and Fragments," *Journal of Aesthetics and Art Criticism* 48, no. 1 (Winter 1990): 21–36.

15. Iser, *Act of Reading*, 118.

16. Ibid., 12, 131–34.

17. There is some irony here from the viewpoint of NTB. For Iser, in rejecting the polyphonic harmony of literary works for their semantic richness, is *substituting* one variety of beauty for another. NTB treats a high degree of harmony (*polyphonic* harmony) and great richness of interpretive potential as simply two (kinds of) beautiful qualities in a "vast sea" of such qualities and has no stake in elevating one over the other.

18. "More possible" for some styles of literature and less so for others, to be sure.

19. This double force is hardly unique to Iser's theory among theories of literature and criticism. And I doubt that it would be denied by Iser and other theorists.

20. Or, what is the same, that less beauty is likely to occur to her in reading.

21. Of course it cannot be true that *everything* about the work can be non-beautiful and the reading itself still beautiful on Iser's model. Beautiful reading of an Iserian sort is possible only if the text itself is semantically rich, i.e., beautiful, enough to support and encourage such reading. Stupid, dull, semantically infecund texts presumably give no purchase to the Iserian reader's activities.

22. Naturally she will probably not be conscious of that fact under a description involving "Relocated Beauty," unless she reads and is convinced by the present essay. But she *will* be conscious that her (activity of) reading exhibits certain qualities to a high degree.

23. Iser, *Implied Reader, passim*.

24. Ibid., 286–89.

25. Ibid., 258.

26. Ibid., 261–67.

27. Ibid., 272.

28. Ibid.

29. Ibid., 259–73.

30. Ibid., 267.

31. The term "certainly," like some other epistemological terms, is notoriously ambiguous between an "objective" sense and a "subjective" one. Some uses suggest that one can *be* certain only if objective conditions obtain that ratify the alleged insight; other uses suggest that being certain is entirely a matter of "internal illumination." My argument here presupposes the latter interpretation. For those who favor the former, the same final results will be attained if "certain-feeling" is substituted for "certain." I take "certain-feeling" to be a quality of "appearance," like "certain-acting," "certain-sounding," "certain-looking," "intelligent-looking," "ripe-smelling," "fresh-smelling," etc.

32. Iser, *Implied Reader*, 273.

33. Ibid., 271–72.

34. Ibid., 270.

35. Shunryu Suzuki, *Zen Mind, Beginner's Mind* (New York, 1970), 107–21.

36. Ibid., 104–07.

37. Iser, *Art of Reading*, 11.

38. Ibid.

39. Iser, *Implied Reader*, 271.

40. As Iser says in his puzzling section on *Imagination Dead Imagine*, discussed above, "The words [of that text] themselves seem almost to beg to be embraced on their own terms." In the light of the implications I am pursuing here, this section becomes even more puzzling, for in these words Iser himself seems to touch on phenomena that cut against his own analyses.

41. This "hypothetical" literature thus would have to be such that its ostensible meanings —its "stories"—virtually disappear and such that its "language," including prominently the physical properties of its language, is foregrounded. And therefore, I believe, this kind of literature would have to be writing that has fully assimilated the work of Gertrude Stein, if it does not include her work itself. (It is significant that Iser neither analyzes nor mentions the work of Stein, a not unusual occurrence even in critics of the most radical pretensions.) The work of Stein that I have read (and "understood") does not seem to me to match the description of my hypothetical literature. A recently published novel, however, clearly written under the influence of Gertrude Stein, exemplifies almost perfectly, it seems to me, the features of my hypothetical literature. It is *London Burning*, by Eric Segura (Santa Barbara, Calif.: Superstition Street Press, 1991).

The Elusiveness of Moral Recognition and the Imaginary Place of Fiction

DAVID K. GLIDDEN

The answer . . . is that he now at all events sees; *so that the business of my tale and the march of my action, not to say the precious moral of everything, is just my demonstration of this process of vision.*

—Henry James

Eliot waited for Heidi in her bed. Heidi was married. Eliot was not. The bed was in a room overlooking Central Park, on the tenth floor of the Ritz Carlton Hotel. Heidi was attending a convention, Eliot was visiting. She had phoned him from Chicago, he had flown from LAX. Neither had ever done this sort of thing before. They thought it best to take precautions.

Heidi figured she would need an extra key, so that Eliot could come and go alone. Discretion is the better part of ardor. Eliot's dilemma was more daunting. He couldn't simply stroll into the lobby with suitcase still in hand and proceed directly to the elevator, bypassing the front desk altogether. Eliot decided to check his suitcase in a locker, in a subway station at 59th Street, so as to enter unencumbered.

They could, of course, have registered for two, but Heidi didn't want that kind of record. And pseudonyms are hard to come by, in this age of credit cards. "My husband will never know" was the promise Heidi made to Eliot the night their plans were laid. She meant to keep her promise too, notwithstanding others she had made.

Eliot and Heidi had flirted with each other for the last ten years by phone. Before that they had been classmates in Wisconsin, years before Heidi met her husband. In college Eliot and Heidi had never even dated, though they had often

gone to church together. Yet, as the years had passed, those phone calls had begun, telling secrets to each other late at night, venting feelings and frustrations they couldn't share with others. Eliot reported a string of disappointing love affairs, delving sufficiently into detail to satisfy Heidi's curiosity about the single scene. Heidi, in turn, complained about her husband's habits, the late hours that he kept, reassuring Eliot's wariness of marriage. Eliot and Heidi had fallen for each other in the course of conversation. And now they were about to act on what they felt.

Heidi answered Eliot's knock upon the door, they embraced. She kissed Eliot the way she once had kissed her husband, before the boredom had set in. Eliot held Heidi in his arms just as he had long imagined he would do someday. The only impediment remaining was a temporary one, the speech Heidi had to make that evening at a dinner. She had been about to leave when Eliot arrived. So she handed him a key and said she'd see him later. Each said they couldn't wait until they would finally be in bed together. Notwithstanding that, they parted.

Eliot's tried and true philosophy had always been to compensate for loneliness with dinner. His choice that evening was not judicious, since Daily's Dandelion was a rendezvous for lovers. Eliot was the only person dining unattached. He watched laughter on faces under candlelight. He eavesdroped on happy conversations. Forsaking his dessert, Eliot headed for the Ritz, took off his clothes and slipped into Heidi's bed.

Hours passed, Heidi didn't show. Eliot began having second thoughts. He thought of Heidi's husband, though he tried not to think about him much. He also thought of phone calls over all those many years, and what might happen next. Heidi might see him as her accomplice in betrayal. And she would in fact be right. Heidi was not the sort to forgive herself. She might never call Eliot again, once the night had passed. Eliot began to fear he had too much love to lose by making love with her.

Yet, if Heidi continued on with the way things had always been, Eliot would think less of her. He might not call her either, if it came to that. An obscure sense of vulnerability gradually appeared should Eliot reach out for a lover he had always wanted, and Heidi disappeared. He had loved her far too many years to trade that love for one night in the city. Eliot played out their future in his head and it conflicted with feelings felt all so vividly, lying naked in her bed. An elusive sense of right and wrong emerged. Eliot thought more of Heidi's husband then.

By the time Heidi finally arrived, Eliot pretended to be sleeping. It seems Heidi had been having second thoughts herself. She had dawdled after dinner. Very quietly, she put on a robe and lay down upon the couch instead of getting into bed, being careful not to wake him. By the time dawn arrived, a limit had been reached in their relation to each other, a lie remained unspoken and another one un-acted on. The year was 1979. As it happened, it was getting toward the end of Lent. It was Passion Sunday, the morning Eliot and Heidi woke up in separate beds.

I

Memories remembered, values inspected, the future touched as if it could be tasted, a decision made, all of this and not a word was said. Such is not the stuff of dialectical encounter, or the kind of decision making philosophers recommend. There is something missing from the customary philosophical technique of reasoning, something Eliot and Heidi found: namely, the particularity of vision.

Experience yearns for clarity that comes with seeing what to do sufficiently to act. Inevitably sufficient clarity must come in order to do anything. This is how humans most often choose, by visualizing things, a very different process than formal reasoning, though reasons clearly enter in, in focusing the setting for decision. At the point where Eliot and Heidi each had come to see the course that lay before them, clouds of indecision lifted, a vision of their future came. Imagination illuminated a decision, just as that same imagination articulated their ambitions for Passion Sunday at the Ritz. The decision each had reached was something envisioned, rather than anything specifically concluded by articulated reasoning, even though Eliot had thought about it long in bed and Heidi had walked for hours before going to her room. Thought may have precipitated imagination, but imagination acted out the scene and led to a decision.

Imagination often plays the vital role in questions of morality. It takes intentions the mind has dimly laid and makes them come alive as fiction painted in the mind, on the way to being acted on in real life. Some all so general or even inchoate scheme of things, an ambition for a lover or another, dimmer sort of need, is fashioned into something quite particular, as if somehow one were to walk into a picture framed within one's head, whose landscape is seen at first as some familiar place, initially sketched out from memory. Then imagination comes fully into play, giving a narrative content to the scene. Something in particular is designed to happen, something not remembered, something made, something ancient Greeks had called *poiesis*.

Poets were seen as moral teachers then. What we call fiction once had this ancient meaning, the making of a poem, the painting of a scene, the living of a life, any sort of human doing. In the daily course of this creation, the line between fiction and reality becomes thoroughly obscured as the future allows itself to be manipulated, being made into itself, becoming real.

Imagination works its course by taking in what is only latently familiar and playing it out again into a story one tells oneself privately at first, beginning in the past and ending in an action planned. Retrospective insight may follow story telling, as the mind is free to reconsider how the plot played out in fact. This insight is then free to frame imagination for the next picture that is painted in the head. But before insight comes the picture, the work imagination did. And imagination is wholly the creation of actors, together with the lives they have lived, things they have read and seen and witnessed, what they have done as well as what has happened to them.

Values enter only indirectly, respect for persons, cultural taboos, that obscure sense of doing the right thing. As imagination focuses on some particular ambition, values shade the scene into light and shadow. The clarity of vision that comes with seeing what to do is naturally allied with acting in broad daylight, publicly and unashamedly. Other imagined actions stand in the shadows of our lives, dark places of the soul where we would not want ourselves to be seen by others. Sometimes imagination accepts these shadows for what they are and even acts on them as such. More often light and shadow are reversed, what movie makers call "the day for night effect," or "la nuit americaine." And so imagination temporarily convinces that the sun rises in the west. Values, it turns out, are more like contrasting illuminations than imperatives or even aphorisms. They shed light on imagined settings building on the way to action. Such are the ethics of imagination.

As the painting is initially sketched out in the mind and an initial plan is laid, a tentative cartoon takes shape in black and white or charcoal. Reason plays a distinctive role, here and there, giving direction to the sketch, setting out the framework for the scene, some problematic to set the poet going, that Heidi is married and Eliot is not. But reason is only outlined in the drawing as a crude cartoon, and as the painting is completed reason is obscured. Reason points in various directions, like a map. It can never be the substance of the scene. Nor does it dominate the making of an action, since the plan given over to an action or a fully painted scene is never quite the same as that first initial sketch laid out by the artist or lying in the agent's thoughts before he acts. Feeling and desires paint the scene in colors, those seducing shades of life born of an all-so-human yearning for lasting satisfaction. And when the painting is done, the colors are the thing. That is when the final goal is seen.

Painters differ in the way they paint, so do imaginations and the role given to the organizing force of reasons. Someone's plan of action might later come to be described even syllogistically, where the framework of the initial sketch is seen throughout the contemplated work from start to finish, top to bottom. Another's imagined plan of action might be seen more psychoanalytically, working from the bottom up. Here reason enters in archaeologically at best, analytically reconstructing the self-obscured foundations for the plan, reasons hidden deeply in the past, the days of childhood or infancy, yielding only a tentative, inductive understanding of an action. Music composition works variously in this way as well. Hayden wrote his quartets more formulaically than Shubert did. Yet, there too, performance is the thing, and the coloring given to the instrumentation makes all the difference in the world.

The work of retrospective analysis is different from making up a plan of action. So many different motivations enter into all the fantasizing that is being done between some initial sketch and the fully painted action. Art historians sometimes revert to x-rays to reveal the history of a painting as it was planned and executed. Monet, as can be seen, moved benches or even trees around and occasionally took an individual entirely out of the scene in which once

she figured prominently. This is the way imagination works in composition, whether painting, poem or action. Scenes are always changing in our inner vision, right up until the action is finished.

In looking back at actions taken, at Eliot and Heidi's night together, different sorts of explanations can emerge, depending on perspectives taken. And each of these perspectives gives a different reading of the scene. The importance of fidelity, the nature of self-interest, the generous forbearance of long-term love, the fear of loss, all of these can enter into a description of that single evening. Which factor proves the best explanation or the most effective motivation is often impossible to tell since there is no truth to landscape—there is only what is done, what is revealed. Where, then, does morality come in?

Traditional moral philosophy fails to show sufficient interest in specific actions, because of a philosophical preference for cartoons, for sketchy descriptions of initial plans, the contemplation of schemata which ignore conflicting motivations in favor of some simple, basic truths, rules, invocations, calculations of advantage. Philosopher's examples, like Saturday's Toontown, are so often very funny as a consequence, with desert islands and ultimate dilemmas, the result of intentionally disciplined, professionally impoverished imaginations. There is a difference between theory and the practice of philosophers themselves. Even philosophical ascetics who only work with pen and ink construct plans of action of their own with an often dazzling display of lines that bend and twist and turn around.

Aristotle's adage that humans do not deliberate about ends, but the means to get there, reflects this insight well. Our motivations are obscured by the time anyone of us is about to act, and before then the goal given is too simple to be taken as the basis for an action. To say of someone's deed that it was motivated by a yearning for happiness is no more informative than to say only of a painting that it is a landscape or only of a poem that it is an elegy. The real interest comes in how the poem was done, in the specifics of the action planned, the particularity of vision manifested. This is the work of imagination. It is not the work of philosophic reason, traditionally conceived.

Imagination serves so many masters. Some work entirely in the first person, other imaginations are voiced in the second person, too, commanding what to do. Some imaginations remove the agent's sense of self entirely from her own actions, as if she were only an observer, rather than playwright of her own. And so Eliot might have seen himself through his own first person planning out the night, or he might have addressed himself the way his father had done when Eliot was young, what you should or should not do. Heidi watched herself and what was planned as if she did not play a part in it at all, after that initially impulsive call. And so she did not act, and in not doing so, she did. Voices of imagination often shift to different persons as the sketch is being planned and perspective changes constantly, carrying through into some single action, one that can be done with many voices speaking all at once. These different voices interact with reason differently, so that different sorts of reasons enter in, from imperatives of right and wrong to thoughts of fear, self-interest, and of love.

Imagination bears the burden of moral recognition, of seeing what to do and acting on it then. But the connection is evasive between telling stories in your head and connecting with the world. Imagination might seem to be intractably subjective, to represent reality only indirectly, the way a poet's image can or the way Heidi thinks about her lover on the phone. How can this sort of fabrication actually precipitate recognition of the right thing to be done?

Stories that we tell ourselves sometimes do succeed this way, achieving moral insight. Eliot and Heidi each came to see the impossibility of sleeping with each other, if their generosity toward one another were to endure the evening and beyond. Yet, this vision of their future took some time in coming. And in the course of its creation another, darker vision could have been, where the shadows were reversed and a breach of faith began. Imaginative thinking and visualizing what might have been are central to the struggle of light and night, of acting morally. At some point in the evening Eliot and Heidi each knew the right thing to be done, but it took some time to see it. There is an elusiveness to moral recognition.

Philosophy, traditionally conceived, will not resolve moral indecision, though it can help in other ways. Moral reasoning and calculations of advantage, duties, obligations, rules— all of these presume generic situations. Actual dilemmas do not lend themselves to that. The decisions that we face are always quite particular, measured in a specific time and place: what am I to do today? Finding specific answers requires coming to the point of seeing what to do, of visualizing acts. This is primarily the work of imagination. It turns out that fiction, not philosophy, is the vehicle of moral action.

It has seemed to philosophers that representation and perception are really very different things. Seeing is perceiving the way the world is, while representation presents a world to us that is itself constructed after our intentions, a case of exegesis more than recognition, of interpretation more than presentation. Imagination is puzzling to philosophy so conceived, since imagination connects representation with recognition, yielding a precariously balanced vision of the scene, where, as Freud was fond of saying, reality and the pleasure principle blend.

Focusing only on feelings, the painter's palette instead of what is depicted, or focusing on what intention initially sketched out as its prime ambition rather than the complexity of some final action done, simplifies and denigrates the work of imagination and ignores the fusion that makes human action real, as actors rub up against reality, in part as they conceived reality to be, in part as the world really is, in fact. Imagination brings the two together, not side by side, but makes them blend. And when everything works well, the result can be a vision of the right thing to be done, a recognition that the fiction one is acting on connects.

There were ancient arguments between Stoics and Epicureans: Epicureans said the world forces us to see it the way it is, the process of perception guarantees the authenticity of what is seen. Stoics said all seeing is conceptual and as such consists of interpretive impressions, which may or may not be insight,

depending on the wisdom of the seer and her harmony with nature. Ancient skeptics played one school against the other, playing off the wish for perfectly mechanical recognition of reality against the representational character of our impressions of the scene. Yet, the ancient skeptics never really grasped the possibility that representation and recognition need not be at odds at all. Storytellers, long before the days of Homer, have always known the two are one.

This is not to say fiction dominates the scene, so that imagination, because of its representational character, invents a world in which we entirely live out our lives as actors, living life behind a veil of fiction, an ironist's detached way of life, separated from the way things really are in themselves and by themselves. This is not to say that actors are lost within dramatic worlds. Nor is this to say that imagination is just another form of vision, the way Epicureans thought all perception worked, impressions mechanically stamped upon the soul by the world. It is to say, instead, that the stories we tell ourselves in our own minds, just as we are about to act, are the poets' work within. It is to say that story telling visualizes our decisions in a way philosophical reflection never can. Connections can be forged between fictions we tell ourselves and the real lives we live. This is the work of imagination.

II

The story of Eliot and Heidi I have narrated could have been a fiction. It was the truth, except for names. That my tale could just as well have been invention suggests there is no fundamental difference between the stories our own imagination tells in visualizing actions and the stories we read about in books or plays or watching movies, documentaries, or dramas. Those are other persons' stories, even if those other persons never lived.

Once whatever story is told, it is recorded history, whether it happened or not, whether it be a memoir or a novel. It could be a history bracketed within a novel, such as the tale of *David Copperfield* or it could be a history bracketed within a life, lived in and out of fiction, the memoirs of Virginia Woolfe. Reflecting on these histories increases the repertoire of scenes our own imagination can concoct in painting pictures of our own. All such histories, novels, diaries, reflect the condition humanity is in. Consequently, they often do connect with lives and real situations, even when they are fictions, even if the stories are not our own. Stories enrich our ability to see, to recognize the right thing to be done, stories that we tell ourselves or stories others tell us, told of them or even us.

Henry James's fiction was preoccupied with dilemmas of visioning and choosing. But his triumph over this form of story telling, *The Ambassadors*, can also serve as a primer of moral recognition, over and above the story that it tells, a story James himself had praised for its "authenticity of concrete existence" ("Preface to the Novel," p. 4).[1] It is a tale told of recognition, proceeding to a picture within the real of the ideal, yielding a sense of character, of virtue, the moral of a life well lived.

The novel focuses on a central figure, Strether—an American in Paris, who came to see what he could not see before and in doing so let go of the life he had been living and the life that he now found:

> The actual man's note, from the first of our seeing it struck, is the note of discrimination, just as his drama is to become, under stress, the drama of discrimination. It would have been his blessed imagination, we have seen, that had already helped him to discriminate; the element that was for so much of the pleasure of my cutting thick, as I have intimated, into his intellectual, into his moral substance. Yet here it was, at the same time, just here, that a shade for a moment fell across the scene. ("Preface to the Novel," 7)

It is in sorting out the light from shadow that Strether "revises and imaginatively reconstructs, morally reconsiders" ("Project of the Novel," 387). [2]

Strether is fifty-five years old, a widower, having lost his wife and then his only son possibly by his own inaction. He is from Woollett, Massachusetts, the editor of a review owned by the widow Mrs. Newsome, who has offered to improve his prospects by assigning him a quest, to rescue her son Chad from Paris and the influence of "a wicked woman" (44). Strether is to persuade Chad to return to the Newsome family business and a propitious marriage his mother has arranged. Strether serving as ambassador to prove his mettle to his publisher, who might possibly marry him should he prove successful in his quest. Strether is teamed up with Waymarsh, a Newsome family friend, who connects with him in England where Strether's ship comes in. The novel opens then. There Strether meets the first of many persons with a deeper, European vision, and in this way "certain images of his inward picture" (24) change.

The first such guide to Strether's vision is Maria Gostrey, who serves from beginning to the end as confidante and guide, as "a civilisation intenser" (21), or, otherwise perceived, as "an agent for repatriation" (35).[3] Gostrey sees so much more than Strether can, even though she is considerably younger: " 'I've known nothing but what I've seen; and I wonder', she added with some impatience, 'that you didn't see as much' " (106, cf. 116–17). In time, Strether's vision proves more discriminating.

Waymarsh is financially successful, compared to Strether, though he too has had his share of grief and even scandal. He exhibits "an ambiguous dumbness that might have represented either the growth of a perception or the despair of one" (37). He is a man of confident calculation, not of vision, saddened at Strether's flights of fancy when they interfere with the business of getting Chad to leave for Massachusetts. Strether, on the other hand, passively dwells on his own failures, financially and morally, with a "fairly open sense of the irony of things" (64).[4] The story told by James unfolds and the reader is forced to ponder whose vision is discerning.[5]

We meet Chad Newsome and his expatriotic friends, who live life as if they were Parisians in some "fathomless medium," fathomless to Strether who marvels at this "picture composed more suggestively, through the haze of tobacco, of music more or less good and of talk more or less polyglot"

(108–109). Chad is twenty-eight, at the very center of the circle. He appears to Strether heroically as "an irreducible young Pagan" (99, 102, 141). In time Strether sees him differently, as indifferent and cowardly. Even so, Chad's falsity leads to a promise that he keeps, just as Strether proves false to Mrs. Newsome.

Chad's young friend, Little Bilham, warns Strether of Chad's character (111–12) in words Strether cannot hear and takes as praise, instead. Strether's corresponding advice to Little Bilham is advice Bilham is too young to understand—that is, to live: "Live all you can; it's a mistake not to. It doesn't so much matter what you do in particular, so long as you have your life . . . I see it now. I haven't done so enough before—and now I'm old; too old at any rate for what I see" (132).[6]

Notwithstanding his other qualities, Chad has no imagination (cf. 290). His mother, Mrs. Newsome imagines only meanly.[7] Strether, on the other hand, has "treasures of imagination" (298–99), but this same facility blocks his vision, while at the same time enriching it. As Strether gradually lets go of his past, he lets his imagination flourish as if he himself were Parisian, too, as if he had lived a different life himself. But getting to the point of letting go is a struggle Strether faces from the very beginning of the novel, where he confesses: "I'm always considering something else; something else, I mean, than the thing of the moment. The obsession of the other thing is the terror" (26). Soon Strether finds "the situation . . . running away with him" (176).

What is apparently keeping Chad in Paris is his attachment to an older, married woman, long separated from her husband: Madame de Vionnet. She has a daughter, Jeanne, of marrying age, perhaps a little older than Sarah Pocock's fifteen-year-old daughter, Mamie, whom Mrs. Newsome has chosen for her son. The question Strether must consider is whether Chad's connection with Mme. de Vionnet and her daughter is "a virtuous attachment" or a wicked one. Otherwise, his mission would not be a rescue, but a wrong.

Such is the task of recognition on which the novel is based. But the task will prove elusive, as Strether is attracted to the life Chad lives and to Mme. de Vionnet herself: "one of the rare women he had so often heard of, read of, thought of, but never met, whose moral presence, look, voice, the mere contemporaneous *fact* of whom, from the moment it was at all presented, made a relation of mere recognition" (150).[8] Strether's exercise of vision gives vent to his imagination, which sketches the Parisian scene in luminous detail: "It was interesting to him to feel that he was in the presence of new measures, other standards, a different scale of relations" (77). Strether, after all, is an editor; his vision is informed by all that he has read,[9] blurring differences between dramas on a stage and dramas lived (cf. 83).

Furthermore, the information at hand is so conflicting, so intertwined with different visions of the scene. Strether dwells on various speculations which prove false (e.g., 139–40), proffering solutions which prove impossible (e.g., 257), yearning all the while for "the thrill of bold perception justified " (148).

At times he doubts the innocence of Mme. de Vionnet's attachment, though he does not want to: "She was so odd a mixture of lucidity and mystery. She fell in at moments with the theory about her he most cherished, and she seemed at others to blow it into the air. She spoke now as if her art were all an innocence and then again as if her innocence were all an art" (230).

This results in Strether's characteristic indecision, and so another set of ambassadors sets sail from Mrs. Newsome: Strether is replaced by Sarah and Jim Pocock and their daughter Mamie, who arrive to direct Chad home. On the one hand, Strether fears "their observation would fail; it would be beyond them; they simply wouldn't understand." On the other hand, Strether doubts himself: "Was he, on this question of Chad's improvement, fantastic and away from the truth? Did he live in a false world, a world that had grown simply to suit him...the alarm of the vain thing menaced by the touch of the real? Was this contribution of the real possibly the mission of the Pococks?—had they come to make the work of observation, as *he* had practised observation, crack and crumble...?" (212). The chance is always there recognition can go wrong, trapped in imagination, a victim of a fiction self-imposed.

At this point in the novel, as "outgoing ambassador" (203), Strether has sufficiently let go of Woollett, Massachusetts, to lose his prospects with Mrs. Newsome. Strether self-consciously senses the depths he is fathoming: "letting himself go, of diving deep, Strether was to feel he had touched bottom" (176). He failed to prove his mettle, but won a sense of being a free man in Paris: "It was the freedom that most brought him round again to the youth of his own that he had long ago missed...to a degree it had never been, an affair of the senses. That was what it became for him at this singular time...—a queer concrete presence, full of mystery, yet full of reality, which he could positively handle, taste, smell, the deep breathing of which he could positively hear" (281–82).[10] Finally, circumstances intervene. It is then that Strether's final moral recognition is obtained, as the ideal and the real meet at the surface once again.

The ensuing discovery scene is one of the most admired in all of English literature, but the device goes back to ancient days and Aeschylean plays. One reason why discovery scenes came into being is because playwrights writing them felt the compelling need to confront the dramatic subject's vision with a scene the subject would not expect to see. It is precisely at that depicted intersection of subjected imagination and reality portrayed that moral vision enters in. The audience, in turn, is watching the subjects on the stage. As surprises in the story come, the audience itself discovers how moral vision forces sights upon us, only after we are prepared for them. That is when recognition comes.

Strether took a train into the country to spend a day walking almost randomly in picturesque idleness, tasting his new freedom, giving himself over to "French ruralism, with its cool special green, into which he had hitherto looked only through the little oblong window of the picture frame. It had been as yet for the most part but a land of fancy for him— the background of fiction,

the medium of art, the nursery of letters; practically as distant as Greece, but practically also well-nigh as consecrated" (301). Strether thought of a small Lambinet landscape he would have bought on Tremont Street in Boston years ago, had he not been too poor to pay the price. Instead, this day, he walked into the picture he had long wanted:

> The oblong gilt frame disposed its enclosing lines; the polars and willows, the reeds and river—a river of which he didn't know, and didn't want to know, the name—fell into a composition, full of felicity, within them; the sky was silver and turquoise and varnish; the village on the left was white and the church on the right was grey; it was all there, in short—it was what he wanted: it was Tremont Street, it was France, it was Lambinet. Moreover, he was freely walking about in it. (302)

Strether spent his liberty this way, continuing in the landscape, not once over-stepping the gilt frame, remaining under the spell of the picture he was in (305). Under this "happy illusion of idleness," he thought fondly of Madame de Vionnet, of the events in Paris. He wandered and explored. As the day began to fade, "not a single one of his observations but somehow fell into a place in it; not a breath of the cooler evening that wasn't somehow a syllable of the text. The text was simply, when condensed, that in *these* places such things were, and that if it was in them one elected to move about one had to make one's account with what one lighted on" (306).

Strether made plans for dinner, at a country inn down by the nameless river. He sat on a bench out by the inn's pavilion right at the water's edge, contemplating: "Strether sat there and, though hungry, felt at peace; the con-fidence that had so gathered for him deepened with the lap of the water, the ripple of the surface, the rustle of the reeds" (307). A rowboat came around a river bend: "What he saw was exactly the right thing—a boat advancing round the bend and containing a man who held the paddles and a lady, at the stern, with a pink parasol. It was suddenly as if these figures, or some-thing like them, had been wanted in the picture, had been wanted more or less all day, and had now drifted into sight, with the slow current, on purpose to fill up the measure" (307). Strether saw something suddenly that startled him. The "two very happy persons" spoke quickly and intensely among them-selves, not wanting to be recognized by him. They were Chad and Madame de Vionnet.

Strether spent the evening afterwards, upon his return to Paris, reflecting on the events that followed, once he couldn't sleep: "what it all came to had been that fiction and fable were, inevitably, in the air . . . there had simply been a lie in the charming affair—a lie on which one could now, detached and delib-erate, perfectly put one's finger," (311). Nevertheless, "the deep, deep truth of the intimacy revealed . . . made him feel lonely and cold" (313). "He was mixed up with the typical tale of Paris" (315). Yet, the sense of horror Mrs. Newsome or Sarah Pocock felt toward Chad's liaison was missing. Strether "reverted in thought to his old tradition, the one he had been brought up on and which

even so many years of life had but little worn away; the notion that the state of the wrongdoer, or at least this person's happiness, presented some special difficulty. What struck him now rather was the ease of it" (316).

In the course of several weeks, appearances had been thrust on Strether (cf. 324) and his world changed, no longer that of Woollett, Massachusetts, but not of Paris, either, now. The fact is, Strether's phantasmagoric vision (cf. 330–31) had not betrayed him. Even though he had been wrong about Chad's virtuous attachment, Mrs. Newsome and Sarah Pocock had not been right. What Strether had discovered was an even grander virtue of a life sublime, one, as it happened, Chad and Madame de Vionnet had not lived, though Strether could perceive what it would be like, from walking in the landscape too.

Clarity came as both Madame de Vionnet and Maria Gostry offered to compensate Strether for his loss brought on by the deception practiced on him. In his final interview with Madame de Vionnet, "Strether's too interpretative innocence" is tested once again by her solicitation: "It's how you see me, (322). Mme. de Vionnet's own moral to the tale are words Strether already knows:

> "What I hate is myself—when I think that one has to take so much, to be happy, out of the lives of others, and that one isn't happy even then. . . . The wretched self is always there, always making one somehow a fresh anxiety. What it comes to is that it's not, that it's never, a happiness, any happiness at all, to *take*. The only safe thing is to give. It's what plays you least false." (321)

Maria offers keeping him in Paris, to compensate for his loss of Mrs. Newsome: "the offer of . . . lightened care, for the rest of his days . . . might have tempted. It built him softly round, it roofed him warmly over, it rested, all so firm, on selection. And what ruled selection was beauty and knowledge. It was awkward, it was almost stupid, not to seem to prize such things" (344). All the same, Strether decides to return home to Woollett alone. The vision of a world so admired faded, and in its place was the vision of what is right, Strether's own "tribute to the ideal" (51):

> "I know, I know. But all the same I must go." He had got it at last.
> "To be right."
> "To be right?"
> She had echoed it in vague deprecation, but he felt it already clear for her. "That, you see, is my only logic. Not out of the whole affair, to have got anything for myself."
> She thought. "But with your wonderful impressions you'll have got a great deal," . . . "But why should you be so dreadfully right?"
> "That's the way that—if I must go—you yourself would be the first to want me. And I can't do anything else."
> So then she had to take it, though still with her defeated protest. "It isn't

so much your *being* 'right'—it's your horrible sharp eye for what makes you so."

 . . . "Then there we are!" said Strether. (344-45)

The ending of the novel proves disquieting to some; James does not tell us the right thing to be done. There is an elusiveness to moral recognition. It comes to persons one by one. The reader must draw his own conclusions. Strether's choice may not be our own, Mme. de Vionnet's homily might not seem perceptive, though the importance of "not taking" is a theme Strether shares with the tale told of Eliot and Heidi. The moral of the novel is subtle and contextual. It cannot be recaptured as advice. Rather, the moral is intertwined with vision, a vision that comes after thoroughly entering into a world so portrayed, seeing things through Strether's eyes and that of the narrator. The result is a sensitivity trained by reading Henry James, a way of looking, rather than a direction or a rule. Interpretation or analysis cannot teach or capture vision. It can at best solicit it.

Reading novels such as this enhances vision, just as Strether's sojourn in Paris improved his own discrimination. But the dilemma faced by Strether is faced by readers, too, lest their vision become itself a congeries of fable. James is especially sensitive to this suggestion, *The Ambassadors* plays against it well. Imagination must be rich enough to see past the surfaces of things, but it must be open to the recognition that the world often differs from the way it is seen by us. Without imagination judgments are too facile to have real application. Such is the blindness Waymarsh suffers, even though his judgment might be right about the situation. But without the facility for recognition, imagination itself is blind.

I find the suggestion present in the novel that vision rich with imagination can perceive past the real failings of all so human situations, lighting on the possibility of character, of virtue even. By coming to see something better than it is, we are in a position to be moral, providing we can recognize the difference between a life envisioned and the world we are living in. For those without imagination, those like Mrs. Newsome and Chad, their moral judgments are impoverished because their worldview is poor. It is black and white, not color. For those like Maria Gostry or Strether imagination is a guide, provided only that it connects. Deep imagination that leads to moral vision is an educated one, educated, as Henry James suggests, by paintings, plays, and novels, the weight of culture and of reading. It is a skill that is being won, a way of seeing rather than any particular thought or technique of reasoning. It is this same skill on which we act as moral agents, dependent as we are on the discrimination of our own imagination.

III

There is an epistemology and even a metaphysic to the place of fiction in moral recognition. But the old philosophic models will not hold. That much revered distinction between knowledge by acquaintance and knowledge by description

obscures their fusion on the printed page, where elaborate descriptions yield to a vision seen. The familiarity that comes with knowing what to do is so much more than knowing that. There is a lack of philosophic presence in the confrontational simplicity of some final recognition that precipitates in action, though that simplicity requires considerable facility. The agent must be intellectually prepared to see before he acts.

The wisdom of a therapist requires the ability to recognize the specific situation of her patient, over and above whatever is said in successive sessions, descriptions given by the patient of his situation. And so a therapist can recognize depression when she hears it, seeing past some peculiar vision of the world presented by her patient, and seeing the significance of clinical descriptions the therapist has learned formally from study. In this way descriptive knowledge facilitates an ability to see clinically. Writers are similar to therapists in this respect, except many of their patients are invented and their observations are made public.

The wisdom of the poet exhibits an ability to use words to convey sights differently, the touch, the taste of things, to present a world with a difference from our own, where that otherness is seized upon by readers as something positively sensed. As the words are heard, a vision fits the scene, compelling recognition of something someone else imagined. The wisdom of the storyteller can be the wisdom of a moral teacher, who teaches values by subtleties of shading, the contrast of light and shadows in the story told. Some stories can be biographical, as with Heidi and Eliot's Passion Sunday. Others can be fully fictional, resting on authorial experience and imagination. Those who would replace the moral of a tale with a sentence or dismantle a visionary stance into descriptions piled one on one lack wisdom, I should think.

The philosophic preference for description over the elusive kind of vision acquaintance brings speaks to a desire to be right about the way the world is, once and for all. This is how Sarah Pocock and Mrs. Newsome think, in black and white: of a Lambinet that it is a landscape, of Strether's failure to take charge as "an outrage to women" like themselves (276). True descriptions, it would seem, ought always to remain the same. The world so depicted should not be plastic, it must not change. Judgments abide, the center holds.

The novel Henry James has written defies description of this sort. It provides a lesson in rejecting definitive descriptions, letting go of the cartoon sketch of things, and in the difference between Paris, France, and Woollett, Massachusetts, gaining obscure insight. Further exegesis of what James has written, such as the one that I have given here, can only lead to additional perspectives on the text, further viewpoints of that world so described. Just as Strether's moral vision becomes imbedded in his own imagination, so James has this same effect on readers. The moral of his tale is deeply personal; it varies with his readers.

That moral recognition should be so dependent on imagination once offended Plato greatly, who thought the work of poets, no matter how inspired,

hopelessly obscured, expressing ignorance instead of moral knowledge, phantasms of the psyche instead of genuine discoveries made. It was then the fatal dichotomy engaged between projections of the mind and the world as it is, between acquaintance and description. Some have welcomed this dichotomy, attracted to the netherworld.

Richard Rorty sees the novelist as living on "contingency," the contingency that ranges over language, selfhood, and community.[11] It is this contingency that is so characteristic of the diverse ways we live our lives. It is also the contingency of story telling, the situational particularity of someone's vision. But Rorty goes on to argue that *ironism* is the best hope for intellectuals: "their realization that anything can be made to look good or bad by being redescribed... never quite able to take themselves seriously because always aware that the terms in which they describe themselves are subject to change, always aware of the contingency and fragility of their final vocabularies and thus of their selves" (73–74). The ironist "does not think her vocabulary is closer to reality than others, that it is in touch with a power not herself" (73). There is no exit from Plato's Cave and Rorty welcomes that.

Rorty's form of pluralism is not confrontational, measured against the way things really are. Instead, he sees humans in terms of a diversity of "incarnated vocabularies" (88). The intellectual ironist is awash with different words, different vocabularies gleaned from all the works she has read. Even though she may have a final vocabulary of her own, she will not give it dominion over other points of view. For her, specific novelists are not her moral teachers. Instead literary critics are: "Ironists read literary critics, and take them as moral advisers, simply because such critics have an exceptionally large range of acquaintance. They are moral advisers not because they have special access to moral truth but because they have been around. They have read more books and are thus in a better position not to get trapped in the vocabulary of any single book" (80–81).

Rorty's ironism has much in common with the worlds novels dwell within, the multiple contingencies of vocabularies, selfhood, and communties—universes of diverse acquaintance broadly written. Yet, the plurality of words the ironist lives within abides within herself, psychologically bound within her own cultivated, multiple imagination. The plurality of words the storyteller spins is different, I would think, designed to communicate with others by connecting with a common world viewed. The plurality of viewpoints which result are aspectual of reality, not psychologically contained contingencies.

A novelist like Henry James is not the sort of intellectual the literary critic is, for Henry James has a particular vision he leads his readers to, some shared communication soliciting a common recognition. Even though interpreters will differ in their exact descriptions of the significance of what is seen, they will have been brought to witness that same vision, as if they themselves were walking in that landscape. The novelist or storyteller directs his imagination toward the world he depicts. Unlike the ironist, the novelist can accept the contingency of characters within his story, and yet direct his readers to the

reality he sees as such. Literary critics, who make a living off others' books, may inspire ironism, but they drain the lifeblood dry of the books they read, since they read them very differently than the ordinary reader would. The ironist cannot concede the existence of moral recognition, the kind Henry James depicted and Strether found, along with James's readers.

Henry James's *Ambassadors* may result from the imagination of the author, but the story that it tells is designed to communicate with others, to designate and ponder concrete situations some of us could have been in. Unless the writer connects with his reader in this way, there will be nothing reader and writer share in common, no basis for communication. The novel, so conceived, is an exercise in realism, dependent on a common vision no matter how constrained by the conditions of invention. It implies the existence of a community.

What is tricky here is this: The novelist is engaged in writing fiction, while at the same time communicating with a real audience living in the world as it is. Consequently, the novelist invites the reader to share some beliefs only for the duration of the story. Wayne C. Booth calls them "nonce beliefs," that a goose can lay a golden egg, for instance (142–49).[12] These beliefs may be only for the nonce, but they do not temporize " 'fixed norms,' beliefs on which the narrative depends for its effect but which also are by implication applicable in the 'real' world" (142–43).[13] The norms the reader seizes on, like books chosen to be read, exhibit a certain therapeutic direction, reflecting the reader's circumstances and real needs. So the norms will vary (cf. 67-77). Yet, the line of communication connecting the story together with its author and the reader requires that the norms be recognized as shared.

The norms that stories recognize need not be descriptive of the worlds so depicted. Characters need not be heroes, except for certain children's tales. Usually authors create an illusion of distance between the world they have depicted and the way that world might have been. So, Strether found in Madame de Vionnet a vision of what she might have been, and Eliot and Heidi found the ideal in each other. Often fiction can do a better job of this than real life exposure, where the possibilities for change seem more remote (Booth, 223).

Some fixed norms are more straightforwardly presented, since many of the stories we tell ourselves as well as many stories we are told are not fiction, but the truth, not in need of "nonce beliefs" to get the story going. Yet, these fixed norms do not spring already fixed eternal from the mind of Jove or Mrs. Newsome. Stories that we tell ourselves in our own imagination, as we are pondering some action, often exhibit norms of shading we have gleaned from other stories we have heard, fictional or fact. Stories we invent affect further stories that we read. The facility for recognizing norms is complex, diversely dependent on an implied community of listeners and readers, as well as writers and individual imaginations.

This leads to certain Wittgensteinean considerations. The existence of a community is implied by the contention that moral recognition is gleaned from storytelling. And communities can vary with the scope of life's experience, from

Wollett, Massachusetts, to Paris, France. So, there is considerable contingency to the facets that we seize upon in life and fiction to recognize as moral norms. This might then seem to undermine any authority to moral vision, the kind derived from story telling. At what point can we concede authority to the norms of the community of authors we have grown into, to feel more or less assured that recognition has truly come, as opposed to just another instance of temporizing and deception, "la nuit americaine?"

I do not think such assurance can ever really come. The more we read, the greater the diversity of communities we live in. But I do not find Rorty's ironism compelling, either, an inevitable concession to the fragility of moral recognition. Previous recognitions of what appeared the right thing to be done often turn out to be false, but it does not follow moral recognitions lose all authority. At some point a final vocabulary comes, not because of the fatigue that comes with living in diversity, but because with time and maturity we find ourselves in a community we trust, where perception of what is right and wrong are shared, not because of some socialized hegemony, but because we find a sense of us. It all depends, as Booth suggests, on "the quality of the company we keep" (172), the authors that we read, the stories that we tell ourselves.

It is a question of realism, authenticating norms we have come to perceive as genuine moral recognitions. Hilary Putnam's mitigated realism— that the world makes its impact on us, though what the impact signifies descriptively is mostly up to us—proves disquieting both to ironists and those who would look for final, moral truths in some single, expert book.[14] Yet, there must be something right about Putnam's compromise, even when applied to the place of fiction in authenticating moral vision. Stories we can comprehend are never fully made-up. They require enough in common with life's experiences to communicate with others. Even though life's experiences are culturally informed, they are not entirely artifactual. Grief and joy connect with real situations, crossing over different cultures, different stories. So, there is an indexical element in fiction and imagination that points to what in the world causes us to see it that way. This element of realism is obscurely imbedded, to be sure, in the final vocabulary of the community we prize, amidst cultural idiosyncrasies and preferences. but even so, it is there.

NOTES

1. All page references to *The Ambassadors* will be to the Norton Critical Edition (1964), which contains a corrected reprint of the 1909 Scribner's New York Edition, the edition James himself regarded as definitive. In the final version of what James himself regarded as his best novel, he presented an "immense array of terms, perceptual and expressional, that . . . simply looked over the heads of the standing terms" (363). Consider the perceptual terms employed on the following pages of the novel: 89, 97, 126, 139, 150, 155, 156, 164, 228, 239, 257, 262, 267, 297, 298.

2. As the narrator says of him, "he was not a man to neglect any good chance for reflexion" (65)

3. On Strether's meeting Maria Gostrey: "He had quite the sense that she knew things he didn't. . . . She knew even intimate things about him that he hadn't yet told her and perhaps never would. He wasn't unaware that he had told her rather remarkably many for the time, but these were not the real ones. Some of the real ones, however, precisely, were what she knew" (22).

4. At first Strether's visionary imagination reflects back upon himself as self-reproach, "I've sinned enough. . . to be where I am" (52). As he sits upon a penny chair in the Luxembourg Gardens, his second day in Paris, where "the air had a taste as of something mixed with art, something that presented nature as a white-capped master-chef" (59), he takes this opportunity to reflect on his life's failures, clinging to the thought of Mrs. Newsome for salvation, feeling his life lost "in the great desert of the years." As James narrates: "What he wanted most was some idea that would simplify, and nothing would do this so much as the fact that he was done for and finished" (61). In the meantime, of course, his imagination is being fed by his surroundings: "Poor Strether had at this very moment to recognise the truth that wherever one paused in Paris the imagination reacted before one could stop it. This perpetual reaction put a price, if one would, on pauses; but it piled up consequences till there was scarce room to pick one's steps around them." Cf. 58–69.

5. The narrator refuses to simplify this choice. Waymarsh sees Europe as an ordeal (30), yet ultimately his view of Strether's situation coheres with Strether's own (cf. 33–34, 74–75). The difference, though, is this. Waymarsh's perspective is more like a primitive cartoon compared to the sensuous landscape Strether is walking in.

6. The narrator comments on this scene: "There were some things that had to come in time if they were to come at all. If they didn't come in time they were lost forever. It was the general sense of them that had overwhelmed him with its long slow rush" (131).

7. Cf. 299: "And yet Mrs. Newsome—it's a thing to remember—*has* imagined, did, that is, imagine, and apparently still does, horrors about what I should have found. I was booked, by her vision extraordinarily intense, after all—to find them; and that I didn't, that I couldn't, that, as she evidently felt, I wouldn't—this evidently didn't at all, as they say, 'suit' her book. It was more than she could bear. That was her disappointment."

8. Cf. 148: "And the relation profited by a mass of things that were not strictly in it or of it; by the very air. . . by the world outside." Cf. 172: "She reminded our friend— since it was the way of nine tenths of his current impressions to act as recalls of things imagined—of some fine firm concentrated heroine of an old story, something he had heard, read, something that, had he had a hand for drama, he might himself have written, renewing her courage, renewing her clearness, in splendidly-protected meditation." Strether first thinks this thought of an unknown woman he is watching in a church, a woman who turns out to be Mme. de Vionnet.

9. Note, for example, the literary references to Balzac, Thackery, etc., sprinkled through the beginning of the novel, exhibiting the context of Strether's perspective and imagination: cf. 23, 34, 36, 37, 51, 62, 65, 67, 145, 174. In the final discovery scene of the novel the shift is significantly from the literary arts to painting.

10. Cf. 277: "Our general state of mind had proceeded, on its side, from our queer ignorance, our queer misconceptions and confusions—from which, since then, an inexorable tide of light seems to have floated us into our perhaps still queerer knowledge."

11. Richard Rorty, *Contingency, Irony, and Solidarity* (Cambridge, 1989). Cf. also David R. Hiley, *Philosophy in Question* (Chicago, 1988), 163: "Since Plato's allegory, it has been thought that liberation or escape from the contingent to the eternal is the realization of our true nature, and for that reason, it is necessary for our moral and social lives. In undermining the philosophical urge to escape, Rorty. . . is disconnecting philosophy and the good life."

12. Wayne C. Booth, *The Company We Keep: An Ethics of Fiction* (Berkeley, 1988). The preparation of this essay owes a great deal to Booth's book, as well as the recent work of Martha Nussbaum, particularly her forthcoming collection: *Love's Knowledge: Essays on Philosophy and Literature* (Oxford). I am grateful to members of a graduate seminar at UCR who met with me at a local coffee house to savor Booth and James, Nussbaum and

Rorty. A willing audience at MIT, brought together in April, 1990, by David Halperin and the Boston Colloquium, also heard my views on the elusiveness of moral recognition and made several thoughtful suggestions.

13. Booth continues: "They are fixed only in the sense that the implied author and the implied reader share them as normal both for the fictional world and for their world as it is or ought to be" (143). This too may seem contingent, yet what fixes them as norms is what the reader takes to be their compelling concrete presence in her own life's experience. Booth continues: "Because our essential ethical experience occurs in the specific relations, moment by moment, inference by inference, among multiple characters who offer and receive, construct and reconstruct, write and rewrite, even the most evasive author simply and paradoxically fails to evade us—unless the work eludes us and lies seemingly inert upon its shelf" (149).

14 Cf. Hilary Putnam, *Reason, Truth, and History* (Cambridge, 1981).

Imaginary Gardens and Real Toads: On the Ethics of Basing Fiction on Actual People[1]

FELICIA ACKERMAN

"Any resemblance of the characters in this work to actual individuals, living or dead, is purely coincidental" is a common disclaimer in novels. Regardless of its accuracy in any given case, its very presence suggests that writers recognize that there can be moral and/or legal objections to basing fiction on real people—objections that the disclaimer is supposed to deflect. In this essay, I will discuss the issue of basing fiction on real people as a problem in professional ethics for the fiction writer. This is a new area for systematic analytical philosophical discussion, and so I will try to do groundwork by laying out issues, offering a conceptual framework for discussing them, and suggesting some conclusions. My discussion will be restricted to moral rather than legal issues; I will consider neither what the relevant laws about libel actually are nor what good laws in this area would be. Also, as the title suggests, I will concentrate on ethical issues involving basing fiction on actual *individuals*, rather than on actual institutions or on actual groups defined in such general terms as race, ethnicity, nationality, age, etc.

I

Why suppose that basing fiction on real people raises moral problems at all? Why shouldn't writers feel free to incorporate into their fiction whatever material they want from the lives of actual people, without even troubling to disguise details that might enable at least some readers to identify the sources? The obvious answer is that basing fiction on real people can harm them. So a useful means of organizing the discussion is to begin by considering various ways in which source S can be harmed by fiction that is based upon him.

(1) Readers might identify the character as S and learn or come to suspect things that are true of him and that he would prefer to keep secret. This can involve both the harm of invasion of privacy and the harm of practical ways in which people may treat S differently or think of S differently as a result of acquiring these beliefs or suspicions. An obvious example of this sort of case would be one in which S is a secret drug addict (or nowadays even a closet smoker), and so is the character recognizably based on S.

(2) People might identify the character as S and acquire false beliefs or suspicions about him because the writer invents juicy details that are not even true of S.

(3) S may be presented in a degrading light, e.g., as a buffoon, a pathetic person, or a horrible example of the likely result of certain types of behavior. This may cause people to regard S more unfavorably than they would otherwise and to treat him differently, even if no new non-evaluative beliefs are acquired.

(4) S's life may be used to illustrate a lesson whose moral he considers not only wrong, but repugnant. For example, if S is an unhappy person who also happens to be a confirmed atheist who is proud of his atheism, a religiously oriented writer might write a novel about S whose theme is the inevitable bankruptcy and misery of the non-religious life.

(5) S may feel a sense of personal betrayal if the writer is a friend of his and uses material S revealed as part of the friendship. S may feel betrayed or at least exploited even if no personal friendship existed, but the writer uses material S would not have revealed had he realized that the writer might use it in his fiction.

(6) The sort of detached attitude involved in viewing someone as material for one's fiction may be inherently antithetical to the spirit of friendship, even if no actual fiction about that person ever results.

The first three of these harms depend on other people's identifying the fictional character as S, while the next three do not, although (4) and (5) may be intensified by such identification. There is another sort of harm, however, that is dependent upon people's *not* identifying the fictional character as S. This is the possibility that

(7) A writer may incorporate into a fictional character S's ideas, phrases, or personal style in such a way as to suggest that the creation is purely fictional and thus that the originality comes from the writer rather than from S himself.

The most extreme and familiar example of (7) would be outright plagiarism, which is defined as "[taking] ideas, writings, etc. from [others] and [passing] them off as one's own."[2] But it might be argued that taking even such aspects of a real individual's personal style as his manner of dressing, decorating, or entertaining, and passing them off as one's own fictional creations by incorporating

them into one's fictional characters who are not identifiable as based on real people raises some of the same moral problems as plagiarism.[3]

II

If basing fiction on real people can harm them, what is the fiction writer's responsibility? William Faulkner's statement that "The writer's only responsibility is to his art. . . . If a writer has to rob his mother, he will not hesitate; the 'Ode on a Grecian Urn' is worth any number of old ladies,"[4] represents one extreme view. There are at least two general sorts of possible justifications for the position that it is morally permissible for a fiction writer to disregard the possibility of harming the people upon whom his fiction is based. One possible justification is the view that literature has an intrinsic value that automatically outweighs any harm that is done in the course of creating it or that results as a by-product, including harm to actual individuals who serve as its bases. Another possible justification is the view that literature causes or is likely to cause benefits (such as enjoyment, insight, or moral enlightenment for its readers) that automatically outweigh any possible harm to its sources.

Both possible justifications seem morally untenable to the point of preposterousness. A relatively minor point is that the Faulkner quotation contains a *non sequitur.* Even if it were true that " 'Ode on a Grecian Urn' is worth any number of old ladies," it would hardly follow that the average writer, or even the average good writer, with no rational expectation of producing a masterpiece, would be justified in sacrificing any number of old ladies, or even any number of young men, to further his work. Moreover, the premise itself seems so blatantly immoral that I find it hard to imagine any common ground as a basis for argument with those who disagree. Would Keats really have been justified in resorting to murder, torture, or rape if he could not have written "Ode on a Grecian Urn" without such actions as inspiration? The answer seems obviously negative, regardless of how many millions of people could benefit from reading the poem, or how great its intrinsic worth may be.

But not only is the average writer not a genius, the average writer is probably not tempted to commit murder or rape or even to rob his mother in the pursuit of his art. What about lesser sorts of harms, such as those I am concerned with in this essay? For example, suppose someone writes a novel based on his older sister, in which she is somewhat recognizable to friends and acquaintances and that represents her as a fool, a charlatan, or as having a shameful secret in her past. (I say "somewhat recognizable" because a reader's equation of real and fictional characters is seldom an all-or-nothing matter. Often, readers will notice similarities, speculate about possible bases of fictional characters in real people, and wonder about such matters as which other traits of the protagonist's psychoanalyst husband who teaches at Yale have been taken from the author's own psychoanalyst husband who teaches at Yale. The greater the likelihood of such identification, the more pressing the moral problems connected with possible recognizability—a fact that should be kept

in mind when, for simplicity of exposition, I talk only about recognizability as such and do not make qualifications about degrees of likelihood.)

One obvious response to moral problems about recognizability is to hold that the writer is obligated to disguise identifying details so that S will not be recognizable to other people. But suppose the details that are identifying are the very details that give the material most of its literary interest. And what about cases where S, although recognizable to no one but himself and the writer, would feel betrayed to have his private life and feelings (e.g., details of nightmares he has revealed only to the writer) used in this way?

A possible suggestion here is that writers use their own moral judgment to determine whether, in any particular case, the likely harm to the persons on whom the fiction is based would outweigh the likely benefits both to the writer and to the people who might read the resulting work. But an obvious objection is that writers are hardly in a position to make unbiased assessments of these risks and benefits; moreover, since it is S rather than the writer who stands to suffer the harm, it would seem that S's own views on the subject should at least be taken into account.

There is a parallel here with some related issues concerning the use of human subjects in experiments. Rather than allowing experimenters unbridled exercise of their own judgment as to when the risks of harm to experimental subjects outweigh the possible benefits to them or to others, the standard practice is to require that the subjects give informed consent, where the conditions for informed consent are that "the person giving consent [must] be *competent,...informed* about [the possible risks and benefits of] the proposed intervention, and [the] consent [must] be *voluntary*."[5] But, of course, informed consent cannot give an adequate criterion for evaluating all cases of human experimentation; for example, the subject may be incompetent. And there are reasons why informed consent is even more problematic as a criterion for deciding when it is morally acceptable to base fiction on real people.

First of all, writers cannot always be sure just where their material comes from and thus cannot always be sure whether it comes from real people, and if so, which ones. Second, since writing fiction based on real people, unlike performing experiments on them, does not require contact with these people at the time the work is being done, the people upon whom fiction is based may be not only "incompetent" to consent, they may be dead. Or they may presumably be alive, but untraceable or otherwise unreachable. Third, the problems raised in (7) of Section I, above, go beyond the issue of informed consent. Any practice raising the moral problems of plagiarism, since it involves deceiving others and claiming credit for work or originality that is not one's own, seems morally objectionable even if the person plagiarized consents to the procedure.

Another point is as follows. It seems at least questionable whether the moral restrictions to protect people from the harm that can result from having fiction based on them should be as stringent as the professional restrictions on the use of human subjects in experiments. Several reasons might be suggested for a disanalogy here. It might be argued that part of the basis for strict

restrictions on the use of human subjects in experiments has to do with values we have about the integrity of the body and with the right not to have invasive procedures performed on one's body for purposes one does not share. But not all human experimentation involves physically invasive procedures; experiments in the social sciences characteristically do not.[6] Another possible disanalogy is that human experimentation often (although not always) involves soliciting the subjects' cooperation to do something they would not be doing otherwise. A third consideration is a practical one. In addition to benefitting from having medical and psychological researchers, human society benefits from having fiction writers. But while the informed consent criterion is workable for experimental research, this criterion seems, as considerations in the previous paragraph suggest, much less workable for the writing of fiction. Writers are almost bound to draw upon their own experiences, including experiences with other people, and any requirement that writers track down every person who might have served as a basis for their fiction and secure his approval of the final product would put a virtual stop to fiction writing.

In fact, moral issues concerning the sorts of harms that can befall people through having fiction based on them—betrayal of trust, public disclosure of intimate information, etc.—are impossible to discuss adequately outside of the social context of the act of writing. Particularly important are facts about the prior relationship between the writer and the people who serve as basis for his fiction, such as whether a prior intimate relationship of trust existed, whether the people knew that they might be written about, etc. In the next section, I discuss these and related considerations.

III

What factors help determine the moral status of basing a work of fiction on an actual person? Plausible candidates include the following:

- (a.) Whether S would recognize himself and whether S would take the resemblance to be intentional.
- (b.) Whether other people would recognize S, whether they would take the resemblance to be intentional, and whether the work of fiction would change their beliefs about S or their attitudes or behavior toward S, and if so, how.
- (c.) Whether S would mind having the writer portray him in this way.
- (d.) The prior relationship between S and the writer, for example, whether S and the writer had a personal friendship that led S to reveal aspects of his private self to the writer, whether S knew in advance that the writer might base fiction on him, or whether S revealed material about himself that he would have chosen not to reveal if he had known its fictional use was a possibility.
- (e.) How much, if at all, the work of fiction would suffer if the identifying details were to be disguised.

The principles I will suggest are all *prima facie*; they can all be overridden by the bizarre sort of case where someone with his finger on the button threatens to blow up the world if one does not violate a certain principle, and also by other dire circumstances as well (although not, of course, by the fact that overriding the principles could allow a writer to write better fiction). What might such principles be? One obvious candidate is the principle that a writer has a *prima facie* obligation to disguise what he reasonably believes are identifying details whenever there is no aesthetic loss in doing so, unless the subject has given informed consent to have such details used.[7] But (to return to some issues mentioned in section II) what if disguise sufficient to preclude identification would harm the story? And what if the subject objects (or it is reasonable to believe he would object) to having material from his life, character, or circumstances used at all, even if the material is so heavily disguised as to be unrecognizable by others?

Here it is useful to consider a remark made in a different context by the character Sandy in Muriel Spark's novel, *The Prime of Miss Jean Brodie*. When the question arises of whether Sandy was the one who "betrayed" her teacher, Miss Brodie (by telling the headmistress damaging information about her), Sandy says, "It's only possible to betray where loyalty is due."[8] Sandy's remark is overstated, as it seems possible to betray someone to whom one does not owe loyalty, for example, by breaking a promise one has made to him under duress not to repeat something he has told one. But Sandy's remark can be applied to the issue at hand by being used to underscore the reasonability of supposing that cases where a writer owes personal loyalty impose requirements that are more stringent than those that apply in other cases. These considerations can be illustrated as follows. (My remarks here are directed at cases where S is still alive. Issues about wronging or harming the dead raise problems I will not deal with here, and so I will not discuss the question of whether the principles I suggest should also be taken to hold in cases where S is dead.)

First, I would say that if a writer has good reason to believe that S has revealed to him information or aspects of his character as part of a personal friendship and would not have revealed these things if he had known there was a reasonable chance they would be incorporated into the writer's fiction, then if S objects to this material being used (or—if he cannot be consulted—if there is good reason to believe he would object), the material should not be used in any case where it seems reasonable to suppose S could be identified by other people. The moral duty not to betray a friend by revealing either secrets he has told one or aspects of his character that his trust in one has led him to reveal seems to outweigh any gain that could come to the writer or his readers by his incorporating the material into his fiction.

A more problematic case is one in which S admits he would not be recognizable to others, but simply objects to having e.g., his private nightmares (which he has revealed as part of a friendship) exposed to readers, even as the nightmares of a character so unlike him as to preclude anyone else's even suspecting an identification. Two questions seem especially important for the

moral assessment of this sort of case. One is the question of what S believed about the writer at the time S revealed this material. Another is the question of just how close the relation is between the work of fiction and the aspects of S's life that serve as a basis. For example, if the writer promised S that nothing S revealed as part of their friendship would ever appear in the writer's fiction in any way if S objected, the writer seems *prima facie* obligated to keep this promise as part of the general *prima facie* obligation of promise-keeping. The cases that are of more specific interest for the issue of professional ethics for fiction writers are those where no actual promise was made (perhaps the writer was not yet even a writer at the time of S's revelations), but where S now claims (or the writer has good reason to believe he would claim) that he would not have revealed the material in question had he known it might be used. This is where the second question comes into play. I suggest that to the extent that the material used draws upon highly specific, detailed, and idiosyncratic things about S, that are recognizable at least to S and the writer as being identifiably about S the material should not be used, on the grounds that using it would constitute a betrayal of friendship. But as the material becomes more general and less reflective of any unique or at least uncommon aspects of S's character, personality, or experiences, the obligation lessens. Thus, these considerations would preclude overriding S's objection to attributing intimate details of his highly idiosyncratic nightmares to even an unrecognizable fictional character, but would not preclude overriding his objection to writing a story about a character who has nothing non-trivial in common with S except for mild mechanical ineptness, even if the original inspiration for the story was S's description of his own mild mechanical ineptness, and even if S would not have let the writer know about this mild mechanical ineptness if he had known the writer might thereby be inspired to write a story about someone with this trait. The problem with S's objection here is that mild mechanical ineptness is simply too general and common a trait for a writer's use of it in a character who is not recognizable to others as S to constitute a betrayal of S.

Another issue that arises in cases of personal friendship is the issue mentioned under (6) in Section I, above, the possibility that the writer's attitude in viewing S as even possible fictional material may be inherently antithetical to the spirit of friendship, regardless of whether the writer ever actually writes anything based on S. The best moral solution here seems to be turning the matter over to S's own judgment; as long as S knows that someone is a writer who is apt to view his friends as potential material, S can decide whether he is willing to maintain a friendship of that sort.

What about cases where there is no special relationship of friendship or trust in personal loyalty between S and the writer and hence where S has not revealed anything intimate to the writer on this basis? Different sorts of cases need to be distinguished here. One is the case where S can hardly avoid revealing certain possibly embarrassing or sensitive things, such as when S is the writer's student, roommate, or patient. In this sort of case, I hold that the writer is obligated not to exploit his professional relationship with S (or, in

the case of roommates, to exploit someone's natural tendency to let down his guard at home) by incorporating into his fiction anything he has good reason to believe other people would recognize as being about S, if the writer has learned this material on the basis of the relationship in question, unless S gives informed consent or it is clear S would give full voluntary informed consent if asked. (The importance of this final disjunct lies in the fact that it seems doubtful that the consent of a student or patient would be fully voluntary. But now the question arises of how the writer can ever know that voluntary consent would be given in such cases. I hold that where there is reasonable doubt, the material should not be used, but in fact there do seem to be possible cases where the writer can be reasonably sure that consent would be given voluntarily. For example, suppose there is material recognizably involving S that S spontaneously suggests that the writer might like to incorporate into fiction, or suppose the material in question is an incident from S's childhood that S obviously considers amusing and frequently recounts in conversation himself). The answer to the question of whether the writer has an obligation not to use even material about S that would not be recognizable to anyone else but that he has good reason to believe S could identify and would object to seems less clear in these cases than in cases involving personal friendship. Also, in both sorts of cases, if the writer is already a writer at the time of the ongoing relationship, he is obliged to let this be known.

With acquaintances where there is no self-revelation based on friendship, or arising from sharing living quarters and also no special professional relationship, the moral restrictions on what an author can use become much less stringent. There is still an obligation to let it be known that one is a fiction writer and not to use any recognizable details where material that is less identifiable with any actual person who objects to its use would serve just as well for literary purposes. And of course there is also (as in all cases) an obligation not to write what seems likely to induce false and damaging beliefs about an actual person, e.g., by writing a novel recognizably based on the principal of one's local high school, but falsely representing him as a secret child molester. But in cases where the interests of a story would be best served by representing a recognizable person in a way he would dislike but that does not violate any of the principles offered above, I suggest that there are no special moral restrictions on the fiction writer *qua* fiction writer. Of course, the writer is still in the common sort of situation where a moral agent must weigh possible harms to one person against possible goods, including possible benefits to others, including himself. But cases where the special restrictions on fiction writers do not apply must be dealt with on an individual basis, and there is no reason to suppose in advance that the conflict must always be resolved in favor of S instead of the writer.

IV

So far, I have been suggesting principles as if the sole problem were possible conflict of interest between the writer's work and the people upon whom his

fiction is based. This obviously omits cases where another person (e.g., S's mother) might take exception to the fictional treatment of S, but I will not go into this further wrinkle here. Instead, this final section will deal with the problem mentioned under (7) in Section I of this essay—the problem that in writing fiction that is based on real people who are not recognizable and who are presented as his own fictional creations, a writer may be committing a wrong akin to plagiarism in using the words, ideas, and styles of others and passing them off as products of his own creative imagination.

The most obvious case here is plagiarism itself, a notion that is not as simple as it may initially seem. The complexity lies in the fact that professional standards for what counts as one's own work and for what ideas and suggestions of others one may incorporate without attribution vary from field to field. Academic philosophers are apt to take for granted the strict standards of their own field, which require that all ideas taken from others, including even relatively minor suggestions, objections, and counterexamples, be explicitly credited to the people who proposed them, whenever these people can be identified. But these standards are by no means universal;[9] there are no footnotes in fiction. Standards for incorporating other people's ideas into one's own work in fiction are less clear than those in philosophy. But it is certainly within the bounds of acceptability for a fiction writer to use people's minor suggestions about plot, circumstances, language, and characterization without attributing them to their makers. For example, after reading a draft of a recent story of mine,[10] Lorraine Cherry convinced me not to have the protagonist's mother's terminal illness be pancreatic cancer, on the grounds that this illness would be too painful for the woman to be able to carry on the extended conversations with her daughter that were a central part of the story. This point was no less important for the story than the points I cite in footnotes (3) and (6) of the present essay are for this essay, but there was no way in the story for me to acknowledge Cherry (or the many other people who helped me in similar ways), nor would anyone have expected me to do so. But while standards of attribution and standards for counting a product as one's own work may differ in different fields, it seems reasonable to suppose that there is a cross-field notion of intellectual integrity that amounts to not going against the accepted conventions of one's field in using the work of others without attribution, because these conventions are the background conditions people in the field assume in giving people credit for their work. As applied to the case at hand, these considerations yield the conclusion that a fiction writer would not be guilty of plagiarism or any related wrong for using the sort of uncited material from others that is generally allowed in the field, which certainly includes drawing upon other people's personal styles, remarks, ways of living, and experiences, in addition to whatever minor suggestions people might offer about the work of fiction itself.[11]

NOTES

1. The reference to imaginary gardens and real toads comes from Marianne Moore's poem, "Poetry," where she speaks of "the poets among us" presenting "for inspection,

'imaginary gardens with real toads in them'" (Marianne Moore, *The Collected Poems of Marianne Moore*, [New York, 1961], 41). It seems however, that the "real toads" she is talking about are real ideas and emotions rather than, as in the issues under discussion in the present essay, real people.

2. This definition of 'plagiarism' is adapted from the definition of 'plagiarize' in *Webster's Third International Dictionary, College Edition* (Cleveland and New York, 1957), 1116.

3. I owe this suggestion to Rosalind Ladd.

4. Quoted in *Writers at Work*, edited by Malcolm Cowley (New York, 1958), 124, Faulkner puts forth this remark as a general statement about the responsibility of writers; he is not specifically addressing the issue of basing fiction on real people.

5. Dan W. Brock, "Informed Consent," in *Health Care Ethics*, edited by D. Van De Veer and T. Regan (Philadelphia, 1987), 110. (Italics in original.)

6. This point was made by Dan Brock and James Van Cleve in separate discussions with me.

7. The possible counterexamples to this principle involving issues related to plagiarism (alluded to in [7] of Section I) will be discussed in Section IV.

8. Muriel Spark, *The Prime of Miss Jean Brodie* (New York, 1984), 186.

9. For example, recent charges that Martin Luther King committed plagiarism in his Ph.D. thesis and also in some of his speeches have been countered with such claims as that "it was not uncommon . . . in dealing with abstract theological concepts, for interpreters to rely on and even paraphrase the same material" and that "Dr. King's speeches . . . borrowed from others because in the oral tradition in which Dr. King lived, it was common for ministers and preachers to adopt as their own the words of prominent men who had come before them." Anthony DePalma, "Plagiarism Seen by Scholars in Dr. King's Ph.D. Dissertation," *New York Times*, November 10, 1990, 1 and 10.

10. "The Forecasting Game," *Commentary* (December 1988): 49–56, reprinted in *Prize Stories 1990: The O. Henry Awards*, edited by W. Abrahams (New York, 1990), 315–35.

11. I presented some of the ideas in this essay in a talk to Rosalind Ladd's philosophy and literature class at Wheaton College in the spring of 1990. I am grateful to Professor Ladd and her students, as well as to Dan Brock, Sara Ann Ketchum, and James Van Cleve, for valuable discussions of this material. This article is dedicated to the memory of Mark Carl Overvoid (1948–88), who was always generous and helpful in discussing my own short stories with me.

Pictorial Representation:
A Defense of the Aspect Theory

T. E. WILKERSON

Mightn't it be taken for madness, when a human being recognizes a drawing as a portrait of NN and exclaims "That's Mr. NN!"—"He must be mad," they say, "He sees a bit of paper with black lines on it and takes it for a human!" [1]

1. SEEING ASPECTS

What is realistic art? What is realistic about it? And what is involved in my successfully interpreting a print, drawing, or painting? I am confronted with a two-dimensional rectangle of wood or plaster or paper or plastic or canvas, and I report that I see (in some sense of "see") a famous soldier or a park or a group of dancers. The objects I see (in that sense of "see") are arranged in three dimensions, and the human beings in the picture have quite definite attitudes, facial expressions, and gestures. Some philosophers have argued that a successful account of pictorial representation must give a central place to the notion of aspect-seeing. [2] They argue that X is a picture of Y if and only if the artist intends, by following the relevant conventions of realistic art, to persuade normal perceivers to see a Y-aspect in X. I interpret X successfully if and only if I manage to see its Y-aspect. Other philosophers have argued that that account of pictorial representation is far too vague, and that the central notion, that of seeing an aspect, will not bear the weight put upon it. [3]

Aspect-seeing is discussed at length in several later works by Wittgenstein, and I freely confess that this essay owes a great deal to my reading his *Remarks on Philosophical Psychology*. [4] I am one of those who believe that interpreting pictures is a special case of seeing aspects, and I plan to answer the accusation of vagueness by offering a detailed account of aspect-seeing. I shall have comparatively little to say about the special case, for if we can produce a satisfactory analysis of aspect-seeing, its role in the special case of pictorial representation can be understood quickly and easily.

Perhaps we should begin by locating aspect-seeing with the aid of a few examples. The most familiar example is Jastrow's duck-rabbit drawing: I see it, turned one way, as a duck, and turned the other way, as a rabbit. Similarly, I see a white maltese cross on a black background or a black maltese cross on a white background. Or I see a configuration of lines as a pyramid seen from the top, or as the inside of a pyramid seen from the bottom. These examples of ambiguous figures are certainly important, because they illustrate one striking feature of aspect-seeing to which I shall return—the occurrence of a distinctive experience. The experience in these cases typically includes a sudden feeling of a change of aspect. But it is worth stressing even at this very early stage that there are many cases of aspect-seeing that do not involve ambiguity. In a rather messy configuration I might see a face or a letter of the alphabet. In a sketch I might see something in motion, something retreating or toppling over. In a portrait I might see anger or delight or fear. I might, perhaps with a feeling of surprise, suddenly see a face in the silhouette of a vase or in clouds or ink blots or cracked plaster.

I shall review the range of cases in the next section, but in this section I want to set out a general account of aspect-seeing. I suggest that aspect-seeing has five main features, as follows.

(i) Aspect-seeing is typically detached from belief. In seeing a Y-aspect in X I typically do not believe that there is a Y in front of me. Whether struck by the duck-aspect or amused by the rabbit-aspect, of Jastow's figure, I do not believe that I am really confronted with a duck or with a rabbit. I do not believe that the triangle is toppling, or that someone in front of me is angry, or that I am imprisoned at the bottom of a hollow pyramid. Indeed, I think that in many cases we can reasonably move the negation operator and say boldly that typically I believe that there is no Y in front of me. I believe that there is no duck and no rabbit in front of me, and so on.

(ii) Aspect-seeing is subject to the will. My efforts to see a certain aspect may be unsuccessful, but I can intelligibly try to see it. Others can guide and assist my efforts by drawing my gaze to crucial parts of the figure, or by obscuring details, by turning the figure round, by offering verbal encouragement: "See it like *this*...." There is a clear contrast here with ordinary seeing, which is not in the relevant sense subject to the will. I can choose to put myself in the right place, polish my spectacles, remove obstacles, and switch on the light, but I cannot thereafter attempt to see what is in front of me. And no amount of cajoling or encouragement by others will help me to see what is in front of me. Whether I see it or not is beyond my control, or, more strictly, beyond the attempt.

Notice incidentally that there is an intimate connection between these first two features of aspect-seeing, for it is subject to the will precisely because it is detached from belief. I cannot attempt to adopt a belief. Nor can I switch back and forth from one belief to another in the way in which I switch back and forth from one aspect to another in an ambiguous figure. I can put myself

in circumstances which, I hope, will induce a certain belief (for example, by deliberately exposing myself to propaganda for one view, and scrupulously avoiding propaganda for any alternative view), but that is the best I can do. I cannot intelligibly choose that these preliminary efforts will produce the right result, will induce one belief rather than another. But, since aspect-seeing is detached from belief, since typically my seeing a Y aspect involves my believing that there is no Y in front of me, I can intelligibly attempt to see an aspect. I cannot try to believe that Napoleon is in front of me, but I can attempt to see a Napoleon-aspect.

(iii) Aspect-seeing often involves definite experiences, and one of them, the experience of suddenly noticing an aspect, or a change of aspect, is akin to the experience we describe as a sudden dawning of understanding. Aspect-seeing does not *consist in* the occurrence of the experiences, any more than understanding consists in the occurrence of drawings of understanding.[5] In both cases the central part of the analysis will be an account of certain capacities. But the experiences that typically accompany aspect-seeing are nonetheless very important. Aspects may suddenly dawn: after effort, I suddenly see a hollow-pyramid-aspect, rather as, after effort, I detect the sense of a knotty passage in a foreign language. The dawning, the flash of understanding, happens at a definite time, and may be accompanied by a feeling of the release of tension. In some cases the experience may involve strong urges or inclinations. When I see a triangle as toppling, or see a letter as pointing one way rather than another, I almost feel the urge to move in one direction, or to glance in that direction. Confronted by a mass of lines, I can almost feel myself tracing an outline, as though I were following the edges of an object with my finger. Success and failure in noticing aspects, and sudden changes of aspect, can be timed, just as we can time the onset or disappearance of a headache, or the noticing of a change in pitch of a sound. Just as it makes sense to ask and answer questions about the beginning, duration, and end of headaches, pains, ticklings, etc., so it makes sense to ask when I first noticed the aspect, how long I managed to see it, when, to my annoyance, I saw it no more. (Wittgenstein even seems to think that aspects can change in intensity: "There is such a thing as the flaring up of an aspect." Unfortunately his next sentence suggests that that remark should not be taken at face value: "In the same way as one may play something with more or less intense expression."[6]

(iv) In seeing a Y-aspect in S, I consciously focus my attention on a resemblance between X and Y. In some cases that will not be a remarkable achievement. For example, in seeing a triangle as a wedge or as a triangular hole I exploit virtually all the material in front of me. In other cases I may focus my attention on certain material only by blotting out the rest. For example, I may struggle to blot out most of a mass of lines in an attempt to pick out the numeral 4. In an ambiguous drawing I concentrate on one resemblance (e.g., to a duck) only by ignoring another (e.g., to a rabbit). I suspect that some philosophers have been trying to capture this fourth feature of aspect-seeing in their remarks about the "looks" or "appearances"

of pictures, clouds, ink blots, cracked plaster, etc.[7] But looks and appearances are very odd animals indeed, and we should, as far as possible, analyze aspect-seeing without referring to them. One very bold proposal could be summarized as follows. First, the "look" of a figure is not a simple non-relational property, but a complex relational property. Second, the relation in question is a three-place relation between figure X, an intentional object Y (the content of the Y-aspect), and a perceiver. And third, in the context of this discussion one term of the relation, namely the perceiver, does more work than the other two. For it is the focusing of attention that pulls everything together. The perceiver sees the Y-aspect in X by focusing attention on a resemblance between X and Y. However, many logicians will, quite reasonably, blanch at the prospect of a three-place relation between one intentional and two actual objects. Moreover, we cannot eliminate the reference to an intentional object, because some objects seen do not exist (e.g., unicorns) and some could not exist (e.g., Escher's staircase and water mill). So we might prefer to say, more simple and sanely, that any analysis of aspect-seeing should include a reference to a figure X, to an intentional object Y seen in X, and to a perceiver; and that we need to concentrate our analytical efforts on understanding the role of the perceiver. I shall return to this point in section 4.

(v) Aspect-seeing is an exercise of the imagination. Indeed, in many respects this is the most important feature of aspect-seeing. Since I shall have much more to say about it in section 3, I shall merely note it for the moment, and move on.

2. A RANGE OF EXAMPLES

In all his later philosophical work, Wittgenstein advised against simplistic theorizing nourished by excessive concentration on a small range of examples. Don't think, but look. And if we look, we find complexities and oddities, and inevitably discover that neat philosophical theories can at best cater for a limited number of examples. His advice is entirely appropriate in our discussion of aspect-seeing, so in this section I want to distinguish some of the main groups of cases, and to discuss certain attempts to simplify the classification. I offer the following list merely in an attempt to advance the discussion, and I pretend neither that the list is complete, nor that there is no overlap between one kind of case and another.[8]

(a) I see a two-dimensional array as three dimensional, and see certain details as a foreground, others as a background. For example, I see the black maltese cross on a white background, or I pick out a pyramid, or I see a staircase in an array of connected parallelograms.

(b) Sometimes I must supply missing detail, for example, in seeing a triangle as a mountain. It is as if I mentally draw in trees, glaciers, a snow line, etc. One of Wittgenstein's remarks, common to the *Philosophical Investigations* and the *Remarks on the Philosophy of Psychology*, is particularly apposite in

cases of this kind: "It is as if an image came into contact, and remained in contact, with the visual impression."

(c) I attribute motion or attitude to an object seen in the figure. I see the triangle as having toppled over; a man as moving uphill, or sliding downhill, or moving away from me. I see the letter F as looking right, or the letter J as looking left. An animal in a picture looks hesitant. A dot representing an eye looks in a definite direction.

(d) When I see humans and other animals in the figure, I see various expressions. I see faces that are sad, aggressive, quizzical, complacent. (Had we but World enough, and Time, we could profitably pursue Wittgenstein's interesting remarks about expression in music. Although there are fewer examples of aspect-hearing than of aspect-seeing, the notion of aspect-hearing certainly has application and repays discussion.)

(e) Some aspects require a selective connection and organization of detail. For example, to see a ship I need to connect certain details to form an outline of a ship, while ignoring the surrounding camouflage. In ambiguous drawings the ambiguity is revealed by organizing details, first one way, then another. Organized one way, the figure yields and F with extra tails; organized another way, it yields a T with a cross stroke; and so on. Wittgenstein sometimes calls these aspects "aspects of organization," and on at least one occasion draws an analogy with our use of brackets to isolate units of sense. The brackets force us to organize the sentence in a particular way, and in certain sentences different arrangements of brackets will yield different senses.

(f) Sometimes the figure is used as the basis of a story. In seeing the aspect I am exploring the reason for the triangle's having toppled over, or the cause of the animal's hesitant posture. I begin to wonder why the Mona Lisa is smiling. In certain cases aspect-seeing positively requires some background story. For example, when I see a battle in the figure (horses charging, soldiers fighting, etc.), I must make complex conceptual connections between what I see in the figure and other things (the rest of the army, out of sight, in another part of the battlefield).

(g) Closely connected with the previous group of cases are those where, in seeing an aspect, I make certain associations. The two cases are, however, not quite the same. In one I put the figure in the context of a story, and there is, as it were, a direct conceptual link between the context and content of the figure—between the charging horses in the figure and the unseen battle that I build around them. But when I make associations, there may be no such direct link. For example, in seeing an F I may think of flowing hair. In seeing a face or portrait I may see someone else's face. (Some of Lady Ottoline Morrel's friends reported, rather unkindly, that her face reminded them of a horse.) I think that one of Wittgenstein's puzzling examples belongs here: he sometimes talks of seeing vowels as having colors.

(h) Finally there are cases where I see a figure as a variation on something else. I might see different styles of printing or calligraphy as variations on common characters. I might connect very different caricatures, by different

artists, as pictures of the same public figure. (Again, some of the most interesting cases are to be found in music, but I shall respect my self-denying ordinance, and pass on.)

Earlier I said that my list of cases was very rough, and that not too much weight should be placed on the division into separate groups. Indeed, that warning is amply illustrated by the fact that examples involving the letter *F* appear in group c the attribution of motion or attitude, in group e aspects of organization, and in group g making associations. However, we might at this point be tempted to divide the list broadly into two halves, into the sensory and the intellectual. Some cases, we might say, are fundamentally cases of sensing, while others are fundamentally cases of interpreting. The earlier cases very much involve picking out or exploiting features directly in front of us (the geometrical features of the maltese cross, the expressions and attitudes of faces and animals, and so on), whereas the later cases involve the telling of stories, making connections and associations. Indeed, Wittgenstein himself toys with this suggestion, and remarks from time to time that "one could distinguish between 'purely optical' aspects and 'conceptual' ones."9

In a very interesting recent article, Malcolm Budd succumbs to a related but rather different temptation. He is apparently content to accept the Kantian language of sense and intellect, seeing and interpreting, but argues that aspect-seeing is neither fully sensory nor fully intellectual: "the concept of seeing an aspect *lies between* the concept of seeing the colour or shape and the concept of interpreting: it resembles both of these concepts, but in different respects."10 Again this suggestion echoes a remark by Wittgenstein: "So should I say that it is a phenomenon between seeing and thinking? No; but a concept that lies between that of seeing and thinking, that is, which bears a resemblance to both."11

My view is that we should succumb to neither temptation. Neither response is quite right. On the one hand, it is no good to distinguish "purely optical" aspects from "purely intellectual" because the perception of aspects, like the perception of everything else, requires the cooperation of sense and intellect. I must both perceive the object in front of me and bring it under concepts, classify it as belonging to a kind or kinds. So no perception is purely optical or purely intellectual; as Kant remarked, thoughts without content are empty, intuitions without concepts are blind. On the other hand, the suggestion that aspect-seeing falls somewhere between the sensory and the intellectual is hopelessly obscure. If, as I have just insisted, perception in general, and the perception of aspects in particular, requires the cooperation of sense and intellect, there can be no position *between* sense and intellect.

3. IMAGINATION

In order to lead us out of this thicket, I shall pursue the Kantian theme a little further. Most well-educated philosophers know that, according to Kant, our knowledge of the world around us is gained through the cooperation of

sensibility (the faculty of intuitions) and understanding (the faculty of concepts). One faculty provides a manifold of intuitions in space and time, and the other faculty combines, connects, and organizes according to various general rules or concepts. What is often forgotten, however, is that understanding on Kant's view is assisted by imagination in its work of organization and combination. What does he mean? In the context of an inquiry about our knowledge of the external world, he means that knowledge requires thought, not merely about actualities, but also about possibilities. If I am to identify a chair or a chimpanzee, I must have views about its *possible* behavior, about how it might and might not behave, how it can and cannot change. This important claim recalls Locke's remark that "powers make a great part of our complex ideas of substances."[12] I need to think about all kinds of counterfactual possibilities. In bringing concepts to bear, in using the faculty of understanding, I am not merely connecting diverse representations in the concept of an object. I am implicitly connecting actual representations with possible representations. Indeed, if I could not think about possible representations, I could not think about actual ones.

If we keep Kant's view in mind, and look a little harder at the role of imagination, we can make more sense of aspect-seeing. The crucial point can be expressed simply as follows. In normal perception the role of the imagination is necessary, but subordinate, to the roles of sense and intellect. But in the perception of aspects the imagination dominates, and sense and intellect are both in a subordinate role. My comprehension of the actual (e.g., the figure in front of my eyes) is subordinated to my thought about what is possible. The imagination takes over, and I concentrate entirely on what might be the case, or on what could be the case, given the limited sensory information available. I use the sensory information, not in an effort to form beliefs, but in an effort to explore possibilities.

The point still holds, incidentally, whether or not we insist on a distinction between "purely optical" and other (e.g., "intellectual") aspects. No doubt in cases which allegedly involve purely optical aspects we need to say something about how the figure strictly *looks*, and in other cases we need to say more about the stories we are inclined to tell ourselves. But in all cases there is a pursuit of possibilities, of what is thought not to be the case, of features and stories detached from anything one might intelligibly believe about the figure in front of one's eyes. That is why it is wrong to reduce aspect-seeing to some kind of sensory achievement, or to some kind of intellectual achievement, or to a combination of both. The detachment from belief (feature i in my general account of aspect-seeing) argues that it is the role of the imagination that is crucial. After all, imagination is often detached from belief, and not just in this context. Developing possibilities and pondering counterfactuals is consistent with believing that they are only possibilities and indeed counterfactual.

The connection between aspect-seeing and the imagination would reveal itself very clearly in a detailed examination of cases. It is no accident that the range of cases I sketched in section 2 closely reflects the range of cases

of imagination. Writers on the imagination, particularly since Wittgenstein and Ryle, have forced us to acknowledge that the imagination turns up in all sorts of guises. One obvious case is the case on which classical British Empiricists concentrated exclusively, namely the case of visualizing, the capacity to produce at will something that one is tempted to describe as a mental picture. But there are many other, equally important though less obvious, cases. A vivid imagination may be displayed in the skill of a novelist or playwright, who develops plot and character in an original, surprising, and illuminating way: in the work of a composer or painter, when producing variations on musical or visual themes. It is required to see new applications of old rules and formulae; to develop original solutions to knotty problems; to make connections between apparently disparate things; to display a sensitivity to, and talent for, metaphor; to possess a sense of humor and a feeling for the incongruous, the ridiculous, the ironic, the ambiguous. It would be very difficult to think of a human activity whose success did not depend on the imagination.

I shall not weary my readers by working solemnly through my examples of aspect-seeing in an attempt to pinpoint the exact role of the imagination in each case. But I hope that some of my remarks in the previous paragraph recalled some of those examples. For example case b, which involves supplying missing detail, is very close to an ordinary case of visualizing. I noted Wittgenstein's remark that "It is as if an image came into contact, and remained in contact, with the visual impression." Sometimes, I argued (case f), the figure is used as the basis of a story. Sometimes (case g) I make certain associations. Sometimes (case h) I see a figure as a variation on something else. In some cases there is an ambiguity which yields different aspects at different times. And so on. Aspect-seeing is clearly a special case of imagining.

4. THREE PROBLEMS

I must now confront my critics. They will complain that the account of aspect-seeing set out in the first three sections is far too vague and far too liberal. Indeed, as we shall see, even philosophers who are generally sympathetic to an aspect account of pictorial representation will find my account unattractive. They will argue that there are three problems that I cannot solve. The first problem, they will say, is that my account of aspect-seeing is so relaxed, so liberal, that I cannot distinguish between aspect-seeing, on the one hand, and eidetic imaging and after-imaging, on the other. We can illustrate the point very well if we borrow Flint Schier's example of the runic stones.[13] Imagine that a tribe has a curious funeral rite. When someone dies, his grandson is trained to project the image of his dead grandfather on to a certain stone, whose only marking is the dead man's runic name. It is a crucial part of the rite that the grandson's image is projected on to that stone and no other. So in some sense he sees his grandfather in the stone, but the seeing is not aspect-seeing.

Unfortunately, my critics will claim, I am committed to regarding that case as a case of aspect-seeing. I argued explicitly that sometimes I may see

what is in front of me as the prelude to a story, or I may associate it with something else, or apply it in a rather surprising or unusual way. If *those* are cases of aspect-seeing, then so is Schier's case, which is absurd. Or, to put the point another way, by loosening the connection between what is literally in front of me and the aspect seen, by allowing the imagination to supply so much, I have demolished the boundaries between aspect-seeing, on the one hand, and eidetic and after-imaging on the other. I have allowed aspect-seeing to collapse into the imaginative projection and exploration of virtually any scene and virtually any story on to the figure in front of me. Curiously, my failure will be evident, not just in my remarks about cases f and g, those where the figure is used as the prelude to a story, or encourages certain associations, but even in the entirely different case b, where I supply missing detail. "It is as if an image came into contact, and remained in contact, with the visual impression." But that is an admirable description of the dead man's grandson, and his skill is an example of eidetic imaging!

One reply to this criticism would not work. One might try, in vain, to extract significance from standard characterizations of aspect-seeing, e.g., as "seing X as Y" or "seeing Y in X" or as "seeing a Y-aspect in X." That is, one might be tempted to argue that aspect-seeing, unlike eidetic imaging and after-imaging, entails at the very least *seeing* something (a surface, a configuration of lines, or whatever), in a straightforward sense of "see." But the reply would not work, because eidetic imaging and after-imaging also require seeing in a straightforward sense of "see": both eidetic images and after-images are projected upon a surface.

A much better reply has three parts. The first part consists in pointing out that after-imaging presents no problem, because it is not subject to the will. I can of course choose to look for some minutes at a bright light in the confident expectation that, when I turn away, I will see an after-image but I cannot simply and directly choose to produce an after-image. But one central feature of aspect-seeing (feature ii in my list) is that it is subject to the will. So I am in no danger of confusing aspect-seeing with after-imaging. If there is a problem, it concerns eidetic imaging. The second part of the reply is to argue that we should not be too anxious to make sharp boundaries. In particular, there may be no clear boundary between aspect-seeing and eidetic imaging, and we may find it very difficult to assign certain cases to one category rather than to the other. Imagine a variation on Schier's example. Suppose that elders of the tribe discover that grandsons often find it difficult to learn how to project images of their dead grandfathers on to the runic stones, but learn very quickly if just one feature of the dead man's face is represented on the stone. If, for example, the line of the nose is represented, the grandson soon learns to supply the rest. Would that be a case of aspect-seeing, or a case of eidetic imaging? I do not know, and I do not think it is important to make a decision. And if it could be shown that some of my examples of aspect-seeing in section 2 are very close to, or even fall over, the boundary with eidetic imaging, I would not be concerned.

This third and most important part of the reply is an invitation to think about the fourth feature of aspect-seeing set out in section 1. I claimed that aspect-seeing involves conscious attention to, and exploitation of, a resemblance between figure or surface and aspect. I fasten on to certain details of what is in front of me and use them to construct an aspect or aspects. And that is true in the two very different cases that allegedly give rise to this first problem. For example, in seeing a triangle as a mountain I supply much missing detail, but only because the triangular figure already bears a partial resemblance to the mountain that is the content of the aspect. As for the other examples, in making connections and associations, or in using the figure as a part of or the prelude to a story, I am exploiting a partial resemblance between it and objects that are the content of the aspect. I tell a story about a battle only if the surface partially resembles soldiers and horses. In contrast, eidetic imaging merely requires a surface of some kind, and the surface may have no significant resemblance to, or connection with, the objects projected on to the surface. Indeed, eidetic imaging is easiest when the surface is bland and homogeneous, when no special flecks of color or indentations can threaten to distract the eidetic imager. I conclude, therefore, that my account of aspect–seeing, though liberal, does not undermine the distinction between aspect-seeing and eidetic imaging.

Let us turn to a second supposed problem. It might be objected that my account is so liberal that I am forced to regard as cases of aspect-seeing cases that are clearly nothing of the sort. The cases certainly are cases of seeing and interpreting, but it is not the kind of seeing and interpreting that counts as aspect-seeing. One kind of example comes from Wollheim.[14] Imagine paintings in which colors are systematically reversed in the service of some artistic effect, so that red objects are represented by patches of green, and green objects by patches of red. I could easily discover the convention, and interpret the picture. That is, I could appreciate the significance of the patches of red and green pigment, and give a plausible account of the point of the unusual convention. But I could not intelligibly see a red aspect in the green, or a green aspect in the red. Another, rather different, kind of example is suggested by Wittgenstein: "I can see the schematic cube as a box, but *not*: now as a paper box, now as a tin box."[15] Presumably I could from a context tell an appropriate story about a paper box, and then a story about a tin box, but at no point would I see a paper-box-aspect or a tin-box-aspect. Yet on my account of aspects, which allows aspect-seeing to cover the making of associations and connections, and the telling of stories, the change from the story about a paper box to a story about a tin box would count as a change of aspect.

Those who hope for guidance from the great philosophers of the past will, I fear, be disappointed in Wittgenstein. His remarks about this problem are often very obscure and apparently inconsistent. At times he seems to be arguing for a restriction on the range of features that could count as the content of aspects, and at others seems to be thoroughly permissive. For example, in one place he seems clearly to take the view that interpretation of pigments is not necessarily aspect-seeing: " 'The aspect is subject to the will.' This isn't an empirical

proposition. It makes sense to say, 'See this circle as a hole, not as a disc', but it doesn't make sense to say 'See it as being a rectangle', 'See it as being red'."[16] But if I interpret him correctly, he is far more liberal elsewhere, even, it would seem, allowing us to see one color in another: "An aspect is subject to the will. If something appears blue to me, I cannot see it red, and it makes no sense to say 'See it red'; whereas it does make sense to say 'See it as . . .' . . . It is essential that one can say 'Now see it like *this*' and 'Form an image of . . .'."[17]

Bereft of Wittgenstein's guidance, let us face the problem. I want to say that there is no problem, because there *are* circumstances in which I might intelligibly see a red aspect in green, or a green aspect in red, and see a paper-box-aspect, rather than a tin-box aspect. I have two connected reasons for taking this apparently perverse view. One reason is that we should be very wary of putting too much weight on considerations about what is directly in front of me when I look at a picture. I suspect that those who disagree with me believe that aspect-seeing is closely circumscribed by the features of the surface— by the color and arrangement of lines and pigments. They believe that green aspects are definitely excluded by red pigment, and that paper-box-aspects are definitely excluded by the impossibility of representing paper as paper (or, *mutatis mutandis*, of representing tin as tin). As I indicated in section 2, I accept Kant's view that all seeing involves interpretation, the use of concepts, and I can therefore see no general requirement that I should bring every patch of red under the concept *red*, or every patch of green under the concept *green*. Nor can I see any general reason for my being unable to bring an area of any figure, in an appropriate context, under the concept *paper* or the concept *tin*.

My other reason, as my list of cases in section 2 amply demonstrates, is that aspect-seeing involves a careful and selective use of detail in the figure in front of me, and the principal details may compel me to see a red aspect in a patch of green, or a green aspect in a patch of red, or to see a paper box rather than a tin box. Indeed, if we consider Wollheim's example, there are actual cases which seem to support my view rather than his. One case is the interpretation of willow pattern pottery. As I make sense of the scenes depicted on the pots, I am not restricted to color-aspects in shades of blue and white or green and white. The scenes, properly interpreted, force me to tell stories or fragments of stories, which in turn force me to see color-aspects in sky and stream and house and bridge that are quite different from the colors of the pigment applied by the potter. Another case is the interpretation of monochromatic photographs, which often force us to see polychromatic tones in the monochromatic tones of the print. Perhaps this point is better illustrated by sepia photographs than by black and white: there are so many connections and associations between sepia and other colors (particularly reds and yellows) that it is comparatively easy to see a range of colors in the monochromatic range from pure white to pure sepia.

We can deal with Wittgenstein's example in very much the same way. Cartoonists are adept at forcing specific aspects economically upon their

readers. Wooden objects can be drawn with grain and knots; shiny metal is drawn as though reflecting images of the passing show; cartoon characters disappear into stretches of water, leaving splashes and ripples behind them, but suffer grotesque bruising when they make contact with bricks and concrete; and so on. In a strip cartoon the earlier frames, depicting a visit to a manufacturer of paper or tin, would be enough to force me to see a paper-box aspect or a tin-box aspect in later frames. I conclude that neither Wollheim nor Wittgenstein has produced a counterexample to my account of aspect-seeing, and that the account is by no means too liberal.

The third problem I want to discuss is very familiar, and concerns the notion of resemblance. My critics will object that my account of aspect-seeing leans very heavily on the notion of a resemblance between the figure and the object that is the content of the aspect. And unfortunately, they will say, for familiar reasons that notion cannot bear the weight put upon it. One difficulty (which I have touched on obliquely in discussing the first two problems) is that any two things resemble one another in some respect, and so the figure will resemble an enormous number of objects, both the object in the aspect and many others. Moreover, resemblances can be very slight, and the resemblance between figure and object can be very slight. Another difficulty is that I might notice a resemblance between X and Y without seeing a Y-aspect in X. For example I might make a perfect copy of a figure without seeing any aspect, without seeing anything but a jumble of lines. Copying requires the ability to see a resemblance, but mundane copiers, who reproduce line for line, dot for dot, still might see no relevant aspect, either in the original or in the copy. Indeed, they might even copy the original upside down![18]

In order to solve this problem we need to appreciate the very close connections between the five main features of aspect-seeing set out in section 1. Indeed, on my account the notion of resemblance carries comparatively little weight. Much more weight is carried by remarks about the will (feature ii), about the visual experience (feature iii), about conscious *attention* to a (typically partial) resemblance between figure and object (feature iv), and about imagination and the related detachment from belief (features v and i). The case of the mundane copier, far from undermining my account, illustrates its virtues very well. Copiers may need the ability to spot a resemblance, and the better their ability, the closer the resemblance between the original figure and their copies. But they will not attach any more significance to one point of resemblance than to any other. They will not deliberately and consciously direct their attention to a (typically partial) resemblance between figure and object (ii and iv). They will not be aware of any special kind of experience, or feel the sudden dawning of an aspect, notice an aspect hitherto unnoticed in the configuration of copied lines (iii). They require no effort of imagination, in its detachment from belief, no thought about counterfactual possibilities (i and v). If they are to do their job properly, mere copiers must give full and equal weight to every detail of the original figure. In contrast, the seer of aspects is positively required to fasten on to selected details. So it is not surprising that

the resemblance between figure and aspect is often very slight, for the important point is that I focus on or attend to the resemblance, feel myself drawn to it, imaginatively exploit it, . . . and so on.[19]

One other point needs to be made about the notion of resemblance. In the previous paragraph I was at pains to stress that the notion bears less weight in the account of aspect-seeing than is often realized. But it is equally important to stress that it cannot be eliminated from the account entirely. We must remember that the aspect account of pictorial representation was in part a response to other views, and in particular a response to Gombrich's view[20] that the interpretation of pictures essentially involves a subversion of belief, and to Goodman's view[21] that it is very similar to the interpretation of sentences. Clearly these views are very different, and although Gombrich's view is simply false (as I have argued elsewhere[22]), Goodman's is not so much false as incomplete. But the two views share one weakness: they include no reference whatever to the one feature that makes realistic art realistic, namely the artist's exploitation of resemblances between picture and object. I cannot see how we can begin to distinguish realistic conventions from others if we are not prepared to grasp this nettle, and include some crucial reference to resemblance in our final account of pictorial representation.

5. SEEING ASPECTS AND INTERPRETING PICTURES

I am now in the happy position of being able to state the obvious, to set out the account of pictorial representation that follows from my account of aspect-seeing. On my account the interpretation of pictures is one special case of aspect-seeing. It is only one case because I can see aspects in cloud formations, in cracked plaster, in the bark of trees, in the silhouettes of rocky cliffs, in capital letters, etc., but none of those are pictures. What extra conditions must we add to isolate the special case in which we are interested, the case of seeing aspects in pictures? I think that there are two main conditions, which are closely connected. We can approach them by first borrowing and adapting an example from Hilary Putnam.[23] Suppose that, when Putnam's ants have crawled across the sand, they leave behind them something that looks to us just like a line drawing of Winston Churchill. Would it be a *picture* of Winston Churchill? I think not. We would see the Churchill-aspect in it, but it would not be a picture of him. I think that Putnam is right to insist on one general constraint on the notion of representation, namely that the representation must have the right sort of causal connection with the real world, and in particular with objects of the kind represented. So that will be my first condition: in interpreting a picture I am seeing appropriate aspects in a genuine *representation*, in something that has the right sort of causal connection with the real world, and in particular with objects of the kind pictured.

But what exactly is the right sort of causal connection? We appear to be in immediate difficulties, for, as I noted earlier, the objects seen in aspect-seeing are intentional and may not (indeed, in certain cases, could not) exist.

I may see unicorn-aspects, or continuously-descending-staircase-aspects. But I think that the difficulty is much less serious than it appears. For it is a general difficulty faced by anyone offering a general account of representation; it is not a difficulty peculiar to my account of pictorial representation as a special case of aspect-seeing. Crudely, when eventually we have a general theory of representation, a theory which describes those features common to sentences, pictures, thoughts, beliefs, etc., I will help myself to it. In case some readers find that remark unacceptably evasive, I will also suggest that one possible way of resolving the difficulty is to distinguish between central and peripheral cases. In the theory of meaning we should first attempt to analyze sentences about brains and vats (whose use must have the right sort of causal connection with brains and vats) and then, much later, attempt to deal with sentences about unicorns and impossible objects. Similarly, in our discussion of pictures we should think first about pictures of shoes and ships and sealing wax, and move on to pictures of mythical and impossible objects much later.

We can now turn to the second condition which distinguishes the interpretation of pictures from other cases of aspect-seeing. Again we can take our lead from Putnam, for he suggests that part of the story about the right sort of causal connection between representation and object represented is an account of intentions. In the context of a discussion of pictorial representation the intentions of the artist are quite specific—and therefore worth articulating in a separate condition. We need to return, yet again, to the notion of resemblance, and to the fourth feature of aspect-seeing: in seeing a Y-aspect in X, I consciously focus my attention on a resemblance between X and Y. A slight paraphrase, and the introduction of a reference to the artist's intentions, yields my second condition: in interpreting a picture I see aspects in an artifact which is intentionally produced according to conventions that exploit resemblances between picture and pictured.[24]

NOTES

1. L. Wittgenstein, *Remarks on the Philosophy of Psychology* (Oxford, 1980), vol. I, para. 965. I shall refer to this as *RPP*.

2. See R. Scruton, *Art and Imagination* (London, 1974), Chap. 8; R. Wollheim, *Art and Its Objects*, 2nd. ed. (Cambridge, 1980), 205–26; T. E. Wilkerson, "Art, Illusion and Aspects," *British Journal of Aesthetics*, 18 (1978).

3. See Flint Schier, *Deeper into Pictures* (Cambridge, 1986), Chaps. 1–2, and D. Peetz, "Some Current Theories of Pictorial Representation," *British Journal of Aesthetics* 27 (1987): 232.

4. I am sorry to say that the indices of both volumes of *RPP* are totally inadequate. They record occurrences of key words such as "aspect," but are strangely insensitive to relevant material in which the key words do not occur. Anyone interested in Wittgenstein's views on these matters should look at the following paragraphs. Volume I: 1–36, 70–77, 80–86, 89, 99–101, 315–21, 379–81, 411–34, 505–46, 860–82, 888, 899–900, 918–20, 953–54, 962–68, 970–71, 974, 976–84, 986–95, 997–99, 1002–25, 1028–36, 1041–49, 1064–77, 1100–07, 1110–26, 1130. Volume II: 36–45, 219, 355–91, 436–53, 456–96, 506–27, 530–56.

5. Compare L. Wittgenstein, *Philosophical Investigations*, 2nd ed. (Oxford, 1958), part I, paras. 151–55. I shall refer to this as *PI*.

6. Wittgenstein, *RPP* I, 507.

7. E.g., Wilkerson, "Art, Illusion and Aspects," 51.

8. Again I lean heavily on Wittgenstein. Comments on each group of cases can be found in the following paragraphs of *RPP*. (a) I: 31, 417, 425, 429, 1023. II: 391, 450, 491. (b) II: 449. (c) I: 19, 24, 315, 865, 880, 1066. II: 358, 459–60, 487, 510–11, 550. (d) I: 71, 247, 381, 545, 919–20, 991, 1041, 1070–71, 1101–03, 1106. II: 385, 550, 552. (Interesting remarks on aspect hearing include I: 22, 90, 507, 517, 545, 660, 888, 945, 1130; and II: 468, 469, 494, 695.) (e) I: 22, 533–39, 970, 992, 1113–14, 1119–25. II: 360, 460, 538. Compare *PI* p. 208d. (f) I: 297, 381, 1003, 1029, 1036. II: 369, 378, 387, 460, 506. (g) I: 32, 100, 528, 970, 1007. Compare PI p. 202g, 210f, 216g. (h) I: 508, 510–17. II: 494.

9. *RPP* II, 509. Compare I, 970.

10. Malcolm Budd, "Wittgenstein on Seeing Aspects," *Mind* 96 (1987): 16.

11. *RPP* II, 462.

12. J. Locke, *Essay Concerning Human Understanding*, II, 23, 8.

13. Schier, *Deeper into Pictures*, 17–18.

14. R. Wollheim, *On Art and the Mind* (Cambridge, Mass., 1974), 25.

15. *RPP* II, 492. Compare PI, 208b.

16. *RPP* II, 545.

17. *RPP* I, 899. I concede that the final sentence of that paragraph may undermine my interpretation of Wittgenstein. He *may* be arguing that colors cannot, after all, be the contents of aspects.

18. Compare *RPP* I, 954, 991, and PI, 198f.

19. Compare *RPP* II, 219.

20. E. Gombrich, *Art and Illusion* (London, 1960).

21. N. Goodman, *The Languages of Art* (Oxford, 1969), esp. 40ff.

22. Wilkerson, *"Art, Illusion, and Aspects."*

23. H. Putnam, *Reason, Truth and History* (Cambridge, 1981), chap. 1.

24. I would like this essay to be regarded as a small Festschrift to mark the impending retirement of Dieter Peetz. He initiated the study of aesthetics at Nottingham University and has for many years single-handedly sustained it. Nonetheless he rejects my account of pictorial representation!

Two Approaches to Representation—and Then a Third

NICHOLAS WOLTERSTORFF

In his recent book, *Mimesis as Make-Believe*, Kendall Walton escapes the curse on twentieth-century Anglo-American aesthetics—the curse of being theoretically non-serious—and offers a theory of representation. As a result of Walton's development of his theory we now know much better than we did the powers and limits of a certain line of thought about the arts. In what follows I wish to contrast Walton's approach to representation with my own, delineated in my *Works and Worlds of Art*; and then, in the light of this comparison, to suggest that what we really need, if we are to account for all the phenomena, is a third approach which incorporates but goes beyond each of ours.

Walton's theory makes essential use of the concept of *imagining*. Walton does not offer a theory of imagination; even what he says about it by way of description is relatively little. He says he is not able to do much more than that. But he also insists that, for his purposes, the relatively little he says is enough: we all know well enough what imagination is for him to be able to proceed to develop his theory. I think he is right about that.

Using the concept of imagination, Walton's central claim is that something is a representation in case its function is to serve as a prop in games of make-believe authorized for it. Games of make-believe are 'games' whose rules specify that so-and-so is to be imagined; they *mandate* imagining, as Walton often puts it. Such rules, for the most part, are not categorical but conditional—for the most part not of the form, imagine that so-and-so, but of the form, *if* such-and-such is the case or occurs, *then* imagine that so-and-so. As Walton repeatedly emphasizes, it may be *mandated* in some game that such-and-such propositions are to be imagined without anybody ever in fact *imagining* them.

An object is a *prop* in a game of make-believe if, in that game, it plays an essential role in bringing it about that such-and-such imaginings are mandated for the players of the game. "Props are generators of fictional truths, things

which, by virtue of their nature or existence, make propositions fictional" (37). Of course props generate fictional truths only when principles of generation (i.e., rules of mandated imagining) are in force for the objects which are the props. Which rules of mandated imagining are in force "depends on which ones people accept in various contexts. The principles that are in force are those that are understood, at least implicitly, to be in force" (38).

Often an object will have the *function* of serving as a prop in some game of mandated imagining rather than just doing so in *ad hoc* fashion; we may then speak of the game as *authorized* for that object (51). At least in the case of representations, function "might be thought of as a matter of there being rules or conventions about how the work is to be used. Appreciators are supposed to play certain sorts of games with the work. . . . In the case of representations, . . . there are meta-rules, constituting the works' functions, which prescribe the playing of certain sorts of games, and these games have their own prescriptions based on conditional rules conjoined with the works serving as props" (60–61).

Walton speaks of the propositions which are mandated for imagining in some game of make-believe as *fictional* in that game; this is the core of his account of fiction. A "fictional truth consists in there being a prescription or mandate in some context to imagine something. Fictional propositions are propositions that are *to be* imagined—whether or not they are in fact imagined" (39). There are games of mandated imagining which do not involve props. So, too, there are objects which serve as props in certain games without this being their *function*. Thus fiction goes beyond representation.

When an object has the function of serving as a prop in games of make-believe authorized for it, we can distinguish between the propositions which are fictional in those games as a whole, and that subset of propositions which are "fictional in *any* game in which it is the function of the [object] to serve as a prop, and whose fictionality in such games is generated by the [object] alone" (60). We may speak of the latter as constituting the *world* of the *work*. "The propositions fictional in the world of a work are [among] those that are or would be fictional in worlds of games in which it is the work's function to serve as a prop" (61).

From the foregoing it is clear that, on Walton's view, "The institution of fiction centers not on the activity of fiction makers but on objects—works of fiction or natural objects—and their role in appreciators' activities, objects whose function is to serve as props in games of make-believe" (88). To this he adds, as one would expect, that "Fiction making is merely the activity of constructing such props."

What, by contrast, are the main lines of the approach I took in *Works and Worlds of Art*? Before I answer that question let me observe that Walton and I are in agreement that there will be three main elements in any satisfactory theory of fictional representation. For one thing, propositions and not just objects will have to play a central role in the theory. Second, the theory will have to appeal to the activity of imagining, or of considering, or of supposing, or to all of

these or something else in that region. In *Works and Worlds of Art* I hesitated plumping solidly for imagining because it seemed to me that to imagine that *p* is to imagine that *p* is the case, and that one cannot imagine that *p* is the case when one is fully aware that logically and ontologically it couldn't be. Yet there are worlds of fiction which we fully know to be logically/ontologically impossible. It may be that my hesitation was not solidly grounded and that Walton is right in connecting fiction with imagination. Nothing that I want to say here hangs on whether that is so. Third, the theory will have to appeal to mandates, or rules, or prescriptions, or something else of that sort—to some locus of normativity, to something which brings it about that one can do things right and do them wrong. The central challenge in formulating a theory of fictional representation is to get these three fundamental elements related in the right way; a secondary challenge is to get a better grasp on those elements themselves.

How then did I relate these elements? By placing at the center of my theory the *action* of representing, which, so I argued, was a speech action, more particularly, an illocutionary action. Thus mine was a *speech act* theory of representation in contrast to Walton's *socially-functioning-objects* theory. Fundamental to representation is not objects representing but human beings performing the action of representing by their use of objects.

To fictionally represent something is to perform an action which *counts* as taking up a fictive stance toward certain propositions; it is to perform an action which counts as *fictively projecting a world.* (Actually I pretty much confined the use of the word "representation" to *pictorial* world-projection; I think we are misusing the English word "represent" when we speak of texts as representing. But nothing of any substantive importance hangs on this difference of word usage between Walton and myself; and for the purposes of this discussion I shall follow Walton in his usage.) The action which counts as fictionally projecting a world may or may not incorporate producing some object, or in one or another way acting upon or presenting some object. When someone does fictively project a world by way of producing a literary text, a painting, a work of music, or whatever, then the world of the work consists of those propositions toward which the artist took up the fictive stance by way of producing that work—plus whatever else is appropriately extrapolated therefrom.

The fictive stance itself, so I suggested, consists of an inviting or enjoining to imagine, consider, or suppose. What makes a text fictional is that it is to be understood as having the tacit preface "Let it be supposed (imagined, considered) that:..." or "Let us suppose (imagine, consider) that:..." I acknowledged that we do speak of certain objects as representing things, that we do not just speak of persons as (performing the action of) representing; but that, so I argued, was a secondary, derivative sense of "represent," parasitic on the primary sense in which it is persons who represent. I said more, much more, on these topics—the better part of a book's worth! But this will do for our purposes here, since it is not the in's and out's of either Walton's theory or mine that here concern me but these two *approaches* themselves.

What does Walton say by way of defending his own approach and rejecting the speech act approach? There is in the literature a type of speech act approach which locates fictionally in *pretending* to perform illocutionary actions rather than locating it in the performance of that unique illocutionary action of taking up the fictive stance toward some proposition—i.e., the illocutionary action of *inviting to imagine*. Walton also considers, and rejects, that alternative speech act approach; but let me here address myself only to the grounds he gives for dismissing illocutionary act theories.

The passage in which Walton presents his objection is one of the least lucid in a book which is otherwise eminently lucid, but I think it is best read as containing three arguments. For one thing, Walton refuses to acknowledge that there is any such action as (fictively) representing something, and so, of course, that there is any such *illocutionary* action as that. There is indeed the non-illocutionary action of making something whose function is to represent—making something whose function is to serve as a prop in games of make-believe. But there is not, in addition to that action of making a representation, a distinct action of representing. "Fiction making is merely the activity of constructing such props" (88).

When a furniture maker constructs a table, he makes something whose function is to serve as a table; he does not, in addition to that, perform the illocutionary action of tabling, since there is no such action. Nor can one perform the action of tabling without producing something whose function is to serve as a table—for the same reason. Walton thinks of fiction making along the lines of table making.

Why does Walton deny that there is the action of representing—i.e., the action of fictional world-projection? The closest he comes to answering that question explicitly is in the following passage:

> The fundamental disanalogy between illocutionary actions and acts of fiction making comes out in differences in the roles of agents' intentions. A crucial question for a person on the receiving end of an illocutionary action is almost always, Did he mean it? Did he intend to assert this, to promise that, to issue such and such an order or apology? But one may well read a story or contemplate a (fictional) picture without wondering which fictional truths the author or artist meant to generate. Photographers, especially, can easily be unaware of fictional truths generated by their works. Authors and other artists may be surprised at where extrapolation from the fictional truths they intentionally generated leads The notion of accidental fiction making is not problematic in the way that that of accidental assertion is. (88)

What exactly is Walton's argument here? One can think of the theory I developed as making four claims at this point: That there is such an action as *inviting to imagine*, that that action is an illocutionary action, that to perform that action is to compose a piece of fiction (i.e., to fictively project a world), and that when one performs this action by composing or presenting an object

(of a certain sort) one represents. Which of these four claims does Walton wish to contest?

I think it is best to think of him as contesting the third, and thereby also the fourth. Nowhere does Walton directly address himself to the question of whether there is the action of *inviting to imagine*; if he had directly addressed himself to the question, it seems most unlikely, given his own theory, that he would have denied that there is this action. Since he nowhere explicitly considers this action, he also nowhere considers whether it is an illocutionary action. Walton's claims are rather that when someone composes a work of fiction, she makes something whose function is that of a work of fiction, that this is not an illocutionary action—*and that there is no other action in the region which has any title to be called representing, or fictionally projecting a world, or anything of the sort.*

Let me halt the progress of the argument for just a moment to point out that I did not merely hold that *inviting to imagine* is an illocutionary action, but that it belongs to a special sort of illocutionary action to which such paradigmatic illocutionary actions as asserting and commanding also belong. I called the members of the sort in question, *mood-actions*. Consider, I said, such sentences as

 (1) "I hereby assert that the door will be closed,"
 (2) "I hereby command that the door (will) be closed,"
 (3) "I hereby ask whether the door will be closed,"
 (4) "I hereby express the wish that the door will be closed,"

and

 (5) "I hereby promise that the door will be closed."

Each of these has the following peculiarity: If a person, by uttering the sentence "I hereby ø that the door will be closed," *asserts* that he thereby ø's that the door will be closed, then it *follows* that he has ø'ed that the door will be closed. In the light of this fact I offered the following explanation of the concept of a *mood-action*:

> Consider some English sentence of the form 'I hereby ø that *p*.' If, from the fact that a speaker by uttering this sentence has asserted that he thereby ø's that *p*, it follows that he has ø'ed that *p*, then ø-ing is a *mood-action*.

(To this formula I added a few refinements; these need not here concern us.) I then observed that the action of presenting (offering, enjoining) for consideration (for imagination, for supposition) fits the definition of a mood-action. *Inviting to imagine* is not merely an illocutionary action but that special sort of illocutionary action which consists of taking up a mood stance (as I called it) toward some state of affairs. There is a deep affinity between this action and such actions as asserting, commanding, asking, and expressing a wish.

Back to Walton. Walton's response is that when someone makes a work of fiction, there is no illocutionary act directly in the region. He does not deny that there is the action of *inviting to imagine*, nor does he deny that this is

an illocutionary action—more specifically, a mood action. He simply does not address himself to these claims. He does not address himself to them because he regards each of them as an irrelevance. There is no such action as fictionalizing or representing—unless one wants to baptize with these words the action of making an object to function as fiction or representation. So of course the question as to the nature and identity of that action does not arise.

What is his reason? This: When we regard someone as having performed such illocutionary actions as asserting, promising, commanding, and apologizing, we are almost always concerned with whether the agent *meant* or *intended* "to assert this, to promise that, to issue such and such an order or apology." By contrast, when we are confronted with what we regard as acts of fiction making, we are not thus concerned with intention. One of the telltale marks of acknowledging the performance of an illocutionary action is missing.

Is this claim correct? Surely not. Someone's being interested in what a speaker meant or intended is far from a telltale clue of his taking himself to be confronted with an illocutionary action but not with fiction; likewise, someone's not being interested in that is far from a telltale clue of her taking herself not to be confronted with an illocutionary action, and possibly with fiction. When a teacher reads student papers, or when any of us read legal documents, our interest is for the most part in what the writer *did* assert rather than in what he or she meant to assert. On the other hand, many people exhibit intense interest in how exactly Jesus *meant* his parables to go. It is true that we typically flesh out the worlds of the fiction we are confronted with. But then, on the other hand, Socrates exhibited intense interest in the implications of what was asserted by those who were participating with him in the dialogues Plato reports. In that, Socrates was hardly peculiar. Whether or not a listener or reader is interested in the intentions behind, and in the implications of, what was said by someone is more a function of the purposes of the listener or reader and less a function of their taking themselves to be confronted with assertion (command, question, etc.) or with fiction. I conclude that Walton gives nothing even near a persuasive reason for his claim that there is no such action as representing.

With some plausibility one can interpret the passage in which Walton addresses himself to the illocutionary theory of representation as containing a second argument against the theory: Even if there were such an action as representing, close scrutiny of how we interact with fiction makes it clear that the action plays no role in our interaction. In much of our interaction with fiction in general, and with representations in particular, we have no concern at all with authors and makers and what they did; we care just about the artifact and how *it* functions. By contrast, in the case of illocutionary actions we care very much about the action.

> Sentences are important as vehicles of such actions. A naturally occurring inscription of a sentence of a kind normally used to promise or request or apologize or threaten would be no more than a curiosity.

Contrast a naturally occurring story: cracks in a rock spelling out "Once upon a time there were three bears" The realization that the inscription was not made or used by anyone need not prevent us from reading and enjoying the story in much the way we would if it had been. It may be entrancing, suspenseful, spellbinding, comforting; we may laugh and cry. Some dimensions of our experiences of authored stories will be absent, but the differences are not ones that would justify denying that it functions and is understood as a full-fledged *story*. . . . To restrict "fiction" in its primary sense to actions of fiction making would be to obscure what is special about stories that does not depend on their being authored, on their being vehicles of person's storytellings. The basic concept of a *story* and the basic concept of *fiction* attach most perspicuously to objects rather than actions.

Stories do not often occur in nature, but fictional pictures do. We see faces, figures, animals in rock patterns and clouds. The patterns of clouds are not vehicles of anyone's acts of picturing, of fiction making. But to rule that this automatically disqualifies them as pictures or that it makes them such only in a secondary sense would be to slight their role as props. (87)

Before considering the argument in this passage, let me observe that it is extremely doubtful that Walton's theory yields the consequence that 'faces' in clouds and 'words' in rock cracks constitute representations. To be representations, they have to have the *function* of mandating imagining; and this function can be thought of, says Walton, as a meta-rule mandating the use of the object as prop in games of make-believe. Obviously cracks in rocks do sometimes *prompt* us to imagine words on the rocks, and cloud formations do rather often *prompt* us to imagine faces in the clouds. But Walton himself emphasizes that *prompting imagining* is not to be identified with *mandating imagining*.

Surely one would not in normal English say that cracks and clouds have the *function* of mandating imagining. Yet Walton explicitly refrains from attaching any special meaning to the word "function." And if one goes by Walton's account of what it is to have the function of a representation—viz., for there to be a meta-rule mandating the use of the object as prop in games mandating imagining—it is even more clear that they do not have this function. If there were such a meta-rule, it would be relevant for one person to say to another, when both are looking at those cracks but the other is not imagining any words there, that he *should* be imagining the words. So, too, it would be relevant for one person to say to another, when both are looking at a cloud formation but the other is not imagining a face there, that he *should* be imagining that. I submit that almost always this would be a very odd response. The natural response would be incredulity—"You *don't* see it!"—rather than injunction.

Walton concedes that it is not at all atypical for us to be interested in the makers of works of fiction as well as in the fictions. He insists, though, that this interest is not like that which we have in the performer of an illocutionary action but—here I once again use my own analogy—like that which we sometimes have in the designers and makers of furniture.

We will not achieve insight into the author or her society if there is no author, nor will we admire her skill as a story-teller or marvel at the perceptiveness of her vision of the human condition. Neither will we acknowledge her affirmations or protestations or receive her promises or apologies. But these opportunities, when we have them, are *consequences* of the author's having told a story, having produced an object whose function is to serve as a prop of a certain sort in games of make-believe. It is because she did this that we achieve insights about her or marvel at her perceptiveness or whatever. . . .

What I insist on is separate recognition of the primary function of being a prop in games of make-believe, whether or not someone's producing or displaying something with this function is also of interest, and whether or not that function is conferred on it by the maker or displayer. (87, 89)

Just as a table may lead us to be interested in, and to admire, the table maker, so a piece of fiction may lead us to be interested in, and to admire, the fiction maker—if there is one.

In the first place, it is indeed true that sometimes in our approach to fiction we are unconcerned with what the maker used the artifact to represent—if there was a maker. But Walton is quite mistaken to see in this a difference in 'the nature of things' between our approach to assertion and our approach to fiction. Admittedly it is characteristic of the reading habits introduced by the Renaissance humanists, and now practiced by most of us most of the time, to look for what the author said by way of his or her composition of the text when dealing with texts primarily assertive. But this reflects not the nature of things but one historical episode in the long history of reading and interpretation practices. One can see in how the medieval philosophers used the texts bequeathed to them that they were far less concerned with what the author said; more prominent was their struggle to interpret the texts bequeathed to them in such a way that all of those texts together would set forth a finely articulated body of truth. Thinkably a consequence of deconstructionism will be that reading practices will become much more like pre-Renaissance reading habits than they have been now for many centuries. It is also worth noting that to this day it is not at all uncommon, in the liturgical appropriation of texts, for the users to be relatively unconcerned with what the original authors used them to say.

On the other hand, in our approach to fiction we are often very much concerned to find out what world the author or painter fictionally projected. Especially is this the case for oral fiction. Of course, as we have seen, Walton contends that whatever interest we have in the makers of fiction is compatible with his theory; and so in good measure it is. But it is also true that every such interest can and will be happily acknowledged by the illocutionary theory. What is worth adding to what Walton observes is that, counter to the recommendations of such theorists as the New Critics, we often determine the references and allusions in a text by finding out who wrote it and when and where and with

which readers in mind. One can press the question as to *why* we do this, what value lies behind this approach which cannot be achieved by treating the text simply as a 'found' object; in pursuing the answer to this question we will discover something about what we find worthwhile in our interaction with fiction. But that we do it is obvious.

In short, sometimes we treat the texts and paintings that come our way as means of communication to us from the makers of those texts and paintings; sometimes we are content simply to interact with the objects which are the texts and paintings, now and then drawing inferences about the makers. The difference in approach represents the realization of different values; the priority given to the values changes across time, and differs from person to person. But the difference does not coincide with the difference between fiction and non-fiction.

There is yet a third argument against the illocutionary theory to be found in the passage on which we have been concentrating, implicit in some of what we have already quoted. It is this: There are cases in which an object represents so-and-so without there being someone who represented so-and-so by way of his composition or presentation of the object. Or to make the point with more theoretical articulateness: Sometimes objects have the function of prop in a game of make-believe and in that game mandate that so-and-so be imagined, without its being the case that someone's making or presenting of that object counted as his performing the action of inviting that so-and-so be imagined. This claim, I now think, is correct. Indeed, I implicitly conceded the point above when I observed that the world associated with a text is not always that which the writer used the text to project. It makes no difference whether the world is projected in the fictive mode or some other. As indicated above, I myself doubt that 'words' 'seen' in cracks and 'faces' 'seen' in clouds are representations in the literal sense of the word "representation." But I do not doubt that representation by objects can occur independently of representation by persons. It is even possible to *make* an object which represents so-and-so without thereby having represented so-and-so, or indeed anything at all—as when one makes representational objects on an assembly line.

But we must not jump to the conclusion that Walton's object-theory of representation wins the palm over the action-theory which I developed; for the converse of the above is also the case. A person, by producing an artifact, can take up a fictional stance toward certain propositions without the artifact having the social function of being a prop mandating the imagining of those propositions in a game of make-believe authorized for it. In fact this sort of thing happens rather often in the arts. Many of the 'games' artists play on an unsuspecting public are of this sort. For example, an artist may produce a work to function as a work of purely ornamental art while yet composing the ornamentation in such a way that he playfully represents plants and animals—without anyone other than himself ever noticing. Though the artist performs the action of representing, what he makes does not have the social function

of a representation. If function can be thought of as a meta-rule for proper use, as Walton suggests, then the meta-rule in force concerning the use of this object mandates that it ought to be treated as ornamental art, not as grounding mandates to imagine.

The reply is likely to be forthcoming that though the object does not function as a representation for the public, it does so function for the artist—that the artist ought to use it in such a way that it grounds certain mandates to imagine. What we have here, it will be said, is the limiting case of a game of make-believe; only one person knows that the game is mandated for this object. But surely this is exceedingly implausible. Suppose that the artist, after playfully composing his work, uses it often, but always and only as a piece of ornamental art. Is he then misusing it? I fail to see that he is.

So, too, the attempts of artists in totalitarian societies to outwit the censor sometimes take the form of representing so-and-so without making something whose function is to represent so-and-so. Knowing what sorts of things function as representations in their society, artists use their ingenuity to represent so-and-so without making objects whose social function is to generate mandates to imagine that. And here, as in the former case, to the suggestion that the object has this function at least for the artist, I reply that even if the artist in his interaction with his work never again imagines that which he represented when he was making it, he may nonetheless not violate any mandate concerning use.

Indeed, the phenomena of persons representing (as I understand that) and of objects representing (as Walton understands that) are distinct and independent to such an extent that either phenomenon might be present in a society without the other being present. Suppose that there are rules in force to the effect that certain objects ought to be used in games of mandated imagining; that could be the case without any actions ever counting as a person's performance of the action of representing some state of affairs. So at least Walton claims; and I think he is correct. But suppose that in some society certain acts of making or presenting objects *count* as the performance of the action of fictively projecting some state of affairs—*count* as the action of inviting those states of affairs to be imagined; that could be the case without anybody having the obligation to use these objects in games mandating imagining, thus without their having the function of props in such games.

But wouldn't the artist's representing things by way of making or presenting objects *automatically* give those objects the function of representations? Wouldn't it *automatically* bring into force the meta-rule that these objects are to be used in games mandating imagining? Why so? There would automatically be the phenomenon of accepting or rejecting the artist's invitation to imagine so-and-so; and to find out what he invites us to imagine, we have to consult the object. But why should it be thought that we were in any way misusing the *object* if we did not thus consult it and did not imagine accordingly? Why should it be thought, then, a *function* of the object to mandate those imaginings?

A complex state of affairs may be associated with a certain object *as* that which someone fictively represents by composing that object. But also a complex state of affairs may be associated with an object *as* that which the object (fictively) represents. What brings about the former association is (on my account) the fact that the maker's action of composing that object *counts* as his performing the action of issuing the invitation to imagine that state of affairs. Or if the count-generated action is not exactly that of *issuing the invitation*, it is something close to that. What brings about the latter association is (on Walton's account) the fact that the object has the social function of generating, in conjunction with some in-force rule of mandated-imagining, the mandate to imagine that state of affairs.

But now the question comes to mind: Are there not other ways, closely analogous to these, in which imagined states of affairs are associated with texts, paintings, sculptures, etc.? Of course objects may simply *prompt* imaginings, but that fails as a close analogue because there is in that no note of normativity.

I think we see in the practice of many critics a style or mode of association which is indeed closely analogous to the two on which we have been focusing; namely this: Allowing a certain *purpose* to determine which imaginings some artifact calls for.

Since the counterpart thing happens often for non-fictional texts, and perhaps more obviously so than for fictional texts, let me illustrate the point with some examples. The practice of the medieval philosophers, to which I have already referred, is a very good example of the point. After setting a few texts off to the side as heretical, or for some other reason unusable, the medieval philosophers aimed to interpret the texts bequeathed to them in such a way that what was said in all these texts together was a highly detailed, finely articulated body of truth. Often this required departure from established practices of interpretation; even more often it required relative indifference to what the author might have used the text to say.

Good examples of the same point are to be found in abundance by looking at the function of sacred scriptures in religious communities. Over and over there come times in the life of such communities when, in the opinion of critics, the desire of the community that the text function canonically collides with both author meaning and established interpretation. The critic assumes that it would be wrong for the text to function canonically if central parts of it are interpreted as asserting falsehoods; the community naturally also assumes this. The critic, however, comes to the conclusion that what the author used the text to say, and/or what the community takes the text as saying, is at central points false. Over and over critics in this situation, rather than suggesting that the text be discarded from the canon, propose that it be reinterpreted. Hans Frei, in his well-known book, *The Eclipse of Biblical Narrative*, offers a lengthy narration of proposals of this sort which have arisen in the Christian community since the eighteenth century. Kant's late book, *Religion within the Limits of Reason Alone*, is a paradigmatic example of the species. Kant proposed a metaphorical way of reinterpreting the New Testament whereby what it says is consistent

with his own philosophy–indeed, whereby it *propounds* the central points of his own moral and religious philosophy. The opening of Section One of Book Two is a good example of the strategy:

> *Mankind* (rational earthly existence in general) *in its complete moral perfection* is that which alone can render a world the object of a divine decree and the end of creation. With such perfection as the prime condition, happiness is the direct consequence, according to the will of the Supreme Being. Man so conceived, alone pleasing to God, "is in Him through eternity"; the idea of him proceeds from God's very being; hence he is no created thing but His only-begotten Son, "the *Word* (the *Fiat!*) through which all other things are, and without which nothing is in existence that is made" (since for him, that is, for rational existence in the world, so far as he may be regarded in the light of his moral destiny, all things were made). "He is the brightness of His glory." "In him God loved the world," and only in him and through the adoption of his disposition can we hope "to become the sons of God"; etc.
>
> Now it is our universal duty as men to *elevate* ourselves to this ideal of moral perfection, that is, to this archetype of the moral disposition in all its purity—and for this the idea itself, which reason presents to us for our zealous emulation, can give us power. But just because we are not the authors of this idea, and because it has established itself in man without our comprehending how human nature could have been capable of receiving it, it is more appropriate to say that this archetype has *come down* to us from heaven and has assumed our humanity (for it is less possible to conceive how man, by nature *evil*, should of himself lay aside evil and raise himself to the ideal of holiness, than that the latter should *descend* to man and assume a *humanity* which is, in itself, not evil). Such union with us may therefore be regarded as a state of *humiliation* of the Son of God.... (Greene & Hudson translation)

In short, it is common practice for critics to approach non-fictional texts with suggestions as to what the texts should be interpreted as saying—i.e., which asserted states of affairs should be regarded as associated with the text *as what it is saying*. And often what guides their suggestions is not their discernment of what the author used the text to say, nor their discernment of what established practices of interpretation mandate. What guides their interpretation is rather a certain purpose which they have embraced, in conjunction, of course, with the details of the text. But all too obviously the same can be and sometimes is true for fictional texts, when the texts are of sufficient complexity and ambiguity as to allow for this alternative.

Imagining such-and-such states of affairs can be associated with a text as what the author by her composition of the text invited us to do. *Imagining such-and-such states of affairs* can also be associated with a text *as* what the rules of some game of make-believe, authorized for that text, mandate. But so too, *imagining such-and-such states of affairs* can be associated with a text *as*

what someone's purpose calls for, or as what best satisfies someone's purpose. To exactly what, in all this, the word "representation" is best and most correctly applied is much less important than the recognition of these various modes and grounds of "association" and the development of a theory of fiction which gives due acknowledgment to all. Both Walton's theory and my theory are too constricted; we need something more general.

MIDWEST STUDIES IN PHILOSOPHY, XVI (1991)

Science and Aesthetic Appreciation

PETER KIVY

I

In the British periodical *Athenaeum*—the volume for 1919—there are four short pieces by J. W. N. Sullivan on the general topic of science and the aesthetic. The same volume contains a brief reply to two of these by Roger Fry, subsequently reprinted in *Vision and Design*. Sullivan was well qualified to write about such things. He was, as some may know, a scientist, popular science writer, and an accomplished musician; and his popular biography of Beethoven outlines a position in music aesthetics philosophically respectable enough to invite periodic bashing. Roger Fry, of course, needs no introduction except perhaps to mention that he took an honors degree in natural science at Cambridge University before undertaking the writings on the visual arts with which we are all familiar.

In a contrast that is, I dare say, if not completely discredited, at least highly suspect, Sullivan distinguishes between two stages in the development of science: a stage of Baconian fact-gathering, and, it is to be hoped, maturation in a stage of theory-making; for, in Sullivan's words: "It is the scientific theory alone that gives to science its true being and makes it worthy of deep concern."[1]

But what makes a theory more worthy of deep concern than a fact? Here I must quote Sullivan at greater length:

> With the construction of theories science enters on a new phase in its development, and serves a different set of human values. Its facts, the products of local curiosities, now take on an order, and serve the desire for comprehension.... The desire for knowledge becomes transformed into the desire for *significant* knowledge—significant primarily for contemplation and secondarily for practice.[2]

It turns out, then, that for Sullivan theories are superior in human value to

facts because they reward contemplation where facts do not. And that reward is nothing other than the reward of aesthetic satisfaction.

> Besides serving curiosity, comprehension and practice science offers richly satisfying objects to the aesthetic impulse. The language of aesthetics is not far to seek in the writings of men of science, and were it not that the word arouses such a proprietary fury, we should agree, reviewing their motives, and the kind of their satisfactions, to call them artists.[3]

The point is articulated still more clearly, and in more extreme terms in the second of Sullivan's pieces in the *Athenaeum*:

> ...since the primary object of the scientific theory is to express the harmonies which are found to exist in nature, we see at once that these theories must have an aesthetic value. The measure of the success of a scientific theory is, in fact, a measure of its aesthetic value, since it is a measure of the extent to which it has introduced harmony in what was before chaos.
>
> It is in its aesthetic value that the justification of the scientific theory is to be found, and with it the justification of the scientific method. Since facts without laws would be of no interest, and laws without theories would have, at most, a practical utility, we see that the motives which guide the scientific man are, from the beginning, manifestations of the aesthetic impulse.[4]

It is this second, and stronger, statement of his view that science is not merely peripherally aesthetic, but foundationally so that elicits Fry's critical response. Quite significantly, as we shall see in a moment, Fry quotes only one sentence from this passage of Sullivan's to the effect that: "It is in its aesthetic value that the justification of the scientific theory is to be found, and with it the justification of the scientific method." His response is sharp and predictable:

> I should like to pose to S[ullivan] at this point the question of whether a theory that disregarded facts would have equal value for science with one which agreed with facts. I suppose he would say No; and yet, so far as I can see, there would be no purely aesthetic reason why it should not. The aesthetic value of a theory would surely depend solely on the perfection and complexity of the unity attained, and I imagine that many systems of scholastic theology, and even some more recent systems of metaphysic, have only this aesthetic value.[5]

The line, then, seems to be sharply drawn between "aesthetics" on the one side and "truth" on the other. For Fry, I imagine, is expressing no more than what most persons' "common sense" will allow when he avers that if aesthetic value is *the* measure, or even an important measure of scientific value, then a false but beautiful theory must be preferred over a true but homely one: Newton over Einstein, or Aristotle over Newton, if that is where the aesthetic chips fall—apparently a *reductio ad absurdum* of the view that science is importantly or interestingly aesthetic.

In my experience discussions of the aesthetic in science, few and far between anyway, never seem to get beyond this rather primitive level. And the reason I have begun, *in medias res* as it were, with this rather out of the way and brief encounter between Sullivan and Fry is that it *does* manage to put the issue in a way that invites rather than discourages serious discussion. That is in part because of the peculiar quality of the two minds at work here. But such intangibles aside, the reason that Sullivan and Fry cast some real philosophical light on the question—or questions—of science and the aesthetic is that each of them is arguing implicitly from a general position in aesthetics and the philosophy of art. Neither position is systematically worked out. Neither writer, after all, was primarily a philosopher. But just a bit of exegetical labor will, I think, pay a handsome dividend in sharpening the issues. So let me dwell a little longer on Sullivan and Fry as a means of arriving, somewhat belatedly, at a clear statement of the general direction this essay is going to take.

II

I said it was significant that Fry quotes just one sentence of Sullivan's. The significance is that that sentence, in stating quite succinctly Sullivan's view that, as he puts it, "It is in its aesthetic value that the justification of the scientific theory is to be found . . .," makes no mention at all of the role in science of questions of truth. Yet Sullivan says quite a bit about truth and "facts" in his little essays; and Fry, paying absolutely no attention to those passages, insists that an aesthetic evaluation of science precludes considerations of truth.

Now I am not for a moment suggesting that Fry, in an act of intellectual dishonesty, has consciously and systematically ignored Sullivan's views on how considerations of truth are relevant to aesthetic evaluations; for Sullivan certainly has such views. Rather, I think we have here a classic case of intellectual myopia, caused, as is common, by a deep theoretical commitment.

None of my readers will be surprised by my pointing out that it is a bit of an over-simplification, but by no means a travesty to describe Fry's position in the philosophy of art as *formalism*. In *Vision and Design* that formalism is fairly extreme. Without going into the details of Fry's account, we may note that Fry concludes in the piece called "An Essay in Aesthetics": "We may, then, dispense once and for all with the idea of likeness to Nature, of correctness or incorrectness as a test. . . ."[6] In his later collection, *Transformations*, there are at least some signs of self-doubt and a grudging concession to "illustrationism." But where Fry seems on the verge of admitting that there may indeed be *two* kinds of things properly called "art," the purely formal and the illustrational, he gives with one hand only to take away with the other. "Our experiments and inquiries have then, I hope, given us one result on which we may rely with some confidence: the notion that pictures in which representation subserves poetical or dramatic ends are not simple works of art, but are in fact cases of the mixture of two distinct and separate arts; that such pictures imply the

mixture of the art of illustration and the art of plastic volumes—the art of Art, our horribly incorrect vocabulary almost forces us to say."[7]

Well, there it is. Illustrational art is "art"—but only with a small "a." The big "A" is reserved for "plastic volumes"; and were it not for "our horribly incorrect vocabulary," "illustrational" and "art" even with a small "a" would be small "*p*" and "not-*p*."

It is small wonder, then, that Fry, with his strong, and more or less unswerving commitment to formalism, should have leaped for what he perceived to be Sullivan's jugular, without taking any notice of the rest of the anatomy. Aesthetic evaluation and appreciation meant, for Fry, as for many, paradigmatically, the evaluation and perception of art *qua* art. But since for Fry the formalist, aesthetic evaluation or appreciation was solely evaluation or appreciation of formal properties, to read that science is evaluated and appreciated primarily on aesthetic grounds is to read that science is evaluated and appreciated primarily for its formal properties, in which case truth is irrelevant, and a false theory, if formally more perfect than a true one, more to be appreciated, more to be preferred—which is, of course, a *reductio ad absurdum* of the position.

Sullivan, however, is under no such formalist constraints. His notion of aesthetic evaluation and appreciation includes both the formal and representational; aesthetic success for him is a complex function of formal beauty and truth, both in science and in art. "The matter of the highest art, like that of true science," he writes, "is reality, and the measure in which science falls short as art, is the measure in which it is incomplete as science. All good philosophy, art or science partakes of the nature of the other two."[8]

Nothing could be more revealing of the contrast between Sullivan's and Fry's general views about art and truth than to compare what they say about literature and music. Not very surprisingly, music is held up by Fry as a model of aesthetic formalism, as where he writes that for a painting to fulfill the highest aspiration of the formalist creed it must achieve "a mood as detached from any actual experience as that of the purest music."[9] Whereas Sullivan's view of music, although correctly described as a version of the expression theory, is equally a version of the theory that music is a revelation of reality: the reality of the composer's attitudes, emotions, experiences. "Musical experiences," Sullivan insists, "do not form a closed world of their own."[10] Rather, musical works of the highest value are communications. "Such communications inform us directly of the spiritual context from which they sprung. . . ."[11] And again: "The function of the kind of music we have been discussing is to communicate valuable spiritual states, and these states testify to the depth of the artist's nature and to the quality of his experience of life."[12] Music, then, is the revelation of a spirit and an attitude: that is its reality, its truth.

But just as Sullivan and Fry are steady to their respective texts in regard to music, so too are they in their brief allusions to literary works. For Fry, "the purpose of literature is the creation of structures . . ., [and] these structures are self-contained, self-sufficing, and not to be valued by their references to what

lies outside."[13] While Sullivan insists, in another of the *Athenaeum* pieces, "Science and Literature," that

> It is mere self-deception to say that a work of literature has a value independent of its assumptions. The fact that we do not share the assumptions made by the Greeks, that we do not live in the cosmogony of Dante, does detract from the value of their work for us.[14]

Taking "aesthetic" and "artistic" as synonymous for the time being, we may say that for Fry, questions of truth or accuracy of representation are never relevant in aesthetic evaluation or appreciation, but always are in the evaluation or appreciation of scientific theories; and from this it follows that aesthetic considerations are never decisive or important in the evaluation and appreciation of science. Sullivan, however, thinks that questions of truth, or accuracy of representation, even in the art of music, and certainly in the other, more obviously representational of the arts, always are relevant in aesthetic evaluation and appreciation. For Sullivan, therefore, it is no objection to "scientific aestheticism" (if I may so call it) that such a view would render the scientist indifferent to truth. On the contrary, for Sullivan truth or accuracy of representation is always an important consideration in aesthetic evaluation and appreciation, even in the seemingly recalcitrant art of "pure" instrumental music; and so, *a fortiori*, truth or accuracy of representation is always an important consideration in the aesthetic evaluation and appreciation of scientific theories. Just as, on Sullivan's view, if two poems are equally beautiful in formal respects, the more beautiful one, *tout court*, is the one that more truthfully represents reality, so also with two scientific theories, equally beautiful in formal respects.

It seems clear, then, from the discussion so far, that the first stumbling block to the plausible extension of aesthetic criteria to the evaluation and appreciation of science is the result of adhering to aesthetic formalism in its more extreme manifestations. And although Sullivan has, it seems to me, gone to an opposite extreme in his rejection of musical formalism, I think he has by far the best of the argument with regard to science; and, although I will not argue the point here, I think he is right about literature as well.

Sullivan, as I read him, is asking us to consider seriously the hypothesis that science is one of the arts; or, as I would prefer to put it, one of the *representational* arts, since, unlike Sullivan, I do not think all of the arts, properly so called, are representational. But if it is one of the representational arts, then science must be, at its very core, *aesthetic*. And although once we kick over the traces of aesthetic formalism (and one impediment to scientific aestheticism is thereby removed), other hard questions remain. Three come immediately to mind. Do we really appreciate or evaluate science *aesthetically*, in the literal sense of that term? If so, is the aesthetic appreciation of science really an important, or even, as Sullivan thinks, the sole motivation of the theoretical scientist? And, finally, are aesthetic considerations really always, or even ever, decisive in the evaluation of scientific theories? These three

questions will occupy me in the rest of this essay, with Sullivan's insightful preliminary discussion as my foundation.

III

There can be no doubt, needless to say, that people who are able to understand scientific theories at the highest level enjoy their contemplation. And sometimes such people describe their enjoyment as "aesthetic." Should we just take them at their word? Could they be mistaken about the correct description of their enjoyment? There are many kinds of enjoyment one can get from contemplating something. How can we be sure that the scientist who describes his or her enjoyment as "aesthetic" is not confusing it with some other kind of enjoyment? Or do such descriptions border on the incorrigible, like reports of being in pain?

G. N. Watson, who spent some years studying the work of Ramanujan, said that contemplating one of the great mathematician's formulae "gives me a thrill which is undistinguishable from the thrill which I feel when I . . . see before me the awesome beauty of 'Day,' 'Night,' 'Evening,' and 'Dawn' which Michelangelo has set over the tombs of Giuliano de' Medici and Lorenzo de' Medici."[15] Why shouldn't we just accept that at face value? Who can know better than the owner of a thrill himself whether or not it is the same thrill as another he has owned?

I suppose that someone who is still scrutinizing thrills to see if they are aesthetic ones or not might be an object of raillery in analytic circles these days. I don't know. Perhaps Dr. Watson will be the one to get the last laugh after all. But in any case, we do have more to go on than just raw feelings. The criteria that scientists customarily cite in support of their apparent aesthetic judgments are certainly the kind that we tend to cite in another, and uncontroversial, cases of the aesthetic: symmetry, simplicity, order, unity, coherence, elegance, harmony, to name the most representative.[16] Those are just the criteria one might cite in praise of a concerto by Mozart, a poem by Pope, or a painting by Raphael. And I take it as received analytic opinion that if we cite *aesthetic* criteria in support of a judgment, we hardly need any more proof that the judgment is an aesthetic one.

Interestingly enough, though, the very criteria that, on first reflection, assure us we are dealing here with the aesthetic, under closer scrutiny cast some doubt on the conclusion. It should not escape our notice that all of the criteria named above are what we might call "Classical" ones. And the art works chosen to exemplify them bear this out: not Bach or Berlioz but Mozart; not Delacroix or the Mannerists but Raphael; not Homer or Shakespeare but Pope.

But if we are dealing, in science, with genuine aesthetic appreciation, should we not expect the same variety of criteria as in the *bona fide* cases of aesthetic appreciation in the arts? Yet who ever heard of a scientist gushing over a theory because of its wild, sublime disorder, its intriguing obscurity and ambiguity, or its awesomely gothic complexity? Doesn't this marked disanalogy strongly suggest that we are not dealing, in science with such concepts as

harmony, elegance, simplicity, unity, and the rest of the Classical repertoire in their true aesthetic sense, but in an attenuated or metaphorical one?

I use the word "suggest" here with purposeful intent because, as far as I can see, it does not *follow* that because only the Classical criteria apply in the appreciation of science, the criteria cannot be genuinely or literally aesthetic. But we are, I think, owed an account by any philosopher defending the aesthetic in science of why there is this anomaly. So let us see what can be done in the way of providing one.

It would be well to observe, to begin with, that the appreciation of what I shall call the Baroque and Romantic aesthetic features is not as bizarre or unthinkable in science as one might, on first reflection, imagine. For example, a historian of science, or a working scientist, for that matter, might well enjoy, aesthetically, the Baroque complexity of the Ptolemaic astronomy with its profligate multiplication of epicycle upon epicycle to save the appearances. What such an example suggests is that the Baroque and Romantic features of theories are objects of appreciation only after the theories have ceased to be in the running; where, that is, the question of truth has ceased to matter because the verdict of "false" has been declared by scientific consensus.

Where scientific theories are, however, established doctrine, or at the cutting edge, in the process of confirmation or confutation, it would appear that the Classical aesthetic criteria exclusively prevail. And so we still have a puzzle. Why should dead theories be the only ones whose Baroque and Romantic features are appreciated aesthetically? The answer obviously is, I would think, that the question of truth is still at stake in living science, and the Classical aesthetic features are, at the same time, what might be termed *ceteris paribus* criteria of scientific truth, whereas the Baroque and Romantic features are *ceteris paribus* criteria of scientific falsity. Why this is so is the concern of epistemologists and philosophers of science. That it is so is a given for aesthetics and the philosophy of art.

But does it not compromise the aesthetic status of the Classical features to recognize that they function as criteria of truth? I have often been told over the years by philosophers of science with whom I have informally discussed my ideas that these features cannot be functioning aesthetically in science since, clearly, they are functioning *epistemically*. However, I believe this disjunction implicitly assumes an aesthetic formalism which I do not share. I am considering science here, so to speak, as a representational art; and to appreciate its Classical features as truth criteria hardly precludes their functioning aesthetically, since aesthetic appreciation of a representational form cannot be prised apart from appreciation of its representational success. When I appreciate the elegance of a theory, I do not have to choose between appreciating its elegance aesthetically or appreciating it epistemically; for in doing the one I am, *ipso facto*, doing the other, and vice versa.

The metaphor of theoretical science as a representational art form can, I think, be illuminatingly pressed a bit further. There are, of course, various representational genres, and science seems to fall most conveniently into that

of *realism* since, presumably, its goal is to represent nature as accurately as possible. It might usefully be analogized as a representational art, then, with realistic painting. And in particular we might consider the Classical criteria as analogous, for example, to linear perspective in painting and drawing, as follows: Linear perspective is neither a necessary nor sufficient condition for pictorial realism, at least as I understand the latter concept. But it may be plausibly thought of as a feature always contributing to realism where it is present, and always a feature to be aesthetically adored, never deplored in a realistic painting or drawing. The same might be said, *pari passu*, of the Classical aesthetic features in science. They are neither necessary nor sufficient, separate or together, for truth. But they always count towards truth where present, and are always of positive aesthetic value.

The conclusion to be drawn from this is that the Classical aesthetic features of science are not unique in their function. When viewed as a kind of representational art, namely, realistic representation, science exhibits a strong analogy, in its purported aesthetic aspects, to realistic pictorial representations. And since there is no doubt, at least for the non-formalist, that we are dealing in the latter with genuine aesthetic appreciation, there seems good reason to believe that that is what we are dealing with in the former as well. I cannot press this question any further now. But at least as far as I have carried it here, no convincing reason has been discovered for not taking the scientists' word for it when they speak of their aesthetic thrills in the presence of scientific beauty. Let us go on, therefore, to other relevant matters.

IV

I said that the second question I wanted to address is the question of whether, as J. W. N. Sullivan claims, the quest for and the appreciation of the aesthetic are the main motivations for scientific inquiry. Sullivan, you may remember, mentions in his first essay four possible motives, all of which he apparently believes are operative. He says, "Besides serving curiosity, comprehension and practice science offers richly satisfying objects to the aesthetic impulse." And in his second, and more extreme statement, he avers that "the motives which guide the scientific man are, from the beginning, manifestations of the aesthetic impulse."[17]

Now I am not at all clear about what distinction Sullivan means to mark out by listing "comprehension" and "curiosity" as two separate motives, for they seem to me to come to the same thing. That is to say, to satisfy one's desire to comprehend how the world works, the way things are, is *ipso facto* to satisfy one's intellectual curiosity. So I shall conflate these two motives and say that, for Sullivan, as for me, there are three plausible motives for the pursuit of science: practice or (as Sullivan later refers to it) "practical utility,"[18] intellectual curiosity, and aesthetic appreciation or enjoyment.

I should add, straightaway, that there are, of course, other motives that might (and do) impel men and women to the practice of science: fame, for

one; money for another. But I am dealing here—as I think Sullivan was—with motives that are not merely personal but institutional and normative as well. We are not asking what the strongest motive is in our society for pursuing a scientific career. For all that I know it may be desire for the Nobel Prize. We are asking, rather, what primary motive drives the institution of science when it is functioning as it ideally should. And I think it fair to say that three plausible answers to this question are utility, intellectual curiosity, and the quest for theoretical beauty, while two very implausible answers would be desire for fame and love of money. Sullivan seems to conclude that the quest for beauty is at least the primary scientific motive, and perhaps even the only one. Can this be right?

Now the dice are loaded against utility, for we are talking here about the higher reaches of theoretical science where practical applications, if they are in the offing at all, are remote enough in time to be fairly negligible as motivational goals. The lay person tends these days to imagine a direct and immediate relation between theory and practice, symbolized since 1945 by a mushroom cloud and $E=mc^2$ in the same picture. But as we all should know by now, the connection between the atomic bomb and the theory of relativity is "a popular myth."[19] And the connection between theoretical science at the level of relativity theory and the practical and technological arts, although certainly not a myth, is much less direct and much more tenuous than the non-scientist is accustomed to think. Richard Feynman tried valiantly to make this clear to a naturally skeptical television interviewer when he insisted that the work he was doing in theoretical physics was not merely of no practical utility in the foreseeable future but, as far as he was concerned, of no conceivable practical utility—ever. I am not, of course, denying that discovery and theory making at the highest levels cannot have unforeseen, or even anticipated, implications for practice. What I am insisting on is that the connection between theory and practice is tenuous enough to make practical concerns a negligible motive for undertaking the demands of theoretical science. If one is interested in labor-saving devices one chooses Edison as one's role model, not Feynman, as Edison well knew when he expressed the hope that his son, who had decided to become a theoretical physicist, would not waste his time, as Edison put it, "like that fellow Einstein."

Utility aside, then, intellectual curiosity and aesthetic appreciation are left as the candidates still in the running. And on first blush it would seem difficult to follow Sullivan in his stronger claim that aesthetics is the only motivating force in theoretical science. Of the two, it may even be difficult to see it as the major. Rather, one is tempted to say that both certainly are operative, but with intellectual curiosity as dominant.

But here, as before in this inquiry, it is therapeutic to be reminded that Sullivan is no formalist, for when formalist constraints are removed, it becomes not only possible but plausible to maintain at least that the aesthetic has equal billing with intellectual curiosity, and even top billing, or sole billing, if we understand how the two play off each other in the higher reaches of theoretical

science. Intellectual curiosity, the desire to know how things work or the way things are, may seem to have little to do with aesthetic appreciation; and at the level of such questions as "How does a thermostat work?" or "What does the pancreas do?" it is doubtlessly true that there is little connection if any. But when one is asking the grand questions in theoretical physics, or cosmology, or evolutionary biology, it is difficult *not* to see the quest as aesthetically motivated and the answers as aesthetically satisfying, since what I have been calling the Classical aesthetic criteria in science are some of the very criteria, as we have seen, of explanatory success, where the explanations are at the high theoretical level.

Now we may ask ourselves what motivates someone to ask and answer questions at this level of theory? Is it desire for the satisfaction of intellectual curiosity or desire for satisfaction of the aesthetic sense? But surely the disjunction on which the question is predicated rings hollow in the context. The answers one seeks at such a theoretical level are ones that must satisfy the investigator's aesthetic sense if they are to satisfy his or her intellectual curiosity. One cannot solve problems of such a theoretical kind without fulfilling at least in part those requirements of theoretical harmony, unity, elegance, simplicity, and the like that excite the scientist's aesthetic emotions. To satisfy one's intellectual curiosity at this level just is to build theoretical structures that are beautiful in the Classical sense. And surely one must be driven to ask and answer the kinds of questions we are talking about by the desire for just the very satisfaction of intellectual curiosity that is an aesthetic satisfaction of that curiosity as well.

I cannot put the point with more eloquence or (needless to say) more authority than Henri Poincaré.

> The scientist does not study nature because it is useful to do so. He studies it because he takes pleasure in it; and he takes pleasure in it because it is beautiful. If nature were not beautiful, it would not be worth knowing and life would not be worth living. . . . I mean the intimate beauty which comes from the harmonious order of its parts and which pure intelligence grasps.[20]

Poincaré speaks of the beauty of nature. But I think what it really comes down to is the beauty of the scientific representation of nature. One can, of course, in a portrait, for example, distinguish the beauty of the sitter from the beauty of the representation because one can gaze at the sitter as well as at the representation. We cannot, in a similar manner, contemplate (say) the general theory of relativity and then, if the spirit moves us, gaze at the aspects of nature that were its "sitter." All we have of the sitter is the sitter *as represented* by the theory. So when, as Poincaré says, the scientific intelligence grasps the intimate beauty which comes from the harmonious order of nature's parts, we must understand it as grasping the theory which represents that order and discovers it to us. In science it is only the representation of *la belle natur* that we can contemplate, not the thing in itself. To say we are contemplating nature is to say we are contemplating theory.

The testimony of theoretical scientists to the primacy of the aesthetic motive can be multiplied, if not endlessly, at least beyond your patience and mine. Many of these statements are by now well known to the lay person. And if we liberate ourselves from the insidious, and at most times unrecognized domination of formalist aesthetics, they lose their sound of paradox altogether. Of course it must be the quest for beauty and not intellectual curiosity that makes of the search for a unified field theory or natural selection the labor of a lifetime. The intellectually curious pull wings off flies. It is a more powerful urge than that at work in theoretical science and the rarified atmosphere of what we think of as the elegant experiment. It was Euclid, remember, who first saw beauty bare.

V

This brings me to the final question that I wanted to consider here. That is the question of whether aesthetic considerations are ever conclusive, in themselves, in the acceptance of a theory.

Well, it ought to be fairly apparent by now that this question as stated only makes sense under a formalist account of the aesthetic. If I were to ask about representational art in realistic style, whether aesthetic criteria are the sole criteria of success, the formalist might answer yes, if he or she thought, like Fry, that formal criteria are preeminent, or no, if representational criteria were thought to be at least relevant. But in either case, the question is intelligible because "aesthetic" and "representational" are being used in mutually exclusive senses. If, however, one thought that, in the case of representational realism, representational success just were one of the relevant *aesthetic* criteria, then, if one thought the question intelligible at all, the answer could only be an utterly trivial yes. And the same must be generally true in the case of science. One cannot intelligibly ask whether aesthetic criteria are ever decisive in themselves in deciding for the truth of a scientific theory, unless one has severed the aesthetic from the true in formalist fashion.

It is clear from reading what scientists have to say about this question, even the most brilliant of them, that they customarily fudge it, because they are, unknown to themselves, construing the aesthetic formalistically, while nursing the altogether valid intuition, part of their scientific blood and bones, that their enterprise is through and through "aesthetic" in some sense or other of that term.

Consider, by way of example, what the great astrophysicist, and Nobel laureate, S. Chandrasekhar has to say in direct response to Fry's contention that, in science, beauty can never prevail over truth. 'We have evidence . . . ," he writes, "that a theory developed by a scientist, with an exceptionally well-developed aesthetic sensibility, can turn out to be true even if, at the time of its formulation, it appeared not to be so."[21] As a counterexample to Fry, this assertion—which is undoubtedly true—is completely off the mark. What it suggests, which Fry would have no reason to deny, is merely that the beauty of a theory may be compelling enough to keep it alive, even if believed false, long

enough for it to be ultimately vindicated. Or, to consider a related scenario, the beauty of a theory may be such that it will be believed true, temporarily, even if there is no observational evidence in its favor, even, indeed, when the only observational evidence is apparently against it. But temporary reprieves on beauty's behalf are not proof against Fry's objection, which is, I take it, that beauty cannot *permanently* prevail over truth, as, for example, *The Divine Comedy* might over *De Rerum Natura*, even though the latter were acknowledged to give the true (or a truer) picture of our universe.

Here is a case that comes closer to the target. It is part of the folk mythology of physics that the general theory of relativity was so compellingly beautiful that physicists were prepared to believe it prior to any observational verification. Indeed, according to Chandrasekhar, ". . . Landau and Lifschitz consider the theory as probably the most beautiful of all existing physical theories."[22] Of course, general relativity has triumphantly stood the test of experiment and observation, and so we no longer need to believe it for its beauty alone. But consider the new theory of matter called "superstring theory." A science reviewer for the *New York Times* says:

> Superstring theory, one of physic's hottest topics, hawks the idea that the ultimate bits of matter are not really pointlike particles but rather tiny, wiggling loops of string. Unfortunately, even the most powerful particle accelerators imaginable would be helpless in searching for these threadlike entities. Can beauty alone serve to convince once again, as it did with Einstein's theory?[23]

The case of general relativity is, obviously, no genuine counterexample to Fry's query but a case of beauty's temporarily prevailing in the absence of observational confirmation until ultimately vindicated by it. And if the analogy being drawn between superstring theory and general relativity is meant to be point for point, then the case of superstring theory is just another of the same.

But the notion that the most powerful accelerator *imaginable* cannot detect "these threadlike entities" suggests another and more intriguing scenario. Let us suppose it was concluded by the best scientific minds that the observational verification of superstring theory would require a particle accelerator of greater mass than the mass of the universe. We would then perhaps be left with only beauty to convince us, and permanently so. However, even the *permanent* triumph of the aesthetic in this hypothetical case is not, clearly, the sought for triumph of beauty over truth that would answer Fry and prove the primacy of the aesthetic in theory choice. Beauty would be neither triumphing over truth nor indifferent to it. Rather, operating in the forced absence of observational confirmation (or disconformation), it would, as the only game in town, simply be the sole criterion of truth; but out of necessity, not choice.

Under the unconscious domination of formalism, then, the theoretical scientist is caught in a dilemma, wanting on the one hand to say that beauty of theory is the sole concern and consuming motivation, and yet, on the other hand, unable to find a *bona fide* example of theoretical beauty either superior or indifferent to theoretical truth.

Now I said when I initially raised this question of beauty versus truth that it only makes sense under the assumption of the formalist that aesthetic features just are formalistic ones. But it can be rephrased in a way that does make sense to the non-formalist. Let us return to the case of representational realism in art to see how this might be done. Suppose the non-formalist were to acquiesce in the formalist's construal of the aesthetic as the formalistic, in order to avoid a mere verbal dispute. He or she might then wish to introduce the term "artistic" to cover what before was covered for him or her by the term "aesthetic." The question could then be intelligibly raised: "Are aesthetic features always or ever completely and solely decisive in the *artistic* evaluation of art works?" This question does make sense to the non-formalist; and where the art works in question are of the representationally realistic kind, the answer would clearly be no, if one were not an extreme formalist of Fry's ilk, since representational features, in this case, would always be at least relevant, if not decisive in evaluation and appreciation.

This ploy is, I am certain, familiar to many. And it will be obvious to many, I am equally certain, that it cannot have application to the case of science, at least as stated. One cannot, after all, sensibly ask the question "Are aesthetic features always or ever completely and solely decisive in the *artistic* evaluation of scientific theories?" for the altogether obvious reason that it makes little sense to talk about the artistic evaluation or appreciation of things that are not works of art.

But there is, actually, an analogous and altogether plausible way to re-phrase the above question for the nonformalist in science. Suppose, speaking with the formalist in my construal of the aesthetic, I put my question this way: "Are aesthetic features ever completely and solely decisive in evaluating the *beauty* of a theory?" An exact parallel in an art context would be: "Are aesthetic features ever completely and solely decisive in evaluating the *beauty* of an art work?" Both questions make eminent sense. There is, however, a difference in scope. Because beauty is not the only feature of aesthetic success at its level of generality that an art work might possess, the question in an art context is of limited application. Whereas in science, because the aesthetic criteria are exclusively Classical, which is to say, beauty-making, the ultimate aesthetic evaluation of a theory is always that it is beautiful (or that it is not). So the question, "Are aesthetic features ever completely and solely decisive in evaluating the beauty of a scientific theory," is of completely general scope: it exhausts the aesthetic possibilities. And the answer the non-formalist must give to it is an emphatic no.

Of course, the non-formalist will insist, aesthetic features can never be the sole and decisive consideration in evaluating the beauty of theory, because the beauty of a scientific theory, like the overall artistic success of a realistic painting, is a function also of its *representational* success, which is to say, its *truth*. The scientist does not admire a theory's beauty and then admire it or not admire it for its truth. It is admired for how beautifully it is true; for how beautifully it represents nature. That is why the scientist frequently swings back

and forth indifferently between talk about the beauty of science and talk about the beauty of nature, as in the quotation from Poincaré above. Chandrasekhar writes, in a similar vein that:

> All of us are sensitive to Nature's beauty. It is not unreasonable that some aspects of this beauty are shared by the natural sciences.[24]

And of course it is not unreasonable. But only under non-formalistic assumptions. The beauty of theoretical science is the beauty of nature where science represents nature truly and beautifully.

Two things are to be noticed on this regard. First, as we have seen, the formal, aesthetic features of theory—the Classical aesthetic criteria, as I have been calling them—are at the same time criteria of formal beauty and criteria of truth. And, second, what we might call the representational criterion—the congruence of theory with observation—is, for the non-formalist, a criterion of beauty; for a representation of nature, in the realistic mode, is the more artistically successful; in the case of science, it is the more beautiful the more accurately it represents nature; and the matching of theory to observation is the measure of that representational success in non-formalistic terms. So either way you look at it, beauty and truth cannot be prised apart for the non-formalist where theoretical science is concerned. Formalistic beauty counts for truth, and representational truth counts for beauty.

If there is paradox in the scientist's dual vision of science as at the same time an embodiment of beauty and our best hope for truth, that paradox is generated by the formalist's disjunction: beauty *or* truth; and only beauty if aesthetic. Once formalism is given up, the claim that, in theoretical science, the beautiful can never prevail over the true loses all appeal, if not all sense, for, of course, there never is a contest between beauty and truth in theoretical science, understood as an attempt to represent nature. It cannot represent nature beautifully, in the fullest sense, without representing it truthfully. And so both of the theoretical scientist's intuitions are vindicated. Beauty is the overriding consideration when one undertakes science at the highest levels of theory because at this level one simply cannot seek the true without seeking the beautiful. Or to put it another way, theoretical truth at this level must be beautiful truth. That is the burden the theoretician takes up.

VI

And now it is time to make an end. I do so with a warning and a reminder.

The warning is that I have all along been assuming a rather simple-minded realistic interpretation of the scientific enterprise. And as some philosophers of science will tell you these days, realism is dead. Perhaps the reports of its death are exaggerated. I am in no position to tell. And I would think that any non-realistic interpretation of science will have to have some way of making the distinction between the true and the false, and between both of these and the formally beautiful. But in any event, whatever claims I am making here, if

they cannot be made in non-realistic terms as well, are to that extent suspect. That is my warning.

My reminder is merely briefly to recall what I have tried to do in this essay, which is to make some progress with an important, little discussed and, until now, intractable issue in aesthetics: namely, the role of the aesthetic in science. The task, like Gaul, was divided into three parts: assuring ourselves that there really is a *bona fide* aesthetic appreciation in science, not merely a counterfeit; assuring ourselves it is not implausible to think, as scientists seem to, that, at least in the upper reaches of theory, aesthetic motivation is paramount, if not the exclusive goal of the enterprise; and, finally, assuring ourselves that beauty and truth are not, in theoretical science, at cross purposes, but, indeed, inseparable.

My argument has been, throughout, that progress is impeded, and paradoxes thrown up to the notion of beauty in science, by an unrecognized commitment to formalism and a resulting estrangement of beauty from truth; and that as soon as that unrecognized and unjustified formalism is given up, progress is made and paradox recedes. If my argument is somewhere near the mark, then, we may be able to conclude with Keats that, at least in the rarefied realm of theoretical science, if not for Grecian urns, "Beauty is truth, truth beauty" But I will not complete the epigram for you. For, I dare say, that is not all ye know on earth, or all ye need to know.

NOTES

1. J. W. N. Sullivan, "The Place of Science," *Athenaeum* (April 11, 1919): 176. Reprinted in *Aspects of Science* (New York and London, 1927), 14.

2. Ibid. *Aspects*, 13–14.

3. Ibid. *Aspects*, 15–16.

4. J. W. N. Sullivan, "The Justification of the Scientific Method," *Athenaeum* (May 2, 1919), 275. *Aspects*, 25–26.

5. Roger Fry, "Art and Science," reprinted in *Vision and Design* (New York, 1960), 79. Sullivan signed his articles in the Athenaeum simply "S"; and that is how Fry, apparently unaware of S's identity, referred to him.

6. Roger Fry, "An Essay in Aesthetics," reprinted in *Vision and Design*, 38.

7. Roger Fry, "Some Questions in Esthetics," *Transformations* (Garden City, N.Y., 1956), 35.

8. Sullivan, "The Place of Science," 176. *Aspects*, 16.

9. Fry, "Some Questions in Esthetics," 51.

10. J. W. N. Sullivan, *Beethoven: His Spiritual Development* (New York, 1960), 24.

11. Ibid., 30.

12. Ibid., 36.

13. Fry, "Some Questions in Esthetics," 11.

14. J. W. N. Sullivan, "Science and Literature," *Athenaeum* (June 13, 1919), 464.

15. Quoted in S. Chandrasekhar, "Beauty and the Quest for Beauty in Science," *Truth and Beauty: Aesthetics and Motivation in Science* (Chicago and London, 1987), 61.

16. For an interesting discussion of these criteria, and their operation in science, see Gideon Engler, "Aesthetics in Science and in Art," *British Journal of Aesthetics*, 30 (1990).

17. See notes 3 and 4 above.

18. See note 4 above.

19. On this, see Alan J. Friedman and Carol C. Donley, *Einstein as Myth and Muse* (Cambridge, 1985), chap. 6.

20. Quoted in Chandrasekhar, "Beauty and the Quest for Beauty in Science," 59.

21. Ibid., 66.

22. Ibid., 64.

23. Marcia Bartusiak, review of A. Zee, *An Old Man's Toy: Gravity at Work and Play in Einstein's Universe, New York Times Book Review*, July 30 1989, 3.

24. Chandrasekhar, "Beauty and the Quest for Beauty in Science," 59.

Understanding: Art and Science

CATHERINE Z. ELGIN

I

Attempts to assimilate aesthetics to epistemology are often dismissed out of hand. Mary Mothersill writes, "in such a light, the arts make a poor showing: as a means of acquiring new truths about the world or the soul, they are in competition with the sciences and with philosophy."[1] She is right. If our overarching epistemic objective is the acquisition of new truths, we would be ill advised to turn to art.

We would also be ill advised to turn to science or to philosophy. The abundance of anomalies and outstanding problems confronting any science is reason to doubt that currently available scientific theories are true. And since science faces the tribunal of experience as a corporate body,[2] we cannot hope to separate a science's constituent truths from its falsehoods. Philosophy is no more reliable. Outside formal logic, few if any philosophical theses have been firmly established. Some may be true, but none supplies the level of justification needed for knowledge.

If our goal is simply to augment our stock of justified true beliefs, we should stick to the more pedestrian claims of common sense. That there have been black dogs, though uninspiring, readily admits of confirmation.

Still, science and philosophy are plainly cognitive enterprises. An epistemology that cannot accommodate them is too anemic to serve. But an epistemology robust enough to account for their cognitive contributions cannot, I suggest, avoid accommodating the arts for the arts make many of the same contributions. If I am right, the issue is not whether, but how the arts function cognitively.

Cognitive excellences and deficiencies are many. We value good questions, apt remarks, illuminating experiments, as well as potentially fruitful hypotheses, insightful studies, significant discoveries. We disparage irrelevant or obvious statements, tortuous, tenuous, or tendentious arguments, unimaginative hypotheses, ad hoc explanations.

But obvious statements are more likely than intriguing ones to be true and justifiable. The routine continuation of the multiplication tables is a far surer source of justified true beliefs than investigation of a bold but risky hypothesis. So if what we want is to increase the number of justified truths we believe, our cognitive values are badly misplaced.

If, however, we seek quality rather than quantity, the aforementioned excellences are genuinely valuable for they provide or promote the development of interesting and important insights.

Because of its narrow focus on the conditions for knowledge, contemporary epistemology cannot say what makes insights interesting or important, thus cannot say what sort of knowledge is worth having and seeking.[3] By broadening our vista to include understanding of all sorts, we will be better equipped to deal with the issue.

Not being restricted to facts, understanding is more comprehensive than knowledge ever hoped to be. We understand rules and reasons, actions and passions, objectives and obstacles, techniques and tools, forms and functions and fictions as well as facts. We also understand pictures, words, equations, and diagrams. Ordinarily these are not isolated accomplishments; they coalesce into an understanding of a subject, discipline, or field of study.

Understanding need not be couched in sentences. It might equally be located in apt terminology, insightful questions, effective nonverbal symbols. A mechanic's understanding of carburetors or a composer's understanding of counterpoint is no less epistemically significant for being inarticulate.[4]

Even a scientist's understanding of her subject typically outstrips her words. It is realized in her framing of problems, her design and execution of experiments, her response to research failures and successes, and so on. Physics involves a constellation of commitments that organize its objects and our access to them in ways that render those objects intelligible. Understanding physics is not merely or mainly a matter of knowing physical truths. It involves a feel for the subject, a capacity to operate successfully within the constraints the discipline dictates or to challenge those constraints effectively. And it involves an ability to profit from cognitive labors, to draw out the implications of findings, to integrate them into theory, to utilize them in practice. Understanding a particular fact or finding, concept or value, technique or law is largely a matter of knowing where it fits and how it functions in the matrix of commitments that constitute the science. And neither knowing where nor knowing how reduces to the knowing that that traditional epistemology explicates.

Aesthetic understanding is similar. It is not primarily a matter of knowing truths about art or truths that art discloses, but of using art effectively as a vehicle for exploration and discovery.

I cannot hope to do justice here to the full range of epistemically important affinities between art and science. So I shall focus on a single device—*exemplification*—and show some of the ways it enhances understanding in arts, the sciences, and elsewhere.

II

The Michelson-Morley experiment demonstrates that the speed of light is constant. Jackson Pollock's *Number One* highlights the viscosity of paint.[5] Neither states a truth. Neither needs to. Each makes its case effectively without saying a word.

The experiment affords instances of light's unvarying speed. There is nothing remarkable about that, though. Every working flashlight does the same. But by measuring the time it takes light to travel equal distances in different directions, the experiment underscores the invariance of the speed of light.

Number One supplies instances of paint's viscosity. So does every other painting. But through its clots and streaks, dribbles and spatters, the Pollock makes a point of viscosity. Most other paintings do not. They use or tolerate viscosity, but make no comment on it.

To highlight, underscore, display, or convey involves reference as well as instantiation. An item that at once refers to and instantiates a feature may be said to *exemplify* that feature.[6] In what follows, I shall call such an item *an exemplar*, and its referent *a feature*. It should be noted that under this usage a feature may be a substance, an attribute, a relation, a pattern, etc.

Since exemplification is a mode of reference, anything that exemplifies is a symbol. Not only do experiments exemplify theoretically significant features, and works of art, formally significant features, ordinary samples and examples exemplify the features they display. A fabric swatch exemplifies its pattern, color, texture, and weave. A sample problem worked out in a textbook exemplifies reasoning strategies to be used in the course. Examples, samples, experiments, and abstract paintings then all serve as symbols. Though they denote nothing and state nothing, they refer by means of exemplification.

Since exemplification requires instantiation, a symbol can exemplify only features it instantiates. *Number One* can exemplify neither the constancy of the speed of light or the pattern of a herringbone tweed, for it does not instantiate these features. Nor can it exemplify *all* the properties it instantiates. For exemplification is selective. *Number One* exemplifies paint's capacity to drip, spatter, blot, and clot, but not its capacity to depict, portray, record, and evoke. Other paintings about painting—seventeenth-century gallery pictures, for example—make the opposite selection, exemplifying paint's capacities as a medium, while merely instantiating its material capacities.

Although a symbol must instantiate the properties it exemplifies, its instantiation need not be literal. Thus an experiment can metaphorically exemplify properties like power, elegance, panache, and promise; a painting, properties like electricity, balance, movement, and depth.

The features an object exemplifies are a function of the categories that subsume it. So opportunities for exemplification expand as new categories are contrived. Some are the benefits of hindsight. When his works were first exhibited, it was, for obvious reasons, impossible to see Cézanne as a harbinger of cubism. Now his paintings practically cry out for such a reading, so plainly

do they exemplify the shapes of things to come. When it was first performed, the Michelson-Morley experiment was not recognized as the death knell of classical mechanics. But through its stubborn resistance to Newtonian interpretation, it came to exemplify the inadequacies of the Newtonian world picture. We rightly read it in retrospect as the beginning of the end of classical physics.

New categories often reconfigure a domain, connecting previously isolated features to form patterns, focusing on factors hitherto unworthy of attention. Not long ago, weak joints, curved spines, and blurred vision were just additional afflictions befalling certain tall, thin, heart patients. But with the identification of Marfan's syndrome, they coalesced into a clinical picture, their exemplification affording a basis for diagnosis and treatment. Similarly, the introduction of feminist categories in literary criticism discloses new contours in fictional works, exemplifying long-overlooked patterns and relationships. And the introduction of Freudian categories gives both life and art a new look. Once we recognize the possibility of unconscious drives, we have to go beyond sincere avowals to discover motivation. Dreams, jokes, oversights, and slips of the tongue acquire salience, often exemplifying desires the (real or fictional) agent can neither acknowledge nor control.

Exemplification of unsuspected features may, moreover, induce reconception. When *The Rite of Spring* exemplifies tonal patterns classical music cannot accommodate, or the Michelson-Morley experiment exemplifies phenomena classical physics cannot coherently describe, the inadequacies of available conceptions are made manifest. Such revolutionary works both attest to the need for and supply constraints on the reconfiguration of their domains. They serve as exemplary instances of categories whose extensions and interrelations remain to be developed.

An exemplar affords epistemic access to the features it exemplifies. From a fabric swatch one can discover the look and feel of a herringbone tweed; from *Guernica*, the horrors of war; from a blood test, the presence of antibodies. An exemplar then is a telling instance of the features it exemplifies. It presents those features in a context contrived to render them salient. This may involve unraveling common concomitants, filtering out impurities, clearing away unwanted clutter, presenting in unusual settings. If motives are ordinarily mixed, it may be hard to find among our fellows a clear example of unmitigated malevolence. But in Iago the feature shines forth. If ores ordinarily contain impurities, we may be unable to extract a sample of pure copper from the mine; but we can readily refine one in the lab. Stage setting can also involve introduction of additional factors. Thus a biologist stains a slide to bring out a contrast, and a composer elaborates a theme to disclose hidden harmonies.

It might seem that instantiation is all that matters—that for epistemological purposes at least, reference is otiose. Not so. For not all instances are telling. A flashlight beam affords an instance of, but no epistemic access to, light's constant speed; Botticelli's *Birth of Venus*, an instance of, but no access to paint's viscosity.

Perhaps what is wanted then is a conspicuous instance, one that makes the feature all but impossible to overlook. This won't do either. Conspicuous instances of a feature frequently fail to exemplify it. A can of house paint spilled on the rug presents an all too vivid instance of paint's viscosity. But it is unlikely to exemplify viscosity or anything else. Moreover, exemplars often convey obscure or elusive features while glossing over glaring ones. The most obvious feature of an experiment may be the complexity of its apparatus; of an opera, the implausibility of its plot. Yet neither is apt to be exemplified. The experiment may exemplify all but undetectible differences among allotropes of sulphur; the opera, nearly indiscernible distinctions among types of love. Even a fabric swatch can exemplify a less than obvious feature, like the difference in drape a bias cut makes. Inordinately inconspicuous features are often exemplified in works of art and science—subtle nuances, almost indistinguishable difference, abstruse kinships, patterns, and regularities that elude all but the most attentive gaze.

An effective exemplar can also revivify the obvious. *Number One* does not exemplify unfamiliar or recondite properties. Quite the opposite. It exemplifies features so obvious that we routinely look right past them. The Pollock forces us to focus on aspects of paint we have overlooked since early childhood. And a significant psychological study may tell us something we have never thought to doubt—for example, that early deprivation leads to lifelong difficulties.

What is wanted then is not just an instance or an obvious instance, but a telling instance—one that reveals, discloses, conveys aspects of itself. And it is by referring to those aspects that an exemplar points them up, singles them out, focuses on them. It thereby presents them for our scrutiny.

III

Exemplars, being symbols, require interpretation. To understand a painting, an experiment, even a paint sample, requires knowing which of its aspects exemplify and what features they refer to. If we take paint samples as our paradigm, interpretation seems straightforward for the system such samples belong to is regimented, its application routine. But exemplars operate in the arts and sciences are generally not so well behaved.

The features a symbol exemplifies depend on its function, and a single symbol often performs a variety of functions. A painting that exemplifies viscosity in a gallery might exemplify volatility in an investment seminar. A chemical reaction that exemplifies acidity in the lab might exemplify economy in a manufacturing process. Function, moreover, varies with context. A picture that does not normally exemplify the heavyhandedness of its imagery may be brought to do so through juxtaposition with works with a surer, more delicate touch. The acidity exemplified in one experiment may be mere by-product in another, even though the same chemical reaction occurs in both.

The intention of its producer does not determine an exemplar's interpretation. For its producer has neither privileged access to nor a monopoly

on the symbol's function. He may just be wrong. Van Gogh intended his *Bedroom* to exemplify comfort, security, and repose. What it actually exemplifies is a restless, feverish agitation. Michelson and Morley intended their experiment to exemplify the presence and magnitude of ether drift. Through its failure to oblige, it exemplified not only the nonexistence of luminiferous ether but also the incapacity of classical categories to accommodate electromagnetic phenomena—something Michelson and Morley found inconceivable. Even commercial samples can decline to exemplify what their makers intend. A swatch that immediately begins to fray may exemplify a fabric's shoddiness rather than the understated elegance the manufacturer intends it to convey.

Moreover, many symbols admit of multiple right interpretations. Theorems common to classical and intuitionistic mathematics exemplify different logical forms in each. Under different, equally correct interpretations, Shakespeare's *Henry V* exemplifies positive and negative attitudes toward war. Whether such multiplicity was originally intended makes no difference.[7]

Exemplars operate against a constellation of background assumptions. An interpreter ignorant of those assumptions may be incapable of interpreting or even recognizing the symbols. An experiment in superconductivity involves assumptions about electricity and temperature, about what has been shown or suggested or left open by earlier investigations, about the capacities and limitations of the experimental apparatus, and so on. A nativity scene is grounded in assumptions about theology, iconology, religious and artistic tradition, as well as assumptions about the representational and expressive range of the medium, style, and subject. These assumptions need not be articulate. Nor need the works presuppose their truth or adequacy. Like an indirect proof, a work of art or science may undermine its grounding assumptions. But without an appreciation of what those assumptions are, an interpreter is ill equipped to tell which features the work exemplifies, ill equipped therefore to understand the work.

Not all background assumptions are propositional. Syntactic and semantic assumptions are also made. These delimit the forms of symbols and the categories in terms of which they are to be construed. The periodic table of the elements supplies categories for the interpretation of chemical samples; plane geometry, categories for the interpretation of cubist works. The forms of classical music and classical mathematics dictate the significant structures of symphony and proof. Vocabulary and grammar need not, of course, be verbal. Properties and patterns exemplified in the arts and sciences frequently have no exact verbal formulation. What we cannot quite put into words is often captured in equations or harmonies or diagrams or designs.

With a change in background assumptions, a symbol can come to exemplify new features. The advent of relativity theory caused the Michelson-Morley experiment to exemplify features that were unrecognized, hence unavailable for exemplification, under the Newtonian framework. New categories of mass, energy, space, time, and acceleration were brought into play. Later classical music provides a new framework for understanding Haydn. Harmonies, textures, tonal patterns and dynamics clearly exemplified, sharply articulated, and

fully developed by Mozart are found exemplified in the works of his predecessors. An attentive ear that has heard Mozart's symphonies listens for, and hears in, Haydn's work patterns Mozart prepared it to find. Nor is it only explicitly artistic development that affects the background for interpreting art. After the Vietnam War, the lighthearted lunacy of Heller's *Catch 22* took on a darker, more sardonic tone.

I have urged that exemplification depends on and varies with context, function, and background assumptions. Although examples from art and science back my claim, commercial samples seem to belie it. The system of conventions governing the interpretation of paint samples apparently treats them as neutral, invariable, and unambiguous.

I demur. Rather than denying the relevance of context, function, and background assumptions, the system privileges a particular set. It can do so because it presupposes its audience shares a well-defined interest in paint. The normal function of paint samples is to aid in the selection of house paint. We are, presumably concerned about the color of the paint we select, and our interest is restricted to available alternatives. So the system is designed to supply easy epistemic access to these. That is all it does. In view of what we use the samples for, it is enough.

The very same samples might, of course, exemplify other features as well: the contemporary preference for rich colors, the unavailability of a warm brown, or the muddiness of one manufacturer's colors as compared with the vibrancy of another's. They may even exemplify features having nothing to do with color— for example, sloppy workmanship and inattention to detail exemplified by paint chips that peel off the sample cards. But to see the samples as exemplifying such features requires overstepping the boundaries the conventional rules define. And outside those boundaries, interpretation proceeds without rules.

Paint samples, as normally interpreted, are thus atypical. Interpretation is rarely a matter of routine application of fixed rules. For exemplars are highly sensitive to context, function, and background assumptions, and these admit of enormous variation. Nevertheless, interpretation is neither arbitrary nor hopelessly difficult. Traditions, rules of thumb, accepted interpretive practices and precedents guide us, though they provide no recipes. And despite their unruliness, context, function and background assumptions often suffice to determine or narrowly circumscribe interpretation of particular exemplars. We do not need an algorithm for interpreting experiments to infer that an experiment consisting of an apparatus hooked up to a volt meter exemplifies voltage. (It may, of course, exemplify other things as well.)

Interpretation of denoting symbols, it is worth noting, also proceeds without rules. As the census bureau recognizes to its regret, we have no nonvacuous rule for determining the extension of the term 'household'. We go by practice and precedent, drawing on available contextual cues, background assumptions, conversational implicatures, and functional roles, resorting to guesswork where necessary to assign referents to our terms. Indeed, we may have an easier time with exemplars for they are subject to a constraint that denoting symbols are

not. An exemplar can exemplify only features it instantiates, but a denoting term can refer to anything or nothing at all.

There are, of course, no guarantees. What a symbol exemplifies or denotes may permanently elude us, or remain forever in dispute. Perhaps we will never know what Schrödinger's cat or Giorgione's *Tempest* exemplifies, or who, if anyone, 'Shakespeare's dark lady' or 'the fifth man in the Cambridge spy ring' denotes.

IV

If we focus exclusively on illustrative or pedagogical cases, exemplars may seem mere heuristics. We provide examples in class to enliven our subject. But if students truly understand the material, we are apt to think, examples are not really necessary. A student has all she needs to do the problem sets when she has mastered geophysics, and all she needs to analyze the *Eroica* when she has mastered music theory.

I doubt it. Every theory admits of multiple models in a given universe.[8] So a student could grasp a theory without knowing how it applies. One role of examples is to select among admissible models. To be sure, an example will not fix interpretation uniquely for models that diverge elsewhere may agree about a particular case. Still, an example grounds a theory in its domain and gives the student a purchase on applications.

In any case, not all exemplars function primarily as heuristics. Experiments do not. Their main function is to test—to disclose whether phenomena have the features a theory attributes to them. Anyone who contended that experiments are superfluous once we master chemistry would profoundly misunderstand empirical science. Without experiments there would be no chemistry. Experiments do not just convey what is already understood, they engender further understanding.

Nor is art primarily heuristic. Like science, it provides telling instances that show that, how, and to what effect particular features are instantiated. No more than in science is this always a matter of illustrating what is already known. *A Doll's House* exemplifies what, many years later, *The Feminine Mystique* describes—the stifling limitations on women's lives that conventional middle-class marriages enforce. When *The Feminine Mystique* was published, critics doubted that the predicament is as painful as Friedan makes it out to be. They did not realize that Ibsen had already answered their doubts. Nora's predicament demonstrates that a guilded cage is still a cage and that the denizens thereof, however pampered, are still trapped. It took nearly twenty years and a scientific revolution to produce a framework that accommodates the features the Michelson-Morley experiment exemplifies, over eighty years and a social revolution to produce one that accommodates the predicament exemplified in *A Doll's House.*

Works of art often bring out hitherto unnoticed or poorly differentiated features. We might think, for example, that there is no difference (except,

perhaps, in degree) between sorrow and grief. We need only compare Michelangelo's *Pièta* with the figure at the left in Picasso's *Guernica* to learn otherwise. Each portrays a woman holding her dead child. The Michelangelo expresses incalculable sorrow; the Picasso, unmitigated grief. Sorrow evidently can be as profound as grief. There need be no difference in degree. But grief, we discover, is grittier; it is tinged with anger. Sorrow, on the other hand, is smooth. The comparison effects a refinement of the sensibilities, leaving us unlikely again to conflate or confuse the two emotions.

Science functions similarly, bringing overlooked features to the fore and drawing distinctions among them. With the articulation of a clinical picture, for example, characteristics that were once considered medically insignificant acquire the status of symptoms. A patient comes to exemplify qualities he previously only instantiated. As the clinical picture is refined, conditions that had been conflated come to be differentiated.

In my haste to recognize parallels between the arts and the sciences, I may seem to neglect a significant difference. Science purports to concern matters of fact. Art does not. Indeed, fiction makes a fetish of indifference to fact. This suggests two difficulties—one semantic, the other epistemic.

The semantic problem is this: an item cannot exemplify features it does not instantiate. Works of art are inanimate. Thus, it would appear, they are constitutionally unable to instantiate emotions, feelings, or other states of mind. If so, they are incapable of exemplifying such features. *A Doll's House* then cannot exemplify Nora's discontent, nor (assuming it is fictional) can the *Guernica* figure exemplify grief. Such works can, of course, exemplify features having to do with style, genre, technique, and the like, for they evidently instantiate such features. But their exemplification of properties like these hardly suits them for the significant epistemic role I have cast them in.

It is quite true that inanimate objects cannot literally instantiate states of mind. But they can and often do instantiate them metaphorically. Metaphorical instantiation, though it is not literal instantiation, is nonetheless real instantiation. The semantic difficulty dissolves. For works of art can and often do exemplify features they metaphorically instantiate. In that case they metaphorically exemplify those features. *A Doll's House* metaphorically exemplifies discontent; the *Guernica* figure, grief.

This leads directly to the epistemic difficulty. It is not at all clear how —or even that—a fiction's metaphorical exemplification can advance understanding of anything beyond the fiction. We cannot infer that the blind obsession metaphorically exemplified by Ahab is anywhere literally instantiated. So what, if anything, could an understanding of Ahab's obsession reveal about the world?

Rather than tackle that question head on, let's turn again to science. For science has fictions of its own—for example, thought experiments. These are imaginative exercises designed to disclose what would happen if certain conditions were met. Thought experiments may be purely cerebral, as Einstein's were. Or they may be mathematical models or computer simulations. But they

are not actual experiments. So they do not literally instantiate the phenomena they concern.

Still, they are obviously informative. Einstein was able to draw out startling implications of the theory of relativity by imagining what someone riding on a light wave would see. Scientists studying superconductivity discover from computer simulations how electric currents would behave in metals cooled to absolute zero.

Like other fictions, thought experiments instantiate phenomena they concern not literally, but metaphorically. The computer simulation will not run until the computer is warm. Still, what occurs can be metaphorically described as at a temperature of absolute zero. And in the context of inquiry into superconductivity, the simulation exemplifies this description of itself. That the simulation occurs in something metaphorically cold is scientifically significant. That it occurs in something literally warm is not.

The simulation discloses that at absolute zero, electrical resistance disappears. It does not, of course, demonstrate that absolute zero ever in fact is reached, or that resistance ever in fact disappears. But by revealing what would happen in the limit, it enhances our understanding of the connection between resistance and temperature, and suggests avenues for further investigation.

The success of a thought experiment turns on the accuracy and adequacy of its background assumptions. If our computer simulation omits factors that affect resistance or assigns them incorrect functions or weights, its output is not to be trusted. In this regard, thought experiments are no different from other experiments. Unless we are right to assume that only acid turns litmus paper pink, litmus tests are unreliable.

Both literal and metaphorical experiments can, of course, disclose that their background assumptions are faulty. The failure of the Michelson-Morley experiment to detect ether drift undermined the assumption that ether is there to be detected. The failure of a simulation of radioactive decay to reach equilibrium demonstrates the inadequacy of the assumptions on which it is based.

Just as thought experiments are fictions in science, works of fiction are thought experiments in art. Both are vehicles for exploration and discovery, providing contexts in which features may be demarcated, their interplay examined, their implications drawn out. Freed from the demands of factuality, fictions can separate constant companions and commingle traditional rivals. By doing so, they may transform our understanding of features and the conditions of their realization.

To anyone of even a mildly behaviorist bent, it might seem obvious that a person could not sincerely resolve to reform, yet continue to behave as badly as ever. Indeed, lack of improvement seems a sure sign that the resolution was not sincere. But through his characterization of Pierre Bezuhov, Tolstoy convinces us otherwise. Pierre truly means to reform his indolent ways, he just never gets around to it. In Pierre is exemplified the capacity of inertia to override resolution. The bond between resolution and action is broken. How resolution relates to action becomes again an open question.

Love and hate, one would think, are natural enemies. Vacillation between them is surely possible, but it seems obvious that one cannot both love and hate the same person at the same time. Obvious, that is, until one encounters a work like *Who's Afraid of Virginia Woolf?* where the possibility and pain of such a mix are clearly exemplified. The play forces us to recognize that antagonistic attitudes are not mutually exclusive and opens our eyes to configurations of emotions we once would have excluded *a priori*. In so doing, it deepens and enriches our understanding of emotional life.

Like other thought experiments, literary fictions often go to extremes. Ahab's obsession is not a mind set one encounters every day. But by seeing how it plays itself out, how it comes to dominate not just Ahab's mind but also the lives and destiny of his crew, we gain insights that may be applicable to more moderate, more familiar cases of psychopathology.

Features that are salient in extreme situations often are realized but are not salient elsewhere. By going to extremes, fictions bring them to the fore, delineating their characteristics, demarcating their boundaries, disclosing patterns of concurrence and independence. Fiction feeds back on fact. Once we have learned to recognize such features and the possibilities open to them, we often can locate them and their kin in their natural habitats.

An exemplar, I said, is a telling instance—an instance that discloses the features it refers to. Its embodiment of those features shows something of what they are and something of how they are realized. An exemplar thus facilitates recognition of further instances of the features it exemplifies.

Features often belong to families of alternatives. The exemplification of one member provides indirect access to others. We acquire the ability to recognize additional instances not only of the exemplified feature, but also of its kin. From a leaden cadence that exemplifies sadness, we readily infer the spritely sound of joy.

Exemplars thus equip us to go on—to apply the categories they highlight to new cases. This is not always easy or automatic. To follow where innovative exemplars lead often requires radical reorientation and reorganization. The stranglehold of habit can be difficult to break.

The insights exemplars afford are tested by further applications. Experimental results are acceptable only if repeatable. But mere repetition is not enough. That would control for dishonesty and negligence, but not for misleading results. By holding exemplified features fixed and varying unexemplified ones, we perform a more stringent test. A result that recurs under such circumstances is one we have reason to trust.

Something similar occurs in the arts. The adequacy of an aesthetic 'experiment' is tested not by trying to produce exactly the same effect in exactly the same way, but by trying to project the exemplified feature or family beyond the work that first exemplifies it. Constable did not continually paint the same cloud configuration. He projected his vision of clouds through a variety of configurations. And the viewer confirms that vision by coming to see actual clouds and other cloud pictures as having the forms Constable's works exemplify.

Not all exemplars afford a valid basis for projection. But even those that do not may enlighten. When we realize that the moral absolutes exemplified in cowboy films do not extend beyond the fictive realm, we learn something about the moral ambiguities and complexities of human life, and about the simplifying assumptions of the genre. When we realize that the fuel economies exemplified in test situations are not matched by cars on the road, we come to appreciate both the effects of driving conditions and techniques on fuel consumption, and the deceptiveness of advertising.

Exemplification's epistemic contribution has little to do with justified true belief. Justification in the sense of argument from accepted premises is out of place. An exemplar is vindicated not by what backs it up, but by what it brings forward. If it illuminates features that are worthy of attention (a contextual matter, to be sure), humble origins are no handicap. If not, the most patrician pedigree is no help.

Nor is truth crucial. Experiments and pictures, paint samples and fabric swatches inform by means of exemplification. Being non-verbal, such symbols are neither true nor false. Their success in advancing understanding thus does not turn on their truth. Nor need epistemically effective verbal exemplars be true. Effectiveness sometimes depends on non-semantic features such as syntax, style, inflection, or emphasis. And even where semantics is involved, a telling falsehood may be as revealing as a truth. If no one ever said, "Give me liberty or give me death!" someone should have.

An illuminating exemplar need not even affect belief. Its cognitive contribution may consist in augmenting one's conceptual repertoire, refining one's discrimination, honing one's ability to recognize, synthesize, reorganize, and so on. Even if extant beliefs remain in place and no new ones are formed, it is hard to maintain that exemplars that perform such functions are epistemically inert.

V

In this essay, I have sketched some of the cognitive functions common to exemplars in the arts and the sciences. My goal is not to reduce the arts to the sciences or the sciences to the arts, nor is it to construe either as underlaborer to the other. Rather, I suggest that the disciplines complement one another, each contributing to the advancement of understanding. That there are differences between them is plain. But these are differences within the cognitive realm, not between things that are cognitive and things that are not. If I am right, they are differences it is the business of epistemology to discern.

NOTES

1. Mary Mothersill, *Beauty Restored* (Oxford, 1984), 8.
2. W. V. Quine, "Two Dogmas of Empiricism." *From a Logical Point of View* (Cambridge, Mass., 1980), 41.
3. See Nelson Goodman and Catherine Z. Elgin, *Reconceptions* (Indianapolis, 1988), 135–52.
4. Ibid., 161–66.

5. The works of art and science I cite throughout this essay are offered by way of example. Nothing in my account hangs on the correctness of any particular example. The reader who disputes my choices can readily provide alternatives.

6. Nelson Goodman, *Languages of Art* (Indianapolis), 52–56. See also, Catherine Z. Elgin, *With Reference to Reference* (Indianapolis, 1983), 71–97. It should be obvious that throughout this essay I am enormously indebted to Goodman's discussion of exemplification and, more generally, to his understanding of aesthetics.

7. Goodman and Elgin, *Reconceptions*, 49–65.

8. Hilary Putnam, "Models and Reality," *Realism and Reason* (Cambridge, 1983), 1–25.

On Pluralism and Indeterminacy*

ROBERT KRAUT

Critical pluralism is the thesis that artistic works, unlike natural phenomena, admit of alternative, equally acceptable ("correct") interpretations, some of which are incompatible with others; it asserts that if there is one way to get an artwork right there are many ways. Thus construed, critical pluralism (hereafter CP) contrasts with critical monism ("There is a single correct, complete interpretation of an artwork"), and with critical anarchism ("All interpretations of an artwork are equally acceptable"). CP is an exciting thesis: it entails that two critics could lay equal claim to understanding the same artistic phenomenon despite serious disagreements with one another. It promises rival interpretations: complete interpretations, each of which accounts for all the artwork's features—yet all equally correct, and genuinely incompatible. CP is thus puzzling: it strains at the ordinary concepts of correctness, completeness, disagreement and incompatibility. In what sense are the touted "rival" interpretations genuinely incompatible? Does one interpretation really affirm what another denies? In what sense are they equally *correct* (does 'correct' here mean 'true')? In what sense do they account for *all* of the artwork's features?

Problems of coherence and intelligibility aside, two immediate questions arise: one concerns the importance of CP, the other concerns the reasons, if any, for accepting it. I shall discuss several arguments for CP, and conclude that none of them succeeds; the critical monist has a ready, if labored, response to each of them. I shall then discuss a strategy—"anti-realism" or "non-descriptivism" about art-interpretive discourse—designed to confront the intelligibility problem and to provide a different kind of support for CP. Finally, I suggest that the entire pluralism-monism problematic has been misconceived: it is not a dispute to be settled by argument. It is rather the manifestation of quite disparate stances concerning the nature of art and the purpose of critical discourse.

I

Franz Kline and Elaine de Kooning were sitting at the Cedar Bar when a collector Franz knew came up to them in a state of fury. He had just come

from [Barnett] Newman's first one-man show. "How simple can an artist be and get away with it?" he sputtered. "There was nothing, absolutely nothing there!"

"Nothing?" asked Franz, beaming. "How many canvases were in the show?"

"Oh, maybe ten or twelve—but all exactly the same—just one stripe down the center, that's all!"

"All the same size?" Franz asked

"Well, no; there were different sizes; you know, from about three to seven feet.'"

The collector continued to complain about the simplicity and nothingness of the work; Kline continued to ask questions: about color, orientation, and width of the stripes; darkness of the stripes relative to the background; colors of the backgrounds; whether the pictures were horizontal or vertical; and so on. Finally,

"Was the stripe painted on top of the background color or was the background color painted around the stripe?"

The man began to get a bit uneasy. "I'm not sure," he said, "I think it might have been done either way, or both ways maybe . . ."

"Well, I don't know," said Franz. "It all sounds damned complicated to me."[1]

This anecdote prompts questions about artistic understanding and about attributions of artistic content.

Kline did more than highlight parameters which the collector had ignored; anyone, however ignorant about Newman's work, could have done that. Kline dismantled the collector's conviction that there was "nothing there" by calling attention to *relevant* parameters—features on which the meaning or significance of Newman's work somehow depended. He was trying to help the collector *understand* the work. If a rival critic had identified different parameters as the important ones he might have gotten it wrong; or perhaps Kline, for all his cleverness, got it wrong. There is, at any rate, something here to be right or wrong about—viz., those features of an artwork which are genuinely relevant to its meaning, and thus to its being understood.

But how many ways are there to get it right? Could Kline and the rival critic have both been correct, despite genuine disagreement with one another? Could they both have *understood* the work, despite disagreement? Again we encounter the intelligibility problem (do they really disagree? If so, can they really both be correct?) which I propose to ignore until later. We are also reminded that the pluralism-monism dispute has something to do with attributions of artistic understanding. Perhaps if we had a better sense of what it is to understand an artwork—or of the purposes served by attributions of artistic understanding—we could see the dispute more clearly. It is not clear how artistic understanding relates to other varieties of understanding: for example,

to the varieties of understanding at work when a native speaker (or translator) understands a grammatical sentence, or when a scientist understands the data, or when a person understands another person's actions or mental states. Nor is it clear how artistic meaning—that which is specified in artistic interpretation—relates to natural language meaning, the meaning of socially significant non-linguistic gestures, the content of psychological states, or any other semantic phenomenon. Perhaps if we knew more about interpretation—artistic or otherwise—we would be in a better position to appraise CP.

This line of reflection suggests an approach to the dispute. Critical pluralism has obvious counterparts in semantic theory. W. V. Quine, for example, claims that natural language meaning is indeterminate: for any given language *L*, it is possible in principle to construct incompatible translations of *L* ("rival translation manuals"), all of which are equally correct. As Quine puts it, "manuals for translating one language into another can be set up in divergent ways, all compatible with the totality of speech dispositions, yet incompatible with one another."[2] The critical pluralist might attempt to appropriate Quine's arguments for the Indeterminacy of Translation—or other arguments which point in similar directions—and urge their applicability to the artworld. This methodology need not assume that artforms are natural languages; it need only assume that artistic interpretation is relevantly similar to natural language interpretation or propositional attitude psychology, and is thus equally susceptible to arguments for indeterminacy. All of this depends, of course, on the soundness of the arguments for semantic indeterminacy.

Quine's arguments for the Indeterminacy of Translation (IT) are controversial; the critical pluralist should be cautious in exploiting them for his purposes. Opponents of IT often claim that Quine's arguments rest on an indefensible bifurcation of translation and natural science; they urge that the analytical hypotheses demanded by translation are, *pace* Quine, genuine hypotheses, ontologically on a par with the theoretical hypotheses of mathematical physics. There are other familiar criticisms: that the bifurcation of semantic discourse and scientific discourse is incompatible with Quine's own scientific realism; that the bifurcation stems from indefensible biases in favor of elementary particles and against intensional entities; or that IT promises full-blown rival translation manuals but that Quine fails to deliver; or that IT is a trivial consequence of too minimal a set of constraints on proper translation; or that the thesis is self-refuting; or that the thesis is unintelligible.[3] There is little agreement about the correctness of IT, the cogency of Quine's arguments for it, or its precise consequences. But *prima facie* the thesis is profound: it tells us that if there is one way to get the natives' discourse right there are many ways. Some ways might seem more natural than others, but this, according to Quine, is a fact about our own provincial sense of what counts as a natural kind, and does not point toward the "incorrectness" of the apparently bizarre translation schemes.

Quine notwithstanding, the critical pluralist may wish to exploit just this controversial bifurcation between the methodology of scientific inquiry

and that of "interpretive" inquiries. Consider Habermas's distinction between "empirical-analytic" sciences, which aim to discover microstructural explanations and covariances among observable events, and the "historico-hermeneutic" sciences, which aim at the discovery of meaning or semantic content. Perhaps the critical pluralist is in the throes of this venerable distinction, intent upon resisting "causal theories of representation" or "naturalistic accounts of semantic content" generally. He may grant that paintings are physical objects in the physical world—as are painters themselves—and thus that there exists a causal story about Newman, his painterly output, and his community. But the critical pluralist may insist that there is another standpoint from which to survey Newman and his work, a different methodological framework for gaining knowledge, a stance which involves interpretation rather than causal explanation. It is here—he might argue—that pluralism gains a foothold, given the nature of the hermeneutic standpoint. How might the argument proceed? Habermas says

> Hermeneutic knowledge is always mediated through this pre-understanding which is derived from the interpreter's initial situation. The world of traditional meaning discloses itself to the interpreter only to the extent that his own world becomes clarified at the same time. The subject of understanding establishes communication between both worlds. He comprehends the substantive context of tradition by *applying* tradition to himself and his situation.[4]

Think of this remark in the context of radical translation. The linguist begins with a capacity to use his own language (this is the "pre-understanding which is derived from the interpreter's initial situation"). He reflects upon the roles played by his words—the complex functions they subserve in the games of gathering evidence, theorizing, communicating, deliberating, and countless other activities. He notes the relationships between individual word-types and perceptual evidence, appropriate behavior, and inferential transformations. He asks—if sufficiently perverse—about the patterns of sensory irritation which prompt assent, *ceteris paribus*, to certain kinds of utterances ("occasion sentences"). He asks about the conditions under which his sentences are true, or the kinds of commitments undertaken in providing certain utterances rather than others. And so on. In doing all of this—in asking about the complex roles played by his individual linguistic items—he is asking about their meanings, thereby "clarifying his own world." He then seeks a pairing of native expressions with his own, hoping to find, for each native expression, an item in his own framework which plays much the same role; this involves idealizations, approximations, counterfactual hypotheses, appeals to normalcy and *ceteris paribus* conditions, and other familiar aspects of theory construction.

One source of indeterminacy might be this: translation, and interpretation generally, is holistic: social practices—linguistic and otherwise—are what they are by virtue of their relations to one another. Perhaps the idea is that holism is itself a source of indeterminacy, insofar as any functional specification of a social practice can be replaced by another, "equally correct" but incompatible

specification—so long as compensatory adjustments are made elsewhere in the theory. But this is a prejudice, not the conclusion of an argument. Pending such arguments, it appears that functional role—including the inferential roles played by bits of language—consists in determinate position in a complex causal and normative network. There is a fact about the nature of that role—a fact about causal, normative, and counterfactual properties possessed by any item which plays that role. As with any other fact, there is one way to get it right, many ways to approximate it, and many more ways to get it wrong. The interpreter, having discovered such facts, seeks to identify items in his own repertoire which have approximately the same functional properties. Such are the dynamics of interpretation. Perhaps he lacks the expressive resources for finding a close translational counterpart; but this is no source of indeterminacy. At most it is a source of ineffability.

So: the fact that social practices—linguistic or otherwise—are constituted by relations to other social practices does not provide any immediate argument for indeterminacy. The pluralist requires an argument from the holistic character of social-institutional phenomena to the existence of "incompatible but equally correct" characterizations of those phenomena. And this argument he does not have.

Perhaps the critical pluralist has in mind a different source of indeterminacy, a source suggested by Habermas's insistence that interpretation "establishes communication between both worlds"—e.g., that of the critic and that of the artist. The idea would be this: imagine two interpreters immersed in quite distinct initial situations; they have different interests and explanatory goals, different senses of what is or is not important, different ideological commitments. These differences between the "initial situations" which constitute the interpreters' "worlds" will, no doubt, engender different interpretations of the same phenomena. But no argument has been provided that these interpretations are in any interesting sense *incompatible* or *rival* interpretations, or that, if they are, they have equal claim to correctness. Different linguists might seek to translate the same object language into distinct background languages; different interpreters might seek to understand the same social practices in terms of quite different background assumptions, similarity standards, criteria of explanatory coherence, and ideological commitments. Some will do better than others (at least, by our lights). Moreover, relative to any such "background interpretive framework," there is likely to exist a plurality of *what appear to be* equally good functional characterizations of a given phenomenon; this includes linguistic, artistic, or psychological phenomena. But this appearance is no indication of indeterminacy. It is rather the result of epistemic underdetermination, and of the theorist's need to idealize and approximate. All of these multiplicities are explicable in ways that provide no support for claims of indeterminacy; none of these multiplicities provides adequate basis for accepting CP.

This much seems right: although artistic genres and natural languages play importantly different roles, artistic phenomena are located in a complex system involving many of the parameters relevant to linguistic meaning. Musical

event-types, for example (i.e., repeatable, reidentifiable musical events) are implicated in "inference-like" practices (for example, certain temporal orderings of pitches imply specific tonal centers); and musical events or paintings are often thought to warrant certain affective-behavioral reactions rather than others. Facts of this kind provide the resources for characterizing a dimension of artistic meaning, and thus provide help in understanding artistic understanding. But no compelling *general* argument for interpretive pluralism—i.e., for the existence of a multiplicity of equally correct but incompatible specifications of these facts—has yet been provided.

II

The social dimension of meaning is back in the news. For many years Wilfrid Sellars advocated a "social behaviorist" theory of word meaning (and intentionality generally), stressing the dependence of semantical content upon communally upheld linguistic norms which constrain a speaker.[5] More recently Putnam has urged that word meaning often depends upon a "division of linguistic labor" throughout a population, and Burge has dramatized the relation between attributions of propositional attitude content and the linguistic norms operative in an agent's community.[6] Such views might provide the critical pluralist with a foothold. He might urge that interpretation, as opposed to causal explanation, cannot proceed unless the phenomenon in question is regarded as located within a system of social practices; artistic behavior, *qua* meaningful, somehow involves the artist's responsibility to shared communal norms. Attributions of artistic content thus covary with the social practices— the community—relative to which the artist's output is understood. Artistic behavior, or products thereof, can be located within a system of social practices only if that behavior or those products are thought of as related to systems of norms, networks of rule-governed regularities. Artworks, in other words, are *artifacts*: they cannot be understood in isolation from the communal norms that spawn and sustain them. So the critic must ask: Who are the other artists in the context of whose work Newman's work should be seen? What is the relevant community, and thus the relevant class of social practices? The critical pluralist might argue that there is no determinate answer to this question. That argument, combined with arguments which tie artistic content to communal norms, might serve to support CP.

Just as linguistic communities play an essential role in the constitution of semantic content—it is the word's use in *this* group which constitutes its meaning—art communities play a corresponding role in the determination of artistic content. The analogies, in fact, are striking. The artworld is constituted by a vast network of partially disjoint communal structures; each such structure is defined in terms of recognition and deference relations among the members. Each such structure, moreover, sustains norms and conventions definitive of a given genre and style. Picasso deferred to Braque, responding to his criticisms and ignoring most others; moreover, Cezanne's reactions would have mattered

more than those of Matisse. The Futurist painter Severini had similar ties with Boccioni and Balla; and so on. These are not inessential facts about these artists; the very meaning and significance of their work depends upon such facts. Recall the anecdote about Kline and Newman; we wondered whether Kline might have gotten things wrong. On the present view, however, the significance of line-width is a socially constituted property; line-width is significant insofar as Kline *recognizes* it as significant and Newman recognizes Kline as worth taking seriously. To be a significant feature of the artwork is to be *treated* as significant by those who matter.

The operative principle here is that Newman's work cannot be treated as an artwork—and thus as susceptible to interpretation—unless it is construed as occupying a place within an institutional, normatively constrained context: an artworld. But there are many such artworlds, just as there are many distinct natural languages. We must make an interpretive choice: shall we mobilize the canons of Impressionism, or Cubism, or Surrealism? The answer is obvious: We should mobilize the *proper* canons. Braque is a Cubist, not an Impressionist: consequently it is line, rather than color, that should be attended to in his work (color was a distraction to the Cubists, given their goals; thus their resort to a monochrome palette). Locating an artist's work within a style or genre—thereby determining what is or is not important in the work—is often difficult: not because we do not know enough, but because the facts underdetermine the classification. It is here that indeterminacy might gain a foothold. There could be an art historian who saw Monet as a "Cubist before his time"; perhaps the historian believes that the works "make more sense" when viewed this way (i.e., that interpretive and explanatory benefits accrue from classifying the work thus). It would be odd to object that such interpretive strategies are ruled out by the fact that Monet was not "really" a Cubist; for what could the objection mean? If style terms like "Cubism" were natural kind terms, the objection might mean that this artwork, though superficially resembling paradigm instances of Cubist pieces, lacks those underlying microstructural properties which explain the salient features of Cubist pieces. But surely it is a mistake to regard the semantics of style terms this way; "Cubist painting," unlike "lemon," does not denote by virtue of hidden (and explanatorily relevant) structural similarities to paradigm cases.

Perhaps, then, the suggestion that Monet's work "is not genuinely Cubist" means simply that rich explanatory dividends are *not* to be derived from placing Monet's work next to that of Gris, Leger, Braque, and Picasso. But that is precisely what our envisaged art historian denies! Given his interests—his explanatory goals—there might be no basis for disputing his claim.

Folk wisdom—doubtless informed by traditional art history texts—dictates that we study Jackson Pollock's work alongside that of Rothko and Newman. If our goal is to understand Pollock's work, we ought to view it as an artifact of the appropriate community; we should theorize about it in the proper context. It is difficult to specify the procedure for circumscribing communities; intuitively, communities are held together and differentiated from one another

in terms of shared interests, cooperative upholding of norms, dispositions to defer to the same authorities, and patterns of mutual recognition. Often—perhaps
usually—we cannot say where one community or interest group ends and the
next begins; because this is equally true of art communities, the corresponding
artistic classifications and interpretations will reflect it. Classification is often
difficult. But surely Jackson Pollock *actually belonged* to the community of
Abstract Expressionists, thereby legitimizing the application of Expressionist
standards to his work.

A theorist already in the throes of CP might resist this specification of a
privileged community: he might invoke a plurality of distinct artistic communities, urging that different important features of the work become evident when
the work is viewed against the backdrop of these various communities; and
this, in turn, would lead to a plurality of equally legitimate interpretations. But
this invocation of a multiplicity of "equally relevant" artworlds seems unjustified, especially in light of our preoccupation with natural language analogies.
The meaning of the work is constituted by the norms operative in the artistic
community which engendered the work. By what right does a theorist invoke
other communities in the interpretive process? Simple analogy: it is easy to discover, in most cases, when a speaker is using good German rather than bizarre
English; determinate facts about the speaker dictate that one set of linguistic
norms, rather than another, bear upon the interpretation of his words. Locating a
speaker's linguistic niche—causal and social-institutional—doubtless involves
various idealizations but we manage to do it. Locating Pollock's artistic niche,
thereby fixing the relevant interpretive canons, should be no more difficult.

But artistic genres are not natural languages. The mechanisms which
enable linguists to identify utterances as belonging to one language or another
might not have clear counterparts in the realm of artworks, styles, and genres.
There could be an artwork produced by one who belongs simultaneously to a
plurality of artistic communities, in each of which different norms and standards
of significance are upheld. Such a case would present an interpretive quandary;
different critics might construe the work as an artifact of different communities,
thereby resulting in a plurality of interpretations—each of which is surely as
correct as the next. Perhaps critical pluralism results from dwelling upon just
such quandaries, and exaggerating their frequency in the artworld.

These possibilities are interesting, but they appear not to give the critical pluralist what he wants. They point toward instances of ambiguity, not
pluralism; no one, critical monist included, ever denied the presence and importance of ambiguity in the arts. But ambiguity is not indeterminacy and it is
not pluralism. I shall return to these distinctions later.

An artwork is an artifact; interpretation and understanding demand that it
be treated as occupying a position in a social-institutional framework, within
which are upheld the norms that constitute the artwork's meaning. We might
avoid all flirtations with pluralism if we could say this: corresponding to every
artist is a determinate deference class—those people whom the artist recognizes
as having the right to judge him. He recognizes the relevance of their criticisms

and suggestions: they matter, and they affect his artistic behavior. They are the viewers, listeners, critics, and other artists to whom the artist has undertaken a commitment. It may be more difficult to identify this class than it is to identify, for a given natural language speaker, the class of persons by whose semantical norms the speaker is constrained. But there is one, and only one, correct answer to the question "What is that class?"

The analogy with natural language translation is especially helpful here; for it provides an opportunity to demonstrate that the identification of "relevant linguistic community"—an identification on which translation often depends— is often beset with puzzles and the need for arbitrary decisions. We should not be so glib about identification of the language community to which a speaker belongs; perhaps, in this connection, there will emerge a basis for genuine translational indeterminacy. If the critical pluralist can then sustain the working analogy between translation and artistic interpretation, an argument for CP might be close at hand.

The interpretation of an individual speaker's words often rests upon the interpreter's choice of a "relevant linguistic community" to which that speaker belongs. To see this, and to see the difficulties involved and caution required in making this choice, consider Hilary Putnam's discussion of our ancestors' use of natural kind terms. Suppose Oscar is a typical English speaker living in 1750; he knows nothing about hydrogen, chemical bonds, or microstructures. Moreover none of those with whom he speaks, and to whom he defers when liquid identification is the task at hand, knows about chemical or microstructural matters. Putnam tells us ". . . the extension of the term 'water' was just as much H_2O on Earth in 1750 as in 1950."[7] It is clear why Putnam believes this. Expressions like 'water' depend for their use upon a counterpart relation, a standard of similarity (what Putnam describes as the '$same_L$' relation in the case of water). A pool of liquid must, to qualify as water, be relatively similar to the stuff originally baptized 'water' by Oscar's predecessors; and Putnam takes the relevant standard of similarity to be *microstructural*. It is hardly clear that Oscar's peers would have taken that to be the relevant relation; their application of the term, and their appraisals of one another's application of the term, do not rest upon microstructural considerations (How could they? They do not yet have the resources). Why is the relevant similarity relation—the counterpart relation on which the interpretation of Oscar's term 'water' depends—dictated by our present standards of relevant similarity? There is something imperialistic about this methodology (phrases like "commitment to scientific realism" do not ease the political-semantic pain). What about the standards operative in *Oscar's* community—standards with which he himself might have been unfamiliar, but which nonetheless would have been mobilized by those "experts" to whom he deferred on such matters? Suppose that speakers in Oscar's relevant linguistic deference class would have been content to apply 'water' to any pool indiscernible from the original exemplars *modulo* taste, color, and macroproperties generally. Would they have been wrong?

This calls for an interpretive decision. The choices are these: (1) No, they were not wrong. Given the observable data concerning the use of 'water' in Oscar's community, we ought to depart from homophonic translation. Perhaps we do better to translate 'water' as 'colorless liquid superficially indiscernible from water', or some such. (2) Yes, they were wrong. For purposes of semantic interpretation, Oscar's words should be interpreted relative to a community which includes our present experts; we may treat Oscar as implicitly deferring to chemists at M.I.T. After all, if Oscar *were* given the opportunity to defer to these people on matters of linguistic usage, he might do so. This counterfactual deferential connection warrants our interpreting Oscar's term 'water' the way Putnam says we ought to interpret it. Moreover, it might be that the people to whom Oscar defers would, if given the chance, defer to people who would defer to our present chemists. Such deferential chains would legitimize Putnam's semantic interpretation, given a willingness to treat deference relations as transitive.

The point is this: Putnam tacitly treats Oscar as though he were a member of our own language community, responsible to the norms—in this case, the similarity standards—which constrain us. This treatment might lead to the best interpretation of Oscar but it might not. We may grant that the interpretation of Oscar's terms is partly determined by facts about the way his words are used in his community. Thus we must be *extremely* cautious in identifying his community; knowing where he lives is not enough. We must know who he talks to—more accurately, who he would talk to—and how he would talk to them. Even if we grant that the semantical interpretation of Oscar's words is constrained by social facts—facts about the linguistic dispositions of those to whom he defers—Putnam's suggested interpretive scheme (e.g., " 'water' in 1750 referred to all and only H_2O aggregates") is not forced upon us. It all depends on the selection of *relevant linguistic community* (i.e., deference class); the meanings assigned to many of Oscar's expressions covary with the choice of this class. There might be determinate facts about the constitution of this class—i.e., about the linguistic community which Oscar should be treated as belonging to for purposes of interpretation. But there might not be such facts; it might be a matter for decision rather than discovery.

The critical pluralist is likely to be encouraged by this discussion. His argument might be this: an artwork is what it is by virtue of the communal artistic norms that bear upon it. For any specification of such norms—i.e., any specification of the community of which that artwork is an artifact—there exists another, incompatible but equally correct specification. One may, for example, view Kasimir Malevich's work as Cubist—thereby highlighting certain of its features—or as Suprematist, thereby highlighting others. These classifications derive from seeking Malevich now as a member of one community, now as a member of another. Neither of these classifications is less correct than the other; each yields considerable critical-explanatory dividends. Many artworks—perhaps most artworks—provide instances of such pluralism. Therefore CP is vindicated.

Art historians can hopefully provide compelling examples of this phenomenon. But the argument for CP is unsound, despite its focus on a fascinating aspect of art. Like most artists, Malevich obviously stood in a plurality of relations to a plurality of groups. There need be no "incompatibilities" among these groups, and even if there are CP is no consequence. The proper interpretation of the artist's work would take into account the tensions and ambiguities engendered by such disparate allegiances. Any interpretation based upon the norms sustained in only one of the many groups to which he belongs would not be, *pace* the pluralist, "one of several equally correct interpretations"; it would, rather, be an incomplete interpretation, an interpretation which fails to account for all the features of Malevich's work.

Thus these considerations about relevant community provide no sound argument for CP. They do, however, point toward subtle and important aspects of the way we think about art in relation to language. Consider again natural language translation. The norms reflected in correct translation are norms upheld in a population: we say "it is the word's usage in *this* population that constitutes its meaning." A speaker's overt verbal behavior involves the use of utterance-types which are, so to speak, the property of the group with which that speaker engages in fluid dialogue. Word-types are community property; semantical interpretation takes this into account by attempting to discover the role played by a speaker's utterance-types *relative to that class of speakers by whose semantical norms the speaker is constrained.* Circumscribing this class is often difficult, depending as it does upon distinguishing semantical differences from differences in collateral information. But we make whatever assumptions and idealizations are required to oil the wheels of smooth translation. None of this tells against the determinacy of semantic content.

Artists also belong to communities: those people with whom they work, those by whom they have been influenced, those to whom they defer. Why not take the norms prevalent among that community as determining the proper interpretation of the artist's work?

Herein lies a difference between our concepts of natural language and our concepts of artistic phenomena; for we balk about designating any particular population as the one in which "property rights" for an artwork reside. We are willing to insist that native discourse belongs to the natives—or, more broadly, to those with whom the natives would be willing to converse. But Picasso's paintings belong to the world. *No* population enjoys privilege over any other in fixing the artistic facts constitutive of the "proper interpretation" of an artwork. And this spells doom for strict analogies between linguistic meaning and artistic meaning.

Sentiments of this kind—whatever their merit—might be the real force behind the insistence upon critical pluralism. Perhaps we should focus on this aspect of CP—viz. the kinds of commitments incurred, or the kinds of stances manifest, when one endorses CP. That is: we have looked for arguments in favor of CP, and have met with little success. Perhaps we should instead ask why someone might be led to advocate CP.

III

When the art critic Leo Steinberg was trying to make sense of Jasper Johns's paintings, he entertained various interpretations. After ruminating about nonsense and anti-art, banality of subject matter, sensuous surface, random and gratuitous desecration of the human body, spatial inversion, and a sense of waiting, he says

> In the end, these pictures by Jasper Johns came to impress me as a dead city might—but a dead city of terrible familiarity. Only objects are left—man made signs which, in the absence of men, have become objects. And Johns has anticipated their dereliction.

Steinberg then turns reflective and raises a profound question about the status of this interpretation:

> What I have said—was it found in the pictures or read into them?[8]

There are two ways to understand this question: (1) Steinberg wants to know whether he *discovered* facts about the pictures or merely *invented* a helpful story which he then projected back onto the pictures. On this reading, the question is whether interpretive discourse plays a "fact-stating" (i.e., descriptive) role. (2) Steinberg wants to know whether he discovered properties *intrinsic* to the pictures, or whether he discovered *relational* properties—perhaps causal or social-institutional properties—which he then treated as features of the pictures themselves. Here the working distinction is not that between discovery and invention, but rather that between intrinsic vs. contextual properties.

Concerning (2): if the properties ascribed *via* art-interpretive discourse are contextual properties—properties which relate a painting to its causal ancestry, or to its appropriate effects in some specified community, or whatever—no support is thereby provided for CP. But this relationality might provide an embarrassing explanation for the pluralist's claims. It is as though someone were to overhear two navigators in conversation, one urging that Dubrovnik is to the east, the other that Dubrovnik is to the west, and were to infer—given the obvious success of both navigators—that there exists a plurality of equally correct but incompatible specifications of position. The specifications are obviously not incompatible: Dubrovnik is both to the east (of Italy) and to the west (of Bulgaria). Relationality can engender the appearance of pluralism if some of the relata are not explicitly mentioned. But the relational character of those properties ascribed via art-interpretive discourse is no ground for CP.

The other reading of Steinberg's question is more interesting. Recall the initial challenges to the intelligibility of the pluralist's thesis: we could not understand how genuinely rival interpretations could be both complete and equally correct. Pressure exerted by such challenges may lead the pluralist to deny that there are any "objective facts of the matter" to which interpretive schemes, if correct, must conform. He might suggest that aesthetic discourse plays a non-descriptive role; that sentences about artistic meaning do not possess truth

conditions: their primary semantic function is not to state facts about artistic meaning ("because," he might urge, "there really are no such facts") but rather to express attitudes, manifest stances, or incur commitments. Then he owes us a detailed and systematic account of the precise role(s) played by such discourse—the kinds of situations that prompt its use, the kinds of situations prompted by its use, the kinds of attitudes projected through its use, and the like.[9] This retreat to anti-realism ("expressivism," "projectivism," "non-descriptivism," etc.) about the discourse of artistic interpretation could allow for a coherent formulation of CP. The agenda would be this: argue that the incompatibility of rival interpretations is not a truth-functional matter consisting in disagreement about the facts; it is more like the incompatibility between a "boo" stance and a "hooray" stance taken toward the same state of affairs. Such incompatibility might be *grounded* in disagreement about the facts but is not *equivalent* to any such disagreement. If the critical pluralist can develop a convincing analogy with expressivist theories of moral discourse (and moral disagreement), and if he can provide a convincing anti-factualist account of the *correctness* of an artistic interpretation, he will thereby have earned the right to persist in his pluralist claim.

But the anti-factualist strategy, even if workable, is extremely dangerous; it threatens to ramify. The discourse of artistic interpretation seems remarkably similar to the discourse of psychological interpretation, linguistic interpretation, and semantic content ascription generally. There seems little plausibility in the claim that "Cezanne's utterance was about the exhibition" is a truth-conditional descriptive sentence, whereas "Cezanne's paintings represent objects viewed from several perspectives simultaneously" is not. Maybe the claim could be rendered plausible: perhaps artistic interpretation is so different from other instances of content-attributing discourse that anti-realism about the former need not bring with it anti-realism about the others. Pending such an argument, however, it seems that anti-realism about semantic content is too high a price to pay for the intelligibility of critical pluralism. Better to give up CP and preserve our realist intuitions about meaning, reference, and the content of propositional attitudes.

There is, however, another way that anti-descriptivist strategies might illuminate these issues: apply the strategies not to art-interpretive discourse itself, but one level up–that is, to the higher level discourse in which the monism-pluralism dispute is carried out. Continue to construe art-interpretive discourse descriptively; construe it as stating facts about artistic meaning (however "contextual" those facts might be). But construe the pluralist claim (and its monist opposition) as non-descriptive: the pluralist, in endorsing CP, is not stating a deep fact about artistic meaning. He is, rather, expressing an attitude (or "projecting a stance") about artworks and art interpretation. It remains to be specified what sort of stances he might be projecting, what sorts of conditions might engender such stances, what overall purposes are served by such projections. Like emotivist theories of moral discourse, Humean theories of causal discourse, or Kripke-Wittgenstein theories of rule-following discourse,

a projectivist account of the monism-pluralism dispute would require careful theorizing about a host of parameters. Moreover such an account does not, without additional information, vindicate CP; but it might illuminate the dispute by suggesting that we were looking in the wrong place for a resolution. Perhaps monism and pluralism are both correct (however we ultimately construe the 'correctness' of such doctrines) though each by its own lights.

The strategy is this: Imagine an art historian who demands that Newman's peers—his knowledgeable peers—constitute the "reference population" for the interpretation of Newman's work. Our historian is dogmatic: he insists upon the distinction between correct and incorrect interpretations of an artwork; he urges that an interpretation, to be correct, must be constrained by the artistic norms and practices operative in the community which produced the work. There are, he realizes, artists who worked in relative isolation, or members of the avant garde who break away from extant systems of norms. No matter; our historian insists upon interpreting the artworks with an eye on precisely those norms and traditions from which the artists and their works break away. He is convinced that there is a unique population against the backdrop of which an artwork must be interpreted; only in this way, he argues, can an interpretation be found which genuinely explains all of the artwork's features. He knows that different viewers—individually or in organized groups—are likely to interpret a piece in different ways, or to regard different features as significant. But this, he says, does nothing to establish that these viewers understand the piece; perhaps they are getting it wrong, and reinforcing one another's interpretive errors.

What are we to make of this historian's insistence upon the existence of a *unique correct interpretation* of an artwork? Here the projectivist strategy might be illuminating. We may construe this insistence as *the expression of a commitment: to the essential explanatory role of that population which is responsible for the artwork*. It is a commitment to the idea that the artistic perceptions and standards of significance within that population provide the constraints on correct interpretation. Our historian believes that only in terms of such perceptions and standards can various important aspects of the work be best explained. His interpretations, and his insistence that there exists only one correct interpretation, manifest his commitment to the norms upheld in a particular population: he is committed to seeing himself as "one of them" when thinking about the work, and to the necessity for seeing himself as one of them if he is to genuinely understand the work. The significance of an artwork, he urges, is as much an artifact of social-institutional forces as is the meaning of an utterance; his insistence upon the uniqueness of that significance manifests an unwillingness to divorce the artifact from the very population that constitutes it.

The pluralist is unimpressed with such considerations. He admits, should the question explicitly arise, that the explanatory significance of that particular population is precisely as the historian portrays it. But he lacks any urgent desire to provide the kinds of explanations sought by the historian; he is content to immerse himself in the work and tingle with aesthetic rapture. The suggestion that some modes of rapture are more appropriate than others, given the

meaning of the work, strikes him as inimical to the spirit of art. Consequently, the population which the historian elevates to privileged status has, for the pluralist, a far less privileged status: it is simply one community among many, one interest group among many, one set of norms among many. He is willing to cut the artwork loose from its causal-historical ancestry and let a thousand equally legitimate reference classes bloom. In defense of this pluralistic strategy, he might insist that art is just the *sort* of thing from which people should derive whatever experiences they can—none being any more or less correct than any other (such sentiments correspond to critical anarchism). Less extremely, he might insist that art is the sort of thing which ought to occasion flights of interpretive fancy, the only constraint being that the interpretation "makes sense" of the intrinsic features of the work. The monist is repulsed by this sentiment. He grants the relativity of artistic significance to population; but he resists the inference from such relativity to pluralism. This he can do because he has already cast his lot with a quite specific population—it is, for him, the only population "relevant" to a correct understanding of the work. We might fault him for this, depending upon our interests, explanatory goals, and conceptions of how art ought to be treated. But if he wishes his interpretations to be constrained by the norms of that community alone, and he believes that such constraints are enjoined by the very nature of artworks, then so be it. It seems perverse to accuse our monist of having made some factual error.

Nor has our pluralist made any factual error. He, like the monist, might well insist upon the population relativity of artistic meaning; but he is impressed with the multiplicity of populations in relation to which interpretation can be imposed. Unlike the monist, he refuses to cast his lot with one particular such population.

So the monist and pluralist are, on this construal of their dispute, not in disagreement about some matter of fact; they rather have clashing sentiments about how art should be approached, about what sorts of considerations should constrain one's artistic experiences.

So far, so good. But what of the pluralist's claim that the various artistic interpretations are, in addition to being equally correct, somehow inconsistent with one another? If the goal of our anti-factualist construal of the pluralism-monism dispute is to account for most aspects of the dispute, it had better illuminate the pluralist's insistence that the rival interpretations are genuine *rivals*—i.e., that they are incompatible.

This it can do. Consider a simple analogy: one interest group sees a diagram as a duck; another sees it as a rabbit. Insofar as these ways of seeing are operative in distinct communities—and explicable in terms of the interests and goals operative in those communities—no explicit "incompatibility" infects the situation. No pronouncement of the form "it is correct to see it as a duck and it is not correct to see it as a duck," uttered in a tone which heralds victory for pluralism, is warranted. So long as the relational character of the attributions is kept in mind, no appearance of incompatibility looms. But there is more to incompatibility than logical inconsistency. The impossibility of seeing the

diagram simultaneously as a duck and as a rabbit, though perhaps ultimately explicable in terms of logical constraints on the computational mechanisms of perception, is *prima facie* not a logical impossibility. It is some other kind of incompatibility: the kind which grounds the inability to think of oneself simultaneously as a member of certain disparate interest groups.

Some person, we might suppose, cannot think of himself concurrently as an autonomous moral agent and as a soldier; perhaps there is a way to do it, but he cannot. He cannot make anything of what it would be like to see the world from both standpoints at the same time. Similarly, some art enthusiast might think of himself as unable to approach Jasper Johns's work from the standpoints of Marxist, Freudian, and Structuralist constraints at the same time. He might believe, given pluralist persuasions, that one standpoint is as legitimate as the other for purposes of artistic interpretation; but he is so overwhelmed with the psychological incompatibility of these diverse standpoints—the differences in interest, explanatory goal, ideology, and perhaps even patterns of argumentation—that his sense of that incompatibility rises to the surface in the form of an insistence upon critical pluralism.

Thus the monism-pluralism dispute is portrayed as a clash of sentiments and commitments: one side dignifies a particular population as the tribunal against which to measure the correctness of an artistic interpretation; the other side refuses to do so. The projectivist strategy in this context provides no quick resolution to the dispute—no more than expressivist theories provide quick resolutions to moral disputes. Rather, the strategy serves to shift the focus: in evaluating the monist's and pluralist's claims we are led to ask about the purposes served by insisting upon uniqueness of correct interpretation, and whether those purposes are worth achieving. We are led to ask about the legitimacy of various commitments and sentiments concerning the role of art and art-interpretive discourse within the general scheme of things.

NOTES

* This piece is dedicated to the memory of Mitch Flower. Mitch combined a formidable knowledge of linguistics and the philosophy of language with a remarkable sensitivity to, and involvement in, the arts. Had he lived he would have made significant contributions to the philosophy of art. I am indebted to him for countless discussions about the relation between art interpretation and natural language translation, and for constantly reminding me that certain analogies, though provocative and worth pursuing, are not arguments.

1. Thomas B. Hess, *Barnett Newman* (Greenwich, Conn., 1971), 89.

2. W. V. Quine, *Word and Object* (Cambridge, Mass., 1960), 27.

3. The literature in this connection is enormous. See, e.g., Donald J. Hockney, "The Bifurcation of Scientific Theories and Indeterminacy of Translation," *Philosophy of Science* 42 (1975): 411–27; Noam Chomsky, "Quine's Empirical Assumptions," in *Words and Objections: Essays on the Work of W. V. Quine,* edited by Davidson and Hintikka (Dordrecht, 1969), 53–68; Richard Rorty, "Indeterminacy of Translation and of Truth," *Synthese* 23 (1972): 443–62; Hilary Putnam, "The Refutation of Conventionalism," *Nous* 8 (March 1974): 25–40; John Searle, "Indeterminacy, Empiricism, and the First Person," *Journal of Philosophy* 84 (March 1987): 123–46.

4. Jurgen Habermas, *Knowledge and Human Interests* (Boston, 1971), 309–10.

5. See, e.g., Wilfrid Sellars, *Science, Perception and Reality* (London, 1967); "Chisholm-Sellars Correspondence on Intentionality," in *Minnesota Studies in the Philosophy of Science*, vol. II, edited by Feigl, Scriven, and Maxwell (Minneapolis, 1957); Wilfrid Sellars, "Language as Thought and as Communication," in his *Essays in Philosophy and Its History* (Dordrecht, 1974).

6. See, e.g., Hilary Putnam, "The Meaning of 'Meaning,'" in his *Mind, Language, and Reality: Philosophical Papers*, vol. 2 (London, 1975); see also *Meaning and the Moral Sciences* (London, 1979); Tyler Burge, "Individualism and the Mental," in *Midwest Studies in Philosophy*, vol. IV, edited by French, Uehling and Wettstein (Minneapolis, 1979), 73–121.

7. Hilary Putnam, "Meaning and Reference," *Journal of Philosophy*, 70 (November 1973): 702.

8. Leo Steinberg, "Contemporary Art and the Plight of Its Public," in his *Other Criteria* (New York, 1972), 15.

9. A good discussion of the projectivist methodology and of the corresponding distinction between "descriptive" and "projective" discourse is Simon Blackburn's *Spreading The Word* (Oxford, 1984), esp. chaps. 5–7; see also my "Varieties of Pragmatism," *Mind* 99 (April 1990): 157–83.

The "Nature" of Interpretable Things

JOSEPH MARGOLIS

We think of cultural entities—artworks, human persons, institutions—as things that, paradigmatically, possess histories intrinsically and are intrinsically interpretable. We believe they have "natures" different in this respect from mere physical objects—stones, for instance—that lack histories and are not interpretable by "nature." Still, our intuitions are unguarded here: there is always a caveat to be weighed.

For example, it is perfectly clear that the Olduvai Gorge is said to *have* a history and to *be* interpretable. We feel entitled to say this because, perhaps, we "theorize" (or thematize) the Gorge, otherwise a mere physical formation, as now instantiating in a certain intimate way certain geological theories that, as cultural items themselves, have histories and are interpretable. By that maneuver, we treat the Gorge as sufficiently culturally freighted to bear the weight of these otherwise alien ascriptions. Once we make that move, however, we cannot deny that the entire physical world may similarly be said to have a history and be open to interpretation. Saying *that* is *not* saying there is no difference between physical time and the time of human history, or between the conditions under which physical nature and human culture are open to interpretation. The difference is open to dispute, of course, on grounds of *intentionality*; although that too merely reminds us of the obvious—it is certainly not to venture any substantive claim.[1]

Still, in mentioning these unresolved matters, we are inviting a bit of patience regarding questions that may at first sight seem quite distant from the puzzles of interpretation. Frankly, we shall need a good deal of philosophical scaffolding in order to broach and answer a certain complex question about cultural phenomena—about artworks in particular. The reason is this: we must undo a certain standard prejudice coloring the logic of truth-claims addressed to the real world—*a fortiori*, about the logic of interpretation. A great deal hangs on the argument.

I

Speaking formally, being able to state that this or that is true means being able to identify what one is talking about and to specify something that one may affirm of it. One would think such remarks were hardly worth worrying into precision, but one would be wrong, as the literature on speech acts (on reference and predication, in particular) makes clear. For example, John Searle insists, not at all unreasonably, on construing reference as a speech act, though not predication in the same sense.[2] Again, Searle treats reference as a peculiarly dependent speech act invariably embedded in "the (purported) performance of an illocutionary act [a speech act proper, so to say, one that could occur as a relatively independent event—making a statement for instance]."[3] P. F. Strawson draws attention to the nagging complexity of "singular statements which make no mention of (i.e., contain no names for, or other expressions definitely or indefinitely referring to) individual instances of general things"— for instance, "It is (has been) raining," "Music can be heard in the distance," "There is gold here," and (in an entirely different sense) "The whale is a mammal"—all of which Strawson explores in a number of important ways.[4] Examples of these sorts overwhelm the supposed simplicity of assertion.

In fact, the matter grows instantly more strenuous when one considers that *whether* specimens of these sorts may be settled in the way Strawson supposes depends not only on grammatical considerations but on substantive ones regarding the nature of the real world. Are there, for example, "real universals," and are they "singular" entities of some kind? Well, we need not bother to answer: we need only take note of the fact that, in a certain sense, *in* the context of serious speech, the analysis of the grammar of what is being said may well be inseparable from the "metaphysics" of the world we are talking about. Also, in spite of their indissolubility, we may not be able to infer reliably the general lineaments of the world *from* our grammar: whether there are universals seems impossible to determine from the grammar of predicates and nominalizations alone; and if that is so, then it is hardly unreasonable to admit that the difficulty may run through all of our theories about how reality is structured—for example, thinking of the world of art, of the reality of intentional properties, and of whether and in what sense artworks and cultural things in general "have" determinate natures.

It was to avoid such and similar complications that Searle forthrightly maintained that "expressions, not universals, are predicated of objects." Still, he did go on at once to qualify (in a footnote) what he says there, conceding that the "identity of the expression predicated is not a necessary condition of identity of predication."[5] He might also have said that the "identity of the expression predicated is not a sufficient condition of identity of predication," unless he believed (which he offered no grounds for supposing) that the "identity" of the meaning of an expression used on two different occasions may be ensured by the mere formal "identity of the expression predicated"; but that, of course, would have instantly reintroduced the close connection between determining

the meaning of expressions and determining the nature of the world in virtue of which meaning—the same and different meanings and the like—could be reasonably assigned.

All this is a little on the strenuous side, not quite on the issue we mean to isolate. But, as we shall see, it does bear on it in an instructive way. In making reference discursively (at least in a great many cases) and in making predications of what we are referring to, we ordinarily suppose that *what* we are speaking about *has a nature* and that when, so speaking, we say something true of it, it is because what we say is, in some fair sense, conformable with the actual nature of the referent of our discourse. So it is usually supposed that it would be preposterous to question whether the referents of veridical discourse *do have natures*: it would be thought tantamount to denying that we could (ever) speak *about* things at all.

The trouble is, this itself is an utter *non sequitur*, or must be counted as one until we have a clear sense of what it is *to have a nature* and of why denying that things "have" natures is demonstrably incoherent. But there is no easy way to show that.

Let us concede at once that the issue is important for the theory of interpretation, in the plain sense that the most challenging current theories about what it is to interpret artworks, texts, histories, human behavior, and the like affirm or entail that such "things" *have no natures*—or, what comes to much the same thing, that such things *"have" natures that may be intrinsically altered as a consequence of being merely interpreted.* (Such a view, of course, is flatly rejected—almost without exception—in Anglo-American analytic philosophy. But is *is* the pivot of a dawning confrontation.) *If* Searle were right in his sanguine attempt to disjoin "predicates" and "universals" in the analysis of predication, of *if* Strawson were right in thinking that there is a perfectly "natural" metaphysics that may be invoked in deciding distinctions between the "particular" and the "general," then there might be good reason to suppose that either the question of whether things have natures could be separated from grammatical studies or that, if they could not, the question of what it is for anything to "have" a nature could still be neatly resolved in a way that would not pretend to be restricted to purely grammatical considerations.

These somewhat stale (but not unimportant) distinctions draw us in the right direction. It is a standard axiom of the philosophical canon that the numerical identity, the self-identity, of, and our capacity to identify, reidentify, and make reference to, real things—chiefly, individual or singular things like *this* and *that* stone or person or lump of clay or painting or novel or theory—entail the individuatability of such things in accord with the common natures they share with other particular things (of the same kinds). In one sense, the axiom is trivially true: it simply affirms the sense in which enunciative speech makes use of referential and predicative devices, even if certain well-formed statements (for example, "The whale is a mammal") do not actually make reference, and even if other well-formed statements (for example, "Hesperus is Phosphorus") do not actually make predications. It is only when the grammatical

generalization bears the weight of a certain profound ontological thesis that the question regarding "natures" is worth going at. It is only then that we dare not ignore the fact that, *the entire world is at stake*. For the deeper canon holds—has held since the days of Parmenides and Plato and Aristotle—that reality is changeless or invariant, or that the "natures" of whatever we discourse about, referentially and predicatively, remain unchanged through the interval in which particular statements are thought to be meaningfully operative at all.

The ancient canon: that what is strictly real is also strictly changeless—the essential doctrine, for instance, of Aristotle's *Metaphysics* (Book Gamma)—has been increasingly retired (it should be said) over the entire 2500-year history of Western philosophy.[6] By this time, the vestiges of that "archaic" doctrine are under attack along at least four principal lines of argument: one, along lines favoring some nominalistic-like account of the use of general predicates, even though, ironically, nominalism has no interest in, or prospect for, ever coming to terms with the epistemic conditions under which general predicates are applied to new instances (not already included among the exemplars by which their meanings were ever first settled or learned);[7] the second, along the lines of challenging the necessity of admitting exceptionless covering laws in the sciences and the validity of particular such invariances in this or that sector of physical nature;[8] the third, along the lines of challenging any principled distinction between analytic and synthetic truths, *a fortiori*, the supposed ineluctability of logical laws like noncontradiction or excluded middle;[9] and the fourth, along the lines of radically historicizing the operative or "normalized" concepts with which we understand our world, communicate intra- and intersocietally, and claim that our conceptual distinctions correspond objectively to the independent features of the world we address both theoretically and practically.[10]

In an interesting sense that has not yet been thoroughly worked out, the attack on the analytic/synthetic distinction could (if suitably elaborated along the lines of a conceptual holism or a tacit constraint on all conceptualization) be construed as a sort of synchronic analogue of the radically historicist thesis (itself elaborated so as to provide for viable reference and predication). So seen, the conceptual currents of the end of our century could very easily mingle the master themes of such otherwise nearly incommensurable thinkers as W. V. Quine and Michel Foucault (if we abandoned the local prejudices of each, and of similar-minded theorists). The prospect is not as unlikely as one might suppose: there is already some progress in that direction.

If we drew the different traditions together in this way, then, under the strong posit of cognitive intransparency and preformation, it would be child's play to oppose the doctrine of the invariant "natures" of things: if we supposed, that is, that, congruently, we could improvise a picture of the affected forms of discourse that would permit something sufficiently like reference and predication to proceed as before. We could then change our "metaphysics" without changing our "grammar." That would be an extraordinarily strategic maneuver. For, it would demonstrate that the human sciences were fundamentally different from what is canonically supposed to be the mark of the natural sciences;

it would also demonstrate that the radically new views about interpretation that have emerged in our own time may count on being coherent in the same formal sense the canon wishes to preserve, in spite of the fact that, on such a view, *the "natures" of interpreted referents could be substantively altered as a result of interpretation alone.* Our own question concerns the viability and reasonableness of just this thesis. But it takes a double form: for, first, we must be clear about what the conceptual possibility entails; and second, we must consider the plausibility of the thesis under the cognitive circumstances we have just sketched.

II

The foregoing may be concisely summarized as follows: it is true that (numerical) identity presupposes individuation, but it does not follow that the success of the relevant enunciative acts need be committed to holding that the referents of our predications must have invariant "natures." On the contrary, it is entirely feasible to oppose the claim that their natures *cannot* change (substantively) through the length of a given discursive episode—through interpretation, preeminently—in which, that is, *the same* referents are submitted to diachronic claims that still take truth-values and do so in a demonstrably rigorous way. To be sure, one could not hold such a thesis conformably with familiar versions of the canonical view: those that subscribe to an inviolable bivalent logic, or to the impossibility of abandoning the law of excluded middle or *tertium non datur*, or to the (Aristotelian-like) doctrine that reality is changeless, or (most relevantly) to the denial of the reality of intentional properties.[11]

But our original objective was to defend the viability of a heterodox proposal. We are now addressing it under extremely constrained conditions: it would be much more amusing to examine particular *interpretive* programs and how they might proceed in a rigorous way—for example, the claims of such literary critics as Roland Barthes and Harold Bloom, perhaps even those of Stanley Fish;[12] but if it were true that their sort of practice was demonstrably incoherent from the start, there would no point to the exercise.

No doubt there is a certain pedantry in our effort. But the interesting fact remains: (i) that the thesis *is* entailed more and more insistently in the recent practice of interpretation—in the arts, in history, with regard to human behavior and character; (ii) that it is explicitly in conflict with prevailing canonical views regarding the logic of discourse; and (iii) that its sustained defense has never actually been attempted in the philosophical literature—or in any way that would be deemed responsive to the claims and worries of the champions of the canon. So we must put aside for a while a more adventurous maneuver, in order to reassure those attracted to the heterodox notion that they are not signing on a sinking ship.

Now, we have divided the question about "natures" in a convenient way: *if* the question is tantamount to that of whether we must concede the practical (or principled) ineliminability of reference and predication, then the grammar

of enunciative discourse does commit us to supposing that things do "have natures"; but admitting that much (we have said) does not commit us at all to supposing that such natures must be invariant, unchanging, fixed, essential, or anything of the kind. On the other hand, *if* the question is taken in the full substantive sense favored by the analytic canon, then the counterargument can gain its point only by demonstrating that the "invariance" reading is neither logically inescapable nor compelling, and that the contrary view is more favorably suited to the developing practice of interpretation. By parity of reasoning, an inquiry into history would yield the same result.

The first step of the argument is easily gained. By and large, there are only three distinct lines of analysis that could possibly show that things must have essential or invariant natures. None of them is successful, however, and all are considerably weakened by the salient concessions of most current philosophies: for instance, by preformative influences on consciousness, by the holism of theoretical understanding, by the indefensibility of cognitive privilege, by the contingency and partial nature of even the most systematic findings, by the horizonal perspective of human judgment, by the open-ended variety of possible conceptual schemes, by the constructed nature of our intelligible world, and so on. (We shall take these matters for granted, but they are certainly acknowledged on all sides as we draw toward the end of the century.[13]) The three strategies are these: first, the view explicitly advocated by Aristotle, that predication yields contradiction whenever it is supposed that the properties things possess may be merely contingent or apparent or may be inherently changeable—that is, whenever it is supposed that things have no invariant nature; second, the view explicitly advocated by strong adherents of the unity of science program, for instance by C. G. Hempel,[14] that, in principle, natural phenomena fall under universal covering laws, or, alternatively, that they may be collected as natural kinds under such laws, or even that they may be redefined homonomically (as such kinds) under such laws;[15] and third, the view (most familiarly associated with the work of Saul Kripke) that, apart from their generic natures, individual things "possess" haecceities, some set of individually instantiated properties in virtue of which they are uniquely what they are in all the possible worlds in which they exist. (This is emphatically not a literal report of Kripke's own view of the matter.)

These are powerful options—but they all fail, or their defenses fall. Given the prize we mean to collect, it will pay us to delay a moment to review the objections to them.

Aristotle's strategy is completely stalemated by its own devices: because it attempts to demonstrate that the "natures" of things must be invariant on pain of contradiction, *if* (or *because*) the principle of noncontradiction itself is never a purely formal principle but is, rather, already committed (metaphysically) *to* the invariance of the "natures" of the things *to which* rational discourse applies.

This will not be easily believed, but the fact remains that it *is* Aristotle's view; *and*, even in our own time (now that the strict invariance of reality is thought either not true or not necessarily true, now that the invariance

of referents is thought to be more a formal or grammatical matter), there is still some vestigial commitment to the correspondingly unchanged "nature" or "haecceity" of the referents in question. *But what that doctrine means has never been satisfactorily explained* in our world or in Aristotle's.

In attacking the views of the sophists and especially Protagoras—traditionally thought to favor construing things, predicatively, in terms only of how they seem to be from this point of view and that—Aristotle says:

> I mean, for instance, that the same wine might seem, if either it or one's body changed, at one time sweet and at another time not sweet; but at least the sweet, such it is when it exists, has never yet changed, but one is of necessity of such and such a nature. Yet all these views destroy this necessity, leaving nothing to be of necessity, as they leave no essence of anything; for the necessary cannot be in this way and also in that, so that if anything is of necessity, it will not be "both so and not so."[17]

We must add, here, Aristotle's finding about noncontradiction, perhaps the most famous formulation of the alleged metaphysics of the principle:

> if not all things are relative, but some are self-existent, not everything that appears will be true; for that which appears is apparent to some one; so that he who says all things that appear are true, makes all things relative. And, therefore, those who ask for an irresistible argument, and at the same time demand to be called to account for their views, must guard themselves by saying that the truth is not that what appears exists, but that what appears exists *for him to whom* it appears, and *when*, and *to the sense to which*, and *under the conditions under which* it appears. And if they give an account of their view, but do not give it in this way, they will soon find themselves contradicting themselves.[18]

Here and elsewhere, Aristotle offers the following account: first, that the principle of noncontradiction is violated wherever the invariant nature of the referents of such discourse is not presupposed or entailed in what we say and claim; second, that such discourse cannot be exclusively limited to how things appear or seem, relative to this or that point of view; third, that discourse so restricted must relativize truth rather than relativize how things merely seem-to-be to what ultimately is true, that is, in the non-relativistic sense; and fourth, that it is for that reason that things are said to have changeless "natures."

The curious thing is that the same argument is very much with us today, even among analytic philosophers prepared to dismiss the excessive stringency with which it was anciently thought that reality must be invariant. For example, thinned out appropriately, it is exactly the same argument that Hilary Putnam presses against the relativist—against Richard Rorty in particular (who, it must be remarked, would resist the charge).[19] But Aristotle's mistake—the same that appears in Putnam, who explicitly rejects the (Kantian) "notion of 'the thing in itself' "[20]—lies in this: that he takes abandoning essential or nominally fixed natures to entail *relativizing truth*, whereas it only entails that *truth-claims*

must be relativized to their conceptual and cultural sources *even where truth is not relativized at all*. Correspondingly, Putnam holds (again mistakenly) that "radical cultural relativity" (as opposed to a moderate "conceptual relativity" or "version-relativity," somewhat along the lines favored by Nelson Goodman) must relativize truth.[21] There may well be those who commit the error Putnam and Aristotle believe they expose—possibly Rorty, possibly not. In any case, the fault charged is *not* a necessary consequence of a strongly relativistic view; and if it is not, then the "invariant-nature" thesis fails.

In fact, it fails for a very simple reason. "Truth" *sans phrase* never plays a critical role except where some characterized correspondence relation is taken to be cognitively operative; and wherever correspondence is denied—as in our own time—truth-*claims* cannot fail to function relativistically, though not (for that reason alone) their *truth*: that is, relativizing "truth" so that "truth" is said to be equivalent to "truth-in-*L*" cannot on the cultural relativity thesis, affect the actual appraisal of distributed truth-*claims* (as *between* "true" and "true-in-*L*"), though it *will* (artifactually) produce (for that very reason) contradictions among particular claims said to be "true-in-*L*" and "true-in-*L'*" (where adherence to "*L*" and "*L'*" yield incompatible truth-values applicable *to the same claim*). The mere (formal) relativizing of truth has nothing whatsoever to do with the (substantive) cultural relativity of truth-claims; and the relativity of the latter need not bear at all on the theory of truth—certainly, need not entail the relativizing of truth.

The other options are much easier to dismiss or neutralize—partly because, to be effective, they must repeat some form of the argument we have just drawn from Aristotle and Putnam. The second option, the unity of science view favoring strict nomological invariances is now very much in doubt for independent reasons; and the third option cannot possibly be more convincing than the first. In fact, Saul Kripke, who has broached a version of the third option in a commanding way, does not really insist on a determinately fixed nature (or haecceity) among singular things: Kripke is much more occupied with attacking "the Frege-Russell view" (which holds that the meaning of a proper name may be given by a definite description"[22]) and with pursuing the bearing of that attack on distinguishing between necessary truths and *a priori* sources of knowledge.

In particular, Kripke shows that the thesis he opposes generates paradox when construed as a theory of meaning. Furthermore, when proper names are viewed in terms of a theory of effective reference, Kripke clearly opposes any appeal to the "invariant-nature" thesis adjusted for haecceity. So he remarks, for instance,

> The question of essential properties so-called is supposed to be equivalent (and it is equivalent) to the question of identity across possible worlds. Suppose we have someone, Nixon, and there's another possible world where there is no one with all the properties Nixon has in the actual world. Which one of these other people, if any, is Nixon? Surely you must give some

criterion of identity here. . . . Really, [however,] adequate necessary and sufficient conditions for identity which do not beg the question are very rare in any case. Mathematics is the only case I really know of where they are given even *within* a possible world, to tell the truth. I don't know of such conditions for identity of material objects over time, or for people. . . . One observes that something has red hair (or green or yellow) but not whether something is Nixon. . . . A possible world is *given by the descriptive conditions we associate with it* . . . "possible worlds" are stipulated, not discovered by powerful telescopes.[23]

Nothing that Kripke says further about "rigid designators"—even the admission of essential properties (which, of course, need not be tied to an essential generic nature)—necessarily bears on actually *identifying* or *reidentifying* anything, or necessarily goes contrary to the argument we have been mounting.[24] In fact, there *is* no operative possibility that cognizing humans, particularly under the conditions we are entertaining, *could* sort out the haecceity of every particular thing in terms of some unique instantiation of general properties. Leibniz himself was uncertain that even God could ensure the *necessity* of such a condition.

The upshot of all this is that there are no compelling formal or "metaphysical" reasons for supposing that artworks or cultural phenomena in general *have changeless* "natures" or need have them necessarily; coordinately, there are no compelling reasons for supposing that whatever is imputed as the "nature" of given referents (artworks in particular) could not change without disrupting the sense in which such referents remain one and the same through such change; finally (though we have still to pursue the point), there are probably no compelling reasons for supposing that the imputed nature of artworks cannot change as a result of their being interpreted. But this is just to return us to the issue we originally wished to explore. We have said nothing as yet about how the trick is done—or, for that matter, what it entails and what is important about it.

III

Consider the matter naively. Imagine a conversation in which the meaning of what is said at any moment changes retrospectively with the unfolding process of the conversation itself, as a result of remarks that interpretively review what was said earlier. Unless we suppose that the *meaning* of what is said at any moment is forever fixed by its having once been uttered (whether because meanings are "objectively there," internal to clocked utterances, or because meanings can always be recovered in principle by way of recovering a speaker's or author's original intention[25]), ordinary conversational practice appears to tolerate relatively orderly complex changes in the meaning of what is actually said—in fact, it even appears to tolerate its never being quite possible to fix its exclusive meaning at any given moment in the life of an exchange. Think, for example, of a quarrel between neighbors as to what each may have said—that is, what each meant-by-saying and meant-in-saying this and that.

Very roughly speaking, grasping the meaning of what is said under conversational circumstances presupposes and entails: (i) sharing a cultural practice or a "form of life" (in Wittgenstein's well-known sense), within the space of which alone verbal utterances "have" meaning; (ii) judging the meaning of what is said—in context and as it may be interpreted and reinterpreted in its changing context—within, and in accord with the habits of, that same encompassing "form of life"; and (iii) having the ability to remember the narrative connectedness of the exchange as it thus unfolds and, through that, having the ability to determine the continued identity of the referents of that changing bit of discourse. As Kripke perceptively observes, "possible worlds" are *stipulated*, not *discovered*: the lesson applies to our remembered world and to our memory of that world.

By parity of reasoning: *if* fixed natures or fixed haecceities cannot be counted on, then the reidentification of particular things in different "possible worlds"—including the reidentification of *what* is (meaningfully) said—is, now, also "stipulated," not "discovered" (or it is determined in some way that mediates between the two, within a "form of life"). On one reading, this is very close to Leibniz's original thesis, except that, for Leibniz, even though "proper names . . . are what are today called 'rigid designators', . . . no proper name designates anything in more than one possible world."[26] (That, of course, is simply another way of emphasizing the ineliminably stipulative aspect of reidentification.)

Now, the indispensable connective thesis that makes all this plausible even in the most modest of conversations is just that *we must be able to track ("stipulatively," of course) the "rigid designators" of an ongoing discourse*, both with respect to *what we say* and with respect to *what we are referring to* by what we say. Our thesis regarding interpretable artworks, then, is simply that the defense of the radical view we are espousing—the view that artworks "have" no natures or "have" natures that may be changed as a result of interpretation alone—is hardly more than an extension of what we acknowledge holds true in ordinary conversations.

In a word, the radical thesis holds that the meaning of what is said at any time *t* in an ongoing conversation is or may be a function, *retrospectively*, of what is said at *t'* later than *t* within the same conversation; that the meaning of what is said at *t*, though uttered once and for all at *t*, may change as a result of being *interpreted* at *t'*; that the meaning of what is said is never fixed or finished at the time of its actual utterance; that it symbiotically implicates, instead, the ongoing enveloping practices of an entire "form of life."

We are claiming that this *is* the ordinary situation with respect to a conversational exchange: that apt speakers are entirely capable of following a line of meaningful exchange under just such conditions in spite of the fact that, plainly, there will always be indefinitely many diverging, competing, interacting interpretive lines generated from the string of particular utterances involved. What is important to grasp is that *this very pattern may be generalized to cover the interpretation of artworks and histories*; and that, in our own time, as in

the critical theories and practices of Harold Bloom and Roland Barthes, for instance, it *is* the picture of interpretation that is slowly gaining ground.

This is explicitly formulated (in a comparatively conservative spirit) in Hans-Georg Gadamer's notion of the "fusing of horizons" (*Horizontverschemlzung*):

> the horizon of the present is being continually formed in that we have continually to test all our prejudices [our tacitly preformed judgments]. An important part of this testing is the encounter with the past and the understanding of the tradition from which we come.
>
> ...Every encounter with tradition that takes place within historical consciousness involves the experience of the tension between the text and the present.... In the process of understanding there takes place a real fusing of horizons, which means that as the historical horizon is projected, it is simultaneously removed.[27]

This is the reason Gadamer speaks of the triune structure of interpretation: "Interpretation is not an occasional additional act subsequent to understanding, but rather understanding is always an interpretation, and hence interpretation is the explicit form of understanding"; moreover, it *is* such in virtue also of "application [*subtilitas applicandi*.]"—effectively, of self-interpretation as both a condition and an entailment of interpreting (or understanding) a text.[28] There is, in Gadamer, no account of the possible forms of interpretive rigor that may be assigned here; but Gadamer is obviously sanguine and just as obviously conservative in what may be pertinently offered in interpretation.

A thinner, not altogether unrelated conception, is offered by Arthur Danto in developing his own notion of history, particularly directed against Charles Sanders Peirce's conception of the fixed past:

> Peirce's statement is false [he says]. We are always revising our beliefs about the past, and to suppose them "fixed" would be unfaithful to the spirit of historical inquiry. In principle, any belief about the past is liable to revision, just in the same way perhaps as any belief about the future.[29]

Danto is well aware that he has not really kept to Peirce's meaning at this point, because he (Danto) has shifted from "the" past to our "beliefs" about the past. And, indeed, contrary to the impression given, Danto does share with Peirce the view (by way of "a kind of ontological interpretation of his original claim") that the past *is* fixed and that our *beliefs* about the past continually change. What Danto wishes to resist, however, once the past is past is the doctrine that "a *full description*" of what happened can be provided at any one time: "Once E [an event] is safely in the Past, its full description is in the I.C. [an Ideal Chronicle]"—so the theory goes.[30] Danto continues:

> *But this is not enough.* For there is a class of descriptions of any event under which the event cannot be witnessed, and these descriptions are necessarily and systematically excluded from the I.C. The whole truth concerning an

event can only be known after, and sometimes only *long* after the event itself has taken place, and this part of the story historians alone can tell.[31]

So Danto distinguishes among the actual historical event (fixed with the fixing of the [physical] past), our beliefs about that event (open to endless change and development), and the "full description" (the "objective" description, evidently) of the original event (which depends on the ongoing processes of history). He offers in evidence the history-like account, in Yeats's *Leda and the Swan*: "A shudder in the loins engenders there/the broken wall, the burning roof and tower/ And Agamemnon dead"—which describes an event (waiving whether what is reported is actual history), he says "nobody could witness under the description 'Zeus engenders the death of Agamemnon.' " Similarly, no one could "write, in 1618, 'The Thirty Years War begins now'—if that war was so-called because of its duration."[32]

But Danto separates the *event* from the *description* of the event—which, in the case of cultural phenomena, is not possible in the same sense in which it obtains in dealing with mere physical events, events that (as we were suggesting earlier) "have no meaning," are not interpretable, have no intrinsic history.

The reason is just that, in the world of humanly significant events—the world of human culture—*we are, finally, at once, the observer and the observed*, the observer and the agent, the one who gives meaning to events and who also produces events (the same events) that are intrinsically meaningful. There *is* no bare physical event that is *the* event, the determinate referent, *to which* the description "the Thirty Years War" could rightly be applied only in the then-future.

The incipient physicalism that Danto favors is essentially the same (and essentially mistaken for the same reason) as may be found in Donald Davidson's well-known account of action: there *are* no "primitive actions" or "basic actions" that are individuatable as mere physical movements,[33] *to which, then,* alternative and changing descriptions, interpretations, or beliefs are assigned (with whatever degree of objectivity) in order to *introduce* humanly significant actions. The reason is this: (a) pertinently meaningful actions are indissolubly described in terms that include in a complex way both meaningful (or intentional) and physical elements; (b) in context, physical features enjoy no epistemic priority over the "meaningful" ones (speaking loosely still); and (c) there is no lawlike connection between the two in either direction, and the individuation of texts, events, actions, and the like is characteristically contextual, notably tolerant of imprecision and inexactitude with respect to its physical features (possibly even in principle). In any case, Kripke's and Leibniz's lesson applies here as well.

IV

Here, Danto touches on a very deep problem that goes to the heart of our puzzle about interpretation and history. He speaks

of two distinct relations in which language stands to the world. In one relationship, language stands to reality merely in the part-whole relationship: it is amongst the things the world contains, and is merely a further element in the order of reality. In its other relationship, language stands in an external relationship to reality in its entirety, itself included when taken as included in the inventory of reality. It is external primarily when we construe it in its capacity to *represent* the world, and hence in its capacity to sustain which I have elsewhere termed *semantical values*, for example 'true' and 'false.' Anything which is representation in this sense I shall construe as language, e.g., pictures, maps, concepts, ideas, these also sustaining this double relationship with the world.[34]

But he never explicitly makes room for representational entities that are *internal* to the world *as* the unusual entities they are, *as* complexly incorporating representational and physical features (representational features indissolubly "incarnated," as we may say, *in* physical features—*in* the cultural world in which they obtain)[35]—and that exhibit features that, though "linguistic" (in Danto's elastic sense), are not true or false about anything: Velásquez's *Las Meninas*, for example.

One could, of course, say that Danto does make room for such oddities in his first category; and so he does, vaguely, except that the nature of interpretation and history is either obscured or misrepresented by his account. For, contrary to what he says, artworks, literary texts, paintings, and the like (to take these metonymically for the entire cultural world) are not merely bits of language that we may inventory as we do stones, but complex actual *referents* that *possess interpretable features* incarnate in physical features (interpretable *because* they are thus incarnated), and that *possess intrinsic histories (because* the way in which they persist temporally *is* inherently "meaningful"—*is* narratizable "by nature").

In a word, artworks and other entities drawn from the world of human culture do *have*, in addition to not "having a nature" in the sense already explored, an interpretable and historical "nature": they are distinctive in that their intrinsic properties are especially suited *to being interpreted* and *to being described historically*. Interpreting and formulating a history are ways of representing (in Danto's sense) *what is inherently representational "by nature"* (in a sense Danto does not countenance). In short, *interpretable referents "have" no natures because they "have" only histories, because they are only historicized with respect to their "natures"*; and, being such, *their natures are alterable as a result merely of being interpreted and reinterpreted*. Furthermore, the meaningful sequence of such interpretation is itself a narrative history in virtue of which interpreted referents are identified and reidentified and their meanings reliably but only contextually assigned.

We are now in a position to bring together perspicuously the elements of the theory we have been at pains to assemble. A convenient tally may help us here: (1) the logic of individuation and numerical identity does not require that

the referents of cognate linguistic acts "have natures" or have them in any way that is necessarily fixed or changeless; (2) on the contrary, there is no compelling argument to show that things that lack "natures,"—or, whose "natures" change or may be changed—are incapable of supporting standard enunciative acts (incorporating reference and predication); (3) artworks, texts, histories, institutions, actions, even persons are entities or referents that lack natures in the sense given, because their would-be "natures" are changed as a result merely of being interpreted, *and* because whatever we take to be their distinctive nature will (prominently) include their meaningful or representational or semiotic features—just those in virtue of which their natures may be changed; and, now, venturing a bit further, (4) the rigor with which such entities may be reidentified and interpreted depends on following a continuous narrative of enunciative discourse within a shared "form of life," within which both reidentification and interpretive relevance are contextually determined in accord with the discursive practices there sustained; and (5) referents whose "natures" may change as a result merely of interpretation *have* "histories" rather than fixed natures, and possess incarnated, meaningful, linguistic, representational, or other semiotic properties that form, within their changing histories, their changing "natures."

Our concern has been to show that (1)–(5) form a coherent conception as well as a conception dialectically favored under the circumstances of what currently prevails in Western philosophy. It is too much to hope to give a knockdown argument here to the effect that the end-of-the-century trend *is* in favor of theories of the sort we are advancing. But that remains our conviction. We have, therefore, made the case as straightforwardly as possible. There remains, however, a corollary remark or two that may help to round out our account and to give a better sense of the power of what otherwise may still seem a sterile exercise.

V

First of all, there is the question of *context*. A moment's reflection shows that there are no more than two possible ways of neutralizing the procedural informality of appealing to context wherever we claim strict objectivity in our judgments: in one, conceptual distinctions applicable in judging the things of this or that sector of the world may be taken to be contextless, invariant with respect to any and all contexts; in the other, even where contexts are admittedly relevant but cognitively uncertain and imprecise, what is being judged may be said to conform to covering rules or laws or systems of a strictly invariant sort. The first fails if all forms of cognitive privilege fail: certainly, the entire drift of late-twentieth-century philosophy is opposed to privilege. It is true that various strong programs of extensionalism—for example, in the unity of science program, in the formal analysis favored by W. V. Quine and his adherents, in Noam Chomsky's efforts to fathom a universal grammar underlying all natural languages, in French structuralism of the sort Claude Lévi-Strauss has invented—have introduced into the sciences and the logical analysis of language

and life an idiom intended to be contextless. But *none* of the champions of these and similar proposals has ever shown us how to *apply* his contextless idiom in espistemically contextless ways: none has ever been able to show how such proposals actually replace those less favorable (contexted) idioms by means of which they are themselves first introduced (and apparently sustained). The second strategy fails if there are no invariantly fixed natures: but that finding is precisely what the foregoing argument has labored to make plausible.

What is perhaps the most candid, also the most tortured, attempt to fix the vagaries of context in literature and the arts, in order to ensure the objectivity of interpretive judgment, appears in E. D. Hirsch's conservative hermeneutics—"conservative," because it is utterly opposed to the strong historicizing tendencies of Gadamer's (post-Heideggerean) hermeneutics, because it supposes that original authorial intent (on which the recovery of the meaning of a text is said to depend completely) may be recovered, in principle, quite unchanged, at any moment in the history of the reception of a given text. Hirsch admits the uncertainty of context (which, in a way, is tantamount to admitting the cognitive uncertainty of history), but he pretends to overcome it by the following resolution:

> by "context" we mean a construed notion of the whole meaning narrow enough to determine the meaning of a part, and, at the same time, we use the word to signify those givens in the milieu which will help us to conceive the right notion of the whole. . . . [T]he essential component of a context is the intrinsic genre of the utterance [literary text, artwork, even action, we may suppose]. Everything else in the context serves merely as a clue to the intrinsic genre and has in itself no coercive power to codetermine partial meanings.

What Hirsch means is: first, that *whatever* is "uttered" in the manner of a speech act, literary text, or the like manifests only a "part" of its actual meaning in the milieu in which it is directly received; second, that that partial meaning is correctly grasped when and only when it is rightly placed within its appropriate context of utterance—in which alone its "whole" meaning may be discerned; third, that what is essential to grasping the structure of that context is the "intrinsic [immutable] genre" to which the utterance "constitutively" belongs and which it actually instantiates; and fourth, that, although the intrinsic genre is fixed and invariant, we can only guess probabilistically, from fragmentary clues, functioning as interpreters of what has been uttered, what right notion of context or genre ought to be brought to bear on understanding (or interpreting) this or that utterance. For these reasons, Hirsch continues:

> To know the intrinsic genre and the world sequence is to know almost everything [about the meaning of the utterance]. But the intrinsic genre is always construed, that is, guessed, and is never in any important sense given.[36]

Fatally for Hirsch, however, although "the fundamental categories of experience are, no doubt, immutable, . . . the every-day types by which we constitute experience are open to revision." Genres, Hirsch says, are, in addition to

being immutable, "constitutive" of every significant human utterance. Hence, our "every-day" categories are verisimilitudinously probabilized to conform with the ultimate constitutive genres of discourse. Nevertheless, as he also insists, genres cannot be assigned a natural entelechy when applied to the forms of speech—simply because genres can only be metaphorically taken to have a "will" or *intention* of their own: they are not animate creatures capable of rational behavior. Hence, Hirsch finally concedes: although "all understanding of verbal meaning is necessarily genre-bound," a genre is itself "a reality that is partly unknown and which may (as in the case of interpretation) never be known with certainty."[37]

Secondly, we must consider the question of the *rigor* of interpretive practice. There are, of course, a great many theorists who believe that the loss of a discernibly invariant reality or of a world conformable with exceptionless rules or laws is a world in which it is impossible to preserve *any* measure of rigor of inquiry: either there is an orderly plenum, they suppose, or there is utter chaos. Nearly all current philosophical and metacritical views, however, fall between those two extremes.[38] But one can hardly doubt that the apparent defeat of the first conviction has encouraged a certain opportunism that either takes it that the loss of invariance justifies sheer methodological and cognitive anarchy or just is straightforwardly equivalent to anarchy as a form of supreme freedom. One sees the evidence in such "postmodernist" voices as those of Jean-François Lyotard and Richard Rorty.[39]

The issue is a vexed one. But the constraints one must concede include at least the following: (a) all inquiry, all assignment of truth-values, all resolution of truth-claims, are tacitly colored by the transient cultural world to which we belong as inquiring agents; but it does not follow that the meaning of "true" is thereby relativized to plural such worlds; (b) interpretable texts are identified as such only within, and in accord with, the tacit constraints of the cultural world we inhabit, and their properties and "natures" are alterable as a result of ongoing interpretation; but it does not follow that interpreted texts are plurally constituted by such interpretation alone, or are individuatable and reidentifiable only in terms internal to the interpretive rules of this or that community of interpreters; and (c) interpretation is "persuasive" rather than "demonstrative," in the sense that the culturally environing conditions in which "objective" inquiry proceeds cannot be shown, in their turn, to be demonstrably correct; they are themselves similarly "constituted" (persuasively), that is, by deeper historical processes that are neither true nor false, neither correct nor incorrect, neither rational nor irrational; but it does not follow that there are or could be no "objective" practices internal to the life of such communities or capable of supporting "demonstrative" arguments.

The right-hand options of (a)–(c) count as the beginning of a reasonable recovery of the rigor of interpretation—always in accord with the heterodox thesis we are defending. By (a), then, we oppose *that* sort of relativism (often called protagorean relativism) that relativizes truth itself; but we remain hospitable to *that* sort of relativism that admits truth-ascriptions to be artifactually

posited under culturally variable conditions incapable of yielding a transparent knowledge of any sector of the real world. By (b), we oppose any precept for individuating interpretable texts such that it is entailed that interpreters who do not share the same conceptual orientation, beliefs, values, norms or the like cannot, logically, be addressing one and the same text; but we remain hospitable to the view that interpretations of the same text may be logically incompatible though jointly (as well as severally) defensible, and we remain hospitable as well to the view that the "natures" of texts may change under interpretation. And by (c), we simply deny that "argument" by "persuasion" and by "demonstration" are ever entirely distinct or separable methodological options.

All three of these distinctions are, we may say, intuitively grasped (but also abused) by Stanley Fish—in a way convenient for our purpose—in his essay, "Demonstration *vs.* Persuasion." For example, Fish holds:

> The fact that a standard of truth is never available independently of a set of beliefs does not mean that we can never know for certain what is true but that we *always* know for certain what is true (because we are always in the grip of some belief or other), even though what we certainly know may change if and when our beliefs change. Until they do, however, we will argue *from* their perspective and *for* their perspective, telling our students and readers what it is that we certainly see and trying to alter their perceptions so that, in time, they will come to see it too.[41]

Here, it is very difficult to deny that Fish has fallen into the self-referential paradoxes of relativizing truth and knowledge. The trouble is that he apparently supposes that the *criteria* of truth and knowledge must be defined in a way entirely *internal* to the "form of life" of "interpretive communities" and in a way that determines true and correct interpretations. Both views are untenable. What Fish fails to see is that the cultural relativity he espouses (reasonably enough) *never* functions to yield such criteria—never functions criterially at all, is always merely holistic. (The point is very clear in Wittgenstein, whom Fish appears to be loosely following[42]—as well as in Foucault and even in Quine, for that matter.)

Unfortunately, it is on the strength of these considerations that Fish mistakenly supposes he is effectively countering the views of such "objectivists" as Hirsch and Monroe Beardsley and M. H. Abrams—the "model of *demonstration* in which interpretations are either confirmed or disconfirmed by facts that are independently specified. The model I have been arguing for [he says], is a model of *persuasion* in which the facts that one cites are available only because an interpretation (at least in its general and broad outlines) has already been assumed":

> In one model the self must be purged of its prejudices and presuppositions so as to see clearly a text that is independent of them; in the other, prejudiced or perspectival perception is all there is, and the question is from which of a number of equally interested perspectives will the text be constituted. In one

model change is (at least ideally) progressive, a movement toward a more accurate account of a fixed and stable entity; in the other, change occurs when one perspective dislodges another and brings with it entities that had not before been available.[43]

What Fish (fatally) fails to keep in mind is that *he*, as a "pluralism," means to hold on to rules of evidence, criteria of truth, and the like *internal* to the life of his own "interpretive community." Furthermore, he insists that there are constraints of pertinence and persuasiveness that range *across* interpretive communities *with respect to the same text*.[44] They are not, he believes, sufficient to confirm the "objectivists," but they also do not (on his own view) lead to relativism or anarchism.[45] He cannot hold all these views consistently.

Fish's fundamental blunder depends entirely on his conflating what is internal to an interpretive practice—or to the "form of life" in which it obtains—and the postulation ("external," so to say) of *that* very practice among other such practices. Our own maneuver, which saves coherent reference and predication while allowing the play of plural interpretive practices, appears to be the only suitably ample conceptual model by which to recover the rigor of such practices. A plurality of interpretive communities bespeaks a shared "form of life" but not necessarily any uniquely adequate criteria of truth.

Finally, we must consider the question of *intensionality*, the feature in virtue of which interpretable things are intrinsically interpretable. We cannot possibly attempt a general theory of inten*t*ionality or inten*s*ionality here: we are interested only in certain minimal concessions affecting our present issue. In fact, *if* texts, paintings, speech acts, human behavior, and the like are actual (really exist, or occur) then *their intensional properties are also real. That* is the sticking point: there *are* things that actually have intensional properties. The presence of the inten*s*ional is logically inseparable from the distributed presence of any of a quite heterogeneous set of complex properties broadly said to be inten*t*ional; although the standard Brentanoesque characterization of the latter (as signifying "aboutness") is surely inadequate. One has only to consider that such properties as *style*, the quality of *belonging to a tradition* or *historical period*, or the quality of belonging to the *Geist* of an age cannot be neatly captured by the usual formula. These properties are certainly problematic, but they cannot be denied once we treat the world of human culture as real. That alone is enough to disqualify any compromising physicalisms like the one implicated in Danto's view of history (which also carries over to interpretation).[46]

What will help us here is an uncomplicated example. If, say, a Rembrandt self-portrait is, as a painting, a *representation* of Rembrandt, then it seems (at least as a first approximation) that the painting *has* the intentional property of representing Rembrandt: it is a genuine property of the painting. It is intentional in the conventionally accepted sense of exhibiting "aboutness." But the interpretable complexities of the "meaning" of that representation constitute the inten*s*ional features *of* that same (inten*t*ional) property. Artworks and texts preeminently count as things that possess intensionally complex

intentional properties ("Intentional" properties, for short[47]). The point at stake is that of ensuring that there *are* such properties, that Intentional properties are real—*if* the world of human culture is real. Once we admit that much, there is no difficulty in accounting for the objectivity of interpretation under whatever conditions may obtain. Here, even Fish is right enough:

> if selves are constituted by the ways of thinking and seeing that inhere in social organizations, and if these constituted selves in turn constitute texts according to these same ways, then there can be no adversary relationship between text and self because they are the necessarily related products of the same cognitive possibilities.[48]

Whatever objectivity the cultural world permits cannot but be linked to the elementary fact that suitably apt human agents (languaged, encultured persons) cannot be massively unable to discern the meaning and significance of the Intentionally qualified practices they are textually introduced to in their own society. That, of course, is just the point of Wittgenstein's notion of a "form of life." Still, if the representational property of a Rembrandt self-portrait possesses intensional import, then so too does its chiaroscuro—and so too does the absence of such a stylistic feature in a slightly later Vermeer study that represents sunlight and shadow in a naturalistic manner. Apart from its representational function, Rembrandt's chiaroscuro functions (intensionally) as a sort of artist's signature.

We may leave the range of Intentional properties as open as we please: they will certainly include representational, expressive, rhetorical, stylistic, linguistic, semiotic, symbolic, semantic, significative, purposive, rule-like, institutional, traditional, ritual, mythic, and similar properties. The question is plainly a strenuous one. What we need to secure is the sense of its not being paradoxical or incoherent in any way to take such properties to be real—in spite of their peculiarities in forming the distinctive "nature" of interpretable things.

There are two essential errors to be avoided regarding intentionality—or, Intentionality in the ramified sense supplied. Both appear very conveniently in the well-known attack mounted by Daniel Dennett. For one thing, Dennett says, capturing the classical objection all "extensionalist" programs favor,

> Intentionality is not a mark that divides phenomena from phenomena, but sentences from sentences. . . . Intentional objects are not any kind of objects at all. [That we treat them as distinct objects is due to] the dependence of Intentional objects on particular descriptions [that is, on its being supposed that] to change the description is to change the object. What sort of thing is a different thing under different descriptions? Not any object. Can we not do without the objects altogether and talk just of descriptions? . . . Intentional sentences are *intensional* (non-extensional) sentences.[49]

Dennett's mistakes are these: first, it is not true at all that those who favor intentionality as "a mark that divides phenomena from phenomena" *do* hold that, in a purely logical sense, a mere change of description changes or may

change any object as such; and second, it *is* true that, on the view under attack, there *are* distinctive things, interpretable things, that may have their properties and "natures" changed as a result of *being interpreted* (which, on the argument, is a way of "affecting" the world—not a merely "logical" consideration of the sort Dennett entertains). In the second instance, *what* changes through interpretation are Intentional properties only.

Certainly it is true that physical objects, objects lacking intentional properties, are neither changed by a change of description *nor* changed as a result of interpretation. The first is nowhere seriously maintained, and the second does not arise on the hypothesis. (It is, of course, possible that what we theorize to be the physical population of our world *will* change as a result of the changing history of science, but that is another matter altogether.) In any event, with respect to the first issue, the "intentionalist" holds only that one cannot always *tell* whether we are dealing with one and the same referent under admittedly different descriptions: even in the Hesperus/Phosphorus case, it took a good deal of empirical inquiry to discern that "they" were indeed one and the same planet. Dennett is simply mistaken in his charge. Secondly, on our argument, *there are real things* that possess Intentional properties. Intentional properties cannot be summarily dismissed on the strength of the erroneous claim addressed to the first issue; we are *not* talking *about* sentences said to be *about* a world intrinsically lacking intentional properties, to which the sentences are only relationably linked. There *is* no known argument to show that we can "do without the [intentional] objects altogether and talk just of descriptions."[50]

These last three questions regarding context, rigor, and intensionality— are certainly the essential ones confronting the coherence and viability of our theory of interpretable things, but they have fallen away quite magically. We *have* demonstrated that it is entirely possible to claim coherently that interpretable things—artworks in particular—can change their "natures" under mere interpretation and, in addition, that that is a distinctly plausible claim.

NOTES

1. This is the locus at least for a very large run of reductive tendencies favored in analytic philosophy essentially inhospitable to strong theories that feature the difference (logical and/or metaphysical) of the cultural world. We may, merely to fix our ideas here, mention as a specimen view Adolf Grünbaum's well-known insistence, regarding history, that there is no difference at all between the "time" of electrodynamics and the "time" of psychoanalysis— or, correspondingly, the sense in which "history" enters these two domains. See, for instance, Adolf Grünbaum, *The Foundations of Psychoanalysis: A Philosophical Critique* (Berkeley, 1984), 17–18. Similarly, with regard to artifacts and artworks, we may add, as a further specimen, John Post's application of a supposedly nonreductive physicalism to paraphrastic or truth-valuational equivalences applied to ancient Anasazi solar observatories. See, for instance, John F. Post, *The Faces of Existence: An Essay in Nonreductive Metaphysics* (Ithaca, N.Y., 1987), chap. 4, particularly 200–03. For a discussion of the issues at stake, see also Joseph Margolis, *Texts without Referents: Reconciling Science and Narrative* (Oxford, 1989), chap. 6.

2. John R. Searle, *Speech Acts: An Essay in the Philosophy of Language* (Cambridge, 1969), 94–95, 122.

3. Ibid., 94.

4. P. F. Strawson, "Particular and General," *Logico-Linguistic Papers* (London, 1971), 37, and "On Referring," in the same volume, 1.

5. Searle, *Speech Acts*, 26 and note 1.

6. For an overview of the issue, see Joseph Margolis, "Radical Metaphysics," *Archives de philosophie*, forthcoming.

7. This, for instance, is surely the *reductio* of Nelson Goodman's heroic efforts to "entrench" some form of nominalism. See, for example, *Fact, Fiction, and Forecast*, 2nd ed. (Indianapolis, 1965), chaps. 3–4.

8. The most advanced attacks of this sort occur in Bas van Fraassen, *Laws and Symmetry* (Oxford, 1989), and Nancy Cartwright, *How the Laws of Physics Lie* (Oxford, 1983). But the general idealizing tendency of the theoretical laws of nature had already been classically argued in Karl R. Popper, "The Aim of Science," *Objective Knowledge: An Evolutionary Approach* (Oxford, 1972).

9. W. V. Quine is unquestionably the best-known champion of this sort of (Millian) attack; see, for instance, "Two Dogmas of Empiricism," *From a Logical Point of View* (Cambridge, Mass., 1953).

10. Possibly, Michel Foucault is the best-known recent theorist to have attempted, usually paradoxically, to champion such a "genealogical" account of conceptual distinctions. See, for example, "Nietzsche, Genealogy, History," *Language, Counter-Memory, Practice: Selected Essays and Interviews*, edited by Donald F. Bouchard, translated by Donald F. Bouchard and Sherry Simon (Ithaca, N.Y., 1977); and "Two Lectures" and "Truth and Power," *Power/Knowledge: Selected Interviews and Other Writing 1972–1977*, edited by Colin Gordon, translated by Colin Gordon et al. (New York, 1980).

11. Quine is, of course, the most important antagonist of intentionality. See. W. V. Quine, *Word and Object* (Cambridge, Mass., 1960), 219–21.

12. The general form of such interpretive criticism is developed in Joseph Margolis, "Interpretation Reinterpreted," *Journal of Aesthetics and Art Criticism* 47 (1989). See also, Roland Barthes, *S/Z*, translated by Richard Miller (New York, 1974); Harold Bloom, *A Map of Misreading* (Oxford, 1975); Stanley Fish, *Is There a Text in This Class? The Authority of Interpretive Communities* (Cambridge, Mass., 1980).

13. For an extensive overview of just these issues, see Joseph Margolis, *The Persistence of Reality*, 3 vols. (Oxford, 1986, 1987, 1989). There is a fourth volume that enlarges the sense in which this general current is now ubiquitous: *Life without Principles: Reconciling Theory and Practice* (Oxford, forthcoming).

14. See C. G. Hempel, *Aspects of Scientific Explanation and Other Essays in the Philosophy of Science* (New York, 1965), part 4.

15. See, for instance, Donald Davidson, "Mental Events," *Essays on Actions and Events* (Oxford, 1980).

16. See Saul A. Kripke, "Naming and Necessity," and "Addenda to Saul A. Kripke's Paper 'Naming and Necessity'," in *Semantics of Natural Language*, edited by Donald Davidson and Gilbert Harman (Dordrecht, 1972).

17. Aristotle, *Metaphysics*, translated by W. D. Ross, Bk. 4, 1010b.

18. Ibid., 1011a.

19. See, for instance, Hilary Putnam, *The Many Faces of Realism* (LaSalle, Ill., 1987), lecture one, and "Why Reason Can't Be Naturalized," *Philosophical Papers*, vol. 3 (Cambridge, 1983).

20. Putnam, *The Many Faces of Realism*, 36.

21. Cf. ibid., 16–21.

22. Kripke, "Naming and Necessity," 254–58.

23. Ibid., 266–67.

24. See, for instance, ibid., 269–73.

25. These two options represent, respectively, two of the most prominent views about discourse and literary art: the New Critical view of Monroe Beardsley and the hermeneutic view of E. D. Hirsch, Jr. See, for example, Monroe C. Beardsley, *The Possibility of Criticism* (Detroit, 1970), and E. D. Hirsch, Jr., *Validity in Interpretation* (New Haven, Conn., 1967).

26. Benson Mates, *The Philosophy of Leibniz: Metaphysics and Language* (New York: 1986), 151.

27. Hans-Georg Gadamer, *Truth and Method*, translated from 2nd ed. by Garrett Barden and John Cumming (New York, 1975), 273.

28. Ibid., 274.

29. Arthur C. Danto, *Narrative and Knowledge* (New York, 1985), 145.

30. Ibid., 145–49.

31. Ibid., 151.

32. Ibid., 151–53. It was this sort of view that Habermas found both appealing and close to the hermeneutic conception favored by Gadamer. See, for instance, Jürgen Habermas, *On the Logic of the Social Sciences*, translated by Shierry Weber Nicholsen and Jerry A. Stark (Cambridge, Mass., 1988), 155–56. But Habermas misses the complications we are here considering.

33. See Donald Davidson, "Actions, Reasons, and Causes," "Agency," and "Mental Events," in *Essays on Actions and Events*; also, Arthur C. Danto, "Basic Actions," *American Philosophical Quarterly* 2 (1965). See for an overview, Joseph Margolis, "Explicating Actions," in *Annals of Theoretical Psychology*, edited by Daniel N. Robinson and Leendert P. Mos (New York, 1990).

34. Danto, "Historical Language and Historical Reality," *Narration and Knowledge*, 305–06.

35. For an account of "incarnate" (cultural) properties, see Margolis, *Texts without Referents*, chap. 6.

36. Hirsch, *Validity of Interpretation*, 87–88.

37. Ibid., 76–78, 100–01, 174, 271–73.

38. For a fuller account of the matter, see Joseph Margolis, "Genres, Laws, Canons, Principles," in *Literature: Rules and Conventions*, edited by Mette Hjort (Stanford, Calif., forthcoming).

39. See, for instance, Jean-François Lyotard, *The Postmodern Condition: A Report on Knowledge*, translated by Geoff Bennington and Brian Massumi (Minneapolis, 1984), particularly Introduction.

40. See, for instance, Fish, *Is There a Text for This Class?* part 2; also, Beardsley, *Possibility of Criticism*; and M. H. Abrams, "The Deconstructive Angel," *Critical Inquiry* 3 (1977). Fish tends, quite mistakenly, to assimilate Hirsch's notion of the determinate meaning of a text to the New Critic's notion of the determinate meaning of a text's being in the independent text; but this is a nicety that we may put to one side here.

41. Fish, "Demonstration *vs* Persuasion," *Is there a Text in This Class?* 364.

42. See Ludwig Wittgenstein, *On Certainty*, edited by G. E. M. Anscombe and G. H. von Wright, translated by Denis Paul and G. E. M. Anscombe (Oxford, 1969), for instance, §§28, 105.

43. Fish, "Demonstration *vs* Persuasion," 365–66.

44. This is the entire point of his essay, "What Makes an Interpretation Acceptable?" *Is There a Text in This Class?*

45. Cf. for instance, his assessment of Jonathan Culler's view, "Demonstration *vs* Persuasion," 366.

46. See Arthur C. Danto, *The Transfiguration of the Commonplace* (Cambridge, Mass., 1981), chap. 6.

47. The "Intentional" is defined in *Texts without Referents*, 292–93.

48. Fish, "How to Recognize a Poem When You See One," *Is There a Text in This Class?* 366.

49. Daniel C. Dennett, *Content and Consciousness* (London, 1969), 28–29.

50. Dennett has tried to mount an additional argument in support of his thesis but it is beside the point. The reason is simply that he argues from the fact that physical objects may be assigned intentional properties (and so may have them denied as well) to the alleged fact that things that initially *have* real intentional properties (on arguments like the one here favored) may, correspondingly, have them denied as well. But the move is an obvious non sequitur. See Daniel C. Dennett, *The Intentional Stance* (Cambridge, Mass., 1987).

Real Beauty

EDDY M. ZEMACH

Not all the predicates in our language designate properties of things in the real world: perhaps only few have that distinction. Yet if there are any such predicates, aesthetic predicates are among them. I offer arguments of three kinds for this thesis: *First*, empiricist arguments show that we detect aesthetic properties in standard, objective ways; therefore we have to acknowledge their empirical reality. *Second*, arguments based on scientific realism show that inferences to the best hypothesis can decide among alternative aesthetic systems. Since science crucially relies on aesthetic predicates a realistic interpretation for them is mandatory. *Third*, arguments assuming only metaphysical realism show that, unlike our science, our aesthetic theory can be known to be true. Besides, since things in themselves have properties, we can know that they have aesthetic properties, too.

1. RELATIVISM IN AESTHETICS

People often disagree on aesthetic matters. Jones says that X is graceful and Smith says no; so who is right and who is wrong? What is the decision procedure? Some aestheticians hold that there can be no such procedure.[1] Aesthetic judgments radically differ: what I find beautiful is ugly in your eyes, and that is the end of the matter. Relativists explain that lack of uniformity by saying that aesthetic properties are subjective ways in which objects look to observers. The logic of the predicate 'gaudy', they say, is different from that of the predicate 'triangular'. We distinguish between being triangular and looking triangular: an object can be triangular without looking triangular, and vice versa. According to aesthetic relativists, aesthetic predicates do not admit of this distinction; to say that X is gaudy is to say that X *looks* gaudy to one. X can appear pretty to Jones and ugly to Smith, and there is no sense in asking whether X is really pretty: to be pretty is to be perceived as pretty. Relativism in aesthetics is therefore a kind of phenomenalism, taking aesthetic predicates to designate ways in which things look, as distinct from ways in which things are. It treats

aesthetic properties as phenomenalism treats sense-data: if '*A*' is an aesthetic predicate, to utter a sentence of the form '*X* is *A*' is to say that *X* appears *A* to one. Like 'it hurts', '*X* is *A*' is to a high degree incorrigible, describing an internal event on which the speaker usually is the best authority. Therefore, there is no arguing about matters of taste: *de gustibus non est disputandum*. If by '*X* is *A*' I only mean that to me *X* appears *A*, you will not argue about it, just as normally there is no room to question my belief that I am in dire pain. Therefore, there is *no* dispute between Jones and Smith on whether *X* is gaudy because they talk about different things. The form '*X* is *A*' makes the impression that both talk about *X*, when neither does: Jones is talking about the way *X* looks to her and says that it is gaudy, and Smith speaks about the way *X* appears to him and says that it is not gaudy. It is as if Jones said "my aunt lives in Miami," and Smith replied, "no, my aunt lives in Rome." Surely there is no conflict if Jones and Smith have different aunts? That is why there is no decision procedure in aesthetics: there is nothing to decide.

Aesthetic relativists hold that aesthetic judgments are about subjective *objects*; they do not hold that they are about subjective *properties*. (That would be like Jones's saying, "my aunt lives in Miami" and Smith replying, "no, my aunt is deaf.") Relativists think that Jones and Smith mention the same property, *being gaudy*, but the controversy is merely apparent because they attribute that property to distinct things: Jones attributes gaudiness to an object that is subjective to her and Smith attributes it to an object that is subjective to him. Now, we must ask the relativist, how can Jones and Smith both understand the term 'gaudy'? If aesthetic terms apply to private objects, then Jones has never examined anything to which Smith ascribes any aesthetic predicate and vice versa. No one can know what objects Jones calls 'gaudy'; so how can one know what property Jones designates by that term? How can we know that we are talking about the same property? How can children learn to use the term 'gaudy' if one cannot show them any example of what this term applies to? This is, of course, a Wittgensteinian point. By making aesthetic predicates meaningless, relativism defeats its own suggested solution.

Unlike Wittgenstein, I believe that there are three good ways to learn predicates attributable to internal items. One way is by analogy from common stimuli. We all use the phrase 'it hurts' in similar conditions; therefore I assume that what you feel in those circumstances is similar to what I feel when I get these stimuli. The second way is by analogy from common reaction. I can learn the word 'pain' because a certain behavior is a *prima facie* criterion for its application: unless counterindicated, I assume that those who behave in that manner feel what I feel when I so react. The third way is by analogy from other predicates. In chapter three of the *Inquiry* Hume suggests that an unknown shade of blue can be imagined if we know darker and lighter shades of blue. Can relativists use these ways to make aesthetic predicates meaningful?

The first way, the analogy from the stimulus, is closed to the relativists by their basic assumption that people can make entirely different aesthetic

judgments of the same public object. If the same stimulus may cause radically different aesthetic experiences in different people, then our use of the same aesthetic term for the same stimulus object does not indicate that we use it to convey the same meaning. We can assume that by similar phonemes we refer to the same property only if we tend to make similar aesthetic judgments of similar objects. Yet relativists in aesthetics hold that the same stimulus brings about aesthetically distinct internal states in people. Thus no one can know what the others mean by any aesthetic term they use.

The second way, using behavioral criteria, is also blocked, because no aesthetic predicate has a specific behavior that is typical to it. One cannot learn what 'gaudy' means from the way people behave with respect to objects that they see as gaudy, for there is no seeing-as-gaudy behavior. Aversive or avoidance behavior is neither typical nor unique to seeing a thing as gaudy. If you do not know what 'gaudy' means it will not help you to know that Smith did not buy a picture because it looked gaudy to him. Many things may repel us, so that information does not tell you why Smith is repulsed, what it is for him to see something as gaudy (try to explain why chocolate is good!). Also, there is no way to distinguish *aesthetic* aversion behavior and *aesthetic* attraction behavior from any other aversion and attraction. Behavior does not show that one is repulsed by X aesthetically and not for other reasons. All interests cause attraction and aversion behavior; that behavior is not specific to its cause. Aesthetic interest is no exception: it has no repertoire of behaviors specific to each of its predicates.

Behavior *can* indicate how one sees the stimulus object if we assume that most objects are not like Wittgenstein's duck-rabbit, which can be seen equally as a duck or as a rabbit. If the same things look to me sometimes as trees, sometimes as tigers, and sometimes as birds, you could not make any sense of my behavior. Behavior makes sense when related to things we know; but relativism associates aesthetic reactions not with public objects but with unknowable subjective items. Had it been so, we could not make any sense of aesthetic reactions. Therefore, behavior cannot be used by relativists to make sense of our aesthetic terms.

The third way, analogy from other predicates, is also closed to the relativist in aesthetics. One *can* learn what 'gaudy' means by comparison with other aesthetic predicates. Dictionaries define 'gaudy' by other aesthetic terms ('irritating', 'cheap', 'vulgar', 'immodest', 'bold contrasts', 'conspicuous', 'showy', 'tasteless'). Yet to define *all* aesthetic predicates in that manner is to pull oneself up by tugging at one's bootstraps. If one understands no aesthetic term, an explanation will not help. I am not any wiser if a word that I do not understand is explained to me in a language that I do not apeak. Can nonaesthetic properties be used? No; to explain aesthetic terms by nonaesthetic ones is like the proverbial explanation of colors by acoustic analogs. The reason for that is *not* that nonaesthetic descriptions of an object can neither entail, nor increase the probability that a certain aesthetic predicate applies to it. That position of Isenberg, Sibley, Mothersill, and others is incorrect. Nonaesthetic facts may

entail the *truth* of aesthetic sentences, just as a blind physicist may discover by acoustic devices that the wall is red. They cannot, however, give meaning to aesthetic predicates. It is impossible to explain *being gaudy* to the aesthetically insensitive. Nonaesthetic properties may be sufficient for the existence of aesthetic properties, and perhaps aesthetic properties supervene upon nonaesthetic ones. If so, one who knows that X has the nonaesthetic property P can truly *say* that X has the aesthetic property A, but one would still not know what it is like to observe X as A. Analogy from nonaesthetic terms is useless, for you could not explain that *gaudy* is not a kind of color, like bright red, or a sound, like the sound of a trumpet, but another *kind* of property.

Thus if relativism in aesthetics is correct, aesthetic terms can have no meaning, and it is inexplicable how we can use them. The relativists intended to explain disagreement: why people who understand an aesthetic term do not agree on its application. Yet if aesthetic terms have no meaning that situation cannot arise, for no one knows what property the other assigns to X by saying "X is A." Radical disagreement implies that we cannot understand each other when we talk about aesthetic matters, and cannot disagree. Therefore relativism in aesthetics is self-contradictory.

Relativism tries to explain *radical* disagreement in aesthetic matters; if disagreement is not radical, relativism is useless. One can be a realist about aesthetic properties, for occasional disagreements about observable properties are common; given a basic agreement there can be disagreement in difficult and marginal cases. There can be radical disagreement on the application of defined, non-observational, predicates; but aesthetic predicates are (relativists admit) observational, so there can be no radical disagreement about them. To disagree whether a given aesthetic term is appropriate in a given case those who disagree need to understand that term. To learn an observation term, one must be shown to what objects it (or others of its family) applies. Thus if aesthetic terms have meaning, we have common paradigms for them: aesthetic judgments attribute properties whose presence or absence can very often be empirically verified.

2. STANDARD OBSERVATION CONDITIONS

If there is a standard use of aesthetic terms, how can we disagree on their application? We almost never disagree on whether a thing is red, but we do disagree on whether it is gaudy; why? I answer that unlike red, whose standard observation conditions (SOC) can be adopted by most people and require no instruments or special training, the conditions that are standard for observing aesthetic properties involve experts.

One and the same object looks differently when observed under different conditions. Descartes was so shocked by that fact, that he came to doubt the objectivity of all observable properties. An empiricist would answer that we can attribute observable properties to things because not all observation conditions have an equal epistemological status: a property can have Standard Observation

Conditions (SOC). 'C are SOC for F' means that X looks F under C if and only if X is F. If you seem to see X kissing Y, that is a good reason to believe that X did kiss Y; but if you dream that, your observation is not a good reason to believe that X kissed Y. Looking red under some but not all observation conditions attests to X's really being red. Some conditions of observation are then *standard* for examining things for redness. What is observed under non-standard observation conditions as red may be blue, what is thus observed as circular may be ellipsoid, etc. SOC are needed not only for "secondary" properties like color, but for "primary" ones, too: you cannot tell an object's shape by measurement unless the conditions under which the measurement was taken were standard (the object was not in motion relative to the rod, etc.). Whether the dial moves or the litmus paper turns red, as a theory predicts, depends on what we take as SOC for motion and redness. The theory is *not* confirmed if the dial is seen to move by an experimenter who bobs his head or if the litmus paper is examined under red light. The very notion of empirical data involves SOC, for the findings of observations or measurements conducted under non-standard conditions cannot be treated as data, detached from the conditions in which they were observed. To have data, one needs SOC.

The need for SOC is not peculiar to aesthetic or other terms that people often disagree on. Most observation predicates have SOC. Green appears black in red light, square things appear round when they spin, sticks appear broken when dipped in water. We do observe when we are drunk, drugged, and while dreaming, but these conditions are nonstandard: that X is observed under these conditions as F is no evidence that F(X). Realists in aesthetics therefore need not hold the absurd view that unless X looks gaudy to all people, under all observation conditions, it cannot be said to be objectively gaudy. Under some conditions, objects will be seen as having aesthetic properties that they do not really have. In that respect aesthetic properties are like all other observable properties: it is no surprise that under certain conditions X looks A and under other conditions it looks nonA.[2] What looks gaudy to you may look dramatic (not gaudy) to me, but that is not the end of the matter. The question is, who observed X under the SOC for these properties?

What observation conditions are standard? Not necessarily those that generally prevail and are more common than others. In a northern country where the sun shines only few hours a day, SOC for determining color involve sunlight. The same SOC also hold for items seldom observed in broad daylight; a dress is red, not gray, even if it is most often seen in neon light that makes it look grayish. The SOC for detecting bacteria do not usually prevail: they involve instruments and techniques unfamiliar to laymen. SOC for wine tasting require preparations, and not everyone can be a qualified wine-taster. Both talent and training are required for hearing a chord X as in key A, having components B, developing the voice or motif C, and of instrument D.[3]

Secondly, SOC are not (as suggested by J. J. C. Smart) those in which more distinctions can be made than otherwise. Smart says:

Let me introduce the concept of a normal percipient. One person is more a normal percipient than another if he can make color discriminations that the other cannot. For example, if A can pick a lettuce leaf out of a heap of cabbage leaves whereas B cannot though he can pick a lettuce leaf out of a heap of beet root leaves, then A is more normal than B.[4]

Smart's motivation has much to recommend it and is important for aesthetic properties (experts observe more aesthetic distinctions than laymen), but his definition is unacceptable. A person who makes myriad distinctions that all others find capricious is not the most normal percipient, who sets the standard for correct attribution of properties. He is merely mad. Otherwise statements of the form "S wrongly believes that there is a difference between X and Y" would all be logically false since, by definition, whoever seems to see a difference is more normal an observer than anyone who does not see it. Since that is the standard, no distinction can be challenged. But this is not how we conduct observations: conditions under which a record number of distinctions is made need not be standard, and those who make the most distinctions need not be the standard setters.

There is a temptation to regard the statement, "C are SOC for F" as analytic, depending on the meaning of 'F', but that cannot be true. What is the best way to detect the presence of a property F is an empirical question that cannot be decided by linguists. Rather, C are SOC for a family of properties F iff for any member Fi of F, X would look Fi under C iff $Fi(X)$. If we justifiably believe that $Fi(X)$ we may call the conditions C in which X appears Fi 'standard', but if X is not Fi, C are nonstandard after all. Nonstandard conditions are external (when a stick is half submerged in water, when light is tinted or dim, etc.) and internal (when the observer is sick, hypnotized, hallucinating, etc.) conditions that induce *illusion*. One who knows what 'F' means may err in applying 'F'; not all factual errors are due to linguistic incompetence. It may look to most observers that X is F, but if it is not F, their observation conditions are nonstandard. Even a staunch empiricist would admit that whether X is F is decided not by mere observation, but by an encompassing theory.

That aesthetic properties are directly observable does not preclude the need for adjudication on their SOC. Observations conflict; to classify some observations as illusory and the conditions under which they were made as nonstandard, that is, to obtain a stable world-picture, we need a theory. When theories change, observations deemed veridical are liable to be reclassified as nonstandard and hence unreliable. Observational findings are not yet data, for it may be denied that the conditions under which they were observed are standard. No attribution of an observational property to an object is unassailable. The decision that X is F, although based on observational findings, is theoretical. When the theory matures, SOC become complex and demand special tools and training; those who are adept in employing them are the *experts*. The experts further regiment the application of F: given their verdict, debates

(whether the earth is round, whether Shakespeare is a good writer, etc.) are simply over. Yet the growth of a theory can be slow, and there may be long periods when a question is fiercely debated and there is no expert backed by a sufficiently substantiated theory to settle the issue. Even with no decisive verdict, *radical* disagreement on the extension of an observational predicate is impossible: as argued above, people understand each other only if there is general agreement on the paradigm cases of observational predicates. Without such agreement 'F' can have no sense, and the question whether '$F(X)$' is true or not is strictly senseless. Now for that agreement to be more than rudimentary, a theory institutes SOC for Fness, such that if X appears F under these conditions we take it to *be F*. (For unobservable properties, X is F iff it appears G under those conditions.) Experts are those who, due to personal genius, proper training, or possession of the right instruments, have those SOC; they are standard observers.

For some observation terms most observers are standard. In those cases nearly everyone can check for oneself whether X is F, with identical results. In most other cases where there are SOC for Fness, there are experts, namely, standard observers, who see X as F if and only if X really is F. Others who observe things as being F cannot claim to know which things are F. The theory, art movement, or school that explains which objects are F and why it is better to take the conditions under which these objects appear to be F as standard trains experts, who determine, in accordance with that theory, which objects are F and which are not. Most observers then accept the experts' verdict that X is F even though they, not being in the SOC for Fness, do not see X as F. That situation is established when we accept a meaning-rule for 'F', that its application is determined not by linguists, who merely codify extant use of speakers, but by experts (scientists or art critics). We learn that there are in language *observation* predicates whose correct application cannot be determined by each person on his own. One learns the rule, that although one may observe some thing *as* satisfying such a predicate, that observation may be illusory, that is, nonstandard.

That rule has been articulated in Putnam's principle of the Division of Linguistic Labor (DLL, for short).[5] Putnam argued that substance terms and names of natural kinds (elm, fish, gold, water, etc.) obey that meaning rule. Thus even if X would look to most native speakers as gold, or water, or a fish, that does not decide the question whether it really is gold (or water, or fish): the decision is relegated to experts in the relevant field. I do not agree with Putnam that DLL applies to all substance terms, but I do think that DLL applies to many terms, especially those whose referents are extensively treated in a mature theory. For example:

Look: a butterfly!
It is not a butterfly, it is a big moth.

She is a good-looking woman.
A person with XY chromosomes is not a woman.

Do you hear the guitar?
A lute is not a guitar.

This is a lovely painting!
It is nauseatingly sentimental.

Let me summarize. Unless aesthetic terms are given realistic interpreta-
tions they cannot be understood or be used in language. Aesthetic terms obey
DLL: that is how they can have meaning despite the fact that distinct observers
often diverge when they apply them by direct observation. Instead of general
uniformity in observing aesthetic properties, there are experts who have the
SOC for them. Thus despite the (considerable, but not radical) disagreement
on the application of aesthetic terms, we can learn them and teach them to
others.

3. PROOFS FOR SCIENTIFIC REALISTS

Scientific realists hold that we are justified in believing that the best theory
is true and its theoretical entities really exist. A theory is better than another
if it explains facts that the other cannot derive from general principles and
the antecedent conditions. Now there is a vast body of behavioral as well as
phenomenal data about artists, performers, and consumers, that is routinely
explained by theories that use aesthetic predicates. "S dislikes the A_1 style of
the era; that is why her works are so A_2." "S plays X in that way to make it
more A." "S will not like X; it is too A." Explanations and predictions such
as these are derived from full-fledged, or mini, theories that use A (aesthetic)
terms. As their place in everyday life as well as in the academia shows, these
theories are successful in doing what a theory should do.

Art has a history. A theory which explains that history is *belief worthy* for
scientific realists. A naturalistic theory that makes no use of aesthetic predicates
can neither explain nor predict what goes on in art. It cannot explain phenomena
in each art, relations among the arts, and connections between what goes on
in art and events in the world at large. It cannot explain why art exists at all!
Finally, a naturalistic theory that abjures aesthetic properties can predict neither
how an art object X will appear to experts (say, as lyrical) nor how it will look to
the untrained (bland, anemic, dull). It dumps *all* these data (with UFO sightings
and religious visions) in the big heap of Unaccountable Perceptual Delusions.
Artists whose work is guided by aesthetic observations would be on such a
theory madmen subject to the delusions of imaginary properties. An aesthetic
theory can do much better, so scientific realists should hold it to be true.

Now which aesthetic theory should one adopt? Some theories of aesthetic
properties are better than others; a scientific realist should not only adopt the
best aesthetic theory, but also believe that, if it says that $A(X)$, then probably

X is really A. True: a theory can be supplanted and justification may expire; we may change our minds about the aesthetic properties of X, and thus about the SOC for being A. Still, opting for one theory and not for another is not arbitrary. Take a straight stick that appears bent when half submerged in water. We have good reasons for saying what I have just said, namely, that the stick is straight and that viewing it as half-submerged in water is a nonstandard observation condition. It is unwise to consider semi-submergence in water as a standard condition and then explain why the stick appears straight when taken out of the water. That all sticks are truly bent is incompatible with a lot of evidence and has such unwieldy results that it would be silly to believe it. Methodologically it is better to explain the phenomena by saying that the stick is not bent even though we directly see it as bent. The best theory, the one most worthy of acceptance, would adopt other SOC, saying that sticks are not seen as they really are when observed in a state of half-submergence in water.

SOC for aesthetic predicates are assigned to objects by art critics in explicit or implied theories. Given theories T and T^*, it often makes more methodological sense to accept one rather than the other, and hence accept its SOC for the aesthetic properties it deals with. A theory that explains why some oratorio would seem boring to a teenager who has had no musical education, even though it is not truly boring, is methodologically superior to a theory according to which the said oratorio is really boring. The first theory has greater explanatory power, it is simpler, more concise, and it connects with other good theories better than its rival. A theory that takes the observation conditions of teenagers who care for rock music only as standard will have to explain how people who had some musical education and exposure to classical music fall victim to the illusion that the oratorio is profound and delicate. It will have to show how a monotonous drone (as the work looks to the said teenagers) causes an elaborate hallucination of fictitious (since unperceivable by the teenagers) properties. It needs to expose the mechanism that causes not otherwise delirious adults to be so deluded that they seem to hear rich emotional and spiritual features in a dull drone. Or perhaps it is a monumental hoax, a worldwide conspiracy of adults against the young? These theories are methodologically inferior to a theory that explains why that oratorio, while possessing beauty and great inner richness, would yet seem monotonous and boring to those unfamiliar with the musical tradition of the west (and whose sense of hearing has sustained an irreparable damage by the loud music they usually listen to).

The choice of SOC is guided by methodological considerations. Take the theory that the stick is truly straight and only appears bent because the conditions of observation are nonstandard. That theory explains many phenomena elegantly, and thus we prefer it to the rival theory that the stick is really bent but appears straight in air. The latter theory is epistemically unjustified and clearly unreasonable. A theory that chooses as standard those conditions under which Bach's work appears aesthetically good can predict that Bach would look boring under observation conditions that do not include an ability to follow a melodic line, tonal variations, nuances, and spiritual meaning. That theory

predicts data that the rival theory has to pass over in silence, for example, how will the musically educated respond to certain variations in the performance of that work. It explains why performers do what they do and makes sense of behavior that a rival theory describes as pathological: to make such a fuss over dull noise! It can explain the relation of a given work to its predecessors and ties it to historical movements and events. It uses art to explain other cultural and sociological phenomena, and vice versa.

Not all assignments of SOC are equal, for not all of them can make sense of the behavior of artists and art-lovers, and make that explanation converge on what we know about human culture from other sources. A good theory in art or literary criticism can explain *in detail* what artists do, and why they do it. A theory that takes as standard the observation conditions under which Bach's work looks boring (or full of clumsy flourishes lacking in taste and meaning) cannot do that. It cannot explain why the work has the structure, and the impact, it has. One *may* hold that our admiration for Bach is due either to a delusion, a hallucination, or else to a secret plot of a cabal, passing off junk as a thing of great merit (as in Anderson's *The King's New Clothes*). However, psychopathic behavior and the behavior of conniving crooks have manifestations that are missing in the Bach case; these theories are therefore weak.

Scientific realists hold that if theory T is better than its rivals, we are justified in believing T. It follows that under the observation conditions C that T decrees standard, things appear as they are, and hence if, under C, X appears A, then X is A. The theory that explains the behavior of the artist, predicts how the experts will see X, and *also* the observations of nonexperts (who see X as ugly, boring, messy, etc.) is worthy of credence.

4. ARE AESTHETIC EXPLANATIONS IMPOTENT?

Some scientific realists have charged that aesthetic and moral theories should not be given a realistic interpretation, for the properties they mention are explanatorily impotent, isolated, and odd. Value theory is a poor predictor of phenomena, and does not sit well with the rest of science. J. L. Mackie argues that aesthetic and other value properties are not "part of the fabric of the world," in the sense that mass, velocity, charge are part of it. Value predicates should be reduced to terms used in psychology and physics.[6] Harman concurs: "scientific principles can be justified ultimately by their role in explaining observations."[7] Protons can be posited by a good theory because "facts about protons can affect what you observe"; but value properties should not be posited, for "there does not seem to be any way in which the actual rightness or wrongness of a given situation can have any effect on your perceptual apparatus."[8] A theory should explain why we make the judgments we do make (including the promulgation of that very theory). Value theory fails that test: it is "completely irrelevant to our explanation"[9] of why the theory in question was suggested whether the moral (and, I suppose, aesthetic) theory judged to be true is true or not. Why

we made the observations that led to it, and why it was offered, is explained by physical and psychological properties, not by value properties.

That argument is unacceptable, on several grounds. First, there simply is no explanation of our value judgments in purely physical and psychological terms. The few (Darwinian, Marxist, biopsychological) attempts to explain aesthetic value in such terms are notoriously inadequate. Their "explanations" of morality are even more pitiful; typically, they consist of ideological harangue, and bear no resemblance to science. Naturalistic theories of art and morality have a very poor record.

Mackie and Harman would probably agree, but say that they did not refer to existing theories; naturalistic explanation of ethical and aesthetic judgments is possible *in principle*. Although no such explanation as yet exists, future science may provide it. But how do they know this? Note, that it is not enough if future science provides necessary and sufficient conditions for the application of value terms. That will only indicate that (as most realists in ethics and aesthetic believe anyway) value properties supervene upon physical ones.[10] Cartesians also hold that mental events are correlated with physical events and cannot occur without the latter occurring. The supervenience of the aesthetic on the nonaesthetic does *not* make the aesthetic property explanatorily redundant, for science gives no explanation, none at all, neither in fact nor in principle, for why brain events of kind K result in our making these specific phenomenal observations. Why do we observe qualia? Why do we see X as red and not as blue, as gaudy and not as dainty, as desirable and not as undesirable? Science cannot (not even in principle, for it does not deal with qualia) explain that; one cannot *deduce* from facts about the brain *how* state S would appear to us, phenomenally. The concepts of the *gaudy* and the *dramatic* cannot be rendered by descriptions of patterns of cell spiking; no such description can make one understand the phenomenal difference between these two properties and why one of them is bad and the other is good. The conceptual resources of science are utterly unsuitable for that task.

Whether we like it or not, the best explanation we have for our having phenomenal experiences is still, as it was in the days of Aristotle, that these are observations of properties of some entities. A Cartesian will say that these entities are mental, not physical, but that does not change the basic feature of the theory: intentionality. The intentional theory of experience is not only the best we have; it is our only working theory. We should accept, therefore, the reality of the properties posited by that theory.

Some philosophers (most notably, Churchland[11]) suggest an alternative: do away with phenomenal terms, and use science's terms instead to report all data. Can that be done? Elsewhere I argued that this is a conceptual impossibility.[12] Eliminating phenomenal terms must result in the expurgated system *losing its scientific character*. "My C-neurons fire!" cannot replace "I see red!" for the former statement does not specify any *ground* for my saying that my C-neurons fire. The information, that I reach that opinion by sensing red, is lost. "I see red" is mode-specific; "my C-neurons fire" is not. There are

many ways for one to reach the opinion that one's C-neurons fire, only some of which make it noteworthy for the scientist. Merely to insist that p (e.g., that my C-neurons fire) is to express an idle opinion, an obstinate dogma that one just happens to adhere to. The purported elimination of sense-terms eliminates the core of science, its distinction between an empirical observation and a mere opinion. It reduces science to a story, a legend with no empirical content, for we lose the means to express the difference between the two. Eliminating phenomenal terms is therefore the end of science; the expurgated language cannot distinguish dogma, or fairy-tale, from empirical data. Thus, phenomenal terms cannot be expunged from a scientific description of the "fabric of the world." Since aesthetic terms are phenomenal terms, they too must remain in any scientific account of reality. They will feature in science's ultimate account.

One claim of Harman and Mackie must be granted without further ado. It is true that moral theory and aesthetics are relatively isolated from the physical sciences. There are connections between acoustics and musicology, geometry and art theory, linguistics and literary criticism; some explanations combine elements from ethics, biology, psychology, and aesthetic. Yet these connections are not nearly as strong as connections between, say, botany and zoology. True; but so what? A theory that is successful in its field, but only marginally interfaces with other theories, is not discarded and the said field left unattended to until that day (which may never come) when a better behaved theory comes along. The unity of science is not a *sine qua non* condition, only a regulative ideal that may or may not be achieved.

My last, and most decisive, argument, is this. Scientific realists hold that the best theory is probably true. The best theory is one that passes all methodological tests with flying colors: it is simple, powerful (has a wide range) and dramatic (we prefer a theory T that has successfully predicted to a theory T^* that has only postdicted: both explain the data, but T is more *dramatic*).[13] These properties are aesthetic; thus theories have aesthetic constraints, and these are their *only* constraints. Theories cannot be refuted: incompatible data and prediction failures make a theory less general and inelegant, that is, uglier, but not false. Thus, scientific realism comes down to this: ugly theories are probably false. A theory that is rich, powerful, dramatic, and simple, i.e., beautiful (Unity in Variety is the oldest definition of Beauty) is probably true.

Let 'electron' be a term that occurs in the aesthetically excellent theory T. According to the scientific realist, that is a reason to believe that T is true. But then what about the sentence 'T is beautiful'? Is *it* true? If it is not true (say, because 'beautiful' fails to denote), then T is not beautiful, in which case it is probably not true. In that case there is no reason to believe that 'electron' is satisfied in reality, that is, that there are electrons. Thus if we should believe that there are electrons (or, for that matter, any other kind of thing) we should believe that some aesthetic predicates are satisfied, too. Let me put it differently: some theory T must be true. If T is true, it is beautiful. If T is beautiful, the aesthetic theory AT, that says that T is beautiful, is true. If AT is true its basic predicates denote real properties. Thus, aesthetic properties are real.

Can the aesthetic properties be reduced to nonaesthetic ones? No. A theory that will show that such reduction can be carried out must itself pass muster, that is, be shown to possess the required aesthetic properties. We may believe that there are no aesthetic properties only if we can establish that some theory T (the theory that says that there are no aesthetic properties) is beautiful. Thus there must be aesthetic properties. Belief in the reality of aesthetic properties is necessary for justifying any other belief. The reason is that for scientific realists, believing a proposition P is justified only if the theory T, that implies P, is beautiful. To believe that T is beautiful, one must believe the aesthetic theory AT, that implies that T is beautiful. Believing AT is then a precondition for believing P.

One may wonder here whether the above line of argument does not lead to an infinite regress, requiring that whoever believes some proposition P must believe an infinite number of aesthetic theories, each of which requires another (implying that it is beautiful)? No; there is no regress, because a theory of aesthetic properties would apply to itself: it will find itself beautiful or ugly, as the case may be, by its own standards.

Another objection runs as follows. Granted, that to adopt a reductive theory of aesthetic properties we must find it beautiful. But once we have adopted that theory we replace Beauty by some non-aesthetic property, say, Causes Brain State N. So there are no aesthetic properties after all. I answer that Causing N does not have the *justificatory power* of Beauty. Why should the fact that X causes N justify the belief that X is true? Why should we prefer a theory that causes N to theories that cause M, or L, or other brain states? Scientific realists find a conceptual connection between Truth and Beauty. A concept that replaces Beauty need not have that connection. For example, there is a conceptual connection between *witch* and *magic*, but the concept *demented woman* that may replace *witch* in some theory has no connection to *magic*. A theory T is credible if, and *because*, it is beautiful. If it is not, it is not credible. The fact that T causes N, and N happens to be a state that common-sense psychology has misdescribed (but now we allegedly know better) as the phenomenal property, Beauty, is irrelevant to the truth of T. If nothing is beautiful, no theory deserves credence, and thus the theory that nothing is beautiful deserves no credence either.

5. PROOFS fOR METAPHYSICAL REALISTS

The scientific realist's answer is not acceptable to realists who, believing that reality is as it is regardless of our theories and practices, do not think that we have any right to believe that the prettiest theory is true. Critics of scientific realism argue that methodological excellence, that is, beauty, does not guarantee truth. The world in itself may be ugly, so why believe an account that presents it as pretty? A beautiful model may explain all that needs explaining, and yet be false, for the world satisfies an uglier model. Thus the metaphysical realist thinks that beauty is irrelevant to truth.

Can a metaphysical realist hold, then, that the real world has aesthetic features? I have shown that some aesthetic theories are better than others; can they still be *false*? What if the world in and of itself has no aesthetic properties? Metaphysical realists hold that even the best theory may be false; so can the theory that grants the existence of aesthetic properties be false, too? Non-realists such as Dummett and Putnam think that a methodologically impeccable theory, say, one that would be accepted by ideally rational beings, cannot be wrong. These thinkers identify *truth* with *justified assertability*. Metaphysical realists, on the other hand, insist on their distinction. Given that position, can we know whether things in reality have aesthetic properties? Is it possible, that is, to be a metaphysical realist *and* a realist in aesthetics?

My answer is, Yes. Even if the world in itself has neither colors nor sounds, even if motion, space, and time do not really exist, even if a description of reality as it is would not include any predicate of our present science, it cannot fail to include aesthetic predicates. It is possible (as Leibniz and Kant thought) that time and space are mere phenomena; perhaps our notion of energy is also erroneous. Let the world be anything at all: if it has *some* nature, it has a character and a structure, and therefore it cannot fail to be pretty or ugly, dramatic or monotonous, dainty or sublime. It is inconceivable that anything could be unamenable to aesthetic evaluation. Even if there is no one to appreciate the world's beauty, aesthetic terms like 'dainty', 'ugly', 'sublime', 'dramatic' are either true or false of it, since they apply to any structured whole. Take 'gaudy', 'central', and 'spherical': which is more likely to apply to spatial things? If space is Einsteinian nothing in it can be circular; if it is Newtonian nothing in it can be central. But things can be gaudy in any manner of space. Under no circumstances is it a category mistake to ascribe aesthetic properties to objects. Just as English words can be satisfied in a possible world where English does not exist, phenomenal predicates can be satisfied in a world where no humans exist. Now not every possible world is spatiotemporal, not every possible world has water, but a possible world that has no features is inconceivable. Yet any arrangement of features satisfies some aesthetic predicate. Therefore the real world, whatever other properties it has, has aesthetic properties, too.

Let me be even more daring and say that we can know not only that the world in itself has aesthetic features, but also that we can put greater trust in aesthetic than in scientific theories. On the metaphysical realistic view, inference to the best hypothesis is unwarranted: empirical adequacy is not truth, and hence even our best scientific theories may be false. In contrast, an aesthetic theory need not rely on an inference to the best hypothesis. There is an independent proof that our aesthetic views cannot possibly be all wrong. My proof may remind you of Davidson's proof that there can be no alternative conceptual schemes,[14] but the similarity is superficial. I reject Davidson's proof: we can, I think, have good reasons to believe that some alien beings speak a language that we cannot learn.[15] My claim is, that it is incoherent to maintain that we usually misapply the aesthetic predicates.

In section 4 I argued that our theoretical constraints are all aesthetic: we have no other criteria of acceptability of hypotheses and theories. Theories cannot be refuted, but they can be shown to be cumbersome, narrow, and devoid of dramatic power; in short, a theory can be shown to be ugly. Suppose that metaphysical realists who hold that the best theory may yet be false think that aesthetic judgments may be false too. Let them maintain that it is possible that our aesthetic judgments are all wrong. In that case what we think is ugly is in fact lovely, and vice versa. Now that robs us of our sole reason not to *use* (not: believe) bad theories. The metaphysical realist suspects that even an atrociously bad theory may not be false; yet he does claim to know that it is atrociously bad. But if we may be wrong in that too, if our verdict that the said theory is ugly can be mistaken, we cannot know even that it is empirically inadequate; we are not allowed to believe that it dissatisfies the methodological criteria. But then, why reject it?

Note, that if our judgment that T is a beautiful theory (that it satisfies our methodological criteria) is doubted, it is useless to produce another theory, with more arguments, to buttress the claim that T is indeed a good theory, for the new argument is not less suspect than the previous one. If our ability to tell a good argument from a bad one is doubted, then it is impossible to allay that doubt by means of further arguments. Therefore, if we are to consider any theory, including the skeptic's and the metaphysical realist's, we need to assume that we apply aesthetic predicates *correctly*. Any argument, including the argument that our aesthetic judgments are wrong, that we misapply aesthetic concepts, is worth considering only if we trust our ability to distinguish a good argument from a bad one, that is, to apply aesthetic concepts and tell the beautiful from the ugly. Thus our aesthetic theory cannot be coherently conceived to be false.

Consider the following example: Can I prove to you that you are utterly mad? Not that you have illogical spells on occasion, but that you are totally insane, a raving maniac who thinks in radically irrational ways? Certainly not. If you are convinced by the argument, you should believe that you are mad, and therefore you should distrust the reasoning that led you to be convinced by the argument. On the other hand if your reasoning is valid you should reject the argument because its conclusion, namely, that your reasoning is invalid, is false. Thus you should reject that argument in every case. Nothing should convince you that you are mad, or (which amounts to the same thing) that your aesthetic judgment is so wrong that you usually mistake inelegant, ugly arguments for flawless and watertight, that ridiculous pieces of reasoning would look nice to you. It is pragmatically paradoxical to doubt our basic aesthetic judgments, for if we do, we should doubt that that doubt itself is well founded. If I think that my thoughts are drivel, that thought itself is drivel, and thus I should not heed it. I cannot empirically investigate and discover whether my reasoning is good, for that investigation, too, would rely on my reasoning. If I do not know *a priori* that it is good, I can never find it to be good. If our aesthetic judgment is no good then what seems a good reason for thinking

that, i.e., that our aesthetic judgment is no good, is also no good. Thus it is never reasonable to believe that our aesthetic judgment is no good: if that proposition is true, we should believe that it is false; if it is false, we obviously should believe that it is false. Hence we should always believe that it is false.

NOTES

1. The classical expositions of that view are in three articles in W. Elton's influential anthology, *Aesthetics and Language* (Oxford, 1954): J. A. Passmore, "The Dreariness of Aesthetics," Arnold Isenberg, "Critical Communication," and Stuart Hampshire, "Logic and Appreciation."

2. I have suggested a defense of realism in aesthetics based on the notion of standard observation conditions for aesthetic properties in my articles "A Stitch in Time," *Journal of Value Inquiry* 1 (1967–8): 223–42 and "Taste and Time," *Iyyun* 20 (1970): 79–104 and in my books, *Analytic Aesthetics* (Tel Aviv, 1970), and *Aesthetics* (Tel Aviv, 1976). A more recent defense of realism in aesthetics along similar lines is given in Philip Pettit, "The Possibility of Aesthetic Realism," *Pleasure, Preference and Value*, edited by Eva Schaper (Cambridge, 1983).

3. I discussed that point in "Seeing, 'Seeing', and Feeling," *Review of Metaphysics* 23 (1969): 3–24.

4. J. J. C. Smart, "Sensation and Brain Processes," in *The Philosophy of Mind*, edited by V. C. Chappell (Englewood Cliffs, N.J., 1962), 166.

5. Hilary Putnam, "The Meaning of 'Meaning'," in his *Mind, Language, and Reality* (Cambridge, 1975).

6. J. L. Mackie, *Ethics: Inventing Right and Wrong* (Harmondsworth, 1977).

7. G. Harman, *The Nature of Morality* (New York, 1977), 9.

8. Ibid., 8.

9. Ibid., 7.

10. Supervenience does not jeopardize the ontological reality of aesthetic predicates. Take the pair of particles that feature in the Einstein-Podolsky-Rosen experiment. The properties of each particle supervene on those of the other, for it is impossible to affect one of them without the other being affected (the famous "collapse"). That does not mean that only one of the particles is real and the other is "reducible to it" (whatever that means); both are real. Indeed logical relations between real things are unusual, but phenomenal-physical relations are unusual in any case; we cannot expect them to follow the laws of classical mechanics.

11. See *Scientific Realism and the Plasticity of Mind* (Cambridge, 1979); *Matter and Consciousness* (Cambridge, 1988); "The Direct Introspection of Brain States," *Journal of Philosophy* 35 (1985): 8–28.

12. In "Churchland, Introspection, and Dualism," *Philosophia*, forthcoming.

13. I have argued this point in my "Truth and Beauty," *Philosophical Forum* 18 (1986): 21–39.

14. "On the Very Idea of a Conceptual Scheme," in D. Davidson, *Inquiries into Truth and Interpretation* (Oxford, 1984), 223–42, and "A Coherence Theory of Truth and Knowledge," in *Truth and Interpretation*, edited by E. LePore (London, 1986).

15. Suppose that a spaceship lands here; its nonhuman crew is obviously highly intelligent. They learn English in a matter of days and converse with us on a variety of topics. However when we ask them to translate some of their writings into English they explain that they cannot do so, for theirs is a language that we cannot understand. The reason is that while we have six senses, they have sixty. They show us the bodily organs for these senses and explain that the simplest word in their language denotes a combination of determinations of at least twenty different kinds of sensation. Further, suppose that their children

take a few hundred years to learn the simplest logical formula expressible in their language (they live for a hundred thousand years), and hence it is reasonable that there can be no English translation of even the simplest expression in their language. Is that impossible? But Davidson would have us believe that our galactic friends are no more intelligent than trees, and that they cannot have a language!

The Aesthetic Value of Originality

BRUCE VERMAZEN

1. ORIGINALITY AND NOVELTY

Originality seems to have begun its career as a valued property of works of art in the eighteenth century, with the publication of Edward Young's "Conjectures on Original Composition" in 1759. With Kant's apparent endorsement in Section 46 of the *Critique of Judgment*, its future was assured, and it has survived into our own day as the shadowy referent of an altogether standard term of praise. Some confusion surrounds the notion at present, owing to the popularity of the discussion, starting with Nelson Goodman's *Languages of Art* (Indianapolis and New York, 1968), of the aesthetic importance attaching to originals as distinct from forgeries. But though there are some loose and interesting connections between the property of being original that figures in the original-forgery distinction and originality as conceived by Young and Kant, the latter is a quite separate idea. I will argue in this essay that originality *per se* is not a property of works of art that should be counted as contributing to their aesthetic value. Nevertheless, the belief that it is such a property stems from confusions that are difficult to avoid and that I propose to examine.

I will use the term 'aesthetic value' in a way that is arbitrary but not unreasonable. I intend the term to pick out a genus of which the species are the value of a work of art as a work or art, the value of a painting as a painting, the value of a piece of music as a piece of music, the value of a poem as a poem, the value of a sonnet as a sonnet, and so on, for all the many kinds of value picked out by 'the value of a *K* as a *K*' where '*K*' is replaced by a general term that picks out one of the kinds thought of as a variety or form of art. Thus I do not include what might with equal justification (but under a different stipulation) be called the aesthetic value of persons, natural landscapes, or mathematical theorems. Here 'art' has the sense in which its instances are products (including performances and processes) rather than the sense in which it is a skill. I have argued elsewhere[1] that aesthetic value so

understood is not a single property of its possessors, a unitary measure of their worth. Rather, it is a multidimensional measure, of which the dimensions are rank-designations or ordinal measures of properties of the work that are valued for reasons stemming from the evaluator's conception of art or of some art-kind to which the evaluated item belongs, for example, the kinds *Petrarchan sonnet* or *story ballet*. The properties ranked (against the same or comparable properties in other works) might include expressiveness, approach to unity, and profundity, as well as properties particular to specific kinds, like beauty of melody or aptness of prosody.[2] I do not think of the properties ranked as coming from some comprehensive list valid for all evaluators; different judges may find different aspects of art valuable, and this facet of taste is only one of many that keep people believing that there is no disputing about taste.[3] My claim that originality is not a property that should be counted as contributing to a work's aesthetic value is the claim that there are good reasons for anyone to exclude originality from the list of ranked properties. In what follows, I will call properties that contribute to aesthetic value in this way 'aesthetically valuable properties'.

What property do we praise a work for when we call it original? And how is that property connected with value? The philosophical discussion of originality starts with an invitation to confusion, as Edward Young says "I shall not enter into the curious enquiry of what is, or is not, strictly speaking, *Original*, content with what all must allow, that some compositions are more so than others; and the more they are so, I say, the better" (215).[4] In what follows, Young provides a number of clues to what he means by "original" and what connection he intends between originality and value, but the clues seem to point in different directions. His claim that "*Originals* can arise from genius only" (221), together with the idea that works of genius are *ipso facto* good, seems to indicate that he thinks that if a work is original, it is for that reason good to some extent. Thus this clue points in the direction (though not *precisely* in the direction) of his opening remark that the more original a work is, the better it is. On the other hand, when he discusses Jonathan Swift, whose writing he dislikes but whose genius he concedes, he adds that "nothing is more easy than to write originally wrong; Originals are not here recommended, but under the strong guard of my first rule—*Know thyself*" (229). This passage seems to contradict the first passage cited, in stating that originality is not a merit *per se*. Perhaps the latter claim is more plausible than the former, aside from what Young says, since genius, originality's parent, can aim at bad ends or simply err.[5] But that view of genius clashes with another of Young's claims: "what, for the most part, mean we by genius, but the power of accomplishing great things without the means generally reputed necessary to that end" (219); and later, "unprescribed beauties, and unexampled excellence, which are characteristics of *genius*. . ." (220). Perhaps the solution is to take "for the most part" seriously: genius is a power to accomplish great things, but there is more to it, and that more makes it possible for genius to produce things that are not great. Similarly, we may suppose that "characteristics" of genius are

only usual qualities of its products, rather than qualities they invariably have. Thus genius may on occasion accomplish poor (though original) things devoid of beauties or excellence. If so, we must read his claims about the *value* of originality in a special way: qualified by the rider that the respect in which the work is original must also be a respect in which it is good, that is, an excellence or a beauty. Only then can we be sure that more originality makes for a better product. So read, 'novelty' seems as good a term as 'originality' to catch his meaning, though of course there is no conceptual or causal connection between novelty and genius, as there is perhaps supposed to be between originality and genius ("what *mean* we by genius").

A puzzle unsolved by taking originality in Young simply as novelty is how "the strong guard of my first rule—*Know thyself*" is supposed to keep the genius from producing something both original and bad. He cavils at Swift for satirizing human nature: "In what ordure hast thou dipt thy pencil?" (229). Swift's misanthropy and tone seem to provoke this criticism, and neither would plausibly be changed merely by Swift knowing himself better, for by "*Know thyself*," Young seems to mean only that the aspiring producer of original work should take his direction from his own powers rather than from classical models, a rule Swift had followed.

Thus originality begins life as a critical category undefined, somehow associated with genius and newness, definitely not to be achieved by following the model of earlier authors, and allied strongly, though not invariably, with value. Its counterpoise is derivativeness or rule-governedness, rather than spuriousness.[6]

Identifying originality with novelty, thought of as mere newness, makes it a very unattractive candidate for an aesthetically valuable property. Perhaps the conviction that originality *must* be aesthetically valuable is what has led some writers to distinguish it from mere newness. Stefan Morawski, for example, makes a threefold distinction, among mere newness, novelty, and originality. A *novel* work, in Morawski's view, is not one that is merely new in some respect or other, but one that involves a "break and departure" from earlier works (139).[7] Novelty so conceived is easier to accept as an aesthetically valuable property than mere newness for two reasons. First, calling something a break or departure suggests that the difference from earlier works is not merely substantial, but somehow worthy. Second, according to Morawski, the newness that makes for "novelty" in this sense must lie in a new use of one of the work's "constituent values" or "residual values," by which he means one of the properties of a work that make it a work of art or that make it a work of art of a particular kind, rather than some property accidental to its status as a work of art or as a work of art of a certain kind. For example, he considers it necessary and sufficient for an object to be a work of art that it be "a structure of sensuously given qualities" (98) that is relatively autonomous (105) and is in some sense a human artifact produced by "*techne*" or skill (110). Some kinds of art further essentially involve *mimesis* or function (118). All these essential properties of works of art arguably involve value, in that if the property is

present in the work at all, the work is to some extent valuable. Presumably they are called 'constituent' and 'residual' because they respectively constitute the thing as a work of art and reside in it insofar as it is a work of art. Thus the kind of novelty Morawski discusses is a property of a work of art only if some property of the work already conceded to be valuable is in some way new. For example, the work may display some new technique of *mimesis* or embody some new structure of sensuously given qualities.

In Morawski's terminology, it is novelty rather than originality that we can recognize as the descendant of Young's notion of originality. Morawski reserves the term 'original' for works in which the intensity and magnitude of the artist's expression of his own mind are unusually great. Expression is a constituent value of at least some kinds of art, though Morawski is unsure whether it is a necessary condition of art *per se* (111). Thus an artist may achieve novelty with respect to it. But the artist who achieves originality may employ some old strategy of expression and thus fall short of novelty. Originality, in this sense, is "exceptionally creative individuality" (113) or personal uniqueness of expression, and thus conceptually independent of novelty, if often found united with it.

John Hoaglund is another recent writer who wants to find aesthetic value in originality. He takes the view that 'originality' may mean authenticity (as in the original-forgery distinction), uniqueness, or creativity.[8] The first of these properties is irrelevant, for the moment, to this inquiry. He seems to treat the third as a property of the artist who succeeds in producing a work with the second. Thus 'uniqueness' probably picks out a descendant of the original-ity lauded by the eighteenth century. He characterizes it as "a uniqueness of aesthetic qualities, or of their arrangement or intensity" (48), explaining that "qualities of the object that contribute to an aesthetic experience are aesthetic qualities" (54n). Thus Hoaglund's uniqueness closely resembles Morawski's novelty in that the properties of the object that make it "unique" or "novel" are for independent reasons properties that make it good. But Hoaglund makes a further claim that sets his view at odds with Morawski's: "to be considered good an art work must have some claim to aesthetic uniqueness" (49). He later makes it clear that he means that this uniqueness is a strictly necessary condi-tion of aesthetic value (e.g., p. 50). For Morawski, a work may be valuable in many respects, and so valuable over all, without being either novel or original in his sense.

The view that originality just is newness and the more sophisticated views of Morawski and Hoaglund have a common core: that whatever is original must be new in some respect (or perhaps only new so far as the maker is aware, since its counterpoise is derivativeness, and the maker who unknowingly duplicates an earlier innovation does not produce a strictly derivative work).[9] The views are particularized by differences concerning what must be new about an original work and what the result is for the value of the work. For the unsophisticated view, the work is original in virtue of being new in any way at all, and from its originality nothing follows concerning the value of the work overall or its value

with respect to the new feature. For Morawski, the artist's employment of the "constituent values" must be new, and the novelty adds a dimension of value to the work, though the work may be good without it. For Hoaglund, the aesthetic qualities, their arrangement or intensity, must be new, and without newness in one of these respects, the work cannot be an aesthetically valuable one.

There is a rational pattern in this diversity of views, created by a natural strategy for dealing with the problem of inheriting a confused concept. Though Young allows for the bad but original and Kant countenances "original nonsense,"[10] at some point in its career 'originality' became the name of a property presumed valuable in itself. The most durable part of this property's non-value constitution was the property of newness, difference from what came before. But no one wants to claim that bare newness confers value on an object. Thus a sensible strategy for understanding the concept of originality is to start with the idea of newness and explore how much or in what respect an object must be new in order to be valuable. Morawski is able to retain the connection between originality and value by positing the property of novelty, which essentially involves newness with respect to an aspect of the object whose value is already conceded. This raises a question that I address below: Where originality amounts to newness with respect to something good, that is, the new production of a good thing or good property of a thing, what reason is there to count the originality as a merit of the work over and above the merit the thing or property has aside from its originality?

Hoaglund, I think, goes too far in linking originality and value. His *uniqueness* would not seem to be a necessary condition of aesthetic worth in view of the many good (if not great) works that are largely derivative. Ghirlandaio, Boccherini, Saint-Gaudens, Stanford White, and Walter Savage Landor produced little that was not derivative and much that was (at least) good, and the goodness of their works lay not just in the small differences between them and the works of their predecessors and contemporaries, but chiefly in those valuable properties common to the high art of the era. Consider also the output of a painter like Frans Hals, who turned out dozens of wonderful portraits that differed significantly from one another only in presenting different faces. It would seem to follow from Hoaglund's claim that either all but one of these portraits (the chronologically first) have no aesthetic value, or that the value of all but the first inheres in the difference of subject matter. Neither alternative seems plausible.

Young suggests that the value of originality results from the fact that original works "extend the republic of letters and add a new province to its domain" (215). It is likely that he considers that extension valuable not in itself, but because the new province, the new way of doing things, is itself valuable. If that is the source of originality's value, then any piece that intimates the new way of doing things should be just as valuable as the chronologically first piece, that is, the one that is really new, really original.[11] The chronologically first piece clearly has a historical and sentimental value that the later repetitions lack. But its historical value must be distinguished from its value as an instructive

object for the artist eager to settle in new provinces or the beholder eager to visit them. This latter value is not quite clearly an aesthetic value, that is, an aspect of the object's value as art or as an instance of the kind of art it belongs to, but whether it is or not, it is distinct from originality.

2. A SCHEMATIC ANALYSIS

I have tried to make two points so far: first, that newness *per se* is not valuable, since there may be "original nonsense," and second, that even if originality is a quality that goes beyond mere newness and somehow incorporates value, that value is only value for historical inquiry, since the value of the original object for the practice and understanding of art could inhere in later repetitions.[12]

But I will set aside these points and explore the aesthetic value of originality in a different way, starting with a very schematic notion of originality that has value built into it. For those who count originality as a value, such as Young, Morawski (under the rubric 'novelty'), and Hoaglund (under the rubric 'uniqueness') a minimal requirement on the original object seems to be that the respect in which the object differs from past objects must also be one respect in which the object is good. They do not envisage a case in which the new property is bad or indifferent but where the newness nevertheless results in an originality which is good. Thus, a plausible skeleton of an analysis might be this: a work is original if and only if it is new with respect to some property p, that is, that it has property p and no work (or no work in that medium), so far as the maker knew, had p before that point, and property p is an aesthetically valuable property. From this schematic account, it follows trivially from a work's being original that it is, other things being equal, good. Further, this follows without the use of the clause about newness. This suggests, though only suggests, that the portion of the value of a work due to its originality has nothing to do with its newness in some respect, but only with its value or goodness in that same respect. The suggestion falls short of being a demonstration because it is conceivable that the property of originality supervenes on the complex of newness with respect to p and goodness with respect to p, and that this supervenient property confers a separate goodness on the work.

There would be a reason to opt for the supervenience claim if we could find a pair of objects that were alike in all their aesthetically valuable properties (or, more abstractly, the sequences representing their rankings with respect to their aesthetically valuable properties, where the rankings in one sequence might represent properties different from those in the other, but commensurated with them) aside from originality, and where one of the objects was new in some respect, the other not; if, in such a case, we felt compelled to say that the new object was better, we could explain the feeling by positing a property or originality that supervenes upon the complex of newness with respect to p and goodness with respect to p. That there are no such pairs is suggested by the Frans Hals example sketched earlier. Indeed, if I found myself in possession of the first Hals in his mature manner (let us suppose that this manner is what is

original about the painting), I might prefer keeping it to keeping the second or eleventh one; but assuming that the second or eleventh one met the conditions in the present thought-experiment, that is, that they were aesthetically just as good as the first, originality aside, it seems clear that the reason for my preference must not be an aesthetic one. Whether it is or not depends on the story one chooses to tell about the preference, but the plausible stories would seem to have to do with the painting's place in history rather than, for example, its instructiveness as to Hals's style.[13]

The schematic analysis of originality was intended to be favorable (as favorable as might be) to those who want it to be a valuable property, but the discussion shows (though not quite conclusively) that there is no distinction to be made between the portion of aesthetic goodness due to originality and the portion due to the respect in which the object is original. The aesthetic goodness of an original work, its other valuable aspects aside, seems to come from the goodness of the original property (a goodness it has even in later cases, where it has no claim to novelty) and not from originality *per se*, whether originality is conceived as a complex of newness and goodness or as a property supervening on that complex.

3. DEAUTOMATIZATION AND DEFAMILIARIZATION

The twin concepts of deautomatization and defamiliarization occupy a prominent place in recent literary theory. I propose to explore the connection between these two and originality, since the claim is sometimes made that deautomatization and/or defamiliarization is the essential task of literature, or even of all art. If the claim were true, and if originality were bound up in some intimate way with deautomatization or defamiliarization, my arguments against the value of originality would appear suspicious. Whatever the merits of the claim about the essence of art, however, I think the connection with originality is weak.

Victor Shklovsky and Jan Mukařovský are the theorists from whose writings the two concepts are chiefly drawn, but they differ sharply from each other in what they say about them. In his seminal essay "Art as Technique,"[14] Shklovsky stresses the way in which literary works deautomatize our *perception* of the *objects represented* in them, and so defamiliarize those objects. Fifteen years later, under Shklovsky's influence, Mukařovský stresses instead the deautomatization of the poet's *act* in the creation of a poem. According to Mukařovský, reading a text is apt to become a process in which the reader pays attention to the words only insofar as needed to understand the literal meaning they communicate. The literary artist constructs his text so as to subvert this stance toward the text. He "foregrounds" some components of his discourse and so deautomatizes the act of utterance. The notion of deautomatization has also this textual aspect for Shklovsky, but it is not stressed. Since the two writers differ on this very important element, I will discuss them separately.

Shklovsky connects defamiliarization with the essence of art: "The purpose of art is to impart the sensation of things as they are perceived and not as

they are known. The technique of art is to make objects 'unfamiliar', to make forms difficult, to increase the difficulty and length of perception because the process of perception is an aesthetic end in itself and must be prolonged" (12). On this scheme, the role of defamiliarization and deautomatization is to break down our usual attitude toward *things* and so to force us to attend to even those of their properties that do not figure in our everyday, non-art-audience dealings with them (and to *attend* to those that do). Thus their role and value are both instrumental. They are to be judged by how well they achieve the goal of forcing the users of art to attend to their ongoing perception of things. Making *forms* difficult seems to be only a way of making unfamiliar the objects represented by the texts (or other art objects) that display those forms, for Shklovsky's examples in the essay all concern describing objects or acts in such a way that the reader sees the object or act in a deautomatized way. "A work is created 'artistically' so that its perception is impeded and the greatest possible effect is produced through the slowness of the perception. As a result of this lingering, the object is perceived not in its extension in space, but, so to speak, in its continuity" (13). Sometimes it is the technique of description (as in Tolstoy) that accomplishes the defamiliarization; sometimes (as in Pushkin) the use of a novel style of language. But what is defamiliarized is the represented object, not the text; and correlatively, it is our perception of the represented object (and then perhaps by contagion our perception of similar objects in the real world), not of the text, that is deautomatized.

In a discussion of Pushkin, Shklovsky introduces the suggestion of a connection with originality. Pushkin's work was original partly in virtue of his employing a colloquial, anti-"poetic" diction. This forced his contemporary readers, says Shklovsky, to prolong their attention to the text (22), and so (although Shklovsky does not make this step explicit) deautomatized their perception of the subject matter of the poems, defamiliarized the things spoken of. The device of using low language focused attention on the text rather than on the thing being said, so what Pushkin produced was art and not simple communication.

Pushkin thus achieved the purpose of art partly by producing a work that was original. Why should we not say therefore that the originality of the work is aesthetically valuable *per se*? First, the power of the original work to defamiliarize the object is relative to the background against which it is produced. By Shklovsky's time, the use of colloquial language in poetry was familiar, so that he had to appeal to his readers to "remember the consternation of Pushkin's contemporaries over the vulgarity of his expressions" (22). Pushkin's style, for the Russian reader of 1917, had lost its power to deautomatize and defamiliarize. Yet it remained original. Thus originality has value when it achieves deautomatization/defamiliarization, but not otherwise. Originality has only what we may call contributive value, since there are situations in which it may result in its possessor having an aesthetically valuable property like the power to defamiliarize or deautomatize represented objects. But there are other situations (usually revealed by the passage of time) in which

the latter power disappears though the originality remains. Shklovsky discusses just such situations: "Should the disordering of rhythm become a convention, it would be ineffective as a device for the roughening of language" (24). There is a chain of consequences behind this remark. The poet disorders rhythm in order to roughen language, roughens language in order to prolongs the reader's attention, and prolongs the reader's attention in order to deautomatize perception. In a situation where the disordering of rhythm has become a convention, language is not perceived as roughened, and the chain of consequences fails. Moreover, it fails not just for the pieces produced under the convention, but for the original pieces that led to the convention.

Second, even if no convention has developed to deprive the original work of its power to defamiliarize, the work itself may have become so familiar to an individual reader or a broader public that it no longer "slows" perception.

Third, a work produced according to some well-worn convention may yet succeed in defamiliarizing a represented object, showing (what is easily shown, but as easily overlooked) that originality is distinct from the power to defamiliarize or deautomatize. Shklovsky quotes a passage from the story "Shame" in which Tolstoy describes a flogging in such detail and in such an order as to make it seem strange to educated Russians of the author's time, to whom real-life floggings were presumably not strange. Just the same technique is used in numerous stories of Tolstoy, and has become familiar to us through the many writers who have followed him in this. Yet though the *technique* is familiar and now unoriginal, descriptions of objects and events as if seen through naive eyes still have the power to defamiliarize the *objects*.

Since Mukařovský's notion of deautomatization focuses on the text or work rather than on the objects represented, the connection with originality is stronger and the argument against the value of originality correspondingly more difficult. Mukařovský is not consistent in his suggestions concerning what category of item is deautomatized or "foregrounded." He says that "The function of poetic language consists in the maximum of foregrounding of the utterance. Foregrounding is the opposite of automatization, that is, the deautomatization of an act."[15] This short passage suggests both that the thing foregrounded or deautomatized is the utterance, that is, the poem as a verbal entity, and the act, that is, the poem as a performance of the poet. In other passages, "components" of the poem, such as intonation, meaning, "the relationship of a word to the lexicon," and "its relationship to the phonetic structure of the text" (20–21), are said to be foregrounded, and poetic canons, that is, the general practice of poets thought of as a set of rules for composition, are said to be automatized (21).

Although Mukařovský presents a confused picture, I think his use of 'deautomatized' and 'foregrounded' can be understood in terms of the act of the poet in producing his poem. The *act* can be automatic in two different respects: as communication and as writing what passes for poetry. The poet can communicate automatically, by merely expressing ideas in the way provided by the practices of ordinary speech, with no component of her speech foregrounded, and hence no resultant foregrounding of the whole utterance. Or she

can write "poetry" (that is, something that passes for poetry but would not be counted as such by Mukařovský) automatically, by expressing ideas in the way provided by the practices of an established school of "poetry." In this case, too, no component is foregrounded, and neither is the whole utterance. The underlying system of connections, then, starts with the poet. She foregrounds (that is, deploys in such a way as to call the attention of the reader to) some component of her act of uttering the poem; this is at the same time a foregrounding and deautomatizing of her act. The relic of a foregrounded, deautomatized utterance is a verbal entity, a string of words once uttered and now preserved, which is therefore entitled also to be called foregrounded and deautomatized. A canon within which one can create "poetry" without foregrounding is spoken of as automatized because it is or suggests a set of principles for producing utterances automatized in the primary sense. Canons can be automatized, but neither deautomatized nor foregrounded. Components of an utterance can be foregrounded, but neither automatized nor deautomatized. Acts can have all three properties, as can the relics of the acts.

Poetry, for Mukařovský, essentially involves foregrounding. It is "the function of poetic language" (19), and "Without it, there would be no poetry" (22). Since "poetry" that is derived wholly from earlier models, according to an automatized canon, is for that reason both unoriginal and not really poetry, it might appear that originality is both necessary and sufficient for foregrounding or deautomatization, and so also a necessary condition of the creation of poetry. If it were, it would appear also that originality must have some important connection *per se* with the value of the poem. I will argue that this is only an appearance.

Certainly the poet who is original in his utterance, that is, whose utterance is not produced in conformity with some "poetic" or communicative canon, is assured of success in foregrounding. Departure from the norm just is foregrounding. Thus he satisfies one condition of producing good and genuine poetry. (But since a good poem must be also a unified structure, for Mukařovský, the poet is not sure to have produced anything good.) If he also satisfies whatever other conditions there are, and so produces a good poem, why should we not say that the foregrounding is an aesthetically valuable property of the poem and identify the originality with the foregrounding?

The problem is that originality is only historically or genetically sufficient for foregrounding, and is not necessary at all. Within a certain historical context, if I create something original, some component of my act, and hence my act, will be foregrounded. But as time passes, the component may recede into the background. Wordsworth or Pushkin may originally employ the language of common speech in poetry and so succeed in calling attention to the text or the act of utterance. But as common speech becomes the ordinary medium of at least one kind of poetry, it no longer calls attention to itself. It becomes a technique prescribed by some automatized (or partly automatized) canon. It is no longer foregrounded. In this, the relics of utterance differ from the initial act of utterance. It is a fact about the latter, now and forever, that it was

foregrounded; but the former may be foregrounded for a while and fade, with time, into the background. These facts would be more apparent had Mukařovský followed Shklovsky in speaking of deautomatization primarily as a property of a reader's *perception* of the text (or the represented world), rather than as a property of the poet's act. The poet's act, a fixed historical event, does not change. It is always original, and thus always foregrounded, if it starts out so. But perception of the text changes. What is in the foreground for a reader of one age, place, or level of subtlety may lie in the background for a reader differently situated. Mukařovský acknowledges this state of affairs in a related matter toward the end of the essay: "In spite of all that has been said here, the condition of the norm of the standard language [and, he should add, of the automatized "poetic" canons] is not without its significance to poetry, since the norm of the standard is precisely the background against which the structure of the work of poetry is projected, and in regard to which it is perceived as a distortion; the structure of a work of poetry can change completely from its origin if it is, after a certain time, projected against the background of a norm of the standard [or a canon] which has since changed" (27). Structure, for Mukařovský, depends on foregrounding. The change of structure spoken of is a consequence of a change in what the reader perceives as foregrounded.

Whatever we might think about the value of foregrounding and of the deautomatization of the poem as something surviving the poet's act, they are independent of the value of originality, for reasons paralleling those advanced against a connection between the value of originality and that of Shklovsky's defamiliarization. First, a work may be original, speaking historically, and yet have lost its foregrounded quality for readers outside its context of birth, either because the work itself has become familiar or because the technique by which its crucial component or components were historically foregrounded has become familiar. Second, the foregrounding of a certain component may not be original. Originality is sufficient for foregrounding, but not necessary. The poet may borrow a device from some poetic practice that has been long neglected, as W. H. Auden revived the obsessive alliteration of Middle English verse in some of his work. Though the device was not original with him, it was unfamiliar enough in the context of modern verse to call attention to his technique and so to foreground his utterance.

4. LAST CONFUSIONS

One source of the temptation to use 'originality' as the name of an aesthetically valuable property may be that the term provides a handy way to generalize over valuable traits of works of art or oeuvres. Masaccio made a substantial advance in the modeling of figures, and his oeuvre, and each painting within it, are valuable partly because of the modeling. Schoenberg introduced a new method of composition with his self-imposed strictures on the use of tone-rows, and his oeuvre and its members get part of their value from this serial method of composition. Adolph Loos's stripping of domestic architecture to

its supposed fundamentals was truly innovative, and one root of its aesthetic value. One way of generalizing over the indicated features of the three artists' work is to say that the work was valuable for (among other things) what was original about it, and it is a short but tricky step from that to saying that the works were valuable for their originality. The trick lies in the fact that in no case was the locus of value originality *per se*, but rather a feature of the work that was, among its other traits, an original one: a particular kind of modeling, a principle of formal musical structure, a conspicuous avoidance of ornament. Cases like this give us no reason to suppose that originality is valuable. We can imagine an instructive parallel: suppose that the traits here cited as original also happened to be the most striking features of the works mentioned. It would be an equally misleading inference to conclude that 'being the most striking feature' was the name of an aesthetically valuable property.

Still, Masaccio, Schoenberg, and Loos respectively extended the republics of paint, tone, and habitable space, and surely that was a valuable undertaking. Nevertheless, the resulting aesthetic value of the works produced lies either in the goodness of the properties whose new birth made the works original or (possibly) in their value to the artist who seeks a new way of working and the lover of art who seeks to understand the new way, not in their originality; repetitions of the original work may have the same value. The works' value as documents or monuments for one who seeks to know how and where the new province was acquired does depend on their being original, but that value is not aesthetic.

Imagine that you are in a gallery and tempted to say, in praise of what you see, that the paintings are original. Should what I have said here lead you to check the impulse? No, for what you would say could be understood in a number of different ways. You might be saying that the painter's style is not a simple appropriation of some other artist's, and thus saying, not that some particular painting is good in virtue of being the chronologically first instance of a new style, but that every piece in the show is in a new and worthy style. The originality you would be praising is not the property of a particular painting, but of the style, though metonymically the paintings—all of them—may also be described as original. Alternatively, you might not even be thinking of the style as particularly worthy, but simply be praising it as a breath of fresh air in an artistic atmosphere grown stale because of the dominance of some earlier style, as people found the Bay Area figurative style a refreshing relief from the abstract expressionism of the early 1950s. Here the object of praise would not properly be the paintings but the emergence of the new style. The paintings are the medium or vehicle of the emergence; again, the style is properly original, and the paintings original metonymically, but the praise is made appropriate by the advent or emergence of the style rather than the style or the paintings themselves. 'Original' survives as a legitimate term of praise in the context of criticism of the arts though originality be excluded from the list of aesthetically valuable properties.

NOTES

1. "Comparing Evaluations of Works of Art," *Journal of Aesthetics and Art Criticism* 34 (1975): 7–14. Reprinted with important additions in *Art and Philosophy*, edited by W. E. Kennick, 2d. ed. (New York, 1979), 707–18.

2. In the terminology developed in "Comparing Evaluations of Works of Art," these are independently valued properties.

3. For a discussion of how some properties get on these lists, see my "Aesthetic Satisfaction," in *Human Agency: Language, Duty, and Value*, edited by Jonathan Dancy, J. M. E. Moravcsik, and C. C. W. Taylor (Stanford, 1988), 201–18.

4. The edition cited is the version of "Conjectures on Original Composition" reprinted in *Criticism: Twenty Major Statements*, edited by Charles Kaplan (San Francisco, 1964).

5. Cf. Monroe Beardsley, *Aesthetics: Problems in the Philosophy of Criticism* (New York, 1958), 460.

6. The original-forged distinction cuts across the original-derivative distinction. An authentic (that is, original in the former sense) work may not be at all innovative (that is, original in the latter sense). Childe Hassam's paintings hang beside his name in many a museum, but a squint at the label is often necessary to distinguish his work from that of other minor impressionists. Conversely, a forgery need not be an attempt to copy some existing work, as witness "Hitler's diaries" and Van Meegeren's Vermeers, and thus may display some innovation. The wise forger will of course aim away from innovation to achieve plausibility and a low profile, but nothing in the nature of forgery prevents him from producing an unprescribed beauty or unexampled excellence. It may help in passing off a poem of my own as one written by Arthur Rimbaud during his African exile to emphasize the ways in which it goes beyond his known oeuvre, for innovation is a characteristic we should expect from such a poet.

7. *Inquiries into the Fundamentals of Aesthetics* (Cambridge, Mass., 1974), chap. 3, "The Criteria of Aesthetic Evaluation," 125–55.

8. "Originality and Aesthetic Value," *British Journal of Aesthetics* 16 (1976): 46–55. Although we speak of an authentic work as original or, more commonly, as an original, we do not seem also to say of it, as we do of works possessing our elusive putative value-property, that it has or displays originality. Thus the first sense of 'originality' Hoaglund discusses may be only a philosopher's sense, in which any word can be turned into the name of the corresponding property by adding '-ity', '-ness', '-hood', or one of their cousins.

9. Beardsley points out (*Aesthetics*, 460) that what is required is not quite novelty, but novelty so far as the maker knows: the opposite not of prior existence, but of derivativeness. Thus work that is not strictly novel, but not derivative either, could be original.

10. *Critique of Judgment*, Section 46.

11. Cf. Beardsley: "It is more of a contribution to our aesthetic resources, so to speak, if another composer will enlarge the range of chamber music and the symphony, with original innovations, rather than work within the same range. For this we praise him, but from such praise nothing follows about the goodness of the work . . ." (*Aesthetics*, 460); and Morawski: "The criterion of newness stems from the human need to make and to perceive new contents and new forms" (*Inquiries*, 140).

12. "It is the composer's originality that counts, not the music's," says Beardsley in this connection (*Aesthetics*, 460). Presumably an original composer (or artist in any medium) is one who produces a work original in one of the senses here under discussion. She is no less original (though we might call her less *consistently* original) if she then goes on to produce a number of works that exploit her first innovation without introducing any further ones. If the question is shifted from the value of the works to the value of the maker, it is easy to separate the value due to originality from the value due to other traits. Young did not always keep the two questions separate.

13. Beardsley (ibid.) uses a similar argument, involving Haydn symphonies, but he is making a point about the value of the mere newness of admittedly good works: "to say that an object is original is tc say that when it was created it differed in some notable way from anything else that was known by its creator to exist at the time." He wants to show that newness does not confer betterness; I want to show that originality, conceived as a property that somehow goes beyond newness (even newness qualified as Beardsley qualifies it) does not confer betterness.

14. In *Russian Formalist Criticism: Four Essays*, translated by Lee T. Lemon and Marion J. Reis (Lincoln, Neb., 1965), 3–24.

15. "Standard Language and Poetic Language," in *A Prague School Reader on Esthetics, Literary Structure, and Style*, selected and translated by Paul Garvin (Washington, D.C., 1964), 17–30.

On Jokes

NOËL CARROLL

Traditional comic theory has attempted to encompass a wide assortment of phenomena. Often it is presented as a theory of laughter. But even where its ambit is restricted to amusement or comic amusement, it typically attempts to cover quite a large territory, ranging, for instance: from small misfortunes and unintentional pratfalls; to informal badinage, tall stories, and insults; to jokes, both verbal and practical, cartoons, and sight gags; through satires, caricatures, and parodies; and onto something called a cosmic comic perspective. Thus, predictably enough, the extreme variety of the subject matter—reaching from puns to the comedy of character—customarily results in theories that are overly vague.

For example, the most popular contemporary type of comic theory—the incongruity theory[1]—is generally very loose about what comprises its domain (objects, events, categories, concepts, propositions, maxims, characters, etc.) and, as well, it is exceedingly generous about the relations that may obtain between whatever comprises the domain (contrast, difference, contrariness, contradiction, inappropriate subsumption, unexpected juxtaposition, transgression, and so on). Consequently, such theories run the danger of becoming vacuous; they seem capable of assimilating anything, including much that is not, pretheoretically, comic.

Moreover, attempts to regiment such theories by making them more precise tend to result in incongruity theories that are too narrow and, therefore, susceptible to easy counterexample. Schopenhauer, perhaps the most rigorous of incongruity theorists, hypothesizes, for instance, that the relevant sense of incongruity always involves the incorrect subsumption of a particular under a concept—an operation he believed could be uniformly diagnosed in terms of a syllogism in the first figure whose conjunction of a major premise with a sophistical minor premise invariably yields a false conclusion.[2] But, as illuminating as this theory is with respect to certain cases, it is hard to mobilize to account for what we find humorous in a funny gesture, like Steve Martin's

silly victory dance at the baseball game in the movie *Parenthood*. Again the problem seems to be that the field of inquiry is so large that any relatively precise theory is likely to exclude part of it, while, at the same time, adjusting for counterexamples appears to send us back in the direction of vacuity.

Starting with the intuition that the objects of comic theory are too unwieldly, I want to propose that the task of comic research might be better served if we proceed in a piecemeal fashion, circumscribing the targets of our investigations in such a way that we shall be better able to manage them. This does not imply that we should ignore the rich heritage of comic theory, but only that we exploit it selectively where this or that observation seems best to fit the data at hand.

In the spirit of the preceding proposal, I will restrict my subject to the joke, which, though it may bear family relations to other forms of comedy, such as the sight gag, I will, nevertheless, treat as a distinctive genre. The purpose of this essay is to offer an account of jokes and, then, to go on to consider certain quandaries that my theory may provoke, especially in terms of ethical issues that pertain to such things as ethnic, racist, and sexist jokes. However, before advancing my own view of the nature of jokes, the leading, rival theory in the field, viz., Freud's, deserves some critical attention.

FREUD'S THEORY OF JOKES

Freud's theory of jokes is certainly the most widely known as well as one of the most developed theories of jokes in our culture. Thus, if we want to field an alternative theory, we must show why this illustrious predecessor is inadequate, along with indicating the ways in which our own view avoids similar pitfalls.

Freud's theory of jokes is part—albeit the largest part—of his general theory of what we might call amusement.[3] He divides this genus into three subordinate species: jokes (or wit), the comic, and humor. Membership in the genus seems to be a matter of economizing psychic energy; the subordinate species are differentiated with respect to the *kind* of psychic energy that each saves. Jokes represent a saving of the energy required for mobilizing and sustaining psychic inhibitions. The comic releases the energy that is saved by forgoing some process of thought. And, lastly, humor is defined in terms of the saving of energy that would otherwise be expended in the exercise of the emotions.

Put schematically: jokes are an economy of inhibition; the comic is an economy of thought; and humor is an economy of emotion. Freud's theory is often characterized as a release or relief theory of comedy[4] for the obvious reason that the energy that would have been spent inhibiting, thinking, and emoting in certain contexts is freed or released by the devices of jokes, the comic, and humor respectively.

A notable feature of Freud's way of carving up this field of inquiry is that he does it by reference to the types of psychic energy conserved rather than by reference to the structural features of distinctive comedic strategies. Thus we

might anticipate that Freud's way of mapping the territory may diverge from our standard ways of, for example, distinguishing jokes from other comedic genres. But more on this in a moment.

Joking for Freud releases the energy saved by forgoing some inhibition. That is, the joke frees the energy that would have gone into mounting and maintaining some form of repression. What is involved here is readily exemplified by what Freud calls tendentious jokes—jokes involved in manifesting sexual or aggressive tendencies. Such jokes, so to speak, breach our defenses and liberate the psychic energy we might have otherwise deployed against the sexual or aggressive content articulated by the joke.

Though the gist of Freud's theory is initially easy to see when the jokes in question involve transgressive content, it is also the case, as Freud himself freely concedes, that there are what to all intents and purposes appear to be innocent jokes—jests, nonsense, and ostensibly harmless wordplay. These do not seem predicated on articulating transgressive content. But Freud's general hypothesis is that jokes involve a saving in terms of psychic inhibition. So the question then arises as to what relevant inhibitions are lifted when one hears an innocent joke—one that evinces no sexual or aggressive purposes?

The second problem that Freud's theory of jokes needs to address is the question of *how*—even if inhibitions are lifted when we hear sexual and aggressive jokes—this liberation from repression occurs. That is, supposing that we agree with Freud that our inhibitions are put out of gear by tendentious jokes, we will still want to know exactly how this happens.

Freud's answers to these questions are interconnected. First, Freud establishes that jokes employ certain techniques, notably: condensation, absurdity, indirect representation, representation by opposites, and so on.[5] These techniques—call them the jokework—are the very stuff of innocent jokes, while at the same time they parallel the techniques that Freud refers to as the dreamwork in his studies of the symbolism of sleep.[6] With dreaming, these structures, such as condensation, are employed to elude censorship—to protect the dream from repressive criticism. *And*, at the same time, eluding censorship itself is pleasurable.

So, when tendentious jokes employ the techniques of the jokework, they avail themselves of the kind of pleasure that beguiles our psychic censor and that lifts our initial inhibitions in the first instance in such a way that the sexual or aggressive content in the joke is free to deliver even more uninhibited pleasures in the second instance. With tendentious jokes, inhibitions are thrown out of gear by the jokework, which protects the transgressive content in the manner of the dreamwork, while also facilitating the relaxation of censorship by means of its own beguiling pleasurableness.

This account, of course, still leaves our first question unanswered, viz., what fundamental inhibitions are relieved in the case of innocent jokes? Freud tackles this in two stages in his *Jokes and their Relation to the Unconscious*. The first stage (which is developed in chapter 4) might be thought of as a nonspecialized approximation of his considered view, while the second stage

(developed in chapter 6) is his specialized (i.e., technical/psychoanalytic) refinement of his first approximation.

The first approximation correlates the jokework—which is also the essence of innocent wit—with childlike wordplay and thought play: the "pleasure in nonsense" of the child learning the language of her culture. Indulging in this childlike pleasure represents a rebellion against the compulsion of logic and a relief from the inhibitions of critical reason. The saving in psychical expenditure of energy that occasions the jokework, then, involves "re-establishing old liberties and getting rid of the burden of intellectual upbringing"[7]

This pleasure in reverting to childlike modes of thought can be further specified psychoanalytically in light of the analogy between the dreamwork and the jokework. Jokes, even innocent jokes, employ infantile (not merely childlike) modes of thought; they manifest the structures of thinking of the unconscious, structures repressed by critical reason. When critical reason is put in abeyance, regressive pleasure is released. "For the infantile source of the unconscious and the unconscious thought-processes are none other than those— the one and only ones—produced in early childhood. The thought which, with the intention of constructing a joke, plunges into the unconscious is merely seeking for the ancient dwelling place of its former play with words. Thought is put back for a moment to the stage of childhood so as once more to gain childhood pleasure."[8]

The inhibitions lifted by innocent jokes (and by the jokework across the board) are those of critical reason against infantile modes of thought and the regressive pleasures they afford. But, as in the case of tendentious jokes, here again we must ask: what makes the lifting of the inhibitions of critical reason possible? That is, what protects the innocent joke in particular and the jokework in general from the censorship of logic and reason? Freud's hypothesis is that for the word and thought play to be protected from criticism, it must have meaning or, at least, the appearance of meaning. The childlike pleasure in alliteration, for example, can elude criticism in expressions like "see you later, alligator," where the saying has some sense, though, admittedly, not of a resounding sort.

Summarizing this theory, then: all jokes involve a saving in inhibition. Tendentious jokes lift inhibitions against sexual and aggressive content. Innocent jokes and the jokework in general oppose the inhibitions of critical reason and allow pleasure in nonsense and the manifestation of infantile and unconscious modes of thought. What protects the tendentious joke from criticism is the jokework, which, like the dreamwork, beguiles the psychic censor. What protects the innocent joke and the jokework, in all its operations, from criticism is the appearance of sense or meaning in the joke.

Clearly, Freud's theory of jokes is intimately connected to his general theory of psychoanalysis. Consequently, it may be challenged wherever it presupposes psychoanalytic premises of dubious merit. For example, if one finds the hydraulic model of psychic energies unpalatable (as I do), then the very foundation of the theory of jokes is questionable. Likewise, if one is

methodologically distrustful of homuncular censorship, the theory is apt to appear unpersuasive. However, for the purposes of this essay, I think that Freud's theory of jokes can be rejected without embarking on the awesome task of contesting psychoanalytic theory as a whole. That is, we can eliminate Freud's theory of jokes as a viable rival and, thereby, pave the way for the formulation of an alternative theory without confronting the entire psychoanalytic enterprise.

For there is a genuine question about whether Freud's theory of jokes is coherent, a question that can be framed independently of the relation of the account of jokes to the rest of the psychoanalytic architectonic. To zero in on this potential incoherence, recall: (1) there are innocent jokes (the operation of the jokework pure and simple); what protects them from censorship is their sense; this implies that there is an inhibition against the jokework that needs lifting; (2) there are tendentious jokes; what protects them from censorship is the jokework (the stuff of innocent jokes).

But, given this, we want to know why the tendentious joke does not auto-destruct. For the meaning or sense that the tendentious joke supplies to lift the inhibitions against the jokework involves the articulation of meanings that are prohibited or forbidden. How can prohibited meanings protect the jokework? Why doesn't the specific sense available through the tendentious purpose of the joke cancel the operation of the jokework?

Moreover, if the jokework cannot be protected by tendentious sense, then the jokework cannot, in turn, serve to neutralize inhibitions against the tendentious purposes of the joke. That is, if the jokework itself is a potential target of inhibition and the tendentious sense of the joke is ill-suited to deflect censorship, then how can the jokework, in sexual and aggressive jokes, begin to function in the service of lifting any inhibitions?

One might attempt to remove this functional incoherence in the system by saying that the jokework (and, therefore, innocent jokes) do not require protection—that they are not inhibited. But this yields the concession that not all jokes—specifically innocent jokes—involve an economy of inhibition. And, this concession, of course, would spell the defeat of Freud's general characterization of jokes. Admittedly, there may be other ways to attempt to negotiate the aforesaid functional incoherence; but I suspect that they will be somewhat *ad hoc*. So one rather damning point about Freud's theory of jokes is that it is either functionally incoherent with regard to its account of tendentious jokes, or its generalizations about economizing inhibition are false, or it is probably headed toward *ad hocery*.

Furthermore, the theory of jokes is too inclusive. One might anticipate that given Freud's analogy between the jokework and the dreamwork that the problem here would be that dreams, especially dreams with sexual or aggressive purposes, will turn out to be jokes. However, Freud is careful to distinguish dreams and jokes along other dimensions, particularly with reference to the publicity of jokes and the privacy of dreams. But I think that Freud still has problems of overinclusiveness on other fronts.

Given Freud's theory of symbolism and his views about art, he would appear committed to agreeing that artworks deploy the symbolic structures of the dreamwork and that artworks also may traffic in sexual and aggressive meanings. Perhaps the winged lions of ancient Assyria—a condensation with aggressive purposes—would be a case in point. Why wouldn't these count as tendentious jokes on Freud's view?[9] Obviously, they are not jokes in our ordinary sense, for jokes are identified in common speech by means of certain discursive structures (to be explored below). But Freud's theory of jokes is so divorced from structural differentiae—preferring the somewhat dubious idiom of psychic energies and inhibitions, and a theory of lawlike relations between certain types of symbolism and psychic states—that it is not surprising that Freud's theory will violate pretheoretical intuitions that are grounded in ordinary language.[10]

Freud's theory also seems to me to suffer from being too exclusive. And, again, the problem is traceable to the fact that Freud tries to map the field of comedy not with respect to the structural features of comedic genres but by putative differences in psychic energies. Jokes are distinguished from the comic and the humorous as economies of inhibition are distinguished from economies of thought and emotion. But, structurally speaking, much of the material that Freud slots as comic or as humorous could be rearticulated in what we ordinarily take to be jokes.

For example, Freud's category of the comic, in opposition to his category of the joke, involves a saving in thought when we compare the way a naïf or a comic butt does something with the more efficient way in which we might do the same thing. Accepting Freud's account, without questioning whether the talk of psychic savings makes real sense with respect to the putative mental processing, it would appear that many "moron" riddles—Why did the moron stay up all night? He was studying for his blood test[11]—would be comic (in Freud's sense), but, pretheoretically, I believe that we think they should count straightforwardly as jokes. For whether or not something is a joke is a matter of its discursive structure, not a matter of the kind of psychic energy it saves (if, indeed, there is any psychic energy, salvageable or otherwise).[12]

AN ALTERNATIVE ACCOUNT OF THE NATURE OF JOKES

Freud's theory of jokes is perhaps the most comprehensive and authoritative in our tradition. However, as we have seen, it is problematic in a number of respects—not only in some of its more controversial psychoanalytic commitments, but also in terms of its potential functional incoherence at crucial junctures and its failure to track what we ordinarily think of as jokes. As indicated above, the latter failure appears due to its attempted isolation of jokes in terms of inhibition rather than in respect to what is structurally distinctive about jokes as a comedic genre. Thus, one place to initiate an alternative theory of jokes is to try to pinpoint the underlying structural principles that are operative in the composition of jokes.

Jokes are structures of verbal discourse—generally riddles or narratives—ending in punch lines. In contrast to informal verbal humor—such as bantering, riffing, or associative punning—a joke is an integral unit of discourse with a marked beginning and an end. If it is a riddle, it begins with a question and ends with a punch line; if it is a narrative, it has a beginning, which establishes characters and context, and it proceeds to a delimited complication, and then it culminates, again in the form of a punch line. In order to analyze the joke genre, I propose to consider it in the way that Aristotle considered the genre of tragedy—as a structure predicated on bringing about a certain effect in audiences. (And, perhaps needless to say, the effect that I have in mind is not that of lifting psychoanalytically construed inhibitions.)

The feature that distinguishes a joke from other riddles and narratives is a punch line. Where tragedies conclude with that state which modern literary theorists call closure, the last part of a joke is a punch line. Closure in tragedies is secured when all the questions that have been put in motion by the plot have been answered—when, for example, we know whether Hamlet will avenge his father and what will become of our cast of characters. But, ideally, a punch line is not simply a matter of neatly answering the question posed by a riddle nor of drawing all the story lines of a narrative to a summation. Rather, the punch line concludes the joke with an unexpected puzzle whose solution is left to the listener to resolve. That is, the end point of telling a joke—the punch line—leaves the listener with one last question which the listener must answer, instead of concluding by answering all the listener's questions.

Question: "What do you get when you cross a chicken with a hawk?" Answer: "A Quail." At first the answer seems to be mysterious, until one realizes that it should be spelt with a "'y," that it refers to our vice-president, and that the "chicken" and "hawk" in the question are meant to be taken metaphorically. In order to "get the joke," the listener must interpret the punch line. In fact, the point of the punch line is to elicit an interpretation from the listener. Indeed, this joke is designed to elicit pretty much the interpretation that I have offered.

Or, for an example of a narrative joke, consider this story: "A young priest runs into his abbott's office shouting 'Come quickly, Jesus Christ is in the chapel.' The abbott and novice hurry into the church and see Christ kneeling at the altar. The young man asks 'What should we do?,' to which the wise old abbott replies, whispering, 'Look busy.'"[13]

Initially, the abbott's remark seems puzzling and inappropriate; one would expect the two holy men to walk forward and to fall on their knees in adoration of their Lord and Savior. But very quickly one realizes that the abbott does not view Christ as his Savior, but rather as his boss, indeed a boss very much like a stereotypical earthly boss who is always on the lookout for shirkers. Getting the point of the joke, again, depends on interpreting the confounding punch line.

What the listener must do at the end of a joke is to provide an interpretation, i.e., to make sense of the last line of the text in light of the salient

elements of the preceding narrative or riddle. This may involve reconstruing or reconstructing earlier information, which initially seemed irrelevant, as now salient under the pressure of coming up with an interpretation. For example, in the joke about the two priests, the narrative "field" is reorganized in such a way that it becomes very significant that the abbott is "old" and "wise" (cagey) and that he is "whispering" (a signal of furtiveness), given our interpretation that he believes the boss (rather than the Savior) has arrived on the scene for a surprise inspection.[14]

The punch line of a joke requires an interpretation because, in Annette Barnes's sense,[15] its point is not obvious, or not immediately obvious to the listener. The punch line comes as a surprise, or, at least, it is supposed to come as a surprise in the well-made joke. It is perhaps this moment in a joke that Kant had in mind when he wrote that "Laughter is an affection arising from a strained expectation being suddenly reduced to nothing."[16]

However, if this is what Kant had in mind, he has only partially described the interaction, while also misplacing the point where the laughter arises. For after an initial, however brief, interlude of blank puzzlement (Kant's "nothing"), an interpretation dawns on the listener, enabling her to reframe the preceding riddle or narrative in such a way that the punch line can be connected to the rest of the joke. It is at this point that there is laughter—when there is laughter, rather than a smile or a mere feeling of cheerfulness. Nor is our mind blank at this juncture. It has mental content, viz., the relevant interpretation.[17]

Of course, if the listener cannot produce an interpretation, the net result of the joke will be bewilderment. This may transpire either because of some problem with the listener—perhaps he lacks access to the allusions upon which the joke depends (e.g., in our Quayle joke, he might not know that a "hawk" can mean a militarist); or because of some problem with the joke—e.g., there really is no compelling interpretation available. Jokes may also fail if they are too obvious, especially if the listener can anticipate the punch line and its attending interpretation. This is one reason that what is called comic timing is important to jokes; if the punch line is likely to be obvious, the teller must get through the joke—often using speed to downplay or obscure salient details—before the listener is likely to guess it.[18] (Moreover, the preceding account of the ways in which jokes can go wrong should provide indirect evidence for the puzzlement/interpretation model that I am advocating.)

Ideally, a joke must be filled-in or completed by an audience. It is intentionally designed to provoke an interpretation—"to be gotten." This, of course, does not happen in a vacuum; jokes are surrounded by conventions. And, once alerted—by formulas like "Did you hear the one about . . ." or by changes in the speaker's tone of voice—the audience knows that it is about to hear a joke, which means that its aim is to produce an interpretation, or, more colloquially, "to get it." That is, the aims of the teller and the listener are coordinated; both aim at converging on the production of an interpretation. Indeed, the interpretation that the joke is contrived to produce is generally quite determinate, or,

at least, falls into a very determinate range of interpretations. For example, the interpretation I offered of the priest joke is *the* interpretation of the joke, give or take a wrinkle.

Of course, even with a well-made joke there is no necessity that the listener enjoy it. Along with the possible failures noted above, the listener may refuse to accept the "social contract" that has been signaled by conventions like changes in voice. That is, the listener may refuse the invitation to interpret and thereby stonewall the joke. This is a technique employed by school teachers—I seem to recall—in order to chasten unruly students.

A joke, on my view, is a two-stage structure, involving a puzzle and its solution.[19] One advantage of the two-stage model is that it can dissolve the apparent debate between what are called surprise theorists (Hobbes, Hartley, Gerard, Kant)—who maintain that laughter is a function of suddenness or unexpectedness—and configurational theorists (Quintilian, Hegel, Maier)—who see humor as a function of things "falling into place."[20] On the two-stage account, each camp has identified an essential ingredient of the joke: sudden puzzlement, on the one hand, versus a reconfiguring interpretation, on the other. The mistake each camp makes is to regard its ingredient as *the* (one and only) essential feature. The two-stage model incorporates both of their insights into a more encompassing theory. Another way to make this point might be to say that the two-stage model appreciates that a joke is a temporal structure, a feature that many previous theories fail to take into account.

So far this approach to jokes may seem very apparent. However, it does already indicate a striking difference between jokes and what many might be tempted to think of as their visual correlates—sight gags. For sight gags, typically, have nothing that corresponds to punch lines and, therefore, they do not call for interpretations to be produced by their audiences. A comic, say Buster Keaton (in the film *The General*) sitting on the connecting rod of the wheel of a locomotive, is so forlorn a rejected lover that he fails to notice that the train has started up. Our laughter rises as we await his moment of recognition and it erupts when we see that he realizes his plight. Similarly, when a comic heads unawares towards the proverbial banana peel, our levity builds as his fall becomes inevitable. Though the characters in gags like these may be puzzled by the dislocation of their expectations, the audience is not puzzled, no matter how amused it may be. We anticipate the pratfall; there is nothing surprising about it for us. The character may be perplexed, but we are not, and so there is no need for us to interpret anything. What has happened is obvious and predicted.[21]

If the punch line/interpretation structure—what we can call the cognitive address of jokes—serves generally to dfferentiate jokes from sight gags, more perhaps needs to be said about why it differentiates them from non-comic riddles and ordinary narratives, not to mention puzzles of the sort Martin Gardener concocts or difficult mathematical problems. In order to draw these distinctions, it is important to take note of the *kinds* of interpretations that jokes are designed to elicit from audiences.

Broadly speaking, joke discourse falls into the category of fantasy discourse. In telling a joke-narrative or posing a joke-riddle, one is not constrained to abide by the rules of everyday, serious discourse. We need not avoid equivocation, category errors, inconsistency, contradiction, irrelevance, paradox, or any other sort of incoherence with our standing body of knowledge, whether physical or behavioral, moral or prudential, and so on. Likewise, neither the punch line nor the ensuing interpretation need make sense in terms of consistency, noncontradiction, or compossibility with our standing body of knowledge. In fact, it is the mark of a joke interpretation that it will generally require the attribution of an error—often of the sort itemized in various ways by incongruity theorists of humor—either to a character in a joke or to the implied teller of the joke, or it will require the assumption of such an error by the listener, or it will involve some combination thereof—in order for the interpretation to "work."

For instance, consider this narrative joke: "An obese man sits down in a pizza parlor and orders a large pie. The waiter asks: 'Do you want it cut into four pieces or eight?' The diner replies 'Four, I'm on a diet.'" To get this joke, we must infer that the diner has ignored the rule for the conservation of quantity which entails that the pie is the same size whether it is cut into four pieces or eight and that, alternatively and mistakenly, the diner is employing the heuristic rule that increases in number frequently result in increases in quantity.[22]

Or, in the riddle—"What do you get when you cross an elephant with a fish? Swimming trunks"—we attribute to the implied speaker not only the belief that elephants and fish can mate, but that the result—obtained by fancifully associating certain of their identifying characteristics by means of the pun "swimming trunks"—could count as an answer, thereby violating the principle of charity twice, both in terms of the implied speaker's beliefs and his reasoning. However, this nevertheless succeeds in connecting the anomalous punch line with the fantastical question. The answer is a mistake, but a mistake we can interpret by attributing outlandish errors—at variance with our standing principles of interpretive charity—to the implied speaker.

Likewise, many ethnic and racist jokes involve not only errors on the part of Polish or Irish characters, but also call upon an interpretation from listeners that embrace exaggerated stereotypes of ignorance wildly at odds with the interpretive principles of charity that we find plausible to mobilize in interpreting ordinary behavior.

In contrast, then, to non-humorous riddles, mathematical puzzles and the like, jokes end in punch lines which may in some sense be mistaken themselves and which call for interpretations that require the attribution to or assumption of some kind of error by the implied speaker, and/or characters, and/or the listener, implied or actual. The solutions to non-humorous riddles and mathematical puzzles, if they are solutions, are error free.

So, on the one hand, to put it vaguely, the interpretation elicited by a joke is implicated in at least one error. For, in a well-made joke, the interpretation elicited by the punch line works; indeed, it works better than any other

interpretation that could pop into one's head at that moment would. What does *working* mean here? That the interpretation connects the punch line to salient details of the narrative or riddle in such a way that the initially puzzling nature of the punch line is resolved. The interpretation fits the punch line and the rest of the joke after the fashion of an hypothesis to the best explanation, *except that* the explanation is not constrained to be coherent with the body of our standing beliefs and knowledge—it need not avoid category errors, contradictions, inconsistency, paradox, equivocation, irrelevance, the gamut of informal logical fallacies, or uncharitable attributions of inappropriate, outlandish, stereotypically exaggerated, normatively unexpected or wildly unlikely behavior, or even full-blown irrationality to human characters or their anthropomorphized stand-ins, and/or to implied authors, and/or to implied listeners.

The interpretations elicited by punch lines are in one sense *optimal*. They get the job done—where the job at hand is interpreting the joke. In this regard, the joke appeals to the optimizer in the human animal—our willingness to mobilize any heuristic, no matter how suspect, to solve a problem, so long as the heuristic delivers an "answer" efficiently. The interpretations we produce in confronting jokes render the punch line intelligible—i.e., understandable rather than believable—in a way that, in short order, fits the prominent, though often hitherto apparently unmotivated, elements of the rest of the joke.

It is this feature of jokes that I think that theorists have in mind when they (ill-advisedly) speak of jokes as rendering the incongruous congruous. Moreover, these interpretations are compelling because they do provide a framework, ready-to-hand, to dispel our perplexities. However, it is not quite right to say that the incongruous has been rendered congruous, because there is always something wrong somewhere in the interpretation, no matter how optimal it is in resolving the puzzle of the joke.[23]

Incongruity theorists of humor have supplied us with many of the recurring errors that must be imputed or assumed in order for our joke interpretations to work. As noted earlier, Schopenhauer believed that it was a matter of the fallacious subsumption of a particular under a category by means of a mediating sophistry. On this view, the error embodied in jokes is always a category error. This works nicely with many jokes, such as our earlier example of the moron and the blood *test* (the relevant category error); but the theory is too imprecise—how are we to understand the range of "concept" (in contrast, say, to maxim) and to know when an incident in a joke counts as introducing a concept rather than a particular? Moreover, the theory is just too narrow; jokes mobilize errors above and beyond category mistakes.

Other incongruity theorists have further limned the kinds of errors that can be brought into play in jokes. Hazlitt speaks of a disjunction between what is and what ought to be; Kierkegaard of contradiction.[24] Raskin introduces the notion of opposed scripts.[25] Each of these suggests slightly different sources of error. Arthur Koestler emphasizes the bisociation or mixing of inappropriate frames.[26] Marie Swabey's inventory of incongruities includes: irrelevance, the mistaking of contraries for contradictories, and the straining of concepts to

the limit case (in addition to category errors).[27] Monro talks of the linking of disparates, the importation of ideas from one realm which belong to another or the collision of different mental spheres, and of attitude mixing.[28] And majority opinion agrees that transgressions of norms of appropriate behavior—moral, prudential, polite, and "what everyone knows"—can serve as the locus of error in the mandated interpretation.

These are very useful suggestions; and further incongruities can be isolated: for example, Bergson's concept of the encrustation of the mechanical in the living,[29] which might be extended somewhat, *pace* Bergson, to include the continuation of routinized or ordinary modes of thought into the fantastical circumstances of the joke.

Given the success of previous incongruity theorists of humor at identifying so many of the errors that we find operative in jokes, it is natural to entertain the possibility that we should build incongruity into the theory of jokes as a necessary constituent—conjecturing that jokes must contain errors that are ultimately traceable to one or another form of incongruity. However, there is no reason, in my view, to suppose that the range of possibilities so far isolated by incongruity theories exhausts the range of error in which a joke-interpretation may be implicated, and, more importantly, there is no reason to believe that all the errors in that range that are yet to be identified will turn out to involve incongruities.

In order to add some substance to these reservations, let me introduce a brief counterexample from Poggio Bracciolini's *Facetiae*, which was first published in 1470.[30] "A very virtuous woman of my acquaintance was asked by a postal runner if she didn't want to give him a letter for her husband, who had been absent for a long time as an ambassador for Florence. She replied: 'How can I write, when my husband has taken his pen away with him, and left my inkwell empty?' A witty and virtuous reply."

On the account of jokes offered so far, this joke has a punch line which is puzzling until we reconceive the wife's apparently nonsensical answer as a set of sexual innuendoes. We need also to attribute an error to the wife; her response is literally a *non sequitur*. Moreover, to my mind, such a non sequitur is not really an example of incongruity.

For incongruity has as its root some form of *contrast* such that a relatively specifiable normative alternative—whether cognitive, or moral, or prudential—stands as the background against which the incongruous behavior, or saying, or whatever, is compared (generally in terms of some form of structured opposition). But with a genuine non sequitur it is difficult to identify the norm that is in play with any specificity. One might say that a *non sequitur* is just nonsense, but stretching the concept of incongruity to encompass nonsense (a rather amorphous catchall, it seems to me) robs the notion of incongruity of definition.

That is, for something to be incongruous requires that we be able to point in the direction of something else to which it stands in some relation of structured contrast or conflict (above and beyond mere difference or lack of

connection). But with the wife's answer in the preceding joke, it is hard to identify a foil with which it contrasts in terms of any structurally determinate relation.[31]

So, though incongruity is very often (most often?) an extremely helpful umbrella concept for isolating what is wrong with the interpretation elicited by the punch line of a joke, I prefer to use the even more commodious hypothesis that the listener's interpretation of a joke simply involves an error somewhere, leaving open the possibility that it may issue from incongruity or elsewhere and, thereby, acknowledging the fact that we humans are eternally inventive when it comes to "discovering" new ways to make mistakes.

A joke is designed to produce a transition in the cognitive state of the listener. We are moved from a standing state ($M1$) of assimilating stimuli by means of our conventional conceptual/normative schemes—what I think theorists often misleadingly call our "expectations"[32]—into the state ($M2$) of producing an interpretation that does not cohere with or, at least, is not constrained by the principles of our standing assumptions nor assimilatable, without remainder, into our body of knowledge.[33] However, if these interpretations oppose rationality in this broad sense, they are nevertheless optimal. For even if they cannot be linked readily and reasonably with our standing body of beliefs, they expeditiously serve the short-term purpose of resolving the puzzle posed by the punch line and of comprehensively reframing the details of the body of the joke.

The joke-situation is one in which the listener is prompted to produce an interpretation which is optimal, while in the broad sense, it is, in some way, not rational. The tension between optimality and rationality is recognized by the listener, and provides the locus of her amusement. This sort of conflict, ordinarily, might be a source of consternation; but within the joke-situation it is advanced for the purpose of enjoyment. The compelling nature or optimality of the interpretation is entertained, despite its implication in absurdity. In the joke-situation, we are allowed to be vulnerable to the attraction of an interpretation that in other contexts would have to be immediately rejected. Speaking only partially metaphorically, in entertaining the interpretation, cum absurdities, while recognizing the rational unacceptability of such an interpretation, we allow ourselves the luxury of being cognitively helpless—appreciating the cognitive force of the interpretation (for example, its comprehensiveness and its simplicity) without feeling the immediate pressure to reject it because of all those liabilities—such as its unassimilability to our body of beliefs—of which we are aware.

Characterizing our cognitive state with respect to joke interpretations as a variety of helplessness is at least suggestive. Laughter, the frequent concomitant of jokes, is also associated with tickling and slight nervousness. If the focus of our mental state with respect to jokes is an interpretation, in which optimality, with an edge, vies openly with rationality, then it seems plausible to speculate that we are in a state that would standardly evoke nervousness. We are vulnerable, but, as with tickling, that vulnerability does not, given the

joking frame, constitute clear and present danger. Moreover, if Ted Cohen is right in saying that the joke-situation is one of community,[34] we might amplify his observations by noting that part of that sense of community is constituted by the willingness of the joke-audience to render themselves vulnerable in a public group.

Summarizing our thesis so far: x is a joke if and only if (1) x is integrally structured, verbal discourse, generally of the form of a riddle or a narrative (often a fantastical narrative), (2) concluding with a punch line, whose *abruptly* puzzling nature, (3) elicits, usually quite quickly, a determinate interpretation (or determinate range of interpretations) from listeners, (4) which interpretation solves the puzzle and fits the prominent features of the riddle or narrative, but (5) involves the attribution of at least one gross error, but possibly more, to the characters and/or implied tellers of the riddle or narrative, and/or involves the assumption of at least one such error by the implied or actual listener, (6) which error is supposed to be recognized by the listener as an error.

This is an account of what comprises the joke. "Getting the joke" involves the listener's production of the interpretation, the recognition of the conflict or conflict*s* staged between what I have called its optimality versus rationality, and, typically, enjoyment of said tension. Often it is maintained that in order to "get a joke," one must find it funny, which, I suppose, means that one must enjoy it. But by characterizing enjoyment as only a "typical" feature of "getting a joke," I intend to leave open the possibility that one can "get a joke" without finding it funny or without enjoying it. Speaking personally, I believe that I have heard certain racist jokes which I "got," but which I did not enjoy.

One counterexample to this account that has been proposed is the trick exam question. And surely graders are familiar with coming across answers to quiz questions that strike them as very funny, as if, indeed, they were a joke. However, such examples, even where the question is designed to prompt a wrong answer, are not jokes, for surely the recipients who advance such questions neither do nor are they supposed to recognize the errors in which their answers are implicated.

Another problem case is the sort of jest beloved by children that goes like this: "Why did they bury Washington on a hill? Because he was dead." Chickens crossing roadways and firemen's red suspenders also come to mind here. Such jokes violate my preceding characterization because they are not implicated in errors. Chickens presumably do cross roads to get to the other side and firemen, when they wear red suspenders, indeed do so to hold their pants up.

What I want to say about such examples is that they are meta-jokes. They are jokes about jokes; specifically, they subvert the basic underlying conventions of jokes—that jokes will elicit interpretations that negotiate puzzling punch lines—in such a way that these presuppositions are exposed. These jokes introduce certain questions in the manner of riddles, while their "answers" reveal both that they were not riddles at all and that what is involved in the listener's conventional stance in regard to a riddle is the anticipation of a puzzle.

Of course, the immediate aim of these meta-jokes is less exalted; it is to trick the listener into adopting the role of a problem solver where no solution is necessary. As an empirical conjecture, I hazard that children come to enjoy this kind of play soon after they acquire initial mastery of the joke form; in a way, such meta-jokes provide a means of celebrating their recently won command of this mode of discourse. Moreover, I do not think that postulating meta-jokes compromises my theory of jokes. For somewhere along the line, every theory will have to come to terms with meta-jokes, like the shaggy-dog story.

Also, since my analysis of jokes relies so heavily on the notion of the joke being filled in by interpretive activity, it may tempt one to indulge the longstanding commonplace that jokes are strong analogs to artworks. I think that we should resist this temptation. Jokes, like at least a great many artworks, do encourage interpretation. However, the interpretation relevant to solving a joke is not only very determinate, but, in general, has been primed by a very economical structuring of information such that it calls forth the pertinent interpretation almost immediately, and, therefore, abets very little interpretive play. The organization of the joke is, in fact, generally so parsimonious that any attempt to reflect upon the text and its interpretation for any period of time is likely to be very unrewarding. Jokes are not designed for contemplation—one cannot standardly review them in search of subtle nuances that inflect, enrich, or expand our interpretations.

The interpretation of a joke, so to speak, generally exhausts its organization, virtually in one shot, or, alternatively, the organization of the joke calls forth a determinate interpretation that is barely susceptible to the accretion of further nuance. This is not said to deny the fact that we may retell a joke in order to discern the way in which, structurally, its solution was "hidden" from listeners. But, again, even such structural interests are quickly satisfied. Thus, the kind of interpretation elicited by jokes is at odds with at least our ideals concerning the protracted interpretive play that artworks are supposed to educe.

Earlier I rejected the Freudian theory of jokes, but one might wonder whether our successor theory is really so different. Of course, one difference between our theory and Freud's is that we do not support the hypothesis that the structures of jokes reflect the modes of primitive thought that Freud discovered in the dreamwork.[35] However, Freud's less specialized account—that jokes lift the inhibitions of critical reason—may not seem so very different from our claim that the joke-situation allows us to entertain a puzzle-solution that we know is not rational.

Nevertheless, there is a subtle difference between the two views. Freud's theory implies that with the joke rationality is banished, if only momentarily. But on my theory, the crux of amusement is the tension between optimality and rationality. Rationality is not banished; it remains as a countervailing force to the "absurd" solution; the mental state we find ourselves in is one in which we are, so to speak, trapped between the rational and optimal. If jokes have a general moral, it is that we humans are irredeemable optimizers. Perhaps, that is why we say we "fall" for jokes. But part of our appreciation of the joke is

that we recognize our "fall," which would be impossible if Freud were right in thinking that jokes send rationality on a holiday.

One outstanding anomaly, however, still plagues our theory. I claim that it is an essential feature of a joke that the listener recognize that the interpretation the joke elicits be in error. But, on the other hand, we are all familiar with racist, ethnic, sexist, and classist jokes which give every appearance of being told to reinforce the darkest convictions of racists, sexists, and so on. It is a fact that such jokes are often told for evil purposes, but my theory makes it difficult to understand how these jokes could serve such purposes. If my theory is correct, then when a racist hears a joke whose interpretation mobilizes a demeaning view of Asian intelligence, if the racist is to respond to it as a joke, it seems that he should realize that the degrading, stereotypically exaggerated view of Asians proffered by the joke is false.

But if the stereotypically degrading view of the racial target of the joke is false, it is hard to see how such jokes could reinforce the racist's view. How can racism be served by racist jokes, if my theory is accurate? And surely we have more faith in our belief that racist jokes can serve racism than we can have in a philosophical theory of the sort advanced so far. In order to deal with this challenge, I must say something about the relation of jokes to ethics.

ETHICS AND JOKES

Initially, it may be thought that one advantage of portraying jokes as devices for eliciting interpretations from listeners is that it explains why people are so deeply troubled about the moral status of jokes—or, at least, some jokes. If what we have said is correct, then jokes involve listeners in producing errors that they may momentarily embrace. The listener fills-in the elliptical joke structure, and, in order to complete it, the listener must supply an optimal interpretation that is implicated in error. Now in the case of many jokes— such as ethnic, racist, or sexist jokes, for example—those errors often involve morally disturbing stereotypes of the mental, physical, or behavioral attributes of the comic butt who stands for an entire social group. Thus, the moralist is worried not only about the moral statement the joke implies, but also about the effect of encouraging the listener to produce and embrace the erroneous and morally suspect thoughts that the interpretation of the joke requires. That is, the moralist may be concerned that, among other things, the very form of cognitive address employed in jokes involving ethnic, sexist, and racist material is ethically problematic.

In this regard, Aristotle contended that the most effective rhetorical strategy was the enthymeme; for by means of this device the orator can draw her conclusions from the audience in such a way that we take them to be our own.[36] Having come upon the conclusion on our own, it strikes us as all the more convincing. That is, in this way, the rhetorical structure reinforces the idea. Jokes, it may be thought, work in this way as well; the audience fills in the interpretation on its own, even though the interpretation is predetermined.

Thus, the danger is that where the interpretation requires us to operationalize suspect moral thoughts, such as sexist stereotypes, the very process itself may reinforce the viability of those thoughts. So what is troubling about a sexist joke is not just its content, but its form of cognitive address.

However, as noted above, my theory of jokes obstructs this conclusion. For a joke-interpretation to "work" requires that the listener not only produce the interpretation but also recognize, at the same time, that it is somehow in error. This recognition is the crux of the humored response. Moreover, racist, ethnic, and sexist jokes seem to presuppose the wrongness of certain stereotypes in order to be gotten.

But, in rejecting the moralist's worry, we seem driven to the conclusion that even a bigot recognizes the error or absurdity of the exaggerated stereotypes presumed in the interpretations proponed by an ethnic joke. If he did not, his response to the punch line would not be laughter, but the matter-of-fact acknowledgment that "yes, that's just how Irishmen or Poles or Italians or Jews or African-Americans really are." But this, in turns, seems to make too many racists appear too enlightened.

However, we need not be forced to this conclusion. Consider: "How do you know that an Irishman has been using your personal computer? There's white-out on the screen." Here the mandated interpretation is something like: any Irishman is so dumb that he can't use a computer properly, *and* he even makes corrections in a way that is ultimately self-defeating. In order to appreciate this as a joke, the listener has to realize that this is literally false. However, the punch line can also be construed figuratively.

Much humor rides on figurative language, employing tropes like litotes or meiosis, and irony. In ethnic and racist jokes involving, for example, stereotypes of exaggerated stupidity, the presupposed interpretation may function as hyperbole. This will be the case where the joke is passed for vicious purposes among those committed to the degradation of persons of another race, sex, class, etc. Within such circles, the presupposed interpretation will be understood as exaggerated—and, therefore, literally trafficking in error—but the exaggeration will be understood as on the side of truth. The racist speaker will be understood by the racist listener as saying something stronger than the literal truth warrants, but also as saying something with the intention that it be corrected so that, though it will not be taken in its strongest formulation, it will still be taken as a strong statement that preserves the same initial polarity (say "major league" stupidity) that the hyperbole did.[37] One might imagine the anti-Irish appreciator of the preceding computer joke saying, after an initial burst of laughter: "Well, the Irish aren't *that* dumb; but they're really pretty dumb nonetheless."

Ethnic, racist, and sexist jokes are very often used as insults, and insults customarily may take the form of hyperbole. Perhaps few mothers wore combat boots, but many could not afford Guccis either. Though they are literally and even intentionally false, hyperboles can figuratively point in the direction of an assertion.[38] And where racist jokes are told with racist intent to racist audiences,

tellers and listeners may regard their presuppositions as strictly and literally false—thereby appreciating them as *merely* jokes—while at the same time correcting the tropological figuration so that it accords with their prejudices.

Thus, if it is agreed that a racist can recognize that the implied interpretation of a racist joke is literally false—thereby "getting the joke"—but also take it figuratively as an instance of hyperbole, then the theory of jokes advanced in the preceding section need not be taken to be incompatible with the view that racist jokes can reinforce racist ideology.

It should be noted that I have claimed that racist, ethnic, and sexist jokes are "very often used as insults." Here I am allowing what may seem troublesome to many, viz., that there may be cases where they are not insults. This seems borne out by the fact that there are many groups, including Jews, the Irish, and African-Americans, who tell jokes about themselves which employ the same exaggerated stereotypes that outsiders use.[39] It seems reasonable to suppose that even if some of this joking reflects intra-group rivalry and, in some cases, possibly self-hatred, some of it, at the same time, is indulged without the intention of insulting one's own ethnic group. Whether a racist joke is morally charged, then, depends on the intentions of the teller and the context of reception. Pragmatic considerations of particular jokes in context determine whether the joke is an insult—whether its literal absurdity is to be taken as an indication of a morally obnoxious assertion by means, for example, of hyperbole.[40]

In emphasizing the relevance of use and context here, I mean to deny the simple moralistic view, sketched above, that jokes, even ethnic jokes, are evil simply in virtue of being some sort of rhetorical machine whose form of cognitive address automatically reinforces wicked ideas. Whether a joke is evil depends on the intentions of its teller and the uses its listeners make of it.

Quite clearly, ethnic jokes do not instill beliefs in listeners simply by being told. When I originally heard the preceding computer joke, it was told about Newfoundlanders, not about Irishmen. I laughed; I "got the joke." But it neither instilled nor reinforced any beliefs I have about that group, for I have no well-formed beliefs about people from Newfoundland, except, perhaps, that they live in Canada and people tell jokes about them.

Likewise, I have heard the joke told by people as ignorant as I am about the inhabitants of Newfoundland to the equally ignorant with successful results. This prompts me to suspect that it is possible to derive an almost formal pleasure from ethnic jokes and their ilk that is apart from their derisory potential. The focus of this formal appreciation may be the way in which the joke, particularly the punch line, is so perfectly structured to bring about what I earlier referred to as our change in mental state.

However, the conjecture that ethnic jokes and the like may be formally appreciated does not amount to a license to tell or to laugh at them in any context so long as one's intention in telling or laughing is not, in one's own judgment, connected to derisory hyperbole and the like. Since such jokes can be used to encourage racism, sexism, classism, etc., one should be morally concerned enough to refrain from telling them in contexts where they might

stoke these sentiments; this probably applies to most of the social situations in which we find ourselves. Of course, it is not just the case that we may not know how our audience may respond to or use such jokes. In matters like sexism and racism, we may not know all there is to know about our own hearts as well. Though we may think that our Irish jokes or Polish jokes do not reflect our beliefs about the Poles or the Irish, the tides of racism and sexism probably run deeper. It is very likely that our own intentions and their background conditions are generally obscure in these matters, in part because what is involved in racism, classism, and sexism is not yet completely understood. Thus our own judgment about our intentions in telling and laughing at racist and sexist jokes may not be reliable. And this supplies us with further moral reasons against indulging in this type of humor.

I have rejected the simple moralist worry that certain types of jokes may be evil as a function of rhetorically bringing listeners to entertain certain immoral ideas in our process of what I call filling-in the joke. This hypothesis conflicts with my view of what it is to "get a joke"; for I maintain that this requires that the listener know that the interpretation one uses to solve the joke puzzle be implicated in error. On the other hand, I do not want to deny that immoral pleasures may be derived from jokes where, despite the recognition of the literal absurdities or errors that the joke mandates, the joke can be used—figuratively, for example—as a serviceable means to insult or to dominate another social group. Jokes, that is, can be immoral in terms of the motives they serve rather than in terms of their particular structure of cognitive address.[41]

NOTES

1. For examples of incongruity theories, see: D. H. Monro, *Argument of Laughter* (Melbourne, 1951); Marie Collins Swabey, *Comic Laughter: A Philosophical Essay* (New Haven, Conn., 1961); John Morreall, *Taking Laughter Seriously* (Albany, N.Y., 1983); John Morreall, "Funny Ha-Ha, Funny Strange and Other Reactions to Incongruity," in *The Philosophy of Laughter and Humor*, edited by John Morreall (Albany, N.Y., 1987); Michael Clark, "Humour and Incongruity," in *Philosophy* 45 (1970); Mike Martin, "Humour and the Aesthetic Enjoyment of Incongruities," in *British Journal of Aesthetics* 23, no. 1 (Winter 1983); Michael Clark, "Humour, Laughter and the Structure of Thought," in *British Journal of Aesthetics* 27, no. 3 (Summer 1987). Early modern examples of incongruity theories can be found in Francis Hutcheson's *Reflections Upon Laughter, and Remarks Upon "The Fable of the Bees"* (Glasgow, 1750) and James Beattie's "An Essay on Laughter and Ludicrous Composition," in his *Essays on Poetry and Music* (Edinburgh, 1778). William Hazlitt's *Lectures on the English Comic Writers* (London: 1885) and Søren Kierkegaard's *Concluding Unscientific Postscript*, translated by David F. Swenson and Walter Lowrie (Princeton, N.J.: 1941) also advance incongruity theories. John Morreall maintains as well that the rudiments of an incongruity theory are suggested by Aristotle in his *Rhetoric* (3,2); see Morreall's *The Philosophy of Laughter and Humor*, p. 14.

2. Arthur Schopenhauer, *The World as Will and Idea*, translated by R. B. Haldane and John Kemp (London, 1907), supplement to Book I: chap. 8, "On the Theory of the Ludicrous."

3. My discussion in this section focuses on Sigmund Freud's *Jokes and their Relation to the Unconscious*, translated and edited by John Strachey (New York, 1960). In his essay "Humor," Freud further discusses the differences between jokes and humor, attributing to the former the aim of sheer gratification and to the latter the aim of evading suffering. I

will not be dealing with these distinctions in my discussion here. Freud's essay "Humor" originally appeared in the *International Journal of Psycho-Analysis* 9 (1928).

4. Other examples of release/relief theories include: Herbert Spencer, "The physiology of laughter," *Macmillan's Magazine* I (1860); Theodore Lipps, *Komic und Humor* (Hamburg, 1898); J. C. Gregory, *The Nature of Laughter* (London, 1924).

5. Freud, *Jokes and their Relation to the Unconscious*, 88.

6. Though unacknowledged by Freud, Bergson also hypothesized a connection between dreams and comedy. See Henri Bergson, *Laughter* in *Comedy*, edited by Wylie Sypher (Baltimore, Md., 1984), 177–87.

7. Freud, *Jokes*, 127.

8. Ibid., 170.

9. If this counterexample is rejected, an alternative approach would be to consider the overlap between Freud's formulas for jokes and his characterization of the uncanny. When the criteria for the uncanny is spelt out, uncanny phenomena bear an unnerving structural affinity to jokes (in the Freudian dispensation). See Sigmund Freud, "The Uncanny," in *Studies in Parapsychology*, edited by Philip Rieff (New York, 1966).

10. It may seem strange to say that Freud's theory of jokes is not sensitive to discursive structure since chapter 2 ("The Technique of Jokes") is a rather compendious inventory of structure. However, these structures are not unique or even semi-unique to jokes. The kind of discursive structure that I have in mind above will be explicated in the next section of this essay.

11. Derived from Victor Raskin, *Semantic Mechanisms of Humor* (Dordrecht, 1985), p. 252.

12. The argument in the preceding paragraph rides on showing that the kind of material that Freud counts as comic, in contradistinction to what he counts as a joke, can be formatted as what we regard as a joke in everyday speech quite easily. Similarly, I think that the kind of anecdote that dissipates emotion, which Freud takes as the hallmark of the humorous, can also be rewritten in a joke structure with no loss of effect.

I should also note that Freud also distinguishes jokes, the comic, and the humorous in terms of the size of the respective audiences required to appreciate them. Defenders of Freud might want to block my counterexamples by excluding them through reference to this dimension of differentiation. I have not developed a defense against this line of counterattack since I think it would take us too far afield in an essay of this scope. However, for the record, I should say that I find Freud's speculations about the size of audiences (e.g., *Jokes*, 143: "no one can be content with having made a joke for himself alone") thoroughly unsubstantiated and unpersuasive.

13. Derived from Harvey Mindess, *Laughter and Liberation* (Los Angeles, 1971), 133.

14. The restructuring aspect of joke interpretation is emphasized by Gestalt theorists of humor. And, though I do not agree with all their claims about the ways in which this should be incorporated in a theory of jokes, I do think that the reconstructing process that they point to provides some support for calling what the listener does in response to a joke "an interpretation." For Gestalt theories of humor, see: Norman Maier, "A Gestalt Theory of Humor," *British Journal of Psychology* no. 23 (1932); Gregory Bateson, "The role of humor in human communication," in *Cybernetics*, edited by H. von Foerster (New York, 1953); and P. A. Schiller, "A configurational theory of puzzles and jokes," *Journal of Genetic Psychology* 18 (1938).

15. Annette Barnes, *On Interpretation* (New York, 1988), chaps. 2 and 3. Though I am not sure that Barnes's claims about nonobviousness are perfectly accurate for the case of literary interpretation, I do think that they pertain to joke interpretation.

16. Immanuel Kant, *The Critique of Judgment*, translated by James Creed Meredith (Oxford, 1982), section 54, p. 199.

17. Daniel Dennett appears to allow that the interpretation here might be some sort of mental, visual representation. See Daniel Dennett, *The Intentional Stance* (Cambridge, Mass., 1987), 76–77.

18. Comic timing can also be important as a means of highlighting the puzzling aspect of the punch line. That is, the pause before delivering the punch line is a way of dramatizing it.

19. For other examples of the two-stage view, see: Jerry M. Suls, "A Two-Stage Model for the Appreciation of Jokes and Cartoons, An Information-Processing Analysis," in *The Psychology of Humor*, edited by Jeffrey Goldstein and Paul McGhee (New York, 1972); Michael Mulkay, *On Humor* (New York, 1988); J. M. Willman, "An Analysis of Humor and Laughter," *American Journal of Psychology* 53 (1940). Also, the Gestalt psychologists cited previously may be thought of as contributing to the development of the two-stage model.

20. For information on surprise and configurational theories, see Patricia Keith-Spiegel, "Early Conceptions of Humor: Varieties and Issues," in *The Psychology of Humor*.

21. The joke and the most general sort of sight gag seem typically distinguishable in this way; but there is a sort of quasi-visual humor that is more akin to the joke, viz., cartoons with captions. The latter, I think, is the closest relation to the joke among comic genres, though, of course, it is not exclusively a matter of verbal discourse.

22. Suls, "Two-Stage Model for the Appreciation of Jokes," 83.

23. Loose talk of "incongruity" and "congruity" in comic theory can generate a great deal of confusion. For example, Roger Scruton attacks Michael Clark's incongruity theory of humor (cited above) on the grounds that caricatures involve "congruity" rather than "incongruity." But, of course, even if caricatures are apt or fitting, they also involve some distortion which I suppose that someone like Clark would want to call an "incongruity." In another vein, Scruton's claim that humor cannot be an emotion because it involves an attentive stance of demolition rather than a formal object would appear to run afoul of theories of the emotions like Amelie Rorty's which take fixed patterns of attention as marks of emotions. See Roger Scruton, "Laughter," *Proceedings of the Aristotelian Society* 56 (1982), and Amelie Rorty, "Explaining Emotions," *Journal of Philosophy* 75 (1978).

24. See note 1.

25. Raskin, *Semantic Mechanisms of Humor*.

26. A. Koestler, *The Act of Creation* (New York, 1964).

27. Swabey, *Comic Laughter*, 103–26.

28. Monro, *Argument of Laughter*.

29. Henri Bergson, *Laughter* in *Comedy*, edited by Wylie Sypher (Baltimore, Md., 1984).

30. From Barbara C. Bowen, editor, *One Hundred Renaissance Jokes: An Anthology* (Birmingham, Ala., 1988), 9. This joke was first brought to my attention by John Morreall as a counterexample to my theory. The discussion above should indicate why I do not regard it as such.

31. Some incongruity theorists claim the *non sequitur* as part of their domain. See, for example, Swabey, *Comic Laughter*, 120–21. As indicated above, I believe that this makes the often otherwise useful concept of incongruity vacuous.

32. The notion that the punch line of a joke subverts our expectations may be misleading since it suggests that we already have some positive view of how the joke will conclude—i.e., a determinate, rival hypothesis to the conclusion that actually eventuates. But often—most of the time?—I think that we have no definite idea of how the joke will end. Thus, if we wish to persevere in speaking of our expectations being subverted, I think that it is best to think of our expectations here as the continuation of our normal modes of thought—though this needs a bit of qualification since we may also bring to a given joke certain "joke expectations" due to the internal structure of the joke (e.g., the expectation of continued regularities in jokes told in "threes"), or "joke expectations" due to the recognition of the genre to which the joke belongs (e.g., light-bulb jokes).

33. The notion of cognitive state transitions derives from Alvin Goldman, *Epistemology and Cognition* (Cambridge, Mass., 1986), 74–80 and chap. 5. An interesting project for future research would be to try to fill out Goldman's format with some example of typical joke-interpretations.

34. Ted Cohen, "Jokes," in *Pleasure, Preference and Value*, edited by Eva Schaper (Cambridge, 1983), 124–26.

35. Although we can incorporate Freud's findings into our theory by noting that sometimes the errors in joke-interpretations, along with the attractiveness of said interpretations, may be a result of the operation of infantile thinking.

36. Aristotle, *Rhetoric* (2, 22–25).

37. See Robert Fogelin, *Speaking Figuratively* (New Haven, Conn., 1988), 13–18.

38. Though I do not want to endorse Davidson's theory of metaphor, something like it may apply to hyperbole, though, of course, an hyperbole does contain certain instructions about the way in which to move from it to its literal counterpart. See Donald Davidson, "What Metaphors Mean," *Critical Inquiry* 1 (1978).

39. Christopher P. Wilson, *Jokes: Form, Content, Use and Function* (London, 1979), 217–18; R. Middleton and J. Moland, "Humor in Negro and white subcultures," *American Sociological Review* 24 (1959); A. M. O'Donnell, "The mouth that bites itself; Irish humour," address to the Institute of Education, University of London, 1975 (cited in Wilson).

40. Forms of figuration other than hyperbole can be in play in such jokes.

41. I have the impression that the view here conflicts with that of Ronald DeSousa in his *The Rationality of Emotion* (Cambridge, Mass., 1987), 289–93. He appears to believe that when a certain kind of wit—which, following Plato, he calls *phthonic*—induces laughter, this implicates us in wickedness, such as sexism, because it shows that we possess an evil attitude. Such attitudes, he maintains, cannot be adopted hypothetically for the purposes of "getting a joke" in the way we entertain the idea that Scots are cheap in order to appreciate certain jokes about them. I am not sure that I follow all of DeSousa's arguments here; indeed, I would want to challenge the thought-experiments that he offers in defense of his thesis. Also, he does not seem to take into account the view that the interpretations that we supply to jokes are recognized to be involved in error. However, DeSousa's position really deserves to be addressed in a separate article rather than to be hastily engaged in a brief rebuttal here. Nevertheless, one reservation about his position that can be stated briefly now is that his claims that certain presuppositions of jokes cannot be entertained hypothetically does not seem obviously consistent with his admission that anthropologists can entertain attitudes that are alien to them in order to appreciate the jokes of other cultures (DeSousa, 293).

In retrospect, I should also note that the type of "why-did-the-chicken-cross-the-road" joke that I analyzed as a meta-joke in my section entitled "An Alternative Account of the Nature of Jokes" could be analyzed in a way that is more in keeping with my overall approach. We could, for example, analyze it as eliciting a mistaken framework. See, for instance, Alan Garfinkel's account of the Willy Sutton joke in Chapter 1 of his *Forms of Explanation* (New Haven, Conn., 1981). However, even if this is the right way to go with such jokes, I still think that we need the category of meta-jokes in order to accommodate shaggy-dog stories.

Art and 'Art'

JULIUS M. MORAVCSIK

It is widely assumed in contemporary analytic philosophy that as far as theoretical analysis goes, answers to questions of the form: "what is F?" and to those of the form: "what does 'F' mean?" coincide. For example, we do not separate the question: "what is a universal?" from "what does 'universal' mean?". In these cases, however, we deal with theoretical entities, introduced by philosophers, to solve philosophical problems. When philosophers treat concepts that have currency also outside of their field, the coalescing of the two types of questions is more problematic. For example, the question: "what is knowledge?" admits of several reasonable interpretations according to which it is not equivalent to: "what does 'knowledge' mean?" The latter question asks for an analysis of the meaning of a word either in technical philosophic use or in non-technical everyday use, with—hopefully—a link between the two. The other question can be construed as asking for the examination of an allegedly basic human state and capacity. This examination could be carried out also in countries in which there is no word corresponding to the English 'knowledge'. An analysis of the meaning of 'knowledge' may or may not be relevant to the understanding of the basic human capacity referred to in the first of our two questions.

In the sciences the two types of question do not ordinarily coincide. Physicists have for centuries tried to understand what is matter. This investigation has a theoretic as well as an empirical component. The word 'matter' has both theoretic and commonsense implications. An interpretation of its meaning may or may not have much relevance to the attempt to understand what matter is, when viewed in the context of the traditional investigation of this substance.

There are contexts outside of both philosophy and the sciences in which the two types of question coincide. We find such in religious, legal, and various other secular ceremonial activities and practices. In these practices the practitioners determine how a word—e.g., name of a ritual, law, initiation ceremony—should be used, and they are also solely in charge of determining whether using common names or other descriptive terms in these contexts has been successful. For example, a priest can decide to call a certain ritual 'sacrifice', and he might be the only person who can say whether or not the

302

performed sacrifice has been successful. This contrasts with the use of a term like 'cure'. To be sure, doctors have a lot of latitude in deciding what should count as a cure, but they cannot apply the name only according to their own standards. If the things they call 'cure' never lead to the restoration of health, then their semantic practice becomes questionable both on the conceptual and the practical plane. Such control from outside the world of practitioners applies also to the most general features of legal practice. Licensing of lawyers may be arbitrary or purely conventional in some ways, but eventually it must relate to a collection of skills, knowledge, abilities, etc., that we associate with the enforcing of rules governing conduct in a community.

There are also many words that denote—at least in one sense—phenomenal, directly observable qualities. In these cases the investigation of the quality and the semantic exploration of the related word are clearly distinct enterprises. It is one thing to understand what redness is, and another to investigate the meaning of 'red'. One could conduct the former examination even if there were no word like 'red' in our language.

It seems, then, that there are two extreme types of cases. At one extreme we find what are traditionally called secondary qualities like red, bitter, loud, etc. In those cases the "what is F?" and "what does 'F' mean?" questions do not converge. At the other extreme we find practices or institutions within which a self-perpetuating group of practitioners can decide what to name some items taken by them to be parts of their practice. What they name to be an F is what an F is; and whether an instance of what is taken to be F does successfully meet the conditions on being an F is determined wholly by the practitioners.

As this very sketchy survey shows, there are many cases that lie in between the extremes. We find among these some of the vocabulary of practices like medicine, teaching, etc. In these cases what F is cannot be determined wholly by the decisions of the practitioners. There are conditions outside the world of practitioner/name givers that constrain the possible ranges of application for some of the words used within the practice. And, correspondingly, the two types of question do not coincide. To find out what curing a patient is does not coincide with finding out what 'cure' means, either for patient or practitioner.

The point of sketching this contrast is to help us understand the relation between asking what art is and asking what 'art' means. Is the case of art more like that of medicine, teaching, producing artifacts, etc., where the two types of questions are distinct, or is it more like the cases of the priests and their rituals, or some fraternal organization and its initiation rituals?

I. ART AND 'ART'

In this section the following two theses will be defended:

Thesis I. Art is more like medicine or artifact production than the practices in which practitioners are the sole arbiters of correct name and description giving.

Thesis II. The investigation of art and the semantic analysis of 'art' can be reasonably viewed as distinct enterprises.

First, an argument for thesis I. One can identify a practice like medicine by some salient features that relate to what the overall purpose or point of the whole practice is; in this case, the maintenance and restoration of health. It may be that notions like those of doctor, patient, health, and cure are articulated in terms of different concepts in different cultures or within different historical periods. One could identify in a reasonable way the practice of medicine across these cultures in spite of such variations. Furthermore, this identification would be partly independent of how words like 'medicine' or 'health' are used today in our culture by the licensed practitioners.

Similar considerations apply to art. Across a wide range of cultures and historical periods the practice of art is normally expected to yield certain types of product. This need not be a sharply delineated set. But paradigmatic kinds include songs, paintings, carving, dancing, etc. Thus the success of an alleged instance of the practice of art—i.e., certain activities by a group in a certain cultural context—depends on whether it achieves at least to some extent the meeting of this expectation in terms of product. If a self-styled and self-perpetuating collection of practitioners keeps calling certain activities 'art' even though these are in no way related to meeting the productive expectations, then there is no reason why such naming practice should influence us in our attempts to identify and understand art.

The other argument concerns the expected reaction by audience or recipient in a wider sense. Again, across a wide variety of cultures and historical periods, it is expected that the products of art should evoke from a qualified audience/spectator a response other than the consideration of the mere utility and practical application of the product. We need not go into the history of the many attempts to come up with a sharp delineation of the expected appropriate response. The details of such a delineation are not relevant to our purposes. It is sufficient to point to the widespread agreement that some set of responses centering on non-functional features involving the beautiful, or the sublime, or the interesting, imaginative, etc., should be evoked by objects produced within the practice of art. If these expectations are not met at all by the activities of a group of self-appointed experts, then the result is a conceptual and practical crisis. Under those circumstances we need not regard the practice in question as belonging to art, regardless of how 'art' or its equivalent is used within that culture or in our own.

Let us now ponder in view of these considerations, how thesis II can be supported. The use of a word like 'art' can vary a great deal through history. The changes are partly a function of the varying relation between artists and such experts as critics or art dealers, on the one hand, and the rest of the population of the culture on the other. These changes are analogous to one between experts in the sciences or law, on the one hand, and the rest of the population on the other. At times the gap between expert and layperson is wider, at times it is more

narrow. Tracing these changes with respect to 'art' does not coincide with the tracing of the development and flourishing—or decline—of the paradigmatic products that art is supposed to produce. In our culture a number of terms used by physicists tend to have more and more restricted technical meanings. Noting this and tracing the development as well as the conditions that bring this about is not the same as sketching the extent to which physics succeeded or failed in the past thirty years to understand the nature of basic spatio-temporal elements. The same applies to art and 'art'. Perhaps we witness today a more and more "expert-oriented" use of 'art'. Examining this is one task; giving an account of paintings, carvings, poems, dances, etc., in our times, and the attitudes that these evoke in the audience or recipient, is another.

These considerations, then, seem to justify our two theses. We shall turn to a proposal of what a theory of art—no longer tied to a close examination of recent uses of 'art'—looks like in rough outline. Before we turn to this, we need to expand on the assumption made in the past few pages about art being a practice.

II. ACTIVITIES, PRACTICES, AND INSTITUTIONS

Medicine, law, art, the production of artifacts have been described above as practices. What does this entail? In order to get a better conceptual grip on this issue, we shall consider the trichotomy of activity, practice, and institution.

Activities constitute a subset of the category of event. Typically, they require animate agents and a functional or teleological element. For example verbs like 'cut', 'kick', 'walk', and 'sing' denote activities. Some of these require objects, others do not. In the case of the activities introduced here, where objects are required, these objects do not belong semantically or conceptually to the activity. We can kick, cut, or kiss a wide variety of entities. We can characterize the activities in terms of the actions involved with only the widest specification of appropriate objects—cutting and kicking require objects that are in some sense material. Furthermore, the activities listed involve achievement, even if, in some cases, of a trivial kind. One needs some strength in order to cut or kick, one needs some ability in order to sing, and different cases of walking involve having traversed distances of the appropriate 'kind. (More on this later.)

In contrast with activities of the sort mentioned, practices have a more complex structure. This structure involves agent, activity, object, product or some other result produced, recipient, and appropriate effects of the product or result on the recipients. Thus, for example, the practice of medicine includes the appropriate agents. Agency need be construed in a wide sense. It includes not only the physician but also nurse, pharmacist, hospital administrator if any, etc. Some of these will be obligatory items, others optional. The "results" of medicine are cured patients or patients whose health is maintained. In the case of artifact production the results will be artifacts.

The following is the general scheme for a practice:

A—agent, practitioner
O—product, result, achievement
R—audience, spectator, recipient
P'—appropriate process linking *A* and *O*
P''—appropriate process linking *O* and *R*

Within the analysis of a specific practice we place conditions on each of these five elements. There may be possible cases in which conditions on some of the five elements are met, but not conditions on others. Such cases require conceptual legislation since our existing concepts of practices do not cover these.[1]

With this scheme for practices in mind, let us turn to institutions. Institutions are institutionalized practices. All of the conditions on practices apply to them, and in addition they have to meet the condition of some law, ceremonial provision, or convention, regulating some of the conditions on some of the five items involved in the analysis of a practice. This broad sense of institution is most useful for our purposes. One could define 'institution' also in a more narrow way, so that instances must be legal entities, assuming responsibility, contracts, etc. Having mentioned this notion, we shall lay it aside.

In our culture medicine and law are not only practices but also institutions in the sense articulated above. We license the practitioners and also some of the activities in which they can participate. Being institutionalized admits of degrees. More or fewer among the five items may be regulated, and the regulations may be more or less specific and restrictive. For example, according to this analysis, business is not only a practice but also an institution. It is, however, not as strongly institutionalized as medicine or law. Some of the activities are regulated by law, but we have no general licensing procedure as with lawyers and doctors, though we have schools for the profession, suggesting that certain skills and some knowledge are seen as desiderata.

Where does art fit into this conceptual map? In our society some kinds of art have some legal constraints. Anyone can paint or compose poems, but one is not regarded a critic unless one writes for a newspaper, magazine, etc. We do not license artists, but there are schools, suggesting once more that certain competencies are included in the concept of an artist. At different stages of history and in different cultures art may be more or less institutionalized. In the history of our culture the institutionalization of art fluctuates. In some cultures in which art consists mostly of folksongs, carving, and dancing, art might not be institutionalized at all.

On the basis of these reflections we can see art emerging as basically a practice, with institutionalization as an optional element, fluctuating across history and cultures.

When a practice, in our sense, becomes also an institution, then criteria for what we should or should not label as falling within the practice become more important. Furthermore, in such contexts it is natural that a group of people should emerge, either from among the practitioners or from among the

"recipients," who will have a privileged position with regard to label fixing. But even in such cases, the group cannot be completely arbitrary. There are general expectations of medicine, law, and even art, and the name-givers have to operate within the constraints of these.

Having located art among activities, practices, and institutions, let us now turn to its own nature.

III. EXPLANATIONS, SEMANTIC AND OTHERWISE

Recent work in semantics centers around three models for lexical meaning. One of these consists of giving necessary and sufficient conditions of application as the meaning of a lexical item. The other loosens this conception and attempts to represent lexical meaning as an indefinite disjunction of conditions of application. The third model construes lexical meaning as analogous to that of proper names; i.e., reference or denotation is fixed without the mediation of qualitative criteria.[2] Recently I developed an alternative to these conceptions. This alternative view represents the meanings of lexical items as explanatory schemes. The elements of such schemes are necessary conditions of application. Together they provide frameworks within which one would explain in virtue of what we should apply a word 'w' to a specific item.[3] Such analyses also generate denotational contexts. Within these contexts we add additional conditions so as to reach the level of sufficiency and thus of denotation.[4]

These lexical explanatory schemes have a general form. They consist of four factors suitably related. These are: m, constituency or category to which items under term belong; s, conditions of individuation, persistence, and features distinguishing denotata from those falling under other descriptive words; f, the functional elements conceptually related to the use of the word; a, causal antecedents and effects conceptually linked to use of word. For example, a rough analysis within this theory for the meaning of 'bird' is: m-factor = materiality, s-factor = living, feathered, having two legs and wings, bodily distinctness, f-factor = flying, propagating; a-factor = biological ancestry and progeny. In some cases some of these conditions are not met. In response we tell a developmental story. Thus penguins and kiwi birds are related to the items that our scheme fits. They are parts of evolutionary accounts and do not cause conceptual crisis. The same considerations hold for deformed specimens.

This lexical theory applies to descriptive words falling into such grammatical categories as noun, verb, adjective, and adverb. For example, the analysis for 'walk' is: m-factor = time, s-factor = activity of locomotion, placing one foot ahead of the other, with one foot on ground at any time, with individuation and persistence determined by continuity and gaps as allowed by this activity; f-factor = accomplishing change in location, a-factor = animate agent. This analysis helps to differentiate walking from running, hopping, trotting, etc. We need additional conditions to reach denotation. Walking is an achievement. What counts as walking for a baby is different from what counts as walking for a healthy adult or a recovering patient. The same applies to 'bird'. The

potentialities included in our general explanations of what counts as a bird apply to the healthy specimen under normal circumstances. In different contexts different conditions need be added to reach a determination of what should count in that context as a bird.

For practices, institutions, and some other types of entities the m-factor is cross-categorial. That is to say, it is not simply time as for most verbs, or materiality as for many nouns, or abstract, as for many theoretical terms. It includes material, temporal, as well as abstract, kinds. For example, for 'university' the m-factor includes faculty, students, buildings, staff, and ideas produced or disseminated.

With this very brief sketch of a lexical analysis in mind, let us look at 'art'.

Since art is a practice, the m-factor is cross-categorial, and includes the five items mentioned in our analysis of a practice in the previous section. The s-factor includes those conditions of skill, knowledge, and ability that make someone an artist, those qualities that make something a product of art, and those conditions that qualify people to be the "recipients" of art. These conditions vary over time in our culture. They changed when a theory of taste was developed, and with it the high-low art distinction. The principles of persistence and individuation govern not the products as such but instances of the practice. Thus they will vary in detail from art form to art form. The building of a cathedral or the finishing of a painting constitute one instance each, but there may be intervals of varying length between periods of actual activity.

The s-factor includes also suitable conditions on P' and P'': for P' these include creativity and concern with form; for P'' it includes whatever set of attitudes and interests make up appropriate responses to art. For the purposes of this analysis it does not matter how vague the criteria of inclusion into this set are. Our use of the word to denote a practice does entail, however, that "not anything goes." The f-factor is the accomplishments of creating entities that qualify under O, and evoking the responses to O from R that fit under P''. The a-factor is animate agent, or devices causally related to such.

This scheme provides an explanatory scheme for what counts as falling under 'art'. It represents what a competent speaker-hearer has as a representation linked to his or her use of 'art'. Many of the conditions listed involve achievement. Thus the scheme given provides only necessary, not sufficient conditions. We reach sufficiency when we consider what counts as art in different contexts. For example, what is art for children, or laypersons taking an art class, for experts, for people in different stages of a culture within which technology develops. These additional conditions are not included in what one would call, in any reasonable intuitive sense, the meaning of the word. Hence within this theory meaning by itself does not determine extension.

This analysis of the meaning of 'art' helps to place different uses of the word as well as certain recent developments in our culture into proper perspective. Let us consider a use in which what counts as art is strictly decided by a group of agents in the widest sense, i.e., artists, critics, art dealers, etc.

This results in a split use, with the s-factor determined somewhat arbitrarily by the privileged group for one use, and it being something like: "whatever the appropriate experts designate" for the lay use, thus construing the word as similar to technical words in some of the sciences. Such use may also place very strong conditions on R; demanding not only taste, whatever that may be, but also the understanding of the condition of the artist in today's society, the history of recent art, and similar factors. Whether such a use is legitimate in view of what was said above about 'medicine' and 'law' is an open question, beyond the scope of this essay. But even if it is, the use must be seen as derived from a much broader use in which within the s-factor we characterize O as paradigmatic products such as paintings, songs, carvings, poems, and dancing, and whatever bears sufficient resemblance to these, and the conditions on R do not go beyond the admittedly nebulous notion of "capacity for aesthetic response." If we found activities that fall today under 'conceptual art' or 'putting urinals into museums' not in any causal and historical way related to traditional and widespread art-forms, then there would be no reason to call these 'art'.

Let us now contrast this semantic investigation with what can be seen in a reasonable way as investigating art, not 'art'. When we attempt to understand the practice of art, we seek understanding of roughly the same five items as in the case of the semantic work, and the four factors which play central roles in semantics do so also in investigations of other types, but the emphasis and orientation is quite different. Within the investigation of art (not 'art') we can start with certain paradigmatic products that appear across cultures and across periods of history. We have mentioned these already. We would then attempt to characterize these across time and cultural contexts and attempt to do the same for the A and R factors and the two processes involved in the practice. We could then raise two further questions: first, are the common features theoretically interesting? and second, what sub-practices and semantic habits appear within this larger framework as anomalies?

This approach is analogous to the one adopted in the past few decades by generative linguistic theory. Instead of worrying endlessly about all actual and logically possible cases that might count as falling under 'language', it takes what we all recognize as languages on a pretheoretical level, such as English, German, Chinese, Swahili, etc., and tries to discover what, if any, theoretically interesting features these have in common. When such features are found, attempts are made to formulate generalizations that have lawlike force, i.e., apply not only to all actual languages, but also to languages that might have developed and be understood by humans as first languages under normal conditions.

This approach to linguistics encountered serious difficulties for it requires definitions of at least some grammatical and phonological categories across languages and language families. The same challenge confronts those who opt for theories of art of the sort envisaged in this section. We need cross-cultural accounts of notions like melody, elements of a painting, dance movement, etc.

These may be hard to come by, but the effort—in the case of the study of languages as well as in the case of the study of art—is worthwhile. To be satisfied with being able to describe only what is a noun in Indo-European languages or what is a melody in Western music is like being able to explain only what is gold in Alaska or in South Africa, but not having any global notion of what gold is. The same applies to chemistry. We attempt a characterization of force, energy, etc., globally, not locally. Rationality demands that we should at least try to do the same with human practices.

This "objectual" approach to art shows also a difference between the cross-cultural investigation and the localized one. If we opt for the cross-cultural approach, then taking what are paradigmatic works of art will be less arbitrary. We will consider painting, carving, dance, etc., as such if these turn out to be in fact universal or at least very widespread. If we concentrate only on Western art—or even worse, only on a certain time period within Western art—then the selection of what counts as paradigmatic has fewer constraints on it, and thus is more likely to be arbitrary.

The global approach can also shed more light on what might seem as all-pervasive features of art when viewed within the narrow perspective of recent Western developments. Some of these features are: the development of a theory of taste, the demand that in evaluating art we consider also the relation that the artist has to society and the view about that relation that he or she tries to express, the obsession with novelty in form, and the insistence that those who produce and are officially appointed as critics of art should have privileged positions in legislating how we should apply the word 'art'. How widespread are these conditions when viewed across historical periods and different cultures? What circumstances lead to their emergence? How do these conditions affect the nature of the works produced? How do they change the contributions that art can make to society?

All of these questions can be studied more fruitfully in cross-cultural contexts and within the objectual theory that is proposed here. An analogy with biology should support this claim. If we look at sick or injured specimens of a species without having a general conception of the whole species, we will not understand the nature of what we observe. Only by looking at the whole species globally can we understand what is expected to emerge under normal circumstances, what is exceptional, and what kinds of factors need to be investigated in order to explain the exceptions. No biologist, or layperson, will try to formulate a definition of 'bird' to cover all logically possible cases, and then worry about every item that seems to be a counterexample. We define a species for certain idealized conditions, and then attempt to account for recalcitrant cases by showing causal links of the exceptional to the expected, and filling in the variables that lead from the expected to the exceptional.

The claim that this methodology will work is empirical. If we find that the paradigmatic artworks emerge without any interesting properties in common, and that art, in our sense, develops a wide variety of arbitrarily different ways across time and cultures, then this approach would be shown to be not suitable.

But the analogies with other disciplines suggest that we should try it. Finding it to fail would be itself the discovery of a very important fact about art and about humans who participate in the practice.

IV. THE OBJECTUAL APPROACH TO ART AND ITS VIEW OF PREVIOUS THEORIES OF ART

Several modern theories of art (or 'art'?) are occupied with defining this practice or word. Some philosophers say that the essential function of art is to express feeling. Others say that the essential function is to express form. Still others think that there must be representational elements in works of art, and most recently it has been suggested that viewing art as an institution might illuminate what is essential to this notion.[5] Within the theory proposed in this essay these suggestions are not seen as rival candidates for a definition, but as stressing various important aspects of the practice of art. We should make a list of these, and add a few others.

1) Expressing feeling
2) Being representational
3) Being institutionalized
4) Related to functional/utilitarian activities
5) Assume a separate faculty of aesthetic taste

We should then examine the practice cross-culturally and across history, and see how often and in what context these elements emerge. Once we have a rough conceptual map of this sort, we can start to formulate explanations for the similarities, and for the divergences. Folksongs in some contexts need no institutionalization, but the same does not hold for opera, or competition between bards.

This theorizing would contain empirical elements, but interaction with the empirical has rarely hurt philosophy.

This approach helps also with the formulation of the hypothesis that art is a cultural universal.[6] In our framework this amounts to asking whether the production of objects or entities like painting, sculpture, carvings, songs, and dance can be found in all cultures at all times. Questions about whether a culture has a word or a concept for art, whether they have aesthetic theories, and whether they are conscious of there being something special about these objects and entities are irrelevant to this investigation. If we find the affirmative answer justified, we can seek evidence that would support moving on to make the hypothesis of cultural universality a lawlike hypothesis, i.e., one that would apply not only to cultures that exist but also to any that might still develop. Even if this hypothesis can be supported, we need additional evidence to support the further hypothesis that the production and enjoyment of art as defined here, relates to a basic human potentiality. For example, it is probably true, even in a counter-factual sense, that every culture produces some material entity that can be used for shelter, but this does not require positing a special shelter-building

capacity. It can be explained on the basis of humans not having natural fur, or good protection against heat, and the weather conditions within which most humans live involving both cold weather and heat. It is an empirical question whether our production and appreciation of art is like that, or like capacities that do seem to require some special innate propensities.

We need to stress also the limitations of the proposed theory. It is a theory about art, as defined. It is not a general aesthetic theory, and in particular it is not a theory about beauty and other qualities that make an entity aesthetically pleasing. Such entities include works of art, but also much else besides. Furthermore, we appreciate art for qualities like creativity and originality, and not just for beauty and interesting representations. But creativity and originality do not apply to the beauty and other aesthetic qualities that we can detect in landscapes like Lake Tahoe or Yosemite.

Finally, this theory steers between the extremes of modern essentialism and anti-essentialism. According to modern essentialism, the task of philosophy would to be find a definition of art (or 'art'?) that would cover all actual and logically possible cases. The approach sketched is agnostic on the issue of whether such a definition could be found, for in any case, it does not aim at that. It aims at examining the nature of a roughly delineated class of entities and looks into the general conditions, if any, under which these entities are created and appreciated. On the other hand, the project differs also from anti-essentialism. According to that view there are no essential qualities determining either the practice of 'art' or the use of the term. The proposed account produces definitions or delineations that do uncover essences in the traditional, Aristotelian sense. This is also the sense in which biologists look for characterizations. Aristotle was not interested in the case of the disciplines dealing with nature in uncovering conditions that applied to species under what we would call today all logically possible circumstances. He wanted to find out what applies to members of a species under healthy, or idealized, circumstances. Discovering essences in that sense is partly an empirical enterprise. This is admitted also by the approach to art proposed.

The main advantage of this approach is not only its bringing together information from different disciplines like philosophy, art history, psychology, and anthropology. Rather, it is its formulating a framework within which interesting questions about art can be related to interesting questions about human nature. Knowing whether there is a basic human aesthetic capacity, or whether typical artworks emerge only in certain cultures and have their roots totally in culture-variant conventions would be to find out something revealing about human nature, and thus help us to achieve at least partly the traditional aim of philosophy, self-knowledge.

NOTES

1. For a treatment of similar dilemmas see J.Moravcsik, *Thought and Language* (London, 1990), 179–90.

2. For more explication, see *ibid.*, 110–17.

3. For a full treatment, see *ibid.*, chap. 6.

4. For a full explanation, see J. Moravcsik, "Between Reference and Meaning," in *Midwest Studies in Philosophy* 14 (Notre Dame, Ind., 1989), 68–83.

5. For an exposition of the last of these views, see G. Dickie, *The Art Circle: A Theory of Art* (New York, 1984).

6. More on this notion in J. Moravcsik, "Art and its Diachronic Dimensions," *Monist* 71, no. 2 (1988): 157–70.

Paul Strand's Photographs in *Camera Work*[1]

NORTON T. BATKIN

Unlike the history of painting, which is shaped by painting's accomplishments, the history of photography is marked by one after another dispute, quite as if photography advanced by argument. The most notorious of these disputes, which itself has a history, is whether photographs can be art. No doubt changing conceptions of art, most often issuing from changes in painting, account in part for the recurrence of the question whether and how photographs can be art. But the fact photographers follow the lead of painting might also suggest that something in the medium of photography itself is problematic yet eludes characterization or confrontation on its own terms. The elusiveness of the problem is confirmed in the criticism of photography.

Consider, for example, Auguste Rodin's defense of painting and sculpture against the claim that photographs reveal the true appearance of people walking or of horses running:

> it is the artist who is truthful and it is photography which lies, for in reality time does not stop, and if the artist succeeds in producing the impression of a movement which takes several moments for accomplishment, his work is certainly much less conventional than the scientific image, where time is abruptly suspended.[2]

Rodin maintains that a painter or sculptor can render different parts of a figure, for example, the fore and hind legs of a galloping horse, in successive stages of the course of a movement so that the viewer's eye, tracing the figure, appears to follow the movement. The explanation is clear enough, particularly in application to the paintings and sculptures he instances. But what are we to make of the claim that by comparison the suspension of time in a photograph is "conventional"? On one hand, a photograph cannot be said to capture the true appearance of reality since in reality time does not stop; yet the photograph, since it is made by a machine, surely is an image of something that has occurred or has been present in reality. If paintings and sculptures capture in their images the appearances of movements, what can photographs be said to capture? Their realities? But apart from the obscurity of the contrast here,

whatever a photograph captures, it also would seem an appearance, not the thing itself. We might speak (no doubt metaphorically) of what the camera sees, in contrast with what the eye sees, but what is the difference between these realms of appearance? Rodin's distinction, that the products of machines and science are more conventional than the products of the human hand, is surprising and unsatisfactory. How is the realm of photographs, which result from the actions of a machine, from optical and chemical processes, the more conventional? Photographs may not address the needs of the human eye, for example, its need to follow a movement, but this does not make them conventional. Why aren't these optical/chemical products, instead, perfect images of some aspect of reality, images wholly unmediated by convention? Of course, speaking here of images rather than, simply, products or artifacts of reality suggests that the photograph shows something we *might* see, when, as Rodin argues, we do not see a walking person or a running horse as depicted in photographs. Yet a photograph offers a depiction, something to be seen, and what are we to call it if not an image?

The difficulties we are circling here, in the effort to characterize the nature of the photograph or of what it captures, are plainly, if obscurely, philosophical. By comparison, Rodin's explanation of how a painting or a sculpture captures the appearance of a movement is, simply, factual, even scientific.

The philosophical difficulty Rodin confronts is not the only one posed by photographs. Photographs give rise to philosophical problems not only about their depictions of movement or motion, but about their depictions of expression or emotion as well.

The philosophical problem with depictions of expression arises not so much from the absence of a succession of moments *in* the expression in a photograph, as the absence of what preceded or follows what we see. What is missing is not simply the expression's immediate temporal or physical context, but what Wittgenstein calls the "weave of life" in which the expression is embedded. The examples that concern Wittgenstein are ordinary: in certain surroundings a look of pain is an expression of sorrow, in others a pretense.[3] With photographs our predicament is wholly out of the ordinary: we lack the surroundings necessary to apply concepts of emotion altogether. It is not just that without knowing what preceded or what follows an expression on the face in a photograph, without knowing how the look arose in the face or how it will depart, we cannot be sure whether the look is genuine or only put on. More, we cannot even be sure *what* look, genuine or pretend, it is. This can become apparent before particular photographs. Is Dr. Monro in Hill and Adamson's portrait (figure 1) captured in a moment of anger? Or is he merely meditative?

The poet Thom Gunn has remarked that the expression in a photograph is "infinitely ambiguous." This implies that the various possibilities it presents are natural, comprehensible, although none can be fixed upon. But a face in a photograph shares no part of the life of a human face. A photograph, in stilling a human face, removes it from life or removes us from our life with it. If photographs give expressions of the human face a stillness unique to

photographs, should we say that these unique expressions are expressions of human emotion, of human passion? Are they so much as expressions, so much as expressive of anything at all? It might be thought that photographs could at least capture looks that express emotion in or by their very fixity. But even the fixity of looks of sternness or anxiety or fatigue or bemusement or absorption, as these looks enter our everyday lives, is not the indefinitely prolonged stillness of looks in photographs. No matter how long the face in a photograph is studied, it remains fixed, still. Its expression is wholly taken up in the photograph's stillness. The stillness of the photograph, not any natural fixity, gives whatever there is of expression to the photographed face.

Both with photographs depicting movements and those depicting expressions, philosophical difficulties arise from a singular feature or fact of the photograph, its stillness. The photograph's stillness presents itself as a philosophical problem, and it does so whether we are attempting to characterize in general terms the nature of the photograph's image or whether we are attempting to describe or respond to a particular image.[4] The fact that philosophical difficulties arise in the effort to characterize in general terms the nature of the photograph's still image suggests that these difficulties are defining of its stillness, hence that the stillness of photographs may not be that of paintings or of sculptures, which do not in the same ways give rise to philosophical difficulties with their depictions. But the fact such difficulties also arise in efforts to describe or respond to particular photographs suggests that their stillness is not just a philosophical problem that arises in general accounts of their nature, but a persistent, problematic feature of their appearance, and this in turn suggests that the difficulties presented by photographs have no single, general resolution. Whatever their fate in philosophy, the difficulties presented by the still images of photographs remain in our responses to these images. Individual photographers cannot escape these difficulties. They can make photographs in which the stillness of their images is given specific significance, in which it appears to capture a moment of stasis within movement or a particular possibility of expression or a particular absence of expressiveness, but what in each case they must give significance, what gives its own cast to whatever moments or expressions or inexpressiveness they capture, is the singularly, persistently problematic stillness of the photograph.

A place to study some of the difficulties I have been tracing—whether photographs can be art, whether they can capture human expression—is in the work of Paul Strand (1890–1976), the subject of a major retrospective that opened in December 1990 at the National Gallery of Art.

Strand's concerns typically are taken, by his admirers and his critics alike, to be technical or formal. Beaumont Newhall describes Strand's early photographs as "prophetic . . . of the return to the traditions of straight photography" after the dominance of pictorialism, thus emphasizing the sharp focus and absence of manipulation in his early work.[5] Hollis Frampton and Alan Sekula criticize Strand for his preoccupation with the craftsmanship of photography and for his aestheticism.[6] No doubt, as Newhall argues, it is Strand's

formal innovations that anticipate or most influence the concerns of photographers after the First World War.[7] Yet Strand did not himself describe his concerns simply as formal or technical, but also as concerns with particular subject matter. In an interview in 1971 he remarked that his early work, which he claimed gave shape to the preoccupations of his later work as well,

> grew out of a response to, first, trying to understand the new developments in painting; second, a desire to express certain feelings . . . about New York where [he] lived; third, another equally important desire . . . to see if [he] could photograph people without their being aware of the camera.[8]

What needs to be made clearer is not just the nature, I might say the depth, of Strand's objection to such practices as the use of soft focus in earlier pictorial photography, but the bearing of these formal concerns on his efforts to realize certain subjects.

Paul Strand was seventeen when in 1907 he first visited the Little Galleries of the Photo-Secession.[9] Alfred Stieglitz, who ran the galleries, had coined the name "Photo-Secession" for the loosely organized group of photographers and others who shared his commitment to individual expression in pictorial photography. In 1903 he had begun publishing the quarterly magazine *Camera Work* as the official journal of the Photo-Secession, presenting articles on photography and art, reviews of exhibitions, and gravure or halftone reproductions of photographs, drawings, and paintings. He opened the Photo-Secession Galleries in 1905, and here and in "291," as his gallery was called after it was relocated in 1908, he exhibited not only photographs by the American Photo-Secessionists, notably, Alvin Langdon Coburn, Gertrude Käsebier, George Seeley, Eduard Steichen, and Clarence White, but works by European pictorial photographers and drawings, graphic works, watercolors, paintings, and sculpture by Brancusi, Braque, Cezanne, Matisse, Picabia, Picasso, and Rodin. The gallery 291 also introduced the work of the American painters John Marin and Arthur Dove. Strand's first visit to Stieglitz's gallery was with a high school photography class; after 1913 he began frequenting the gallery, and it was in its exhibitions and in the quarterly magazine *Camera Work* that he encountered the work, both in photography and in painting, that most deeply informed his early photographic efforts.

In 1916 Stieglitz exhibited some of Strand's photographs, presenting his work concurrently with an exhibition of Modern American Painters at the Anderson Gallery in New York. This was the first exhibit Stieglitz had given any photographer since 1913, and he likened his gesture of juxtaposing Strand's photographs and the paintings at the Anderson Gallery with his presenting, three years earlier, a show of his own photographs at 291 simultaneously with the International Exhibition of Modern Art at the 69th Regiment Armory. Stieglitz apparently thought that apart from his own accomplishments in photography, only Strand's stood comparison with the modern painting and sculpture he most respected. After the exhibition of Strand's work at the gallery 291, Stieglitz reproduced seventeen photographs by Strand in two numbers of *Camera Work*.

The eleven, black-bordered images published in the second number, confident in their repudiation of the pictorial work the magazine had represented for fourteen years, foretell *Camera Work*'s demise. Stieglitz did not publish another number of the magazine.

Strand's work owes much to *Camera Work*. The magazine represented the present of photography for Strand as it did for others interested in photography as an art. For Strand it also represented the tradition of photography. The magazine did not fully give "the whole development of photography," as he claimed in one of his occasional essays.[10] David Octavius Hill and Robert Adamson, Julia Margaret Cameron, and Frederick Evans are the only photographers whose work appears in *Camera Work* and who are not contemporary with its publication.[11] But in *Camera Work* Strand did find a history, however, incomplete, of various attempts and discoveries in photography. *Camera Work* and the exhibitions at Stieglitz's galleries presented a body of work, past and present, from which Strand could select high achievements of photography and in which he could begin to work out—by study of his predecessors' successes and failures—the strengths and limitations of photography.

Strand's singularity, his individual achievement, arose from his effort to realign the present of photography—what he saw to be its present possibilities— with achievements of its past.[12] In part this meant for Strand freeing photography from painting, since painting had become the predominant inspiration or source for the subjects, composition, and methods of many pictorial photographers. Strand had to free photography from what had come to be its pictorial ambitions, ambitions that had led photographers to the use of soft focus and to subjects removed from the everyday, for example, nostalgic scenes of work or leisure in country settings or scenes of vaguely allegorical or narrative import (figure 2).

In interviews late in his life Strand remarked that a leading preoccupation of his early work was "to express certain feelings [he] had about New York," "to see whether one could photograph the movement in New York—movement in the streets, the movement of traffic, the movement of people walking in the parks."[13] He cites in this connection the first and last of his photographs reproduced in the next to last number of *Camera Work* (figures 3 and 4). The third of his photographs in this number (figure 5) also fits his description.[14]

Strand's preoccupation with movement in the streets and parks of New York is a preoccupation with the movement or life of this particular city, a preoccupation with what was for Strand the everyday life of his present, the everyday as he knew it. This preoccupation with the everyday, ordinary life of New York marks the point at which Strand's work was most deeply indebted to that of Alfred Stieglitz, specifically to Stieglitz's photographs of city streets (figure 6), most notably, the photographs he titled *Snapshot—From my Window* (figure 7). In this last series we find the same high viewpoint that we find in Strand's photographs of streets and parks. We also find similar subjects— urban streets and the people walking on the streets. In calling these photographs "snapshots," Stieglitz calls attention to the fact that the scenes and activity

they capture are everyday scenes and activity. And in declaring that these photographs are taken from his window, Stieglitz calls attention to two facts: first, that these views are not arbitrary, but chosen precisely because they are *his* views, the views he has on his world; and second, that in taking these views, he has not altered by his presence, that is, by the presence of his camera, the course of the activity he captures. This second fact is a fact of Strand's photographs of city streets as well, declared in their high viewpoints. It also is a significant fact and, indeed, an explicit concern of other of Strand's photographs that I will discuss later. The first fact I noted, that Stieglitz's "snapshots" are views that he takes precisely because they are *his* views, makes Stieglitz's subjects out to be subjects of his everyday life, the life of his present, again exemplifying a concern with what Strand called "the immediate world around [us]."[15] The concern marks Stieglitz's and Strand's departure from tendencies in pictorial photography to seek subjects in the past, specifically, in painting of the past (figure 8), or to seek subjects of an indefinite temporality (figure 2). But the contrast here, especially between Strand's work and that of earlier pictorialists, is deep and complex. It is not a simple difference in subject matter, not simply a matter of Strand being interested in the everyday and the pictorialists being interested in other subjects. The idea I wish specifically to propose in this connection is that the use of soft focus by pictorial photographers, integral to certain of their subjects, may not simply be dictated by their subjects, but may itself dictate them.

Soft focus is a simple means of unifying a picture, unifying it by blurring and merging objects and flattening out pictorial space. To speak here of a picture and of requirements of unifying a picture is to speak of a preoccupation or intention of pictorial photographers that lies at least as deep as their interests in any particular subject matter. What a pictorial photographer wished to make, what by calling himself a pictorial photographer he declared himself to be seeking to make, were pictures.

In addition to meeting strictly pictorial demands, soft focus can satisfy certain expressive demands that also arise from the pictorialists' wish to make works of art, at any rate works of beauty. For example, soft focus in a portrait such as Alvin Langdon Coburn's *A Portrait Study* (figure 9) generalizes features of the face and generalizes its attitude or pose. Soft focus here does not just unify the picture, but does so in part by generalizing the expression and the emotion of the face, by generalizing its expressiveness altogether. More specifically, soft focus casts an aura of emotion over the particularity of expression in the human face, over the expressiveness of its features and its attitudes, thus offering what looks to be a means of approaching in photographs the universal, timeless beauty of paintings of the human face and figure. I might put what is at issue here this way: A painter can make a face or figure of perfect beauty. That, at any rate, is a myth of painting, as old as Pliny's story of Zeuxis choosing five maidens as models for different parts of a painting of Hera. But a photographer, left with the imperfect beauties of this world, might think that if he is offered no perfect beauty to be captured in a photograph, he can at

least make a photograph that obscures the imperfections of the human face
and figure, that casts over these imperfections an aura of emotion, and that by
doing both achieves for itself a condition of timeless, universal beauty.—The
pictorialist seeks to realize an image of human spirituality by obscuring, by
overwhelming, the fact of our materiality altogether.

I have described the pictorial photographer's motivations naturalistically.
That is, I have described these motivations as in part an attempt to accommodate
the *natural* imperfections of human faces and figures. That may in fact be how
pictorial photographers thought of their efforts. But soft focus also provided a
solution of a yet deeper problem, the problem I described earlier as inherent in
the stillness of the photograph's image: namely, that expressions and gestures
are given an unnatural stillness in photographs, that the life expressions and
gestures have in the human face and figure is not present in the photographed
face and figure. This absence of their life and of their identity is not a *natural*
imperfection of expressions and gestures; it is not a failing to which they are
naturally subject. Rather it is a feature of photographs. But it is a feature that
also needed to be accommodated or overcome if photographs of the human
were to achieve the universal, timeless beauty sought by the pictorialists. In
casting what I called an aura of emotion over the human face and figure, soft
focus imposes a life of its own on the face and figure. It overcomes doubts that
we might otherwise have about *what* expression, *what* gesture, we are seeing.
It removes our doubts about what emotion lives in a photographed face or a
photographed figure by removing the face or figure from its natural life and
setting altogether and substituting its own remove for that of the photograph's
stillness. The pictorialists may have thought of the virtues of soft focus in
other terms, but if it had not overcome the unnatural stillness of photographed
human faces and human figures, as well as the natural imperfections of human
faces and figures, it would not have worked to the pictorialist's end: to realize
pictures of a universal, timeless beauty.

There is a further way that soft focus might be thought to satisfy a de-
mand imposed by the very ambition to make significant pictures, a demand that
is perhaps neither strictly pictorial nor expressive although it may appear in
particular instances to be one or both. Since soft focus need not be evenly dif-
fuse over the entirety of a picture, it can offer a means of creating a foreground
or a focus of attention.

An example of such a use of soft focus is Eduard Steichen's *Portrait
of Clarence H. White* (figure 10). The pictorialists employed other means of
creating a foreground or focus of attention—in particular, they sometimes cast
a background into shadow, using light to capture or to focus attention, or they
scratched in or brushed in a background, again, as in the use of soft focus
discussed just previously, creating an aura, an atmosphere, surrounding the
foregrounded objects. And as is the case in Steichen's portrait, the pictorialist
might combine soft focus with one of these other means. Steichen's portrait
also illustrates the way that the use of soft focus in question might serve both
pictorial ends—in creating a focus of attention in the picture—and expressive

ends—in singling out the eyes of the sitter, focusing our attention on their expressiveness.

I can now say how I think the use of soft focus contributes to, dictates, pictorial photographers' choice and treatment of their subjects. I noted that the subject of Stieglitz's "snapshots" and of Strand's photographs of New York—namely, the everyday life of their present—contrasts with tendencies in pictorial photography in general towards subjects removed from the present, subjects that are, for example, nostalgic or vaguely allegorical. In a great many pictorial photographs we find people posed, dressed in costumes, placed in settings that are artfully contrived or, if the settings are in nature, artfully etherealized. An example here is a photograph by George Seeley reproduced in the July 1906 number of *Camera Work* (figure 11), in which a woman, dressed in a white gown and a dark robe, stands or walks on a path in a hazy, dissolving landscape. The effect is of a scene taken from romance or from a poem or tale of a fictional past. What I wish to suggest about the way the use of soft focus contributes to the pictorialists' choice and treatment of their subjects is this: Soft focus, as I have been arguing, satisfies certain demands, pictorial or expressive or otherwise, that arise from the ambition of pictorial photographers to make significant pictures, specifically, pictures that would have the significance of paintings. But soft focus places its own demands. In surrounding the human subject with an aura of emotion, it gives the human face and the human figure an indefinite setting, and this in turn works to theatricalize the human or to call for, demand, a theatricalization of the human.

Lacking particular expressiveness, the human face or the human figure in a soft focus photograph needs to be given a dramatic or extreme pose or attitude, one that can be seen through the haze of soft focus. (The pose might yet be simple: a woman standing, head lowered.) Soft focus *gives* a setting to the human face, to the human figure, and to human activity. It gives them a setting rather than discovering them in the world. No doubt pictorial photographers on occasion wanted to depict subjects that themselves called for poses, costumes, and artificial or etherealized settings, subjects that in turn demanded soft focus.[16] But if soft focus itself satisfies—at least superficially—certain demands arising from the very ambition to make significant pictures, pictures that would have the significance of paintings, then the pictorialists' use of soft focus might have been dictated by this ambition prior to any choice of subject. In that event the sorts of poses, costumes, and settings that we find in pictorialist photographs, hence the sorts of subjects that would allow such poses, costumes, and settings, would have been demanded by the use of soft focus, by the theatrical setting—the impression of a setting altogether—created by soft focus.

A second preoccupation of Strand's early work, also mentioned in the interviews I have cited, arose from his attempt "to understand the new developments in painting."[17] What Strand learned from the new painting might be described as certain techniques of composition, more generally, certain techniques of abstraction. But to describe what he learned in these terms is

somewhat simplistic since he had to discover means by which he could realize in photographs the sorts of abstraction he had seen in paintings, means specifically different from those employed in abstract painting. We yet can speak of some of his early photographs and of some photographs he made later in his life as exhibiting a flattening of pictorial space characteristic of abstract painting, often a flattening achieved by characteristically cubist juxtapositions of planes parallel to the picture plane. An example is the seventh photograph reproduced in the last number of *Camera Work* (figure 12). The juxtaposition of parallel or seemingly parallel planes to flatten and to unify pictorial space is one element of this photograph that invites a comparison with cubist practices of composition. Again, Strand's juxtaposition of areas with similar textures (the horizontal lines of the building and of the roof behind it) to create an impression of parallel planes might be compared with Braque's and Picasso's use of collage, and his inclusion of the "Garage" sign in the upper left corner and of the billboard in the lower right corner might also be compared with their use of lettering and of bits of newspapers pasted to the surface of their paintings to flatten out pictorial space.[18]

There is yet a further, more important, reason why it is too simplistic to speak of what Strand learned as certain *techniques* of abstraction. This is suggested in Strand's claim that in attempting to make abstract photographs of what he termed "object matter... such as kitchen bowls, cups, plates..." and so on (figure 13), he "learned... what the painters were doing... and that no matter what is included, that unity must be there and be continuous."[19]

Beyond anything to be called techniques of composition or abstraction, Strand's attempts to make abstract photographs required a more explicit understanding than he had previously of the nature and of the importance of pictorial unity. Soft-focus, as he remarked late in his life, can unify pictures, "pull things together," but only because it "flattens and mushifies."[20] His attempts at abstraction provided him a number of alternative methods of flattening pictorial space in a photograph and of unifying it; but more, with these methods he gained confidence that a photograph could be unified without obscuring what he called the "individual qualities"[21] of objects. What Strand finally learned about pictorial unity was that it did not have to be achieved at the expense of "objectivity."[22] It is this lesson that in time allowed him to abandon soft focus altogether.

What Strand means by "objectivity," with objects such as kitchen bowls, is no doubt what a sharper focus immediately offers: the possibility of preserving their particular identity, that is, their physical appearance. (Although, as in figure 13, the identity or appearance of objects can also be obscured in the compositional drama of abstraction.) But Strand's desire for objectivity takes on a special, and especially problematic, significance with his portraits in the last number of *Camera Work*. Naomi Rosenblum's description of these portraits as conveying a "sense of the heightened reality of the object" perhaps means to suggest something of this.[23] But more simply, Strand's express intention of making candid portraits, which we might also describe as a wish for

"objectivity," plainly goes beyond a desire to preserve the particular identity or the physical appearance of his subjects.

Strand's portraits, that is, what I will call portraits, in the last number of *Camera Work* (figures 14–19) were made with a camera which he had modified so that while it appeared he was pointing the camera in one direction, he in fact could take a picture of someone to his side. The photographs that resulted were more than striking. They were shocking, surprising in their power. They also were comical.

The first photograph is of a fat, ruddy woman, unembarrassedly yawning. The second is of a fat man on a bench, looking to his side, who appears startled or slightly frightened. The third is of a blind woman, with a sign designating that she is blind and a badge designating that she is a licensed peddler. The fourth is of an old woman, looking down past her shoulder. The fifth is of the face of a man who again looks slightly frightened. The sixth is of a bearded man carrying sandwich boards.

The shock of these photographs in the context of the work that had preceded it in *Camera Work* is due not so much to a change in technique from earlier pictorial portraits as to a radical departure in subject. The first photograph, the yawning woman with a darkened face, is a jarring departure from and parody of the artistically lit and posed photographs that had appeared in *Camera Work* to this date. Her unkempt clothes, her heavy, unattractive body and face, her yawn, her lack of every grace of the elegant women, women of wealth or liveliness, who had appeared earlier in *Camera Work*—every feature is a departure from the past, perhaps even a yawn at the past, a deliberate and open rebellion, prompting a laugh. The humor in Strand's rebelliousness also touches the puzzlement or puzzled fright of the fat man with the cane and the blindness of the blind woman. Yet the yawning woman is eminently alive, and a sympathy and humanity informs the portraits of the man with the cane and the blind woman. With the old woman looking down, the depth of Strand's compassion and humanity appears indisputable. All these facts about Strand's portraits are immediately striking.

Our knowledge of Strand's techniques or strategies in making these portraits may tell how he captured these expressions. But from knowing this we could not foretell the impact the expressions, the subjects Strand is drawn to, have on us. There is an irony to these portraits. Strand goes to great lengths to prevent his subjects from knowing they are being photographed. What he gets are photographs of the bored, blind, frightened; photographs of people looking elsewhere than in the direction of the camera; photographs of people who apparently would not, even could not, know they were being photographed even if the camera were pointed at them without artifice.

The irony has further twists in Strand's photograph of the blind woman, a woman who could not know she is being photographed—at least could not know this from her blank eye, the eye directed at us, at the camera. But suppose that this woman can see out of her other eye, the eye that to all appearance is good. Although Strand's trick camera was meant to take pictures of people

without their knowing they were being photographed, it was nonetheless the case that these people might have seen his camera and might have seen it being used to take a photograph. So perhaps the blind woman is looking in the direction she thinks the camera is pointed, looking to see what is happening, looking to see what calls for the taking of a picture. But if the woman is looking away for this reason, then the reason she does not know she is being photographed is that she *is* aware of the camera, it draws her attention, but to something other than itself. The irony of the woman's blindness would then be about us: we would be the ones who have not seen the presence of the camera, the presence it has for this woman.

There is another irony or another level of irony in the photograph of the blind woman. Not only may this woman be only half blind—like Strand's camera—but the positions of her eyes, the blind one directed forward, the good one to the side, mimic Strand's camera. (In Strand's original trick camera the working lens was mounted at right angles to a fake lens. In a modification of this camera he used a prism so that his lens's view was at right angles to the camera's blind front.) The blind woman might even turn her apparently good eye away to convince us that she is not looking at us, the very reason that Strand directs his camera away from his subjects.

Is Strand's camera blind? It is mechanically as blind as this woman apparently is blind, that is, it is half blind, with one bad and one good lens. But is it further blind, as blind as her blank eye? The lens the camera turns to the blind woman is its actual lens. The eye the woman turns to the camera is her blank eye, her obviously blind eye. Is the camera's view through its actual lens as blind, as blank, as the woman's blank eye—This question is posed by this photograph, by the woman's eyes and by her sign, which captions this view as blind. But how is Strand's camera blind? What can't it see?—One thing it cannot see is what, if anything, this woman sees. The camera cannot so much as tell if she has sight.

The blind woman's eyes and her sign perhaps declare something true of all the portraits made with Strand's trick camera: not just that they were taken half blindly and with artifice (one lens not knowing what the other is doing), but also that every one of Strand's subjects is blind—that is, these people, but also, perhaps, these photographs, these views.

The blind woman's blank eye and her sign declare not only that she cannot see, but particularly that she cannot see us. So also the obliviousness of the fat woman's yawn is an obliviousness of us. Why does Strand go to such extremes to show that his subjects cannot see us? Might he think that anything short of these extremes would not convince us, would not convince us that these people in fact do not know they are being photographed? But then these extremes might not convince us either. The first woman might be yawning out of depths of boredom even as she sees her picture taken. And the blind woman might avert her good eye knowing that the camera is pointed at her, knowing that through the camera Strand is looking at her as we now are looking at her.

A reason I hesitate to call these photographs portraits is that they are anonymous. I do not just mean that their subjects' names are not given in their titles. Why aren't they? One reason we might offer ourselves is that these people themselves are anonymous: they are the anonymous of Strand's world, the anonymous rather than the rich, the famous, the beautiful. They are anonymous not because Strand has not given their names, but because their names do not matter. Even if Strand had given their names, they would not matter. Yet perhaps there is another reason these people—at any rate these photographs—are anonymous. These people, these photographs, might be anonymous because Strand himself wants anonymity, because he wants us to know that these people did not know they were being photographed, subject to his work. If Strand had given names, they would matter. They would matter because we might think that these were people whom Strand knew or who knew him, people who might be posing for him. So then why are these people, these photographs, anonymous? Because their names do not matter or because Strand does not want names to matter?

The need not to be seen accompanies and arises from a necessity (emblematized by a mechanical necessity of photography) to look at others in order to know anything about them. We must look, but if we are seen, what we discover may be a response to our looking, not a natural attitude of the other. Strand's predicament, which I am taking to foreshadow *our's* before his photographs, arises from his insistence that we know our views of others to be free of their responses to our looking. For us to know that our views are so free, it is not enough that they be so. How can we be sure that someone is not acting for us unless we are sure that he or she cannot see us, unless he or she shows that we are not seen?

The expressiveness of Strand's subjects—of the yawning woman, of the puzzled or startled fat man, of the face of the frightened man—offers a striking contrast with the inexpressiveness of pictorial portraits, that is, the inexpressiveness of the latters' human subjects, whatever expressiveness is given them by soft focus. But the expressions of Strand's subjects are not so much expressions of the life of these subjects as expressions to convince us that we are unseen. The countenances of Strand's subjects are wholly taken up with showing us that these people do not see us. And in this way we do not see them, we do not see what they feel when they do not have to show that no eye is on them. The fact that we need to know we are not seen—the fact that we do see the countenances or the expressions of his subjects as showing we are not seen—makes this all we see, *that* we are unseen. Our need to know we are not seen comes between us and these people, and so we are blind to the people before us. The desire to be certain that our knowledge of them is unaffected by the camera's presence—the desire to be certain that our knowledge of them is candid—stands in the way of our having any knowledge of them at all.

I have described Strand's portraits as both seeking to defeat the theatricalizations of pictorial portraiture and as theatricalizing their own subjects. In these respects they are representative of two important features of the course of the

late history of the notion of theatricality, a history traced in Stanley Cavell's work on Shakespearean drama and on philosophical skepticism, in Michael Fried's studies of French painting from the middle of the eighteenth century to Manet, and in David Marshall's accounts of the importance in eighteenth-century English and French thought of notions of theater and sympathy.[24] In the first place, theatricality in the modern period has come to denote for visual artists as well as dramatists not just a particular way in which representations of the human might fail, for example, for philosophical purposes, but the principal threat to the arts, what it is the arts must defeat if they are to remain of human interest. But, secondly, efforts in the face of this threat not just to avoid the theatrical but to bring about a perspicuously non-theatrical depiction have repeatedly, in their very address to the needs of the beholder, defeated themselves. Fried argues that when in the late 1790s Jacques Louis David criticized his *Oath of the Horatii* for its theatricality, a painting acclaimed during the preceding decade as the epitome of the compelling, that is, untheatrical, representation of human action, he did so because he had come to find action and expression "as such" theatrical.[25] But if we suppose that what threatened to make *every* action and expression theatrical, that is, every action and expression depicted in painting, was not so much their apparent exaggeration or extremity as their coming to appear directed to, meant for, the viewer of the painting, then David's revaluation of the *Oath of the Horatii* can be seen as a response to his own demand for the untheatrical, to the very fact that he had chosen the gestures and placement and expressions of the figures in the *Oath* precisely to satisfy *his* need, the need of the viewer, to be convinced by them. With time the figures had come to seem, after all, to be directed by this need, to be acting *for him*, rather than acting on their own.

In the last portrait in Strand's series there is a man carrying sandwich boards. On the board facing us we can see "[3 or 8]0 W. 18th St. / The Price / [Pay]." Is Strand, by placing this sign at the end of his series of portraits, declaring that subjects from this neighborhood are the price that has to be paid for this immediacy, this frank humanity, this directness? But the sign might also be taken to declare that these portraits are the price that has to be paid for subjects unaware they are being photographed, the price that has to be paid for unselfconsciousness. What price have we paid? The answer suggested a moment ago is that we have paid the price of our knowledge of these people, that is, what Strand, in his attempt at candidness, presumably sought. We finally are without knowledge of these people because it seemed essential to our knowledge, essential to it being knowledge of *them*, that we be certain Strand's camera was not seen by them, that we be certain his camera did not affect their lives, that it did not alter their natural attitudes, making them poses. If these portraits give us no knowledge of their subjects, do they offer us any knowledge of ourselves? It seemed essential to our knowledge of these people that we be certain the presence of Strand's camera, that is, his presence and our presence now, be unknown to them. But then one thing we

might learn from these photographs is that to have knowledge of these people we will have to let our presence be known to them.

The question of what necessities there might be of acknowledgment here, by Strand of his presence, by us of ours, parallels a question Stanley Cavell asks about theater, particularly Shakespeare's drama, namely, how the audience to a tragedy can acknowledge its passivity, so that its passivity does not implicate it in the events it views. What is demanded in theater, Cavell argues, is that we acknowledge the present of the characters' lives as their present, however "porous" our knowledge of their motivations; that we acknowledge their condition as theirs and for this reason alone out of reach of our help, an acknowledgment which we express in a particular response to their lives, our awe of them. The alternative to such acknowledgment is to fail to take the events we see as the working out of other human lives. We theatricalize the characters' lives.[26]

With photographs, our situation is in one respect similar, but in another deeply different. We can theatricalize the figures in photographs, projecting emotions upon them, fantasizing conditions of their lives rather than discovering their realities. But far from being a failure in our response to what photographs present us, this appears to be a condition of our having any response to them at all. With photographs the motivations of the figures we are presented are not just porous to us, they can seem wholly without definition. The problematic stillness of these images and the absorption of expression in this stillness can raise a question whether we can know *anything* about their motivations. If the images of humans in photographs lack a before and after, if they are removed from the contexts in which our concepts of emotion and of motivation and hence our knowledge of others find their hold, then it would appear we can only ascribe as much motivation, as much inner life, to the figures in these images as we impose on them. We must fantasize their lives, or they have none.

Out of his wish for candid portraits, portraits revealing the truth of his subjects, Strand attempts to prevent his role in their taking from being seen, as if knowledge of it would implicate him in his subjects' lives, distorting their truth. The wish, so fraught, cannot be satisfied. Since Strand was present, he might have been seen; since nothing in these portraits declares his particular presence, his taking of them, nothing can assure us it has not affected their subjects. So he and we never can be sure the looks we see are not meant for us, that they are not poses for or evasions of Strand's camera. The candidness Strand seeks in these photographs, the assurance that his subjects' looks have not been affected by his wish to capture them, cannot be attained. Strand's failure to achieve unquestionably candid portraits can be accounted to his failure to acknowledge his presence. It also can be accounted to his failure to acknowledge, at least in his wish for the candid, the stillness of his photographs. We cannot know how the stilled looks we see came into the faces in Strand's photographs, nor how they leave them.

What knowledge, if any, photographs can give us of their human subjects remains to be worked out, in other photographs than these. What I earlier

remarked as a lesson of Strand's portraits in *Camera Work*, that to have knowledge of his subjects, we will have to let our presence be known to them, is a lesson learned in Strand's later work: specifically, the photographs of people, dwellings, and landscapes that from 1940 he gathered into book-length portraits of the inhabitants of a country or region or village. In the worlds, for example, of *Tir a'Mhurain* (1962) and *Living Egypt* (1969) Strand's subjects face the camera, revealing themselves (figure 20). But this is only the beginning of a story. Strand could not avoid the failing of his earlier portraits, he could not avoid theatricalizing his subjects, simply by letting them see his camera. To say that his subjects in his later work face the camera, revealing themselves, is merely to set terms for an account, yet to be given, of these portraits. What awaits telling is what is revealed, in Strand's later books, of these people and their worlds.

NOTES

1. I have read drafts of this essay at the Yale School of Art, Vassar College, the Southwest Regional Conference of the Society for Photographic Education, and the Midwest Philosophy Colloquium. I would like to thank Andrew Forge, Barbara Jo Revelle, and Pieranna Garavaso for their invitations and all those who have offered comments on one or another draft of the essay, particularly Stanley Cavell, Joel Eisinger, and Harry Frankfurt.

2. Paul Gsell, *Rodin on Art*, translated by Romilly Fedden (New York, 1971), 75–76.

3. See Ludwig Wittgenstein, *Zettel*, edited by G. E. M. Anscombe and G. H. von Wright, translated by G. E. M. Anscombe (Berkeley, 1967), § 534; Ludwig Wittgenstein, *Last Writings on the Philosophy of Psychology*, vol. 1, *Preliminary Studies for Part II of Philosophical Investigations*, edited by G. H. von Wright and Heikki Nyman, translated by C. G. Luckhardt and Maximilian A. E. Aue (Chicago, 1982), § 861. The expression "weave of life" is from Wittgenstein, *Last Writings*, § 862.

4. For a fuller discussion of the philosophical difficulties that arise in our responses to and efforts to account for the still image of photographs, see my *Photograph and Philosophy*, Harvard Dissertations in Philosophy, edited by Robert Nozick (New York, 1990).

5. Beaumont Newhall, *The History of Photography: From 1939 to the Present*, rev. and enl. ed. (New York, 1982), 1973–74.

6. Hollis Frampton, "Meditations around Paul Strand," in *Circles of Confusion: Film Photography Video, Texts 1968–1980* (Rochester, N.Y., 1983), 127–36; Alan Sekula, "On the Invention of Photographic Meaning," *Artforum* 13 (January 1975): 43. See also Alan Trachtenberg, "Camera Work: Notes Toward an Investigation," *Massachusetts Review* 19 (Winter 1978): 836.

7. This was apparent in the recent exhibition "The New Vision: Photography between the World Wars," prepared by Maria Morris Hambourg of the Metropolitan Museum.

8. *Paul Strand: Sixty Years of Photographs* (Millerton, N.Y., 1976), 144.

9. For historical information about Strand's work see "Excerpts from Correspondence, Interviews, and Other Documents," in *Paul Strand: Sixty Years*, 141–73; Naomi Rosenblum, *Paul Strand: The Early Years, 1910–1932* (Ann Arbor, Mich., 1978); and the title essay by Naomi Rosenblum in the catalog *Paul Strand: The Stieglitz Years at 291 (1915–1917)* (New York, 1983). For more general information, see Newhall, *The History of Photography*, 140–78. A list of Stieglitz's exhibitions in The Little Galleries of the Photo-Secession, which from 1908 were called "291," can be found in Sue Davidson Lowe, *Stieglitz: A Memoir/Biography* (New York, 1983): 429–33. All the plates of *Camera Work* are reproduced in Alfred Stieglitz, *Camera Work: A Pictorial Guide*, edited by Marianne Fulton Margolis (New York, 1978); indices to the editorial matter, articles, and reviews in *Camera Work*, as well as to its plates,

are in *Camera Work: A Critical Anthology*, edited by Jonathan Green (New York, 1973): 353–76.

10. Paul Strand, "Photography," in *Photographers on Photography*, edited by Nathan Lyons (Englewood Cliffs, N.J., 1966), 136. This essay was originally published in *Seven Arts* (August 1917).

11. *Camera Work* also did not contain the work of every contemporary of Strand who might have influenced him. In particular, *Camera Work* did not present any work by Lewis W. Hine, who taught Strand photography at the Ethical Culture School and who first took Strand to Stieglitz's Little Galleries of the Photo-Secession. There is a similarity of subjects in Hine's and Strand's early portraits: both photographed ordinary people, people encountered on New York's streets. But Hine's work differs importantly in its treatment of its subjects and in its intentions from Strand's early work. Strand's photographs are not so much political or social documents as attempts to capture the human in photographs that could stand with works of art. Strand does not mention Hine in his writings on photography, and it is not clear that he knew any of Hine's work. The similarity of their work may have derived simply from their independent concerns, which converged on similar subjects.

Recent writing on Stieglitz and the work he promoted in *Camera Work* has sought to point up a conflict between Stieglitz's formalism and the social and ideological concerns of Lewis Hine. See Sekula, "On the Invention of Photographic Meaning," 36–45, and Trachtenberg, "Camera Work," 834–58. I believe that Strand's *Camera Work* portraits, by presenting everyday, in some cases evidently impoverished, inhabitants of New York, reject the prevailing subjects of pictorial photography. This may suggest that Strand saw a conflict between the preoccupations of pictorial photographers and certain humanistic concerns that he sought to introduce into photography. But as I already have suggested, Strand's humanism in his early portraits is not Hine's. Whether and how Strand aestheticizes the human condition, as Sekula and Trachtenberg suggest, is something that cannot be assessed until we have a fuller account of Strand's humanism. In my discussion of his early portraits at the end of this essay I examine his concerns with the candid and the anonymous, concerns with what photographs can reveal of their human subjects.

12. Strand repeatedly praised in his writings the portraits of David Octavius Hill, some of which are similar in treatment, if not in subject, to Strand's early portraits. See, for example, David Octavius Hill [and Robert Adamson], *Dr. Monro* [Monro], *Camera Work* 11 (April 1905): 5 (figure 1); David Octavius Hill [and Robert Adamson], *Mrs. Rigby*, *Camera Work* 28 (October 1909): 13; and David Octavius Hill [and Robert Adamson], *Lady in Flowered Dress*, *Camera Work* 37 (January 1912): 31.

13. *Paul Strand: Sixty Years*, 144.

14. The preoccupation with the everyday, ordinary life of his present appears as well in other of Strand's early photographs, including the portraits reproduced in the last number of *Camera Work*. See my discussion below of the last of these portraits (figure 19).

15. Paul Strand, "The Art Motive in Photography," in Lyons, *Photographers on Photography*, 154. "The Art Motive in Photography" was originally published in the *British Journal of Photography* 70 (1923): 612–15.

16. Demanded it not just to etherealize settings, but for reasons similar to those I have given: namely, to unify the picture, to heighten and at the same time to simplify or to universalize the picture's expressiveness, and to create a focus or a foreground of attention.

17. *Paul Strand: Sixty Years*, 144. Strand mentions Picasso, Matisse, Braque, and Léger.

18. Strand's "cubism" also is discussed by Rosenblum in *Paul Strand: The Stieglitz Years* and in Van Deren Coke, "The Cubist Photographs of Paul Strand and Morton Schamberg," in *One Hundred Years of Photographic History: Essays in Honor of Beaumont Newhall*, edited by Van Deren Coke (Albuquerque, 1975): 35–42.

19. *Paul Strand: Sixty Years*, 144, 145.

20. Ibid., 142.

21. Ibid.

22. Strand, "The Art Motive of Photography," 147.

23. Rosenblum, *Paul Strand: The Early Years*, 137.

24. See Stanley Cavell, "The Avoidance of Love: A Reading of *King Lear*," in Stanley Cavell, *Must We Mean What We Say?* (Cambridge, 1976), 267–353; Michael Fried, *Absorption and Theatricality: Painting & Beholder in the Age of Diderot* (Berkeley and Los Angeles, 1980), and "Thomas Couture and the Theatricalization of Action in 19th Century Painting," *Artforum* 8 (June 1970); 36–46; and David Marshall, *The Figure of Theater: Shaftesbury, Defoe, Adam Smith, and George Eliot* (New York, 1986) and *The Surprising Effects of Sympathy: Marivaux, Diderot, Rousseau, and Mary Shelley* (Chicago, 1988).

25. Fried, "Thomas Couture," 41–42.

26. Cavell, "The Avoidance of Love," 337–39.

Figure 1. David Octavius Hill [and Robert Adamson],
Dr. Munro [Monro]. *Camera Work* 11 (July 1905): 5.

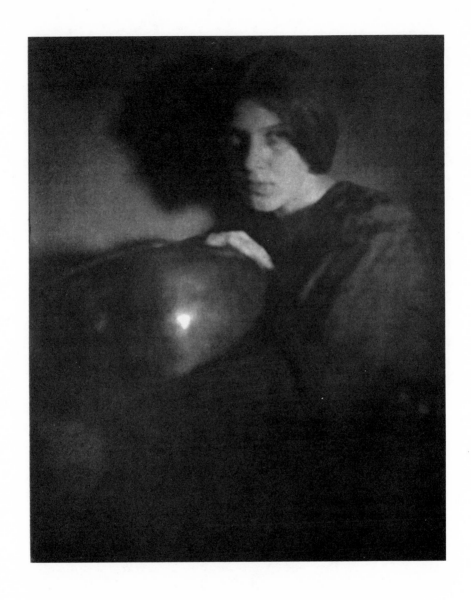

Figure 2. George H. Seeley, *Girl with Bowl. Camera Work* 29 (January 1910): 5.

Figure 3. Paul Strand, *New York*. *Camera Work* 48 (October 1916): 25.

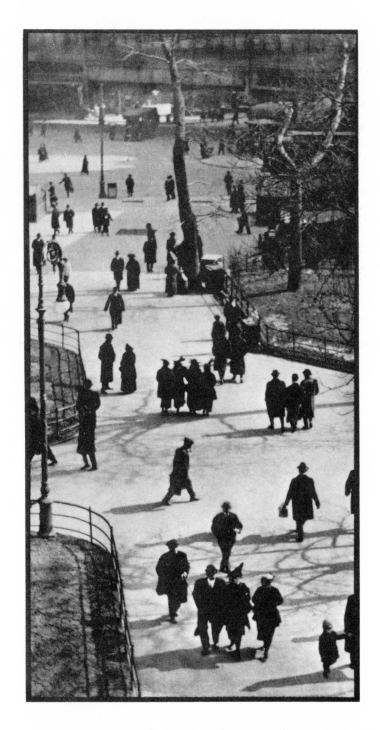

Figure 4. Paul Strand, *New York. Camera Work* 48 (October 1916): 35.

Figure 5. Paul Strand, *New York. Camera Work* 48 (October 1916): 29.

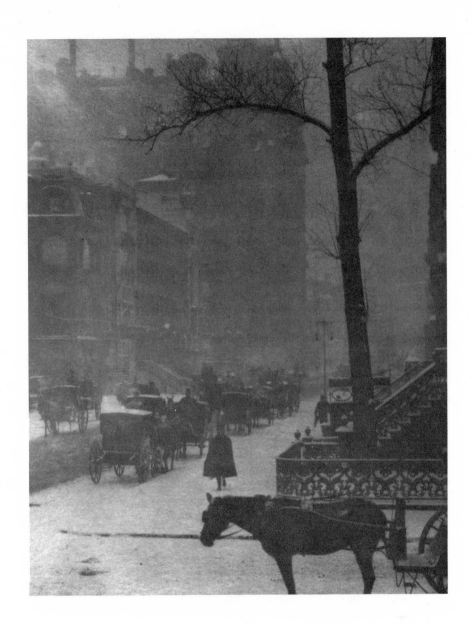

Figure 6. Alfred Stieglitz, *The Street—Design
for a Poster. Camera Work* 3 (July 1903): 47.

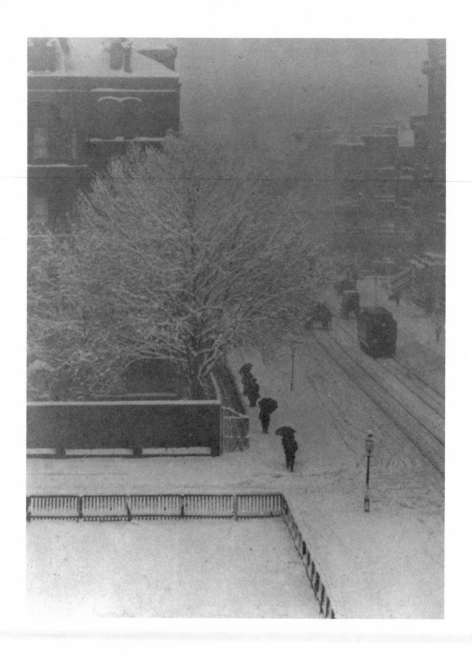

Figure 7. Alfred Stieglitz, *Snapshot—From my Window,
New York. Camera Work* 20 (October 1907): 41.

Figure 8. Clarence H. White, *Letitia Felix*. *Camera Work* 3 (July 1903): 7.

Figure 9. Alvin Langdon Coburn, *A Portrait Study. Camera Work* 6 (April 1904): 7.

Figure 10. Edward Steichen, *Portrait of Clarence H. White. Camera Work* 9 (January 1905): 15.

Figure 11. George Seeley, *No Title. Camera Work* 15 (July 1906): 39.

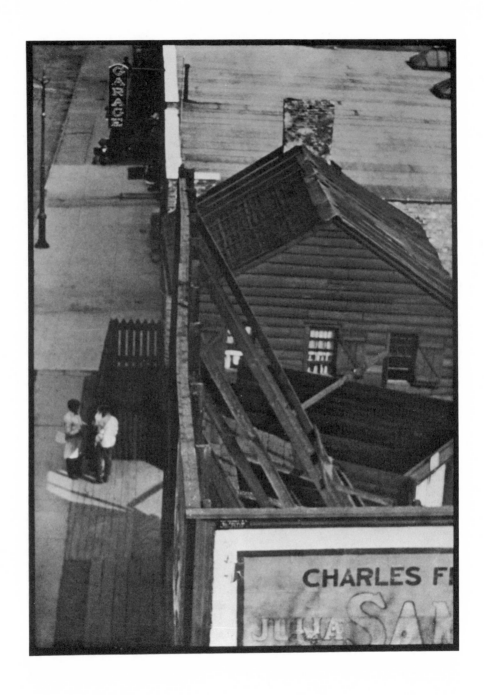

Figure 12. Paul Strand, *Photograph—New York. Camera Work* 49/50 (June 1917): 21.

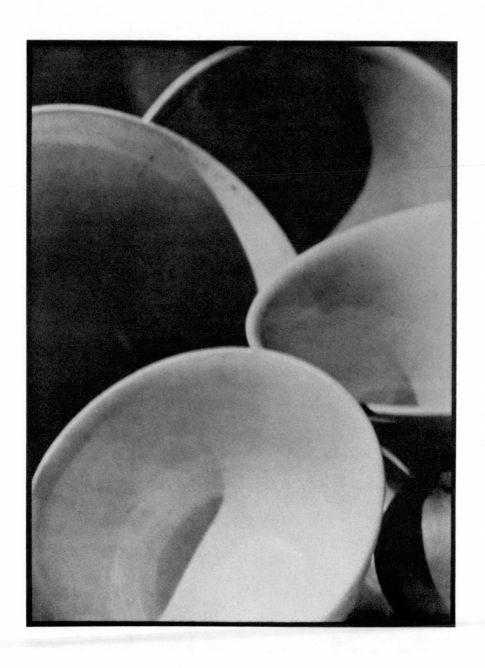

Figure 13. Paul Strand, *Photograph*. *Camera Work* 49/50 (June 1917): 29.

Figure 14. Paul Strand, *Photograph—New York. Camera Work* 49/50 (June 1917): 9.

Figure 15. Paul Strand, *Photograph—New York*. *Camera Work* 49/50 (June 1917): 11.

Figure 16. Paul Strand, *Photograph—New York*. *Camera Work* 49/50 (June 1917): 13.

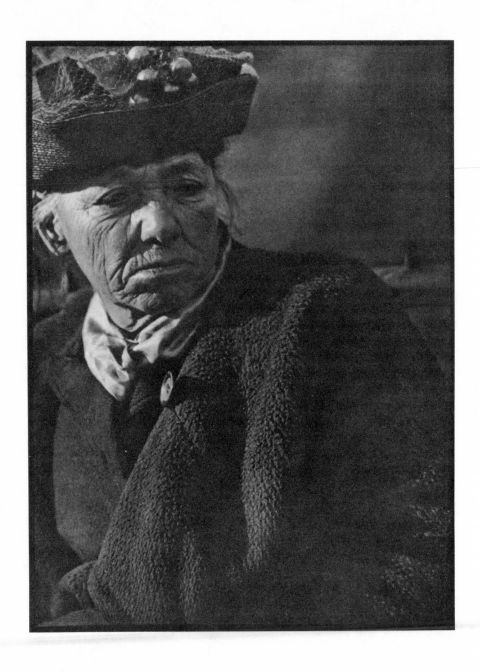

Figure 17. Paul Strand, *Photograph—New York*. *Camera Work* 49/50 (June 1917): 15.

Figure 18. Paul Strand, *Photograph—New York. Camera Work* 49/50 (June 1917): 17.

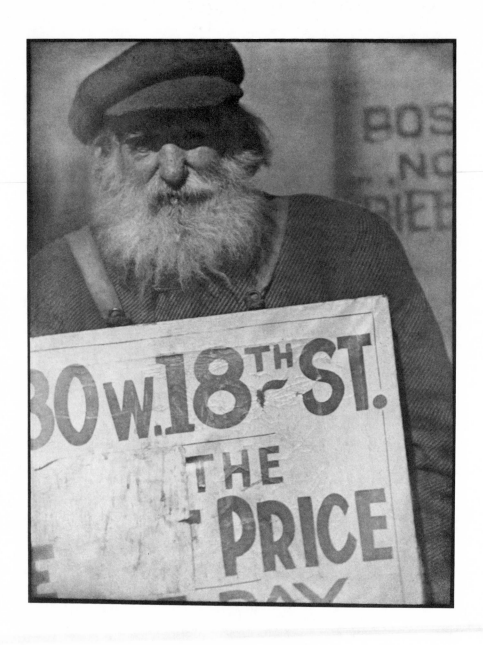

Figure 19. Paul Strand, *Photograph—New York*. *Camera Work* 49/50 (June 1917): 19.

Figure 20. Paul Strand, *Mrs. Mary McRury, South Uist, Hebrides,*
1954. Reproduced from Paul Strand and Basil Davidson,
Tir a'Mhurain (London: MacGibbon & Kee, 1962), 98.

Rules of Proportion in Architecture

PATRICK SUPPES

The ancient Roman architect Vitruvius begins the second chapter of the first book of his *The Ten Books on Architecture* with the statement that architecture depends on order, arrangement, eurythmy, symmetry, propriety, and economy. Although the other works on architecture from the ancient world are mostly lost, there is every reason to believe that Vitruvius was stating a commonly and widely accepted view in his emphasis on order, eurythmy, which we may think of as proportion, and symmetry. In the first chapter of Book 3, he also makes the familiar classical assertion that the principles of proportion and symmetry used in architecture are in fact derived from the symmetry to be found in the shape of the human body. He even states his conclusion this way: "Therefore, since nature has designed the human body so that its members are duly proportioned to the frame as a whole, it appears that the ancients had good reason for their rule, that in perfect buildings, the different members must be in exact symmetrical relations to the whole general scheme" [Dover edition, 1960, p. 73].

In Chapter III of Book 6, Vitruvius gives specific rules for the proportions of principal rooms; I cite three typical cases.

> In width and length, atriums are designed according to three classes. The first is laid out by dividing the length into five parts and giving three parts to the width; the second, by dividing it into three parts and assigning two parts to the width; the third, by using the width to describe a square figure with equal sides, drawing a diagonal line in this square, and giving the atrium the length of this diagonal line. [177]

> Peristyles, lying athwart, should be one third longer than they are deep, and their columns as high as the colonnades are wide. Intercolumniations of peristyles should be not less than three nor more than four times the thickness of the columns. [179]

> Dining rooms ought to be twice as long as they are wide. The height of all oblong rooms should be calculated by adding together their measured length

and width, taking one half of this total, and using the result for the height. [179]

There is, however, an important point about these proportions and the concept of symmetry that Vitruvius is using that should be made explicit. In the preceding chapter of the same book Vitruvius has this to say about symmetry.

> There is nothing to which an architect should devote more thought than to the exact proportions of his building with reference to a certain part selected as the standard. [174]

The meaning of symmetry here and elsewhere in Vitruvius is not in the sense of symmetry as used in modern mathematics and physics but in the related but different sense of using a given measure as a unit of proportion. Thus the proportional relationships between various dimensions of a room or of the house itself should satisfy simple relations of proportionality. These relations need not be those of commensurability as the passage stated above about the diagonal of the square makes clear. Simple proportions can lead immediately to quadratic equations. A famous example is the Golden Section or Golden Rectangle: the width is to the length as the length is to the sum of the width and length. Vitruvius states in various places that of course it is necessary to deviate from a single set of rules of symmetry or proportion, perhaps because of the nature of the site, or perhaps because of perceptual illusions, as in the case of oars half placed into the water. Adjustments for such perceptual phenomena has a long and important tradition in ancient architecture, and Vitruvius certainly makes a place for it. On the other hand, it is obvious that an architect was expected to have explicit principles of proportion in mind in constructing a building, and to be able to defend for a particular site and particular building, the principles of proportion he adopted. It should be noted that there has been a small industry over a good part of this century and some of the last, in attempting to impose a single theory of symmetry or proportion on a great variety of ancient buildings ranging from famous temples to ampitheatres and villas. It is fairly obvious upon examination that no single concept of proportion will account for the relationships of size to be found in the dimensions of a building or in the proportions of rooms, but it does not mean that such principles play no role.

These classical ideas of symmetry or proportion in architecture, which were at least partially derived from ancient theories of music beginning with Pythagoras, were very influential in the Renaissance, much written about and much used. Perhaps the most influential architect of the Renaissance was the sixteenth-century Italian architect, Andrea Palladio, much of whose work is still preserved and who wrote one of the most influential works in the history of architecture, *The Four Books of Architecture*, published in 1570. I use the wonderful 1737 English translation by Isaac Ware, which has been reprinted by Dover. Writing in a vein that sounds very close to that of Vitruvius, this

is what Palladio has to say about the proportion of rooms in Chapter XXI of Book I. "The most beautiful and proportionable manners of rooms, and which succeed best, are seven, because they are either made round (tho' but seldom) or square, or their length will be the diagonal line of the square, or the square and a third, or of one square and a half, or of one square and two-thirds, or of two squares" [p. 27]. Palladio also gives a detailed discussion in Chapter XXIII of the same book of the height of a room given its length and width. He distinguishes whether the ceilings are vaulted or flat. His three alternative rules for vaulted ceilings use just the arithmetic, geometric, and harmonic means respectively—all familiar to the Greeks since the time of Pythagoras. One is that the height should be equal to half the sum of the width w and the length l of the room, which is the rule derived from the arithmetic means. In modern notation, but in terms of proportion

$$l - h = h - w \qquad \text{(arithmetic mean)}$$

The second "geometric" rule is that as the length of the room should stand in proportion to the height, the height of the vault stands in proportion to the width. This means that the height of the vault will be the square root of the product of the width times the length, i.e.,

$$\frac{l}{h} = \frac{h}{w} \qquad \text{(geometric mean)}$$

The "harmonic" rule for the height is slightly more complicated. It may be represented by the following equation

$$\frac{l-h}{h-w} = \frac{l}{w} \qquad \text{(harmonic mean)}$$

which can easily be solved to find h and which Palladio gives an example of. Palladio ends his discussion by saying "There are also other heights for vaults, which do not come under any rule, and are therefore left for the architect to make use of as necessity requires, and according to his own judgment." Palladio has a number of other rules of proportion for the dimensions of doors and windows, and principles for the location of doors and windows. However, it will be enough for the purposes of the discussion here to restrict ourselves to the rules and remarks cited from Vitruvius and Palladio.

There are two obvious points to be made about the rules cited from Vitruvius and Palladio, and similar ones that they give. The first is that no real justification of the rules is made. There is no extended argument in Vitruvius and Palladio as to why these particular rules are the ones that should be taken seriously, and why they have the special status they are given by the authors. It may be reasonably argued that it was precisely their immersion in the classical tradition that made no argument necessary. The theory of proportion was central to this tradition. The second comment is already to be anticipated by remarks by the architects themselves. Namely, the rules are not rules that are to be followed with precision and with algorithmic dedication. They are rules that are adjusted to particular sites and situations.

By the middle of the eighteenth century a sea change in philosophical attitudes toward beauty had taken place. Not uniformly but widespread was the

advancement of a wholly subjective concept of beauty. As in other matters an early bold step was taken in this direction by Hume in his famous essay *Of The Standard Of Taste* first published in 1757. This is what he has to say:

> Beauty is no quality in things themselves: It exists merely in the mind that contemplates them; and each mind perceives a different beauty. . . . To seek the real beauty, or real deformity, is as fruitless an inquiry, as to pretend to ascertain the real sweet or real bitter.

Later he has this to say, directed even more at the classical theory of proportion.

> To check the sallies of the imagination, and to reduce every expression to geometrical truth and exactness, would be the most contrary to the laws of criticism; because it would produce a work, which by universal experience, has been found the most insipid and disagreeable.

Similar sentiments were expressed in the same year by Burke in his work *Enquiry into the Origin of our Ideas of the Sublime and Beautiful.* Burke spoke in even stronger terms than Hume. He criticized the theory of proportion as being a matter of mathematical inquiry and not at all a matter of aesthetics. He objected to the classical relation between the proportions of the human body and proportions in architecture. Even more, he poked fun at the use of this idea. But these views were not confined to British philosophy. They may also be found, although expressed in quite a different idiom, in Kant's *Critique of Judgment.* As Kant insisted, with his usual method of repetition in many different passages, back of the observation of beauty there lies no concept, for the judgment of beauty has as its source the feeling of the subject, not a concept in the object as its determining ground. Kant's analysis of the nature of beauty is notable for its endlessly repeated abstractions and its lack of detailed examples, but in matters pertinent to discussion here, he does have some particular things to say that reinforce his general view. In the following paragraph he states a general objection to taking as indisputable examples of beauty geometrically regular figures:

> Now geometrically regular figures, such as a circle, a square, a cube, etc., are commonly adduced by critics of taste as the simplest and most indisputable examples of beauty, and yet they are called regular because we can only represent them by regarding them as mere presentations of a definite concept which prescribes the rule for the figure (according to which alone it is possible). One of these two must be wrong, either that judgment of the critic which ascribes beauty to the said figures, or ours which regards purposiveness apart from a concept as requisite for beauty. (Hafner edition, 1968, p. 78)

Later he speaks even more strongly against mathematical ideas of proportionality being closely connected with the nature of beauty:

> All stiff regularity (such as approximates to mathematical regularity) has something in it repugnant to taste; for our entertainment in the contemplation

of it lasts for no length of time, but it rather, in so far as it has not expressly in view cognition or a definite practical purpose, produces weariness. On the other hand, that with which imagination can play in an unstudied and purposive manner is always new to us, and one does not get tired of looking at it. (p. 80)

The strongly subjectivistic view of beauty that received detailed statement in the eighteenth century has continued to be part of the talk about architecture both by architects and critics alike. Unfortunately, it has encouraged a rhetoric that is naive and primitive in conceptual formulation. With some notable exceptions this is as true of what Frank Lloyd Wright has to say about "organic architecture" as it is about Robert Venturi's admonitions about complexity and contradiction in modern architecture. Fortunately, in both their cases, but especially in Wright's, their architectural practice has in its underlying design much closer affinity to the classical theory of proportion and symmetry than would appear from their own descriptions of their work. Many of Wright's most famous works, for example the Johnson Administration Building in Racine, Wisconsin, exhibit a relentless pursuit of symmetry in the sense of Vitruvius that no doubt is one of the main reasons for the impressive quality of the building.

It is certainly true that we do not necessarily expect from modern architects a clear and explicit statement of how they think about the proportions of the structures they design. This is, as has already been noted, in contrast with earlier traditions. Palladio wrote about architecture in very explicit terms and also was active as an architect himself. It is disappointing that what pronouncements we do have from the great modern architects, such as Frank Lloyd Wright, le Corbusier, Walter Gropius, and Mies van der Rohe, are maddeningly vague and general in nature instead of interesting and detailed about how particular problems are solved.

Of course, most of us tend to be intellectually put off by the bald statements about proportions to be found in classical architects, like the examples from Vitruvius or Palladio cited earlier. What they are saying is not entirely wrong or mistaken, it is just put in far too simple a way. The rules are stated categorically. Even if reservations are expressed elsewhere, there is no real defense of why these particular rules should be adopted. There is no detailed attempt to give either more fundamental principles from which they may be derived or a rich account of past experience on which they are based.

But classical or modern architects are no worse in these matters than the philosophers cited. Hume and Kant work in that great tradition of philosophical legislation without empirical representation and without concern for legislative detail. The psychologically subtle question of why proportion does appeal and has appealed so strongly in our architectural evaluations of buildings is not addressed in any serious way at all by Hume or Kant, or more generally, the philosophical traditions in which they are working.

Visual illusions. Perhaps the most disappointing aspect of developments since the time of Palladio is the absence of a rich theory of architectural

illusions. Already in the design of the Parthenon, specific methods for dealing with illusions were not only evolved as a matter of experience, but given general and explicit formulation as a matter of theory. A good example of this is to be found in the following quotation from Book 3, Chapter III, of Vitruvius:

> These proportionate enlargements are made in the thickness of columns on account of the different heights to which the eye has to climb. For the eye is always in search of beauty, and if we do not gratify its desire for pleasure by a proportionate enlargement in these measures, and thus make compensation for ocular deception, a clumsy and awkward appearance will be presented to the beholder. With regard to the enlargement made at the middle of columns, which among the Greeks is called εντασις, at the end of the book a figure and calculation will be subjoined, showing how an agreeable and appropriate effect may be produced by it. (p. 86)

Detailed geometric drawings computing the enlargements to be made in the middle of columns were included in various editions of Vitruvius, and were, as indicated in the quotation, part of the text from the beginning.

Given this exemplary beginning of how theoretical corrections for perception could be implemented to improve the simple mathematical theory of proportion, the current state of developments is disappointing. It is quite true that architects are generally aware of the nature of these corrections and make many empirical adjustments in the design of current structures, but it is a reasonable thesis that the gracefulness of many classical buildings is due to the relentless application of a clear set of theoretical ideas worked out in a tradition of experience of many hundreds of years.

There is at the same time an extensive scientific theory of visual illusions that can be used to develop a more adequate theory of proportion, i.e., a theory of proportion with built-in perceptual adjustments. There is scarcely any topic in the psychology of perception that has been studied more extensively than visual illusions. The experimental and theoretical literature numbers thousands of articles and books, but excellent overall synthesis and surveys exist as well. A good example is *Seeing is Deceiving: The Psychology of Visual Illusion* by Stanley Coren and Joan Girgus (1978). The existing writing of architects and even more of architectural critics and historians does not indicate anything like a thorough and useful knowledge of this literature on visual illusions. In many ways there is an unhappy contrast to the interest in the psychology of music by musicians. The intensive work on music, which in cumulative amount does not compare to that on visual perception, is marked by close collaboration between psychologists and musicians—see, for example, *The Psychology of Music*, edited by Diana Deutsch (1982). The nature of pitch, timbre, rhythm, and harmony are not Eleusinian mysteries never to be solved, but are perceptual phenomena that are subject to thorough scientific study.

There is in the older psychological literature in this century experimental study of preferences for rectangles, triangles of a certain shape, etc. aimed at understanding in a general way what is psychologically correct about the

classical theory of proportion. But this approach has not been systematically extended, so far as I know, in the past several decades. In studies of this kind or in the Greek computations of *entasis*, we should be able to come to an understanding of the contributions of proportion and symmetry to our perception of beauty, and also to understand the role of illusion as well. It will not do, with Hume and the British empiricists, to think of the mind as a *tabula rasa* fixing individually on its own conception of beauty without any attention to innate capacities of perception and how they relate to the physical world. I am not suggesting for a moment that a deepened and more sophisticated theory of proportion will encompass all that is interesting about the perception of beauty in architectural structures, but I do believe that a more thoroughly developed modern theory would be able to provide on many occasions systematic reasons why we find some buildings more pleasing to the eye than others.

What we expect of a theory of proportion as a guide to the construction of beautiful structures is in many ways not much different from what we expect of a physical theory in the design of buildings. Proper use of physical theory eliminates unsound structures and also suggests new possibilities, but physical theory does not categorically dictate how the parts should be arranged. And so it is with the theory of proportion in organizing the elements of a structure aesthetically. The aesthetic elements of a building cannot be reduced to simple formulas, and neither can the physical elements of the mechanical structure and function. Yet a building, constructed without proper engineering and understanding of the strengths and weaknesses of the technology used, is unacceptable. So should it also be with the way the elements are proportionately arranged.

The Meaning of Music

DIANA RAFFMAN

It is a recurrent theme in the history of musical scholarship that music has "meaning"—or "symbolic content," or "semantics," or, at the very least, something we would want to call "significance." It is, of course, a theme with many variations: Schopenhauer will say that music expresses the inner nature of the metaphysical will, Goodman that music metaphorically exemplifies the likes of fragility and heroism, Kuhns that music represents itself: "Tones in music represent other tones. A modulation from major to minor refers as it moves, and establishes referring relationships as it sounds."[1] The most prevalent strain by far, however, has it that music somehow symbolizes human *emotions*. Langer will contend that music symbolizes the dynamic forms of human feeling, Collingwood that it expresses an emotion in the mind of the composer, Dowling and Harwood that it "*represents* emotions in a way that can be recognized by listeners."[2] Roger Scruton writes:

> To understand musical meaning . . . is to understand how the cultivated ear can discern, in what it hears, the occasions for sympathy. . . . [For example, in] the slow movement of Schubert's G Major Quartet, D.887, there is a tremolando passage of the kind that you would describe as foreboding. Suddenly there shoots up from the murmuring sea of anxiety a single terrified gesture, a gesture of utter hopelessness and horror. . . . No one can listen to this passage without instantly sensing the object of this terror—without knowing . . . that death itself has risen on that unseen horizon. . . . In such instances we are being led by the ears towards a knowledge of the human heart.[3]

Like any interesting thesis, the view has its detractors as well. Though much of the skepticism finds expression "in the corridors," as they say, some notable statements can be found in the literature. Peter Kivy writes:

> Unlike random noise or even ordered, periodic sound, music is quasi-syntactical; and where we have something like syntax, of course, we have one of the necessary properties of language. That is why music so often gives the

strong impression of being meaningful.... [But] although musical meaning may exist as a theory, it does not exist as a reality of listening.... It seems wonderful to me, and mysterious, that people sit for protracted periods of time doing nothing but listening to meaningless—yes, meaningless—strings of sounds.[4]

Stravinsky, writing in the *Poetics*, is similarly negative:

Do we not, in truth, ask the impossible of music when we expect it to express feelings, to translate dramatic situations, even to imitate nature? And, as if it were not enough to condemn music to the job of being an illustrator, the century to which we owe what it called "progress through enlightenment" invented for good measure the monumental absurdity which consists of bestowing on every accessory, as well as on every feeling and every character of the lyrical drama, a sort of check-room number called a *Leitmotiv*—a system that led Debussy to say that the *Ring* struck him as a sort of vast musical city directory.[5]

The formulation and evaluation of any theory of musical meaning will require answers to a daunting collection of questions. For instance, is musical meaning, if such there be, more like the meaning of a sentence or like the meaning of a picture, or of a frown, or of a scientific datum, or of life? Answering this question will in turn require that we explicate each of these various brands of meaning, and of course the challenges of that exercise are well known. Just for starters, does a linguistic expression get its meaning from its truth conditions, or from the abstract sense or proposition it expresses, or from the ways we use it, or from the information it conveys, or from something else altogether? Tracing a path through this thicket is only made the more difficult by the ambiguity of the term 'meaning' as between, roughly, *content* and *value*: compare ' 'Bachelor' means 'unmarried man' ' with 'Your support means a lot to me'.[6]

In the face of such perplexities, my present goals are modest. I will try to bring to light a feature of the musical case that functions, in certain respects, just like the linguistic meaning or semantics. I shall remain neutral on the existence of musical meaning so-called, however; my present claim is a merely conditional one: viz., that insofar as talk of musical meaning or semantics is justified *at all*, the feature in question is a plausible candidate. I shall also cite some reasons for thinking that, whatever musical meanings may be, emotions are not among them. The present discussion is set in the framework of a recent cognitivist theory of music perception; however, any conclusions drawn herein, if they hold at all, hold independently of the details of that framework.

I

Cognitive theory has it that perception, among other things, is a matter of mentally representing the world in certain ways. On at least one popular

view, perception consists roughly in the computation of a series of increasingly abstract mental representations of the environment which proceeds from peripheral stimulations to full-blooded conscious percepts.[7] Elaborating this computational story for music perception, composer Fred Lerdahl and linguist Ray Jackendoff have borrowed techniques from standard Chomskyan linguistics to develop a so-called *generative grammar* for tonal music. By analogy with its linguistic cousin, the musical theory is designed to model "the largely unconscious knowledge which the [experienced] listener brings to music and which allows him to organize musical sounds into coherent patterns."[8]

The idea is roughly this. The musical grammar is a set of analytical rules which the experienced listener has stored unconsciously in his head. As he hears the incoming musical signal, he mentally represents it (i.e., he recovers the score, more or less) and then analyzes it according to the grammatical rules; that is to say, he computes a *structural description* of the piece. In short, the grammar takes as input a "mental score" and produces as output an analysis or structural description of the piece—all this transpiring unconsciously, of course. Having the right sort of structural description in one's head is what hearing the piece *as tonal* consists in; as Lerdahl and Jackendoff will put it, that is what *understanding* the piece consists in, just as having the right sort of linguistic structural description in one's head is what understanding a sentence consists in.

A quick look at a sample structural description will help to give an idea of what is intended (see the illustration).[9] Dots immediately below the score indicate relative beat strength, while brackets parse the piece into rhythmic groups. The tree structure or *time-span reduction* above the score is computed on the basis of the lower level beat ("metrical") and grouping analyzes and specifies a hierarchy of structural importance among all the pitch-time events in the piece. Basically, the longer the branch assigned to a given pitch-time event, the greater its structural importance; thus events registering at level *a* are more important than events registering at level *b*, those at level *b* more important than those at level *c*, and so forth. Not shown here is a fourth level of analysis, the *prolongational reduction*, which "expresses the sense of tension and relaxation involved in the ongoing progress of music," the "incessant breathing in and out of music in response to the juxtaposition of pitch and rhythmic factors" (179); prolongational structure, too, is represented by branching trees.

As I observed above, the operations of the musical grammar are unconscious, but *ex hypothesi* the final results of those operations are somehow accessed consciously: for example, the fact that the time-span reduction (above) assigns the first chord in bar 1 a longer branch than the first chord in bar 2 means that the former is consciously *heard* or *experienced*—we often say: *felt*—as being structurally more important than the latter.[10] A substantial "core" of structure is assigned more or less uniformly across listeners, but intersubjective variation is likely to occur at relatively "high" levels of analysis, especially in the prolongational reduction. If a person has been listening to a

lot of Stravinsky, he is likely to "hear" or "feel" a Mozart symphony some-what differently than his companion who has been listening to Wagner. Such underlying disparities could easily account for the perennial disputes among musicians as to where phrases begin and end, where dynamic changes should occur, what the tempo ought to be, and so forth.

The structural description is so called because it represents the basic structural elements of the piece—pitches and durations—as well as the higher order or more "abstract" structural features (groups, meters, time-spans, prolongations, etc.) computed from these fundamental two. In the present context, to say that certain features are the *structural* features is to say that they support a rule-governed system of discrete, repeatable elements type-identifiable exclusively by appeal to their physical (here, acoustic) shape or "form."[11] The musical theory postulates that certain rule-governed mental operations impose such structures on acoustic stimuli in a way that accounts for the character of conscious musical experience (*inter alia*). This scenario is viewed on analogy with the linguistic case, where rule-governed mental operations impose structure on acoustic stimuli in a way that accounts for the understanding of grammatical sentences.[12]

Despite their *prima facie* plausibility, music-language parallels have come in for some harsh criticism in the philosophical literature. Scruton speaks for many when he warns that "current theories of music tend to go wrong . . . [insofar as] they describe musical understanding in terms of some theory whose primary application is in a field (such as linguistics) which has nothing to do with music."[13] Indeed, Lerdahl and Jackendoff themselves are rightly and emphatically wary of forced analogies; they write:

> Many previous applications of linguistic methodology to music have foundered because they attempt a literal translation of some aspect of linguistic theory into musical terms—for instance, by looking for musical "parts of speech," deep structures, transformations, or semantics. But [this] . . . is an old and largely futile game. . . . There are no substantive parallels between elements of musical structure and such syntactic categories as noun, verb, adjective [and so forth, and] no musical counterparts of such phonological parameters as voicing, nasality, tongue height, and lip rounding. . . . [Furthermore,] whatever music may "mean," it is in no sense comparable to linguistic meaning. (5–6)

> [M]usic is pure structure, to be "played with" within certain bounds. (9)

It is this last claim, about a musical meaning or semantics, that concerns us at present. In what follows I shall argue that, though substantive parallels of the sort Lerdahl and Jackendoff reject are indeed ill-conceived, there is a feature of the musical case that is in certain respects precisely comparable to the linguistic meaning.

II

Typically we envision linguistic meaning as playing a role for which there would seem to be no musical analogue, substantive or otherwise. Specifically, it forges a tie to the extra-linguistic world, thereby enabling its bearers (well-formed strings) to refer, assert, command, inquire.[14] Musical strings, on the other hand, do not seem to do any of these things—or, ar least, they do not do them *autonomously*, one might say.[15] Granted, if we set things up right we can *lend* the music a certain intentionality: to the listener armed with his glossary of Wagnerian leitmotifs, a given theme may assert, in some sense of 'assert', "Here comes Siegfried"; to the listener informed of Greek mythology and the intended allusion, the descending Phrygian scale that opens Stravinsky's *Orpheus* may refer, in some sense of 'refer', to the young hero's descent into the underworld. Perhaps there are also various pragmatic meanings borne by the performances (particular "utterances") of a work: imitating Isaac Stern's interpretation of Ravel's *Tzigane* during a performance of the work in honor of Stern's birthday might, I suppose, provide such an instance. However, *these* cannot be instances of the variety of musical meaning at issue in the debate described at the outset (recall Scruton's words: "No one can listen to this passage without instantly sensing the object of this terror"). *These* cases of musical meaning, I want to say, are *parasitic* on linguistic meanings. That *Orpheus* opens with a descending scale and closes with the same scale in ascent is, of course, a stroke of genius; but those scales do not, taken by themselves, mean anything about Orpheus at all.

Perhaps the disparity between language and music on this score can be brought out by a little thought-experiment. Suppose we leave an arbitrarily selected, competent English speaker alone in a room with nothing but a passage of text in English—an article from the day's *New York Times*, say—and ask him to read it. Left entirely to his own devices, he will understand it; in other words, he will recover its meaning. Lacking various contextual cues, of course, he may miss some of its so-called pragmatic meanings; nevertheless, in a very straightforward (indeed paradigmatic) sense of 'understand', if he does not understand the article we shall want to say that, contrary to hypothesis, he is not competent in English. Then my present point is, no meaning or understanding of that "autonomous" sort exists in the Siegfried and Orpheus examples. The thing about language, as Chomsky reminds us, is that it is *creative*: competent speaker/hearers can produce and understand indefinitely many novel sentences. Let's put this by saying that linguistic understanding "passes the novelty test." The variety of understanding in the Siegfried and Orpheus examples, on the other hand, *fails* the novelty test.

The intentional role of enabling reference, assertion, command, and the rest is not the only role played by the linguistic meaning, however. It has other, (shall we say) more "architectural" roles to play, and it is to two of these that a musical analogy may be drawn. First, and most important, the recovery of meaning is presumably the *purpose* of the speaker/hearer's assignments

of structure—phonological, lexical, and syntactic—to incoming strings; by hypothesis it is (at least partly) in virtue of assigning such structure that he is able to recover the meanings of the sentences he hears. Recovery of meaning is what the assignment of structure is *for*; syntax, we are repeatedly told, is the "vehicle" of semantics. Second, semantic considerations frequently serve to *guide* the process of grammatical theory construction; that is to say, just which structures the theorist assigns to the sentences of the language will depend to a significant extent on semantic considerations. (The degree to which this second claim applies to phonological structure is not entirely clear; hence for present purposes I shall confine my arguments to syntactic and lexical structure. That much will suffice for a musical analogy.) Let me explain.

Consider the following passages (just a few among many, many examples) taken from two recent, prominent works in linguistics—Geoffrey Horrocks's *Generative Grammar*,[16] and Scott Soames and David Perlmutter's *Syntactic Argumentation and the Structure of English*,[17] a "manual" for syntactic theory construction:

> We cannot plausibly regard 'ignorance' as the nominalization of 'ignore' since, despite the formal relationship, their meanings are quite different. . . . Since it is assumed in the standard [Chomskyan] theory that deep structures provide all the syntactic and lexical information required for semantic interpretation, it is clear that transformations cannot be allowed to change meaning. . . . Hence we cannot derive 'ignorance' from 'ignore' by transformation.[18]

> The idiomatic phrase ['keep tabs on'] may be seen as a particular instantiation of the complement structure of 'keep'; it has to be listed separately [in the lexicon] because unlike 'keep bikes in (the shed)', for example, it has a meaning which is not simply 'the sum of its parts'.[19]

Rejecting a so-called "Phrase Structure" representation of the structure of sentences like "Harriet I spotted yesterday at the movies' and 'The Bahamas you said were warm in January',[20] Soames and Perlmutter observe that

> even if it were possible to generate [such] sentences in underlying structure, the grammar would need some device to capture the fact that the "extra NP" [noun phrase] in initial position bears the semantic relations it would have if it were in the "gap."[21]

The details of these accounts, and their ultimate success as theories of grammatical structure, are unimportant in the present context. All I am concerned to show, and what the cited passages clearly indicate, is that grammatical theory construction is frequently guided by an appeal to semantic factors: it is because 'ignore' and 'ignorance' are "quite different" in *meaning* that the theorist eschews a derivation of the latter from the former by transformation; it is the "non-compositionality" of the *meaning* of 'keep tabs on' that alerts the theorist to the need for a separate entry in the lexicon. In cases like these,

the theorist's knowledge of meaning guides him in the assignment of syntactic structure.

Perhaps it will be objected that, in principle, the construction of a grammatical theory need appeal only to intuitions about grammaticality (syntactic well-formedness), and that the references to semantic factors are (at best) no more than convenient methodological shortcuts. Now granted, were the theorist to have access to a subject with exhaustive and explicit introspective knowledge of his own syntactic competence, the correct grammar could be constructed "by dictation" from his testimony, independently of any reliance on semantic factors. But of course there *is* no such subject; the vast majority of our linguistic competence is notoriously opaque to introspection. Consequently, as a matter of practical fact, the theorist must rely on what clues he can gather from his own and others' linguistic intuitions (semantic as well as formal), from his own and others' verbal and nonverbal behaviors, from his knowledge of simplicity constraints, and so forth. Rejecting the "Bloomfieldian" pursuit of an algorithm for grammatical theory construction, Chomsky himself observes that

> one may arrive at a grammar by intuition, guess-work, all sorts of partial methodological hints, reliance on past experience, etc. It is no doubt possible to give an organized account of many useful procedures of analysis, but it is questionable whether these can be formulated rigorously, exhaustively and simply enough to qualify as a practical and mechanical discovery procedure.[22]

Let me emphasize two points here. First, I do not mean to be making a claim about language *processing*; in other words, I do not mean to claim that the language user himself must have access to semantic factors in order to assign structure to incoming strings. Rather, my claim concerns the methodology of theory construction: the *theorist*'s assignment of structure to sentences is guided by an appeal to semantic considerations. Second, I do not mean to be making a claim about the substance of the grammatical theory; i.e., the theory itself need make no mention of semantic factors. To put the point another way, I do not mean to deny the independent *specifiability* of structure and meaning; once the syntactic theory has been formulated, an exhaustively structural description of any string can be provided. For example, 'keep' might be listed as a verb taking a noun phrase and a prepositional phrase (as in 'keep bikes in the shed'); 'keep tabs on' could then be listed separately as a particular instantiation of that same structure requiring 'tabs' as the relevant noun phrase and 'on' plus some noun phrase as the relevant prepositional phrase.[23] Only syntactic and lexical categories need be mentioned. Similarly, the theory might derive the sentence 'Harriet I spotted yesterday at the movies' from the sentence 'I spotted Harriet yesterday at the movies' by a so-called *movement* rule which moves the noun phrase 'Harriet' to initial position.[24] My claim is only that semantic considerations are (sometimes) brought to bear in the *isolation* or *discovery*— not the definition or constitution—of structural kinds.

III

The foregoing discussion suggests that the linguistic meaning or semantics plays at least these two "architectural" roles vis-à-vis the assignment of grammatical structure to linguistic strings: first, and foremost, the recovery of meaning is the purpose of the *speaker/hearer*'s assignment of structure (call this the "teleological" role); second, and as a result, an appeal to semantic considerations often serves to guide the *theorist*'s assignment of structure (call this the "guiding" role). What I shall now try to show is that a precisely analogous situation obtains in the musical case. That is, there is something in the musical case that plays the same pair of roles and hence, *to that extent*, may merit the name 'musical meaning' or 'semantics'. What might the something be?

We begin by asking what the experienced listener's assignment of musical structure is *for*. What is its *telos*? Now of course I cannot *prove* that the answer I am inclined to offer is correct; we have no idea what the evolutionary biological history of our musical competence may be, and to boot there will be many ways of characterizing any current psychological motivations one might propose. Nevertheless, there seems to me an overwhelmingly plausible candidate for this first, teleological role—and that is, simply, conscious musical experience. Having a certain kind of experience is the purpose of listeners' assignments of structure to incoming musical strings. As I observed earlier, our conscious access to our underlying representations of musical structure consists in the experience of *feeling* certain events as points of instability, *feeling* certain progressions as increases in tension, *feeling* certain events as points of resolution (just for example). If linguistic understanding is the ability to use linguistic strings in certain ways, in particular to recover linguistic meanings, musical understanding is the ability to "use"musical strings in certain ways—in particular, to have certain sorts of feeling experiences.

More must be said in the way of delimiting the class of feelings at issue, especially if certain negative claims about the emotions (to be elaborated below) are to have any force. Of course its boundaries will be fuzzy; but there are clear cases, and clear non-cases, and a sturdy rule of thumb, at least, for deciding its membership. Crudely put, to see which feelings play the teleological role at issue, look at the formulation of the (best) grammatical theory and see. For instance, in the Lerdahl-Jackendoff theory, Metrical Preference Rule #2 says "Weakly prefer a metrical structure in which the strongest beat in a group appears relatively early in the group." Beat strength is something the listener *feels*: consider "In 4/4 meter, the first and third beats are felt to be stronger than the second and fourth beats" (19). In other words, there is a "beat-strength feeling," as we might call it. Indeed, meter itself is felt: "It is the . . . regular alternation of strong and weak beats . . . that produces the *sensation* of meter" (69; my emphasis). Prolongational structure, recall, is said to underlie the tension and relaxation of the music; for example, a melodic descent from E-natural to C-natural over a C Major triad "is felt as a relaxation . . . because the second event is more 'consonant' [than the first]" (180). Examples abound.

What about, say, feelings of tautness, peacefulness, and restfulness? If the best musical theory does not mention them, and they are not explicitly invoked during the process of theory construction, are they thereby excluded from the "teleological" class? There is likely to be no clear answer here; as I remarked above, the class in question has fuzzy boundaries, and tautness *et al.* are probably borderline cases. We are not altogether at a loss to say anything constructive, however. To see what more can be said, it will be helpful to consider the second of the "architectural" roles played by a semantics, viz. that of guiding the theoretical assignment of underlying structure.

Not surprisingly, our attempt to provide a test for membership in the teleological feeling class has already begun to illustrate that, like the linguistic meanings, the musical feelings play the guiding role as well. In the Lerdahl-Jackendoff theory we find the following, for instance:

> For beats to be strong or weak there must exist a *metrical hierarchy*—two or more levels of beats. The relationship of "strong beat" to "metrical level" is simply that, if a beat is felt to be strong at a particular level, it is also a beat at the next larger level.... Translated into the dot notation,...[in 4/4 meter, at] the smallest level of dots the first, second, third, and fourth beats are all beats; at the intermediate level there are beats under numbers 1 and 3; and at the largest level there are beats only under number 1. (19)

Evidently the metrical feelings *guide* the theorist in postulating metrical structure. A similar dynamic can be seen in the construction of the prolongational reduction:

> In the grouping, metrical, and time-span components there is nothing that expresses the sense of tension and relaxation involved in the ongoing progress of music.... We wish to be able to speak of points of relative tension and repose and the way music progresses from one to the other. This is the function of prolongational reduction. (179)...We begin by defining tension and relaxation in terms of right and left prolongational branching.... [A] tensing motion will be represented by a right branch, a relaxing motion by a left branch. (181)

As before, two points require emphasis. First, I do not mean to be making a claim about music *processing*; i.e., it is not that the listener himself must be in any way cognizant of the relevant feelings in order to assign structure to incoming strings. Quite the reverse, presumably: those feelings are the *result* of his assignment of structure. Second, I do not mean to be making a claim about the substance of the grammatical theory; the grammar itself need make no mention of the feelings in question. In other words, I do not deny the independent specifiability of musical structure; once the grammatical theory is in place, we can perfectly well provide a purely formal or structural description of the music. Strong beats, for instance, will be those which register at relatively large levels in the structural description (i.e., those which receive a relatively large number of dots). The E-to-C melodic transition cited above—the one said

to be "felt as a relaxation"—will be described as a so-called weak prolongation of the C by the E, where a weak prolongation is represented by a certain type of left branching and is defined as the succession of two events whose harmonic roots "are identical, but one of the events is in a less consonant position" (181–82). The (completed) musical grammar is, as advertised, a purely formal theory.

Returning now to the question of tautness and peacefulness, what I want to say is this. To the extent that they can be viewed as playing the teleological *and guiding* roles vis-à-vis the assignment of musical structure, such feelings merit inclusion in the teleological-*cum*-guiding class. No doubt we shall typically defer to the intuitions and practices of music theorists and grammarians when a decision is required in borderline cases (perhaps the experts would endorse a replacement of 'tension' by 'tautness' throughout). But even so, there may be no consensus. Such disagreements should not trouble us, however; we expect the class in question to admit some clear cases (e.g., musical tension and relaxation), some clear non-cases (e.g., joy and sadness, I will argue), and some borderline cases (e.g., tautness and peacefulness). A demand for sharp divisions is inappropriate here.

IV

If what I have been saying is correct, there is a roughly delimited class of peculiarly musical feelings (feelings of beat strength, of metrical stress, of prolongational tension, and so forth) that play the same teleological and guiding roles with respect to the assignment of musical structure that the linguistic meanings play with respect to the assignment of linguistic structure. Of course, playing those roles is hardly sufficient for being a semantics; it is at most necessary, and is probably better viewed as being, shall we say, "symptomatic" of semantic import.[25] However, the musical feelings turn out to display certain other "symptoms" which further enhance the plausibility of casting them in a semantic role. I will briefly mention three.

First, the identification of musical meaning with certain sorts of feeling experiences gets a boost from the fact that, alone in his room with Wagner and Stravinsky, the experienced listener cannot help but understand; that is, he cannot help but have the relevant feeling experiences. *This* brand of musical understanding passes the novelty test. The experienced listener can no more fail to understand his native music than his native tongue. Second, if he *does* fail to feel the tonic as the most stable pitch in the scale, or a 4–3 suspension as moving from a point of tension to a point of rest, or the downbeat as the strongest beat in the bar, then he is liable to censure: we will be justified in saying that he has misunderstood the music, that he ought to listen again, more carefully. In this regard the musical feelings satisfy what does seem to me to be a necessary condition for the existence of meaning—viz., the possibility of error. Meanings are the sort of thing one can get *wrong*. Our musical feelings are not *merely* a response to the music; they are also our preeminent mode

of (consciously) *knowing* the music: they constitute our knowledge of musical *structure*. That is why they can be "right" or "wrong."

Third, and last, our proposal serves up an attractive account of musical communication. If the musical feelings are to be musical meanings, we shall want to be able to say that, just as linguistic meanings are communicated via the production of linguistic strings, musical feelings are communicated via the production of musical strings. Jerry Fodor characterizes linguistic communication in this very helpful way:

> Verbal communication is possible because, when [an acoustic object] U is a token of a linguistic type in a language [both speaker and hearer] understand, the production/perception of U can effect a certain kind of correspondence between the mental states of the speaker and the hearer. The ultimate goal of a theory of language is to say what kind of correspondence this is and to characterize the computational processes involved in bringing it about. . . . It may be worth emphasizing that this sort of account has a quite natural inter-pretation as a *causal* theory of communication. For if, as I have supposed, the utterance of a wave form can bring about a certain correspondence between the mental states of the speaker and the hearer, this is presumably because, in the relevant cases, the utterance is causally sufficient to initiate the sequence of psychological processes in the hearer which eventuates in his coming to be in a mental state that corresponds to the one that the speaker is in. . . . So, one might say, a necessary and sufficient condition for communication between speaker and hearer is that the mental states of the one should be in the right sort of causal relation to the mental states of the other.[26]

One can imagine the communication of musical feelings proceeding in much the same manner, underwritten by the representation of "corresponding" musical structures in the minds of performer and listener.[27] In this way, what the performer communicates in his *experience* of the music—how he *hears* it, how it *feels* to him.

In the final analysis, then, do the musical feelings constitute a semantics? The answer is: say what you like. If you require (e.g.) that a semantics specify truth-conditions for well-formed strings, then you'll be inclined to answer in the negative. If on the other hand you are impressed by the fact that the musical feelings result in systematic ways from grammatical operations, sustain robust notions of correctness and error, pass the so-called novelty test, underwrite a theory of musical communication, and play the teleological and guiding roles characteristic of meaning in the natural language, then you may well answer in the affirmative. If the idea of a musical semantics has any plausibility at all, these feelings are likely to be its best hope.[28]

V

I will close with a few negative remarks about the candidacy of the emotions for musical meanings. A breathtaking variety of phenomena have been cited

under the rubric of emotion in philosophical and psychological writings on music. A well-known psychological study by Hevner, for instance, includes being merry, joyous, sad, pathetic, spiritual, lofty, dignified, dreamy, tender, and dramatic; Bell posits a special "aesthetic emotion," while Hanslick insists that music expresses not emotions *per se*, but rather their "dynamical properties"—the "speed, slowness, strength, weakness [etc.] . . . accompanying psychical action."[29] At present I do not wish to become mired in the details of these various accounts. I have already indicated the conditions under which such feelings as tautness and peacefulness might win inclusion in a musical semantics. In the space remaining I should like to urge that, whatever a musical semantics may turn out to be, the so-called garden-variety emotions will find no place in it. Ideally one would want to present a fully developed theory of these affective states, but I am not in a position to do that here;[30] hence for present purposes I shall specify the garden-variety emotions by appeal to paradigm cases—for example, happiness, sadness, anger, jealousy, fear. These are the sorts of affective states at issue in what follows:

It does no good to deny outright that emotions play the teleological role outlined above, for the proponent of emotive musical meaning will simply dig in his heels and insist otherwise. We can make considerably more headway with respect to the guiding role, however. So far as I am aware, there is no formal musical theory (i.e., no theory engaged in the business of assigning musical structure) whose construction is or was guided by an appeal to garden-variety emotions felt by listeners or otherwise ascribed to musical works. Music theorists do not isolate scales or chord functions or tone rows or pitch class sets, any more than psychologists isolate groups or phrases or time-spans or prolongations, by appeal to facts about happiness or anger. Where feelings enter into theory construction, they are the peculiarly *musical* ones about which we have now heard so much. Of course this does not *prove* anything one way or the other, but at the very least it tells strongly against the plausibility of casting the emotions in the teleological role: if the experience or "understanding" of emotions were the *purpose*, the *raison d'etre* of listeners' assignments of structure to musical stimuli, how could (an appeal to) those emotions fail to guide the construction of the theory? It is *because* the recovery of meaning is the purpose of linguistic structural analysis that an appeal to meaning guides linguistic theory construction, and *because* the having of certain feelings is the purpose of musical structural analysis that an appeal to those feelings guides musical theory construction. Or so I have wanted to say.

Even setting all that aside, however, emotions *cannot* constitute musical meanings. And that is because, *pace* Scruton anyway, they do not sustain the requisite normativity. I have allowed that if we are told, or perhaps read in the program, that (e.g.) Schubert intended his quartet to be about terror, then there may be some justification for claiming terror to be (part of) the meaning of the work, and in particular for claiming that someone has failed to (completely) understand the work if he fails to ascribe it that meaning. But this "parasitic" sort of meaning is clearly not what Scruton and other proponents of an emotive

musical meaning have had in mind. As they see it, emotions are (part of) what I have called the "autonomous" meaning of the work; our "understanding" of them passes the novelty test. Again, recall Scruton's words: "No one can listen to this passage without instantly sensing the object of this terror." See what such a strong position commits us to, at the very *least*: if I listen to the Schubert, alone in my room, and find no emotional significance in it at all, or if I find it beseeching, or even just mildly unsettling, rather than terrifying, *I am mistaken.* I have misunderstood the work.[31] Now I do not know what Scruton's musical community is like, but in my twenty years as a practicing musician I do not recall ever hearing it said that a listener was *mistaken* in his *emotional* assessment of a piece. Indeed, the musicians I have polled regard the idea of such an emotional "mistake" as something of a category mistake. A listener's emotional response to a work may surprise us, of course: if he finds the Schubert jolly, for example, we may be mystified and wonder what he "hears in it"; but we should no more call *him* mistaken than the diner who prefers swordfish to salmon. Suppose the listener in question is Arnold Steinhardt (the principal violinist of the Guarneri Quartet), who, we may assume, has performed the Schubert many times, and magnificently. Suppose further that Steinhardt finds the "terrifying" passage jolly. On what *emotional* ground could one deny that he understands the music? The character of his playing, for one thing, would overrule any such putative emotive evidence. To be sure, it is always open to us to dispute his phrasing, dynamics, articulations, and so forth; here, *argument* can take place, grounds can be supplied for one way of hearing or playing the music as opposed to another. "The phrase ends here because that E-natural is already preparing the modulation to the dominant!" Such disputes may prove unresolvable, of course; indeed, impasses are common, presumably occurring when listeners "hear the music differently" owing to differences in their unconscious structural descriptions. But the point is, these are genuine arguments: reasons can be given, grounds can be summoned for and against different hearings. Musicians—at least the ones I know—argue about phrasing and dynamics and articulations. They do not argue about the emotions they feel or otherwise ascribe to the music.

Of course I do not mean to deny that we (sometimes) have emotional responses to, and associate emotional experiences with, music. Indeed there is evidence indicating that listeners can pair musical selections with adjectives from predetermined lists (e.g. 'tender', 'buoyant', 'doleful', etc.) with a fair degree of uniformity.[32] But mere uniformity of response, absent the requisite normativity, does not get us meaning. On the contrary, in music the tacit rule is: in matters affective, to each his own.[33]

NOTES

1. Arthur Schopenhauer, *The World as Will and Representation*, I, translated by E. F. J. Payne (Indian Hills, Col, 1958), and *The World as Will and Idea*, I, translated by R. B. Haldane and J. Kemp, 4th ed. (London, 1896); Nelson Goodman, *Languages of Art* (Indianapolis, 1976); Richard Kuhns, "Music as a Representational Art," *British Journal of*

Aesthetics 18 (1978),: 122. Actually, indefatigable nominalist that he is, Goodman claims that music expresses the *predicates* 'fragile' and 'heroic'; see *Languages of Art*, 87, for example.

2. Susanne Langer, *Philosophy in a New Key: A Study in the Symbolism of Reason, Rite, and Art* (New York, 1942), for example; R. G. Collingwood, *Principles of Art*, VI (Oxford, 1935); W. J. Dowling and D. L. Harwood, *Music Cognition* (New York, 1986), 203.

3. Roger Scruton, "Analytical Philosophy and the Meaning of Music," *Journal of Aesthetics and Art Criticism* 46 (Special Issue, 1987): 174–75.

4. Peter Kivy, *Music Alone* (Ithaca, N.Y., 1990), 8–9, 12. To be honest, I am putting Kivy's remarks to a slightly (but only slightly) tendentious use here. He allows that music can *be* (e.g.) tranquil or melancholy but that it does not, except in certain special circumstances, *mean* either of these things. See *Music Alone*, chapter 9, and *The Corded Shell: Reflections on Musical Expression* (Princeton, 1980).

5. *The Poetics of Music* (Cambridge, Mass., 1942), 77.

6. See Kivy, *Music Alone*, chap. 4, for a helpful survey and analysis of different meanings of 'meaning' in the philosophical literature on music.

7. Jerry Fodor, *The Modularity of Mind* (Cambridge, Mass., 1983).

8. Ray Jackendoff and Fred Lerdahl, "Review Article: *The Unanswered Question* by Leonard Bernstein" in *Language* 53, no. 4 (1977): 111. The experienced listener is one familiar with a given idiom (here, Western tonal music); he need not be schooled in its theory.

9. Lerdahl and Jackendoff, *A Generative Theory of Tonal Music* (Cambridge, Mass., 1983), 276. Future references to this work will be noted in the text.

10. The slide between talk about the acoustic stimulus, talk about the music, and talk about our auditory experience is ubiquitous in the literature. In particular, properties like tension and relaxation are ascribed equally to the music and to our experience thereof; hence such seemingly Janus-faced constructions as 'the music is felt as being tense'. This way of talking is inevitable insofar as the piece of music is identified with a set of structures—pitches, groups, meters, time-spans, etc.—which are themselves explicitly defined in psychological terms. No doubt a more meticulous way of talking could be developed, but I shall not attempt that here.

11. Philosophers would refer to such a system as having a *syntax*; I shall refrain from that usage, however, in order to avoid confusions with the special sense of the term in linguistic theory.

12. For present purposes I shall take the liberty of envisioning the linguistic grammar, on analogy with the musical one, as a so-called input-output model; whereas strictly speaking, the Chomsky grammar is a purely logical device. The liberty is an innocent one, however, for as Lerdahl and Jackendoff explain, "it has been an unquestioned assumption of actual research in linguistics...that what is really of interest in a generative grammar is the structure it assigns to sentences, not which strings of words are or are not grammatical sentences...Despite the term "generative," the goal in linguistic theory is to find the rules that assign correct structures to sentences. Consequently the sentences as such in linguistic theorizing are usually taken as given" (pp. 6, 112). Adding phonology into the brew, we can envision the linguistic grammar as assigning structure to incoming acoustic strings.

13. Scruton, "Analytical Philosophy and the Meaning of Music," 170.

14. This is not to endorse any particular metaphysics of meaning; the view proposed herein is meant to be neutral in that regard.

15. Of course, such a claim flies in the face of at least some of the views cited at the beginning; though I do not address all of those here, I offer some criticisms of emotivist theories of musical meaning in section V below.

16. Geoffrey Horrocks, *Generative Grammar* (New York, 1987). The examples are taken from Horrocks's exposition of the so-called standard Chomskyan theory of *Aspects of the Theory of Syntax* (Cambridge, Mass., 1976). Of course, Chomsky's views have undergone considerable revision since that time, but the differences do not affect our project here.

17. Scott Soames and David Perlmutter, *Syntactic Argumentation and the Structure of English* (Berkeley, 1979).

18. Horrocks, *Generative Grammar*, 57.

19. Ibid., 50.

20. Such sentences contain "gaps," i.e., missing constituents; the first contains a gap between 'spotted' and 'yesterday' (which would normally be filled by 'Harriet'), while the second contains a gap between 'said' and 'were' (which would normally be filled by 'The Bahamas').

21. Soames and Perlmutter, *Aspects of the Theory of Syntax*, 23.

22. Noam Chomsky, *Syntactic Structures* (Hague, 1957), 56.

23. Horrocks, *Generative Grammar*, 50.

24. Soames and Perlmutter, *Syntactic Argumentation*, 232.

25. N.B. I have not attempted to specify a procedure for determining the "meanings" (feelings) of particular works; on the supposition that musical works are abstract structures of a certain kind, that enterprise would require some way of determining just which structures constitute a given work. That has not been my project here. My claim, rather, concerns the nature of musical meaning *in general*, and might be expressed this way: to the extent that the notion of musical meaning makes sense at all, the meaning of a musical work consists in the feelings that constitute conscious awareness of the structures that constitute the work, *whatever these latter may be*.

26. Jerry Fodor, *The Language of Thought* (Cambridge, Mass., 1975), 103–04.

27. Interestingly, R. G. Collingwood had a similar picture in mind some fifty-five years ago:

> The noises made by the performers, and heard by the audience, are not the music at all; they are only means by which the audience . . . can reconstruct for themselves the imaginary tune that existed in the composer's head. . . . The listening which we have to do when we hear the noises made by the musicians is in a way rather like the thinking we have to do when we hear the noises made, for example, by a person lecturing on a scientific subject. We hear the sound of his voice; but what he is doing is not simply to make noises, but to develop a scientific thesis. The noises are meant to assist us in achieving what he assumes to be our purpose in coming to hear him lecture, that is, thinking the same scientific thesis for ourselves. . . . We must think of communication not as an 'imparting' of thought by the speaker to the hearer, the speaker somehow planting his thought in the hearer's receptive mind, but as a 'reproduction' of the speaker's thought by the hearer, in virtue of his own active thinking. (*Principles of Art* [Oxford, 1938], 140)

28. It is worth mention that I do not mean to be suggesting the idea of a musical semantic "component" analogous to the hypothesized semantic component of the linguistic grammar. There simply is no motivation for such rules as 'When a pair of pitch-time events is structurally described by a left branching in the prolongational reduction, have the relaxation feeling'. That is as it should be, of course, for whereas the relation of a linguistic string to its meaning is a more or less conventional one, the relation of a musical string to *its* "meaning" is non-conventional: we are presumably just *wired* in such a way that we have those feelings when generating the relevant sorts of mental representations. The having of musical feelings is not plausibly regarded as a rule-governed affair.

29. Kate Hevner, "Experimental studies of the elements of expression in music," *American Journal of Psychology* 48 (1936): 248–68; Clive Bell, *Art* (London, 1914), 3–37; Eduard Hanslick, *The Beautiful in Music*, II, translated by Gustav Cohen (Indianapolis, 1957), 24. Peter Kivy has recently made an admirable attempt to inject some taxonomic clarity into the proceedings; see *Music Alone*, 175–81.

30. There is little consensus on the nature of emotions in the philosophical literature; see Daniel Farrell, "Recent Work on the Emotions," *Analyse & Kritik* 10 (1988): 71–102, for an extremely helpful survey.

31. Actually, Scruton's claim is even stronger than I have made it out: he thinks the listener must "sense" the *object* of the terror, namely death.

32. See Dowling and Harwood, *Music Cognition*, chap. 8, and John Sloboda, *The Musical Mind: The Cognitive Psychology of Music* (Oxford, 1985), chap. 2, for a survey of relevant studies.

33. I am indebted to Robert Kraut, Ted Uehling, Pieranna Garavaso, John Sloboda, Mari Jones, Peter Culicover, Craige Roberts, and Bob Levine for many helpful comments.

Conceptions of Musical Structure

MARK DEBELLIS

1. INTRODUCTION

Music, by most accounts, enjoys a vocabulary of technical description that has a precision and expressive power unrivalled in the other arts. The language of analysis is generally regarded to allow a rich and detailed delineation of the structure of a musical work. And we have intricate and elaborate theories of structure, such as that advanced by Schenker for tonal music.

The main question I shall address in this essay is the following: what *is* musical structure, of the sort described in music theory and analysis? What does it mean to say that this, rather than that, is the structure of a piece? What, if anything, are theorists who disagree over the structure of a passage disagreeing *about*? And what sort of thing is a structure, anyway? The present inquiry is thus a philosophical one, into such matters as the form and content of structure ascriptions, rather than a study within music theory that attempts to describe what structures certain works have.

The plan of the essay is as follows. First I discuss the logical form of structure ascriptions, making a distinction between strong and weak readings of such ascriptions. On the view I advance, ascribing a structure to a passage in the strong sense amounts to picking out a certain feature of the passage and asserting that the feature *is structural*. What makes a feature structural is the subject of the next section: I distinguish two main conceptions of structure, one whereby a feature is structural in virtue of its role as an object of perception or cognition, the other whereby the feature is structural in virtue of its having a certain kind of causal efficacy. In the last section I note how the existence of diverse aims of theory helps to account for the presence of diverse attendant notions of structure, and urge that these distinct notions not be conflated.

378

2. THE FORM OF STRUCTURE ASCRIPTIONS

Let me begin with some examples of the object of investigation. Consider the passage in Example 1, which is the opening of Mozart's Piano Sonata in A Major, K. 331.

Example 1

According to the theorist Heinrich Schenker, the topmost melody of the passage is a prolongation, or elaborated version, of the stepwise descending line E-D-C♯-B, or 5̂-4̂-3̂-2̂ in A major. (The caret notation indicates scalestep numbers. Since the line begins with scalestep 5, it is called a 5̂-line.)[1] This conception of the structure of the passage can be conveyed graphically as in Example 1a.

Example 1a

Note that alternative readings of a passage are possible and can be the locus of debate among theorists. The Mozart passage, for example, might also be regarded as a prolongation of a 3̂-line (beginning on C♯ ; see Example 1b).[2]

The question is then: when theorists disagree over structural descriptions, what are they disagreeing *about*? What does it mean to say that a 5̂-line, rather than a 3̂-line, is the structure of the passage?

Let me turn now to a second example, drawn from the traditional Roman numeral analysis of chords. A standard structural description of chord (*) in

Example 1b

Example 2 would be as a dominant triad or V in C (G-B-D; the E would be considered an ornamental tone).

Example 2

Again, an alternative reading is possible, III_6 (E-G-B with G in the bass; here the D would be ornamental). But most theorists would view the latter as an incorrect structural description.

We are concerned with such sentences, then, as

(1) P_1 (the passage in Example 1) is a prolongation of a $\hat{5}$-line.

and

(2) Chord (*) in P_2 (Example 2) is a V in C,

where these are read in such a way that one who accepts (1) or (2) may well reject

(1') P_1 is a prolongation of a $\hat{3}$-line.

or

(2') Chord (*) in P_2 is a III_6 in C.

The question is then how these sentences are to be analyzed. In what follows, I take it that they express facts of some sort, that someone who asserts (1) is saying that P_1 has a certain structural property, and that someone who denies (1) is saying that P_1 lacks it. The question is then what sort of property this

is, or what sort of "structural fact" is expressed here.[3] The main reason I take structural ascriptions to be truth valued is that they enter into all the usual truth-functional contexts: it is usual for theorists to say that (*) is *not* a III_6; and at least some music theories can be stated in terms of truth-functional connectives, quantification, etc., with structural ascriptions such as the above as constituents.

But if we are to understand the language of structure ascription we must take note of a seeming inconsistency. Theorists are not entirely happy about calling (2′) *false*, for (as is plain to see) the simultaneous collection of pitches E-G-B is present. Nonetheless, (*) is not "really" a III_6, many will say.[4] Similarly, a theorist who prefers the $\hat{5}$-line reading of P_1 to the $\hat{3}$-line may not want to call the latter false since (depending on how the operations are defined) the passage may well be generable from one line as well as the other. (Yet, such a theorist might say, P_1 is not "really" a prolongation of a $\hat{3}$-line.)

How are we to make sense of this? How can a chord be a III_6, but not "really"? (If we cannot make sense of this, so much for music theory's vaunted status as an articulate descriptive system.) Let me suggest that structural descriptions, or at any rate many of them, are systematically ambiguous. The point can be made clearest with a simple example. Consider

(3) P_3 (the passage in Example 3) is made up of four groups of three notes.

and

(3′) P_3 is made up of three groups of four notes.

Example 3

(3) can be read as equivalent to

(3_w) P_3 is a mereological sum of four groups of three notes,

and on this reading someone who accepts (3) is apt to accept (3′) as well. Let me call this the *weak* reading. But there is clearly a sense, central to the whole enterprise of music-theoretic structure ascription, on which P_3 is "really" structured as four threes and not three fours. Call this the *strong* reading. (The strong reading is what we are centrally concerned with understanding here.)

Now, I want to suggest that (many) music-theoretic structure ascriptions admit of strong and weak readings. The weak reading of (1) is that P_1 is *generable from* a $\hat{5}$-line, whereas the strong reading of (1) asserts something more. (Hence it may well be that (1′) is true on the weak reading though false on the strong reading.) (2), on the weak reading, asserts something such as that

the pitches of (*) *belong to* the triad G-B-D; on the strong reading, it asserts something more.

We can gain further insight into the matter if we take note of a way we commonly make it clear that the strong reading is intended, *viz.*, talk in terms of "functioning as." We are apt to say, e.g., that chord (*) is (in the weak sense) a III_6, but that it does not *function as* a III_6, but rather as a V. What this suggests is that the weak reading of a structural ascription simply ascribes a certain feature to a passage, whereas the strong reading says not only that the passage has this feature, but that the feature plays some special role. Chord (*) *is* an ornamented E-G-B and *is* an ornamented G-B-D; but its *being* an ornamented G-B-D plays a role that being an ornamented E-G-B does not. The chord's being an ornamented G-B-D is a feature that *is structural* in this context, in other words, whereas its being an ornamented E-G-B is not. That is why (2′) is false on the strong reading though true on the weak.[5]

Now, it may well be that not every case of structure ascription in music theory fits the model just given. Pitch orientation, for example—assigning a home pitch or *a fortiori* a key to a passage—does not obviously admit of a strong-weak ambiguity, at least as far as I can see. Nonetheless, what I propose to do here is to explore the sort of case that does fit the present model, leaving exceptions for another occasion.

To summarize the model, then: on the weak reading, a structural ascription predicates some feature F of a passage (chord, etc.); on the strong reading, it says that the passage functions as an F—or that F, as it occurs in the passage, is structural. The question is then what it is to function as an F, or what relation there is, if any, between being an F and functioning as one. The point I shall make is that while there are systematic connections to be described, music-theoretic notions of structure and "functioning as" are basically heterogeneous. My concern in the next section will be to sketch what I think are the two most important such conceptions.

But let me make one point clear before I proceed. I have invoked the notion of the *role* (or roles) into which properties that deserve the name 'structure' enter, which is to say I have suggested a functionalistic account of structure. But I do not assume that such functional roles have to be described or conveyed entirely *within* music theory. I do not assume, that is, that music theory tells us *what it is* for a passage to have a certain structure, as contrasted with (e.g.) telling us how certain passages correspond systematically with certain structures, or what laws govern structure. It may be that some music theories do the former, but there is no need to confine our notion of functional role to those within music theory.

3. CONCEPTIONS OF STRUCTURE

The question I should like to turn to now is this: in virtue of what is a feature structural? In my view there are two main ways of answering this, corresponding to distinct conceptions of structure relevant to music theory. The first is to

be explicated in terms of intentional notions: on this conception something's being a structure depends upon its being a structure *for* someone, being apprehended or grasped by the mind. (Structure on this conception may be compared with meaning, at least as the latter is often analyzed.)[6] On the second conception what is significant about structure is its causal role irrespective of whether anyone grasps or perceives it. Hence, the notion of musical structure is sometimes akin to that of the structure of a building in the sense conveyed by Nelson Goodman's phrase "how buildings mean"[7] and sometimes in the sense of "why things don't fall down."[8] As I will outline later, these diverse notions proceed from diverse purposes of music theory.

3.1. The Intentional Conception

On the first conception, structure is to be explicated in terms of intentional notions. The primary locus for this purpose is the listener and how he or she perceives the music (though it may also be relevant how others, such as the composer, think of the music, how they intend the listener to hear it, etc.) In hearing a passage, one has relative to one's auditory experience a certain intentional object: one hears the passage *as* having certain properties. (The intentional object is to be contrasted with the *real* object; among other things, the former but not the latter is incomplete.) A property's being structural, accordingly, derives on this conception from its being perceived, i.e., its being included in the listener's intentional object. In other words, a passage's functioning as an F is to be explicated in terms of its being perceived as an F. This is essentially a phenomenological analysis of structure.

A simple theory along these lines might go as follows:

(4) F (in passage W) is structural iff a listener of kind K would perceive W as F.

On this view, P_1 has the structure $\hat{5}$-$\hat{4}$-$\hat{3}$-$\hat{2}$ in virtue of being perceived *as* $\hat{5}$-$\hat{4}$-$\hat{3}$-$\hat{2}$; P_3 has the structure four groups of three in virtue of being perceived *as* four groups of three; etc.[9] (Curiously, what makes chord (*) "really" a V is that it is *apparently* one.)

The account just given amounts to a dispositional theory of structure, one on which a passage has a certain structure in virtue of having a disposition to bring about a certain response in the listener, *viz.*, a cognitive or intentional state directed toward that structure. One is apt to notice the analogy with traditional accounts of secondary qualities; but note that the present view avoids certain difficulties associated with them. A dispositional theory of *red* is standardly given in terms of *looking red*; and then either we have what I call an intentionalistic circularity, on which a property is defined in terms of intentional states directed toward that very property, or else 'looks red' is to be taken to be semantically indivisible, in which case we are apt to postulate "sensational," rather than representational, properties of experience.[10] Neither untoward consequence occurs here since strong and weak levels are distinguished: the property that *is* a structure is distinguished from its *being structural*. Consequently the

latter is defined in terms of intentional states directed not toward itself, but toward the former.

Now, the account just sketched can be filled in or amended in various ways. One item that remains to be specified is the relevant sort of listener. We might want to take into account the fact that the composer has written for a certain actual, historically determinate audience (say Leipzig churchgoers of 1750), or, in the case of certain recent composers, has a particular kind of listener in mind (who may, with the exception of the composer, not yet exist).[11] We might want to put in a restriction to sensitive, adept listeners who have *satisfying* experiences of the music in question. Or the relevant notion in the dispositional account might not be that of a property's being *perceived*, but of its being perceived in a certain *way*. What is relevant may be not that the work is perceived as having a certain tempo, but that the tempo strikes the listener as unusually fast.[12]

However these details are to be worked out, it remains that what is central to the account is that structure is something to be *heard*. Does this interpretation of theory and analysis square with practice? In my view it does; or at any rate it is a good first approximation to the practice of certain kinds of analysis. In such cases, analysts seem to rely primarily on the introspection of the objects of their listening experience in arriving at structural descriptions. Or, rather: however they arrive at such descriptions, the test for their *validity* seems bound up with how the music is heard. This is particularly true of Schenkerian analysis, in my experience: the teacher with whom I studied Schenkerian analysis seemed to speak interchangeably of the sketches I wrote and "how [I] heard" the music.[13]

Let me point out one respect, however, in which the story might be made more complicated. We might want to preserve the idea that the notion of structure is bound up with that of what we can hear, while giving up the assumption that the structure of a given passage is to be defined in terms of what we can hear *in that passage*. That is, we might give up the idea of trying to define structure in terms of the listener's response, *considering each passage one at a time*. It might sometimes be correct to count a feature in a particular context as structural because of our more general capacities for listening and organizing our experience of music, even if in that context the feature is inaudible because we are unable to exercise those capacities fully. An occurrence of a fugue subject in an inner voice, for example, might count as a structurally relevant feature because of our recognitional abilities for melody generally, even if the particular occurrence is difficult to detect. (The analogy is with meanings or syntactic structures too complex to understand, yet nonetheless determinate.)

Now this raises questions about the nature of music theory parallel to the recently discussed issue of whether linguistics is properly understood to be a branch of psychology. Jerrold Katz, for one, has argued in response to Chomsky's program for linguistics that a theory of linguistic *competence*, or of someone's *knowledge* of linguistic structure, is not to be conflated with a theory of that structure.[14] Scott Soames, likewise, has argued that linguistic theory is

both "conceptually distinct" and "empirically divergent" from the psychology of language.[15] Now, concerning music, Fred Lerdahl and Ray Jackendoff have explicitly favored a psychologistic interpretation of their own theory, along with a parallel conception of linguistics:

> Linguistic theory is not simply concerned with the analysis of a set of sentences; rather it considers itself a branch of psychology, concerned with making empirically verifiable claims about. . . language. Similarly, our ultimate goal is an understanding of musical cognition, a psychological phenomenon.[16]

Should we go along with them as far as music theory is concerned?

Let me remark first that later in this essay I shall point out a kind of structure which does *not* depend upon being an object of cognition; hence even if some music theory is psychological, not all is. Second, the analogy with syntactic structure noted above gives us room to retreat from a conception of music theory as a theory of what a listener hears in a passage, though continuing to think of structure as basically deriving from facts about what the listener perceives. The idea is that our perceptual or recognitional abilities considered in general, not just case by case, might furnish a basis for the systematic attribution of structure.

Now, I certainly do not want to maintain that this idea is straightforward or unproblematic. The crucial question is how our abilities are supposed to project to instances beyond our competence. Compositionality seems to be the key in the linguistic case, and perhaps it is relevant to the musical case as well. A musical structure may be built up in some sense from more basic properties or relationships, e.g., tonic and dominant. But a problem that arises here is of knowing when to stop, when the projection to further cases becomes unwarranted. This arises specifically in the case of Schenkerian analysis: many listeners report that configurations that occur (in their experience) on lower structural levels seem to lose their meaning when applied to higher ones. One might hear a phrase as $\hat{5}$-$\hat{4}$-$\hat{3}$-$\hat{2}$, but it is difficult to hear a progression such as this over the course of a movement. At what point does the ascription of large-scale structures to extended passages lose its sense? Does this point coincide with that at which one no longer hears such structures, or does it lie beyond? I am uncertain how this is to be answered in a principled way.[17]

3.2. The Causal Conception

So far we have considered a notion of structure on which structure is something to be grasped. I now wish to contrast this conception with one on which it is a property's location in the *real* object, rather than the intentional object, that determines its being structural.[18]

The main problem with the phenomenological analysis of (certain kinds of) music theory is that it just seems psychologically incorrect. Consider "set-theoretic" analyses of atonal music along the lines of Allen Forte's taxonomy (see Example 4).[19]

[1,2,6,7,8] [3,4,8,9,10]

Example 4

Such analyses segment a passage into collections of pitches systematically related to one another by inclusion, transposition, etc. (In the present example, the second set is obtained by transposing the first up a whole step.) There is experimental evidence that such relationships are inaudible to normal listeners.[20] (This does not preclude the possibility that Forte's theory models what some *elite* listener hears, but it seems doubtful that this captures the real value of the theory.) There is also the example of Golden-Mean analysis: such proportions pervade the music of Bartók, but it seems unlikely that a listener can (or should) hear sections of a piece *as* 0.62 as long as other sections.

Of course, it is always open to us to interpret such theories and analyses as attempts to model the perceptual—just botched ones. But the principle of charity, as a canon of interpretation, dictates that we look elsewhere; and it seems plausible to think that these analyses get their point from certain causal powers of the relevant musical properties.

The idea emerges most clearly with traditional descriptions of form. Consider, for example, the form of Guillaume de Machaut's chanson "Douce dame jolie" (Example 5), which features a pattern of repetition of text as well as music, as follows: *A bbaA ccaA...qqaA* (where 'A' designates the occurrence of the initial refrain with the same words and music, '*a*' the same music with different words).[21]

Example 5

As we listen to the chanson, are we, or need we be, aware of it *as A bbaA* (etc.)? There are two ways of understanding the question, and on each the answer is no. First, one need not have a synoptic grasp of the whole in anything like the way one typically takes in all of a painting at once; second, one need not hear the *parts* of the song in relation to some plan one has in mind.[22] Yet the point of the structural ascription may well derive from the fact that the aesthetic qualities of the chanson depend upon its having this formal arrangement. There is likely to be a psychological explanation for this such as the following: the listener is apt to become fatigued by hearing the same melody and text over and over, but at the same time will be overly taxed by constantly new material; this plan strikes the proper balance. (As a consequence, the eventual recurrence of *A* delights the listener and somehow seems right and inevitable.) The point, of course, is that nothing in this explanation requires that the plan *itself* be an intentional object for the listener.

Although Schenkerian analysis often appears to be best understood along phenomenological lines, perhaps in some cases it should be looked at in terms of the current model. Concerning the analysis of the Mozart passage (Example 6), note that there is an identity in pitch between the first three pitches of the large-scale descent, E-D-C♯, and the second, third, and fourth pitches of m. 4. Immediately after the large-scale descent has occurred, it is repeated more quickly—or "mirrored in the small," as Schenkerians would say. Now though one might deny that when one hears m. 4 one hears those notes *as being identical* in pitch to the large-scale descent—since one's perceptual powers may just not extend to comparisons among structural levels—it would be consistent to assert that the fact that this identity holds helps to explain what is elegant about the passage. It may well be that one's having *heard* the large-scale descent has an effect on one's hearing of the notes in m. 4 *because* they are the same in pitch. The latter pitches may well sound right because they have already occurred, albeit in large-scale form; and the unity or coherence

Example 6

of the passage may well derive, in part, from this identity. If so, what is important is that the identity is *there* and helps to explain coherence, even if the identity itself is unperceived.[23]

Hence on the second conception a feature F is structural by virtue of F's causal powers, in particular ones between formal arrangements and our perception of aesthetic properties such as cohesiveness, unity, rightness, and so on.[24] Now, there are possible variants to this account: perhaps the relevant notion should be the dependence of aesthetic properties themselves, rather than our perception of them, upon structure. In this case, the dependence would perhaps not be causal, though would still be explanatory in some sense.[25] However, for present purposes, I will continue to call the account 'causal'.

In any case, I want to maintain that certain sorts of musical analyses are to be interpreted as proffering causal (or other) explanations of coherence or other aesthetic properties. Note, however, that they need not be interpreted as *true* or successful. Writers such as Peter Kivy note that music theory smacks of pseudo-science in this connection: in criticism of Reti, he points out that thematic analyses which purport to show the unity of a work can hardly be very revealing if the relevant constraints are so loose that virtually any resemblance counts as relevant.[26] And another writer claims to present evidence that the order of movements of an extended work—hence, *a fortiori*, whatever structural relations supervene on that order—are irrelevant to (certain) listeners' aesthetic responses.[27]

Nicholas Cook's investigations into tonal organization are relevant here. In a recent article, Cook reports experimental results showing that normal listeners do not exhibit a statistically significant preference for pieces that begin and end in the same key over versions that do not.[28] He takes this to show that large-scale closure is unperceived, but allows that its aesthetic effects may be "indirect" (204). I take this to mean that he understands tonal structure along causal rather than intentional lines. Cook cites James Mursell in this connection:

> We have [in tonal plans] a foundational structural factor without which effective relationships could not be established among elements of tonal content, and which are essential for the general architecture of music, its harmonic sequences, and above all for the writing of subtle and expressive melody.[29]

But (in my view) the crucial and interesting question is not whether a tonal plan is part of, in Cook's words, the composer's "abstract conception" (204)—which may mean merely that it serves as a propaedeutic to composition—but whether a certain counterfactual dependence holds, i.e., whether the relevant relationships, subtlety, and expressiveness *would* not obtain if the plan were not present. And this, on my reading of Cook's results, seems more to be disconfirmed than supported by them. For he finds no correlation between tonal plans and aesthetic satisfaction, which weighs against not only the truth of the relevant structural ascriptions on an intentionalistic interpretation, but on a causal one as well.

This, I maintain, we ascribe causal/explanatory connections at our peril. But let me say I think it would be a mistake for music theorists to allow their speculations to be inhibited by adhering strictly to scientific standards of confirmation. For they are mainly in the business of discovering and suggesting plausible hypotheses about how music works, not establishing them by scientific standards.

4. REFLECTION AND CONCLUSION

The fact that the notion of structure does diverse sorts of work is related to the fact that music theory has a diversity of purposes. Some of these purposes are related to the perception and appreciation of music, whereas others are more concerned with its production and technicalities. And within each of these areas theory can have the status of an inquiry, a pursuit after truth, as well as be important for its effects on composers, performers, and listeners. In what follows I primarily have the effects of theory in mind.

Musical analysis can serve as a means of communication among listeners, a way of sharing interesting features they have noticed with one another. It is thereby a means of transmitting interesting intentional objects. (This might happen indirectly, by way of a performer's projecting a certain intentional object revealed by analysis, making it available to be heard.) Moreover, analysis can contribute to the formation of new and interesting objects of listening experience. Two ways in which it can do so have been pointed out by Kendall Walton. First, features that are important for their causal powers—answers to the question "what makes this piece work?"— can *themselves* become items of interest to be perceived. That is, features that are structural in the second respect can become structural in the first. This does not obviate the distinction between the two conceptions, but means that there is a certain fluidity in what features belong to what category. Exploring music with this sort of transformation in mind is of central interest to analysts of music.[30] Second, analysis can aid in the *recognition* of what one's intentional object is—becoming aware *that* it includes such-and-such features.[31] For reasons such as these, it is not surprising that the notion of musical structure should be closely linked to that of the intentional object.

At the same time, other roles of theory in musical production and culture leave room for a wider notion of structure, one not limited to the intentional object but extending to the real object as well. A composer (writing in a certain idiom) will want to avoid parallel fifths not necessarily because they will be perceived *as* parallel fifths but because, all else being equal, such progressions are apt to strike the listener as ugly. The feature of parallel fifths is significant here for its causal properties.

I have been arguing, essentially, that we have divergent conceptions of structure, on the one hand something to be perceived, on the other something with a certain causal efficacy. The question arises whether these roles ought to be combined somehow into a unified account. We might thereby understand

'structure' not merely to express a conception internal to a particular theory, but as referring to an entity (or property) that lies behind a variety of theoretical purposes and conceptions.

It is relevant to consider in this connection views about music theory recently put forth by Matthew Brown and Douglas Dempster.[32] The main thrust of their article is that if music theory is to be a respectable discipline it must meet standards of explanatory adequacy appropriate for science. In the course of their argument, Brown and Dempster suggest that we think of terms such as '*Ursatz*' as theoretical in the sense familiar from the philosophy of science, rather than as operationally defined observation terms (96). This (though it does not entail it) seems congenial to the view under consideration, that structure is something that stands behind diverse conceptions of it held by theorists with diverse purposes.

I am skeptical, however, concerning the unity of structure. It is sometimes plausible to think of certain modes of inquiry as converging on the same entity: we think of heat as what feels a certain way to us, what causes mercury to expand, what causes ice to melt, etc. But we need to have good reason to believe in such convergence, as we would if we had a truly explanatory theory on which a single entity is involved. But it is far from evident that we do; the situation, I want to suggest, is instead like the investigation of intelligence according to those who hold that intelligence is a matter of having diverse aptitudes and skills, not a single trait.[33]

There is no reason, as far as I can see, to think that different music-theoretic projects must have a common object of inquiry, one which detaches from the particular explanatory goals of any one such project. To be sure, music theorists do not always make this clear; and there may well be in use a notion of structure, as of intelligence, something like Wittgenstein's table that "stands on four legs instead of three and so sometimes wobbles."[34] But it does not follow that this notion is justified, i.e., that we are justified in believing in some entity standing behind such a heterogeneous conception.

If we do not conflate what are in fact distinct notions of structure, moreover, we may avoid disputes at cross purposes. I suspect that the question of whether triads and tonal functions are present in music before the eighteenth century is one such dispute.[35] To summarize the matter very briefly: those who answer this question in the affirmative point to clear instances of triads and root movement by fifth in the music; their opponents cite the theory of the time, charging that such tonally based analysis is anachronistic. It seems to me that much of the debate depends on an equivocation over intentional and causal conceptions of structure. I hope to expand on this elsewhere.

Let me summarize the view of musical structure advanced in this essay. Certain music-theoretic structure ascriptions point out a feature of a passage and distinguish it as structural. A feature's being structural can stem from either of two main sources: its role in the intentional object of a listener's experience, and its causal powers irrespective of being perceived. Both these conceptions

of structure need to be recognized if we are to understand what the rich and intricate systems of music theory have to tell us.[36]

NOTES

1. The relevant prolongation operations are detailed in Heinrich Schenker, *Free Composition (Der freie Satz)*, translated and edited by Ernst Oster (New York, 1979). Analysis after Allen Forte and Steven E. Gilbert, *Introduction to Schenkerian Analysis* (New York, 1982), 134. The line is incomplete here since it does not go all the way to $\hat{1}$, but this complication need not concern us.

2. The motion to $\hat{2}$ at the end is a deviation I shall ignore. The above interpretation essentially follows that of Lerdahl and Jackendoff. For discussion, see John Peel and Wayne Slawson, review of *A Generative Theory of Tonal Music* by Fred Lerdahl and Ray Jackendoff, in *Journal of Music Theory* 28(1984):284–87.

3. An alternative would be a "non-cognitivist" construal, such as one on which the speaker expresses an attitude or recommends some action.

4. Kivy uses 'really' with this kind of force in *Music Alone: Philosophical Reflections on the Purely Musical Experience* (Ithaca, 1990), 138.

5. The "functions as" terminology is not strictly synonymous with the strong reading since we sometimes want to say that something that is not an *F* functions as one. I shall ignore this complication.

6. See Brian Loar, *Mind and Meaning* (Cambridge, 1981), 210. But see Gilbert Harman on calculation vs. communication and content vs. meaning in "(Nonsolipsistic) Conceptual Role Semantics," in *New Directions in Semantics*, edited by Ernest LePore (London, 1987), 56.

7. See the chapter "How Buildings Mean" in Nelson Goodman and Catherine Z. Elgin, *Reconceptions in Philosophy and Other Arts and Sciences* (Indianapolis, 1988), 31ff.

8. J. E. Gordon, ed., *Structures: Or Why Things Don't Fall Down* (New York, 1978).

9. An account of pitch orientation might be given along these lines, in terms of a listener's propensity to hear the pitches of a passage as bearing certain relations, such as intervals, to the home pitch.

10. Each of these has been regarded as a difficulty by some philosophers. See Michael A. Smith, "Peacocke on Red and Red′," *Synthese* 68(1986):559–76, and Christopher Peacocke, *Sense and Content* (Oxford, 1983), 28ff.

11. See Milton Babbitt, "Who Cares If You Listen?" *High Fidelity* 8(1958):38.

12. Or as "contrastandard," in Kendall Walton's terminology. See his "Categories of Art," *Philosophical Review* 79(1970):339.

13. To be sure, this need not commit us to an egoistic theory of the semantics of analysis: how a theorist hears a passage may be taken as evidential rather than constitutive of what an analysis means.

14. Jerrold J. Katz, "An Outline of Platonist Grammar," in *The Philosophy of Linguistics* (Oxford, 1985), 203.

15. Scott Soames, "Linguistics and Psychology," *Linguistics and Philosophy* 7 (1984):155.

16. Fred Lerdahl and Ray Jackendoff, *A Generative Theory of Tonal Music* (Cambridge, Mass., 1983), 6.

17. Before going on to the next section let me mention a special case. The motivating thought on the present conception has been that structure is meaning-*like*. A welcome version of this idea would be that structure really *is* a kind of meaning. This view is taken by Goodman, who holds that a variation exemplifies, and hence refers to, certain of its properties, including ones it shares with its theme (*Reconceptions*, 69). Insofar as music theory is concerned with structure in a sense in which theme and variation have the same structure,

Goodman's explication of variation via semantic notions strikes me as potentially fruitful for the understanding of certain kinds of music-theoretic structure. A semantically based view of musical relationships may be found also in Richard Kuhns, "Music as a Representational Art," *British Journal of Aesthetics* 18(1978):120–25.

18. Clearly, a feature must *exist* in order to enter into causal relations; and it is neither necessary nor sufficient for entering into those relations that it be *perceived*.

19. Allen Forte, *The Structure of Atonal Music* (New Haven, 1973).

20. Don B. Gibson, Jr., "The Aural Perception of Nontraditional Chords in Selected Theoretical Relationships: A Computer-Generated Experiment," *Journal of Research in Music Education* 33(1986):5–23.

21. Notated version after Leo Schrade, ed., *Polyphonic Music of the Fourteenth Century*, vol. 3: *The Works of Guillaume de Machaut*, Second Part (Monaco, 1956), 168. Recording: *The Mirror of Narcissus* (Gothic Voices, Hyperion CDA 66087). The given pattern is that of a *virelai*, one of the medieval *formes fixes*. The point made here applies also to rondo, bar form, etc.

22. Though of course one *may*, but that does not seem to me to capture the real significance of the formal analysis. I have profited from Jerrold Levinson's discussion of the views of Edmund Gurney in "Apprehending Music: A Concatenationist Perspective" (typescript), and from the discussion of cohesiveness in Wendell V. Harris, *Interpretive Acts* (Oxford, 1988), 50ff.

23. Another analyst whose work might be understood on the current model is Rudolph Reti, who finds heretofore unsuspected thematic connections among movements of a work, and even in what is generally considered contrasting material in the same movement. Reti says that a kind of "unconscious recollection" of earlier material occurs when one hears later, related material, and I take this to mean that what one hears later is familiar because one has heard the earlier material, not because one hears the later material *as* a repetition or transformation of the earlier material. Hence it is plausible to understand Reti's approach as falling under the present model. See Rudolph Reti, *The Thematic Process in Music* (New York, 1951).

24. More "local" perceptions might come into the picture as well—e.g., a chord might function as a V rather than a III because it is heard as having the tension normally associated with V.

In contrasting the present "causal" conception of structure with the intentionalistic conception, I do not mean to deny that perceptual notions themselves should be analyzed in terms of causality. What is relevant in the present case is causal powers *other* than those directly relevant to *F*'s being perceived.

25. I am not claiming that we should always understand music analysts as actually *giving* the relevant explanations. They might leave them implicit, or they might present data they think are *capable* of entering into such explanations, without having determined exactly how the explanations are to go.

26. Kivy, *Music Alone*, pp. 136–37 (see note 23 above).

27. Vladimir J. Konečni, "Elusive Effects of Artists' 'Messages'," in *Cognitive Processes in the Perception of Art*, edited by W. R. Crozier and A. J. Chapman (Amsterdam, 1984).

28. This is true for passages of over a minute or so in duration. See Nicholas Cook, "The Perception of Large-Scale Tonal Closure," *Music Perception* 5(1987):203.

29. James L. Mursell, *The Psychology of Music* (New York, 1937), 215–16, cited by Cook, 204–05n.

30. This was pointed out to me by Marion Guck.

31. Kendall L. Walton, "Understanding Humor and Understanding Music" (typescript, 1989), 12.

32. Matthew Brown and Douglas J. Dempster, "The Scientific Image of Music Theory," *Journal of Music Theory* 33(1989):65–106.

33. See, e.g., Stephen Jay Gould, *The Mismeasure of Man* (New York, 1981), 24.

34. Ludwig Wittgenstein, *Philosophical Investigations*, 3rd ed., translated and edited by G. E. M. Anscombe (New York, 1958), 37.

35. See, e.g., the discussion in David Schulenberg, "Modes, Prolongations, and Analysis," *Journal of Musicology* 4(1986):303–29.

36. I am grateful to Gilbert Harman and Jonathan Kramer for their comments.

Look What They've Done to My Song: "Historical Authenticity" and the Aesthetics of Musical Performance

ARON EDIDIN

Introducing a recent collection of essays entitled *Authenticity and Early Music*, Nicholas Kenyon writes that

> No change has more profoundly influenced the development of our music-making during the last two decades than the growth of the historical performance movement. The search for original methods and styles of performance has brought about a sea-change in our listening habits, and indeed in our approach to the whole question of repertory and tradition in classical music.[1]

It is a measure of the change to which Kenyon refers that he can assume that his readers won't need to be told that 'original methods and styles' refers not to originality on the part of contemporary performers but rather to methods and styles characteristic of the time of origin of the music performed. The term 'historical authenticity' has come to be used for the extent to which performances employ such "original methods and styles" and instrumental resources, and honor the directions provided by the composer in the score and (occasionally) elsewhere.[2]

If the last twenty years have seen the flowering of the historical performance movement, the last ten have been enriched by a flurry of polemical writing about it.[3] Numerous authors have argued that the movement is, or is not, a Good Thing. My concern here is with what is in one sense the most abstract element of that debate. My most central interest will be in two questions:

> Is there any reason to expect that important aesthetic values might more readily be realized in more historically authentic[4] performances than in performances that are less historically authentic?

and

Is there any reason to expect that important aesthetic values might more readily be realized in performances that are less historically authentic than in ones that are more historically authentic?

These mildly indigestible questions can be abbreviated:

Is there any reason to think that either more or less historically authentic performance enjoys any aesthetic advantages vis-à-vis the other?

But in using the abbreviated form, it is important to remember that an aesthetic advantage in the intended sense doesn't at all guarantee aesthetic superiority either overall or in any particular respect. What it amounts to is a reasonable expectation of *potential* for aesthetic superiority in some respect or other. It's a matter of fallibly but reasonably foreseeable opportunities.

The answer I'll defend is that each sort of performance offers some aesthetic advantages vis-à-vis the other. In spite of the congenial and inoffensive nature of this answer, two factors (apart from its truth) make this view one worth defending at length. In the first place, there is among recent commentators fairly widespread and not unreasonable skepticism concerning the question of whether or not historical authenticity or its reverse is ever relevant at all to the merit of a performance. In addition, the defense of my inoffensive "eclecticist" conclusion will involve the exploration of issues concerning the relations among performer, composer, and past performers, that are of interest even apart from their relevance to the merits of more and less historically authentic performance.

I'll be writing, then, about the aesthetic evaluation of performances of old music. By aesthetic evaluation I understand the description of an object in terms of the aesthetic values that characterize it. Aesthetic evaluation thus understood is not restricted to ranking or judgments of degrees of merit, though such judgments will be instances of aesthetic evaluation. The objects of aesthetic evaluation I call aesthetic objects.

One source of difficulty when considering the aesthetic values to be expected of more (or less) historically authentic performances is the especially complex context of aesthetic evaluation in which such questions arise. I'll begin, then, by looking at some elements of that context.

PERFORMANCES OF EXISTING
WORKS: SOME SPECIAL FEATURES

Although the aesthetic evaluation of performances of old music is an example of aesthetic evaluation in the general sense I've introduced, it is an example with some very special features. These can best be brought out by contrasting the evaluation of such performances with the evaluation of other sorts of aesthetic objects.

When we evaluate a painting, it is tolerably clear just what it is we're evaluating: the painting. It is the features of the painting itself that are relevant to its aesthetic value; there is no other bearer of aesthetic value in the

neighborhood. This is not to say that the features in question cannot be relational. How well a portrait captures the character of its subject, for example, or how original it is (how much or little it resembles earlier works by other painters), *might* be relevant to its aesthetic value. It is also not to say that there are no subtle issues concerning the nature of paintings as aesthetic objects. One can wonder, for example, whether a painting is best conceived as a token, an individual material object, or instead as a type, embracing tokens that are visually similar enough (e.g., originals and perfect copies). But these issues *are* subtle; there's nothing obvious about paintings *per se* that complicates their aesthetic evaluation as such.

In these respects the evaluation of a theatrical improvisation resembles that of a painting. Here the object of evaluation is not an enduring thing (or similarity-type of such things) but rather a performance, a passing sequence of actions (or a similarity-type of such sequences). But once more there is only one aesthetic object in question, and it is tolerably clear at least approximately what that object is.

The performance of a play or of a musical composition seems to present a very different sort of case. Here there are two aesthetic objects: the performance itself and the play or composition performed. Moreover, the two objects cannot be evaluated independently. The most important aesthetic values of a play or composition are typically realizable only in performance. The value of a composition resides not (for instance) in what it looks like, but rather in what it sounds like. But of course the composition itself does not literally sound like anything. It is particular performances of the composition that sound, and which can thus embody the values that characterize the composition. What makes a play or a composition valuable is a matter of what performances of it are (or at least could be) like. On the other hand, of course, the values achieved in a performance will depend to a great extent on the features of the work performed. In addition, we often evaluate performances of a particular work precisely as performances *of that work*, rather than solely as autonomous performances-events comparable to improvisations. Whatever aesthetic values might characterize a performance in itself as a piece of acting or directing, fiddling or conducting, we are typically also interested in how and to what extent it realizes what we take to be the values inherent in the work performed. The focus of interest on the performance *qua* autonomous event or *qua* realization of the work performed will depend largely on the degree of our esteem for the work: we think of great plays and compositions as more than mere vehicles for performers, and look for different things in their performance than we do in the performance of "display pieces."

There are, I think, deep questions to be asked about the relation between evaluating performances *qua* autonomous events and evaluating them *qua* realizations of preexisting works, and about the legitimacy of the latter sort of evaluation as distinct from the former. But in what follows I shall simply take for granted what seems to be the common presupposition of almost all contemporary performance criticism, namely, that there *is* a coherent and important

sort of evaluation of performances *qua* realizations of the works performed. In the sense I have in mind, an excellent realization of an excellent work will of necessity be an excellent piece of music-making. Moreover, other things being equal, a performance of a better work will constitute a better piece of music-making than a performance of a less-good work. It *won't*, however, follow from the fact that one performance is an excellent realization of an excellent work and another is a poor realization of the same work that the first is superior as a piece of music-making to the second. (It follows directly from these, of course, that performance which is a poor realization of the work performed can nevertheless be an excellent performance *qua* autonomous event.)

MUSEUM CULTURE: AESTHETIC EVALUATION AND AESTHETIC OBJECTS NOW AND THEN

The role in western society of the performance of old music is just one example of a cultural orientation toward art which is very different from the stance characteristic of most of the societies in which the great masterpieces of the past were produced. The matter is sometimes put by saying that we live in a museum culture. This is understood to involve two distinct factors. On one hand, the role of the museum (or concert hall) as a separate place for art is emblematic of the fact that art tends to be isolated from the rest of our lives in a way that is relatively new and would be quite foreign to the experience and expectations of the great artists (including composers) of the past. On the other hand, it is the work of those past artists that, gathered in museums and performed in concert halls, figures most prominently in our aesthetic lives.

What this means in the case of performances can be brought out by considering what is in many ways an extreme case, that of Bach's cantatas and passions. The *Johannes-Passion* (to choose a particular example) was composed for performance as part of the Good Friday vespers service in a Lutheran church. The context for which it was composed was one of worship, not of aesthetic contemplation. Today, the context in which the *Johannes-Passion* will be heard is entirely different. Even if it is heard at a public performance rather than on a recording, the context will almost always be that of a concert. It goes without saying that the values relevant to the functioning of the *Johannes-Passion* as a part of a worship service are largely different from those relevant to its functioning as a piece of concert music. When we describe the work as a masterpiece of music, we are evaluating it in terms very different from those in which it was conceived.

This difference in conception is important, but it is also important not to overemphasize its consequences. So, in the first place, it should be noted that the fact that our evaluation of the *Johannes-Passion* is in terms largely foreign to the intent of its composition in no way undermines the *correctness* of our evaluation. Even if the aesthetic virtues we prize in the work had no relevance at all to its original conception, it does not follow that the work does not really have those virtues. But it is also unrealistic to suppose that the aesthetic values

in terms of which we evaluate the *Johannes-Passion* were entirely irrelevant to its conception or to its functioning in its original context. Bach composed the music for performance as part of a worship service, but the excellence of the music *per se* was surely considered relevant to the status of its composition as an act of service to God. Bach's aim was presumably to compose excellent music for a certain role in worship. Some of the factors involved in suiting the music to that role may not have anything to do with the excellence of the music, and might indeed create conflicts with the aim of composing excellent music. It may be that the excellence of the music was sacrificed in various ways to its suitability to its role in the service. On the other hand, it might well be that the suitability of Bach's music to its religious purposes contributes to its aesthetic value even as assessed and experienced in contexts removed from those purposes by listeners who do not share the religious views that engendered the religious role of the composition in the first place. (Similarly, the suitability of artifacts to their functions can contribute to their aesthetic value.)

If, then, we consider various features of the original performances of the *Johannes-Passion*, some will be clearly identifiable as results of the religious function of the work. For example, women were not allowed to sing in the Lutheran churches of the time, so the soprano and alto soloists were boys, as were the sopranos and altos in the choir. But the fact that his choice of boy soloists and choristers rather than women was dictated by the religious function of the work and not by aesthetic considerations in no way establishes the independence of the aesthetic value of the work from that choice. We expect at least the greatest artists to make virtues of necessities. Bach knew that regardless of such aesthetic preferences as he might have, the music assigned to high voices in his church music would be sung by boys, and it is reasonable to suppose that this knowledge led him to write music that exploited the special characteristics of boys' voices.

The *Johannes-Passion* is an extreme case, but the musical life of most present-day listeners[5] is taken up chiefly with works that are like it in that they were composed long ago by someone now dead for performance in contexts quite unlike modern-day concerts, to say nothing of recordings. I have said that the difference in context need not in any way undermine our aesthetic appreciation of the old works we hear. But what is to be made of the fact that most of the music we hear was composed long ago? Clearly we do not think of music as an art that has progressed through its history to an aesthetic pinnacle in contemporary compositions. But without belief in general progress in matters musical, it's hard to make a case for the view that present performance practices, instruments, or even musical judgment and taste represent the pinnacles of their own processes of historical progress. Of course, the very vehemence with which audiences reject contemporary music suggests that they often feel quite confident in their judgments of musical worth. But the recognition that much old music is at least as worthwhile as the best contemporary music recommends a degree of openness toward other elements of older musical cultures, including both performance practices and approaches to musical aesthetics. This goes

especially for judgments about and practices involved in the performance of the works with which the earlier cultures were most intimately concerned, namely those produced within each culture itself. At the very least, it seems likely that we could learn something about the music we admire and its performance from the musical cultures in which it was composed.

If we open ourselves in this way to the practices and values of older musical cultures, we will not reject archaic practices or judgments out of hand even if the initial response of our musical taste is to disagree with the judgments and dislike the result of following the practices. Openness to items that we do not initially appreciate is an important part of what is involved in going beyond ethnocentrism (perhaps in this case a better word would be 'chronocentrism') in any realm. In the long run, of course, we will have to rely on our musical taste to judge the results of our openness. Rejecting chronocentrism (or ethnocentrism) need not involve rejecting critical judgment altogether. The taste that we bring to bear in such judgment will inevitably be in large part a product of *our* cultural context. But openness to old values and practices can itself be an element of that context, and while our judgments ultimately remain ours, we might reasonably hope that familiarity with the practices and judgments of earlier musical cultures, along with the experience of sympathetically exposing ourselves to the results of those practices and judgments, will make us better judges.

It seems fairly clear that for our musical culture to turn away from contemporary music in favor of older compositions is in many respects regrettable. Surely it's bad for audiences to be cut off from the creative expression produced by their contemporary society, and it's bad for the sources of creative expression to be cut off from audiences in their society. Still, the connection between the rejection of contemporary music and the absence of a dominant contemporary aesthetic that would prevent genuine openness to the musical cultures of the past is not altogether clear. *Maybe* the healthiest situation overall would be one in which musical culture is so dominated by contemporary composition that earlier works could be appreciated only as elements of the living tradition that culminates in contemporary music.[6] But as far as the aesthetic appreciation of old music is concerned, the absence of a set of universally imposed practices rooted in contemporary composition would seem to be a very Good Thing, and the "museum culture" of which it is a feature may not be altogether unfortunate.[7]

APPROACHING THE QUESTION OF HISTORICALLY AUTHENTIC PERFORMANCE

I am at last in a position to begin addressing the question of the advantages that might reasonably be expected from either historical authenticity or historical inauthenticity as approaches to the performance of old music.

I'll begin by noting two sources of evidence concerning the questions I'm addressing that I do not want to pursue. One approach is to begin with

an account of the essential nature of music (or some particular sort of music) and the aesthetic values to be sought in musical performance, and then attempt to identify the sorts of performance most conducive to the realization of those values. For example, if the aesthetic essence of (baroque and later Western art) music is a matter of its use of the structures of functional tonality, then the best performances will arguably be those that best bring out the use of those structures. Choice of instruments might be relevant to the realization of these values in performance, but there certainly won't be any automatic presumption in favor of instruments familiar to the composer and, in any case, choice of instruments will probably not be an extremely important factor in the realization of these values. Moreover, reorchestration and other modifications may be called for if we can ascertain that they will contribute to better conveying the use of tonality in a piece.

These questions will, of course, be debatable. Thus, it might be that the very best composers tailored their use of tonality to the capabilities and infirmities of the instruments at their disposal, so that their structures are likely best to be conveyed by the instruments they knew. But the terms of the debate are fixed by the initial judgment concerning aesthetic essences. The debate will look very different if we decide that the aesthetic essence of music consists of a play of sonorities in which harmony and even pitch are not automatically privileged over such elements as timbre. Again, if we decide that the essence of music concerns the expression or elicitation of emotion, our evaluation of performance practices will be still different. In this last case more than the former two, considerations of the expressive conventions familiar to the audience played to are apt to be important. Perhaps it's just silly to try to use baroque practices to elicit the appropriate emotions from contemporary audiences.

So if one knows the essential nature of music in general or some composition in particular, one is apt to be in a position to draw conclusions about the comparative virtues of different ways of performing the composition. Unfortunately, I'm not in a position to exploit this fact, because I don't know what the relevant essences are. Moreover, like everything else in aesthetics (and for that matter the rest of philosophy), questions of the essence of music and the aesthetic values central to it are perennially controversial. Whatever position on the essence of music I might choose as a basis for investigating the virtues of different kinds of performance will be one that is opposed by philosophers no less experienced, informed, and thoughtful than myself. This suggests that it would be well to approach with a certain measure of diffidence the question of what values one or another kind of performance might be best suited to realizing. If we are not willing to insist that we know what all of the relevant aesthetic values are, we need to allow the possibility that a performance might reveal to us values in the work performed whose presence we did not suspect. This is, I think, a possibility we typically admit.

Of course, none of this implies that those with strong opinions concerning the essence of music in general or of particular works should not investigate the consequences of those opinions for the evaluation of performances. Nor

does it imply that their confidence in those opinions does not warrant for them a similar degree of confidence in the consequent evaluations. And it certainly doesn't imply that performers who hold such opinions should not let those opinions inform their performances. But it does at least suggest the value of an approach to the questions I've posed that does not depend on solving the problem of the aesthetic essentials of music.

In what follows, I will not be able entirely to avoid general aesthetic considerations, and I have no doubt that certain overall aesthetic positions are implicated even where general aesthetic matters are not explicitly at issue. At the very least, there are views about general aesthetic matters which are incompatible with the conclusions I will defend and the strategies I will use in defending them. But my practice will in general *not* be to infer conclusions about the advantages of different sorts of performance from premises about the essence of art in general, or of music, or even of particular works.

The claim that historically authentic and historically inauthentic styles of performance each especially promote important aesthetic values might also be defended *empirically* by noting that each sort of performance is preferred, apparently for aesthetic reasons, by some excellent musicians. This, of course, does not *prove* anything, but I think it is a fairly powerful bit of evidence. Of the same general sort is the evidence that can be got by listening to many performances of both kinds and seeing whether characteristic virtues emerge. Here again, proof will not result; it is possible that, say, such characteristic virtues as emerge in more historically authentic performances are the result not of historical authenticity but of some feature contingently correlated with it. Still, the evidence provided by *listening* is surely a most important source of evidence concerning the merits of different sorts of performance, and arguably the ultimate source of such knowledge as we might obtain of aesthetic matters concerning music in general and performance practices in particular.

In spite of their significance, I will no more focus on these more empirical sources of evidence than on matters of ultimate aesthetic essence. I think that it is possible to defend *a priori*[8] at least a limited range of claims concerning the likely presence of aesthetic advantages to both more and less historically authentic kinds of performance. Such an approach will treat the questions I have set as ones of reasonable expectation under uncertainty. Its results may be thought of as *a priori* plausible hypotheses which might be confirmed by listening to performances of appropriate sorts. The *a priori* defensibility of such hypotheses is important both in providing a context for thinking about kinds of performance as yet unattempted and in accounting for the success or failure of particular performances. For example, if one can defend *a priori* the claim that a performance that is historically authentic in a certain respect is likely to exhibit virtues of a certain general sort, than one may be able to explain the success of such a performance at least in part as an outcome of its authenticity. Of course, the same goes, *mutatis mutandis*, if one can defend *a priori* the corresponding hypothesis for performances that are historically in-authentic. I should note at this point that my discussion of potential advantages

of historically authentic and historically inauthentic performances vis-à-vis one another will introduce few considerations that are entirely new. Most of the issues I'll be discussing are widely treated in the literature surrounding the historical performance movement. Moreover, the selection of issues I will treat is far from comprehensive. My hope is that the stage-setting I have done in terms of the context of the discussion and the status of proposed advantages as *a priori* plausible hypotheses will make it easier to see their merits and limitations, and that it will not be hard to see how those considerations will apply even to issues I don't discuss.

SOME ADVANTAGES OF HISTORICALLY AUTHENTIC PERFORMANCE

As I formulated it at the beginning of the article, historical authenticity of performance involves three elements: original methods and styles of performance, original instrumental resources, and observance of composers' directions. As the case for using historical practices and instruments is typically made in terms of the value of realizing composers' intentions, and since those intentions are most directly expressed in the explicit directions that comprise the written texts of their compositions,[9] it will be useful to begin with those.

Fidelity to the Composer's Directions

It is possible to take seriously the value of fidelity to composers' intentions without getting involved in period performance practices or instruments at all. Many performers with no interest in period practices or instruments nevertheless insist on fidelity to the score. We can usefully distinguish aspects of faithfulness to composers' intentions which do from those which do not go beyond fidelity to the score, and start with the case for the former.

There are various ways in which a performance can deviate from the score of the work performed. Portions may be cut, orchestration or harmony modified, sections recomposed, markings altered or ignored.[10] What might a performer expect to lose by any of these deviations? Performers presumably exercise their musical judgment in deciding which works to perform in the first place. Shouldn't they also exercise their judgment in deciding which elements of the score to follow and which to modify or ignore?

One difference between the two issues is that in deciding to perform or not to perform a piece, a performer is not likely to be acting against the musical judgment of the composer. In modifying or disregarding the score, on the other hand, the performer presumably *is* acting against the judgment of the composer as to how the piece should go. But why should that matter? As a number of writers have pointed out,[11] we are under no moral obligation to dead composers with respect to our performances of their compositions. If we have any reason to respect the musical judgment of dead composers it will be because we think that their judgment is apt to be good. But of course, we typically *do* think this, at least of the composers whose compositions we value must highly. In fact, to

value a composition just *is* to endorse the musical judgment of the composer as embodied in the decisions that together constituted the composing of the work. That is, to judge that a composition is good is to judge that in composing it the composer chose well, at least on the whole.

The issue that arises when we consider alteration of a score we admire can be put this way: If I think a certain passage in one of Mozart's symphonies should go one way and Mozart wrote it another way, there are three possibilities (which are not mutually exclusive):

(1) I can see something Mozart missed,

(2) Mozart saw something I am missing,

or

(3) Things that have happened since Mozart's time have changed what is the best way for the passage to go.

The judgment that favors following what is written in the score suggests that at least in most cases (2) is more likely than (1) or (3). Our inclination to make that judgment will reflect the degree of our esteem for Mozart as a composer. In any event, by playing the passage as written we will be in a position to realize whatever values characterize Mozart's version as opposed to such alternatives as we are likely to come up with, and our respect for Mozart's compositional genius suggests that this is apt to be worth doing.

Of course, we have not come up with anything like a *proof* that the work will go better if it is played as written than if it is not. In the first place, it is at least possible that the passage in question represents a lapse of Mozart's usually wonderful musical judgment. Extensive experience with different ways of playing the passage may reasonably convince us that this is so. On the other hand, even if extensive experience does not change our preference for a modified version, it might *still* be that we are missing something, even something important, in the passage as written. And in the cases of the composers of whom we think most highly, it does not seem that this is a possibility that can reasonably be ignored (though in the case of a performer it may be that the conviction lost by performing the composer's version will more than offset the possibility of aesthetic revelation gained).

Possibilities of the kind suggested by (3) represent a source of reasons for choosing modified over unmodified versions based on the virtues of adaptability. They might suggest reasons to expect that special virtues might be available to historically inauthentic performances, but they do not really undercut the expectation that some good is to be expected of respecting the musical judgment of the composers we admire.

One way of putting the matter is in terms of the relative merits of the work the composer produced and other, closely related works she might have composed by modifying the relevant features of the one in question. This is not to say that a performance of *La Traviata* that cuts a verse of an aria (as almost all do with several arias) is not a performance of *La Traviata* at all,

but rather of a different though closely related opera that Verdi might have composed but didn't. Still, it is the directions conveyed in the score that one way or another constitute the identity of a written composition. At this point it might be helpful to recall the distinction between the evaluation of a performance *per se* and its evaluation *qua* realization of the work performed. The considerations raised above suggest that the work produced by a great composer is apt to be better than the close variants obtainable by local departures from the composer's directions. A performance of the composer's version is thus apt to be aesthetically more valuable *in itself* than a performance of such a variant. But if we consider the evaluation of a performance *qua* realization of the work performed, it would seem in addition that local departures from the features that, taken together, make the work what it is diminish a performance *qua* realization of the work. In a trivial sense, of course, they make it *less* a realization of the work. Reflection on the point of judging performances *qua* realizations of works suggests (at least to me) that such a diminution also counts against the *value* of the performance as a realization of the work.[12]

Again, this does not imply that any performance that plays a work as written will be a better realization of the work than any performance that does not play it as written. It does not even imply that any excellent performance that plays a work as written will be a better realization of the work than any comparably excellent performance that does not play it as written. It may sometimes be that, to put the matter traditionally, the spirit of a work can best be served by departing from its letter. Of such a case I would want to say that the loss incurred by departing from the written text, while real, is outweighed by gains made possible by the same departure. In spite of this possibility, it seems clear that the avoidance of such losses does in the relevant sense constitute an advantage to textually observant performance in addition to such others as our admiration for the composer may lead us reasonably to expect.

Going beyond the Text: Period Styles and Practices

When we turn to issues of performing style that go beyond the written score, matters get hazier. "Historical authenticity" concerning such matters as tempo, phrasing, dynamics, and added embellishment is typically a matter of adopting practices that were in common use[13] at the time of composition. The principal sources of information concerning such practices rarely include instructions from the composer, and there is often no direct evidence of the composer's attitude towards the common performing practices of her day. At one extreme, the composer might have taken these practices to be essential to her works, to the extent that she would have prescribed them explicitly except that she could take their use for granted. At the other extreme, she might have despised the common practices but despaired of preventing their use by specifying alternatives.

Conclusive evidence of a given composer's attitude toward a given element of performance practice is usually unavailable. But it is possible to establish some reasonable, if defeasible, presumptions. In the first place, of

course, even radically innovative composers are to a considerable extent products of their times. We are, to be sure, dealing mainly with composers out of the run-of-the-mill of their cultural milieux.

Beyond the mere fact of a composer's immersion in a context in which certain practices were valued, there are other sources of indirect evidence concerning her attitudes towards those practices. If a certain convention is in force in the relevant musical community, a composer will surely expect performances of her work to observe the convention unless steps are taken to prevent such observance. In the absence of evidence that she opposed the conventional practice in general or took some such steps, there is some reason to suppose that she at least acquiesced in its observance. Again, if the practice was sufficiently pervasive that deviation from it would be noteworthy, and if there are accounts of performances supervised by the composer which are otherwise relevantly informative but mention no deviation from conventional practice, this will provide some reason to believe that the composer accepted the practice. In general, the more pervasive is an element of conventional practice, the more a composer could be expected to take its observance for granted, and the more likely it is that objection to it and deviation from it will be noted. Of course, if specific information about the composer's preferences exists, the need to rely on such general presumptions will be reduced or eliminated. But in the absence of such information, we are still not entirely at a loss.

It will, then, often be reasonable to presume that a composer at least did not oppose the practices that constituted the conventional style of performance at the time of composition within the relevant community.[14] But what does such acquiescence signify concerning the composer's musical judgment regarding her work? The best case for observing period practice, parallel to the case for observance of the written score, would come from the conclusion that failure to observe the practices in question would be contrary to the composer's musical judgment. But this conclusion is not available. Acquiescence in a practice does not imply a judgment against alternative practices. Still, to say that a composer did not oppose a practice *is* to say that we will not *contravene* her judgment by observing it. This is something we *cannot* typically say about alternatives to period practices. Moreover, practices whose employment the composer could presuppose need not be notated or otherwise indicated even if they are essential to the composer's plan for the work. (In the absence of metronomes, it's hard to imagine planning with respect to at least approximate tempi that does not rely on conventional practice. Added embellishment seems another likely candidate for the status of a "planned but unnotated" element.) Certain elements of the work as conceived by the composer may be realized only by observing period practice. It goes without saying that alternatives to such practices offer no such possibilities. Finally, it seems likely that in addition to deliberately counting on conventional practices in composing, composers respond consciously or unconsciously to their awareness of prevailing practice in various ways that might (by stretching somewhat the usual meaning of the term) be gathered within the general category of "writing idiomatically for their performers." To

the extent that this is so (and it will surely differ from composer to composer and from work to work), works and performance practices will be suited to each other in ways that reflect the musical judgment of the composer. Such a matching of work and practice can be expected to produce aesthetic values that can be realized only in performances that observe period conventions.

These considerations turn on composers' responsiveness to contemporary performance practices. There is, of course, a reciprocal responsiveness. Styles of performance evolve in part in response to the music that performers are called upon to sing or play. Charles Rosen has emphasized the time-lag common in this latter response.[15] This suggests that valuable results might be achieved by experimenting with performance practices from periods slightly later than that of the composition itself, at least in the case of highly and immediately influential composers. The suggestion relies on the musical judgment of the performing community at large at the relevant times, and we may well have less reason to respect that judgment than we have to respect the judgment of our most-admired composers. Still, there is reason to expect styles adapted to the performance of a body of music to fit the music in rewarding ways.

Finally, the practices observed and valued within a given musical culture may be expected to reflect the aesthetic values that are characteristic of that culture. Perhaps current musical taste is either so perfect or so isolated from earlier values that we cannot *qua* aesthetic valuers learn from past musical cultures. But to the extent that we can, practices calculated to realize in performance values of significance to such a culture have the potential of revealing to us values in the works performed whose presence we might not otherwise have suspected.

Original Instruments

Probably the most glamorous and instantly audible product of the historical performance movement is the use of instruments of the period of the music performed. (The instruments themselves may be either antiques or modern copies.) But the connection between period instruments and composers' musical judgment is even more tenuous than the latter's connection to period performance practice. Mozart could decide to compose a piano concerto as he thought best and to play it in accord with conventional practice or not as he chose, but he could not choose to play it on a twentieth-century Steinway concert grand piano rather than an eighteen-century fortepiano. So while we can *see* what Mozart chose to write in his compositions and at least *speculate* intelligently about the practices he chose to observe in his performances, we cannot even speak sensibly about a choice to use then-contemporary versions of instruments rather than later ones.[16] The case is different from a choice among available instruments. Bach chose to write his viola da gamba sonatas for viola da gamba as opposed to, say, cello. But he did not and could not choose to write his cello suites for baroque cello *as opposed to* its modern counterpart.[17]

Still, some of the considerations that count in favor of observing period practices apply as well to the use of period instruments. A central part of the

case for observing period practices turns on the possibility that composition may be influenced consciously or unconsciously by the presupposition that these practices will be observed. In this respect, the case of period instruments is similar. The deliberate exploitation in composition of features of the instruments to be used is at least a possibility when the composer can assume that instruments of a particular type *will* be used. To a certain extent, the availability of this assumption is ensured when the composer specifies the instrumentation of her work. But a composer who is not composing primarily for distant posterity knows a good deal more about the instruments which will be used to perform her works than just that the violin parts will be played on violins, the bassoon parts on bassoons, and so on. She knows that the parts will be performed (in the performances that are most salient for her) on the violins, bassoons, and so on of her here-and-now, and she is apt to know very well what those instruments are like. She will, then, be able to rely on features more specific than the generic characteristics of violins-through-history or bassoons-through-history or pianos-through-history. It is at least possible that Bach or Mozart or Beethoven or Chopin made various decisions in composing with the intention of exploiting features of the instruments they knew which are not features of later versions of the same instruments (later violins, bassoons, pianos, etc.). And again, even if such conscious intentions played no role in their composing, it seems likely that many composers respond consciously or unconsciously to their awareness of the features of the instruments with which they are familiar in ways which might (persisting with a somewhat extended sense of 'idiomatic') be gathered within the general category of writing idiomatically for those instruments. To the extent that this is so (and it will surely differ from composer to composer and from work to work), works and instruments will be suited to each other in ways that reflect the musical judgment of the composer. Such a matching of work and instrument can be expected to produce aesthetic values that can be realized only in performances on period instruments. So the chief aesthetic advantage of using period instruments is that it creates the potential for realizing such values. Note that to the extent that such values are not present in the work, so that the features of one instrument as opposed to another play no role in the values that characterize it, transcriptions will not typically differ in value from the work in its original scoring. In this respect, the case for using period instruments is essentially the same as the case for performing original works rather than transcriptions. The salient differences are first that idiomatic writing for a certain kind of instrument is more apt to be idiomatic for later versions of the same instrument than for entirely other sorts of instrument and, second, that the choice of one instrument as opposed to another can represent an exercise of a composer's musical judgment whereas composing for the instruments of the time as opposed to their later versions does not constitute such an exercise of judgment. But the latter difference is relevant only to the extent that the composer's choices produce a work to which her chosen instruments are especially suited, i.e., to the extent that the work is idiomatic for the instruments used. So even this second difference does not

create a difference in kind between the reasons for preferring the composer's scoring and the reasons for preferring the use of period instruments.

Historically authentic performance incorporating the three elements of fidelity to the composer's directions, observation of period performance practices, and use of period instruments will have the potential of (i) realizing in maximally many cases the values that result from the excellence of the composer's musical judgment, (ii) realizing such values as may derive from the composer's judgment in exploiting the features of then-current practices and instruments in her composing, and (iii) realizing such values as may derive from idiomatic writing for contemporary practice and instruments, whether the idiomaticness is the product of intentional adaptation or unconscious responsiveness to familiar sounds and practices. Nothing guarantees that any such values will actually be realized in any given historically authentic performance of any given work. Nothing guarantees that any such values as suggested under categories (ii) and (iii) even characterize any particular work, even among works we admire by composers we admire. The extent and character of such values will, as I have suggested, vary widely from composer to composer and from work to work. But it does seem likely that such values frequently will characterize the works of the composers we most admire, and surely historical authenticity will contribute to the likelihood of their realization in performance.

In no way does all of this constitute a case for the overall superiority of historically authentic performances over historically inauthentic ones, or even for the practice of seeking historical authenticity in performance over the practice of neglecting any or all of its components. But it does, I think, establish that historically authentic performances may have aesthetic virtues *qua* historically authentic, and that a preference for historically authentic performance may be based on factors other than fashion, the love of novelty, time-travel fantasies and other delusions, or modernist sensibility.

SOME ADVANTAGES OF HISTORICALLY INAUTHENTIC PERFORMANCE

The considerations raised so far might be taken to suggest that all performances should aim at historical authenticity, since such authenticity produces the potential for virtues in performance that are unavailable to performances that are historically inauthentic. But that is not the end of the story. The advantages of historically authentic performance are purchased at an aesthetic price, or rather, the aesthetic opportunities created by historically authentic performance have aesthetic opportunity costs of their own.

Familiar Virtues

Informed admiration for a work of music *qua* aesthetic object will be based on familiarity with the work. Since the aesthetic value of works of music is realized only in performance, the relevant sort of familiarity is aural, the result of hearing the work. The values for which we admire a work are those that

are realizable in performances of the sort with which we are familiar.[18] The informed consensus that identifies at least many of the great masterpieces of old music[19] is based on sorts of performance that the works in question have frequently received over the years. Those performances have almost always been historically inauthentic, the products of the performers' musical judgment as formed by their own musical cultures. If we focus more narrowly on the judgments of informed current taste, the most relevant performances will be the most admired within recent performing tradition.

The case for authentic performance in most of its particulars required that we move from admiration for works to confidence in the skill and judgment of their composers and thence to conclusions about the potential of one or another sort of performance. But the present considerations suggest a more direct connection between admiration for works and preference for certain sorts of performance. If our admiration for a work is based on certain values that we take it to possess, then there will be reason to prefer the sort of performance which we know to be capable of realizing those values. In the case of most of the canonical masterpieces of the musical past, that sort of performance is historically inauthentic. Bluntly, the Beethoven we have most reason to admire is Beethoven-cum-traditional-accretions. We know the value of *this* Beethoven's work; historically authentic Beethoven is by comparison an unknown quantity.

This sort of consideration becomes less significant as we become more familiar with historically authentic performances of the works in question. So it is now much more salient to the case of Beethoven than to that of, say, Bach. And for works which have come to be most admired since the advent of the historical performance movement on the basis of historically authentic performances, these considerations cut the opposite way, in favor of such performances.[20] But their force in favor of traditional sorts of performance should not be underestimated, especially as the search for historical authenticity proceeds to involve an ever larger body of ever more recent works.

The Fruits of Experience

Still, considerations that depend on the relative familiarity or unfamiliarity of different sorts of performance may well seem fundamentally unstable. A sufficient proliferation of performances of all kinds will remove relative familiarity as an issue. A more robust set of advantages for historically inauthentic performance may be expected to emerge from the benefits of experience and perspective which are enjoyed by present-day performers.

To begin with, we can note that when a composition is new, nobody (including the composer) has very much experience performing it or hearing it performed. The more a composition is performed, the more one would expect alert performers to learn about how best to perform it. Some of the lore that develops will concern more or less technical matters of how to deal with one passage or another. In addition, the more the work is performed and heard and studied, the greater the opportunity to understand it, i.e., to learn what aesthetic values it embodies and how. And this sort of understanding surely improves

the position of a performer who wishes in her performances to make manifest the values that characterize the work.[21]

Both practical performing lore and aesthetic understanding can be transmitted from generation to generation of performers, so the gains in practical and theoretical understanding can be cumulative. In this sense, the anachronistic traditions of performance of the masterpieces of the past can be seen as embodying the experience of generations of musicians all searching for the best ways to perform the works in question. To the extent that performing traditions embody such experience, ignoring those practices in favor of historically authentic ones will deprive a performer of the opportunity to utilize the fruits of that experience in realizing the values that characterize the work.

Of course, performing tradition is not *necessarily* the embodiment of the wisdom of the ages. Old music may come to be performed in new ways as a result of applying automatically styles and practices suited to new music,[22] or of fashion. In many cases too, it might be that such wisdom as tradition does embody can be applied to performances that nonetheless also aim at historical authenticity. In such cases, of course, the advantage of inauthentically traditional performance will disappear.

In addition to the attention a composition can receive in the years and generations after it is written, those years will have seen the composition of generations of new music. The perspective that our familiarity with later works provides constitutes a resource that can usefully inform performances of earlier ones. In the most general terms, the wider our experience of different kinds of music the more material we have for forming views of what music *is*, and these general views will influence our views of particular works of music. Performances ought surely to be informed by the performers' aesthetic evaluation of the work performed, and that evaluation to be informed by their understanding of the nature of music, and that understanding ought to be informed by their experience with music of all kinds, including music composed later than the work to be performed. Taruskin quotes T. S. Eliot approvingly in this regard:

> . . . what happens when a new work of art is created is something that happens simultaneously to all the works of art which preceded it. The existing monuments form an ideal order among themselves, which is modified by the introduction of the new . . . work of art among them. The existing order is complete before the work arrives; for order to persist after the supervention of novelty, the *whole* existing order must be, if ever so slightly, altered; and so the relations, proportions, values of each work of art toward the whole are readjusted; and this is conformity between the old and the new.[23]

The fact that Eliot is not here speaking only of performing arts points to the complexity of the issues. Even a work like a painting, whose aesthetic values are fully realized in the work itself *qua* persisting artifact, is changed by subsequent works in the ways that Eliot describes. The change does not require that in any straightforward sense we *do* anything different with the work. In the case of a work of music, a performance that takes place after a new work

is created will reveal the old work as changed in the relevant respects even if the performance is aurally indistinguishable from earlier ones. In fact, if a particular performance is preserved in the form of a recording, the creation of new works and even new performances of the same work will change the old *performance*, considered as an aesthetic object in its own right.

Still, a work thus changed by the appearance of new works *might* best be served by a new mode of presentation, and in the case of works of music new sorts of performance *may* have value. Those new sorts of performance *might* involve practices incompatible with the conventional practices of the time of composition, or the use of modified instruments, or the violation of the composer's directions. Of course, it might be possible to adapt to the changes in our understanding of the works within the limits of historically authentic performance, but those limits do restrict the sorts of adaptations available, so that ignoring them will create broader opportunities for adaptation in light of subsequent compositions.

Clear and convincing examples of this sort of adaptation seem to me hard to come by, but here's a candidate: It seems likely that our experience with Wagnerian and post-Wagnerian music drama significantly enriches our understanding of the potential in opera for the realization of dramatic values. This might make us aware of the presence of musico-dramatic values in earlier operas that can best be served by cutting numbers which, however beautiful and powerful in themselves, hold up the drama to a degree that we now find excessive. The fact that the sort of integration of music and drama in question may have been entirely foreign to the intentions of the earlier composer is beside the point; if the earlier opera, suitably cut, really does embody the musico-dramatic virtues in question to a significant degree, and to a degree significantly greater than does the same opera uncut, that will be a reason to prefer the cut version. If the cost in terms of other virtues is not excessive, the cut version may be preferable overall. To say this is not to reduce Handel[24] or Mozart or whomever to the status of proto-Wagners. To say that an earlier opera, whether cut or not, embodies certain Wagnerian virtues is not to deny that it also embodies lots of wholly unWagnerian virtues. A performer will presumably want to achieve the best balance of virtues available. The point is only that the Wagnerian virtues, which may be observable only from a post-Wagnerian perspective, are among the ones to be balanced, and the best balance *may* be one that (in the context of suitable attention to the other virtues) uses judicious cutting to bring them out.

Changed Circumstances

Changes in our understanding of music in general or a single work in particular are among the developments that might lead to changes in what is reasonably thought to be the best way to perform the work. To the extent that our understanding genuinely advances, the kinds of performance suggested by later stages of development will be superior to those suggested by earlier views. But other changes in circumstance might actually change the identity of the

best sort of performance. There are a number of different kinds of potentially relevant changes.

In the first place, there are factors centering on extra-aesthetic constraints on the composition. For example, during Mozart's life, operatic convention dictated that certain secondary characters be given arias to sing. In observance of this convention, Mozart composed (among others) two arias for Arbace in *Idomeneo*, and arias for Basilio and Marcellino in *The Marriage of Figaro*, which are widely thought to hold up the action without displaying significant compensating virtues. If the decision to include these arias was a mere accommodation to convention and not an exercise of Mozart's musical judgment, then a decision to cut some or all of them does not involve substituting the conductor's musical judgment for the composer's. (Note that the judgment that the arias in question hold up the action unduly might or might not be a product of a post-Wagnerian view of music drama. The present point concerns not the *gain* to be expected from cutting the arias, but rather reason to doubt the significance of any *cost* incurred by cutting.)

Against these considerations are some that I mentioned earlier in the context of discussing the role of non-aesthetic factors in the creation of works that we now esteem exclusively as aesthetic objects. Even if we grant that aesthetic judgment played no role at all in Mozart's decision to include the arias in question, it does not follow that they don't contribute to the aesthetic stature of the whole. Again, we expect a composer of Mozart's stature to make virtues of necessities. Moreover, in addition to what might be termed their positive aesthetic function, the arias might also be expected to serve as parts of the larger-scale design in the sense that the material surrounding them was presumably planned on the assumption that there would be arias at the designated places. Their omission could thus hamper the realization of the aesthetic virtues of other parts of the opera.

It is certainly possible to make too much out of such considerations. Mozart's own willingness to cut arias, as in Act III of *Idomeneo* before its premiere, at least counts against the suggestion that everything in any of his operas must be deemed indispensable to the maximal success of the whole.[25] Still, these considerations serve as a reminder that identifying a feature of a work as "merely conventional" or otherwise "extraneously imposed" does not automatically make it a good candidate for cutting or other modification.

Another sort of change relevant to the identity of the best sort of performance of old compositions concerns the need for choice in realizing composers' intentions. Historical dislocation is apt to make it impossible to realize those intentions in every respect. For example, a passage in one of Bach's violin sonatas is supposed to have *this* sonority (sound of a baroque violin); also, it is supposed to sound like a *violin*. But violins don't sound that way anymore—play it so it sounds like *this* and it won't sound like an ordinary violin. Here is a more significant example: a passage in Bach or Handel is supposed to sound full and rich, like *this* (the sound imagined by the composer, and perhaps heard at excellent early performances). But we who have been raised on modern

instruments and the German Romantics do not find *this* full and rich at all; it sounds pretty scrawny (or, to remove the pejorative tone, it sounds transparent and incisive). A particularly striking example concerns the evolution of the piano. Steven Lubin notes that "by the time of [Beethoven's] Fifth Concerto a new and far more powerful instrument reigned, one that had sacrificed some of the older instrument's charms in favor of new desiderata."[26] But the evolution of the piano continued in much the same direction throughout most of the nineteenth century. Compared to a modern concert grand piano, the "new and far more powerful instrument" of around 1810 is conspicuously lacking in power, though it retains much of the charm of the smaller earlier pianos. If we respond to the sound of a period piano in middle-period Beethoven by reference to its relation to the sound of present-day pianos, we'll get the sense of relative size and volume precisely backward. What then sounded (and presumably was meant to sound) remarkably loud and powerful will now sound remarkably subdued and quiet. And considerations like these apply as much to historical styles and techniques of performance as they do to historical instruments.

In cases like these, it may be necessary to use historically inauthentic means to achieve the composer's ends. The use of such means will sacrifice such values as depend on the intrinsic character of the intended sound in order to realize the values which depend on its relation to familiar sounds. There are, to be sure, limits to the support such considerations can provide for historically inauthentic performance. On one hand, it is not obvious that more important values in a work will typically depend on sound-characteristics relative to the familiar rather than the intrinsic sound-characteristics of the instruments or practices involved.[27] On the other, a sufficient dose of performances of a variety of old music on period instruments might so alter the expectations built into our hearing that the sound of a modern violin, for example, will no longer constitute for us "what a violin sounds like." The sound of baroque violins in baroque music might come to sound as normal and natural to us as the sound of modern violins in later music. (As far as I can tell, this is how violins now sound to me.)[28]

The issue of familiarity can also work in the opposite direction. Composers are apt to want certain elements of their works to sound *un*familiar. Roland Dipert notes that

> One of the early uses of the clarinet, let us say by Gluck, was probably to startle an audience and to make it aware of a musical line by stating it in an unfamiliar timbre. If today we perform a work of Gluck's with the originally scored clarinet, we are preserving his low-level intention but are sacrificing his high-level one. Modern audiences are completely acclimated to a clarinet sound, and its shock value is completely lost.[29]

Gluck, in the situation described by Dipert, would have intended both that the passage sound like *this* (sound of a clarinet playing normally) *and* that it have a startling timbre, and there is no way a modern performance can realize both intentions.

As the passage I've quoted suggests, Dipert enriches his discussion of potential conflict among a composer's intentions from the standpoint of the performer by distinguishing different *levels* of composers' intentions. Dipert explains these as follows:

> [The composer's] intentions concerning the means of production of sound will be termed *low-level* intentions, which include the type of instrument, fingering etc. *Middle-level intentions* are those that concern the intended *sound*, such as temperament, timbre, attack, pitch, and vibrato.[30]

> My third and last category is termed *high-level intentions* which are the effects that the composer intends to produce in the listener. These effects can range from the perception of both tonal and formal relationships to the particular emotional response he wishes to evoke. High-level intentions often embody the noblest intentions of a composer (although less noble purposes are also included, such as when a composer writes grandiose music to curry favor with a prince).[31]

Dipert seems to think that the aesthetic value of a work of music is a matter of its effect, so that the sonic characteristics which are the objects of middle-level intentions are, like the means of sound production, merely means to aesthetic ends. He defends this view by noting that "no composer would be even partly satisfied by the fulfillment of only his low- or middle-level intentions without an audience."[32] But this is perfectly consistent with the possibility that the relevant high-level intention is simply to have an audience listen to a performance that satisfies the relevant middle-level intentions (i.e., one that sounds right). Even if other effects are intended, it might well be part of the intention that they be produced by hearing the appropriate sequence of sounds. This sort of connection to middle-level intentions is clearly essential to some of Dipert's examples of high-level intentions, e.g., the intention that the audience *perceive* tonal and formal relations. In fact, it seems that the very notion of a work of music as an aesthetic object depends on essential connections between its aesthetic value and the production of certain sorts of sequences of sounds, or at least of auditory sensations.[33] Otherwise, appropriate sequences of nonauditory (perhaps emotional) effects produced, say, by sequences of pills, could be entirely equivalent to heard performances as realizations of works of music.

Dipert claims that "if we obtain reasons for following a composer's intentions, we should follow first and primarily his high-level intentions." This might seem to provide the basis for resolving conflicts between intended intrinsic sound-characteristics and intended expectation-relative characteristics in favor of the latter. But the considerations I have raised suggest that Dipert's claim can be defended only if we include among the relevant high-level intentions the intention that certain sorts of sound-sequences be heard. Given the presence of an audience (which need not extend beyond the performers themselves), this amounts to eliminating the difference in status between high- and middle-level intentions. Where intentions concerning the intrinsic features

of heard sound are in conflict with intentions concerning other effects, it is not obvious that the aesthetic value of the work is always best served by realizing the latter rather than the former.

Yet another respect in which the distance between the time of composition and our own is relevant to the virtues of different sorts of performance has to do with general cultural context. Most of the considerations I have discussed to this point focus most naturally on the virtues of performances as realizations of the works performed. But performances are themselves artistic endeavors, and late-twentieth-century performances are late-twentieth-century artistic endeavors. As such, they can have value as expressions of the musical imagination and artistic sensibility of the performers along with whatever value they might have as presentations of compositions which express the musical imagination and artistic sensibility of their composers. I have discussed above some of the features of the original performances of old works as elements of the overall cultural life of the time which are not shared by present-day performances. But present-day performances are elements of the cultural life of the present, in addition to being performances *of* products of the cultural life of the past. Self-expression on the part of performers should not in general be contrasted with fidelity to the values of the work performed. It seems clear, though, that such fidelity places additional constraints on the musical self-expression of the performer. It is not unusual to see a performance condemned for "telling us more about (say) the conductor than it did about Beethoven." But performers are musicians and it is not clear why we should not want at least some performances to tell us more about the sensibility and musical imagination of a present-day conductor than about the sensibility and musical imagination of even the most revered of dead composers. There seems to be something perverse about using the immortal works of Bach or Beethoven or Mozart as "mere" vehicles or occasions for the exercise of a performer's art, but if what's exercised is *art* (rather than, say, mindless virtuosity), I'm not sure the perversity is genuine. The degree of musical creativity that is possible in the performance of others' music is of course limited. Still, at a time when the performance of old music dominates musical life, contemporary musical creativity in the context of such performance can be an important element of "contemporary music."[34]

Performances that ignore considerations of historical authenticity will then have the potential of (i) presenting great works in a form and style that is known to realize the recognized elements of their greatness, (ii) realizing wherever possible such values as might result from the lessons of many performers' long experience with the work in question and with other music as well, (iii) realizing composers' "high-level" intentions where that is now incompatible with realizing their "middle-level" intentions, and (iv) providing maximal scope for the musical artistry of performers *qua* creative contemporary musicians. Nothing guarantees that any such values will actually be realized in any given historically inauthentic performance of any given work. The extent and character of such values will surely vary widely from work to work. Moreover, the sorts of performance best calculated to realize values associated with categories (i)-(iii)

will not be particularly suited to those associated with category (iv). But it does seem likely that in many cases ignoring historical authenticity can in fact be conducive to the realization of at least some such values.

In no way does all of this constitute a case for the overall superiority of historically inauthentic performances over historically authentic ones, or even for the practice of ignoring historical authenticity in performance over the practice of observing any or all of its components. But it does, I think, establish that historically inauthentic performances may have aesthetic virtues *qua* historically inauthentic, and that a preference for historically inauthentic performance may be based on factors other than laziness, ignorance, or arrogant chronocentrism.

IN SUM

So where does this all leave us? The most obvious conclusion, I think, is that there are no easy answers to the question of how best to perform a given work. Every possible approach has costs. Corollary to this is the desirability of a situation in which excellent performers are pursuing a variety of different approaches to the musical masterpieces of the past.[35] The historical performance movement is in this respect a Good Thing, but its total triumph would not be.

It is, though, important to bear in mind that the costs to which I refer always have to do with the potential to realize values which *might* be present as the result of, say, the good judgment of the composer or the wisdom that comes with a history of performing experience. There are surely cases in which even our favorite composers suffered lapses of judgment, and some traditions surely just are *schlamperei*, as Mahler is said to have asserted of tradition in general. In such cases, the values for which one might reasonably hope simply will not be there to be found. So the general desirability of a variety of kinds of performance coexists with the fact that for some works, performances of one sort will be systematically superior (other things equal, of course) to performances of another sort.

Even more important, I think, is the fact that performances of a given sort may succeed in part *because* they are of that sort even though variety is desirable and even if performances of that sort are not in general systematically superior to others. To praise a performance of Schumann's *Humoreske* for virtues consequent upon the use of a period piano is not to say that the work should only be performed on such a piano or that performances on other pianos cannot be as successful as the one in question or even that performances on other sorts of pianos are *typically* less successful than the one in question. All that follows from the fact that the success was in part a product of the use of a period piano is that performances on modern pianos are relatively unlikely to succeed *in the same way*. The use of the period piano conduced to success of the particular kind that the performance enjoyed. Of course, if the use of a period piano is conducive to certain virtues and a performance on a modern

piano fails in part because of the absence of those virtues, the use of the modern piano may reasonably be cited as a factor in the failure of the performance.

These last points serve to illustrate the ultimate moral with which I want to conclude. The sort of discussion of generalities concerning the potential virtues of historically authentic and historically inauthentic performances can provide a useful context for the evaluation of particular performances without relying on dubious aesthetic first principles or historical generalizations and without prejudging any performance on the basis of its degree of conformity to the procedures of the historical performance movement. The categories of historical authenticity and historical inauthenticity—or at least "historical authenticity" and "historical inauthenticity"—are indeed relevant to the assessment of performances of old works of music.

NOTES

1. Nicholas Kenyon, ed., *Authenticity and Early Music* (Oxford, 1988), 1.

2. In what follows, I will use the term in just this way. The elements I've described are often gathered under the general heading of producing performances like those of the composer's time. This approach is developed by Peter Kivy in "On the Concept of the Historically Authentic Performance," *Monist* 71(1988): 278–91. Kivy argues persuasively that historical authenticity in the sense of similarity to early performances involves elements that go beyond those I have mentioned and sometimes conflict with them. Thus, for example, early performances typically took place within a "living" performing tradition rather than a reconstructed one; a modern performance will be unlike an early one in this respect if it observes the period practices which have since dropped out of general use. I'll return to this issue later in the essay. But let me repeat that I am using the term 'historical authenticity' in the more limited sense described above.

3. Some of the best is to be found in Kenyon, *Authenticity and Early Music*. The flow of ink reached *Time* in 1983 (Michael Walsh, "Letting Mozart be Mozart," *Time*, 122, 10(Sept. 5, 1983): 58–59), and the philosophy journals in 1988 (Kivy, "On the Concept of Historically Authentic Performance," and Stan Godlovich, "Authentic Performance" in the same issue of *Monist*, 258–77. Other important contributions include Robert Donington, Introduction to *The Interpretation of Early Music, New Version* (London, 1974), 27–83; Harry Haskell, *The Early Music Revival: A History* (London, 1988), esp. chaps. 8 and 9; Joseph Kerman, *Contemplating Music* (Cambridge, Mass.; 1985), chap. 6; Charles Rosen, "Should Music be Played 'Wrong'?" *High Fidelity* 21(May 1971): 55–58, and "The Shock of the Old" (a review of the Kenyon anthology), *New York Review of Books*, 37, 12(July 19, 1990): 46–52; and the contributors to "The Limits of Authenticity: A Discussion," *Early Music* 12, 1(February 1984): 3–25.

4. From this point, I'll usually take the scare-quotes around "historically authentic" as read. Richard Taruskin is concerned by the "unearned positive connotations" accompanying the use of the word 'authentic' (see "The Pastness of the Present and the Presence of the Past," in Kenyon, *Authenticity and Early Music*, 136–39), but I suspect that current skepticism about the notion of historical authenticity has produced enough of a sense of irony when such authenticity is mentioned to counteract the unearned good vibes.

I shall also frequently speak of 'historically authentic' and 'historically inauthentic' performances as though the difference between them is one of kind rather than degree. When I do, 'historically authentic' should be understood as 'more historically authentic' or 'informed to a significant degree by the goal of historical authenticity', and 'historically inauthentic' as 'less historically authentic' or 'not significantly informed by the goal of historical authenticity'. I emphatically do not want to convey the impression that 'historically authentic' denotes a (nonempty) class of performances which perfectly embody the aims of the

historical performance movement. I am painfully aware that speaking without repeated qualification of historically authentic performances does tend to produce that impression. But I am even less willing to repeat over and over the circumlocutions that would be required to avoid it, so I hope this note will suffice.

5. I refer, of course, to listeners to "classical" music, conveniently ignoring (as do most writers concerned with these issues) the fact that the music most listened to in contemporary culture does not fall within that category. The relevance of rock and related music to "museum culture" is an important issue that needs to be explored.

6. This is suggested by both Robert P. Morgan in "Tradition, Anxiety, and the Current Musical Scene," and Will Crutchfield in "Fashion, Conviction, and Performance Style in an Age of Revivals," both in Kenyon.

7. Taruskin makes a convincing case for the claim that there is a sort of general *style* of performance, associated with at least fairly recent composition, that is now typically applied to all sorts of music, old or new. ("The Pastness of the Present and the Presence of the Past," in Kenyon.) This reflects the fact mentioned above that our response to any elements of old culture must ultimately be a product of our own historico-culturally rooted sensibility. We need to be open-minded, not empty-headed, and I am inclined to join Taruskin in welcoming evidence that there is something genuinely contemporary in contemporary approaches to old music. At the same time, I want to emphasize the value of the contemporary openness to practices not at all associated with recent composition. The issue, of course, is one of balance. To the extent that the products of past culture are to be of value to *us*, we must make them *ours*, but to the extent that *the products of past culture* are to be of value to us, we must make *them* ours.

8. That is, independent of the evaluation of particular performances; no strict sense of apriority is intended.

9. This is not meant to minimize the problems involved in finding a text that accurately reflects the composer's directions and in interpreting the notation found in even a good text. On some aspects of the first set of problems, see Philip Brett, "Text, Context, and the Early Music Editor" in Kenyon. On some examples of the second, see Nikolaus Harnoncourt, "Problems of Notation," in *Baroque Music Today* (Portland, Ore., 1988), 28–38.

10. This is not intended to be an exhaustive list.

11. See, for example, Nicholas Temperley's contribution to "The Limits of Authenticity: A Discussion," 16, and Donington, *Interpretation of Early Music*, 44–46.

12. I hope that the respect in which one performance can be more a realization of a work than another performance is clear in the absence of a discussion of the conditions under which a performance *is* a performance of a given work. Indeed, I fervently hope that the points I want to make about the value of performances *qua* realization of works are quite independent of the entire tangled debate over the necessary and sufficient conditions of what might be called 'performance-*of*-hood' ("*P* is a performance of *W* if and only if. . . ").

13. This is a bit of an oversimplification. The "authentic" practices are more accurately described as those commonly recommended, or in common use in what were thought to be the best performances at the time of composition. Practices which were widely employed but generally disparaged don't count.

14. The need for the cumbersome 'at the time of composition within the relevant community' instead of the neater 'at the time and place of composition' derives from the fact that for composers who travelled, the salient practices might not be the ones current at the place of composition.

15. See both of Rosen's previously cited articles.

16. A few composers have chosen to develop or participate in the development of new instruments rather than compose for those in current use. Examples include Wagner (to a very limited extent) and, more recently and radically, Harry Partch. But the decision to do so is not a decision to use later instruments rather than contemporary ones; Wagner tubas of course date back to Wagner's lifetime.

17. Similarly, at least until the last part of his life, Bach could not choose to write for harpsichord as opposed to piano. Godlovich writes: "...it is curious to reflect that whereas we don't seem to hesitate playing old harpsichord concerti on pianos, few would think it appropriate to play a *modern* harpsichord concerto like Poulenc's on anything but a harpsichord. My suspicion is that there are no good reasons for this seeming simple inconsistency" ("Authentic Performance," 269.) But when a twentieth-century composer like Poulenc chooses to write a harpsichord concerto, the choice of harpsichord *as opposed to piano* is one of the most prominent involved in the composition.

18. Given sufficient skill at score-reading, experience with performances of various works, and musical imagination, it is of course possible to reason about the values of works one has not heard. But the conclusions of such reasoning are in a sense essentially provisional even beyond the wide limits of a proper sense of fallibilism in aesthetic matters generally. In any event, even in the case of such informed reasoning, a crucial role is that of one's experience with performances of suitably analogous works.

19. The claim that such consensus is ultimately decisive, or as decisive as anything can be, for establishing the stature of works of music, is defended by Derek Cooke in "The Futility of Music Criticism," in *Vindications* (Cambridge, 1982), 201–07.

20. The place of historical performance in the larger context of an "early music revival" that also includes the performance of vastly many old works from outside the traditional canon of masterpieces promotes the emergence of works fitting this description. Many of Monteverdi's works are prominent examples.

21. This point has been emphasized by Hans Keller in "Whose Authenticity," *Early Music* 12, 4(November 1984): 517–19.

22. This source of change in styles of performance is emphasized by Crutchfield, Morgan, and Taruskin.

23. "Tradition and the Individual Talent," quoted in Taruskin, "The Pastness of the Present," p. 157.

24. Perhaps in Handel's case some of the oratorios provide better examples of the point than do his operas.

25. But note that those cuts do not yet tell against the suggestion as applied to "finished versions" of Mozart's operas.

26. "Beethoven's Pianos," note to Lubin's recording of Beethoven's piano concertos on L'Oiseau Lyre 421 408, p. 18.

27. The importance of intrinsic characteristics is emphasized by fortepianist Malcolm Bilson when he insists that

> There is something of great importance, something that I would call, for want of a better expression, "tone of voice." Singers have different kinds of voices, and these different voices have a great deal to do with what kind of repertoire they sing. For instance, we don't imagine Birgit Nilsson and Elly Ameling interchanging roles. And if we don't want to listen to Elly Ameling sing Isolde, it's not because we think she isn't a good enough musician. I believe the same kind of situation prevails for these instruments. (In Robert Winter and Bruce Carr, eds. *Beethoven, Performers, and Critics* [Detroit, 1980], 51)

28. Different listeners will at any given time be acclimated to the sounds of old instruments and practices to different degrees. This suggests an invidious distinction between the cognoscenti, for whom historically authentic performance is most appropriate, and the *hoi polloi* who might (if *relative* sound-characteristics are particularly important) thrive best on anachronism, but whose chance of crashing the elite depends on listening to historically authentic performances until the old sounds become sufficiently familiar. Still, it is important to remember that any sizable contemporary audience (and probably any sizable audience at any period) consists of individuals whose personal histories differ in all sorts of ways that could be relevant to their ability to appreciate the realization of the composer's intentions or,

indeed, the realization of the aesthetic values of the work performed however those values are related to the intentions of the composer.

29. Roland Dipert, "The Composer's Intentions: An Examination of their Relevance for Performance," *Musical Quarterly* 66(1980): 210.

30. Ibid., 206.

31. Ibid., 207–08.

32. Ibid., 208.

33. The qualification is necessary to accommodate possibilities like that of "mainlining Brahms" by direct brain-stimulation, as described by Dennett ("Where am I?" in *Brainstorms* [Cambridge, Mass., 1978], 318).

It does not seem that the *musical* nature of the experience is compromised by its unorthodox etiology.

34. Of course, as Morgan is at pains to point out, the historical performance movement is itself a product of contemporary musical culture, and Taruskin emphasizes the strain of hostility toward performers' self-expression (or even, expression of their sympathetic understanding of the works they are performing) in the modernist aesthetic associated with Stravinsky that dominates present-day performances.

35. This suggests that one important value of recordings is to preserve not only individual interpretations of excellence or even genius but also the products of approaches to performance which may no longer be in favor.

How Can Music Be Moral?

COLIN RADFORD

1

The winter sky lours, the cruel wind cuts through us, howling, roaring, scream-ing, the rain lashes our faces. Winter changes to spring. The sun smiles, balmy breezes caress our cheeks, daffodils nod, lambs gambol, blackbirds sing . . .

We are not savages, nor, for that matter, god and spirit-ridden Ancient Greeks. For us, most of the above remarks are metaphorical. (Whether a phrase is a metaphor or a remark metaphorical depends not on word meanings alone but the beliefs of their user.) However, most of them are scarcely avoidable, which is why they are sometimes labeled "dead." That is to say, there are no readily available and more literal words to characterize, e.g., the sound made by a gale force wind other than "howling."

Nonetheless, we do 'anthropomorphize' the world. Secularized human be-ings do not attribute actions, emotions, feelings, intentions, motives, awareness, to the dead and insensate parts of the natural world, and the more sophisticated do not make these attributions of animals. But we are all prone to perceive—especially to see and hear, or as we sometimes defensively say, to "half-see" and "half-hear"—to think, talk, and write about the non-human world as if it were human. This is normal in both senses of that word.[1] (Which is not to say that this propensity is not more marked in some than others.) Browning writes of the English thrush in spring that "he sings each song twice over,/ Lest you should think he never could recapture/ The first fine careless rapture!" Neither Browning nor his readers, nor does Browning expect his readers to, think that the bird has expectations of his audience—but doesn't it sound as if he does? And what should we think of and feel about someone who does not hear the thrush in this way after that person had read the poetry?

We not only are prone to see and hear the non-human world as if it were human, we are prone to act on it and, especially, to react to it, as if it were human. Having painfully struck our head on a car door we sometimes submit

to the temptation to kick what he half-seriously and momentarily are strongly tempted to see as the 'offending' door. Others laugh at us, and if we can control our anger and resentment, which we see as inappropriate and irrational, we join in. But it is not that others do not understand—they understand only too well, and, understanding, their laughter is not only critical but forgiving. (This raises the question: if it is irrational to kick the car door, why is it not also irrational to see its mid-1950s, American, front elevation as the face of a grinning shark?)

In perceiving the world as—or as if, or as if we believed that it were— human, in acting and reacting towards it as if it were human, we also sometimes are affected by it as if it were sub-, super-, or merely human, *because that is how we perceive it*. The world, especially its weather, can strike us as cruel, obdurate, implacable, capricious, indifferent, benign, and we respond by feeling angry, resentful, grateful, etc.

We are, then, prone not only to humanize the world, but to moralize it. But this is neither to say that the rest of the world *is* moral, immoral, or even amoral, nor that we believe that it is.

2

Because—or if—human beings are capable of rational choice, decision and action, they are proper objects of moral judgment. However, we make moral judgments not only of human beings, but of their actions, thoughts, feelings, emotions, motives, intentions, and works.

There are, apparently, two oddities here. The first is that thoughts, feelings, and emotions are, characteristically, involuntary, yet some of these we judge in moral terms, e.g., as improper, ignoble, unworthy, unkind, etc. Secondly, it is not only human beings who are sometimes, say, cruel, but their thoughts, motives, intentions, actions, and works. Now to act cruelly is to cause suffering *for that very reason*. So a person acts cruelly if she acts from that motive, or with that intention, and she is cruel if she is prone to act in this way. Yet we say not only of the person that she is or acted cruelly, but also that her motive, intention, action, and what she did or produced are also cruel. So a writer acts cruelly if he writes something with the intention of hurting another, and succeeds. But of course the cruel work has no motive or intention; it is the expression and realization of that cruel motive or intention, which in turn does not have intention or motive but is the writer's motive or intention.

I mention this second point especially, not because of some gratuitous and irrelevant wish to draw attention to an apparent confusion in our moral thinking, but to show how *human beings and their works are yoked together in the moral world*.

3

Since music is a human product, it is not ruled out from being a proper object of moral judgment. Music comes in pieces, which are compositions, i.e., instructions to make certain sounds, or performances, i.e., the obeying of those

instructions (or their recording). Composition and performance are sometimes fused, of course. The sounds comprising music are semantically meaningless unless words are sung, and are—or, traditionally, they have been—aesthetically pleasing, primarily and immediately to the ear. In this essay I shall be concerned with performances rather than compositions, with sounds rather than with instructions to make them.

Before proceeding, I must deal with an objection that would dehumanize and, hence, demoralize music. Doesn't the blackbird sing and, in singing, make music?

I would say that what is, in evolutionary terms, probably territory-defending behavior is not music but musical, that is, it is pleasing to our ear and so sounds rather like music. If the blackbird knew what he were doing, viz., producing beautiful sounds, and doing so with that intention, then he would be performing, and also, perhaps, composing, pieces of music; to whit, songs without words. Of course, if animals were capable of producing sounds (I ignore the very much more remote possibility that they might produce instructions to produce sounds) which in structure, complexity, and, therefore, appeal more closely resembled the sound of music than they do, then either the less confident we should be in denying them musical intentions, or the more natural a phenomenon we should allow music to be. After all, the important thing about music is the sound!

And how about computers? Don't some of those sometimes compose, and perform, music? Well, perhaps they do, but only because they have been programmed to do so.

4

How can music be moral? How can sequences of mere *sounds* (however powerfully they affect us) be *moral*? Surely they cannot be! May it not be that any tendency to moralize music is akin to our tendency to humanize and moralize the natural world? And yet my *donnée* is that, e.g., Mozart's music is, I believe—I am certain I *know* this—superior to Tchaikowsky's not just as music, but as music it is morally superior to Tchaikowsky's. How can this be? My task is to explain and justify this intuition. I shall be disappointed if I explain it away.

5

It is tedious but no doubt necessary to make clear that my problem arises in its most acute form, and in the clearest way, in what might be called 'pure' music, music that is perhaps the analogue of abstract painting.[2] The problem of how a piece of music might be the subject of moral responses is too easily answered if we consider songs, or at any rate some songs such as "The Wearing of the Green." This song is unproblematically sad, ironic, brave, etc., because, given its historical context, the sentiments expressed in the verses which are sung are these. And there is, I think, little problem in accepting that, and establishing

how, the setting of the words can be appropriate, or inappropriate, to the words. (A musical setting can indeed be over-appropriate, to the words. (A musical setting can indeed be over-appropriate, i.e., too obvious and insistent, and so coarsen the feeling of the verses or poem of which it is a setting. Conversely, the music can go against those sentiments or reduce them, negate them, or make them risible and produce something enjoyably ironic. But what could the music do and be by itself, without words?)

So, too, dramatic music, operas especially, will not raise our problem or will offer too easy a solution. We need examples where the obvious solutions are not there to distract us. Sacred music must also be discarded, though if we can find an account of how pure music can be the subject of moral responses, we shall then be able to allow that narrative or dramatic and sacred music may work in this way also.

With less confidence, but for that very reason, I shall initially and reluctantly discard examples which have, and which one knows to have, certain titles. If only we did not know that Chopin's Étude, op. 10. no. 12, is called "The Revolutionary Study" and is said to express the composer's feelings on hearing of the taking of Warsaw by the Russians in 1831, then we could address ourselves to the question of what the music expresses—(how) could it be passionately defiant, etc.? So I cannot, initially, allow myself not only Dvorak's *New World* symphony, or his *My Homeland*, but Tchaikowsky's *Pathétique* symphony.

6

Pieces of music, being composed, are things which, in our world, human beings have devised, invented, created, or labored over at certain times and in certain places, in particular circumstances. As such they are—and we believe them to be, and hear them as being—original, characteristic, labored, routine, clichéd, imitative, pastiche, anachronistic, etc. Our responses here, some of which have a moral dimension, have nothing to do with the music per se, but everything to do with its production. Thus, a piece of music may strike us as poignant, not because of anything inherent in the music, but because of the circumstances of its production; the composer was deaf and yet the bagatelle is so gay and tuneful, or because it is rather uninspired, sounds so like his first string quartets, and is unfinished. (I am thinking here of Haydn's last strong quartet which was abandoned, "It is finished," after the first two movements.)

Even the labeling of a piece of music, for example, as an impromptu, can have consequences for how we hear and respond to it. Here we may be moved in all kinds of complex ways, not by what is inherent in the music, which is our proper concern, but by the incongruity between that and the circumstances of its commission and performance.

Opus numbers are almost as anodyne identifications as we can get. But of course, opus 1 may lead us to look for and hence to find, to hear in the work, freshness, naïveté, clumsiness, another's voice, astonishing maturity; a

large opus number might lead us to look for exhaustion or the opening of new vistas. A classification title which is otiose, or, even better, not understood is better for this purpose; no title better again.

Although it would involve losing one's best, i.e., clearest, most powerful, best-loved examples, it would be better still to work with pure music which is unknown to listeners striving to make sense of their moral responses. One could do that in principle, and for some readers, with examples in musical notation. But one needs to both listen to and become familiar with a piece to experience problematic sentiments.

We are in pursuit of the pure sound, pure music, unencumbered by our knowledge of biographical, cultural, and historical information about it which may color and inform our responses to it. The fact that we cannot reach it just makes our task more difficult. Although we can, for our philosophical purposes, restrict our examples to non-programmatic music, i.e., that which is not representational, narrative, imitative, and although we could try to confine ourselves to examples that are unknown to us, it is virtually impossible to achieve a sterilized, sanitized response—one not infected by a prior knowledge of music. For if we are interested in music, listen to music, and so know about music, we cannot but know that this sounds French eighteenth century, early Beatles, by one of the Scarlattis, Eastern perhaps. If by whatever miracle or tragedy we have heard no music, or remembered none, our response will not be just sterile but atrophied.

7

So, and at last, we can begin our pursuit.

Music of the purest sort, and quite unknown to us (but in our tradition, I should add) must have a rhythm, though that may be more or less marked, more or less shifting, and will be more or less quick or slow.

Now the rhythm of some music is so marked and of such sort—and most of us are so constituted—that it makes us want to move in time to it, to—however rudimentarily, inelegantly—*dance*. We may not know that this 3:4 time is called a "waltz," but it is a very primitive but wholly human response to—not jig; we jig in response to a jig—move in time, waltz. Most 'dances', i.e., music that makes us want to dance, or is in a traditional dance tempo, are gay—though the speed at which it is performed and its orchestration may inhibit that; and the music may be such that to want to dance could only be shallow, vulgar, inadequate, etc. (cf. the last movement of Mozart's String Quartet in G Minor, K.516). Of course some dance music is not gay, cf. a saraband.

Such music often *strikes us* then as cheerful, gay, bright. That is how we would *characterize* the way it sounds and, sounding thus, the music tends to make us feel bright, cheerful, inclined to dance. (These effects are, of course, heightened by the tune, especially by those tunes we call 'catchy'.) And if its tempo quickens then, with suitable orchestration, it can be wildly exhilarating and exciting (Ravel's *Bolero*, even Dukas's *Sorcerer's Apprentice*).

But, as yet, there is nothing moral, surely? Well, of course, some people and certain religious or political groups *do* find some such music *immoral*. To see jazz, for example, as decadent may be a response informed—or misinformed, distorted, distracted—by ideology. But the puritan is, surely, not wrong when he hears in the frantically frenetically throbbing, pulsing, beating rhythm something *abandoned* which invites an abandoned response? The nun who casts off her habit of a lifetime and starts capering about to the irresistible strains of "Great Balls of Fire" is not making an aesthetic error but may well be making a religious and moral one. Such music asserts nothing, portrays nothing, it is *about* nothing; it may be written and performed by gloom-laden cynics. Nonetheless, inherently, in itself, it is, is expressive of, and tends, perhaps irresistibly, to elicit anything varying from cheerful foot-tapping to orgiastic abandon.

I am inclined to think that a philosopher, and only a philosopher, might say that although the performance of such music may be inappropriate to some occasions, may understandably upset certain persons or sensibilities, it is in itself not merely innocent but not even in the race, contest, category for such characterization. For it would be like saying that a candy-colored, tangerine-flake funeral chapel was immoral when it was merely and at most in bad taste. (Yet some might want it thus. Traditional jazz was in its earliest years played at funeral processions.) But I think the puritans are right. For example, rock and roll–the very music, not (just) the words—is subversive of decorum, restraint, solemnity, deference; unlike the puritans, I not only enjoy its subversiveness but believe it to be a force for good.

Music with a strongly marked rhythm may be quite other than an invitation to the dance. Take something as simple as a slow, regular, single beat, especially if it is played on a muffled drum. The combination of rhythm, tempo, and timbre is—to we of the West anyway—solemn, portentous. So that in certain situations it may strike us as terribly moving, sad. In other situations, and for that very reason, it may be so incongruous as to be a joke, or at least as to be funny whether intended or not.

Starting an evening's entertainment with the first few bars of "God Save the Queen," which brings an audience to its feet, and then switching into "When the Saints Go Marching In" is also funny, but not because of anything inherent in the music. Still, one feels one can 'see', i.e., understand, just by attending to the spacious, dignified, rather pompous strains of "God Save the Queen" why this was chosen for Great Britain's national anthem. Similarly one can understand why Australians rejected "Waltzing Matilda" as their national anthem and chose instead the abysmal "Australia the Fair."

It will be noticed that not only have I been unable to avoid mentioning, using as examples, named pieces of music—how else could I proceed?—but have been unable to stick to mere rhythm and tempo. I have mentioned not only tunes but instrumentation (a muffled drum, or what sounds like one. Of course, drums can sound very different).

Pianos, guitars, and violins are also wide ranging in emotional character. Other instruments produce sounds, timbres ("sound-colors") with a very marked

emotional feel and connotation. The oboe sounds plaintive, introspective; a trumpet the antithesis of that. A cello is mellow, but if it is required to be agile, i.e., to go up and down the scales and quickly, it can sound ponderous, even elephantine. So the opening of Haydn's cello concerto in D major, op. 101 combines a beautiful, singing tune with a lumbering scamper as the tune quickly descends. For me, anyway, the result is a wonderful combination of beauty, humor, and pathos.

<div align="center">8</div>

I must turn aside again to deal with an objection foreshadowed in section one. Someone might object that I am discussing 'mere associations' and other cultures might associate differently—their sad music might not sound sad to us, and vice versa—in which case the argument is that there is nothing inherent in music which sounds like the expression of, or elicits, feelings and emotions, so they must be learned responses, learned modes of expression. But since we could be taught, conditioned to associate moral responses with anything, e.g., to recoil at the sign of a crooked cross on an arm band, there is no philosophical problem here. The crooked cross, the KKK hood, may strike us as inherently evil-looking but are not and cannot be.

I would prefer to use the word "association" for personal contingent and *external* connections. "A Fine Romance" I find unbearably moving—and I know why. It is not the wry 1930-ish song's tune or words but the fact that it was playing one night when my mother dressed in her black, going-out clothes, smelling of scent and powder, wearing a hat with a black snood, bent over the rails of my cot to kiss me goodnight. It felt like goodbye.

But the *match, mapping, consonance* between tempi and rhythms and human movement is not simply contingent and external. Of course, we can imagine that human beings had no tendency to respond to the rhythm of music by echoing it in their own movement, but they do, and I suggest that it is not learned and not teachable to those who lack it, though no doubt it could be suppressed by a culture and different connections established. Moreover, these human movements more or less match those which are the natural expression and accompaniments of certain moods, emotions, or feelings. We skip when light of heart (and unembarrassed by *gravitas* or prevented by infirmity). We move slowly and draggingly when we have lost a vital point in tennis, a golden chance, or a dear friend. We do not simply learn, are not conditioned to find "The Dance of the Sugar Plum Fairy" incongruous to our feelings in such situations.

Orchestration, 'color', does have a larger cultural, learned dimension, no doubt. Actual colors do, perhaps, for I cannot deny that the Chinese color of mourning is white, and Buddhist priests wear saffron robes.

Still, if we knew more about their cultures, their beliefs about death and god, we no doubt should be less surprised, not even puzzled. The Chinese strike gongs and let off fire crackers at funerals. All is explained, transparent,

when we learn that they are frightening off demons. Though white is for them far from what it is for us, a conventionalized but not unnatural expression and symbol of purity, a short story could make us understand why the Chinese mourn in white. (Their widows wear black.) An oboe sounds like the call of a wild duck or goose, does it not? Is that evocativeness *learned*? But if these things are your dinner or your sport, the connotations of its reedy, plangent—to me—voice may, and for some, will be different.

How about difference within a culture? For example, some people respond scarcely at all to any music, others' responses are aberrant, or simply and sometimes different from one's own. Do they defeat my claim that certain feelings, moods, emotions, are inherent in certain pieces of music and elicit similar or connected feelings, emotions, moods, in the hearer?

As I have already said, we might not have responded as we do to music, and some scarcely respond at all. They may not even be deaf, tone deaf, retarded, or demented. They may be otherwise normal. Moreover, we cannot show that they are in error by producing arguments or adducing evidence. It is rather that they lack an innate capacity, which may have been suppressed in their case, to respond emotionally to a part of the world to which we thus respond.

They may regret this or, Dalek-like, they may find our responses irrational (like kicking the car door), or, of course, both. We reject the charge of irrationality—to a form of which charge I must turn in the next but one section—and charge them with insensitivity.

This charge may, and if we are honest, sometimes must be leveled at those whose responses differ from ours. Sometimes they may cheerfully admit to, or regret, their insensitivity. But they may not, and if they know a lot about music, and love music, that disagreement is more challenging.

Before we tackle it, we should do well to remind ourselves that such disagreements among the *cognoscenti* take place against a large measure of agreement about who are great composers, and which are great pieces of music, and are often not really disagreements but differences in appetites and taste. My little appetite for Wagner is partly for reasons I know to be irrelevant—the author's nationalism and anti-semitism, and the self-indulgent, self-congratulatory, widely advertised appetite of *aficionados* (especially Bernard Levin)—and for idiosyncratic reasons—I have little appetite for very richly orchestrated music and a much greater appetite for the vast quantities of music written by composers whose works I adore and so I tend to listen to them. Wagner? No, let's have the Beethoven (Mozart, Schubert, Haydn, Bach).

But real disagreements remain, and I can accept that. Sensitivities differ, the natural expression of feelings, moods, emotions differ somewhat, and responses to those feelings and their expression differ. Since music also has dimensions other than the emotional, it is not surprising if some can scarcely abide the romantics—they are too romantic—and others find a Bach partita for solo violin just too austere, or whatever.

What I have to say could not even get going if there were not a consensus about the nature, quality, merit of music. But there is, and if there were not, writing many forms of music would be impossible, and the rest—well, very different!

9

Besides rhythm, tempo, orchestration, and melody, there is yet another feature of (some) music which plays at least as important a role in determining its emotional feeling and, hence, effect as any. This is harmony, the so-called "clothing of melody." What is philosophically interesting here is that the documentary evidence of European music shows that as music developed from the plainsong of mediaeval times, and counterpoint emerged, different chords began to be employed. The fourths and even seconds commonly found in the parallel voices deployed in plainsong, and which now strike our ears as archaic, even harsh, were largely replaced by the triad (the chord consisting of a note with its third and fifth). So, it would seem, our musical sensibility has not only developed, expanded, with the appearance of more complex writing and new instruments—that is (comparatively) unpuzzling—but it has *changed*. Doesn't this show that the language of music is not a metaphor to this extent, that the significance of musical sounds, though perhaps emotional rather than intellectual, is nonetheless conventional and has to be learned? In which case, whatever I might claim about the connection between rhythm and tempo and our responses to those, the emotional connotations of harmony are conventional: it must be because it changes and hence has to be learned?

I do not wish to, and do not have to, I think, deny that some modicum of learning, albeit of this most informal sort, mere habituation, is involved in the most uninstructed responses to music. As the heroine in the silent film frantically dashes from one side of the cabin in which she is trapped to the other, the pianist will play a piece in which the rhythm and accelerating tempo of and the repetitive, simple, up and down melody matches, mirrors, and helps to heighten her feelings and the responses of an engaged and sympathetic audience. These dimensions of the accompaniment could, I think, achieve their effects with any audience, were it to take place in a showing of the film to a native Chinese audience in Bejin in the 1930s, or a native African audience in Lusaka in the 1940s or 1950s. But now suppose the director 'cuts' to a man, moving towards the cabin, possibly to rescue her. Perhaps non-European audiences would not respond, as the director intended, to the pianist's playing diminished sevenths. (I suspect, and am committed to the view, that they would understand another cliché here, viz., his or more probably her deploying 'tremulando'.) Perhaps only those habituated to 'European' music would do so. Nonetheless, they, and we, are not taught the 'meaning' of the diminished sevenths as we do have to be taught the meaning of the words 'danger' and 'fear', or their foreign language synonyms. That expressive quality of the diminished seventh is available, without specific instruction, to at least those who are familiar with

the idiom of European music. To that extent, the feeling in this dimension of the music, and its effect, is inherent in it.

To most persons reading this, including those who are illiterate musically as the writer, and excluding very few indeed, some chords seem 'at rest', complete in themselves. (Anthony Hopkins has called these, 'sit down and rest chords', in "Music as a Language," a lecture given, on February 2, 1990, at the University of Kent, Canterbury, England.) Others have been called 'dissonant' chords. They are not necessarily displeasing, but 'incomplete', needing resolution with another chord. (This feeling can be so strong that many stories are told of musicians, e.g., Parry, who, having heard a dissonant chord and then silence, have had to get up, go downstairs, open their piano, and play a resolving chord.)

Given the richness of its resources, it is scarcely contentious that at least some 'pure' music, and perhaps especially that written in the European idiom between, roughly, 1600 and 1900, can express an enormous variety and, of course, a succession of feelings and emotions. Thus, a Mozart violin concerto, e.g., his third, might begin with a first movement the beauty of the melody, the tempo, orchestration, and development of which is not only beautiful but exhilarating. Indeed it may feel as if, and be, that this particular beauty is not sad, that is, sadness is somehow and almost entirely denied, i.e., not indulged. This is followed by a slow, poignant movement, in which, again, the feeling—this time of aching sadness—is somehow resolved at the end of the movement. This composition is then completed by something predominantly gay, brilliant, and emotionally, almost, 'lightweight'. Beethoven, more driven than Mozart, freer of the constraints of classicism, using a bigger orchestra than Mozart, is characteristically less restrained. But even he decided to replace the "Grosse Fuge" that originally formed the finale of his String Quartet in B-flat, Op. 130, with something less—enormous?

10

There is one further feature of our music which, though it is a product and consequence of other features already mentioned, melody, rhythm, tempo, orchestration, and harmony, is so important in securing the feeling and effect of music that it deserves separate mention and a name. I shall call it inflection or intonation, and it is especially important, I find, in chamber music.

Musical phrases, played perhaps on an unaccompanied violin, can sound *questioning*. This—*au pied de la lettre*—untutored response, seems to depend on the melodic line, rhythm, and changes in loudness echoing the 'inflection' deployed by speakers when asking a question. The response by other instruments in the piece may have the character, feeling of a reply. If played fortissimo, it may sound *vehement*, impassioned. So, to many ears, a movement or part of a movement in a string quartet may 'sound' like a conversation.[3] The timbre of the instruments, their rhythm, volume, and tempo may make the conversation seem grave, sad, and then, perhaps, resolute and, finally, triumphant or

despairing. Question is followed by discussion, answer, further discussion, and conclusion. The feeling of the 'conversation' may well be grave, sombre, resolute, despairing, frantic, resigned, accepting, triumphant, in succession. And, of course, beautiful. And, being beautiful, moving: and, perhaps and therefore, not only sad but joyous. (Why something beautiful can move us to something approaching grief or joy, or somehow both, I do not have the space or, presently, the resources to explore, let alone explain.) Now to hear a quartet, for example, Mozart, Haydn, Beethoven, or the early Mendelssohn as a 'conversation' can sometimes be reductive. One can only too easily hear it thus, but I do not always wish to; it can somehow diminish the music, constrain it. But, even when I do not hear it in that way, the effect of those intonations or inflections plays, I think, a crucial role in the feeling, emotion, and, hence, effect of the piece.

This dimension of music, the feature or effect, has been called by my colleague Robin Taylor (a classical guitarist) the 'speech act' dimension of music. It can sound as if it is asking a question, debating it, raising further questions, and then providing an answer, all through what I have called 'intonation'. (And since intonation, inflection, 'sound', i.e., orchestration and timbre, vary from country to country, language to language, dialect to dialect, locale to locale, it is little wonder if, say, French music seems to have a particular 'feel', a quality to the ear which can be recognized even by those who do not speak French.)

But *which* question is being posed, *what* answer given, *what* pondered? It is natural to think like this, and to say in reply that one does not know. But of course it is not that there is anything we do not know, that is an illusion. As a result, we might—and perhaps some do—feel that there is an element of hoax, sham, pretentiousness in music. But there is good reason for feeling that such a reaction would be ultra-rationalistic and shallow. Because music, not being, literally, a language, could not literally be making a statement, raising a question, etc. And given its beauty, dignity, passion, restraint, despair, those of us who respond intensely to music will find its 'ineffability', i.e., the impossibility of saying that it is saying or asking, not diminishing, but the contrary. Perhaps the biggest and deepest of the questions which exercise us are so big, so deep, that they transcend our ability to articulate them.

Only a philosopher would feel it necessary to argue that music, in and of itself, can not only express but elicit feelings of hope, resignation, acceptance, despair, gaiety. I have argued this thesis, especially that music can elicit, create, these feelings, elsewhere.[4] But, no doubt, only a philosopher, such as myself, would wish to argue that *therefore* music has a moral dimension.

I shall next deal summarily with the first, and some related, issues and finally, and at some length, with the second.

11

Can, then, music express emotion? Can it elicit emotion? Can it be the target of emotion, i.e., what the emotion is directed to?

Peter Kivy will allow that it can be expressive of emotions, including sadness,[5] when the expression is inherent in the music, i.e., is not an inferential judgment about the composer. (But why should we want to make such inferences?!) However he disagrees that it makes one sad. How could it? What is there to be saddened by? The beautiful music is not suffering—and that is what one should be attending to. In any case, if it did make one sad, who but the irrational would choose to listen to it?

Well, we weep for Anna Karenina knowing her to be fictional so her suffering is unreal, and we are frightened of and by the Beast With Five Fingers. But in the case of music which makes us sad I do not want to say that we are irrational, for although it is the cause of our sadness, and although it is the focus of our attention, it is not the target of our sadness. We listen to and are saddened by the music but not sad about it or for it.

What then are we sad for or about? Since we are at loss for an answer here, the proper, non-vulgar answer, is "nothing." "Life" or "everything" are the least vulgar positive answers, and they have the merit of acknowledging that our sadness is not gratuitous, is not inappropriate to the music or to the human condition.

But what then are we transported by? The *music*; it is both the immediate cause and the target of this joyful response.

Isn't our sadness maudlin, though, that is to say, self-indulgent? (It will not do in a philosophy essay to brush this question aside as philistine.) Yes and no. Yes, because it is justified by no appropriate belief and leads to no action. It inhibits practical action. And, of course, it could be avoided. What if anything warrants it? Why, the beauty, profundity, sadness of the music. (Indeed, to be musically sensitive to *and* unmoved by Beethoven's late quartets, *that* would be moral turpitude—but of course we should say of someone not thus moved that he had a musical blind spot, not a moral one.)

12

If philosophers were more accepting than they are, they might accept most of what I have said so far and yet still reject what I want to claim, viz., that music can have a moral dimension in and of itself. It may sound sad, profound, etc.—But so what? This is mere sounding.

But music *is* sound. If music sounds sad or yearning, it *is*. But what follows? Well, consider almost any composition by Tchaikowsky. So lyrical, beautiful, sad, yearning—and, for me, too yearning. This is music in which sadness is indulged and which indulges sadness.

But music cannot be or do that—it just sounds like that! So it *is*. Moreover, how *can* we deny the 'biographical inference'? Tchaikowsky's work is sentimental and that is a moral fault! Either he is blind to its sentimentality or corruptly indulges it.

Mozart, whose music I once heard a music teacher describe as gay, is almost never just gay, but when he is heartbreakingly sad he never wears his

heart on his sleeve. With his music I find dignity, restraint; these are moral traits and moral responses.

Now, of course, I cannot infer that Mozart was dignified and restrained in his personal life. In fact his letters are ones I wish I had not read. They seem to show him to be coarse, shallow, and vulgar. *But* unless I try to imagine that he achieved his sublime effects accidentally, or despite himself, I have to 'assume' that he knew, i.e., I cannot comprehend that he could be ignorant of, what he was doing and hence, of enormous depth of feeling, which he seems to have reserved for his music.

But what has he to be sad about? More particularly, what sadness is his Quintet in G Minor an expression of? Mozart is aware of and gives expression to a sadness that is global as it can be, sadness at life, at being human. As we have already noticed, we have to say this if we allow ourselves to say anything. And he is aware of it, but does not indulge it. Not to be aware of it is to be shallow, and that shallowness is not avoided by cheeriness, or ac-knowledged by something Aristotle seemed to value morally, *gravitas*. (Such a demeanor bespeaks too great an awareness of and concern with what others will think of you.) He was aware of this feeling, and so felt it, and yet he did not indulge it. No doubt his classical training helped him here. Of course he could have spent his time in good works. But his doing so would not only have been an absurd and terrible waste of his genius, if he and everyone else acted on this terrible utilitarian maxim, it would be counterproductive. The world would be robbed of what makes human life something more than food, warmth, etc.—and he and others whose talent is for the non-practical would themselves no doubt be miserable or avoiding misery with delusions of what God or utilitarianism properly demands of them. Mozart was, almost liter-ally before all else, and to the very end—he died dictating orchestration to a pupil—a musician, a transcendentally great one whose greatness has a large moral dimension.

But whatever I say about Tchaikowsky and his music, to say that he and his music are sentimental, or that he is cynical about exploiting sentimentality, are scarcely *major* moral criticisms. I have conceded that no inferences can be drawn from the qualities of Mozart's music other than that he was aware of the central sadness of life but did not indulge it—in his music. He may well have been, though was in fact not, maudlin. Indeed, it might even be asserted that he need not have been *himself* aware of life's central sadness, and centrally did not feel it, but was aware at most of that feeling in others. Given that this awareness is expressed in his music, i.e., its character and effect are not accidental, that is all that can be claimed.

The objection now is that to claim that the music has a moral dimension is to aestheticize morality. For someone might be aware of that awareness in the music, and respond with delight to the dignified restraint of its expression, and yet, as certain Nazis conspicuously demonstrated, nothing follows about what such a person may do, and delight in doing. He could be the very embodiment of wickedness.

I accept this argument, but deny the objection. Consider the case of someone who is intellectually and emotionally shallow, who nonetheless leads not merely a blameless life but one devoted to good works. This person not only gives what he or she can give, without sacrificing his or her financial independence, to the poor, but devotes much, or almost all, of her 'spare' time to charitable work. Perhaps she is a trained nurse who, on retirement, goes to Bangladesh or Ethiopia and gives the wretched there medical treatment, instructions in hygiene, helps to dispense and prepare alien food that they unaided could or would not prepare or eat.

We who have the time, the leisure, and are prepared to indulge our theoretical interests in considering philosophical questions, would do well to criticize such a person at our moral peril. Nonetheless, I wish to say that such a person could well be morally vapid. They act well; that is not to be denied, nor is its importance: in practical ways they achieve what the rest of us do not. There would be less selfishness, suffering, *angst*, unhappiness in the world if there were more like them. But, I wish to assert, the world, humanity, would be morally impoverished if more—or if, *per impossibile*, everyone—were as this paragon is. (If everyone was purely concerned for the well-being—particularly, the physical well-being—of others, that concern would be self-defeating.)[6] However properly shy we should be about saying so, we must, if we are honest, agree that what we have here is moral 'do-goodery'. I hasten to add that the person I have envisaged may not be in such case. She could be fully aware of the paradox of being human, viz., that when all our basic needs are met, and more than met, our very being is ineluctably unhappy, and yet believe that, given the pervasive self-concern of most of us, and the pervasive basic causes of suffering, she chooses to deny indulging that awareness, and does not allow it to inhibit her decision, nevertheless, to alleviate that suffering as and where that need is most urgent.

Conversely, imagine a case of what I will call 'vapid do-baddery'. The person in question is brutish, animal-like, in his lack of awareness of what others may want and feel. He delights in indulging his violent, destructive, and cruel desires. Yet he lacks sympathy, empathy, understanding of what it is to be, to feel, or think, differently from himself. Impetuous, uncontrolled, selfish, ignorant, violent, and cruel, this person indulges his immediate, unreflective passions. He is indeed a terrible person, and yet he does not achieve the very heights of wickedness. Indeed, if we imagine him to be sufficiently shallow, stupid, thoughtless, he does not even attain the nursery slopes of turpitude, of moral depravity.

The point I am trying to make, against an intellectual tradition which, perhaps, has its first documented beginnings with the thoughts of Aristotle, is that morality is *not* purely a practical matter. (Those, like R. M. Hare, who have striven to make it so, are chronically embarrassed by *akrasia*. If what constitutes a person's morality is what he does, we cannot distinguish between a person who has certain moral principles, but fails to live up to them and someone who has no such principles.) I am arguing, against this whole tradition, that morality

is not just a matter of practice, not even in our environmentally beleaguered and humanly suffering world.

As Christianity is well-aware—though it clothes that awareness with a metaphysical, ontological commitment that I find obscurantist and reductive—true wickedness demands the moral awareness which, I concede, is insufficient to ensure that those who have it will act well. Some music, especially, I find, Mozart's, and in its own and different ways that of Bach, Haydn, Beethoven, Schubert, and the early Mendelssohn, articulates and displays that awareness. (Very roughly speaking I would say that music earlier than that of Bach is too formal, i.e., too constrained by formal constraints—which indicates social, intellectual, and emotional constraint—and that later music, that of the full-blown and late Romantics, and Modernists, is too subjective to allow us any moral characterization of the music, our response to it, or to the author. Compare this with the astoundingly 'modern' nature of some of Villon's poetry. Music might have had such works, but unless I am deafened by ignorance or prejudice, in fact it does not.)

So many writers on aesthetics have wanted to say that the emotions expressed and elicited by art are merely 'quasi'-emotions. Writers, such as Kendal Walton, have wanted to deny, and for not inconsiderable reasons, that in responses to films or music, we do not feel fear or grief. To think that we do is a phenomenological illusion. Because to be frightened requires a belief, viz., that what frightens us can cause harm, and a behavioral response (which may of course be inhibited) to run away, or stay and fight, which are simply lacking when we watch certain films or plays, or read certain stories.

Despite these arguments, which I have discussed elsewhere, and Wittgenstein's—who advises us that it is always a mistake in seeking to understand and identify a feeling, emotion, or whatever, to introspect the putative phenomenon—I do wish to accept such evidence. Moods neither characteristically have, nor do they need, perceived causes or specific focus. Neither do they manifest themselves so much in action but, rather, and insofar as they do, in demeanor. The expressive quality of music can induce or reinforce a mood ("If music be the food of love, play on; / Give me excess of it . . .") so that if, for example, we are feeling low, bleak, despairing, we may not feel strong enough to listen to a late Beethoven quartet, and play perhaps something by Purcell instead.

I hope, then, that I have explained, made sense of, and justified the puzzling *donnée* with which I began—that music per se can have a moral dimension and, therefore, so can our responses to the music. Doing so involved dealing with prior objections which would have precluded making the attempt. We can—indeed we cannot avoid—making such claims as the following: Haydn's later compositions (composed by a man who bestrode the musical world like a colossus, yet who was capable not only of learning from the young Mozart but acknowledging to Mozart's father that his son's music was the greatest he knew, directly, or by report) display a moral stature, an awareness, that we

may recognize and must acknowledge in listening to his music and trying to
discuss it afterwards.

Moral awareness, of the most general and profound sort, can be found
in music. But, as Stravinsky once said about sincerity in composition, it is a
sine qua non which guarantees nothing.

Postscript. The problems which led me to write this essay also led me
to write the following poem, which raises a further problem. Do I accomplish
anything more, or better, in the essay than in the poem?

A Puzzle in Aesthetics

To-day,
If we may,
Let us not pray
Of sought for, seemingly impossible,
Yet mere objectivity
In matters aesthetic.
Instead,
My head
Cudgels this:
"Mere music, asserting nothing, about nothing,
Being, *doing* nothing
But merely sounding—
How can *it* be *moral*?

"Don't forget
Aesthetic wretch
How Nazis loved the great composers."
Mainly German, of course,
And one will not,
But we should pay
Due, though not deferential,
Attention to this
Thought which is a feeling.
For can the power, profundity
Of the latter mislead
Concerning the former?
The unimpressable sceptic
In us shakes his head.

Barenboim's famous rallentando
(I am like a jackdaw for example,
even in this simile)
May become strained, self-conscious,

But is never merely *deft*,
And the executant
Does well here to slow and pause,
The gravity of music's feeling
Renders it appropriate.
"But you are already at the level
Which is puzzling!"
I am.

Mozart is—
Which is ellipsis for—
His music never sounds
Nor, therefore, is
Merely gay.
Rossini is.
"A man who composes for anything
But money is a fool"
For which exuberance we love him
But think, find, feel it
Less. Is it not so?
Of course I cannot argue
Only—try to—show

The Waldstein's second movement,
If not played too slow,
Captures and echoes the cadences
Of a soliloquy:
Grave, measures, inspired,
Resigned, passionate,
Harking to its beginnings,
Seeming to draw conclusions,
Not obvious; and beautiful.
So true, or
Seeming, *surely* true? As
Elsewhere, and here,
All that seems is not always and only
Mere seeming.

"Chopinetto! Schoolgirl music!"
(This already sounds moral
And is wrong.)
Then schoolgirls' noises, and their pleasures,
Are revolutionary, passionate, firm,
Very much their own,
Instantly recognisable!

Being thus,
May we not merely excuse
But delight, revel
In their aching,
Sweetly sad beauty?
It sounds all right to me—
Though one might not always want
Just this.

When words came in to play
there is more to say and seize on,
As in song.
But Fats's Honeysuckle *words*
Are not so much what works
On me. It is his ever changing
Time signatures
And the unique, liquidly
Glowing piano.
How does he make it sound like this!
Brave, brilliant, bright, amused,
Sad and shrewd—
This is moral talk.

"Just *talk* and about what seems,
And suppose it did not seem thus
To me, or us?"
Yes, of course.
And a rose is not red
To the blind
In the dark.

NOTES

1. Indeed, failure to see human figures in symmetrical ink-blots is regarded as indicative of psychopathology in Rorschach testing.

2. Such music is indeed called 'abstract' music, in *The Oxford Companion to Music*, 10th ed. (Oxford), 834, where it is also called 'absolute' music.

3. In the Cavatina of the Beethoven String Quartet in B-Flat, Op. 130, marked "Adagio molto expressivo," a quite astonishing few bars occur just over halfway through. The violin utters a series of broken cadences and the second violin, viola, and cello seem to murmur rhythmically, sympathetically, in unison.

4. "Emotions and Music: A Reply to the Cognitivists," *Journal of Aesthetics and Art Criticism*, 47, no. 1 (Winter 1989); also "Muddy Waters," forthcoming.

5. In *Sound Sense* (Philadelphia, 1989). Cf. pp. 160, 224–227.

6. Cf. "Utilitarianism and the Noble Art," *Philosophy* 63 (1988): 63–81.

7. Cf. "Replies to Three Critics," *Philosophy* 64 (1989): 93–97.

MIDWEST STUDIES IN PHILOSOPHY, XVI (1991)

What Is a Temporal Art?

JERROLD LEVINSON AND PHILIP ALPERSON

I

In an interview aired on National Public Radio, novelist Margaret Atwood discussed the problem of adapting her novel, *The Handmaid's Tale*, to the film screen. One of the great difficulties of transforming a novel into a film, Atwood observed, is that novels have what she called "stretchy time." Films, she said, have what she called "set time." This temporal difference was significant enough, Atwood told her interviewer, that she became quite nervous about writing the screenplay for her novel and, in the end, entrusted the task to Harold Pinter.[1]

It is a common critical observation about the various arts, at a fairly general level, that some of them are temporal arts, and some are not, or that some arts are more purely temporal than others. Lessing, for example, is well known for his argument that painting is a spatial art, best suited for the imitation of visible objects whose parts coexist in space, whereas poetry is an art of time more adept at narrative presentations of action.[2] Music is usually given pride of place as the most purely temporal art (especially by musicians), as for example, in Zuckerkandl's claim that music is "the temporal art par excellence"[3] or Nattiez's comment, "La musique, elle, est fondamentalement art du temps. Comment alors réussir a lui conférer une transcendance intemporelle?"[4] But the honor (if such it be) has also been accorded to other arts, as in Gerald Mast's suggestion that "the cinema is the truest time-art of all, since it most closely parallels the operation of time itself."[5]

On the surface, critical claims such as these would seem to involve a relatively straightforward distinction. A temporal art is presumably one that involves or concerns time in some obvious way. The phrase "the time arts" is sometimes used, in fact, as a variant label for the category in question. But what is it for an art form to involve or concern, or even require, time? This is already disturbingly vague, for if taken sufficiently, though not outlandishly, broadly

it appears capable of encompassing all the arts: activities and experiences are crucial to appreciation in all the arts; activities and experiences possess, as does any segment of life, temporal duration; thus, all arts are temporal arts. Evidently, this would be to give up without even a conceptual tussle the distinction that is intended to be marked by the pair "temporal–non-temporal."

Apart from the intrinsic interest of ferreting out plausible senses of this distinction, there is an additional justification for doing so. Often, when the notion of temporal arts is invoked, the thinker goes on either to offer a further generalization about the temporal arts ("All the temporal arts display the following features . . ."), or else to make some evaluative or normative claim regarding the temporal arts ("Their fundamental value lies in the following . . ."). It will be impossible, manifestly, to tell what is being asserted, much less gauge its validity, if we do not know what senses may conceivably be assigned to the phrase "temporal art" and which arts are therefore comprised in its ambit.

Consider, as an example, one specific normative claim often advanced about the arts: the ideal of medium-specificity. This is the idea, associated particularly with Lessing in the eighteenth century and with Clement Greenberg in the twentieth, that each art should pursue or exploit its own specific nature most vigorously, or even exclusively. Evidently, insofar as temporality turns out to be central to the nature of a number of arts, it will be necessary to be clear as to the differing "temporal natures" they possess, if we are fairly to assess a normative ideal such as medium-specificity.

Our goal in this essay is to fix the main aesthetically significant senses in which one might say of an art that it is "a temporal art." First, we propose a set of specific criteria to which such an attribution might appeal, either implicitly or explicitly. Second, we review these specific criteria and gather them up into three groups, yielding those which refer primarily to temporal characteristics of art objects, those which bear upon the temporality of the experience of art objects, and those which pertain to reference to temporality by works of art. In so doing, we hope to present a reasonably complete taxonomy of such ascriptions. Third, we briefly consider some further questions about the adequacy and interest of the distinctions we have outlined.

II

We shall take it that an art (or art form) is to be described as temporal if and only if its standard or paradigm objects display some distinctive characteristic— possibly relational, and possibly involving the mode of experience at which they aim. To put this even more neutrally, we shall assume that we can at least frame the question of an art form's possession or lack of temporality in terms of some condition on the standard or paradigm objects of the art form. (Thus, the fact that avant-garde or self-consciously experimental instances of the art might not meet the condition would not count against its adequacy as a characterization of the art form's temporal status.) What we are after, of course, are construals

of "temporal art" that count some of our familiar arts as temporal and some as not, that make for interesting groupings among these familiar arts, and that permit "temporal art" to have application to art forms which do not currently exist, but which are theoretically possible. In line with our effort to make sense of familiar intuitions about the arts, we shall construe the artistic object as a physically embodied entity or historically tethered type, rather than as an "ideal object" in the manner of Croce or Collingwood. We shall also hold as a background condition of adequacy the intuition that certain existing art forms (e.g., music) must end up counting as temporal, and others (e.g., painting) as non-temporal, on any acceptable construal.

We now proceed to consider several time-related characteristics of the arts which might count as conditions by appeal to which we could plausibly characterize an art (or paradigm instances of works of the art) as "temporal."

(1) *Objects of the art form require time for their proper aesthetic appreciation or comprehension.* This, the notion that engagement with an artwork takes time, is certainly an obvious enough idea. But its defect is equally obvious: it would appear to cover almost any conceivable art since most, if not all, artistic experiences are durational. This temporal aspect is therefore not likely to be what anyone has in mind in thinking of the temporal arts as a special group. The imaginable exceptions to this condition would be avant-garde forms of visual art designed and projected ideally for instantaneous reaction or absorption. One is reminded of Vlaminck's desire for an art which could be fully comprehended from the window of a speeding automobile or of Noland's determination to produce "one-shot paintings, perceptible at a single glance."

(2) *Objects of the art form require a significant interval of time for the mere perception or apprehension of their full extent.* This is a notion that covers music, dance, film, novel, murals, architecture, sculpture, drama, epic poems, kinetic sculpture—but not haiku, easel paintings, small facades or reliefs. By "apprehension of their full extent" we mean here a fairly minimal perceptual sort of experience, rather than something like adequate artistic comprehension or understanding—which might take quite a while even for the tersest haiku.

(3) *Objects of the art form require time in presentation, i.e., they require performance or exposition of some sort over an interval of time; the parts of the artwork are not all available at any one moment, but only consecutively.* Here is a notion which comprises music, dance, film, kinetic sculpture, spoken poetry—but not novels or written poetry or murals. It is roughly this meaning of "temporal art" that Susan Sontag is invoking when she argues that "both cinema and theatre are temporal arts. Like music (and unlike painting), everything is not present all at once."[6]

(4) *Objects of the art form consist of elements or parts arranged in a linear order, with definite direction, from first to last.* Strictly speaking, the quality of linear order with definite direction from first to last is what we normally describe as "sequentiality," and sequences (such as the series of positive integers) are not necessarily temporal. Linear order and unidirectionality are, however, so closely associated with the notion of time that we may well think of sequentiality as

a temporal condition. On this conception of temporality, music, dance, drama, novel, poem, film, and certain indoor "installations" count as temporal, but not painting, sculpture, architecture, kinetic sculpture, or mural—though in these last cases there may be something analogous, but weaker: a suggested direction of appreciative movement.

(5) *Objects of the art form are properly experienced in the order in which their elements are determinately arranged, and at a rate defined by, or inherent in, the artwork itself or its prescribed mode of presentation or performance.* In other words, the order and pace of an audience's experience is fixed by the manner in which the work is made available for appreciation. The parts of a Beethoven sonata, for instance, are made available only successively in a performance, at tempi broadly inherent in the sonata as composed—though narrowly determined by the pianist on a given occasion. The events of a play are enacted on stage in a definite order, without repetition, and at a pace determined collectively by the director and the actors. Something similar could be said for the role of dancers' and choreographer's choices in fixing what an audience will behold at each point. This conception would seem roughly to pick out what are called the "performing arts," with the understanding that film must also be included, given the way in which the sequentiality and fixed speed of projection of film wholly constrain what viewers will see and when they will see it.

Thus, music, dance, drama, film fall under this conception, but not novel or poetry: there the reader properly, and as intended, controls pace and the possibility of immediate reexperiencing (rereading) and back-referencing (flipping back), as he or she judges appropriate or useful. A similar claim would apply to murals.

It is worth remarking how the advent of VCRs and CD players, which enable the experiential prescription inherent in the musical or cinematic object and its intended mode of presentation to be sidestepped or virtually neutralized, is clouding this difference in practice, and even threatening to obscure the conceptual point.[7] At any rate, this feature of temporal control by the artwork over the structure of the experience of appreciation or apprehension itself, with regard to the order and rate of presentation of its elements, is not entailed merely by the sequentiality of a work's elements, as shown by the example of novels and poems.

Thus, there is a fundamental distinction here between music and film, on the one hand, and literature, on the other. Yet one might have doubts, for something like the control over the pace of absorption of the successive elements of the work which is inherent in music and film may be at least approached in certain forms of experimental poetry. Nicole Broissard, a Quebeçoise writer, claims to have crafted the poems in her book *Picture Theory* in such fashion that the reader's speed of reading, traditionally a matter of individual decision, is effectively manipulated and constrained by the text's inherent structure. And even traditional poetry has always had at its disposal numerous resources and techniques for influencing the tempo at which a reader progresses through a

text, e.g., enjambment, caesura, line length, syncopation, clustering of conso-
nants, etc.

Still, there is a difference between the kind of control exerted by a prear-
ranged sequence of shots projected at an invariable rate and that exerted by an
arrangement of words spread out over several pages which guides a receptive
eye and hand without coercing them. Perhaps we would do better to speak,
not of degrees of control, but of *determination* (in the case of music and film)
as opposed to *direction* (in the case of literature), of the order and pace of an
appreciator's experience.

(6) *Objects of the art form are such that non-temporally extended parts
of the object do not count as aesthetically significant units of it. That is to say,
such parts are not isolatable for study in a way that contributes significantly to
the full experience of the object.* For example, the individual frames of a film,
even if not detectable as such in normal viewing, are components of a film in
a way in which instantaneous slices of sound are not components of a musical
work. "Freeze-frame" is possible in viewing a film, but there is no such thing
as "freeze-moment" in auditing a piece of music; "freezing" (e.g., pushing
the "Pause" button of one's CD player) gives you nothing, rather than some
smallest quasi-perceptual unit. A temporal cross-section, an instant, of a film—
but not a piece of music—has some intrinsic interest, is part of the aesthetic
object from the point of view of analysis, and can be related to the film as
experienced in proper time. What this points to is that music is an unbreakable
temporal process, and that its essence lies in relationships of elements which
are intrinsically almost formless (e.g., single notes, chords) to a greater degree
than in film.[8]

(7) *Objects of the art form are about time, or our experience thereof, in
some significant way.* Music, dance, novel, film all figure here—but also some
paintings, such as Renaissance allegories of Time, Futurist pictures by Balla
and Severini, Dali's *Persistence of Memory* with its melting pocket watches, or
Peter Blume's *The Eternal City* which depicts a devastated Rome in the wake
of Mussolini's fall.[9] Some would claim that certain examples of post-modern
architecture (much of the work of Michael Graves, for example) is also about
time insofar as it seeks by means of architectural "quotations" to allude to the
architecture and symbolic meanings of the past as well as to the relationship
between architecture and the passage of time.

A noteworthy subcategory of works which refer to time would be works
that are about time in the sense that they project, sometimes surprisingly, a
sense of *timelessness*. A good example might be Schubert's String Quintet in C,
whose slow movement conveys to a listener a sense of utter suspension, at least
in a good performance. Paradoxically, in such a case the essential temporality
of music is highlighted by contrast. Something similar might be said of certain
peculiarly temporal films as Michael Snow's minimalist *Wavelength*. This film,
in which an ostensibly static view of the walls of a room is progressively
transformed, succeeds, in opposition to the usual invisibly edited Hollywood
narrative, in foregrounding processes of duration and perception through time.

(8) *Objects of the art form use time as a material, or as an important struc-*
tural feature. Obviously, music and dance come to mind here, then (arguably)
novel, drama, film—but less plausibly sculpture, architecture, painting. Again,
it is true that any art could be said to use time as a material in the weak sense
that duration seems to be an essential condition of experience generally. It is
also true that certain works of architecture, painting, and sculpture sometimes
seem to approach the use of time as material, especially in the case of works
of extraordinary size and scale (the cathedrals at Notre Dame and Chartres, the
ceiling of the Sistine Chapel, the Statue of Liberty) where some claim might
be made in virtue of the durational and sequential aspects of the experience of
the work. But the point here is rather that certain arts typically play with time,
so to speak, or manipulate it, and that such play or manipulation is central to
the aesthetic interest of objects of the art.

(9) *Objects of the art form generate a kind of time that is peculiar to*
them, that exists for a perceiver only in and through experience of the work.
The most plausible candidates here are music and film. Claims of this sort
have been advanced by Langer and Zuckerkandl for music, and by Balazs and
Morrissette for film. Langer, for example, writes, "All music creates an order
of virtual time, in which its sonorous forms move in relation to each other—
always and only to each other, for nothing else exists there. . . . Music makes
time audible, and its form and continuity sensible."[10]

(10) *Objects of the art form represent a series of events in time distinct*
from the series of events constituting the art object. This is a distinct potential
of novel and film, and to a lesser extent, of theatre, but only faintly realizable
in, say, music, dance, or kinetic sculpture. Novel and film are temporal in
a sense difficult if not impossible for music, unassisted dance, and kinetic
sculpture, insofar as they can explore temporal relations *representationally*.
They can represent a series of events having their proper temporal relations
within themselves, while presenting those events in a manner not necessarily
paralleling, or conforming to, that internal order.

Drama can also do this, but not with the freedom and flexibility of narra-
tional forms. In a narrative art such as novel or film, we are often confronted
with two series: one, the series of presentational events comprising the filmic
or literary narration, and two, the series of fictional events which we recon-
struct, or posit, on the basis of that. Although in conventional narrative there
is usually little obvious discrepancy between these series, in more adventur-
ous narrative efforts (e.g., those of Proust, Kundera, Robbe-Grillet, Welles,
Resnais) their distinctness and independence can become foregrounded, some-
times shockingly so. Since the result of this foregrounding is invariably to
induce reflection on the nature of time, memory, and the process of living—or
perhaps constructing—a life, such art can be considered temporal in a more
special and potent sense than most others we have invoked. In any case, this
power to explore temporality representationally is doubtless what critics and
theorists often have in mind when they regard novel and film as quintessential
"time" arts.[11] It is true that certain musical techniques point in the direction

of such capacity (Wagner's use of leitmotifs, the *idée fixe* intended to denote images of the Beloved in Berlioz's *Symphonie Fantastique*), but they fall far short of enabling depiction of a series of events and their internal relations.

(11) *Objects of the art form are created in the act of presentation, so that the time of creation, time of presentation, and (usually) time of reception all coincide.* We can distinguish an artistic object's "time of creation" (the extent of time of the artist's conception and production of the object), the object's "time of presentation" (the extent of time during which the object is made available for direct apprehension by its appreciators), and the "time of reception" of an object (the extent of time during which the object is actually apprehended by its appreciators). Leonardo's *Mona Lisa* was created over a four-year period (probably from 1503 through 1507), which was its time of creation in the specified sense. Its times of presentation and reception probably coincide, ranging from roughly 1507 to the present. In painting, as in most art forms, time of creation clearly precedes times of presentation and reception.

In the case of certain arts, however, the time of creation coincides with the time of presentation, and often the time of reception as well. Manifestly, we have to do here with the category of *improvisational* performing art, e.g., jazz, some modern dance, etc. One of the chief sources of delight in the case of improvised art is clearly the appreciation of the-artwork-in-the-process-of-being-produced. When we listen to an improvised piece of music, for example, we accept as a matter of course all sorts of musical sounds and effects which, in the usual listening situation, where time of composition and time of performance are entirely disjoint, we would regard as mistakes. We are more forgiving in the case of improvised music in part because we understand that the times of composition and performance have been collapsed, with revision being an option only for future trials. We attend to a different set of qualities because we are apprehending a specific sort of aesthetic object generated by a distinctive sort of human activity: we appreciate the work as the production-of-the-object-in-time in relatively spontaneous creation.[12] The temporality of improvisational performing art, then, as opposed to that of its non-improvisational analogues, thus deserves special notice.

(12) *Objects of the art form require presentation in a time lived through and by the presenters.* What this aims to capture is the role of performers in even notated, non-improvised music, in contrast to that of projector (or even projectionist) in film. Our primary access to the object (e.g., a musical composition) is through an instance produced by living performers then and there, as we experience it. This distinction might be loosely glossed as that between "live" and "canned" time in an art object or its presentation. Recordings of "live" performances are interesting, in part, because they on the one hand preserve, but on the other hand, negate or belie, the temporality of the music in the sense in question.

(13) *Objects of the art form lack relatively fixed identities over time, but are rather mutable and shifting.* This distinguishes certain folk arts with oral traditions of transmission, e.g., Norse sagas, or the Wayang Kulit shadow puppet

plays of Java, from typical Western high art forms, especially those whose masterworks are thought to comprise a canon.

III

If we step back for a moment, and consider the thirteen criteria or conceptions of "temporal art" we have come up with, they can be seen to fall roughly into three broad groups, which we may label "object-based," "experience-based," and "content-based." Although all the criteria were uniformly formulated as conditions on the (standard or paradigm) objects of the art form, they are not all "object-based" in the sense we are now invoking. An *object-based* criterion of temporality is one which asks for duration, temporal extent, successiveness, or changeability over time primarily in the objects of the art themselves (or in their form of presentation). An *experience-based* criterion demands rather that the characteristic experience or central way of interacting with the art object possess some non-trivial duration, temporal extent, or imposed linear order. And a *content-based* criterion, finally, is one which locates temporality primarily in an artwork's referential or representational relation to, time or temporal process. With a certain amount of squeezing, criteria (3), (4), (6), (11), (12), and (13) can be ranged in the object-based drawer, criteria (1), (2), (5), and (9) in the experienced-based one, and criteria (7), (8), and (10) in the content-based one.

The object-experience-content trichotomy is important because it corresponds to three obvious foci of attention in artistic practice. At the same time, we should note how closely interrelated these three wider categorizations are. Consider, for example, the relationship between features of the artistic object and features of the artistic experience. To the extent that artistic experience is experience of an artistic object, we can expect a strong parallelism of features between artistic objects and the experiences thereof. This was already implied in our previous discussion of VCR and CD technology, where we spoke of the experiential prescription inherent in the art object.

Similarly, when we distinguish between artistic experiences which are temporal in the sense that they are normatively sequential and those experiences which are both sequential and determinate with respect to tempo or rate, we can apply the same distinction with respect to artistic objects. A novel, at least insofar as we consider it to be a structure of words or sentences, might be considered inherently sequential but indeterminate with respect to tempo, whereas a piece of music in performance is both sequential and determinate with respect to tempo. Tempo is both an "experience-based" attribute as well as something that can be predicated of the object, as is the case when the tempo of a musical piece is specified by a metronome marking.[13] In a similar vein, the claim that, from an experiential point of view, we can distinguish between the epic poem and the haiku on the grounds that the former requires a greater interval of time for the mere perception or apprehension of its full extent, depends upon certain (quite reasonable) assumptions about the time of

presentation of the respective art objects: the time of the mere perception of haikus is shorter because haikus themselves are shorter. Or, to move to a different pair of categories, to say that an art's temporality may be "content-based" insofar as time may be used as an artistic material is very close to identifying an object-based characteristic.

These reflections suggest the possibility of one further proposal, broader in scope, perhaps, than any of the preceding [leaving (1) aside]:

(14) *Objects of the art form are such that their proper appreciation centrally involves understanding of temporal relations within them.*[14] This proposal clearly straddles the "experience-based" and "content-based" classifications, and may cover most of the narrower criteria of greatest interest formulated earlier. It is possible that when an art form is described as "temporal," without any further specification of what is meant, then this proposal, with its built-in relevance to criticism, provides the best overall default construal.

Having formulated a number of individual conditions in an attempt to cover all that might conceivably be meant in predicating temporality of an art form, we should at this point acknowledge the likelihood that a fair number of critical observations involving temporality may not conform exactly to any of our conditions, either singly or conjunctively. Workable critical vocabulary might easily cut across, to some extent, the senses we have clinically laid out. The example with which we opened our essay is instructive, perhaps cautionary, in this regard. It turns out that when Margaret Atwood spoke of the difference between the "stretchy time" of a novel and the "set time" of a movie, she had three points in mind. First, the novel can represent a character's evolving thoughts; it is more difficult to portray an interior monologue on the screen. Voice-overs can be used in film, but they can quickly make the film seem artificial or precious. It is possible to show a disparity between the character's words and actions and his or her facial expressions, but this can at most suggest what a character is thinking. Second, the reader has some control over the sequence of events and descriptions in the novel, insofar as he or she has the freedom of reread sections or even jump ahead, whereas the sequence of events and portrayals on the screen is controlled by the film-maker(s). And third, the reader determines the amount of time spent in reading the work, by which Atwood appears to mean, not that the amount of time spent in reading a novel or a section of it is in itself of great aesthetic importance, but rather that the reader has the freedom to speed up or slow the rate at which he or she reads or dwells upon this or that passage or section. The amount of time spent watching a film is fixed by the film-makers (assuming that the film does not break, that the projector runs to speed, that the audience does not fall asleep, and so on).[15]

The terms, "stretchy time" and "set time," as Atwood uses them, then, are multi-faceted, ranging over several of the categories we have been delineating, functioning in this way like Langer's term "virtual time." The terms have a conceptual integrity in themselves and are certainly aesthetically relevant to the question of the temporality of *The Handmaid's Tale* in book and film form,

respectively. Atwood tells her interviewer that she was anxious about writing the screenplay for her novel because the overall effect of the difference between "stretchy time" and "set time" is to make films more strictly narrative (and therefore constraining) than novels. In reading *The Handmaid's Tale*, with its dark narrative twistings and turnings, its stories and reconstructed stories, one can well understand her nervousness about the difference. We therefore must allow that there may be an indefinitely large number of artistically relevant temporal descriptions, each important in its own way, but we suspect that most of the content of such descriptions would be articulable in the context of the taxonomy presented above. Still, the articulation between such descriptions as they occur "in the field," and the senses we have explicitly delineated, may often be rather rough.

IV

Might there, finally, be any point in trying to decide which art form is the "most" temporal of all? One could, of course, determine which art counts as temporal by the greatest number of criteria and award the title—Oscar-style— to the candidate with the largest number of votes. But the purpose of such an exercise seems obscure outside of a context in which the ascription of temporality acquires some positive value.

Such a context might be supplied, however, by a global theory of art in which the temporality of an art would figure prominently. If one held to an imitation theory of art, for example, one might claim (in the manner of Lessing) that some arts (such as poetry) might, in virtue of certain of their temporal features, be better (or best) suited to narration and representation of, say, human action. On the other hand, there is also an historically important line of expression theorists extending from Schopenhauer and Hegel through Susanne Langer, each of whom places one art—music—at a strategic point in his or her theory on the basis of a specifically temporal feature of music. The reason for this is that they have been convinced by the Kantian claim that time, as the form of inner sense, is intimately bound up with the very idea of consciousness and they believe that music has an unusually strong referential relationship to time or time-consciousness, either as a copy or objectification of the movements of the human (and cosmic) will(s) (Schopenhauer), as the most adequate nonspatial sensuous presentation of the inner life (Hegel), or as an illusion begotten by sounds of psychological time (Langer). The general form of their arguments is something like this: (1) Identify some temporal aspect of music as the core of musical experience or significance. (2) Argue that no other art exhibits this temporal feature as purely or prominently as music. (3) Argue that this aspect of temporality is intimately associated with consciousness. (4) Argue that music, the most temporal of the arts, is therefore best suited to the expression of consciousness. (5) Advance an expression theory of art. (6) Conclude that music, in virtue of its being the most temporal of the arts, is the purest or highest form of art.

If one were to buy into this sort of argument, one would have identified a very important reason indeed for settling which of the arts is the "most temporal." We are far from personally recommending the argument, but it is certainly one which has been influential in the history of aesthetics.

Another approach to the question of the "most" temporal art would be to review our conditions and decide which of them are really the most crucial or aesthetically *significant*. This would be to allow that being temporal in some senses was more weighty than being temporal in others. Thus, we might venture that (3), (5), (7), (8), (10), and (11) define more distinctive, central, and critically noted modes of temporalness than the others, and thus that art forms satisfying the former, rather than the latter, criteria are in way more properly qualified as "temporal." But this suggestion must await fuller development at another time.[16]

NOTES

1. "Morning Edition," National Public Radio, 5 March 1990.

2. Gotthold Lessing, *Laocoön: An Essay on the Limits of Painting and Poetry*, translated by E. A. McCormick (Indianapolis, 1962). See especially chapters 16 and 20.

3. Victor Zuckerkandl, *Sound and Symbol* (Princeton, N.J., 1956), 151.

4. "Music is fundamentally a temporal art. How, then, can we ascribe to it transcendence of the temporal?" J. J.Nattiez, "Gould singulier: structure et atemporalite dans la pensee gouldienne," *Glenn Gould Pluriel*, edited by G. Guertin (Louise Courteau, 1988), 61.

5. Gerard Mast, *Film/Cinema/Movie* (New York, 1977), 112.

6. Susan Sontag, "Theatre and Film," *Styles of Radical Will* (New York, 1966) [p. 354 as reprinted in *Film Theory and Criticism*, edited by Gerald Mast and Marshall Cohen, 3rd ed. (New York, 1985)].

7. Gerald Mast's discussion of this matter is tonic: "[a film's] experience is exactly as long as it is, and no one . . . can tamper with its ceaseless flow once it has begun . . . the cinematic work moves ceaselessly forward. Cinema fugit. The apparent exceptions truly prove this rule. One is the possibility of studying a film, viewing it alone—stopping, starting, reversing, slowing, speeding it, as the kind of study demands. But studying a film is not experiencing it as was intended; it is a dissection which, at best, reveals how and why it is experienced" (*Film/Cinema/Movie*, 112).

8. Relatedly, serialization—some tonight, some tomorrow night, and the rest next week—makes some sense with novel or film, but (typically) much less with music: you would not give one movement tonight and the next tomorrow night, or (even more clearly) the exposition and development of a sonata movement tonight, and the recap and coda tomorrow. *Wagner's Ring Cycle* might initially appear to be something of a counterexample, but the fact that it is a *theatrical* (and not just musical) work, and consists of four relatively *independent* operas, obviously puts it in another class altogether.

9. Both these latter pictures are in the Museum of Modern Art, New York, which one of us frequented much as a teenager.

10. Susanne K. Langer, *Feeling and Form* (New York, 1953), 109–10.

11. One might, within this rubric, take it to be a mark of even greater "temporality," if the representation *of* temporal relations in the art form was standardly achieved *by* temporal—as opposed to other (e.g., spatial, grammatical) relations or features—in the artworks themselves. Film and drama would thus score higher, by these lights, than novel or mural.

12. See Philip Alperson, "On Musical Improvisation," *Journal of Aesthetics and Art Criticism* 43, no. 1 (Fall 1984).

13. Actually, the situation is further complicated by a distinction one might wish to draw between musical *objects* and musical *works*. If, for example, we construe the musical

work as some sort of type which can be instantiated in particular performances which are understood as particular musical *objects*, then given the vagaries of notation and performance practice, the musical work—in comparison, say, with a cinematic work—would seem to be only *relatively* determinate with respect to tempo. [For more on musical works vis-à-vis performances, see Jerrold Levison, "What A Musical Work Is" and "Evaluating Musical Performance," both in *Music, Art, and Metaphysics* (Ithaca, N.Y., 1990).]

14. Note that this formulation cannot read merely "involves understanding temporal relations" *tout court*, since all artworks require to be placed in their historical relation to previous works if they are to be properly appreciated. Thus, the relevant mark here is internal, as opposed to external, temporal relations.

15. I.e., the period of time *normative* for viewing the film is fixed by the film makers in making it.

16. We would like to thank Gregory Currie, Eric Dayton, David Goldblatt, Monique Roelofs, Joel Rudinow, Anthony Wall, and especially Stan Godlovitch for suggestions and examples which made their way into this essay.

Contributors

Felicia Ackerman, Department of Philosophy, Brown University

Philip A. Alperson, Department of Philosophy, University of Louisville

Norton T. Batkin, Center for Curatorial Studies, Bard College

Noël Carroll, Sage School of Philosophy, Cornell University

Donald Davidson, Department of Philosophy, University of California, Berkeley

Mark DeBellis, Heyman Center for the Humanities, Columbia University

Aron Edidin, Division of Humanities, University of South Florida at Sarasota/ New College

Catherine Z. Elgin, Department of Philosophy, Dartmouth College

Ivan Fox, Department of Philosophy, Yale University

David K. Glidden, Department of Philosophy, University of California, Riverside

Karsten Harries, Mellon Professor of Philosophy, Yale University

Peter Kivy, Department of Philosophy, Rutgers University

Robert Kraut, Department of Philosophy, Ohio State University

Jerrold Levinson, Department of Philosophy, University of Maryland

Joseph Margolis, Department of Philosophy, Temple University

Julius M. Moravcsik, Department of Philosophy, Stanford University

Philip L. Quinn, Department of Philosophy, University of Notre Dame

Colin Radford, Keynes College, University of Kent at Canterbury

Diana Raffman, Department of Philosophy, Ohio State University

Amélie Oksenberg Rorty, Mary Ingraham Bunting Institute, Radcliffe College

Guy Sircello, Department of Philosophy, University of California, Irvine

Josef Stern, Department of Philosophy, University of Chicago

Patrick Suppes, Lucie Stern Professor of Philosophy, Stanford University

Bruce Vermazen, Department of Philosophy, University of California, Berkeley

Terence E. Wilkinson, Department of Philosophy, Nottingham University

Nicholas Wolterstorff, Yale Divinity School

Eddy M. Zemach, Department of Philosophy, Hebrew University of Jerusalem

Peter A. French is Lennox Distinguished Professor of Philosophy at Trinity University in San Antonio, Texas. He has taught at the University of Minnesota, Morris, and has served as Distinguished Research Professor in the Center for the Study of Values at the University of Delaware. His books include *The Scope of Morality* (1980), *Ethics in Government* (1982), and *Collective and Corporate Responsibility* (1980). He has published numerous articles in the philosophical journals. **Theodore E. Uehling, Jr.,** is professor of philosophy at the University of Minnesota, Morris. He is the author of *The Notion of Form in Kant's Critique of Aesthetic Judgment* and articles on the philosophy of Kant. He is a founder and past vice-president of the North American Kant Society. **Howard K. Wettstein** is professor of philosophy at the University of California, Riverside. He has taught at the University of Notre Dame and the University of Minnesota, Morris, and has served as a visiting associate professor of philosophy at the University of Iowa and Stanford University. He is the author of *Has Semantics Rested on a Mistake? and Other Essays* (Stanford University Press, 1992).